Saul Steinberg, *Untitled*. Originally published in *The New Yorker*, January 9, 1965.
© 2004 The Saul Steinberg Foundation/Artists Rights Society (ARS), New York.

# The Visual Experience

## Third Edition

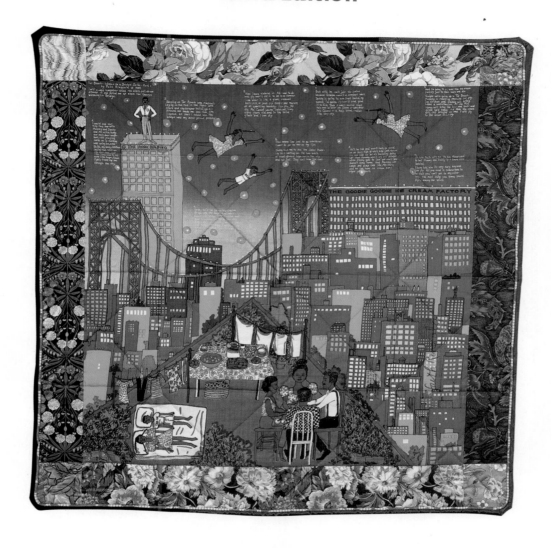

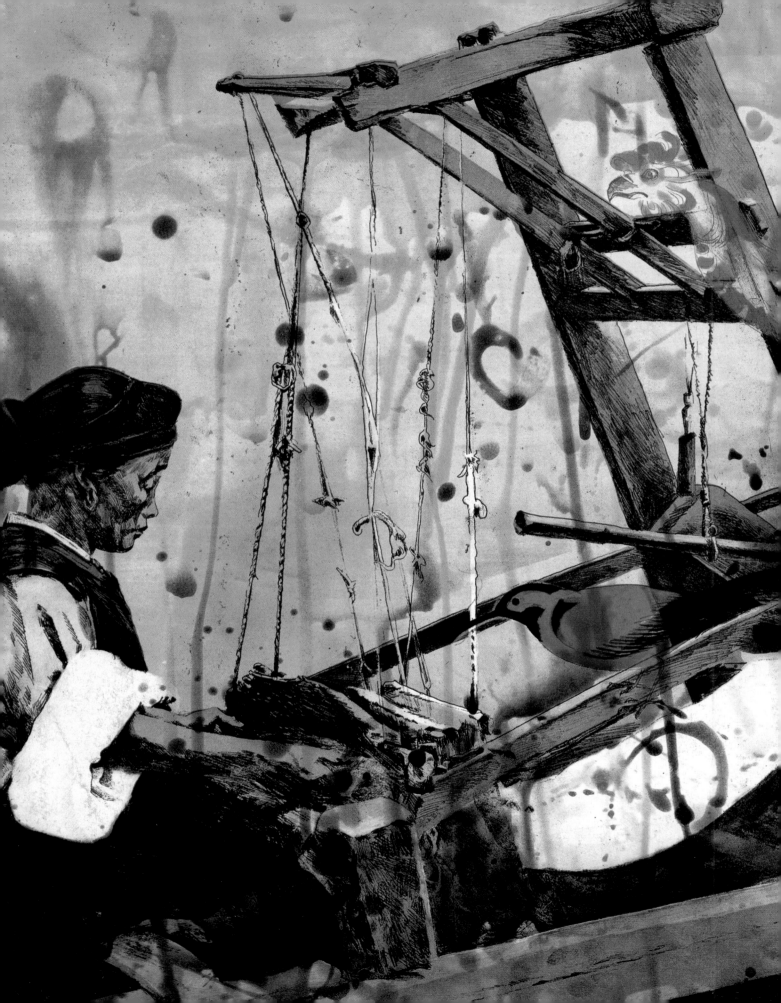

# The Visual Experience

**Third Edition**

**Jack Hobbs      Richard Salome      Ken Vieth**

**Davis Publications, Inc.**  **Worcester, Massachusetts**

**Jack Hobbs** is professor emeritus at Illinois State University. He served as art supervisor for nine years at Crystal Lake Public Schools, Illinois. He completed his PhD at the University of Iowa. Dr. Hobbs is also the author of several college texts including *Art in Context* and *Teaching Children Art*. He has been active as an exhibiting artist and has been featured in such shows as the National Exhibition of Prints and the Art in the Embassies Program held in Washington, DC.

**Richard A. Salome** is professor emeritus at Illinois State University. He has also taught at the University of Minnesota and Stanford University, where he received his EdD. Most of his public school art teaching experience has been at the secondary level. Dr. Salome served as coeditor, and senior editor, of the National Art Education Association's *Studies in Art Education*, and was the originator and first editor of *Translations: From Theory to Practice*.

**Ken Vieth** taught high school art for twenty-one years at Montgomery High School in Skillman, New Jersey. He has also taught at the K–8 and college levels. He holds an MA from Goddard College. His efforts in visual problem solving have been supported by the Geraldine R. Dodge Foundation, Princeton University, the Christa McAuliffe Fellowship Program, the Fulbright Memorial Fund, and the Fulbright International Exchange Program. His artworks are held in private collections in the United States, Canada, and Great Britain. He is a frequent contributor to *SchoolArts Magazine*, and the author of *From Ordinary to Extraordinary: Art and Design Problem Solving* (Davis).

© 2005 Davis Publications, Inc., Worcester, Massachusetts, USA

Printed in the USA
Library of Congress Catalog Card Number: 2003116215
ISBN 10: 0-87192-627-X
ISBN 13: 978-0-87192-627-2
10 9 8 7 6

Half title page illustration: Faith Ringgold, *Tar Beach 2*, 1990. Quilt. Silk, 66" x 64 1/2" (167.6 x 168.8 cm). Philadelphia Museum of Art: Purchased with funds contributed by W. B. Dixon Stroud, 1992. Photo by Graydon Wood, 2002

Title page illustration: Hung Liu, *Women Working: Loom*. Color aquatint and softground etching, Ed. 35, 40 3/4" x 50" (103.5 x 127 cm). © Hung Liu. Courtesy Paulson Press.

Cover artist **Trenton Doyle Hancock** has been drawing since the age of two. He lives and works in Houston, Texas. He is featured in the PBS series **art:21**.

Cover illustration: Trenton Doyle Hancock, *Strudi Flooo* (detail), 2002. Mixed media on felt, 78" x 126 3/4" (198 x 322 cm). Courtesy Dunn & Brown Contemporary, Dallas, Texas. See pages 206–7 for full image.

# Contents

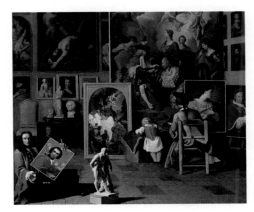

# Chapter 4

## Shape and Form    58

See page 88

# Chapter 5

## Value and Color    88

See page 58

# Chapter 6

## Space

116

See page 116

See page 148

# Chapter 7

## Texture

148

See page 166

See page 208

See page 254

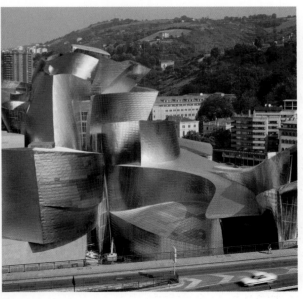

See page 296

See page 326

See page 352

See page 380

See page 410

# Chapter 16

## Western Art History II 442

See page 480

## Part Five

# Resources

See page 442

# Features

## Artist Biographies

# Features

## Art Criticism Step by Step

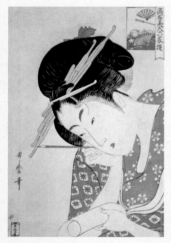
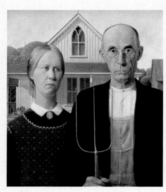
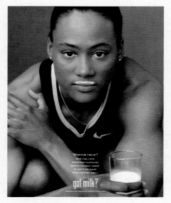

# Features

## Studio Experiences and Studio Backgrounds

See page 89

# Features

## Studio Experiences and Studio Backgrounds

See page 149

See page 209

See page 407

# The Visual Experience—Much More Than

## Part One
## Introduction to Art

### Start with the basics
This part of *The Visual Experience* will help you learn to define art, and introduce you to the critical method you'll use throughout the text to evaluate the art you see.

#### Chapter 1
#### What Is Art?
Get acquainted with the many forms of expression that we call art in the twenty-first century.

#### Chapter 2
#### How Should We Look at Art?
Learn about the four steps of art criticism, and how you can use them to evaluate artwork.

## Part Two
## Elements of Art and Principles of Design

### Learn the building blocks of art
To understand art, it helps to know how it's constructed. This part of the book explores the elements of art and the principles of design that artists use to organize their compositions.

#### Chapter 3
#### Line
Find out the complicated ways artists use this deceptively simple element, and learn to use lines yourself.

#### Chapter 4
#### Shape and Form
Get to know the flat and 3-D world around you, and look at it as artists do.

#### Chapter 5
#### Value and Color
Learn value and color vocabulary as you marvel at the range of emotion that can be expressed using colors in different ways.

#### Chapter 6
#### Space
Discover the creation of depth in 2-D artworks, and the importance of space in 3-D works of art and architecture.

#### Chapter 7
#### Texture
Sometimes you can feel it, and sometimes it only looks like you can feel it. It's texture, and it packs a big wallop in art, as you'll learn as you "feel" your way through this chapter.

#### Chapter 8
#### The Principles of Design
Find out how artists organize their compositions using unity, variety, emphasis, balance, proportion, pattern, movement, and rhythm.

## Part Five
## Resources

# the Sum of Its Parts

## Part Three
## Art Media and Careers

### Find out how the pros do it

Knowing how and why a particular art medium is used can help you appreciate a work of art more fully. This part of your text shows you how art media are used, and how you might like to use art in a career of your own.

## Part Four
## Art History

### Explore the past to understand the present

When and where an artwork was made, who made it, and what was going on in the civilization of the time are all important clues to what the artwork means. This part of the text gives you a context for the art you see.

---

### Support materials you'll rely on

**Student Handbook**  Need a quick reference to common studio concepts and techniques? You'll find it here.

**Glossary with Pronunciation Guide**  Forgotten the meaning of an art term? Check here, and find out how to say it, too.

**Index**  Looking for something you know you read, or an artist's work? Look here first.

# Experience the Power of Art

*The Visual Experience* is organized in a consistent format. Easy to follow, engaging, colorful, and stimulating, this book truly makes learning about art a visual experience.

## Know What's Ahead

### Chapter openers

tell you where you're headed, and what you'll be learning as you move through the chapter.

- **Clear number and title** let you know where you are in the book
- **Large, colorful artwork** relates to chapter content
- **Caption** gives you information about the artwork or artist; credit line gives you the details of date, medium, size, and who owns the artwork

**Key Terms** lists the main vocabulary words used in the chapter, in **English** and **Spanish**

**Artists lists** let you know which artists' works you'll find in the chapter

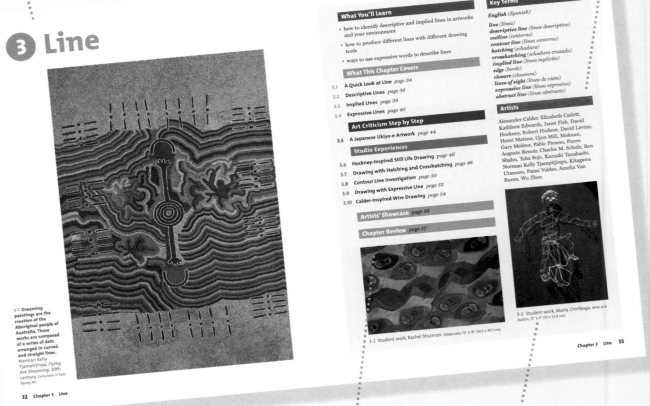

**3 Line**

3-1 Dreaming paintings are the creation of the Aboriginal people of Australia. These works are composed of a series of dots arranged in curved and straight lines. Norman Kelly Tjampitjinpa, *Flying Art Dreaming*, 20th century. Collection of Tom Raney, NY.

32   Chapter 3   Line

**What You'll Learn**

- how to identify descriptive and implied lines in artworks and your environment
- how to produce different lines with different drawing tools
- ways to use expressive words to describe lines

**What This Chapter Covers**

3.1   A Quick Look at Line *page 34*
3.2   Descriptive Lines *page 36*
3.3   Implied Lines *page 38*
3.4   Expressive Lines *page 40*

**Art Criticism Step by Step**

3.5   A Japanese Ukiyo-e Artwork *page 44*

**Studio Experiences**

3.6   Hockney-Inspired Still Life Drawing *page 46*
3.7   Drawing with Hatching and Crosshatching *page 48*
3.8   Contour Line Investigation *page 50*
3.9   Drawing with Expressive Line *page 52*
3.10   Calder-Inspired Wire Drawing *page 54*

**Artists' Showcase** *page 56*

**Chapter Review** *page 57*

**Key Terms**

*English (Spanish)*

*line (línea)*
*descriptive line (línea descriptivo)*
*outline (contorno)*
*contour line (línea contorno)*
*hatching (echadura)*
*crosshatching (echadura cruzada)*
*implied line (línea implícito)*
*edge (borde)*
*closure (clausura)*
*lines of sight (línea de vista)*
*expressive line (línea expresiva)*
*abstract line (línea abstracto)*

**Artists**

Alexander Calder, Elizabeth Catlett, Kathleen Edwards, Janet Fish, David Hockney, Robert Hudson, David Levine, Henri Matisse, Gjon Mili, Moknan, Gary Molitor, Pablo Picasso, Pierre Auguste Renoir, Charles M. Schulz, Ben Shahn, Toba Sojo, Kazuaki Tanahashi, Norman Kelly Tjampitjinpa, Kitagawa Utamaro, Patssi Valdez, Amelia Van Buren, Wu Zhen

3-2 Student work, Rachel Stuzman. Watercolor, 12" x 18" (30.5 x 45.7 cm).

3-3 Student work, Maria Chiriboga. Wire and button, 13" x 9" (33 x 22.8 cm).

Chapter 3   Line   33

**Student artworks**
from a chapter Studio Experience will inspire your own creative ideas

### Here's your map of the chapter content:

- **What You'll Learn** tells you the basic objectives of the chapter
- **What This Chapter Covers** lets you see the chapter's main lessons, including **Art Criticism Step by Step**
- Hands-on **Studio Experiences** are listed by number
- **Artists' Showcase** and **Chapter Review** are easy to find here

# Take a Quick Look

## A Quick Look at...
gives you a condensed version of the chapter content. It's handy as a preview before you start the chapter, or as a review once you've gone through it.

## Lesson number and title
at the beginning of each lesson allow you to navigate the chapter

### 3.1 A Quick Look at Line

The word **line** has many definitions in the dictionary. You can hit a *line* drive in baseball, memorize *lines* for a play, and avoid being last in *line* in the cafeteria. In art the word *line* is used to describe long, thin marks, and there are many examples that fit this meaning.

Lines can be found in nature in such things as the veins of a leaf, the branches of a tree in winter, or the sands of a desert (fig. 3-4). Lines are everywhere in the world around you (fig. 3-6).

In fact, the printed letters and numbers you are reading right now are shapes made with lines. The letters *c* and *s* and the number *5* are made with single lines that are open at the ends. Some letters, like *f*, *t*, and *x*, are made with lines that cross. Some, like *y* and *k*, are made with open lines that are connected in places.

A road map is another example of lines. Lines and shapes on a map are symbols. They stand for other things like interstates and roads and rivers and streams (fig. 3-9).

3-4 **Line plays an important role in the structure of most natural and human-made objects.** Look closely at these leaves and notice their internal lines, as well as their outlines. Photograph: Brian Braye.

3-5 **Expressive lines give artworks a particular feeling.** What feeling do these lines convey? Gary Mollter, *Baghdad by the Bay.* Computer graphic in woodblock style. 72" x 56" (183 x 142 cm).

3-6 **Look out a window or around a room.** How many lines can you find? Write a list of words describing them. These descriptive words will help you better understand the variety and abundance of line in your everyday life. Photograph: Brian Braye.

3-7 Henri Matisse, *Woman with Folded Hands*, 1918–19. Pen and India ink on white paper, 10 5/8" x 14 7/16" (26.98 x 36.67 cm). The Minneapolis Institute of Arts, Gift of Mrs. Horace Ropes for the John De Laittre Memorial Collection.

Art has as many kinds of lines as the lines you find in nature or in books and maps. Many lines in art are created by moving a tool such as a pencil, charcoal stick, pen, or brush (figs. 3-5, 3-7). Some lines can even be made with light! (fig. 3-8)

The main kinds of lines in artwork are *descriptive lines*, *implied lines*, and *expressive lines*.

**Descriptive lines** are lines that help us understand what we are seeing. Descriptive lines include outlines, contour lines, single lines, and hatching.

**Implied lines** are lines that suggest an edge rather than clearly defining one. Implied lines occur where textures, colors, and values change at edges of shapes in artwork.

**Expressive lines** are lines that send us messages about what the artist wants his or her work to make us feel. Abstract lines, which are expressive, may not show us objects we recognize, but can still create a feeling in us. This chapter will help you learn to see and appreciate this most basic artistic component.

3-8 **Pablo Picasso was adept with line.** He could create an image with just a few strokes. Using a very slow exposure, a photographer captured Picasso drawing with a lighted torch. How would you describe the lines he is using? Gjon Mili, *A Centaur Drawn with Light—Pablo Picasso at the Madoura Pottery in Vallauris, France.* Photograph © 1984 Sotheby Parke Bernet, Inc., New York.

3-9 **The lines and shapes on this road map are symbols.** Can you think of other instances in daily life where lines are understood to be symbols?

### Linking Disciplines
**Geography**
Borrow **contour maps** from the drafting teacher or a surveyor's office. Discuss the relationship between contour drawings by an artist and the making of contour maps. Then make a drawing of your face or hand as if you were making a contour map.

## Sample artworks
drawn from the chapter help reinforce the main concepts

## Captions
provide background, ask thought-provoking questions

## Page number, chapter number, and chapter title
at the bottom of every page let you know where you are in the book

## Major vocabulary
for the chapter defined within the text

## Learn by Looking Carefully

### Text pages

As you move through each chapter, you'll find more special features to enliven and deepen your understanding of the world of art.

**Sidebars** on how art relates to the other subjects you're studying, possible art careers to pursue, writing, thinking, or hands-on exercises to try—appear throughout the chapter

### Large, exciting artworks

by artists from around the world and throughout history invite a closer look

---

**Try It Yourself**

Try to find the vanishing point and eye level of *The Country School* **(fig. 6-34)**. (Tip: Lay your straightedge along the lines formed by the benches on either side of the room, the top edge of the window on the left, and the top edge of the wall on the right.)

---

### 6.6 3-D Space in Abstract Painting

People tend to think that abstract art does not show spatial depth. Painters of abstract works are concerned with more than just the two-dimensional space of the picture plane. For some abstract painters, the suggestion of three-dimensional space is equally a concern.

Look at the depth in Paul Gauguin's stylized picture of a South Pacific scene **(fig. 6-31)**. It conveys a sense of depth through employing variations of size, overlapping, and high-low placement.

In *The Golden Wall* **(fig. 6-32)**, Hans Hofmann manipulated depth by both overlapping and color variation. The blue rectangle on the right seems to be on top of the yellow patches that it overlaps. Yet the yellow patches tend to come forward because they are warmer and lighter than the blue rectangle. See especially how the large yellow square in the lower left corner comes forward.

6-31 Paul Gauguin, *Tahitian Idyll*, 1892. Oil on canvas, 34 ½" x 44 ¼" (87.5 x 113.7 cm). Hermitage, St. Petersburg. Photo by Erich Lessing/Art Resource, NY.

6-32 "Push and pull" is the name Hofmann gave to his technique for using color and shape to create a sense of space, depth, and movement. Which colors and shapes in this painting "push"? Which ones "pull"? Hans Hofmann, *The Golden Wall*, 1961. Oil on canvas, 59½" x 71½" (151 x 182 cm). The Art Institute of Chicago, Mr. and Mrs. Frank G. Logan Prize Fund. Photo by Greg Williams.

### 6.7 Framing

*Framing* establishes the limits of what is seen in a picture. Winslow Homer framed *The Country School* **(fig. 6-34)** so that we see almost the whole one-room school. Because of the teacher's size and location, she is the most important person. But she, along with the students, is relatively small in comparison to the size of the picture. Therefore, she appears to be relatively far away.

Framing can affect the space, the point of view, and the meaning of a scene. Look at the single boy sitting on the bench near the teacher. He is one of the farthest-away people. In the new frame **(fig. 6-33)** he is much larger in comparison to the size of the picture. Therefore, he appears to be very close. Pictures like this that are framed very close to the central figure are sometimes called *close-ups*.

In the new picture the focus is just on the boy and what he is doing. In the original, he was merely a small part of a large scene. In what ways do you think the story has been changed? Is the new story more interesting or less interesting than the original?

6-33 Creating a close-up is one result of changing the frame of a picture. Winslow Homer, *The Country School* (detail), 1871. Oil on canvas, 21¼" x 38 ¼" (54 x 60 cm). The Saint Louis Art Museum (Purchase).

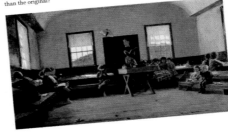

6-34 One of the reasons Homer is such a popular artist is because his works always "tell" an interesting story. Why is framing a key factor in establishing the boundaries of a narrative, or story-telling, image? Winslow Homer, *The Country School*, 1871. Oil on canvas, 21¼" x 38 ¼" (54 x 98 cm). The Saint Louis Art Museum (Purchase).

9-12 Gino Severini was part of a small group of Italian artists, called the Futurists, who sought to represent the dynamism of the modern age. Would this work be considered a good representation of their ideals? Why or why not? Gino Severini, *Paris Subway, Ferris Wheel, and Eiffel Tower*, c. 1912–13. Pastel and charcoal, 21½" x 19" (54.6 x 48.2 cm). © The Cleveland Museum of Art, Gift of Malcolm L. McBride.

...qualities we associate ...in its young subject.

9-31 John Valadez's pastels involve layers of pigment built up on the paper. Why might he have found this approach to be useful for illustrating the dreamlike "battle" scene of this painting? John Valadez, *La Frontera/The Border* (panel #2), 1993. Pastel on paper, 30" x 36½" x 2¼" (76.2 x 92.7 x 5.7 cm). Carnegie Art Museum Collection, City of Oxnard.

---

**Artist Biography**
**Mary Cassatt (1844–1926)**

Born in Pennsylvania, Mary Cassatt lived most of her life in France. Over her parents' objections, in 1861 she boldly enrolled at the Pennsylvania Academy of Fine Arts. This was at a time when art was frowned upon as an occupation for women.

Cassatt's keen desire to learn brought her to Paris, the center of the art world, in 1865. There she was able to pursue her studies of the great masters of the past, while working with influential Impressionist artists. Inspired by what she saw, Cassatt began to create paintings and prints, especially on the subject of mothers and children. She chose not to marry or have children herself. Rather, she focused her life on the pursuit of technical expertise in painting and print-making, and on achieving a beauty in her art that is uniquely her own.

9-33 Mary Cassatt was encouraged by her close friend the artist Degas to begin using pastels in her work. Why might Cassatt have made the face of the child more finished, but left the remainder of the work rather sketchy? Mary Cassatt, *Margot in a Dark Red Costume Seated on a Round Backed Chair (La Petite)*. Pastel on buff papers. Private Collection. © Christie's Images Ltd.

### Biographies of artists

or groups of artists who have made significant contributions to the world of art. Learn the life stories of major artists and the background behind their art

# Learn by Analyzing

## Art Criticism Step by Step

Develop your own critical skills while taking a journey of understanding. Carefully crafted questions lead you through analysis of a work of art, pointing you to its main features, helping you identify the art elements and principles of design used to create it, and allowing you to move toward comprehension of meaning and message.

**Colorful artworks** from a variety of cultures and time periods invite closer analysis

The **four-step critical method** takes you through simple **description**, to **analysis** of the artist's use of the art elements and principles of design, to **interpretation** of the work's meaning, and finally to **evaluation** of its success as an artwork

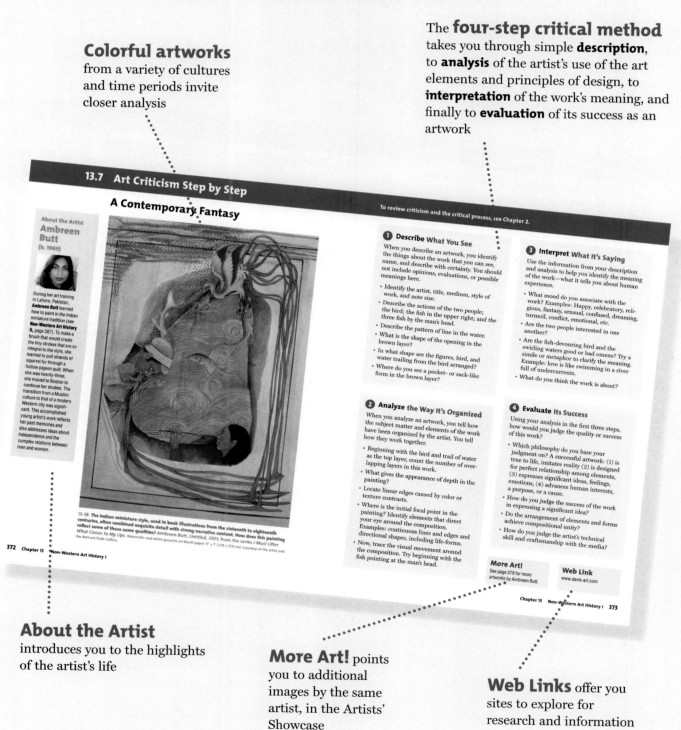

### 13.7 Art Criticism Step by Step

#### A Contemporary Fantasy

**About the Artist**
**Ambreen Butt**
(b. 1969)

During her art training in Lahore, Pakistan, **Ambreen Butt** learned how to paint in the Indian miniature tradition (see **Non-Western Art History II**, page 387). To make a brush that would create the tiny strokes that are so integral to the style, she learned to pull strands of squirrel fur through a hollow pigeon quill. When she was twenty-three, she moved to Boston to continue her studies. The transition from a Muslim culture to that of a modern Western city was significant. This accomplished young artist's work reflects her past memories and also addresses ideas about independence and the complex relations between men and women.

13-38 The Indian miniature style, used in book illustrations from the sixteenth to eighteenth centuries, often combined exquisite detail with strong narrative content. How does this painting reflect some of these same qualities? Ambreen Butt, *Untitled*, 2003, from the series *I Must Utter What Comes to My Lips*. Watercolor and white gouache on Wasili paper. 9" x 7" (219 x 118 cm). Courtesy of the Artist and the Bernard Toale Gallery.

372 Chapter 13 Non-Western Art History I

To review criticism and the critical process, see Chapter 2.

**① Describe What You See**

When you describe an artwork, you identify the things about the work that you can see, name, and describe with certainty. You should not include opinions, evaluations, or possible meanings here.

- Identify the artist, title, medium, style of work, and note size.
- Describe the actions of the two people; the bird; the fish in the upper right; and the three fish by the man's head.
- Describe the pattern of line in the water.
- What is the shape of the opening in the brown layer?
- In what shape are the figures, bird, and water trailing from the bird arranged?
- Where do you see a pocket- or sack-like form in the brown layer?

**② Analyze the Way It's Organized**

When you analyze an artwork, you tell how the subject matter and elements of the work have been organized by the artist. You tell how they work together.

- Beginning with the bird and trail of water as the top layer, count the number of overlapping layers in this work.
- What gives the appearance of depth in the painting?
- Locate linear edges caused by color or texture contrasts.
- Where is the initial focal point in the painting? Identify elements that direct your eye around the composition. Examples: continuous lines and edges and directional shapes, including life-forms.
- Now, trace the visual movement around the composition. Try beginning with the fish pointing at the man's head.

**③ Interpret What It's Saying**

Use the information from your description and analysis to help you identify the meaning of the work—what it tells you about human experience.

- What mood do you associate with the work? Examples: Happy, celebratory, religious, fantasy, sensual, confused, dreaming, turmoil, conflict, emotional, etc.
- Are the two people interested in one another?
- Are the fish-devouring bird and the swirling waters good or bad omens? Try a simile or metaphor to clarify the meaning. Example: love is like swimming in a river full of undercurrents.
- What do you think the work is about?

**④ Evaluate Its Success**

Using your analysis in the first three steps, how would you judge the quality or success of this work?

- Which philosophy do you base your judgment on? A successful artwork: (1) is true to life, imitates reality (2) is designed for perfect relationship among elements, (3) expresses significant ideas, feelings, emotions, (4) advances human interests, a purpose, or a cause.
- How do you judge the success of the work in expressing a significant idea?
- Do the arrangement of elements and forms achieve compositional unity?
- How do you judge the artist's technical skill and craftsmanship with the media?

**More Art!**
See page 378 for more artworks by Ambreen Butt.

**Web Link**
www.davis-art.com

Chapter 13 Non-Western Art History I 373

**About the Artist** introduces you to the highlights of the artist's life

**More Art!** points you to additional images by the same artist, in the Artists' Showcase

**Web Links** offer you sites to explore for research and information

# Learn by Creating

## Studio Experience

Apply in the studio what you've learned in the chapter, solving two- and three-dimensional design challenges in many media. Student artworks and examples from art history will show you other approaches for reference, but these Studio Experiences are designed to help you create artwork that is meaningful to *you*.

**Step-by-step**
instructions take you
through the process

**Materials lists**
outline the media you'll
be using

**Computer Options**
offer alternatives
for creating artworks
using software
technology

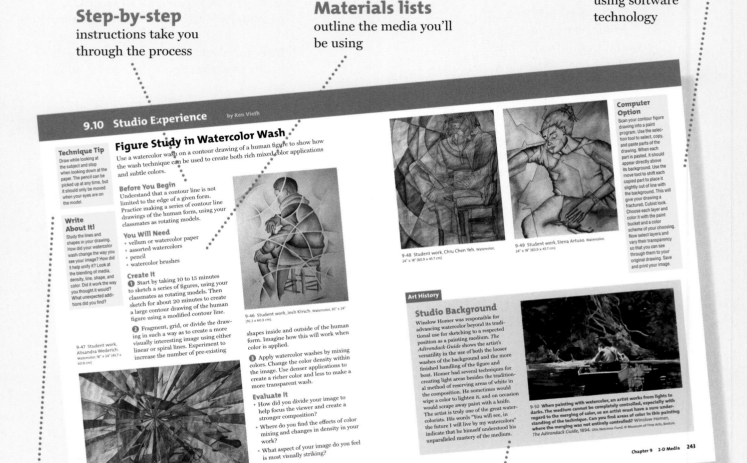

**Technique Tips**
offer point-of-use strategies
for success in using art media

**Write About It!**
offers personalized suggestions
for reflective writing on the
Studio Experience

**Student artworks**
give you a sense of how
other students approached
the Studio Experience

**Art History Studio Backgrounds**
introduces you to fine art or other concepts that
relate to your Studio Experience, and offering
you related art history background information

xxiv

## Artists' Showcase and Chapter Review

The final pages of each chapter offer you more artwork related to chapter content, summarize what you've learned, and allow you to check your understanding before moving on. Additional research, portfolio, and sketchbook exercises help reinforce the chapter's content and take you deeper into the chapter's subjects.

**Artists' Showcase** More chapter-related artwork, including additional images by the artist featured in Art Criticism Step by Step

**Review** the chapter content and test your critical thinking by responding to the six review questions. Some require writing, sketching, or studio work; others are in short-answer format

**Portfolio tips** help you begin and maintain a showcase of your best work

Dig into the **Web** to do further electronic research on a range of art topics

**Sketchbook** suggestions help you sharpen your observation and drawing skills with

Explore beyond the boundaries of each chapter by **Going Further**

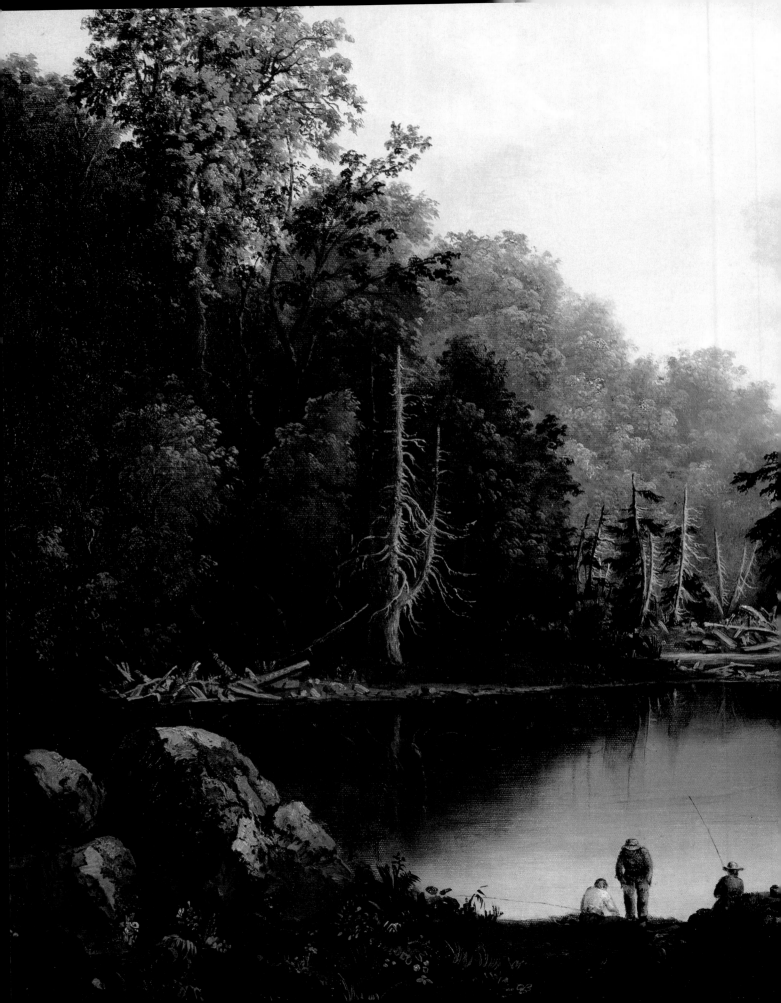

# Part One
# Introduction to Art

1  What Is Art?
2  How Should We Look at Art?

Robert S. Duncanson, *Blue Hole, Flood Waters, Little Miami River*, 1851.
Oil on canvas. 29¼" x 42¼" (74 x 107 cm). Cincinnati Art Museum. Gift of Norbert Heermann and Arthur Helbig.

# 1 What Is Art?

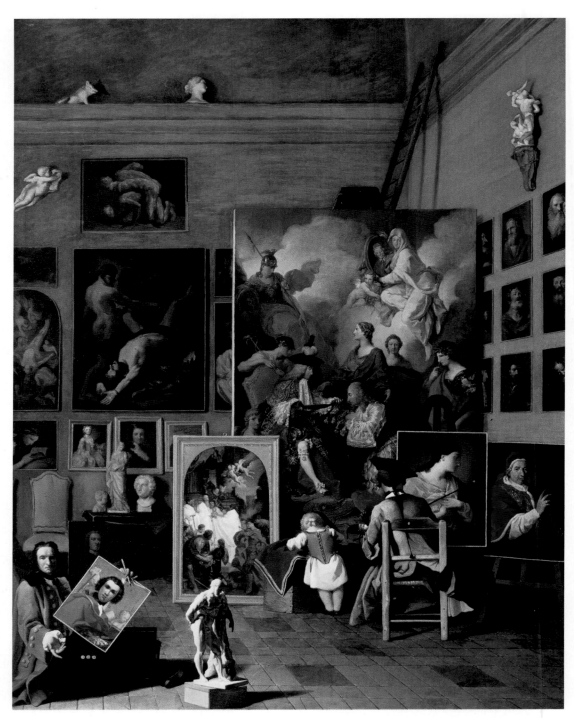

1-1 **This painting from the 1700s is about being an artist. It is also a painting about paintings. How does this work agree or disagree with your idea of what art is?** Pierre Subleyras, *The Artist's Studio*. Oil on canvas, 125" x 99" (317.5 x 251.5 cm). Courtesy Gemäldegalerie der Akademie der bildenden Künste Wien.

What does the word *art* mean to you? Does it remind you of paintings and sculptures? Does it make you think of an art gallery or art museum where these objects are displayed? Or does art make you think of a classroom full of paints and other supplies where you and your classmates make artworks and talk about them?

If the word *art* made you think about those kinds of objects and places, you were correct. But art is more than that. It is also people. *Artists* make art and *viewers* visit galleries and museums. *Teachers* talk about art and *students* like you study it. All of these people see, wonder about, and enjoy art.

Art obviously involves seeing. But seeing effectively is a special skill. If you know how to see art, it can fill you with wonder—with a sense of curiosity, amazement, or even astonishment. And art can give you enjoyment, not just because it is pleasant to look at art. Seeing art is meaningful and worthwhile.

A good place to begin this book is with the artwork itself. What is an artwork? What sets it apart from other objects? You probably already have some ideas about this subject.

Before you take the ungraded quiz on the following pages, take two minutes to list as many artworks as you can, including what they are made of (their *medium*) and what they show (their *subject*). Try a second list after you've read the chapter, and compare them.

## Key Terms

**English** (*Spanish*)

**art** (*arte*)
**medium** (*medio*)
**subject** (*asunto*)
**traditional** (*tradicional*)
**abstract** (*abstracto*)
**ceramic** (*cerámica*)

Test your ability to recognize an artwork by taking the quiz on these pages. You won't be graded on this.

**Art Quiz**

Answer the question that goes with each of the ten pictures. The answers are on page 6.

**1** This is
   a. a panel from a comic strip
   b. an artwork

**2** This picture is
   a. an illustration for a children's story
   b. an artwork

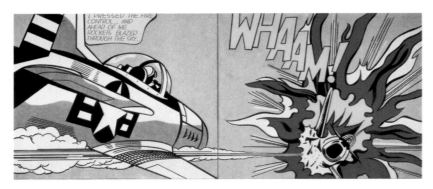

**3** This is
   a. a major piece of American architecture
   b. just another old office building

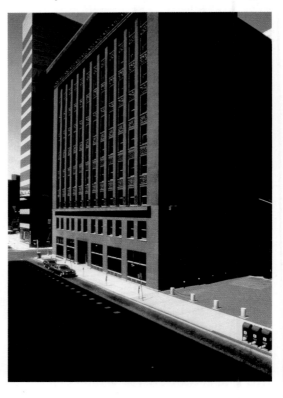

**4** This is
   a. a briefcase
   b. an artwork

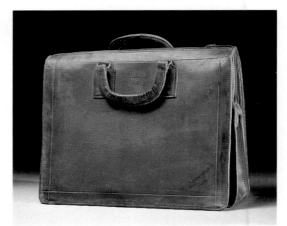

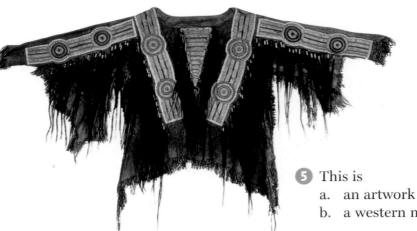

**5** This is
   a. an artwork
   b. a western movie costume

**6** This is a photograph of
   a. an oil spill cleanup
   b. an environmental artwork

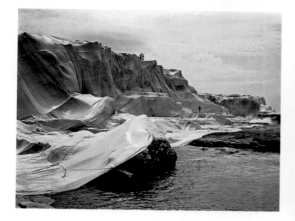

**7** This is
   a. an artwork
   b. a suit of clothes

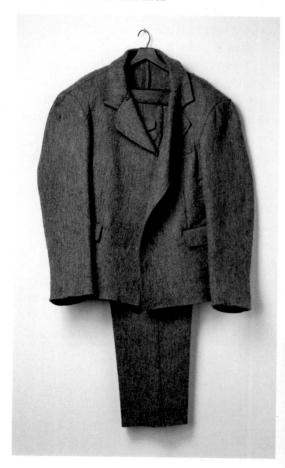

**8** These cave images are
   a. a painting made over 15,000 years ago
   b. graffiti made as a joke by some boys around 60 years ago

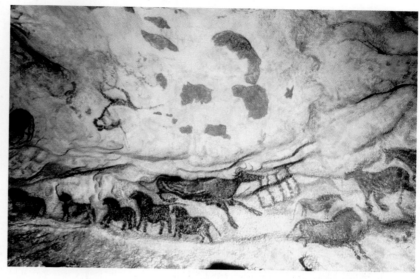

**9** This is
   a. a diagram of color/ value relation- ships
   b. an artwork

**10** This is
   a. a protest by animal rights activists
   b. an artwork

Quiz Answers

**1** b; **2** b; **3** a; **4** b; **5** a;

**6** b; **7** a; **8** a; **9** b; **10** b

Were you surprised by any of the answers? You may have answered that some things were not art, when they really are. This is because you may not realize that art today comes in so many forms and varieties.

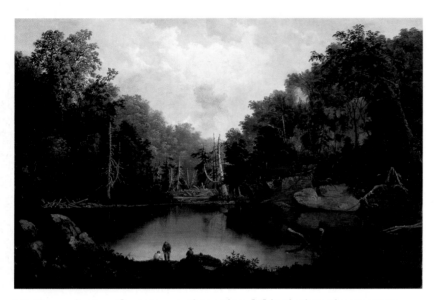

1-3 **Many nineteenth-century artists painted this Cincinnati-area scene. How might it have changed in the past 150 years? Do you think you would recognize it today?** Robert S. Duncanson, *Blue Hole, Flood Waters, Little Miami River*, 1851. Oil on canvas, 29 1/4" x 42 1/4" (74 x 107 cm). Cincinnati Art Museum, Gift of Norbert Heermann and Arthur Helbig.

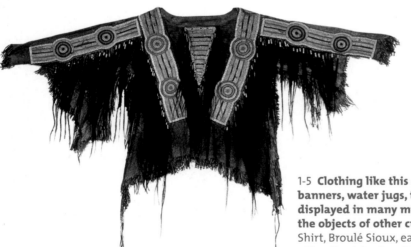

1-5 **Clothing like this shirt, as well as masks, banners, water jugs, tools, and weapons, are displayed in many museums. Why do we collect the objects of other cultures and time periods?** Shirt, Broulé Sioux, early 19th century. Buckskin with quillwork, beads, and hair locks, 58" (147 cm) arm spread. Courtesy of The National Museum of the American Indian.

1-4 **These images of animals were painted on cave walls about 17,000 years ago, and are the oldest paintings known to us. What artwork being created now might last 17,000 years?** Cave painting, Lascaux, c. 15,000 BCE. Dordogne, France. Courtesy Woodfin Camp and Associates, Incorporated.

You may have recognized artwork **2**, the landscape painting (fig. 1-3), as an artwork. It is very ***traditional***. It has a familiar and recognizable form, style, and subject matter. Yet the detail and the people shown in it may have led you to believe it was an illustration. Many artworks seem to tell stories.

Although you won't see artwork **8**, the cave painting (fig. 1-4), in a museum, you probably knew it was made many thousands of years ago. You can often find pictures of cave paintings in art books. And although some boys found this particular cave painting, they did not create the art themselves.

The object in artwork **5** (fig. 1-5) is a genuine buckskin shirt of the Broulé Sioux people. Such objects—especially if they are from an ancient culture—are highly valued today. Objects like this are collected and placed in museums.

The object in question **9** (**fig. 1-6**) is an *abstract* painting by Josef Albers. Abstract art does not resemble things you see in real life. Albers's works often involve investigations of color. So, if you guessed "a diagram of color/value relationships," you were not far off. Before the twentieth century, however, Albers's work would not have been considered art because it was not realistic. Today, of course, we are accustomed to abstract art—whether of the free-form type or the geometric kind, like Albers's.

Artwork **1** (**fig. 1-7**) has a style that makes it look like a comic strip. Before World War II, an artist could not have gotten away with imitating something so ordinary as a comic. But an art movement in the 1960s called Pop Art changed attitudes about this. Pop artists like Roy Lichtenstein used images from popular culture to comment on American society and values. You'll learn more about this in later chapters.

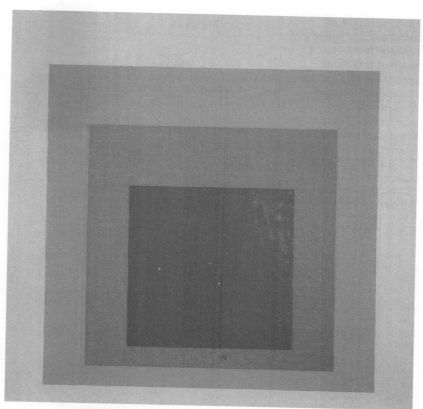

**1-6** **Artists who create abstract paintings are often interested in how shapes and colors work together. What do you think this artist wanted you to notice when he painted this series of squares?** Josef Albers, *Homage to the Square: Glow*, 1966. Acrylic on fiberboard, 48" x 48" (122 x 122 cm). Hirshhorn Museum and Sculpture Garden, Smithsonian Institution, Gift of Joseph H. Hirshhorn, 1966.

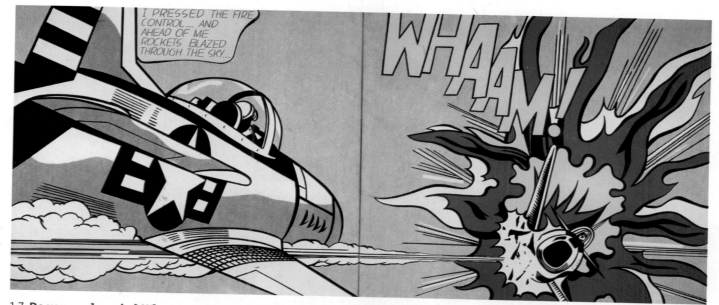

**1-7** **Do you read comics? When a comic is enlarged to over thirteen feet long, how is its impact changed?** Roy Lichtenstein, *Whaam!*, 1963. Magna acrylic and oil on canvas, 2 canvases each 68" x 80" (172.7 x 203.2 cm). © Contemporary Arts Services, NY. Tate Gallery, London. Art Resource, NY.

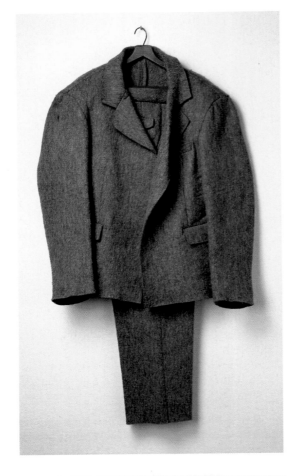

**1-8** Why might an artist want to make a realistic felt suit as a piece of art? Think about a material that has special meaning for you—flannel, wood, straw, leather. What could you make from it? Joseph Beuys, *Felt Suit*, 1970. Felt, wood, and wire, 67" x 39" (170.2 x 99.1 cm). The Art Institute of Chicago; Twentieth Century Purchase Fund. ARS, New York/VG Bild-Kunst, Bonn.

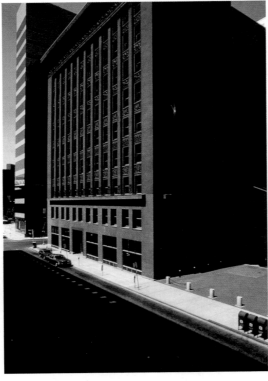

**1-9** High-rise buildings like this one became possible when builders developed iron and steel frame construction in the 1800s. Can you think of new building materials that have changed the look or construction style of buildings around you? Louis Sullivan, Wainwright Building, St. Louis, Missouri, 1890–91. Photograph by George Barford.

Another example of Pop—or Pop-related—art is the felt sculpture by Joseph Beuys in question **7** (fig. **1-8**). Did you think it was just a man's suit? Beuys was a fighter pilot for the German air force (Luftwaffe) during World War II. When he was shot down, some peasants rescued him and kept him warm by covering him with layers of felt. For that reason, many of Beuys's artworks include felt material.

Do you think of architecture as art? Louis Sullivan, one of America's most distinguished architects, designed the Wainwright Building, shown in question **3** (fig. **1-9**) in 1890–91. Yes, it is an old St. Louis office building, but it's not *just* an old building. Architects recognize it as a major advance in the style of high-rise commercial architecture. For more on the history of architecture, see **Chapter 11**.

Were you fooled by artwork **4**, the ceramic sculpture (fig. **1-10**)? *Ceramic* refers to fired clay, a material that has been used for thousands of years for making pottery. Until quite recently ceramic artists made only useful objects such as plates and jars. Now many artists feel free to make anything out of clay.

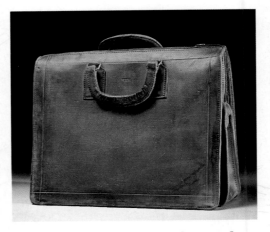

**1-10** The idea of making artwork—namely paintings—so realistic they "fool the eye" was very popular in nineteenth-century America. Do you feel tricked or fascinated by this briefcase made of clay? Marilyn Levine, *H. R. H. Briefcase*, 1985. Clay and mixed media, handbuilt (slab constructed), 16" x 17½" x 6¾" (41 x 45 x 17 cm). O. K. Harris Works of Art.

Artworks **6** (fig. 1-11) and **10** (fig. 1-12) may have seemed the least like art to you. How can throwing yards of fabric over a coastline be artwork? Why would people go to a museum to see a stuffed goat with a tire around its middle? Years ago, people had a difficult time accepting even abstract paintings as art, although they were made with traditional paint on canvas. But over the past hundred years, our idea of what art is has become much broader.

Artists today are likely to use almost any material and shape it into almost any form. They may even perform their art. New technologies have allowed some artists to experiment with neon lights, video, digital photography, and sound. Some new art uses techniques that had not been heard of even thirty years ago. This new freedom and technology, however, has raised some questions about the definition of art. In the next chapter, we'll explore some of those questions.

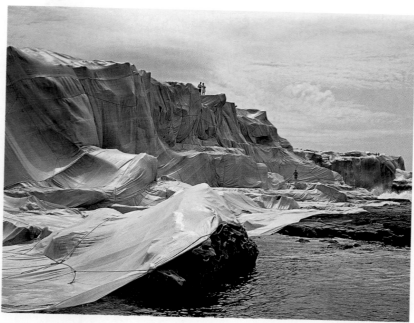

1-11 **Try to imagine what Christo and Jeanne-Claude's *Wrapped Coast* looks like from above, and from different distances. How does it change the landscape? How does a coastline change over time?** Christo and Jeanne-Claude, *Wrapped Coast, One Million Square Feet, Little Bay, Sydney, Australia* (detail), 1968–69. 90,000 square meters of erosion control fabric and 35 miles of rope. Photograph: Harry Shunk. © Christo 1969.

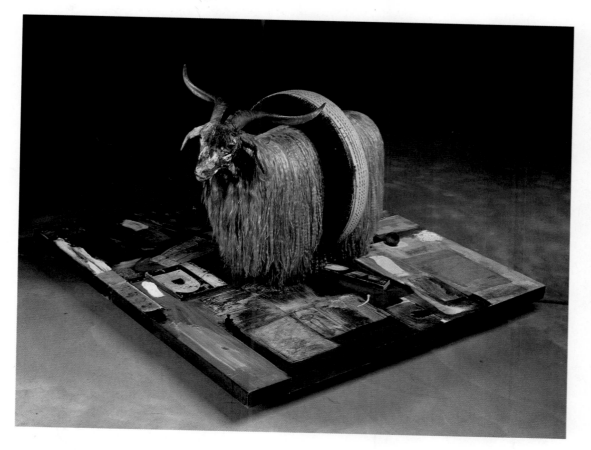

1-12 **Robert Rauschenberg found many of the materials for his artworks on the streets and in the junk shops of New York City. Look around your neighborhood. What could you make from things you find on the street or the ground? What would they reveal about where you live and who you are?** Robert Rauschenberg, *Monogram*, 1959. Construction, 48" x 72" x 72" (122 x 183 x 183 cm). Moderna Museet, Stockholm.

*Video artists* like Nam June Paik (**fig. 1-13**) use moving images to make their artworks. *Installation artists* like Ilya Kabakov (**fig. 1-14**) may combine video with other objects, while *performance artists* like Jose Alvarez (**fig. 1-15**) "act out" their works before a live audience. A century ago, it would have been difficult to conceive of these artworks. What new kinds of art can you dare to imagine might be possible in the year 2100?

1-13 Nam June Paik, *Video Flag*, 1985–96. 70 video monitors, four laser disc players, computer, timers, electrical devices, wood and metal housing on rubber wheels, 94 3/8" x 139 3/4" x 47 3/4" (239.7 x 354.9 x 121.3 cm). Hirshhorn Museum and Sculpture Garden, Smithsonian Institution, Holenia Purchase Fund, in Memory of Joseph H. Hirshhorn, 1996.

1-15 Jose Alvarez, *Knowledge Sessions "number IV (tonal)."* The Whitney Museum of American Art.

1-14 Ilya Kabakov, *The Man Who Flew into Space from His Apartment*, from *Ten Characters*, 1981–88. Six poster panels with collage, furniture, clothing, catapult, household objects, wooden plank, scroll painting, two pages of Soviet paper. Installation at Ronald Feldman Fine Arts, NY.

# Chapter Review

## Summary

Usually, the word *art* makes people think of artworks, museums, and galleries. Art, however, is also people: artists, viewers, art historians, archaeologists, teachers, and students.

You have read just one chapter in this book. Yet you have already learned that today's art comes in an endless variety of forms. Most of this variety came about in the twentieth century. Before that, painting and sculpture were the only objects people thought of as art. Today the idea of what art is, and can be, has broadened. Everyday objects from the past and from other cultures are now considered art.

The objective of this book is to introduce you to some of the rich variety of today's art—a world of objects, places, and people for you to see, wonder about, and enjoy.

## Review Questions

1. **Recall:** Define the word *medium* as it is used in art.

2. **Understand:** Explain why people today might think of a stuffed goat as an artwork.

3. **Apply:** Choose an object you like and use regularly—a pen, a mug, or a key chain, for example—and write a short paragraph describing what the object tells about life in your culture today.

4. **Analyze:** Divide the works in this chapter into two groups: those made before 1940 and those made after 1940. Explain what the works in each group have in common.

5. **Synthesize:** Write two short stories or poems. Base one on the Lascaux cave paintings and the other on Josef Albers's *Homage to the Square: Glow.* Use words that seem to match the paintings.

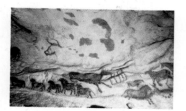

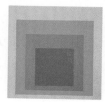

6. **Evaluate:** Imagine you are an art buyer for a museum. Recommend three nontraditional works from this chapter for purchase by the museum. Justify your choices: What makes these works nontraditional?

## Electronic Research

Using the Internet, conduct a search using only the names of artists found in this chapter. Examine and evaluate the Web sites of the ones you are able to find. Which sites seem to have the most credibility? Which sites are the best designed? Which sites have the most significant content? Make a list of the criteria you develop to evaluate the sites. Share and discuss your list with another student.

## Going Further

In the history of Western art, there are five basic theories that explain beliefs about art: formalism, instrumentalism, imitationalism, expressionism, and institutionalism. Find out more about each of these theories. Then select one artwork from any of the chapter openers in this book and try to explain it from each of these theories. By doing this, you might find that some theories are more applicable than others. You might also reflect on and perhaps modify or reaffirm your beliefs about art.

# 2 How Should We Look at Art?

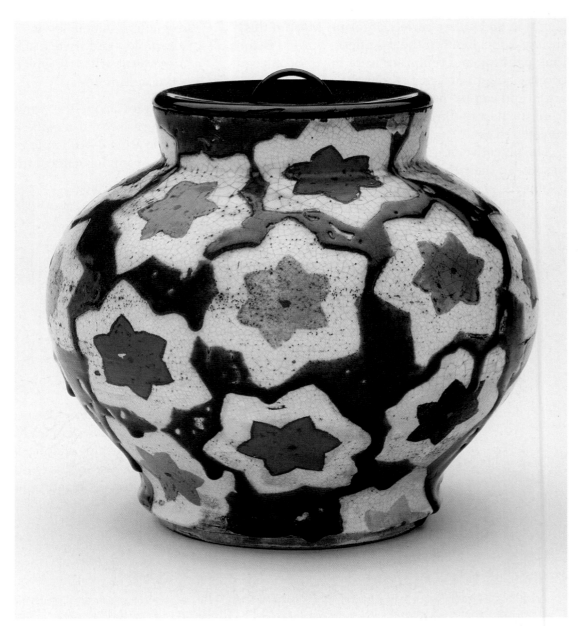

2-1 **Take a moment to consider this little jar. What do you notice about it? What qualities about it catch your eye?** Ogata Kenzan, Water jar with design of maple leaves, c. 1731–43. Buff clay, white slip, iron pigment under transparent glaze, and enamels over glaze; lacquer additions, lacquered wooden lid, 5¹⁄₂" x 6¹⁄₈" (14.2 x 15.9 cm). Freer Gallery of Art, Smithsonian Institution, Washington, DC: Gift of Charles Lang Freer.

In Chapter 1 we saw many things called art—from a stuffed goat to a ceramic briefcase. Today's art can be almost anything. It can even be a wrapped coastline or an Indian shirt. However, the exciting variety of art in our time raises questions: Can anything be art? Are *all* stuffed goats and Indian shirts art?

These questions are part of the larger question, "What is art?" Long ago, this question was easy to answer. If something was a painting, a sculpture, or an architectural monument, it was art. But today, this question is difficult to answer.

Perhaps a better question to ask is *When* is it art? Under what conditions do things like ceramic briefcases and stuffed goats become art? What is needed for something, *anything*, to be called an artwork?

In this chapter, we'll talk about art, the people who evaluate art, and how you can begin to look at it carefully yourself.

## Key Terms

*English (Spanish)*

*philosophy of art* (*filosofía del arte*)
*design* (*diseño*)
*aesthetic experience* (*experiencia estética*)
*art criticism* (*crítica de arte*)
*description* (*descripción*)
*elements of art* (*elementos de arte*)
*analysis* (*análisis*)
*principles of design* (*principios de diseño*)
*composition* (*composición*)
*interpretation* (*interpretación*)
*evaluation* (*evaluación*)
*formalism* (*formalismo*)
*expressiveness* (*expresividad*)

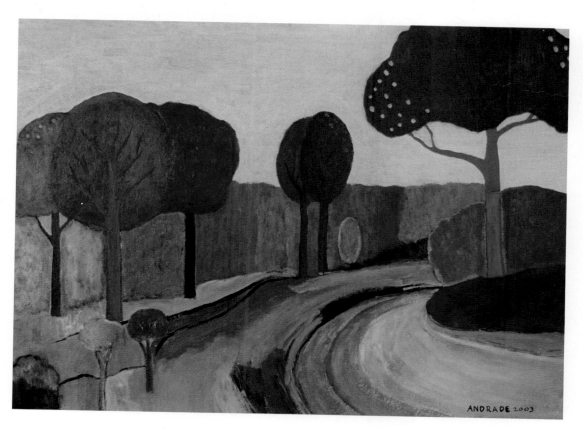

2-2 **"Nature's charm has given me a keener sensibility, and a point of reference, for my quest of inner truths," says the artist who created this painting.** Bruno Andrade, *Days Ahead*, 2003. Acrylic on panel, 14" x 18" (35.6 x 45.7 cm). Buchanan Gallery, Galveston Island, Texas. Courtesy of the artist.

## Try It Yourself

Are you a philosopher? Do you have questions about astronomy, prehistoric life, geography, animals, or just life in general? List some questions that you wish you knew the answers to. List questions that you think are important about art. What does art mean to you?

Asking serious, hard questions and then trying to answer them is called *philosophy*. Asking good questions is often more important than finding the answers. Philosophical questions often have many answers. Some cannot be answered at all, but can make people think in more creative ways. The ***philosophy of art*** involves asking and answering all kinds of questions about art. Philosophers of art are interested in discovering more than just what art is. They want to know how art can be evaluated, how people respond to it, and how art relates to our lives and our societies.

### What Do Artworks Have in Common?

A philosopher may try to answer questions about art by grouping artworks into classes of objects. He or she then begins by asking what a group of objects, as a class, have in common.

Remember the art objects we saw in Chapter 1. They do not seem to have anything in common. Art can be made out of anything from leather to stuffed animals. Furthermore, some artworks, like Christo's wrapped coastline, are not even objects in the usual sense of the word. Clearly, the materials and form of an artwork are not what artworks have in common.

Good ***design*** may be an important trait to consider besides material and form. Good design can be defined as a logical and harmonious relationship among all the parts of an artwork. The opposite of good design is *chaos*.

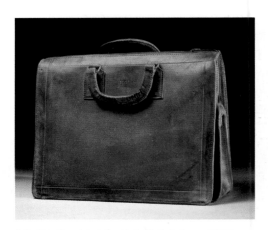

2-5 Marilyn Levine, *H. R. H. Briefcase*, 1985. Clay and mixed media, handbuilt (slab constructed), 16" x 17 1/2" x 6 3/4" (41 x 45 x 17 cm). O. K. Harris Works of Art.

2-3 **Is the relationship between the goat and the tire logical or harmonious? What makes it a work of art?** Robert Rauschenberg, *Monogram*, 1959. Moderna Museet, Stockholm. NMSk 1963.

2-4 **What makes the cave painting a work of art?** Cave painting, Lascaux, c. 15,000 BCE. Dordogne, France. Courtesy Woodfin Camp and Associates, Incorporated.

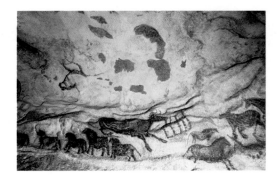

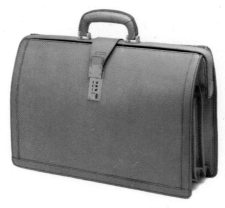

2-6 **EC28 Lawyer's briefcase.** Courtesy Hartmann Luggage Co.

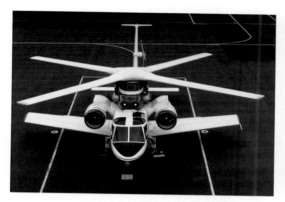

2-7 **In what ways does a Sikorsky X Wing plane demonstrate high standards of unity and balance? Is it a work of art?** Photo courtesy United Technologies.

2-8 **Compare the design of these crystals to that of *Discs* (fig. 2-9). Are the crystals a work of art?** Magnified crystals of vitamin C (ascorbic acid) x20. Courtesy Getty Images.

Good design seems to be very important in evaluating art. Young people who are studying to become artists are taught the *principles of design.* Artists use these principles to make their art better. Knowing these principles can help you to appreciate art more. (They are covered in depth in **Chapter 8.**)

Let's look again at some of the objects we saw in Chapter 1. Does a stuffed goat with a tire around its middle have good design **(fig. 2-3)**? Is the relationship among the animals in the cave painting logical or harmonious **(fig. 2-4)**? The animals are placed haphazardly. Some are not even finished. Does a ceramic briefcase **(fig. 2-5)** have a better design than a real briefcase **(fig. 2-6)**? Why isn't the real briefcase a work of art?

The example of the fake briefcase versus the real briefcase points up an important fact. Many things that are *not* artworks have good design. For example, we admire the design of products from real briefcases to Japanese cameras to military planes **(fig. 2-7)**. In nature, we admire the design of trees, flowers, crystals **(fig. 2-8)**, rocks, and snowflakes. The list seems endless.

Even though good design may be important for many works of art, it is not found in all works of art. Many philosophers of art now say that there

2-9 Tom Moody, *Discs*, 1998. Photocopies, linen tape, 29 1/2" x 27", from show *Post Hypnotic*.

are probably no special traits that *all* artworks have in common. Therefore, you could not decide if an object was an artwork on the basis of its materials, form, or design.

## Try It Yourself

Think of some events you have been to, such as fairs, parades, festivals, and concerts. Also recall some things you have done with family or friends: celebrations, picnics, hiking, and nature walks. Have you taken any trips recently? Have you been to the beach?

Which memories are the most vivid? Did you enjoy any of these events purely for their own sake? Make a list of the events that gave you an aesthetic experience. Describe one or two of them to a friend or a classmate.

## The Aesthetic Experience

Suppose a philosopher of art has admitted that artworks as a group of objects have nothing in common. He or she may try to decide if an object is art by looking at the experience it gives a person. As a general rule the purpose of an artwork is to provide viewers with an *aesthetic* (es-THE-tick) *experience*. Philosophers tend to agree that an aesthetic experience has to do with enjoying something for its own sake. People make artworks to be seen and appreciated for their own sake. Artworks do not have to be useful. Some, like the Broulé Sioux shirt in Chapter 1, are meant to be used *and* to provide aesthetic experiences.

However, looking at an artwork is not the only way to have an aesthetic experience. For example, when you enjoy the outdoors **(fig. 2-10)**, cheer at a parade, smell roses, or blow seeds off a dandelion ball, you are not trying to impress friends, earn money, or get a good grade. Instead, you do these things for their own sake. In other words, you

2-10 Photograph: John Vogel.

2-11 Josef Albers, *Homage to the Square: Glow*, 1966. Acrylic on fiberboard, 48" x 48" (122 x 122 cm). Hirshhorn Museum and Sculpture Garden, Smithsonian Institution, Gift of Joseph H. Hirshhorn, 1966.

do them because you like the colors of a sunny day, the smell of roses, or the sight of dandelion seeds floating on a gentle breeze. Many things besides looking at art can provide aesthetic experiences. Therefore, you will not be able to tell if something is an artwork just because it gives you an aesthetic experience.

On the other hand, would it be possible to tell if something is *not* an artwork because it does not give you an aesthetic experience? No. Suppose you saw Josef Albers's painting *Homage to the Square: Glow* **(fig. 2-11)** and were bored by it. This would not mean that others would not appreciate it. Indeed, on a different day, you might appreciate it yourself. The point is this: You cannot rely on your personal likes and dislikes on any given day to judge whether something is a work of art.

## Intentions and Art

Today, many philosophers of art say that *human intention* is a necessary factor in determining whether or not something is art. People who make paintings "intend" them to be art. When Robert Rauschenberg attached an old tire to a

stuffed goat, and mounted them to a canvas, he *intended* the whole thing to be a work of art. If you saw a piece of driftwood on the beach (**fig. 2-12**), you probably would not call it art. But if you saw it mounted on a wall in someone's home you probably would. The person who mounted the driftwood intended it to be seen as art.

The principle of human intention seems to be the answer to our question, When is it art? Perhaps this principle explains all of the examples presented in Chapter 1.

But does it answer all the questions? *Who* is to do the intending? Can anyone —you, for example—intend something, *anything*, to be art? Suppose you wrapped your house with bedsheets. Would other people consider it a work of art—or a mess (**fig. 2-13**)? Would your neighbors appreciate it? Would your art teacher praise you for it?

## The Art World

Some art is ancient, like the cave paintings. Some is traditional, like Duncanson's in Chapter 1. Some is modern, like Albers's. Regardless of their styles, we have no trouble telling that these objects are art. Useful objects and experimental forms, however, often raise questions.

In the final analysis, *there is no perfect method for determining when something is art.* Human intention is necessary. Good design and the aesthetic experience are important. But ultimately, determining when something is art seems to be a matter of judgment.

Who makes the judgments? Artists, dealers, collectors, art critics, museum directors, and art teachers make them. They make up what is known as the *art world.* They are involved not only in the production of art, but in selling it, collecting it, displaying it, writing

2-13 Christo and Jeanne-Claude, *Wrapped Coast, One Million Square Feet, Little Bay, Sydney, Australia* (detail), 1968–69. 90,000 square meters of erosion control fabric and 35 miles of rope. Photograph: Harry Shunk. © Christo 1969.

about it, and teaching it. Their training, experience, and commitment give them the authority to make judgments.

Do these people ever make bad judgments? Yes. Some examples of experimental art could be considered unworthy of public display. Many traditional paintings and sculptures that were once deemed to be important have now been removed from exhibition. Some of these experts are called *art critics*—our next subject.

## 2.2 Criticism and Critics

We tend to think that *criticism* means disapproval. Have you ever thought that criticizing something can involve saying positive things about it? For example, when criticizing one of your drawings, your teacher may point out just its good qualities. In one sense, criticism is simply a discussion of the characteristics of something—particularly if that something is a work of art (fig. 2-14).

For our purposes, we will say that **art criticism** is a systematic discussion of an artwork involving, usually, four stages: (1) description, (2) analysis, (3) interpretation, and (4) evaluation. This will be discussed in more detail later in this chapter.

2-14 **One is a famous sculpture of a biblical hero by Michelangelo; the other is a popular comic by Charles Schulz. Although they are vastly different in form and content, what might we be able to learn if we take time to examine these works critically?**
Top: Michelangelo Buonarroti, *David*.
Bottom: Charles M. Schulz, *Charlie Brown*.
*Peanuts* reprinted by permission of United Feature Syndicate, Inc.

2-15 **Film critics like Roger Ebert can provide writing and commentary that help us decide whether we want to see a film.** Roger Ebert.
Pacha/Corbis. Photograph: Michel Bourguard.

### Professional Criticism

Professional criticism can be found in newspapers and magazines and on radio, television, and the Internet. The people who write it or broadcast it are paid for doing so.

To understand professional criticism, think about why you choose to see a movie. Perhaps your friends said good things about it, or you saw an advertisement that made it seem exciting. And perhaps you were disappointed. Advertisements can be very misleading. Your friends' idea of a good movie may not be the same as yours.

You need information if you want to avoid wasting time and money on every film that comes to town. One source of information is film criticism. Film critics do not sell movies, and they say negative things about them as well as positive things. A criticism (sometimes called a *review)* will give you a

better basis on which to make up your mind than would either an advertisement or a friend's opinion.

Roger Ebert **(fig. 2-15)** is probably the best-known American film critic. He appears on television and also writes film criticism for the *Chicago Sun-Times*. Newspapers like the *Sun-Times* also contain reviews of art shows, books, musical programs, plays, and even architecture.

Reviews also appear in magazines. For people interested in the visual arts, the kind of art we're discussing here, there are many magazines to choose from—*Artforum, Art in America, Art News,* and others.

Good criticism also educates. It can point out things to look for in an artwork that we might overlook. It can encourage us to see artworks that are unusual or unfamiliar. Over the long run, it can challenge our taste. If the challenge succeeds, we may grow to like more difficult things.

## Nonprofessional Criticism

As long as there are people who are paid to criticize artworks, why should other people—such as you and I—do it too?

First, criticizing art is good training. It helps you learn about the field of art.

Second, doing your own criticism engages you in making selections, discovering new things in familiar works of art, exploring unfamiliar works of art, and developing your taste without the help of professionals.

Third, criticism enables you not only to discover new things about artworks but also to organize this knowledge in such a way that you can share it with others. You may talk about popular music with a friend; it can be fun to talk about art, too.

Fourth, artworks, like good films, often deal with attitudes or ideas about life. Have you and your friends ever analyzed a good film? Analyzing an artwork can also generate ideas for sharing and discussion.

Remember, art is not the only thing that can be a focus of critical analysis. There are many things in our visual world that you encounter on a daily basis. Taken all together, these images and events add up to what is sometimes called *visual culture*. We've already talked about music and movies. You may want to analyze a magazine advertisement **(fig. 2-16)**. It will probably contain not only the main message—namely, that the product or service it is selling is a good one. It may also contain hidden messages intended to make you spend your money.

The more you learn about art and the ideas it expresses, the more you learn about yourself and your own ideas and feelings. As we said earlier, art criticism involves four steps: (1) description, (2) analysis, (3) interpretation, and (4) evaluation. Each of the following sections reviews a step. When criticizing a work of art, an important thing to remember is that each step builds upon the previous one.

2-16 **Young people are a favorite target for all kinds of products and services. What kinds of messages do you encounter in the advertisements you read?**
Photograph: Tom Fiorelli.

### Description

The first step in art criticism is *description*. When describing an artwork you must stick to the *facts*. Include things like the objects, people, shapes, and colors that you and others can see. Do not include opinions, such as "The man is wearing a *stupid* hat" or "This picture is about people having a lot of fun." These statements may be true for you but they are your opinions, not facts.

How well can you describe a painting? Look carefully at *Luncheon of the Boating Party* (**fig. 2-17**) by Pierre Auguste Renoir. Give yourself only fifteen minutes to write a careful description. Do not continue reading until you have finished the description.

Did you feel that you needed more time to describe the picture? If you said yes, you are right.

Your description probably noted that there are a number of men and women gathered on what appears to be a deck. They look young and are in good health. You probably also noted the table, the food and drink, the young woman holding a little dog, the railing behind the table, the people leaning on the railing,

2-17 **This painting includes a wealth of people, objects, and even a puppy. What other things can you describe about the painting besides the actual subjects it depicts?** Pierre Auguste Renoir, *Luncheon of the Boating Party*, 1880–81. Oil on canvas, 51 1/4" x 68 1/8" (130 x 173 cm). The Phillips Collection, Washington, DC.

the awning overhead, and the leafy foliage beyond the deck. Did you write about the people's clothes, hats, or what they are doing? Did you notice the sailboats in the distance?

If you mentioned all those things, you did quite well, but that is only a *beginning*. A good description would have pointed out several more things about the people. For example, some are nearer to the viewer than others. Those near the viewer, especially the men, are informally dressed, whereas some of those farther away are dressed in black. One even wears a top hat.

Both the table and the railings are on the left side of the picture, but both lead your eye to the right. A good description would have called attention to this.

If you said *all* of these things, you did *very well*. But even so, your description would have left out some of the most important things, such as *lines*, *shapes*, *colors*, and *textures*.

We hope you said something about color. Did you note that the white tablecloth (**fig. 2-18**) is not a single color of white, or that the foliage (**fig. 2-19**) is not a single color of green? Did you point out that some colors are lighter (or darker) and some brighter than others?

2-19 **Notice the many different colors seen in the foliage. What are the lightest colors? Which colors are the darkest?** Pierre Auguste Renoir, *Luncheon of the Boating Party* (detail), 1880–81. Oil on canvas, 51¼" x 68⅛" (130 x 173 cm). The Phillips Collection, Washington, DC.

As you can see, if you were to write a really good description, you would need more than fifteen minutes.

Even if you used one hundred minutes, you probably would have left out many important things. It's not just a matter of time, however. You also need to *know what to look for* and to have the appropriate *vocabulary*. You need the right words to describe what you see.

**Knowing What to Look For** To describe a work of art you need some knowledge about what you are looking at, and some practice using that knowledge. For example, you may recognize the color orange, but you may not know that it is a *warm color* and a *secondary color*. You may notice the colors in *Luncheon of the Boating Party* and the objects they describe, but you may not know the roles they play in suggesting a mood and providing unity and balance.

Probably the easiest thing for you to talk about in a picture is the *subject matter*—the people and objects. It may be more difficult for you to talk about lines, shapes, colors, and textures. The upcoming chapters of this book will help you learn the vocabulary of art. In chapters 3 through 8, you will learn about the ***elements of art***—the building blocks of art—and how to recognize them.

2-18 **The artist has used a variety of colors to depict the light reflected from the "white" tablecloth and napkins. What are some of the colors that you see in these fabrics?** Pierre Auguste Renoir, *Luncheon of the Boating Party* (detail), 1880–81. Oil on canvas, 51¼" x 68⅛" (130 x 173 cm). The Phillips Collection, Washington, DC.

## Analysis

*Description* involves pointing out *facts* about the people and objects as well as the lines, shapes, and colors in an artwork. *Analysis* has to do with pointing out the *relationships* among these things. Do they clash or harmonize? Are they balanced? Is there variety? Is there unity without monotony? Knowing the **principles of design** will help you talk about visual relationships in art.

### Analyzing the Composition

**Composition** refers to the way that the subject matter, along with lines, shapes, colors, and so forth, has been put together. The artist, of course, is the person who has to put these things

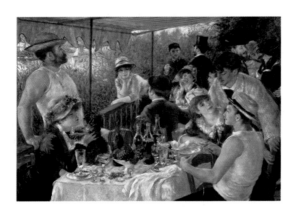

2-20 **Notice how the group below forms a kind of triangle. How do the lines of sight among the three people add interest to the composition?** Pierre Auguste Renoir, *Luncheon of the Boating Party* (detail), 1880–81. Oil on canvas, 51¼" x 68⅛" (130 x 173 cm). The Phillips Collection, Washington, DC.

together. This process is called *composing.*

A key issue in composing or analyzing is *unity.* Unity describes the way in which an artwork is treated as a single, indivisible whole. A parallel issue is *variety.* Variety describes the differences in the work, involving subject matter, visual elements, or even materials. Too much (or too little) of either unity or variety can be a bad thing. Your thirty-piece school band playing the same note over and over would have unity but sound boring. If your band played thirty different tunes at the same time, on the other hand, it would have variety but sound chaotic. It may appear that variety and unity are opposites. If so, they are fruitful opposites that work together rather than against each other.

*In Luncheon of the Boating Party* Renoir organized an incredible variety of elements to make a very stable composition. How did he do it?

One thing that Renoir did was *group* the many people and things. By doing this he created fewer centers for the eye to focus on.

Another method of unifying is through similarity or repetition. To unify an outfit, a woman might match the color of her scarf to the color of a purse or her shoes. In *Luncheon,* splashes of white appear in the tablecloth, a shirt, a collar, a bodice, a hat. A shade of orange is repeated in people's faces, and echoed in the flowers of the woman's hat on the left and in the stripes of the awning. Yellow is repeated in the hats. Note that yellow and orange are warm colors.

Notice the relationships between and among the people. On the near right, the young woman is looking at the man wearing a hat. Hovering over her is a man looking at her **(fig. 2-20)**. Could they be flirting? Notice the direction other people are looking. The direction of looking in a picture is sometimes

called a "line of sight." The lines of sight in *Luncheon* help to pull the composition together.

Still another issue in composition is *balance*. Balance occurs when visual "weight" on both sides of a picture is about equal. If a picture is absolutely *symmetrical* (the same on both sides of an imagined center line), such as *Homage to the Square* by Albers (**fig. 2-21**), then balance is not an issue. But if it is *asymmetrical*, like Renoir's, it is an issue. The deck railing in *Luncheon* tends to lead our attention toward the right. But this is countered by the airy river view on the left. In looking at *Luncheon*, most viewers do not sense that it is out of balance. Do you?

Another device for unifying a work is *emphasis*, which refers to a dominant feature. The dominant feature of *Blue Hole* by Duncanson (**fig. 2-22**) is the body of water. In *Luncheon*, it is difficult to identify a single dominant feature. Is it the man at the left who seems to gaze off into space, the little dog, the objects on the table, or the

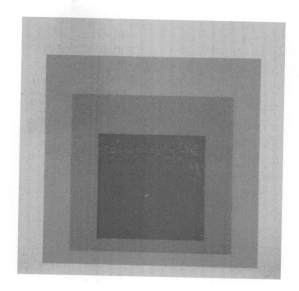

2-21 **This abstract painting offers the viewer multiple optical effects. Why isn't balance an issue in this work?** Josef Albers, *Homage to the Square: Glow*, 1966. Acrylic on fiberboard, 48" x 48" (122 x 122 cm). Hirshhorn Museum and Sculpture Garden, Smithsonian Institution, Gift of Joseph H. Hirshhorn, 1966.

threesome on the right? Clearly, as a group, the revelers gathered around the table compose an area of emphasis.

You can read a more thorough explanation of compositional strategies and terminology in **Chapter 8, Principles of Design**.

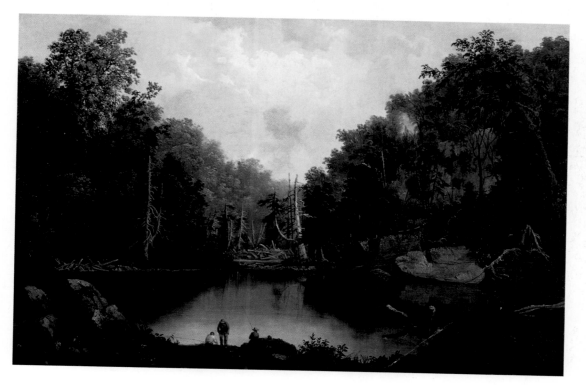

2-22 **The pond in the center of this painting serves as its dominant element. What is it that draws your attention to this feature?** Robert S. Duncanson, *Blue Hole, Flood Waters, Little Miami River*, 1851. Oil on canvas, 29¹/₄" x 42¹/₄" (74 x 107 cm). Cincinnati Art Museum, Gift of Norbert Heermann and Arthur Helbig.

Take candid photographs of two groups of people eating food. The pictures could both be of school-mates or of family—or one of each. If making two shots of the same group, take your pictures on different days and from different views. Ask your subjects to try to act naturally and avoid look-ing directly at the camera while you are shooting. Compare and contrast the content and expres-sion you see in the two pictures. How are the people dressed? How do they interact? What do the subjects' faces and the food, drink, and objects seen on the tables tell you about the "meaning" of the respec-tive scenes? Is the mood serious or lighthearted? Write a metaphor for each of your two pictures.

## Interpretation

To *interpret* an artwork is to explain the meaning of it: What is it express-ing? What is its content? This is per-haps the most creative part of criticism.

Are you ready to plumb the meaning of *Luncheon of the Boating Party?* Of course, you could say "it's about people having a good time at a party." That's certainly true, but also very obvious. Surely there's more to this painting.

Sometimes we have to be indirect, to resort to the use of *metaphor* to explain the meaning of a work. You may recall the term from your English or language arts class. Simply, a metaphor is a figure of speech in which a word or phrase referring to one thing or idea is

applied to something different, such as "she was *green* with envy" or "our ship *ploughed* the sea."

We noted in the Description and Analysis sections the numerous youth-ful people, most of whom are dressed informally, possibly flirting, and also the predominance of warm colors.

Because of the warm colors, the festive table spread with food and drinks **(fig. 2-23)**, and the many young people brimming with health and good looks, we might say that *Luncheon* is a metaphor for "youthful revelry" or even "the impulse of life." One writer com-pared Renoir's painting to the richly colorful paintings in Venice during the Renaissance. Of course, Venetian painting usually illustrated Greek and Roman myths, which *Luncheon* obvi-ously does not. Nevertheless, the writer referred to the people in *Luncheon* as "young gods and goddesses"—another use of metaphor.

Many of these gods and goddesses, incidentally, were friends of Renoir. The young lady with the dog, whom he later married, was one of his models. The girl on the right was another of his models.

2-23 **Food has been shown in artworks throughout the ages, not only to reflect solemn or festive occasions but also to hint at the fleeting nature of life's pleasures. When you eat a meal with your family or attend a party, how do food and refreshments affect the quality of the experience?** Pierre Auguste Renoir, *Luncheon of the Boating Party* (detail), 1880–81. Oil on canvas, 51¼" x 68⅛" (130 x 173 cm). The Phillips Collection, Washington, DC.

The young man straddling the chair was Caillebotte, an artist friend who also became famous later.

These facts bring us to another point: In a painting, there often is "more to it than meets the eye." You wouldn't have known just by looking at the picture that the people were Renoir's personal friends. Also you probably didn't know that Renoir was a member of a group of revolutionary French painters of the late nineteenth century known as the *Impressionists*. Maybe the informally dressed men in the foreground are these revolutionary "free spirits" as opposed to the soberly dressed men in the background (fig. 2-24).

The Impressionists were especially known for their use of bright colors and

2-24 **Think about how the figures in dark top hats compare to the other subjects shown in the painting. What metaphor might you use to describe them?** Pierre Auguste Renoir, *Luncheon of the Boating Party* (detail), 1880–81. Oil on canvas, 51¼" x 68⅛" (130 x 173 cm). The Phillips Collection, Washington, DC.

2-25 **Sometimes the smallest details in a work of art have both direct and indirect meanings. Why do you think the artist included the glimpse of a river view? How does it help you to understand the painting?** Pierre Auguste Renoir, *Luncheon of the Boating Party* (detail), 1880–81. Oil on canvas, 51¼" x 68⅛" (130 x 173 cm). The Phillips Collection, Washington, DC.

short strokes of paint, and for painting out-of-doors. Some of their favorite subjects were the small towns downstream from Paris on the Seine River. The new technology of railroad travel enabled all Parisians, not just artists, to get out of the city for a weekend to enjoy the outdoors (fig. 2-25).

Knowing these things helps to enhance your interpretation. Often art galleries and museums provide such information to accompany their special shows. Also, you can discover information like this by studying art history—some later chapters of this book will give you some useful background.

2-26 **Notice some of the similarities between the three works from very different time periods shown on this and the next page. How might an awareness of art history affect your evaluation of a work's originality?** Michelangelo Merisi da Caravaggio, *Supper at Emmaus*, 1601. Oil on canvas, 54 3/4" x 76 3/4" (139 x 195 cm). National Gallery, London. Photo by Nimatallah/Art Resource.

## Evaluation

The purpose of ***evaluation*** is to determine the quality or lasting importance of a work. At first, you may judge a work by your personal response. There is no reason to be dishonest or to conceal your feelings. If a person is knowledgeable about art, such feelings can be a reliable way to judge quality. But there is a difference between personal feelings about a work and the public value of that work. It is certainly possible—and reasonable—to like a bad artwork or to dislike a good one.

The question is what *criteria*—what standards—should you use to decide whether an artwork is excellent? This is perhaps one of the most difficult questions in the world. To answer it in detail is beyond the scope of this chapter. But let's discuss some of the criteria critics have used.

**Design Quality** In the *Analysis* section, we saw how Renoir organized *Luncheon of the Boating Party* by using different design strategies such as grouping, lines of sight, and the repetition of colors and shapes. He also

2-27 Pierre Auguste Renoir, *Luncheon of the Boating Party*, 1880–81. Oil on canvas, 51¼" x 68⅛" (130 x 173 cm). The Phillips Collection, Washington, DC.

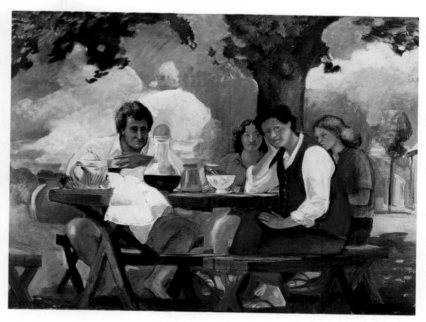

2-28 Paul Georges, *Back Yard*, 1976. Oil on canvas, 60" x 81" (152.4 x 205.7 cm). Virginia Museum of Fine Arts, Richmond. Gift of Sydney and Frances Lewis. © Virginia Museum of Fine Arts.

managed to balance a decidedly asymmetrical painting. Using the elements and principles of design as a criterion in art criticism is called *formalism*.

*Expressiveness* refers to how effectively the work expresses or reflects a theme or worldview. Rather than concentrating on just the design elements and principles, this criterion takes into consideration such things as subject matter and symbols. Renoir depicted spirited, healthy young people, in lively colors, to express a point of view about his time.

**Originality** This is a judgment about the work's inventiveness or novelty. Does it display a fresh theme, or a fresh treatment of an old theme? Is the medium unique in some way? Originality operates at different levels, depending on the critic's past experience with art. What appears to be very fresh to some people may in fact have been done many times before. The degree of originality in a work, therefore, is not purely a visual matter. It depends on what you know **(fig. 2-26).**

Originality has been a major criterion for judging art going back hundreds of years. A high value tends to be placed on works by artists who pioneered new ideas of style, theme, or medium. Other factors that critics and art curators consider when evaluating a work include the fame of the artist, the importance of the artwork in the history of art, the market value of the work, and the opinions of other critics, collectors, art dealers, and art historians.

There is no single cluster of criteria for judging excellence in art. Different kinds of art require different criteria, and there are different schools of thought about what is good art. Still, when you evaluate an artwork, state your reasons—just as Roger Ebert does when he evaluates a film. Your reasons should be grounded in the information and analyses you assembled from the first three stages of this criticism method.

Now that you've learned about art criticism and the four-step critical process, here's a glimpse of some of the other artworks you'll have the chance to critique in the following chapters.

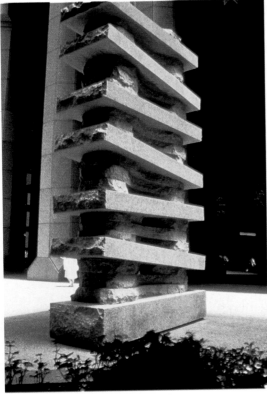

2-29 Jesús Moroles, *Lapstrake*, 1987. Sardinian granite, 22' x 12' x 4' (6.7 x 3.6 x 1.2 m). E. F. Hutton, CBS Plaza, New York. Courtesy of the artist.

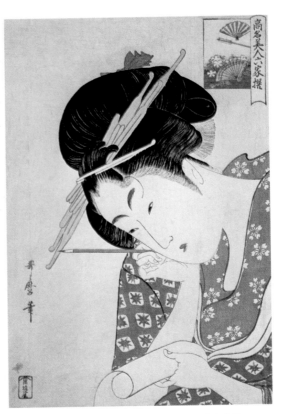

2-30 Kitagawa Utamaro, *Hana-Ogi of Ogi-Ya*, 1794. © Barney Burstein Collection/Corbis.

2-31 Georgia O'Keeffe, *My Backyard*, 1937. Oil on canvas. New Orleans Museum of Art; Museum Purchase, City of New Orleans Capital Funds.

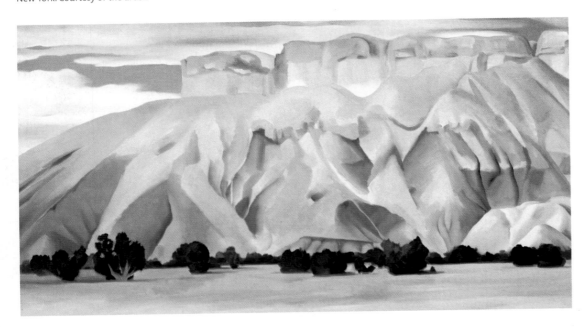

## Summary

*Philosophers of art* ask probing questions about art to try to define what art is. It is almost impossible to define art by looking for traits that all artworks have in common. Most works possess good *design,* but not all do. Furthermore, many things besides art have good design. Artworks are intended to give people an *aesthetic experience.* But many things besides art can be experienced this way. Therefore, neither good design nor the aesthetic experience is a complete test of what makes something a work of art.

One thing that all art has in common is human intention. Members of an institution called the art world make judgments about what things are art—whether traditional paintings, ceremonial objects, or experimental works. The art world consists of artists, but also museum people, art critics, art teachers, and writers on art.

Professional criticism of the arts can be found in newspapers and magazines and on radio, television, and the Internet. Basically, professional critics inform and educate the public through studying and writing about works of art.

People who are not professional critics can benefit from criticizing art in many ways: learning more about art and criticism, developing their own taste and responses to the visual world that surrounds them, and sharing experiences with others.

*Art criticism,* as defined in this chapter, is a systematic discussion of an artwork consisting of four stages: *description, analysis, interpretation,* and *evaluation.*

## Review Questions

1. **Recall:** What is an aesthetic experience?

2. **Understand:** Explain what professional critics do.

3. **Apply:** Find a review of an event, exhibition, book, movie, or CD in a newspaper or magazine. Highlight negative statements in one color, and positive statements in another. Is the review balanced, or more positive than negative? Is it persuasive? Explain why you think so.

4. **Analyze:** Compare and contrast Michelangelo's *David* with Charles Schulz's drawing of Charlie Brown. Discuss what the works are made of, what they look like, the artists' possible intentions, and how they make you feel.

5. **Synthesize:** Choose an artwork in Chapter 1 or 2 other than Renoir's *Luncheon of the Boating Party*. Write what you think is a complete description of the work.

6. **Evaluate:** Assemble an "exhibition" of your four favorite works of art from Chapters 1 and 2. Explain clearly why you like each one, and why you chose them for your exhibit. Describe the kind of aesthetic experience you would like viewers to have as a result of seeing these works.

## Electronic Research

Visit the Ebert Archives <www.suntimes.com/ebert/>, which collects film critic Roger Ebert's *Chicago Sun-Times* movie reviews going back to 1985. Search the archive for a review of one of your favorite movies. After reading Ebert's review, write your own critique of the same film, explaining why you agree or disagree with Ebert's commentary.

## Going Further

How do your schoolmates or people in your community look at works of art? Do a small-scale research project and interview individuals to find out what they notice and like or don't like when looking at art. Use small postcard-size reproductions of artworks. Be consistent in your approach and in the questions you ask. Use a check sheet to record responses to questions such as: What do you see when you look at this picture? What do you like about this picture? You might be surprised by your findings.

# Part Two

# Elements of Art and Principles of Design

Paul Cézanne, *Still Life with Apples and Peaches* (detail), c. 1905.
Oil on canvas, 31⁷/₈" x 39¹/₂" (81 x 100.5 cm). © National Gallery of Art, Washington. Gift of Eugene and Agnes Meyer.

# ③ Line

3-1 **Dreaming paintings are the creation of the Aboriginal people of Australia. These works are composed of a series of dots arranged in curved and straight lines.** Norman Kelly Tjampitjinpa, *Flying Ant Dreaming*, 20th century. Collection of Tom Raney, NY.

## What You'll Learn

- how to identify descriptive and implied lines in artworks and your environment

- how to produce different lines with different drawing tools

- ways to use expressive words to describe lines

## What This Chapter Covers

### Art Criticism Step by Step

### Studio Experiences

## Key Terms

*English (Spanish)*

*line (línea)*
*descriptive line (línea descriptivo)*
*outline (contorno)*
*contour line (línea contorno)*
*hatching (echadura)*
*crosshatching (echadura cruzada)*
*implied line (línea inplícito)*
*edge (borde)*
*closure (clausura)*
*lines of sight (línea de vista)*
*expressive line (línea expresiva)*
*abstract line (línea abstracto)*

## Artists

Alexander Calder, Elizabeth Catlett, Kathleen Edwards, Janet Fish, David Hockney, Robert Hudson, David Levine, Henri Matisse, Gjon Mili, Mokuan, Gary Molitor, Pablo Picasso, Pierre Auguste Renoir, Charles M. Schulz, Ben Shahn, Toba Sojo, Kazuaki Tanahashi, Norman Kelly Tjampitjinpa, Kitagawa Utamaro, Patssi Valdez, Amelia Van Buren, Wu Zhen

3-3 Student work, Maria Chiriboga. Wire and button, 13" x 9" (33 x 22.8 cm).

3-2 Student work, Rachel Stuzman. Watercolor, 12" x 18" (30.5 x 45.7 cm).

The word *line* has many definitions in the dictionary. You can hit a *line* drive in baseball, memorize *lines* for a play, and avoid being last in *line* in the cafeteria. In art the word *line* is used to describe long, thin marks, and there are many examples that fit this meaning.

3-4 **Line plays an important role in the structure of most natural and human-made objects. Look closely at these leaves and notice their internal lines, as well as their outlines.** Photograph: Brian Braye.

3-5 **Expressive lines give artworks a particular feeling. What feeling do these lines convey?** Gary Molitor, *Baghdad by the Bay.* Computer graphic in woodblock style, 72" x 56" (183 x 142 cm).

Lines can be found in nature in such things as the veins of a leaf, the branches of a tree in winter, or the sands of a desert **(fig. 3-4)**. Lines are everywhere in the world around you **(fig. 3-6)**.

In fact, the printed letters and numbers you are reading right now are shapes made with lines. The letters *c* and *s* and the number *5* are made with single lines that are open at the ends. Some letters, like *f, t,* and *x,* are made with lines that cross. Some, like *y* and *k,* are made with open lines that are connected in places.

A road map is another example of lines. Lines and shapes on a map are symbols. They stand for other things like interstates and roads and rivers and streams **(fig. 3-9)**.

3-6 **Look out a window or around a room. How many lines can you find? Write a list of words describing them. These descriptive words will help you better understand the variety and abundance of line in your everyday life.** Photograph: Brian Braye.

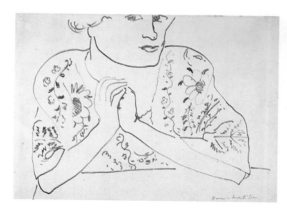

3-7 Henri Matisse, *Woman with Folded Hands,* 1918–19. Pen and india ink on white paper, 10 5/8" x 14 7/16" (26.98 x 36.67 cm). The Minneapolis Institute of Arts, Gift of Mrs. Horace Ropes for the John De Laittre Memorial Collection.

Art has as many kinds of lines as the lines you find in nature or in books and maps. Many lines in art are created by moving a tool such as a pencil, charcoal stick, pen, or brush (figs. 3-5, 3-7). Some lines can even be made with light! (fig. 3-8)

The main kinds of lines in artwork are *descriptive lines, implied lines,* and *expressive lines.*

**Descriptive lines** are lines that help us understand what we are seeing. Descriptive lines include outlines, contour lines, single lines, and hatching.

**Implied lines** are lines that suggest an edge rather than clearly defining one. Implied lines occur where textures, colors, and values change at edges of shapes in artwork.

**Expressive lines** are lines that send us messages about what the artist wants his or her work to make us feel. Abstract lines, which are expressive, may not show us objects we recognize, but can still create a feeling in us.

This chapter will help you learn to see and appreciate this most basic artistic component.

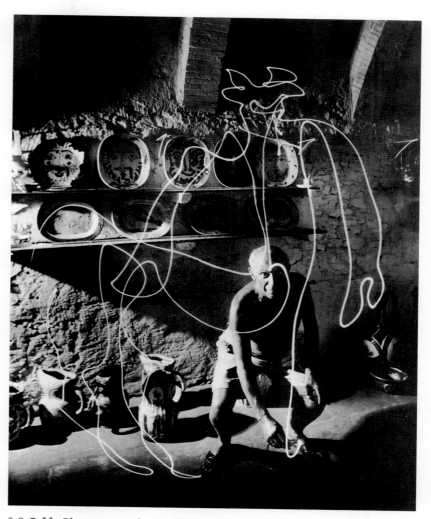

3-8 **Pablo Picasso was adept with line. He could create an image with just a few strokes. Using a very slow exposure, a photographer captured Picasso drawing with a lighted torch. How would you describe the lines he is using?** Gjon Mili, *A Centaur Drawn with Light—Pablo Picasso at the Madoura Pottery in Vallauris, France.* Photograph © 1984 Sotheby Parke Bernet, Inc., New York.

3-9 **The lines and shapes on this road map are symbols. Can you think of other instances in daily life where lines are understood to be symbols?**

## Linking Disciplines
### Geography

Borrow **contour maps** from the drafting teacher or a surveyor's office. Discuss the relationship between contour drawings by an artist and the making of contour maps. Then make a drawing of your face or hand as if you were making a contour map.

## 3.2 Descriptive Lines

You have been making lines since the first time you picked up a pencil. Your early scribbles eventually turned into recognizable pictures. This use of lines—whether by a child or an artist—is called **descriptive**. Descriptive lines come in many varieties.

### Outlines

The most basic kind of descriptive line is an **outline**. An outline is a line that surrounds a shape.

Comic strip artists use outlines to create their characters, such as Snoopy and Woodstock in *Peanuts* (fig. 3-11). The lines of an outline drawing are usually the same thickness throughout. Also, only the outer edges of the shapes are defined. For these reasons, an outline drawing seems to have little depth. Snoopy and Woodstock are almost as flat as cutouts.

3-11 Charles M. Schulz, *Peanuts*, 1973. Reprinted by permission of UFS, Inc.

### Contour Lines

**Contour lines** also define the outer edges of shapes. Unlike outlines, however, contour lines vary in thickness and darkness. They also define the edges of shapes within a form. They give a greater sense of depth to the object.

Henri Matisse used ink to create lines that describe a woman seated at a table (fig. 3-10). Some lines are thin and faint, while others are more pronounced. Some, like the ones that show the woman's wrists, forearms, and elbows, are both thin and thick. Compare Matisse's drawing to the comic strip showing Snoopy and Woodstock. Which image seems to you to be the most delicate, the most sensitive? Which picture has the most variety in its lines?

Because of their variety, contour lines are more interesting and descriptive than outlines. Lines in drawings by professional artists are often called contour lines rather than outlines. When you draw, which kinds of lines do you use most often: outlines or contour lines?

3-10 **Matisse used contour line to create description and interest in this drawing. Why might an artist drawing a person's portrait choose to use contour line rather than outline?** Henri Matisse, *Woman with Folded Hands*, 1918–19. Pen and india ink on white paper, 10 5/8" x 14 7/16" (26.98 x 36.67 cm). The Minneapolis Institute of Arts, Gift of Mrs. Horace Ropes for the John De Laittre Memorial Collection.

## Individual Lines

Just as a single line can represent the letter *S*, it can describe an individual leaf shape. Wu Zhen used single strokes of an ink-loaded brush to describe the stalks and leaves of a bamboo plant (**fig. 3-13**). He also used individual strokes for each symbol of the Chinese writing on the left of the picture. This elegant writing is called *calligraphy*.

## Hatching/Crosshatching

David Levine used contour lines to make a humorous drawing of a famous person (**fig. 3-12**). But look closely at the lines that describe shadows. The artist used many thin, closely spaced, parallel lines called **hatching**. Hatching lines that cross, which make a more solid shadow, are called **crosshatching**.

**Hatching**

**Crosshatching**

In hatching, the black lines are so thin and close together that they blend with the white of the paper. When this happens, they appear gray. This effect is called *optical mixing*. The mixing of black and white happens in the eye. The use of lighter and darker grays to make a form seem three-dimensional is known as shading. You will learn more about shading in **Chapter 5, Value and Color**.

3-13 **Bamboo has traditionally been a favorite subject in Chinese painting, and Wu Zhen was one of that country's great bamboo painters. What individual lines can you see in this artwork?** Wu Zhen, *Bamboo*, 1350. Album leaf, ink on paper, 16" x 21" (41 x 53 cm). Collection of the National Palace Museum, Taipei, Taiwan, Republic of China.

3-12 **When you look at this picture, the black hatching lines are optically mixed in your vision. You see a variety of grays. These grays help to describe the facial features.** David Levine, *Rembrandt*, 1970. Reprinted with permission from The New York Review of Books. © 1963–73, Nyrev, Inc.

The lines we have seen so far are just that: seen lines. They are visible. They have width and length. However, there are some lines that are not seen, at least not in the usual way. They are *implied*; that is, they are indicated indirectly. An actual line does not have to be present in order for a line to be suggested, or implied. Lines can be implied by edges, closure, and lines of sight.

## Edges

Look at Renoir's painting of a boating party (fig. 3-16). Renoir did not use outlines or contour lines to set off one shape from another. Nevertheless, the lines are implied by edges due to changes. An *edge* exists where one shape ends and another begins. In Renoir's painting, an edge is formed where an

3-14 **Catlett focuses on women, especially African-Americans, as a central theme in her work. What do you think the artist is communicating about women in this work? How does she use edges to convey her message?** Elizabeth Catlett, *Mother and Child #2,* 1971. Walnut. Malcolm Brown Gallery.

## Artist Biography
# Elizabeth Catlett (b. 1915)

African-American artist Elizabeth Catlett has focused her life and her art on civil rights. "I have always wanted my art to service Black people—to reflect us, to relate to us, to stimulate us, to make us aware of our potential."

Catlett's first experience with discrimination occurred when she was rejected from an art college because of her race. Determined to succeed, she entered Howard University, a mostly African-American school, and pursued her studies with several prominent Black art professors.

In 1938, following in her father's footsteps, Catlett got her first job as an art teacher. She would go on to fight for equal pay for teachers of all races.

Catlett's dedication to the civil rights movement continued through both her political activities and her artwork. In 1946 she visited Mexico for the first time. She ended up staying in that country, and eventually became a naturalized citizen. In her later life she would divide her time between Mexico and the United States.

Elizabeth Catlett's devotion to Black people remains an important aspect of her work in the twenty-first century. Her public sculpture honoring the African-American author Ralph Ellison, author of the novel *Invisible Man,* was unveiled in New York City in 2003.

arm ends and a white shirt begins, where a face ends and a hat begins, or where a hand ends and the fur of a dog begins. All these edges suggest the presence of lines. The lines are implied.

In a sculpture, an edge exists where the sculpture ends and the space around it begins. The edges of Elizabeth Catlett's carving of *Mother and Child #2* imply many graceful lines (**fig. 3-14**). If you were to draw her carving, the outside line would look almost like a rounded parallelogram. The curves of the mother's arm are repeated in the infant's head. What other curved lines and angles do you see in this sculpture?

## Closure

Our tendency to "see" complete figures where lines are left open is called *closure*. Closure is required to connect the loosely drawn and delicate lines in Mokuan's *The Four Sleepers* (**fig. 3-15**). Can you see the four sleepers? Would you agree that the incomplete figures make the picture more interesting and humorous? Why?

## Lines of Sight

Have you ever looked up when someone else looked up? Looking in the same direction as another person is a natural tendency. You may recall from Chapter 2 that the lines along which people look are called *lines of sight*. In Renoir's *Luncheon of the Boating Party* (**fig. 3-16**), the merrymakers are looking at each other. It is very natural for the viewer to also look along the same lines of sight. It is similar to the process of closure. Artists often use lines of sight to connect different parts of a picture. Which of the many lines of sight do you think are the most important in *Luncheon?*

3-15 **What kind of environment surrounds the figures? How does closure help your mind fill in the barely indicated background and foreground?** Mokuan, *The Four Sleepers* (detail), mid-14th century. Ink on paper, 14" x 28" (71 x 36 cm). Maeda Ikutokukai Foundation, Tokyo.

3-16 **In a complex work such as this painting, the artist carefully uses line in a variety of ways to build an interesting and well-constructed composition. Can you find four lines of sight in this artwork?** Pierre Auguste Renoir, *Luncheon of the Boating Party*, 1880–81. Oil on canvas, 51" x 68" (130 x 173 cm). The Phillips Collection, Washington, DC.

We have seen that artists use lines to describe shapes or forms. They also use lines to indicate shading. We have also seen how painters, cartoonists, sculptors, and architects use implied lines. In addition to these uses, lines are also used by artists to express feelings and ideas. The implied lines of the Catlett sculpture **(fig. 3-14, page 38)** can be described as "graceful." The vertical and diagonal lines of Gary Molitor's computer graphic **(fig. 3-19)** suggest power and glitz. Look at the "intense, scratchy" lines in Ben Shahn's drawing **(fig. 3-17)** and the soft, flowing lines in the photograph below **(fig. 3-18)**. Lines—descriptive or implied—have their own "personalities."

3-18 **Describe the expressive quality of the lines found in this photograph.** Amelia Van Buren, *Untitled (Profile Portrait of a Woman Draped in a Veil),* c. 1900. Platinum print, 6" x 4 3/8" Frances Benjamin Johnston Collection, Library of Congress, Washington, DC.

3-17 **Dr. Oppenheimer was a key physicist in the field of atomic research during WWII. How would you describe the personality of the scientist based on the expressive quality of Shahn's line drawing?** Ben Shahn, *Dr. J. Robert Oppenheimer,* 1954. Brush and ink, 19 1/2" x 12 1/4" (50 x 31 cm). The Museum of Modern Art, New York. Purchase.

3-19 **What type of line dominates this image? What effect does that line type have on the work?** Gary Molitor, *Baghdad by the Bay,* 1995. Computer graphic in woodblock style, 72" x 56" (183 x 142 cm).

## Line Personalities

How does a line acquire a personality? There is no single answer to this question. However, we tend to associate lines with other things in our experience. We associate certain feelings with a line's shape, movement, and direction.

**Shape** Straight lines remind us of things like buildings that are strong or powerful. Curved lines remind us of people, animals, or plants that are soft, delicate, or graceful. Jagged lines suggest objects like broken glass, sawteeth, or lightning that are bristling, aggressive, or wild.

**Movement** A line, as we explained, is often the record of real movement. We associate lines with the movements of animals, people, or even our own bodies. Straight lines may seem rigid or swift. Curved lines seem relaxed or graceful. Jagged lines seem nervous or awkward.

3-20 **This Japanese calligraphy is charged with energy. At what points is the tension highest?** Kazuaki Tanahashi, *Breakthrough*, 1998. East Asian calligraphy, ink on paper, 34" x 24" (86.4 x 61 cm). Courtesy of the artist.

3-21 **Can you find examples of each of these line types in images from other chapters in this book?**

straight

parallel

diagonal

curved

jagged

vertical

**Direction** If a line has movement, it also has direction. Lines that move in vertical directions seem strong; horizontal lines seem calm or stable; and diagonal lines seem unstable (fig. 3-21).

These descriptions are generalizations. The personality of a particular line may be due to its shape, movement, and direction. But it can also be influenced by other elements in the artwork. For example, shapes, colors, textures, and even other lines in a work of art can affect the personality of a line. (The visual elements of shape, color, and texture are discussed in later chapters.)

## Abstract Lines

*Abstract lines* are mainly found in abstract art (fig. 3-22). Abstract art can be *nonrepresentational* (also called *nonobjective*). There may be little or no attempt to show a pictorial likeness or image. Abstract lines are not used to symbolize, to outline, or to look like shading. Abstract lines are expressive, not descriptive. As a viewer, you have little choice but to see abstract lines for what they are: lines.

3-22 **Picasso's lines in light would probably be called semi-abstract. What did you see when you first looked at the lines in this photograph? How does the title in the photo credit help you to see more than just abstract lines?** Gjon Mili, *A Centaur Drawn with Light—Pablo Picasso at the Madoura Pottery in Vallauris, France.* Photograph © 1984 Sotheby Parke Bernet, Inc., New York.

# A Japanese Ukiyo-e Artwork

## Kitagawa Utamaro
**(1753–1806)**

The early life of **Kitagawa Utamaro** is a bit of a mystery. We know little about it. We don't know where he was born, and there is little information about his family. He is best known for his skillful prints of beautiful women *(bijin),* and for his sympathetic observation of his subjects. The idealized slenderness and beauty found in these images were much admired by the Japanese public, as well as by newly opened trade markets in Europe. An incident in Utamaro's personal life that is recorded is his arrest and brief imprisonment. This came about because one of his prints offended the ruling Tokugawa government. The artist died about a year after his release.

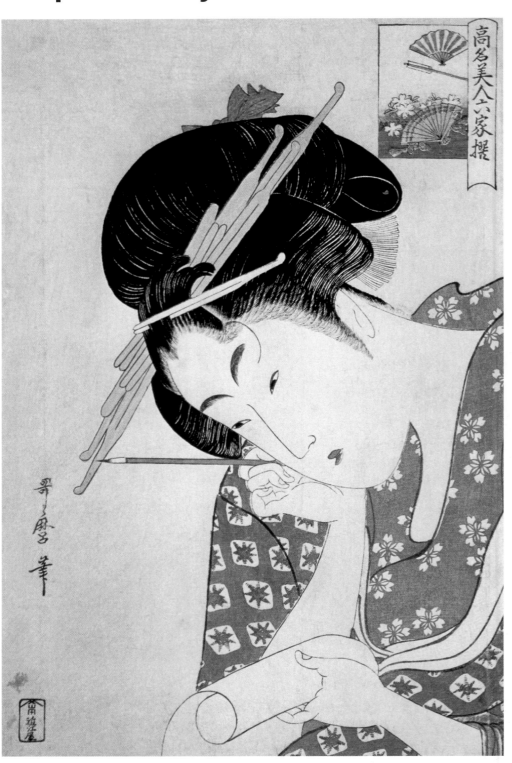

3-23 **Ukiyo-e (u-kE-O-eh), which means "the art of the floating world," was a painting style developed in seventeenth-century Japan. The style was later adapted to woodcuts, making multicolored prints available to the middle class at very low prices.** Kitagawa Utamaro, *Hana-Ogi of Ogi-Ya,* 1794. Woodcut print. © Barney Burstein Collection/Corbis.

## 1 Describe What You See

When you describe an artwork, you identify the things about the work that you can see, name, and describe with certainty. You should not include opinions, evaluations, or possible meanings here.

- What is the artist's name?
- When was the work created?
- What medium did the artist use?
- Describe the woman's position, and what she is holding.
- List the other things you see in the picture plane.
- What kinds of lines has the artist used: Outline, contour, implied, calligraphic, line of sight, abstract, hatched?
- Where do you see descriptive lines?
- How many patterns are there?

## 2 Analyze the Way It's Organized

When you analyze an artwork, you tell how the subject matter and elements of the work have been organized by the artist. You tell how they work together.

- What is the most important art element in this artwork?
- Where is the focal area of this print, and why? (Notice the triangle formed by the hairpins and paintbrush.)
- How are the contour lines varied?
- Where have lines been used to imply movement?
- How do the patterns contribute to a feeling of movement?
- What did the artist do to balance the figure placed on the right side of the work?

## 3 Interpret What It's Saying

Use the information from your description and analysis to help you identify the meaning of the work: what it tells you about human experience.

Assume the figure's position and think about things and moods you experience when sitting like this.

- What mood does this artwork suggest?
- Write a simile or metaphor that expresses the feeling the artwork conveys.
- What do you think the work is about?

## 4 Evaluate Its Success

Using your analysis in the first three steps, how would you judge the quality or success of this work?

- Which philosophy or philosophies of art apply to this work? A successful artwork: (1) is true to life, imitates reality; (2) is designed for perfect relationship among art elements; (3) expresses ideas, feelings, and emotions; (4) advances human interests, a purpose, or a cause.
- How do you judge the success of the work in terms of the philosophy or philosophies?
- How do you judge the craftsmanship in this woodcut print?
- How original do you feel the work is in treatment of the subject and idea?
- What is the importance of this artist's achievements? (See **About the Artist**.)

**More Art!**
See page 56 for more artworks by Kitagawa Utamaro

**Web Link**
www.davis-art.com

# Hockney-Inspired Still Life Drawing

In this exercise, you can explore the use of varied line and see its influence on a subject. Start by developing three line drawings of a still life from three different perspectives using contour line, weighted line (lines of different thicknesses), and expressive line.

3-24 **Still life arrangement**

## Computer Option

How many different ways can you make lines with your drawing program? Experiment with each one. Then make a computer drawing using three of the tools available to you. Make a drawing in pencil of the same subject matter. Compare the two drawings. Which is more effective? Which is more expressive? Did you find one easier to create than the other? Which one?

## Write About It!

Select a work in this book that shows expressive line. Describe the work, as if in a letter to someone far away, telling everything you see. Use plenty of adjectives; think carefully about the way the work makes you feel and why. Show your writing to someone else. Can he or she "see" what you have described?

## Before You Begin

Study a still life from different angles. How do light and shadows interact? Decide what point of view provides an effective composition for each of the three drawings you will make.

## You Will Need

- drawing paper
- drawing pencils in a variety of hardnesses
- drawing pens in a variety of sizes

## Create It

**1** For your first drawing, select an area of the still life to draw using contour lines. With your eyes on the still life, use a No. 2 pencil to create the image on your paper. Whenever you look at your paper, stop drawing. After your pencil drawing is complete, go over the lines with black pen so as to emphasize the continuous, flowing quality of line.

**2** Move to the spot where you will create your second drawing. As you draw with different pencils, vary the thickness of your lines. Notice the effect you can achieve by making a change in thickness or switch between a light gray and a rich black.

**3** In your third drawing, made from a different perspective, incorporate expressive lines. You can use pencils, pens, or both.

## Evaluate It

- In what ways do your drawings clearly show contour lines, weighted lines, and expressive lines?
- How did you change the perspective for each of the three drawings?
- How would you describe the expressive lines you used in the third drawing? Choose two adjectives and write them lightly on the back.

3-25 Student work, Joe Contuzzi. Pencil, ink, 12" x 18" (30.5 x 45.7 cm).

3-27 Student work, Zavan Rosser. Pencil, ink, 12" x 18" (30.5 x 45.7 cm).

3-26 Student work, John Milhiser. Pencil, ink, 18" x 12" (45.7 x 30.5 cm).

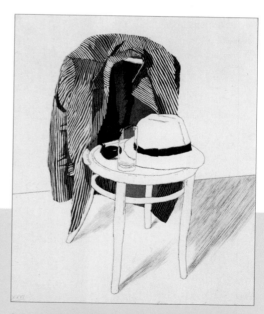

3-28 **During the past twenty-five years this important British artist has created several representations of a Panama hat placed on a chair. How has he relied on line to articulate objects in this composition?** David Hockney, *Panama Hat*, 1972. Etching and aquatint, 17" x 13½" (43.2 x 34.3 cm). Courtesy of Brooke Alexander Gallery, New York, NY. © David Hockney.

Art History

# Studio Background

Practice makes perfect. Arranging and depicting a group of objects enables an artist to explore a variety of skills. Most great masters have labored at this task. It is a wonderful and very controlled way to work. Though found in artworks dating from ancient Greece, it was seventeenth-century Dutch painters who made the still life an enduring genre in Western European art.

Practicing and studying line, even the simplest drawings, is not just an exercise for beginners. Masters repeatedly return to these basics to further develop their eye and hand and their understanding of composition.

# Drawing with Hatching and Crosshatching

How can hatched and crosshatched lines contribute to form in a composition? Create a set of five pencil drawings to explore the possibilities.

### Before You Begin

Divide a large piece of paper into five rectangles. Allow a three-inch border at the edge of the page. Draw a rectangle on the left, 13" wide by 17" high. On the right, make four, each 6" wide by 8" high.

### You Will Need

• an object or tool that you can hold in your hand
• vellum drawing paper
• drawing pencils in a variety of hardnesses
• ruler or straightedge, triangle

### Create It

❶ Hold an object in your hand and study it from different angles. Note its characteristics.

❷ Lightly draw the object, and your hand holding it, in the large rectangular space. Pay attention to the overall composition and to the proportions. This drawing will be "larger than life" and serves as a serious warm-up exercise.

❸ Draw four smaller variations of your hand holding the object. Again consider composition as you change the angle in each rendition. Use hatching and crosshatching to create values in shadow areas of the hand, the object, the negative space, or all these areas. Carefully develop the effect of three-dimensional forms in the four variations.

3-29 Student work, Josh Kirsch. Pencil, 23" x 35" (58.4 x 88.9 cm).

**Write About It!**

In two or three paragraphs, describe the works on this page that were drawn by students. What feeling do you get from these drawings? Which do you think was done the most skillfully? The least skillfully? Why?

**Technique Tips**

• For better clarity of line, work with sharp pencils.

• Place a small piece of scrap paper under your drawing hand so it will not smudge your work as it moves across the paper.

## Evaluate It

• How effectively did you use hatching and crosshatching to create values?

• What did you do to make your drawings look three-dimensional?

• What did you learn as you changed the angle of each composition?

3-30 Student work, Catherine Singley. Pencil, 23" x 35" (58.4 x 88.9 cm).

**Art History**

## Studio Background

Hatching and crosshatching allow an artist to quickly define a form in two dimensions. Look at the hammer shown here. One can almost see the rapid hand movements making the hatched lines. The same is true of David Levine's caricature of Rembrandt **(fig. 3-12, page 37)**. Hatched lines are usually crisp and often bold. The contrast of the dark hatched lines against a white background can be used to great advantage.

Watch for hatching and crosshatching in print media. You should spot them in magazine and newspaper advertisements and book illustrations.

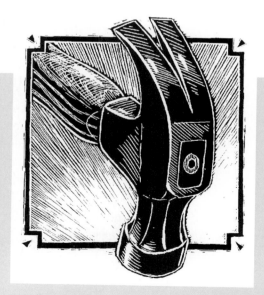

3-31 **California artist Kathleen Edwards made use of hatching and crosshatching to create a lively image. Why do illustrators rely on these techniques? One reason might be preference; another might be speed. Often illustrators are asked to create many images in a very short time.** Kathleen Edwards, *Hammer*. © Stockart.com, Fort Collins, CO.

• When drawing the can, exclude any small text that cannot easily be shown by contour line.
• Move the pencil on your paper only when your eyes are on the can. This will produce a better observational drawing.

**Computer Option**

Scan and save your small drawing of the visually intriguing area that you based your pattern on. Add color. Create and save a pattern by copying and pasting this image repeatedly. Now use that pattern as a "fill" in a larger drawing of a can shape. Why does this new image look flatter than your pencil drawings of the can?

# Contour Line Investigation

In this three-part exercise, you will create a contour drawing of an aluminum can, then draw the crushed can, and finally make a pattern based on a detail from one of your drawings.

### Before You Begin
Consider a can from various angles. How does light strike its surface? Remember that contour lines can define not only the edges of a form but also its interior. Study the possibilities of applying contour line before you put pencil to paper.

### You Will Need
• an aluminum soda, tea, or juice can
• vellum drawing paper
• tracing paper
• drawing pencils
• watercolors or colored pencils
• a black felt-tip pen

### Create It
**1** Use a variety of contour lines to draw an aluminum can on a large sheet of paper. Draw only when you are looking at the can, and stop drawing whenever you view your work. Capture not only the overall shape but also the reflections on the can's surface. Include any bold lettering that comes into view from the perspective you have chosen.

**2** Lightly crush the can and notice how this action has changed the can's form. Observe the can closely. What happened to the lettering? Draw the can once again with contour lines, noticing the ways in which your contour lines are different in this second drawing.

**3** Look at your two drawings to find a small area that you find visually intriguing. Trace this area in a line drawing, using a pencil and a small piece of tracing paper.

3-32 Student work, Pawa Stamos. Pencil, 9" x 9" (22.8 x 22.8 cm).

3-33 Student work, Michael Moore. Pencil, 12" x 9" (30.5 x 22.8 cm).

4 Plan your pattern. Tape the small drawing to a window or light box and place a piece of vellum over it. Draw the pattern component. Move the vellum. Repeat, moving the vellum and drawing the area in pencil until you are satisfied with the resulting pattern.

5 Add color with either watercolor or colored pencil. Repeat the color to emphasize and further develop the pattern.

6 With a black felt-tip pen, outline the shapes that form the pattern. How does this step transform your work?

## Evaluate It

• How did you vary the use of lines in your first drawing?

• How did your drawing change when the can was crushed?

• Can others easily identify your pattern component in your original drawings?

3-34 Student work, Meghan Heil. Watercolor, 12" x 18" (30.5 x 45.7 cm).

3-35 Student work, Rachel Stuzman. Watercolor, 12" x 18" (30.5 x 45.7 cm).

### Write About It!

What are the strengths and weaknesses of using contour line to represent an object? Write a sentence describing the strengths, and a sentence describing the weaknesses. Exchange your sentences with a partner and read each other's sentences silently. On your partner's paper, add a third sentence agreeing or disagreeing with the statements he or she made. Return the paper.

## Art History

## Studio Background

Observational drawing is the act of looking very carefully at an object and recording what you see. Drawing with contour line informs the artist about an object's structure. A glance through any great artist's sketchbook would reveal contour drawings.

Notice the strong, steady contours of *Skowhegan Water Glass*. The reflected colors create patterns within these lines. Because the glass is clear, the tonal variations are contrasting rather than gradual.

3-36 **For many years Janet Fish has depicted subjects made of glass. She meticulously records an object's contours, the way light hits its surfaces, and the manner in which nearby objects are reflected.** Janet Fish, *Skowhegan Water Glass* (detail), 1973. Pastel, 27" x 17³/4" (68.6 x 45 cm). © Janet Fish/Licensed by VAGA, New York, NY.

# Drawing with Expressive Line

In this exercise, you will apply your new knowledge of varied line to create an expressive linear drawing of a given subject.

3-37 Student work, Josh Kirsch. Marker, 24" x 18" (60 x 45.7 cm).

3-38 Student work, Katrina Chue. Charcoal, 18" x 12" (45.7 x 30.5 cm).

## Before You Begin

Consider a list of diverse words that represent feelings, emotions, and ideas. Think about how each of these words might be translated into a visual line expressing a particular emotional concept. Then look at examples of work in line by a number of different artists. Note the range of styles and expressive qualities.

## You Will Need

- white vellum paper
- pen and ink, brush and ink, charcoal, black felt-tip markers or calligraphy markers

## Create It

❶ Choose a simple art room object like a stapler, a container of paintbrushes, or bottle of glue to be drawn with an expressive use of line based on a particular artist's style. Ask yourself how this object would look if drawn using the broad linear simplicity of Matisse, the quick linear movement of van Gogh, or the focused, detailed line of Rembrandt.

❷ Develop one or two images of the object that show the visual influence on your chosen artistic style.

❸ Select an object from nature or a human-made object from which to develop a final expressive line drawing. Options might include a tricycle spray-painted completely black, a stuffed owl

3-39 Student work, Ian Brennan. Marker, 24" x 18" (61 x 45.7 cm).

3-40 Student work, David Jou. Marker, 24" x 18" (61 x 45.7 cm).

## Computer Option

Choose at least two objects with different visual weights, such as a feather and a book, and arrange them in a still life. Using a paint program, open an 8½" x 11" blank canvas. Using only the color black, experiment with a combination of different types and sizes of brushes to find the style that will describe each object best. Use light, thin brushstrokes to express any delicate qualities of the objects, and bolder lines where the objects appear heavier. Save and print for critique.

natural branch, or a vase filled with white lilies. Feel free to alter the subject to emphasize the kind of line you have chosen.

### Evaluate It

- How would you describe the linear quality of your images?
- In what ways is the linear quality of your images constant and expressive?
- Which images are most successful? Why?

## Studio Background

For centuries, the great masters of China and Japan have explored the expressive qualities of line. The brushstroke is the single most important part of their craft. The Japanese often employ line in the interest of another of their passions, satire. Consider this detail from the *Scroll of Frolicking Animals (Choju Giga)*. Here the artist has relied on fluid lines to describe the flower vase as well as the droll expression and pose of the Buddha-frog. Compare the feeling of these lines with those in *Dr. J. Robert Oppenheimer* (fig. 3-17, page 40). In what different ways do the artists distort visual information to create drama?

3-41 **This scroll is one of several in a series that depict cavorting animals engaged in satirical human-like behavior.** *Monkeys Worshiping a Frog* (detail), from Choju Giga Handscrolls attributed to Toba Sojo, c. late 12th century. Ink on paper, detail c. 12" x 18" (30.5 x 45.7 cm). © Barney Burstein Collection/Corbis.

# Calder-Inspired Wire Drawing

How can you work three-dimensionally with line? Try creating wire images of the human form, and explore connections between drawing and sculpture.

## Technique Tips

Use thicker wire when working three-dimensionally, for support to maintain the overall form of your sculpture. Remember that with this project "less is more." Avoid clunky wrapped wire forms.

## Computer Option

Scan your drawing of a human form in exaggerated movement into a paint program. Use a selection tool to select, cut, and copy the drawing onto a new window with a canvas size of 8½" x 11". Use a transform tool to experiment with stretching and distorting the drawing to emphasize the movement. Save and print the distortion that best shows movement or humor and replicate the printed image in wire.

3-42  Student work, Lila Symons. Wire and button, 16" x 13" (40.6 x 33 cm).

3-43  Student work, Mike Matejek. Wire, 10" x 7" x 4" (25.4 x 17.8 x 10.2 cm).

### Before You Begin

Study examples of wire sculpture, including Alexander Calder's *Circus*. How does the artist engage the viewer into his world of fantasy?

### You Will Need

- wire in a variety of kinds and thicknesses
- recycled buttons and electronics parts
- pliers and wire cutters in a variety of sizes

### Create It

❶ In your sketchbook, draw a human form in exaggerated movement (skydiver, pole vaulter, gymnast, dancer, etc.). The drawing can be loose—aim for flowing lines that suggest direction and force.

❷ Use your line drawing from your sketchbook as a model for a two-dimensional, flat wire form. The form should be about ten inches in length. Make cuts with pliers or wire cutters. Secure joints by wrapping, tying, and knotting. Consider selecting from a variety of wire, buttons, and electronics parts to bring a sense of whimsy to your creation. Your form will be completely flat and should match your drawing.

❸ Develop a second wire image. This time, cut, bend, and manipulate the wire to create a human form in three dimensions.

## Evaluate It

- How does your work reflect flow and movement?
- How does your sculpture use expressive line? Are any of the lines implied?
- How does the viewer's eye take in the linear qualities of your sculpture?

## Safety Note

To prevent injury, use caution when working with sharp tools. Always use the proper tool for the job. Do not cut wire with metal snips or scissors, or cord or string with wire cutters.

3-44 **Student work, Jesse Kirsch.** Wire and button, 12" x 7" x 7" (30.5 x 17.8 x 17.8 cm).

## Write About It!

Imagine you are a spectator at Calder's Circus. Describe the performance. Focus on the movement, energy, expression, and gesture of Calder's wire sculptures. Pay special attention to the whimsical performance and playfulness of the circus performers. You may wish to focus on just one or two performers or describe the overall effect of the performance.

## Art History

# Studio Background

Using wire, fabric, and other small odds and ends, Calder created a miniature circus with high-wire acts, animals, and other performers. Traveling between Paris and New York from the mid-1920s to the early 1930s, he carried the ever-evolving circus with him in suitcases. His performances of the manually operated circus won him recognition among the avant-garde of the time.

With these small, expressive, and movable wire creations, Calder was using line to work through some of his ideas about movement and balance. The concepts developed from his witty circus figures eventually translated into the large movable sculptures, or mobiles, for which the artist is so well known.

3-45 **Employing wire in the creation of his miniature circus, Calder discovered that he could produce realistic figures with relative ease. Why do you think this process is sometimes called "drawing with wire"?** Alexander Calder, *Calder's Circus*, 1926–31. Mixed media; wire, wood, metal, cloth, yarn, paper, cardboard, leather, string, rubber tubing, corks, buttons, rhinestones, pipe cleaners, bottle caps, overall: 54" x 94¼" x 94¼" (137.16 x 239.4 x 239.4 cm). Whitney Museum of American Art, New York. Photo by Jerry Thompson.

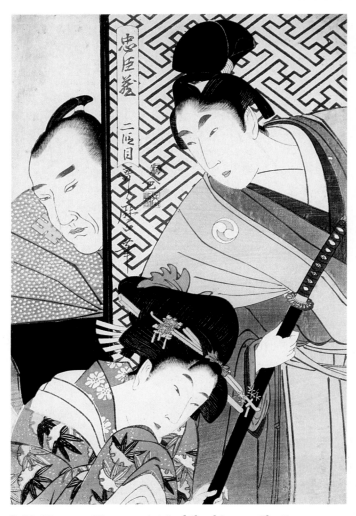

3-46 Kitagawa Utamaro, *Act II of Chushingura, The Young Samurai Rikiya, with Kononami, Honzo Partly Hidden Behind the Door,* late 18th century. © Christie's Images/Corbis.

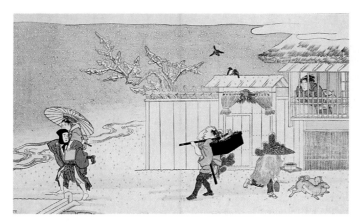

3-47 Kitagawa Utamaro, *Snow Scene,* from the book *Young Ebisu* or *Verses for Ebisu,* c. 1786–89. © Peter Harholdt/Corbis.

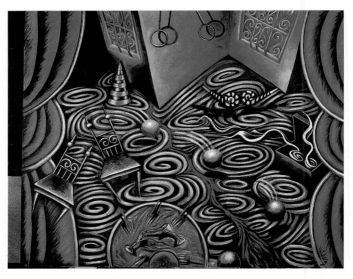

3-48 Patssi Valdez, *The Magic Room,* 1994. Acrylic on canvas, 96" x 119 5/8" (243.8 x 303.8 cm). Smithsonian American Art Museum, Museum purchase through the Smithsonian Institution Collections Acquisitions Program.

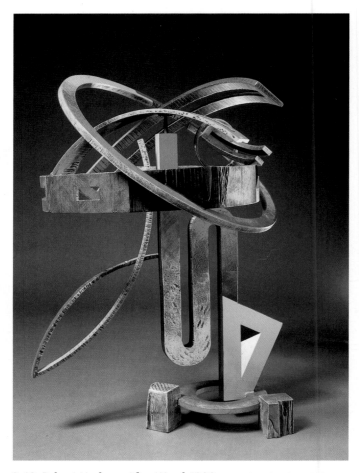

3-49 Robert Hudson, *After Wood,* 1990. Painted steel, 34" x 23 1/2" x 22 7/8" (86.4 x 59.7 x 58.2 cm). Smithsonian American Art Museum, Gift of Mrs. Jacquelin Hume.

# Chapter Review

## Summary

There are many kinds of lines. We can see lines in nature and in our human-made environment. Letters and numbers on book pages are made up of lines. Lines appear on maps and even musical scores.

Lines in art also come in various forms. Lines can be *descriptive, implied,* and *abstract.*

Descriptive lines are created with a variety of tools, and can be *outlines, contour lines, individual lines,* or *hatching.* On the other hand, lines can be *implied* by the *edges* of forms in paintings and sculptures. Lines can be implied by the process of *closure* and by *lines of sight.* Abstract lines, unlike descriptive lines, usually do not symbolize or represent anything except themselves.

All lines—whether descriptive, implied, or abstract—can express feelings and ideas. We can talk about lines as having personalities. We give personalities to lines by associating certain feelings with a line's shape, movement, and direction. The *expressive* qualities of lines are an important part of the aesthetic experience.

## Review Questions

1 **Recall:** List two examples of line in nature.

2 **Understand:** Explain how optical mixing occurs when using thin black lines on white paper.

3 **Apply:** Demonstrate your understanding of hatching and crosshatching by creating a small drawing of everyday objects that makes use of both of these techniques.

4 **Analyze:** Look at Gary Molitor's computer artwork, *Baghdad by the Bay.* Describe in writing how the artist has made effective use of hatching, outlines, lines that make shapes, and lines that show movement.

5 **Synthesize:** Use line to create three cartoon characters, each quite different from the other. Give each character one main emotion to express, and use line to express that emotion clearly in all features of the character, not just its face. Write a short description of each character.

6 **Evaluate:** Choose the artwork in this chapter that you think uses lines most expressively. Defend your choice in writing, using vocabulary you have learned.

## For Your Portfolio

Select one of your works that shows your understanding of line. Write a description of this artwork, explaining how you emphasized line.

## For Your Sketchbook

Create a visual reference to types of line: Include the categories Descriptive Line, Implied Line, and Expressive Line, and show your own examples of each. Use several different media in each category.

## Electronic Research

Choose a contemporary artist from this chapter whose work interests you. Use the Internet to find more of that artist's work. Select one artwork you particularly like, and write a critique of it, using the four-step critical process described in Chapter 2.

## Going Further

Have you ever thought about where artists find inspiration for the work they do? Some artists look closely at the world around them and fill their sketchbooks with visual studies. Start making a well-mounted collection of natural things, such as insects, weeds, leaves, flowers, or shells. Create a visual studies journal and begin drawing your collection, focusing on line quality and linear details.

# ④ Shape and Form

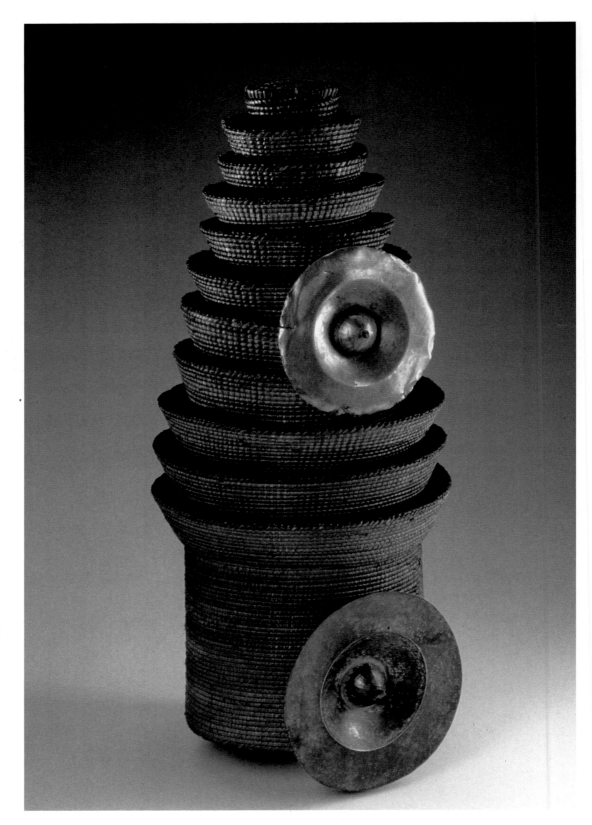

4-1 **Worn by the *nkumu*, or chief of the village, this type of hat *(botolo)* is a symbol of authority and importance. How does the botolo's form help emphasize its symbolism?** Ekonda peoples, *Hat (Botolo)*, Democratic Republic of the Congo, early 20th century. Raffia, brass, copper, dye, 21 3/4" x 9 1/8" x 9 5/16" (55.2 x 23.2 x 23.6 cm). National Museum of African Art, Smithsonian Institution, Museum Purchase. Photo by Franko Khoury.

## What You'll Learn

- the definitions of shape and form
- how to identify figure-ground relationships in images
- what foreshortening is, and how it can be used in artworks
- ways organic and geometric shapes and forms, and open and closed shapes and forms, can help artists express ideas

4-2  Student work, Alerica Lattanzio. Foam core and acrylic paint, 15" x 12" x 20" (38.1 x 30.5 x 51 cm).

### Key Terms

*English (Spanish)*

*shape* (*figura*)
*figure and ground* (*figura y tierra*)
*positive shape* (*figura positiva*)
*negative shape* (*figura negativa*)
*form* (*forma*)
*shape constancy*
   (*constancia de la figura*)
*foreshortening* (*escorzo*)
*size constancy* (*constancia del tamaño*)
*organic* (*orgánico/a*)
*geometric* (*geométrico/a*)
*closed* (*cerrado/a*)
*open* (*abierto/a*)

### Artists

Cassandre, Chunghi Choo, Ekonda peoples, M.C. Escher, Hans Holbein, Edward Hopper, Käthe Kollwitz, Kathleen McCarthy, Andrea Mantegna, Henry Moore, Alice Neel, Louise Nevelson, Isamu Noguchi, Jessie Oonark, Pablo Picasso, Camille Pissarro, Rembrandt van Rijn, George Rickey, Auguste Rodin, Sansetsu, Vincent van Gogh, Charles White

4-3  Student work, Catherine Singley. Tissue paper, 24" x 18" (60.1 x 45.7 cm).

Shapes and forms are all around you, wherever you go. A **shape** is a two-dimensional area with a recognizable boundary. When you draw or paint on paper you are making shapes. A **form** is a three-dimensional shape. When you mold clay, you are making a form.

Shapes can be seen in more than one way. A **figure** is a shape that appears to be on top of background shapes. A **ground** is a shape that seems to be underneath or surrounding a figure. We call a figure a **positive shape**. A ground is called a **negative shape** (fig. 4-4).

Forms can also be seen in more than one way. *Real forms* are all around you: your desk, your chair, and other students are all three-dimensional. Sculpture, pottery, and architecture are also three-dimensional forms. *Forms in two-dimensional artwork* are not real

4-6 **Artists shorten the dimensions of some objects to show them at an angle and receding in space. This is called foreshortening. How would the red part of this truck look if viewed from the side?**

forms. Instead, they are representations of three-dimensional objects on a two-dimensional surface.

Artists use many special techniques to make objects on a two-dimensional

4-4 **You can see this diagram in two ways: first, as two faces (the "figures") with white space (the "ground") between them, or as a vase (the "figure") on a black background (the "ground"). Can you identify positive and negative space in the diagram?**

4-5 **What organic and geometric forms can you identify in this picture?** Photograph: Jack Hobbs.

surface look three-dimensional. One important technique is called *fore-shortening*. Foreshortening is a method of making an object seem to recede in space and appear three-dimensional by shortening the depth dimension (fig. 4-6).

Shapes and forms can be classified in several ways. *Organic* shapes and forms are irregular, such as those often found in nature—leaves, stones, clouds. *Geometric* shapes and forms are usually found in things made by people, such as buildings, bridges, and office machines (**fig. 4-5**). *Closed* shapes and forms seem solid and heavy. *Open* shapes and forms have space around and between them.

Artists can use organic and geometric shapes and forms, and closed and open shapes and forms, in their artwork to express different feelings or ideas (**figs. 4-7 and 4-8**).

**4-8 Does the house in this painting seem heavy and closed, or light and open? Why do you think so?** Edward Hopper, *House by the Railroad*, 1925. Oil on canvas, 24" x 29" (61 x 74 cm). The Museum of Modern Art, New York, NY, Given anonymously. Licensed by SCALA/Art Resource, NY.

**4-7 Do you see geometric or organic shapes in this work? Would you describe it as open or closed, overall?** Kano Sansetsu, *The Old Plum*, c. 1645. Four sliding door panels *(fusuma),* ink, color, gold leaf on paper, H: 68 3/4" (174.6 cm) x W: of one panel 45 11/16" (116 cm). W: of all four panels 15' 11 1/8" (485.3 cm). The Metropolitan Museum of Art, The Harry G. C. Packard Collection of Asian Art, Gift of Harry G. C. Packard, and Purchase, Fletcher, Rogers, Harris Brisbane Dick, and Louis V. Bell Funds, Joseph Pulitzer Bequest, and The Annenberg Fund Inc. Gift, 1975. Photograph © 1983 The Metropolitan Museum of Art.

## Linking Disciplines
### Mathematics
**Mathematical concepts** connect to art in many ways, including measurement, symmetry, scale, proportion, congruent shapes, tessellations, and technical drawing. Geometry connects to art through two-dimensional shapes and three-dimensional forms, perspective, and geometric patterns. Look around your community for good visual examples of these connections.

## 4.2 Shape

A *shape* is a two-dimensional area with a recognizable boundary. When you draw or paint on paper you are making shapes. When you cut something out of paper you are making a shape.

As you can see, there is a relationship between lines and shapes. Lines, particularly outlines, describe shapes. On the other hand, the edge of a shape implies a line.

### Shape Quiz

Identify the following:

4-9

a. a vase
b. two faces
c. either a or b

a. eight dots
b. a circle
c. two squares
d. any of the above

a. a locomotive
b. a black-and-white pattern
c. either a or b

a. an ellipse
b. a football
c. a top of a soft drink can
d. any of the above

a. a trapezoid
b. a blade of a utility knife
c. side of a truck
d. any of the above

How do you think you did on questions 1, 2, and 3? Here are the answers: ❶ c ❷ d ❸ c

All of the shapes in the quiz can be seen in more than one way. Look again at the illustration for question 1 (fig. 4-9). It is a good example of the tendency to see a pattern as two kinds of shapes: *figure and ground*.

A figure appears to stand out, to be "on top of" a ground. A ground, on the other hand, appears to be underneath and surrounding a figure. The white shape in the illustration is the figure and the black shape around it is the ground *if you see the pattern as a vase*. However, the black shapes are figures and the white is the ground *if you see the pattern as two identical faces looking at each other*. Try to see it either way. Such a pattern can be "read" in two different ways, but not both ways at once. You can reverse the figure and ground. Artists use the terms *positive shape* to refer to a figure and *negative shape* to refer to a ground.

*Circle Limit IV* by M. C. Escher (fig. 4-10) is an excellent example of figure-ground, or positive-negative, reversal in an artwork. Which is figure: black or white? Can you see it either way? Can you see it both ways simultaneously?

## Artist Biography
## M. C. Escher (1898–1972)

Edges link together and the spaces between them form angels. Or, do the spaces between the angels form devils? Maurits Cornelis Escher experimented with many repeating patterns similar to the one in *Circle Limit IV,* in which the edges of one object help to form the shape of another.

An accomplished printmaker, Escher first became interested in art in his high school in the Netherlands. There he learned to create designs by rolling ink on the textured surface of a carved linoleum plate, imprinting this inked surface onto paper. This printmaking process could be repeated to make multiple copies of a single image.

Following formal training in graphic arts at college, Escher experimented with a range of subject matter for his prints. His interest in nature and reality gradually gave way to an obsession with invented landscapes—dreamy worlds filled with strange creatures and impossible perspectives.

Like the multiple patterns of devils and angels in *Circle Limit IV,* there are multiple levels on which to look at this artist: as a master printmaker, a master drawer, and as a creator with a masterful sense of imagination.

4-10 **The decorative surfaces M. C. Escher found on the Moorish buildings of Spain were an important early influence on his work. How does this work force the viewer to notice the interaction of figure and ground?** M. C. Escher, *Circle Limit IV,* 1960. Woodcut in two colors, diameter 13½" (34 cm). © 1960 M. C. Escher Foundation, Baarn, Holland.

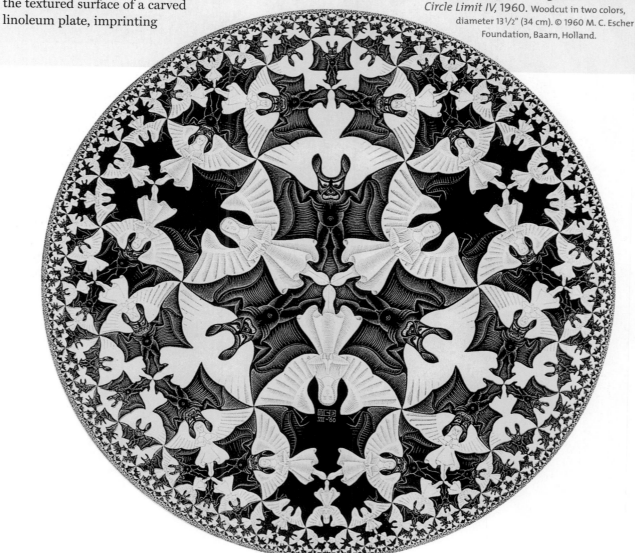

Return again to the quiz: questions 2 and 3 involve *closure*. You learned about closure in the previous chapter. You probably saw the eight dots of question 2 as a circle (**fig. 4-11**). With some effort you could connect the dots to see them as forming two separate squares (**fig. 4-12**).

4-11

4-12

4-13

It is much easier, however, to see a circle.

Did you see question 3 as a random pattern of white shapes or as a locomotive (**fig. 4-13**)? At first you may not have seen the locomotive. But once your mind's eye connects the shapes, the locomotive stands out clearly.

At first glance the cover of the 1938 issue of *Harper's Bazaar* (**fig. 4-14**) seems to be just some stripes that change color in the middle. A longer look reveals a few stars. The stars, together with the red and white stripes, remind us of the "Stars and Stripes," the

4-14 **Cassandre was a French graphic designer who spent the years 1936–39 in the United States designing covers for *Harper's Bazaar*. How does the artist use shape to integrate the title into this cover design?** A. M. Cassandre, *Harper's Bazaar* magazine cover, March 1938, USA. Courtesy Harper's Bazaar.

4-15 **This painting has been described as a "whimsical musical trio." How do the shapes help create a sense of whimsy?** Pablo Picasso, *Three Musicians*, 1921. Oil on canvas, 6' 7" x 7' 3 3/4" (201 x 223 cm). The Museum of Modern Art, New York, NY, Mrs. Simon Guggenheim Fund. Licensed by Scala/Art Resource, NY.

Write
About It!
Imagine that Picasso's *Three Musicians* is a puzzle. What shapes make up the image? How are they assembled to create pattern? Notice that the shapes and patterns repeat throughout the image. Write a paragraph describing the shapes and patterns in *Three Musicians*. Which shapes or patterns do you notice first? Do you notice those large shapes or do you notice those shapes that repeat to make a pattern? How does the assemblage of the shapes affect what you see?

American flag. Eventually, we see the image of a sewing machine. Because the sewing machine is not outlined, it is virtually a part of the black and lavender stripes. It is "embedded" in the background. It stands out from the background only because of a few changes in color and the addition of a spool of thread. The theme of the magazine is American fashion. In what ways does the cover express that theme? Do you think it is successful? Explain your answer.

The magazine cover was influenced by early twentieth-century art, such as Picasso's *Three Musicians* (**fig. 4-15**).

The painting can be read as three odd-looking musicians. Or it can be read as an abstract pattern of shapes. Picasso probably intended you to appreciate the pattern more than the image, which is primarily humorous. The shapes in this painting are cleverly assembled. Although the shapes may not be reversible, it is difficult to distinguish between figure and ground, or between positive and negative. Suppose this painting were an album cover. What kind of music would it be used for?

Most of the things we encounter in everyday life are three-dimensional shapes, or forms. A *form* has height, width, and depth. The chair you are sitting on and the desk you are working at are good examples of forms that have height, width, and depth.

### Forms in Pictures

In this section we will be concerned with forms in pictures, that is, the *representation of three-dimensional objects on a two-dimensional surface.* Now, how do you think you did on questions 4 and 5 of the Shape Quiz?

Answers to questions 4 and 5:

**4** d **5** d

4-16

4-17

4-18

You probably guessed that the answer for both questions was "any of the above." Like the examples used in questions 1, 2, and 3, these can be seen in different ways.

The example in question 4 is an *ellipse* (fig. 4-16). An ellipse is a curved shape that is longer in one dimension than it is in another.

But in a picture, an ellipse can also represent a three-dimensional ellipsoid (fig. 4-17), a type of form. A football is an ellipsoid. (Did you ever kick an ellipsoid? Did it bounce like a round ball, or a *sphere?*) An ellipse can also represent the top of a soft drink can seen from an angle (fig. 4-18). But as you know, the true shape of the can top is a circle (fig. 4-19).

4-19

You may think of the can top as being the shape of a circle, even when you see the top from an angle. This is an example of *shape constancy*, or the tendency to see a shape as unchanging regardless of the angle at which you see it.

The artist who drew the ellipse wanted you to see it as a circle at an angle. He or she also wanted you to see the whole image as a three-dimensional *cylinder*—or a soft drink can as it might be seen on a table in front of you. To make it seem this way the artist deliberately shortened the height of the top in comparison to its width (fig. 4-20). The artist also

4-20

curved the bottom edge of the can to match the curve of the ellipse at the top of the can. The object appears to be three-dimensional and receding in space. Making a three-dimensional object in a picture seem to recede in space by shortening the depth dimension is called *fore-*

4-21

4-22

*shortening*.

Now look at the shape (**fig. 4-21**) in question 5. It is a *trapezoid*, with four straight sides. Two of its sides are parallel. A

4-23

trapezoid can easily be used to represent the flat blade of a utility knife (**fig. 4-22**). It can also represent the side of an eighteen-wheeler that is coming toward you (**fig. 4-23**). Compare the foreshortened view of the truck with its full view

4-24

(**fig. 4-24**). Because of shape constancy, you think of it as being the same truck.

The use of foreshortening to make objects appear three-dimensional is very common in traditional drawings and paintings. Many items in Hans Holbein's *Portrait of Georg Gisze* (**fig. 4-25**) have been foreshortened. Identify as many items as you can. Some of these—the table, books and letters, and the writing implements resting on the table—have been diagrammed to show how they appear in the picture as it is (**fig. 4-26**), and how they would appear if not foreshortened (**fig. 4-27**).

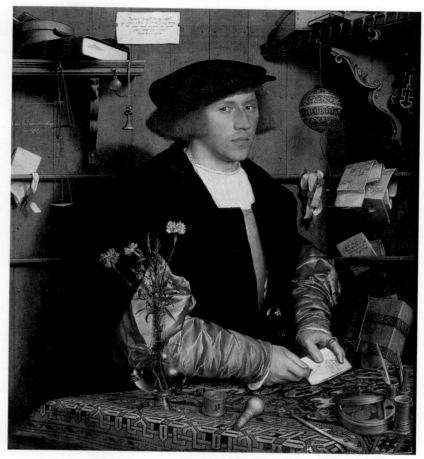

4-25 **During a visit to London, Holbein painted this German merchant who was living in that city. If you commissioned a portrait of yourself, how would you dress, and what objects would you include?** Hans Holbein, *Portrait of Georg Gisze of Danzig.* Staatliche Museen zu Berlin, Gemaeldegalerie. Photo by Joerg P. Anders.

4-26 **Foreshortened**

4-27 **Not foreshortened**

## Write About It!

Study Charles White's *Preacher.* Notice his gesture, point of view, and expression. Pay attention to the size and position of his arms and hands compared with the size and position of his head. Imagine that you're looking up at him. What is he saying? Write a short script for a sermon, a political speech, a dramatic speech in a play, or a poetry performance based on the man's expression and gesture. It is not necessary that the script be religious in subject matter. Include a short narrative describing the space, point of view, and energy of the speaker.

4-28 **Working during a time when African-Americans were fighting discrimination and slowly gaining civil rights, this artist made a point of depicting the strength and grace of black people. How is foreshortening used to communicate these qualities?** Charles White, *Preacher,* 1952. Ink on cardboard, 21³/8" x 29³/8" (54.3 x 74.6 cm). Collection of Whitney Museum of American Art, New York (Purchase). Photograph copyright 2000.

So far, we have seen examples of foreshortening in objects—soft drink cans, trucks, tables, books, and even office supplies. Foreshortening can also be applied to people. In the Holbein portrait on the previous page, you may have noticed foreshortening in the subject's left arm. Several parts of Charles White's *Preacher* (fig. 4-28) clearly show foreshortening. Look at the lower part of the preacher's right arm, the upper part of his left arm, the palm and fingers of his right hand, and even his head. Notice how complicated the foreshortening is in both hands.

In Alice Neel's portrait of the artist Sari Dienes (fig. 4-29), both the subject and the chair she sits in are foreshortened. The technique is readily seen in the form of the sitter's chair, especially in the chair's arm on the left. The effect of foreshortening is a bit difficult to see in the form of the sitter because of her billowy garment. The most extreme effect occurs in the limb that rests on the arm of the chair. Look at how the artist has radically shortened her forearm. As your eye moves from the ringed hand's fingertips to the elbow, you see the limb as if from a sharp angle.

## Try It Yourself

Find a small object with an interesting shape— a tool, thimble, wood scrap, or small sculpture. Do not show your objects to one another. Put them in paper bags. Without looking inside the bags, "view" each object with your hands. Then draw pictures of the objects. Compare your drawings with the actual objects.

Look at the illustration of the fore-shortened truck (fig. 4-30). Did you notice that the back of the truck is shorter than the front? This is because the back is farther away. To make something look farther away in a picture, the artist makes it smaller. To show something close, the artist makes it larger. We tend to think of an object's size as unchanging no matter how close or far away it is. This tendency is called *size constancy*. An illustration of size constancy can be seen in a picture of utility posts (fig. 4-31). The artist drew the farthest-away post twice—once on the left-hand side and again on the right-hand side at the foot of the nearest post. Were you surprised to learn how small the image of the farthest-away post is?

4-30

4-31

Camille Pissarro's painting in **figure 4-32** depicts a wide avenue that seems to go on forever. In the mid-1800s the streets of Paris were widened to allow for unobstructed views and lines of fire in case of invasion or rebellion. Since then, however, they have been admired more for their grandeur than for their military value. Pissarro captures this grandeur in *The Boulevard Montmartre on a Winter Morning*. The artist accomplished this by an effective use of one-

4-32 **Pissarro painted this view from a room that he rented in a Paris hotel. What instances of size constancy can you find in the view outside your classroom window?** Camille Jacob Pissarro, *The Boulevard Montmartre on a Winter Morning*, 1897. Oil on canvas, 25½" x 32" (64.8 x 81.3 cm). The Metropolitan Museum of Art, Gift of Katrin S. Vietor, in loving memory of Ernest G. Vietor, 1960. Photograph © 1990 The Metropolitan Museum of Art.

point perspective (a topic that we discuss in **Chapter 6, Space**). But he also used foreshortening and varied the sizes of people and objects according to the principle of size constancy.

Foreshortening is most apparent in the buildings facing the boulevard. We must assume that these six- or seven-story apartment blocks are very wide. But the artist has compressed their widths, especially those on the left side of the boulevard. Also compressed are the window openings. All of this reinforces the perception that the structures are three-dimensional.

Size constancy is clearly seen at work in the horse-drawn cabs in the street, the trees bordering the street, and the people on the broad sidewalks. While the image of the nearest cab may be little more than a quarter of an inch wide (measure it), the ones farther up the street are barely the size of a pinhead. This is also true of the trees and people (compare the size of the near ones with those farther away).

## Real Forms

So far we have been talking about three-dimensional forms in pictures. Technically, all the pictures in this book, even the photographs, have only two dimensions—height and width—even though they may represent depth. However, *real* forms are all around you. You, the other students, and the teacher, as well as the tables, cupboards, equipment, books, and the room itself have height, width, and depth.

Sculpture, pottery, metalwork, and architecture are a few examples of three-dimensional art. When a person makes a sculpture, he or she is making a *real* form, not the picture of a form. Suppose you wanted to make a sculpture of a truck. You would not foreshorten the side to make it *seem* long. You would make it long in reality.

When you look at a sculpture, you need to move around it in order to see its different sides (**fig. 4-33**). The many-sided form of a sculpture does not have to be viewed just by the eyes. You can also "view" it by moving your hands across its different surfaces, edges, and corners.

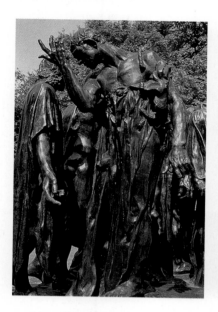
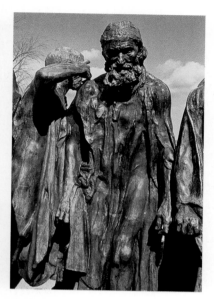
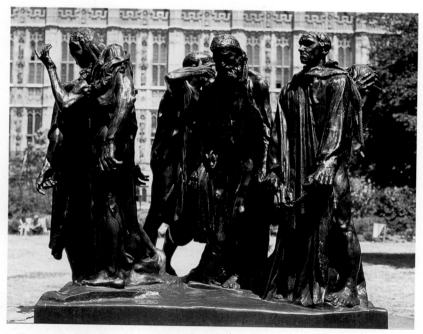

4-33 **This sculpture commemorates the heroic act of six citizens of Calais who in 1347 offered their lives to save their besieged city. How does the artist count on the viewer's ability to move around the piece in order to tell his story?** Auguste Rodin, *Burghers of Calais* (3 views), 1884–86. Houses of Parliament, North Bank of the Thames, London. Courtesy Davis Art Images.

In Chapter 3 you learned about the expressive qualities of lines. For example, lines could be described as relaxed, excited, energetic, strong, and unstable. Shapes and forms also have expressive qualities. Artists typically classify shapes and forms as *organic* or *geometric* and *closed* or *open*.

4-34 **Organic shapes and forms**

## Organic versus Geometric

***Organic*** shapes and forms (**fig. 4-34**) are found throughout nature: earth, water, clouds, plants, animals, and people. Organic shapes tend to be irregular. Sometimes their edges are relatively straight, but never perfectly so.

Sometimes their surfaces are relatively flat, but never perfectly so. Sometimes they are curved, but never perfectly round like a circle or a sphere.

4-35 **It is logical that natural organic forms would dominate landscape paintings. What words would you use to describe the organic shapes in this painting?** Rembrandt van Rijn, *The Mill*, c. 1645–48. Oil on canvas, 34 1/2" x 41 5/8" (87.6 x 105.7 cm). Widener Collection, Image © 2003 Board of Trustees, National Gallery of Art, Washington, DC.

*Geometric* shapes and forms (fig. 4-36) are typically found in things made by people, such as buildings, bridges, factories, and office machines. Unlike organic forms, geometric forms are very regular. Their edges and surfaces are straight or perfectly curved.

4-36 **Geometric shapes and forms**

The forms of *The Mill* (fig. 4-35)— a famous landscape painting by Rembrandt—are primarily organic. Even the few human-made objects, such as the mill and the rampart wall below the mill, show the effects of natural weathering and erosion. The edges of the forms are irregular.

Compare this painting to *House by the Railroad* (fig. 4-37), a landscape, or "townscape," by Edward Hopper. The forms are primarily geometric. Except for the somewhat irregular lines of the roof and windows, the rest of the lines are fairly regular and straight. Note the vertical lines of the sides of the house. Horizontal lines are used for the eaves, the porch overhang, and the railroad track. Finally, notice the diagonal line of the shadow.

## Linking Disciplines
### Science

Artists often get ideas for their artwork by looking closely at the world around them. But have you ever thought about getting ideas for sculpture by looking at natural forms not visible to the human eye, such as a **DNA molecule**? Find out more about the Human Genome Project and why scientific illustrations and models are necessary for the advancement of scientific research.

## Closed versus Open

The scenes by Rembrandt and Hopper are similar. Both consist of single forms set against a broad expanse of sky. Both express loneliness. But the loneliness in *House by the Railroad* is starker because of its geometric forms. Furthermore, the forms in both paintings seem solid and heavy. The mill and the land it rests on seem massive. Even though the house by the tracks has a few windows, it looks heavy and dense. These are **closed** forms in both paintings. Nothing can penetrate them.

**Open** shapes and forms, on the other hand, allow space to penetrate.

Notice the forms in *The Old Plum* (**fig. 4-38**), by Sansetsu. Unlike the forms of Rembrandt and Hopper, the Sansetsu tree is so open that it seems to float in its golden environment. Indeed, space—in this case sky and distant mountains—embraces the entire tree. While the winding tree trunk is thick and robust, the small branches are

delicate and fragile. How do the ideas and feelings expressed in the Sansetsu compare with those in the Rembrandt? in the Hopper?

Forms in abstract art can also be described as organic or geometric and closed or open. The abstract sculpture in **figure 4-40** by Isamu Noguchi is organic and closed. Abstract art does not represent things we see. However, it does express ideas. Noguchi's piece is called *Great Rock of Inner Seeking*. Do you think it expresses the ideas suggested by its title? Explain your answer. Why did Noguchi use an organic form? a closed form?

*Four Lines Oblique* (**fig. 4-39**) by George Rickey is also abstract. However, unlike the Noguchi, it is geometric and open, *very* open. Notice the amount of environment showing through its skeletal spokes of metal. Metal sculptures, made of rods pieced together by a welding torch, have become quite popular for outdoor display.

4-38 **The panels of this work originally formed the wall of a room in a Kyoto temple complex. Do you think this image works well as a wall? Why or why not?** Kano Sansetsu, *The Old Plum*, Edo period, c. 1645. Four sliding door panels *(fusuma)*, ink, color, gold leaf on paper, H: 68 3/4" (174.6 cm) x W: of one panel 45 11/16" (116 cm). W: of all four panels 15' 11 1/8" (485.3 cm). The Metropolitan Museum of Art, The Harry G. C. Packard Collection of Asian Art, Gift of Harry G. C. Packard, and Purchase, Fletcher, Rogers, Harris Brisbane Dick, and Louis V. Bell Funds, Joseph Pulitzer Bequest, and The Annenberg Fund, Inc. Gift, 1975. Photograph © 1983 The Metropolitan Museum of Art.

4-39 **Rickey is one of contemporary art's foremost metal sculptors. Could a kinetic sculpture ever be a closed form?** George Rickey, *Four Lines Oblique*, 1973. Stainless steel. New Orleans Museum of Art; Gift of the Sydney and Walda Besthoff Foundation.

4-40 **Artists can use open and closed forms to help communicate the meaning of a work. Judging by the title, why might the artist have chosen a closed form for this piece?** Isamu Noguchi, *Great Rock of Inner Seeking*, 1974. Basalt, 128" x 63" x 35" (325 x 160 x 89 cm). Gift of Arthur M. Sackler, M.D. and Mortimer D. Sackler, M.D., Image © 2003 Board of Trustees, National Gallery of Art, Washington, DC.

## Write About It!

Compare Noguchi's *Great Rock of Inner Seeking* with George Rickey's *Four Lines Oblique*, focusing on their use of form. Study their use of weight, direction, negative and positive shape and space, and organic and geometric form. You may wish to begin this exercise with a list of similarities and differences. How does their use of form, weight, and direction affect the way you interpret the work?

# A Contemporary Metalwork

**About the Artist**
## Chunghi Choo
### (b. 1938)

**Chunghi Choo** says her goal is to create "graceful and timeless objects" that reflect simplicity and harmony. The influence of her early training in the arts of Asia is evident in much of her artwork.

Born in Inchon, Korea, Ms. Choo was educated at Ewha Women's University, in Seoul, where she majored in Oriental painting and also studied the philosophy of Oriental art. In 1961 she came to the United States to pursue studies in metalsmithing, weaving, and ceramics at the Cranbrook Academy of Art in Bloomfield, Michigan, receiving her master of fine arts degree. Since 1968, she has taught jewelry and metal arts at the University of Iowa, in Iowa City. Her hollowware, jewelry, flatware, sculpture, mixed media objects, and textiles have been exhibited internationally and her pieces are owned by major museums in the US and Europe.

4-41 **Today's metal artists often work with traditional and modern materials to create objects that combine jewelry and sculpture. Looking at the components of these works separately and carefully will help you to appreciate their complexity. It might also help stir your emotions and stimulate your thoughts.** Chunghi Choo, *Orb in Cradle*, 1998. Aluminum sculpture, acrylic urethane paint, 79" x 53" x 49" (200.6 x 134.6 x 124.5 cm). Photo by Steven Tatum. Courtesy of the artist.

## 1 Describe What You See

When you describe an artwork, you identify the things about the work that you can see, name, and know with certainty. You should not include opinions, evaluations, or possible meanings here.

- List the name of the artist, title of work, category of art, and materials used.
- Describe the three-dimensional forms and two-dimensional shapes you see. Are they geometric or organic?
- Describe the arrangement of the forms and shapes.
- Where do you see negative space defined by shapes?
- Identify the kind of lines that imply movement.
- List the colors you see.

## 2 Analyze the Way It's Organized

When you analyze an artwork, you tell how the subject matter and elements of the work have been organized by the artist. You tell how they work together.

- Where do you see rhythm created by repetition? by alternation?
- Where do you see continuous lines for the eye to follow?
- What elements provide variety?
- What is the dominant element, and why?
- What balance is evident in the composition?

## 3 Interpret What It's Saying

Use the information from your description and analysis to help you identify the meaning of the work—what it tells you about human experience.

- List some descriptive words you associate with the construction.
- What objects does this form remind you of?
- Try writing a simile or metaphor to help you interpret the meaning or message of the work.
- What do you think the message or theme of the work is?

## 4 Evaluate Its Success

Using your analysis in the first three steps, how would you judge the quality or success of this work?

- What philosophy or purpose best describes the work? Is the emphasis on: (a) good design, (b) communicating ideas, (c) advancing a cause, or (d) imitating the real world? How do you judge the success of the work in terms of that philosophy or purpose?
- How do you judge the success of the compositional arrangement?
- How do you judge the originality of the work? Consider the materials used and whether there is an inventive treatment of an idea.
- To what extent does the work hold your attention, arouse your curiosity, make you think?

**More Art!**

See page 86 for more artworks by Chunghi Choo

**Web Link**

www.davis-art.com

## Write About It!

Find an everyday object at home or outside that has a number of negative shapes. In a single paragraph, describe the object, including its positive and negative spaces. Never say what the object is. Ask your classmates to guess the object's name based on the words you used to describe it.

# Drawing with Negative Shapes

Have you ever thought about drawing nothing? Here's your chance to compose a still-life drawing that balances positive and negative shapes. You can use color to help define the negative shapes within the composition.

4-42 Student work, Josh Kirsch. Cut paper, 18" x 24" (45.7 x 60.9 cm).

## Before You Begin

Study the visual forms that your teacher has assembled for your still life drawing. Focus your attention on the spaces or shapes between the solid forms.

### You Will Need

- newsprint paper
- white vellum paper
- a pencil
- pastels, colored pencils, markers

4-43 Student work, Danielle Weaver. Colored pencils, 24" x 18" (60.9 x 45.7 cm).

4-44 Student work, Ian Brannan. Colored pencils, 18" x 24" (45.7 x 60.9 cm).

## Technique Tips
• Close one eye in order to flatten your perception of the three-dimensional objects.
• Pick a section of the still life that has at least three objects and many negative shapes.

## Computer Option

Redraw your still life into a computer paint program. Using paintbrush tools and the paint fill bucket, fill the negative spaces with a chosen color scheme and either a geometric or curved linear pattern. Experiment with and save different color scheme variations to produce a triptych artwork.

## Create It

**1** On your newsprint paper, slowly develop a contour line drawing, focusing on one negative shape at a time. Before you continue, evaluate changes that need to be made to achieve balance and visual interest.

**2** When you are satisfied with a final drawing, transpose it onto the white vellum paper in the medium of your choice.

**3** Create a color for your negative shapes. Blend the color so that it fades in intensity as it moves through your composition.

## Evaluate It

• How did this exercise make you more aware of space?

• To what extent did you maintain a balance between positive and negative shapes?

• How did you alter, manipulate, and control color?

## Art History

## Studio Background

The German Expressionist Käthe Kollwitz created over one hundred self-portraits during her lifetime. The first one dates from 1885, when she was eighteen, and the last from a few years before her death in 1945. Each portrait shows strong contrasts of light and dark. Kollwitz was very honest in her portrayal of herself. As she aged she recorded the sagging of her skin and the whitening of her hair. In this very late profile portrait we see her aging shape against the stark whiteness of the paper. How does her handling of negative and positive shapes in this self-portrait differ from that of her self-portrait shown in figure 6-19?

4-45 **From the early days of her career, Kollwitz avoided color and came to rely heavily on the contrast of black and white. Why is this contrast particularly suited to Kollwitz's introspective self-portraits?** Käthe Kollwitz, *Self-Portrait in profile facing right,* 1938. Original lithograph, fine impression on wove paper annotated lower right: from the collection of Hans Kollwitz, the artist's son. Illustration courtesy Spaightwood Galleries, Madison, WI.

# Foreshortening in Figure Study

Did you know that Renaissance artists were the first to apply perspective to the figure so that it appeared to recede in space? **Figure 4-48** on page 81 offers a striking example of this technique. You can apply this same principle, called foreshortening, to create a figure study.

## Write About It!

Welcome to the world of science fiction. Your classmates are shrinking and expanding right before your very eyes. As you sit on the floor at the base of the ladder and watch a student-model ascend the steps, his or her body proportions alter beyond recognition. Take visual measurements. Notice how the size of the student-model's arms, legs, head, and clothes changes, and then changes again as he or she descends the ladder. Describe the evolution of the visual measurements you take. From where do these perceptions originate? How much stranger will the figure become?

4-46 Student work, Nancy Chu. Charcoal, 18" x 24" (27.9 x 35.6 cm).

4-47 Student work, David Jou. Charcoal, 11" x 14" (27.9 x 36.6 cm).

## Before You Begin

Consider examples of foreshortening in art, including Mantegna's *Dead Christ* (fig. 4-48). Study a classmate-model from different angles. Sit on the floor and note how your perspective changes as the model climbs a ladder. Climb the ladder yourself and look down on a model seated on the floor. Or, view a model lying on a table. How does your view change as the angle of vision changes?

## You Will Need

• newsprint paper
• white vellum paper
• charcoal, pencil

## Create It

❶ Select an angle from which to draw a student-model who is either standing or lying down. Based on the angle of vision you have selected, consider how you will create foreshortening of the human form in your drawing.

❷ Take ten minutes to draw the pose in charcoal, clearly expressing the subtle distortion found in foreshortening.

❸ For homework, draw a self-portrait or a portrait of a family member in pencil, using foreshortening. The subject might be parent or sibling reading the newspaper or watching television. Or, try

drawing yourself standing on a mirror or facing a large mirror with your feet propped up in front of you.

## Evaluate It

- How did you position your model to increase the need to apply foreshortening?
- To what extent did you experiment with different viewpoints before deciding upon an angle from which to draw the model?
- What adjustments did you have to make in your drawing to make the figure appear to recede in space?

4-48 Student work, Josh Kirsch. Fine line marker over pencil, 18" x 24" (45.7 x 60.9 cm).

## Computer Option

Use a digital camera to photograph a model from three different distances. With the camera at the wide-angle setting, take pictures of the same pose at twenty feet, five feet, and then as close as the camera will allow while still keeping the majority of the model in the picture frame. Print out the three pictures and use a ruler to measure the proportional differences between the nearest part of the model and the farthest. Repeat the assignment using pencil and paper and see how successful you are in drawing the foreshortening effect.

**Art History**

# Studio Background

Images with extreme or unexpected foreshortening always make us stop and say "Wow!" Why is that? We stare at the bottom of the dead Christ's feet as the body extends back into space at a startling angle, yet we know the painting is flat! When artists of the Renaissance discovered linear perspective, it was logical that they would apply it to the human figure. These artists immediately understood the power foreshortening had to create great drama. Artists such as Mantegna utilized foreshortening as one of the principle design elements in their compositions.

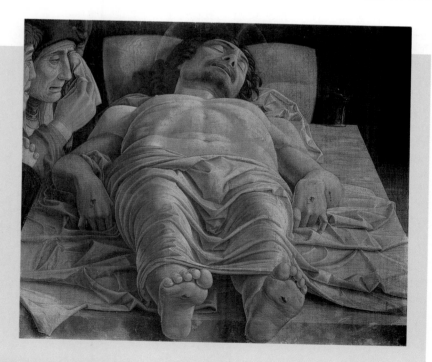

4-49 **Despite his success in depicting the dead Christ's foreshortened legs and torso, Mantegna was unable or unwilling to paint Christ's feet realistically large. Compare these feet with those of the students shown in figures 4-46 through 4-48 (and recall the principle of *size constancy* from page 70).** Andrea Mantegna, *Dead Christ ("the foreshortened Christ"), mourned by the Virgin, a pious woman and Saint John the Apostle,* c. 1490. Tempera on canvas, 26 3/4" x 31 3/4" (68 x 81 cm). Pinacoteca di Brera, Milan, Italy. Photo by Erich Lessing/Art Resource, NY.

# Family Structure in Abstract Sculpture

How can you symbolically represent your family structure and show your relationship to the group? Try doing it as a foam-core sculpture. In this exercise you can explore ways that abstract, open forms can express ideas about family.

## Technique Tip

• It can be difficult to cut the foam core while maintaining a clean edge. Also, X-Acto blades tend to dull quickly. When the foam core edge becomes uneven, change the blade. In some cases very fine sandpaper helps keep edges smooth.

## Computer Option

Create a PowerPoint presentation about your own family or extended family. Scan photos of you and your family or friends as a group. Interview these people who are closest to you either in person or via e-mail. Gather quotations about such things as how they felt the day you were born or the day they met you, or their favorite memories of you, or have them write a letter to you. Juxtapose these words with photos of you at various stages of your life. Treat each page of your PowerPoint as a separate design composition, and use shapes both to enhance each page and to unify your entire presentation. Save to a disk or CD.

Your PowerPoint will be your personal portrait of your family through your eyes.

4-50 Student work, Andrew D'Alessandro. Foam core, 20" x 20" x 20" (50.8 x 50.8 x 50.8 cm).

4-51 Student work, Jay Thompson. Foam core, 20" x 14" x 12" (50.8 x 35.6 x 30.5 cm).

## Before You Begin

Study examples of sculpture by various artists. List interesting qualities of your family members, including yourself. Think about shapes that would best represent each person.

## You Will Need

• oak tag
• scissors
• masking tape
• foam core
• metal straightedge
• X-Acto knives
• straight pins
• acrylic paint
• epoxy or white glue
• white gesso

## Create It

❶ In your sketchbook, draw a series of shapes that best represent each person in your family. More than one shape may be needed to fully represent each person. Avoid all symbolic symbols such as arrows, hearts, peace signs, and question marks.

❷ Using oak tag, scissors, and masking tape, experiment by creating a small model (called a *maquette*). Your small model should be approximately 8" (20 cm) tall. Refer to your sketchbook as you create this.

❸ As you work, consider the size and relationship of each individual unit. They will later be put together to form one whole family unit.

❹ When you are ready to move on to your final sculpture, use an X-Acto knife and metal straightedge to cut your

4-52 Student work, Alerica Lattanzio. Foam core and acrylic paint, 15" x 12" x 20" (38.1 x 30.5 x 51 cm).

4-53 Student work, Regan MacKay. Foam core, 18" x 20" x 15" (45.7 x 50.8 x 38.1 cm).

## Write About It!

Describe in a short essay how your shapes represent your family members. Consider the size and complexity of your shapes. Are they sharp, rounded, straight, or curvy? organic or geometric? How do your shapes interact with one another? Do they overlap or stand alone? Is there negative space between your shapes or are they dependent upon one another for stability? Compare the structure of your sculpture with the dynamics of your family. How does it reflect your family unit?

shapes. Connect one shape to another with epoxy or white slur and straight pins. Use white gesso to cover the exposed pinheads.

## Safety Note

X-Acto knife blades are extremely dangerous. To prevent injury, use caution in cutting with these tools and in changing the blade. Keep plenty of free space around you. Always pull the knife toward you, keeping your free hand well out of the way.

## Evaluate It

• How do your shapes symbolically represent each family member? What is communicated?

• How are relationships within your family unit expressed in your sculptural form?

**Art History**

## Studio Background

The birth of his daughter in 1946 prompted abstract sculptor Henry Moore to explore the theme of family. It is a recurring subject in his work. In the groupings of mother, father, and offspring, Moore communicates his somewhat traditional perspectives of the relationship of family members. Form and placement are the keys to unraveling Moore's messages about interfamily relationships. In this family group, the mother nurtures the young child with her enclosing shape. The father's more open form protects the older child, yet it also, perhaps, is meant to help shepherd the child into the outside world.

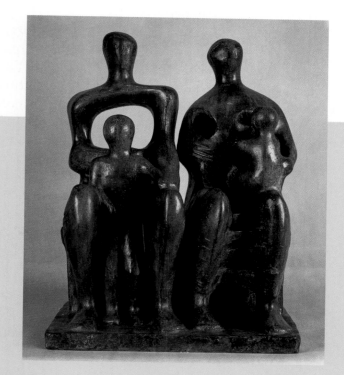

4-54 Moore's sculptures have been described as "biomorphic abstractions" because they incorporate the forms of living organisms. Sometimes the form is readily recognizable, and in other cases it is extremely abstracted. What advantages are there in using an abstracted form to communicate the idea of "family"? Henry Moore, *Family Group*, 1946. Bronze with green patina, 17 1/4" (43.9 cm). © Christie's Images Ltd. Courtesy The Henry Moore Foundation.

# A Relief Sculpture Collaboration

Imagine a collaboration between Louise Nevelson and Vincent van Gogh. For a class project, use a variety of scrap wood shapes to create a low-level relief. Work with your classmates to capture the rhythm and movement of a van Gogh painting and the sculptural style of Nevelson.

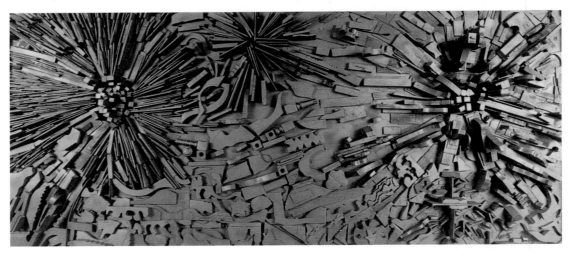

4-55 Student work, collaboration (full view). Plywood and glue.

## Computer Option

Scan or photograph digital images of your school or your downtown. Select one image to open and manipulate into a Nevelson-style artwork. Convert the artwork done in the style of Nevelson to a value scale (see **Chapter 5**). Increase the contrast, or if available, use an embossing tool or filter to simplify and abstract the image. Select, copy, and paste parts of the image to create rhythm and movement as would be found in a Nevelson sculpture. Save and print your image to critique.

## Safety Note

To prevent injury, exercise caution in using handsaws. Keep plenty of free space around you, and keep your free hand well away from the blade at all times.

## Before You Begin

Study examples of the sculptural work of Louise Nevelson (**fig. 16-39, page 465**). Take time to "play" with the collected wood scraps. Manipulating the wooden shapes will help you understand their possible relationships.

Study a relief map as an example of the low-level relief you will create. Study van Gogh's *The Starry Night* (**fig. 4-58**). How does the artist use shape and form to create rhythm and movement in the painting?

## You Will Need

- scrap wood of different sizes
- a sheet of plywood
- carpenter's glue
- black, white, or gold spray paint
- a handsaw

## Create It

❶ Using the wood scraps as building blocks, and sawing the scraps as necessary, practice constructing, deconstructing, adding to, and subtracting from a structure. This is the basis for creating the sculpture.

❷ With your classmates, begin to build a low-level relief on the sheet of plywood. The highest level of the relief should not extend above 5½" (14 cm). Use the image of *The Starry Night* as inspiration. Do not copy the composition of van Gogh's image, but use it to help create movement in the relief.

❸ Add and subtract pieces of wood each day. Discuss with your classmates what is working and what should be changed. Do not make the design permanent until the group agrees on the final image.

❹ When you and your classmates have settled on a final design, brush generous amounts of glue onto each piece of wood. Apply the pieces to the plywood backing. When the glue is dry, spray paint the relief, using a single color, to unify the final image.

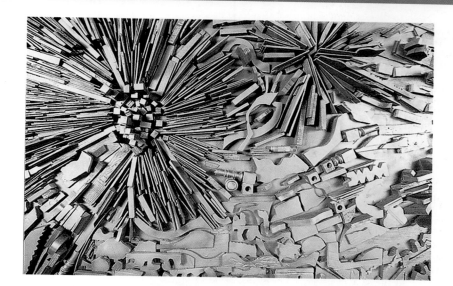

4-56 Student work, collaboration (detail). Plywood and glue.

**Write About It!**

Study the rhythm and pattern achieved in your class's relief sculpture. Identify the beat or rhythm and movement of the sculpture. Create a poem, song lyrics, or prose paragraph that describes the sculpture and reflects or mimics its rhythm or beat. The ideas you express might be derived from the individual lines and shapes seen in the sculpture. The way your words are combined should draw on the sculpture's composition, pattern, and movement.

## Evaluate It

- In what specific ways does the artwork compare to Nevelson's sculptures and van Gogh's painting?

- How does the arrangement of the varied shapes and forms help achieve visual interest?

- What specific teamwork and cooperative skills were most helpful in accomplishing this task?

4-57 Student work, collaboration (detail). Plywood and glue.

## Art History

## Studio Background

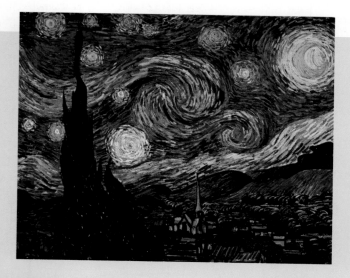

In one of his famous letters to his brother, Theo, van Gogh describes how he watched the countryside from his window before daybreak and observed the morning star (Venus). Perhaps the energy-filled forms of *The Starry Night* were inspired by this window-side reverie. The undulating rhythm of the artist's thick textured strokes moves across the sky, through the hills, and up the cypress tree. We know for certain it is not a representation (even a stylized one) of the view of Arles that van Gogh saw from his window, for the small town seen in the painting is imaginary.

4-58 *The Starry Night* was one of the few works by van Gogh exhibited during the artist's lifetime. Why do you think this painting has become so extraordinarily famous and instantly recognizable? Vincent van Gogh, *The Starry Night*, 1889. Oil on canvas, 29" x 36¼" (73.6 x 92 cm). The Museum of Modern Art, New York, NY. Acquired through the Lillie P. Bliss Bequest. Licensed by Scala/Art Resource, NY.

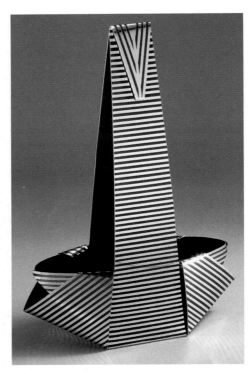

4-59  Chunghi Choo, *Folded Basket*, 1986. Aluminum sculpture, acrylic lacquer paint, 16¼" x 11" x 4¼" (41.3 x 27.9 x 10.8 cm). Collection of Jack Lenor Larsen. Photo by Peter Krumhardt. Courtesy of the artist.

4-60  Jessie Oonark (Inuit), *Man and Woman with Decorated Cloth*, 1979. Colored pencil and graphite on wove paper (watermark: "BFK RIVES/FRANCE"), 30" x 20" (76 x 56 cm). National Gallery of Canada, Ottawa; Gift of the Department of Indian Affairs and Northern Development, 1989. The Public Trustee for Nunavut, estate of Jessie Oonark.

4-61  Chunghi Choo, *Fleur*, 1986. Electroformed copper, silver plated, 19" x 13½" x 19¼" (48.3 x 34.3 x 48.9 cm). Photo by Peter Krumhardt. Courtesy of the artist.

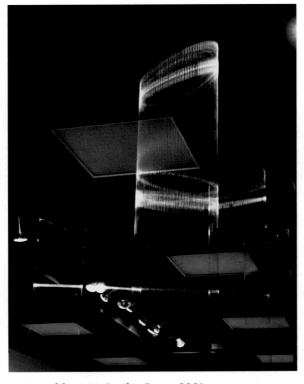

4-62  Kathleen McCarthy, *Beam*, 2001. Monofilament, dimensions variable. Collection, The University Museum, Illinois State University, Normal, IL.

## Summary

*Shapes* have height and width but no depth. *Forms* have height, width, and depth. Most of the objects around you are forms.

We tend to see shapes in certain ways. We see shapes because of other shapes around them (*figure-ground*), and we "finish" partial shapes (*closure*). An artist creates a shape with line, or by defining the shape's edges through contrasts of color, value, and texture.

*Shape and size constancy* mean that we tend to see a shape or size as unchanging regardless of the angle or distance from which we see it. *Foreshortening* compresses space, and allows artists to show three-dimensional objects in a picture the way we see them in life. Artists will make an object larger or smaller in a picture to make it appear closer or farther away from the viewer.

Artists who make sculptures or design buildings deal with real forms. Real forms must be seen from all sides to be fully appreciated.

Shapes and forms can be classified as *organic* or *geometric* and as closed or open. Organic shapes and forms are similar to forms found in nature, and are irregular. Geometric forms are almost always human-made, and are very regular. *Closed* forms tend to be dense or massive. *Open* forms include negative shapes or space.

## Review Questions

1. **Recall:** Name three shapes and three forms from the world around you.

2. **Understand:** Describe the difference between positive shapes and negative shapes.

3. **Apply:** Produce a drawing of a simple foreshortened shape or reversible pattern.

4. **Analyze:** Compare and contrast the use of geometric shapes in these two artworks: Pablo Picasso's *Three Musicians* and Edward Hopper's *House by the Railroad.*

5. **Synthesize:** Create a simple plan for a building or a park. Explain why you would use the shapes and forms you choose, and what meaning they have for you.

6. **Evaluate:** Choose three two-dimensional or three-dimensional artworks from this chapter. Rank them from "uses most pattern" to "uses least pattern." In which artwork does the use of pattern contribute most effectively to the success of the artwork?

## For Your Portfolio

Select one of your two-dimensional artworks that demonstrates your understanding of shape and the illusion of form. Write a description of this artwork, explaining why you think the artwork is successful.

## For Your Sketchbook

Make several sketches of your hand holding an object. Sketch quickly and lightly to find the shape of the hand and the object. Then add darker lines. Add shading to one of your sketches to create the illusion of form.

## Electronic Research

Visit M. C. Escher: The Official Website <http://www.mcescher.com/> and M. C. EscherLife and Work—at the National Gallery of Art <http://www.nga.gov/collection/gallery/ggescher/ggescher-main1.html>, to view the artwork and learn about the life of the Dutch graphic artist. How did a visit to the Alhambra, a fourteenth-century castle in Granada, Spain, profoundly influence his work? How have his mathematics-based artworks affected the design of tessellations and other geometric art today?

## Going Further

Have you ever noticed the many different shapes and forms in the architectural details in buildings in your community? Use any kind of camera to document interesting arrangements of shapes and forms on the street where you live. Make sure your subject is in sharp focus. Mount a display of your photos.

# 5 Value and Color

5-1 **This work shows evidence of two of the artist's many interests: popular culture and technology. In what ways has technology changed the way we think about color?** Eduardo Paolozzi, *Protocol-Sentences from Universal Electronic Vacuum,* 1967. Color screenprint, 35¹/₂" x 24¹/₁₆" (90.17 x 61.07 cm) image; 40" x 27" (101.6 x 68.58 cm) sheet. The Minneapolis Institute of Arts, The Hershel V. Jones Fund, by exchange.

## What You'll Learn

- how to define hue, value, and intensity
- how artists vary hue, value, and intensity to create many different effects in artwork
- how to recognize and discuss artworks that use value and color to show mood or emotion
- differences between the basic color schemes

## What This Chapter Covers

## Art Criticism Step by Step

## Studio Experiences

## Key Terms

*English* (Spanish)

*value* (valor)
*shading* (sombreado)
*chiaroscuro* (chiaroscuro)
*spectrum* (espectro)
*hue* (tono)
*primary colors* (colores primarios)
*secondary colors* (colores secundarios)
*intermediate colors* (colores terciarios)
*complementary colors*
 (colores complementarios)
*monochromatic* (monochromático)
*intensity* (intensidad)
*color harmonies* (armonías del color)
*warm colors* (colores cálidos)
*cool colors* (colores fríos)

## Artists

John James Audubon, Georges Braque, Helen Frankenthaler, Andy Goldsworthy, Herat School, Kuna peoples, Ellen Lanyon, Alexander Maldonado, Henri Matisse, Eduardo Paolozzi, Pablo Picasso, Pierre Auguste Renoir, Henry O. Tanner, Vincent van Gogh, Marie-Denise Villers, James Turrell, Tom Coleman

5-2 Student work, Stephanie Song. Cut paper, 18" x 12" (45.7 x 30.5 cm).

Objects reflect light. That is what allows us to see them. In a cave or in a room without lights or windows, what can you see? Probably not very much. But in your everyday life, and in art, you see thousands of objects, and they all have value and color.

In artwork, the range of light and dark is known as *value*. A value scale (**fig. 5-3**) shows you nine steps in the value progression from white (the lightest value) to black (the darkest value). One way artists use values is to help them make objects look solid. Using dark and light values in this way is called **shading**. The technical term for this is **chiaroscuro** (kee-ah-roh-SKEW-roh). Shading can also be used to create mood in artwork.

*Color* is a property of light. When a beam of light passes through a prism, the light divides into the seven colors of the rainbow, also called the **spectrum**. We use a *color wheel* to show the spectrum colors.

Color has three dimensions: hue, value, and intensity. **Hue** identifies a color, tells you what it is. Red, yellow, and blue are the **primary** hues on the color wheel. Orange, green, and violet are the **secondary** hues. **Intermediate** hues lie between the primary and secondary colors on the color wheel: they are yellow-orange, yellow-green, blue-green, blue-violet, red-violet, and red-orange. **Complementary** hues are directly opposite each other on the color wheel: red and green are complementary colors, as are orange and blue, and so on (**fig. 5-4**).

You have already learned about *value*, the lightness or darkness of a color. Color values can be changed by adding white or black to the color. Lighter values of a color are called *tints*. Darker values are called *shades*. Paintings that make use of tints and shades of just one color are called **monochromatic** (**fig. 5-5**).

5-3 **We show the range of values on a value scale such as this one. In a black-and-white photograph or drawing, you are able to see the differences between objects because of their different values.**

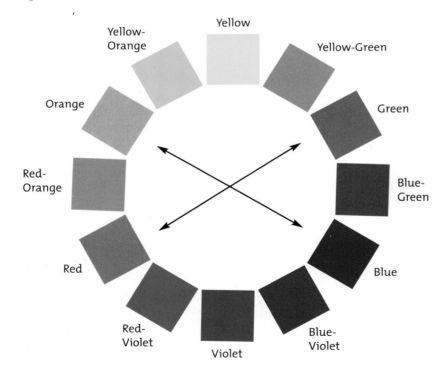

5-4 **This color wheel shows primary, secondary, and intermediate colors. The arrows indicate complementary colors. How might a color wheel help you when you want to mix colors of paint?**

5-5 **How many different values can you find in this painting? How has the artist used values to create shaded areas?** Pablo Picasso, *Woman in White*, 1923. Oil on canvas, 39" x 31½" (99.1 x 80 cm). The Metropolitan Museum of Art, Rogers Fund, 1951; acquired from the Museum of Modern Art, Lillie P. Bliss Collection. Photograph © 1994 The Metropolitan Museum of Art.

5-6 **Point out high-intensity and low-intensity colors in this work of art. Where do you see warm or cool colors? tints or shades? How do the colors make you feel?** Helen Frankenthaler, *Cravat*, 1973. Acrylic on canvas, 62½" x 58¾" (159 x 149 cm). Courtesy of the artist.

***Intensity*** is the brightness or dullness of a color, also called its *saturation*. We see low-intensity colors as dull; high-intensity colors are considered bright. Mixing a color with its complement results in a duller color, while colors straight from the bottle or tube tend to be bright.

Colors are affected by other colors placed on top of them or near them. A color's hue, value, or intensity can be affected by colors nearby. These effects are called *color interactions*.

Colors that create satisfying or startling effects when placed together are called **color harmonies**, or *color schemes*. There are many different color schemes that artists can use. Each scheme can create a particular visual effect.

Colors create powerful reactions in people, so artists use them to help express ideas and feelings. ***Warm colors***, such as red, orange, and yellow, make us think of hot things like the sun and fire. Blue, green, and violet—the ***cool colors***—remind us of cool things, such as leafy trees, cool water, and shade (fig. 5-6).

Imagine a world without color. What might you notice more easily? What things would be more difficult to see if you saw only values?

Without light we could not see lines, shapes, forms, or any objects. In fact, unless it is a source of light itself, an object is visible only to the extent that it *reflects* light.

Light, along with its opposite, dark, appears in the legends of most cultures. Light is often used to symbolize truth, hope, and new life. On the other hand, dark is often associated with evil, the fear of the unknown, and death. Have you ever seen the sky just before a storm when light turns to dark (**fig. 5-7**)? Light and dark are also important in art.

Imagine the possible ranges of light and dark in this world. One extreme might be looking directly at the noonday sun. The other might be experiencing the blackness of a deep cave. But in daily life the range of light and dark is much less obvious than that.

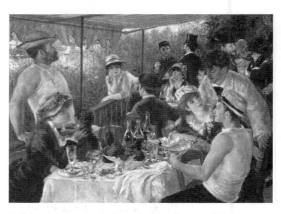

5-9  Pierre Auguste Renoir, *Luncheon of the Boating Party*, 1880–81. Oil on canvas, 51¼" x 68⅛" (130 x 173 cm). The Phillips Collection, Washington, DC.

In artwork, the range of light and dark (seen under normal light conditions) is known as *value*. Typically, values are represented on a nine-step scale (**fig. 5-8**). White is at one extreme and black is at the other. In "black and white" reproductions (**fig. 5-9**) everything consists of different values on the gray value scale. Yet we are able to distinguish different objects because of their different values.

The lightness or darkness of a particular value is *relative,* depending on its context. In other words it is light or dark in comparison to its surroundings. For example, the banjo face in Henry O. Tanner's *The Banjo Lesson* (**fig. 5-12**) appears light when compared to the shadows around it. But compared to the light values in the background, it appears rather dark.

5-7  Photograph: Adam Houston.

5-8  **A value scale**

The amount of reflected light can make the value of an object seem lighter or darker. You see the cue ball in **figure 5–10** as being very light—either white or off-white. Now, cover the right half of the ball with your hand. You see that the left half of the form is not very light (or white) at all. Reflected light causes the difference in value between the right and left halves of the ball. In this case the reflection is stronger on the right.

Artists often take reflected light into consideration when they want a form to look solid. The artist made the polyhedron **(fig. 5-11)** look three-dimensional by making some surfaces darker than others. Using lighter and darker values to make something look three-dimensional is called **shading**. The technical term is **chiaroscuro**, an Italian word that literally means "light-dark." Earlier, in Chapter 3, Line, you saw an example of shading. Hatching and crosshatching were used to make the caricature of a famous artist look more three-dimensional.

5-10 **What is the color of the cue ball: white or dark gray?**

5-11 **How many values did the artist use to make this polyhedron appear solid?**

Henry O. Tanner, *Self-Portrait,* c. 1910. Pencil and conte crayon on paper, 8 1/2" x 8 3/8" (21.6 x 21.3 cm). Smithsonian American Art Museum, Washington, DC/Art Resource, NY.

## Artist Biography
# Henry O. Tanner (1859–1937)
Before embarking on his career as an artist, Henry Ossawa Tanner claimed he did not want to be "one of your everyday kind of artists." This dream was certainly realized, as many now regard him as one of the most accomplished African-American artists of all time.

Tanner decided at age thirteen that he wanted to be an artist, after watching a painter working in Philadelphia's Fairmount Park. He studied at the Pennsylvania Academy of Fine Arts from 1879 to 1885. After moving around for six years, Tanner settled in Paris in 1891. France was more accepting of his ethnicity than America at the time, and Tanner's work became fairly popular there.

One of Tanner's legacies was the dignified portrayal of African-American life, and *The Banjo Lesson* is a perfect example. The painting was well received even in the United States, despite the country's strong racial tensions. It captured the hearts of both blacks and whites with its tender appeal and depiction of the bonds between generations.

5-12 **This painting was created less than three decades after the Civil War ended. What important messages about post-war African-American life does it convey?** Henry O. Tanner, *The Banjo Lesson,* 1893. Oil on canvas, 49" x 35 1/2" (124.46 x 90.17 cm). Hampton University Museum, Hampton, VA.

## Value and Artistic Expression

Shading is a very effective way for an artist to create a mood. You may recall that light and dark often stand for good and evil. These notions stem both from our culture and our own experiences. Artists often capitalize on these notions to express ideas or moods. However, light and dark in art do not always stand for good and evil. Look back at two examples in Chapter 4. In Hopper's *House by the Railroad* (fig. 4-37, page 73), the light seems oppressive and depressing. In Rembrandt's *The Mill* (fig. 4-35, page 72), the darkness seems peaceful.

In *A Woman in White* (fig. 5-13), Picasso used mostly the middle range of the value scale. He kept the contrasts of light and dark to a minimum. The colors are neither light nor very dark. The whole picture seems bathed in soft light. It gives a peaceful feeling that's echoed in the peaceful and relaxed position of the woman herself. Light seems to play a positive role. Do you think that it was meant to symbolize something positive about womanhood? Why?

In *Young Woman Drawing* (fig. 5-14), the artist used mostly the dark end of the value scale. However, very light values were used in places. A single source of light illuminates one side of the woman. The rest of the picture is left in relative darkness. The use of dark

5-13 **Picasso painted this classic-looking figure at a time when he also was continuing to experiment with new ideas in abstraction. How might the mood of this painting have been different if Picasso had used strong contrasts of light and dark?** Pablo Picasso, *Woman in White*, 1923. Oil on canvas, 39" x 31½" (99.1 x 80 cm). The Metropolitan Museum of Art, Rogers Fund, 1951; acquired from the Museum of Modern Art, Lillie P. Bliss Collection. Photograph © 1994, The Metropolitan Museum of Art.

5-14 **This painting may be a self-portrait. Assuming this is so, why do you think the artist chose to use strong value contrasts to depict herself?** Marie-Denise Villers, *Young Woman Drawing*, 1801. Oil on canvas, 63 1/2" x 50 5/8" (161.3 x 128.6 cm). The Metropolitan Museum of Art, Mr. and Mrs. Isaac D. Fletcher Collection, Bequest of Isaac D. Fletcher, 1917. Photograph © 1981 The Metropolitan Museum of Art.

shading and strong contrast to create drama or establish a mood became popular in the 1600s. Like Picasso's woman, this woman seems relaxed—though perhaps more solemn. Here, dark contributes to a somber mood, but not necessarily an evil one.

In *Untitled (Futuristic City)* **(fig. 5-15),** Alexander Maldonado used mostly the light range of the value scale. Many of the hues are white or near-white, such as those in the foreground and the sky. What do these light colors say about a city of the future? Do they suggest optimism or bleakness? Here the role of light seems more ambiguous than either positive or negative.

5-15 **At the age of sixty, Mexican-born artist Alexander Maldonado began to paint as a hobby. He eventually received national recognition. What questions would you ask the artist about his view of the future?** Alexander A. Maldonado, *Untitled (Futuristic City)*, 1976. Oil, 23 7/8" x 35 7/8" (60.7 x 91.1 cm). Smithsonian American Art Museum, Gift of David L. Davies.

**Linking Disciplines**
### Science

Have you ever observed the spectrum of colors when white light is passed through a prism? The individual colors separate within the prism as the different wavelengths of the white light are bent or refracted. Compare the position of the colors in the spectrum with the placement of colors on the color wheel. Find out more about the difference between mixing color pigments and mixing projected light colors.

Of all the visual elements, *color* is the most fascinating and puzzling. Because of its effects on people, color has been studied more than any of the other elements. To analyze color, we must return to the discussion of light.

In a famous experiment over three hundred years ago, Isaac Newton demonstrated that color is a property of light. When a beam of light is passed through a glass object, called a prism, the light divides into the seven colors of the rainbow (**fig. 5-16**). Each of these colors represents a different ray of light. All seven rays—a small fraction of the total number of light rays—make up what is known as the **spectrum**. Newton demonstrated that white light includes all of the spectrum colors. For reasons still not fully understood, only the rays of the spectrum are visible to the human eye. Each ray is visible as a different color. Newton created a color circle to show the spectrum (**fig. 5-17**). Today, we use a color wheel (**fig. 5-18**).

The average person thinks of color as belonging to objects. Strictly speaking, this is not true. There is a difference between light and *reflected* light. Light is the real source of color. Reflected light is the kind of light given off by objects. When white light strikes a red apple, the apple looks red because it *absorbs* every color of light except red, which it reflects. A lemon absorbs all the colors *except* yellow (**fig. 5-19**). When all light is absorbed, the result is black.

Newton's theories refer to only one dimension of color, hue. Color has three dimensions: hue, value, and intensity.

### Hue

***Hue*** identifies a color as blue, yellow, red, or green, and so on, as seen in the spectrum or the color wheel. People with normal vision not only see different hues, but have names for many of them.

In addition to the hues of the spectrum, an infinite number of hues can be created through intermixing. At this point, a distinction must be made between colored light and pigment. Pigment is the coloring matter found in such things as inks, crayons, paints, dyes, and glazes. Mixing colored lights is an *additive* process. When all colors are combined, the result is white (**fig. 5-20**). Mixing pigments, on the other hand, is *subtractive*. Pigments behave the same as the surfaces of lemons or apples. They absorb all the colored rays except those we see.

5-16 **The visible spectrum.**

5-17 **Newton's color wheel.** Isaac Newton, *Optice* (Color Wheel), 1706. Courtesy British Library, London.

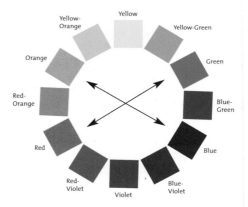

5-18 **Today's color wheel. Complementary colors are opposite in hue and are also opposite each other on the color wheel.**

5-19 **A lemon absorbs all the colors of light except yellow.**

5-20 **Primary and secondary hues in lights.**

5-21 **Primary and secondary hues in pigments.**

## Try It Yourself

Imagine you have a friend who is seeing-impaired. Try to explain what red is. You could describe value as being like loud or soft in music. (Both exist on a continuous scale.) You could describe the form of a sculpture (Chapter 4) by having your friend touch it. But again, how could you describe red—or, indeed, any hue?

Combining more and more pigmented colors creates increasingly darker results—as you know if you've ever mixed paints. Theoretically, if all three primaries were combined in the correct proportions, the final result would be black (**fig. 5-21**). A black surface absorbs all the spectrum colors. Since almost all artworks involve the use of pigments, the following discussion will focus on the behavior of pigment hues.

Red, yellow, and blue are called *primary colors*. Supposedly you can make any other hue with just these three, if you know how to mix them properly. Yellow and red make orange, yellow and blue make green, and red and blue make violet. Orange, green, and violet are called *secondary colors*. Notice that on the color wheel (**fig. 5-18**) each secondary color is placed midway between the primary colors that produced it. Lying between the primaries and secondaries are the *intermediate colors*: yellow-orange, yellow-green, blue-green, blue-violet, red-violet, and red-orange.

Hues directly opposite each other on the color wheel are called *complementary colors*: red and green, orange and blue, yellow-orange and blue-violet, and so on (**fig. 5-18**). Complementaries are exactly opposite in hue. For example, yellow, a primary color, has nothing in common with its complement, violet, which is composed of red and blue. Complementaries play a role in both *intensity* and *color harmonies* (to be discussed).

Soon, you will learn about primary and secondary hues and intensity. But first enjoy a feast of brilliant color in the *mola* shown in **figure 5-22**. *Molas* are a form of tapestry art made by the Kuna peoples of the San Blas Islands (Central America). *Molas* have been produced for more than a hundred years.

5-22 **The *mola* is a folk craft of increasing interest to museum curators. Using the vocabulary terms you have learned, describe the color in this *mola*.** Kuna, Mola. From the Collection of the Textile Museum of Canada.

## Value

You have already learned about the element of value. Value can be associated with shades of gray. Black, white, and gray are sometimes called neutral colors or *neutrals*. Unlike spectrum colors, black, white, and gray have no identifiable hues.

However, value is an aspect of all colors. Every color has a normal value, which is shown on the wheel. The value, or lightness and darkness of a color, can be changed by adding white or black to the color. Different values of red (**fig. 5-25**), for example, can be displayed on a scale just as they can for gray. Lighter values of a color are called *tints*. Darker values are called *shades*. Artists sometimes create paintings that use tints and shades of just one color. Such paintings are called **monochromatic**, meaning one color.

## Intensity

*Intensity* describes the brightness and dullness of a color (sometimes called *saturation*).

A color's intensity can be represented on a scale from bright to gray (**fig. 5-26**). All of the hues on the color wheel are bright (or as bright as the printer was able to make them).

Yellow, blue, or red straight from the bottle will be bright. Mixing any two of the primaries, as you saw earlier, produces a new color. Secondary or intermediate hues on the color wheel are also bright. But if you mix a color with its complement, the resulting color will be a duller one, because each color subtracts from the other. If you mix them in the right proportions, not necessarily in equal amounts, the result may be a neutral gray (**fig. 5-24**).

Colors of low intensity that have identifiable hues can be just as beautiful as bright colors. Most of the colors in nature are of this type: the olive greens and forest greens of spring and summer, and the golden-yellows, burnt-oranges, and brown-reds of fall. The colors in Andy Goldsworthy's *Rowan Leaves with Hole* (**fig. 5-23**) resemble those of autumn leaves. The yellow hues around the rim are the most intense, suggestive of aspen leaves in the sun. Those farther from the rim are less intense and more reddish—perhaps those of sugar maple leaves in the shade.

5-23 **All of Andy Goldsworthy's works are made of transient natural materials that he leaves to disintegrate or come apart through natural forces. How does the increasing intensity of color toward the center of this work influence its dramatic effect?** Andy Goldsworthy, *Rowan Leaves with Hole*. Courtesy of the artist.

The fifteenth-century Persian artist was quite aware of the rich variety that colors offer in terms of hue, value, and intensity. Some of the colors in *A King and a Queen in a Garden* (**fig. 5-27**) are quite bright. But others, such as the king's gown, his carpet, the wall coverings, and the calligraphy in the lower part of the picture, consist of hues of duller intensities.

The colors of clothes are not always bright. Look at your friends' clothes: They typically consist of dulled reds, greens, and blues (blue denim, for example), as well as browns. The colors of woodwork also tend to be of low intensity: mahogany (deep, reddish brown), oak (brownish yellow), and maple (brownish yellow-orange).

5-24 **Mixing a color with its complement can produce a neutral gray.**

5-27 **Do you agree with descriptions of this style of painting that call it "jewel-like"? Where are the most intense colors used in this work?** Herat School, Persian (Iran), *A King and Queen in a Garden*, page from the "Chahar Magaleh" (Four Discourses also known as "The Mirror for Princes" probably made for Baysonghar, the grandson of Tamarlane), 1431. From the Timurid dynasty, Middle East, Asia. Ink, colors, and gold on paper, 8 3/4" x 5 3/4" (22.2 x 14.6 cm). The Minneapolis Institute of Arts, Bequest of Mrs. Margaret McMillan Webber in memory of her mother, Katherine Kittredge McMillan.

5-25 **Value scale of red. What color should be added to make a tint of red?**

Orange          Gray          Blue

5-26 **Saturation or intensity scales for orange and blue.**

## Color Interactions

Colors rarely appear in isolation. They are affected by other colors. A particular color can look different when placed side by side with, or on top of, another color. Its hue, value, or intensity can be affected, depending on the combination. The following illustrations provide some examples:

**Hue Interaction** A patch of yellow-orange appears more orange on top of a square of yellow. On top of a square of orange, it appears more yellow (**fig. 5-28**).

**Value Interaction** A light-colored square appears darker on a light background than it does on a dark background (**fig. 5-29**).

**Intensity Interaction** A medium bright blue will appear brighter on top of a neutral than it does on top of a bright blue (**fig. 5-30**).

## Color Harmonies

*Color harmonies* are combinations of colors that are considered satisfying, or that produce certain effects. In the discussion of hue, you learned of some color groups: secondaries, complementaries, and so forth. These color combinations can also be thought of as types of color harmonies, or color *schemes*.

*Triad* harmonies consist of three equidistant hues on the color wheel. The triad harmony shown in **figure 5-33** is made up of the three secondary colors. Other triad harmonies would be the primaries or three of the intermediates. Because of their mutual dissimilarity, a triad of the primary colors would be the

5-28 **Which of the smaller squares appears more orange? Why?**

5-29 **A light color appears much darker on which tint?**

5-30 **Which of the smaller squares appears to be of brighter intensity?**

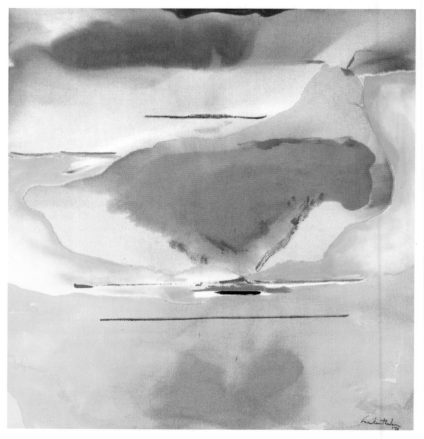

5-31 **This artist developed the "soak-stain" technique, which involves pouring turpentine-thinned paint onto unprimed canvas. What other colors could the artist have used to make a triad harmony?** Helen Frankenthaler, *Cravat*, 1973. Acrylic on canvas, 62 1/2" x 58 3/4" (159 x 149 cm). Courtesy of the artist.

most daring combination—like strangers who tense up when made to share a room together. Secondary or intermediate hues, on the other hand, are apt to be more agreeable, because of their shared colors. Perhaps this is why Helen Frankenthaler chose a triad harmony of secondary colors. She poured diluted colors of violet, green, and orange onto a white canvas (fig. 5-31).

Complementary colors, as we have seen before, are opposite colors. Therefore, a *complementary combination* would provide the strongest contrast. There is also a greater chance that the colors would "clash." For this reason, some designers prefer a *split complementary* scheme. They might choose one hue and combine it with hues on either side of its complement (fig. 5-34). This brings two of the colors closer together and tends to tone down the "violence" somewhat.

The colors of Henri Matisse's *Boy with Butterfly Net* (fig. 5-32) pit green against the reddish colors of the trail and the boy's hair and necktie. These reddish colors are not pure red but vary between orange-red and rust. The neutral tones of the boy's clothes and butterfly net help to soften the contrast even further.

*Analogous* harmonies consist of adjacent hues on the color wheel, for example: yellow, yellow-green, green, and blue-green (fig. 5-35). Because of their strong "family resemblances," these kinds of hues are very agreeable. Yet they are different enough to provide interest. If necessary, contrast can be strengthened by varying the values.

*Monochromatic* combinations consist of tints and shades of a single hue (fig. 5-25, page 99). Because all the colors are the same hue, they go together very well. However, the gain in harmony comes with a loss in boldness. A monochromatic scheme risks being uninteresting.

5-33 **A triad scheme.**

5-34 **Split complementary scheme.**

5-35 **An analogous scheme.**

5-32 **Matisse was one of the great modern colorists. Do you see another complementary color scheme besides that formed by the red and green?** Henri Matisse, *Boy with Butterfly Net*, 1907. Oil on canvas, 69 3/4" x 45 15/16" (177.17 x 116.68 cm). The Minneapolis Institute of Arts, The Ethel Morrison Van Derlip Fund.

Imagine you are an interior decorator. What colors would you use to paint a hospital room? What color would relax the patients? Or cheer them up? Would your choice depend on the ages of the patients? Explain.

Imagine you are designing stage settings for a play. What colors would you use for a lively musical? A mystery play set in England? A comedy?

Imagine you are a graphic designer. What colors would you use in a safety poster? An ecology poster? A travel poster?

## Expressive Qualities of Color

Picasso's *The Old Guitarist* (fig. 5-36), though mainly blue, could not be called uninteresting. Because of the subject, the colors are very appropriate and contribute to the dominant mood of sadness.

Why is blue appropriate for a picture with a sad mood? Imagine *The Old Guitarist* painted in tones of red, yellow, or orange. Given these alternatives, blue clearly seems to be the best choice. But this is not to say that blue always expresses sadness. In other contexts, blue can suggest such qualities as serenity, dignity, and elegance.

Color's effect on people has been the subject of more research (and guesswork) than any other element. Red is said to raise blood pressure, while blue lowers it. Pink, a tint of red, has been shown to have a calming effect on violent children. In one experiment, factory workers thought that the room temperature had been raised after the colors of the room were changed from blue and gray to red and brown. In fact, the temperature had remained at 70 degrees.

Artists are aware of the power of color—whether they have read the research or not. Reds, oranges, and yellows (the colors on the left side of the wheel) are considered **warm colors**. Blues, greens, and violets (the colors on the right) are considered **cool colors** (fig. 5-38). Reds and yellows make us think of such things as blood, fire, and the sun. Blues, greens, and violets remind us of sky, water, trees, grass, and shade. Whatever the reasons, the use of warm colors in a design is likely to excite us, while cool colors are likely to have a quieting effect.

Vincent van Gogh was one of the first artists to understand how color could be used for its own sake. He wrote about a painting in a letter to his brother, Theo: "I tried to express the terrible passions of humanity by means of red and green." Van Gogh often used color as a cry of pain and anguish, but he also used it in more peaceful ways (fig. 5-37).

Color is something you have lived with all your life. Are you surprised to learn that color is so complicated? Actually this discussion barely scratches the surface. Entire books have been written about color theory and the variables of color. Artists and designers deal with these issues all the time.

5-36 **This work is from Picasso's Blue Period, which was, in part, an outgrowth of the suicide of a close friend. How does value help emphasize the feeling of sadness in this painting?** Pablo Picasso, *The Old Guitarist*, 1903. Oil on panel, 48" x 32½" (122.9 x 82.6 cm). The Art Institute of Chicago, Helen Birch Bartlett Memorial Collection.

Why learn more about color? In some tribal cultures, color is apparently not very important. The people have normal vision, but they have not bothered to develop the sensitivity needed to recognize many hues. In one tribe, for example, the people had words only for light and dark and the color red. In effect, they could not "see" yellows, oranges, pinks, and so forth.

Think what you would be missing if the only hue you could distinguish were red! Knowing more about color enables you to *see* more of it. This will help you to enjoy the infinite variety and rich possibilities of color in art, and also in life.

5-37 **There are three painted versions of van Gogh's bedroom scene in Arles. How would you describe the colors that dominate this scene? What role does the red play?** Vincent van Gogh, *The Bedroom*, 1889. Oil on canvas, 29" x 36" (73.6 x 92.3 cm). The Art Institute of Chicago, Helen Birch Bartlett Memorial Collection. Photo by Greg Williams.

Warm Colors

Cool Colors

5-38 **Color wheel**

### Write About It!

Imagine redecorating your room in the colors of van Gogh's bedroom. How would the colors affect your room's mood or character? Would it reflect your personality more or less than the present colors? Would you feel more comfortable or out of place, calmer or awkward? Explain.

# A Contemporary Surrealist Painting

5-39 **The Surrealists were the first to claim that the dreamworld is superior to reality as a subject for art. Today's artists working in this style continue to plumb the imagination—sometimes delivering social commentary along with their fantastic visions.** Ellen Lanyon, *The Green Heart*, 1998. Acrylic on canvas, 44" x 52" (112 x 132 cm). Photo copyright Ellen Lanyon.

### About the Artist
# Ellen Lanyon (b. 1926)

By age fifteen, **Ellen Lanyon** had a job in the drafting department of Beardsley and Piper, a company in her hometown of Chicago. There she reproduced designs for mechanical parts. Following her artistic leanings, she completed a master's degree in fine arts. Since the mid-1940s Lanyon has been an active painter. A trip to the Florida Everglades in the early 1970s prompted a three-decade-long engagement with the idea of ecological balance. Her images often pose questions to the viewer about humankind and its treatment of the environment. Lanyon is noted for her public commissions, including the River Gateway in Chicago and a large mural for the city of Minneapolis. She currently resides in New York City.

## ❶ Describe What You See

When you describe an artwork, you identify things about the work that you can see, name, and describe with certainty. You should not include opinions, evaluations, or possible meanings here.

- List the artist, title of the work, medium, and date.
- What is the size of this painting?
- What style does the work belong to?
- What colors are evident? Are they bright, dull, contrasting? What is the dominant color?
- Describe the plant forms. Are they true to life?
- Where do you see fantastic or imaginary forms?
- What is unreal or out of kilter about the contents of the painting?

## ❷ Analyze the Way It's Organized

When you analyze an artwork, you tell how the subject matter and elements of the work have been organized by the artist. You tell how they work together.

- How does color contribute to the unity of this artwork?
- Where do you see a complementary color used? Where is dull green used?
- What is the dominant arrangement of forms in the painting, and why?
- How are the mechanical forms connected? Where do the tubes go?
- In which plant forms have the strongest value contrasts been used? Which plants seem the healthiest?
- Use the above information to explain visual movement through the painting.

## ❸ Interpret What It's Saying

Use the information from your description and analysis to help you identify the meaning of the work—that is, what it tells you about the human experience. (The title provides a clue to some imaginary or magical content.)

- What moods or feelings do the pulsating colors in the plant forms and the glowing reds suggest?
- What do you think the "green heart" apparatus is doing? Is it magic? Do the imaginary organisms symbolize something?
- Write a metaphor or simile that relates to what the work is saying.
- What does the work communicate to you?

## ❹ Evaluate Its Success

Using your analysis in the first three steps, judge the quality or success of this work.

- How do you judge the compositional arrangement of the work?
- How does this work compare to other surrealistic works you have seen?
- How successfully does the work use unreality to arouse your imagination and help you grasp a situation?
- How original do you think the work is in presenting the subject matter and theme?

### More Art!
See page 114 for more artworks by Ellen Lanyon

### Web Link
www.davis-art.com

## Write About It!

Imagine you're a shape in the center of your drawing. Locate and describe the source of light surrounding you. Is it coming from the right, left, front, back, or multiple angles? Describe how the negative space affects your light and shape. Do you stand out or blend into your background?

## Computer Option

Photograph an object or model with a digital camera from three different sides. Open the images in a paint program along with another window that has an 8½" x 11" canvas. Using the selection tool, copy and paste parts of each picture onto the blank canvas. Using the brightness tool, enhance the individual parts by making them lighter and darker than they really are. Finalize the arrangement of the different parts into a Cubist image. Save and print for critique.

## Technique Tip

One way to explore value study is to systematically enlarge a selected image with the use of a grid. Add the values after making the enlargement. This allows you to examine changing proportion as well as values.

# Value Study: Shattered Images

Cubism can be a jumping-off point for creating a large, single-subject drawing to demonstrate your understanding of value. This exercise will increase your knowledge about shades of gray and help you to understand how Cubist techniques can be used for personal expression.

5-40 Student work, Eric Bennett. Pencil, 18" x 24" (45.7 x 61 cm).

## Before You Begin

Study examples of Cubism, especially the paintings of Georges Braque and Pablo Picasso (see **Studio Background**, page 107). Look at how the artists broke up and recombined the objects, and used textures and shading. Then, select a single item such as a car, insect, person, or fish as your subject for a large contour line drawing. Consider creative ways to develop value study.

## You Will Need
• white drawing paper
• drawing pencils

## Create It

❶ Draw a large contour line drawing of your subject. Use your understanding of Cubism and apply the techniques to your drawing.

❷ To help decide how you will break up your image, think about what it might look like when viewed through shattered glass or wavy lines of water. The idea is to fracture the image into many more shapes, as in a giant puzzle.

❸ Draw new lines over your original image in the pattern you have chosen. Experiment with gradations of value from rich black to light black within all the shapes you have created.

## Evaluate It
• How did you use shading and fragmentation to enhance your subject?
• Can the viewer still recognize the main subject?
• How successful do you think you were in using the techniques of Cubism?

5-42 **Student work, Devi Sengupta.** Pencil, 18" x 24" (45.7 x 61 cm).

5-41 **Student work, Chris Campbell.** Pencil, 24" x 18" (61 x 45.7 cm).

# Studio Background

The evolution of Cubism was truly a collaborative endeavor. From about 1909 to 1914 Georges Braque and Pablo Picasso built upon each other's work to develop the style that would impact the entire twentieth century. During this period, the works of Braque and Picasso are sometimes indistinguishable. Choosing simple objects and subdued colors, the artists broke apart their subjects and reassembled them in interlocking planes. Their purpose was to depict the multiple surfaces of an object, not simply those you would see from a single viewpoint. The artists forced a rethinking of traditional ideas about space and form. How has Braque used value to assist in accomplishing this goal?

5-43 **Note how the artist has placed the palette and curtain "behind" the fractured space of the music and violin. The nail holding the palette even casts a shadow. How does this detail help you think about the contrasts between traditional and Cubist representations?** Georges Braque, *Violin and Palette (Violon et palette)* (detail), 1909. Oil on canvas, 36 1/8" x 16 7/8" (91.7 x 42.8 cm). Copyright the Solomon R. Guggenheim Foundation, New York. Photo by Lee B. Ewing.

# Feathers in Monochromatic Colors

How colorful is a feather? A feather is not one solid color, but many shades of one color. With careful observation, you can see that no two feathers are exactly the same. Using tints and shades of a color, plus neutral colors, you will create a realistic monochromatic painting of a feather.

### Technique Tip
To create soft browns, mix turquoise blue or primary blue, with small amounts of primary yellow or red orange. Add black to this mixture to achieve dark, rich browns.

### Computer Option
Scan the feather with a white sheet of paper on top of it so as to get a white background. Open the image into a paint program along with a new window with an 8½" x 11" canvas. Copy, paste, and resize the feather so that it fits in the top half of your blank canvas. Under the original, reproduce the feather using a brush with good blending characteristics (oil, pastel, and watercolor are good brush media choices) and also make use of the transparency settings to achieve a color match of the original feather. Save and print for critique.

5-44  Student work (detail). Watercolor, 11" x 8½" (27.9 x 21.6 cm).

### Before You Begin
Choose a feather to study. Investigate its structure and its range of color. Study examples of artwork by John James Audubon.

### You Will Need
- feather
- illustration board
- watercolors

### Create It
**1** After examining the feather, lay it down on a piece of illustration board. In pencil, lightly trace just the contour of the feather.

**2** Place the feather in front of your drawing and draw in the shaft and individual shapes you see within your feather.

**3** Mix and test your watercolors until you have achieved colors that match your feather's colors. Work slowly and carefully to paint in the shapes that you have drawn.

### Evaluate It
- What have you learned about color and color mixing through this process?
- How accurately did you paint the feather? How did you achieve realism?

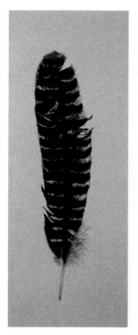

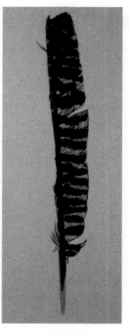

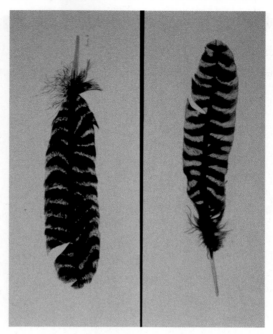

5-45 Student work
(detail). Watercolor,
11" x 8 1/2" (27.9 x 21.6 cm).

5-46 Student work
(detail). Watercolor,
11" x 8 1/2" (27.9 x 21.6 cm).

5-47 Student work (details). Watercolor, each 11" x 8 1/2"
(27.9 x 21.6 cm).

## Write About It!

In your mind, picture the bird whose feather you see. Picture its color. Think about the value, saturation, blends, and hues. Perhaps its plumage contains other colors in addition to those you've included in your drawing. Use your imagination. Describe the colors of your bird. Include those that are on your feather. Use color vocabulary in your description.

## Art History

## Studio Background

John James Audubon had a mission. In 1820 he decided to devote all of his efforts to depicting every bird in America. His images of over four hundred different birds set standards in ornithological illustration that have yet to be surpassed. Though he sometimes worked from specially wired and posed specimens, Audubon was able to render the birds in a remarkably life-like fashion because of his extensive direct observation of nature. His accomplishment is that much more remarkable because he did not have any formal training in the natural sciences. Audubon, in fact, was not accepted by the American scientific community and was forced to travel to England to have his famous prints published.

5-48 **Audubon spent twenty years traveling throughout the United States and parts of Canada to record 1,065 birds and their habitats. Why are Audubon's depictions considered valuable documents?** John James Audubon, *Wood Wren*, Birds of America—Plate 119. Courtesy Haley & Steele, Boston, Massachusetts.

# Creating a Spectrum of Color

How often do we take color for granted? In this lesson, you can use the power of color to give life to an ordinary object.

## Technique Tips

• When using water-colors, always consider the quantity of water on the brush. Test the brush on a separate sheet of paper to make sure that the color and quantity of water are right. Use a variety of brush sizes depending on the size of the shape being painted.

• Color density refers to the richness of the mixed color as it fades from strong to light intensity. Changing the color density of the media, and thoughtful mixing, will add to your overall success.

5-49 Student work, Sharyn Hess.
Watercolor, 24" x 18" (60.9 x 45.7 cm).

## Before You Begin

Choose an everyday object as the subject of your drawing. The object should have no significant color. Some examples include paper clips, pushpins, safety pins, scissors, and paintbrushes.

## You Will Need

• watercolor paper
• pencils
• brushes
• watercolor paints
• found objects such as paper clips, pushpins, safety pins, scissors, brushes

## Computer Option

Scan a variety of reflective objects, such as paper clips, scissors, safety pins, etc., at a high resolution. Be sure to have the objects overlap in several places. Leave the cover off the scanner in order to get a black background. Open the image in a paint program and then crop or scale down the image to a good composition showing a variety of shiny objects. Use the gradient fill tool to select and color each area of different reflections on each object. Experiment with various color fills and their direction. Save and print.

5-50 Student work, Jennifer Chen. Watercolor, 18" x 24" (45.7 x 60.9 cm).

5-51 Student work, Gena Ross. Watercolor, 18" x 24" (45.7 x 60.9 cm).

## Create It

**1** Draw an enlarged outline of your subject three times on one piece of paper. Decide on placement and size to make the composition visually interesting. Your subject can touch the four sides of your piece of paper, but it should not continue off the paper.

**2** Fill in each shape with watercolors. In one of your outlines, use the whole range of the color spectrum. Paint the other two shapes in colors of your choice. Choose colors that express your own personality or style.

**3** To create the appearance of layers, draw your subject three more times on your paper, overlapping the colored shapes. Paint these outlines with a gray value scale.

**4** Use a fine-line black marker to define the edges of your final composition.

## Evaluate It

• How have you used color intensity to energize your composition?

• Is your use of color in the image visually balanced with your use of black and white? How would you describe the arrangement of this balance?

### Write About It!
What effect does color have on the way you create space in your painting? Focus on color, density, value, and overlap. Consider how objects of color appear next to your gray objects. How does color affect the form of each object? Does it stand out alone or blend together as one? What role does color play in making the gray objects appear farther away?

**Art History**

## Studio Background

The Kuna Indians live on a cluster of islands called the San Blas Archipelago just off the Atlantic coast of Panama. Kuna women are famous for their appliqué work. Drawing from their colorful tropical surroundings, the motifs they sew often reflect local flora and fauna. The women pass their understanding of color and pattern from generation to generation. Girls begin learning the art at the age of three or four. High color contrast is an important element when the Kuna judge the quality of a work. For this reason, the women make expansive use of all colors of the spectrum.

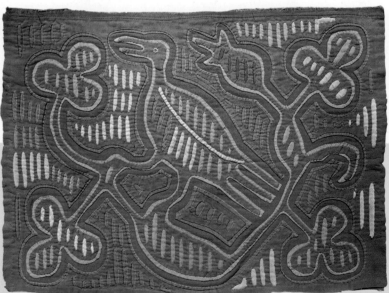

5-52 *Mola* is the Kuna word for clothing, though the term is often used by outsiders to refer to the appliquéd panels that are sewn together to create an item of clothing. How can a unique artform such as this help foster a sense of cultural identity? Kuna Indian mola, *sikwi* (bird) design, from the San Blas Islands, Panama. Collection of Jo Miles Schuman, author of *Art from Many Hands*.

# Exploring Mixed Color

Artists often work in series. In this lesson, you will first use watercolors to develop a series of five geometric designs based on color types: primary, secondary, complementary, split complementary, and analogous. Then you can apply what you learned about color to compose a cut-paper design.

5-53 Student work, Julie Baker. Colored pencils, 6" x 18" (15.3 x 45.7 cm).

5-54 Student work, Danielle Weaver, *Untitled.* Cut paper, 12" x 18" (30.5 x 45.7 cm).

## Before You Begin

Study the color wheel and practice mixing paint to achieve specific colors. Study primary, secondary, and intermediate colors. Also, look at the later works of Henri Matisse. Understand that he used cut paper to create works of art in the style of *scherenschnitte*, a German folk art tradition.

## You Will Need

- newsprint and white vellum paper
- fadeless paper in different colors
- plastic triangles, circles, and square templates
- ruler, pencil, brushes, scissors, X-Acto knife, rubber cement
- watercolor paints

## Create It

❶ Divide a piece of 12" x 18" paper into 6" squares and develop six to twelve geometric designs within these squares (one per box, front and back). Use your ruler or templates to create geometric designs. Focus on creating a strong design that maintains interest within each 6" square. Select your best four designs. Divide the white vellum strip into four squares, using pencil, not by folding. Sketch each design in light pencil.

❷ Use watercolors to paint the shapes within each square, starting with primary colors only in the first one. In the second square, use secondary colors. Use complementary colors in the third, and split complementary colors in the fourth. Change the density to create visual interest.

❸ For the next part of the lesson, choose a single subject and create a line drawing as a preliminary sketch on the other piece of newsprint. Choose your final composition. Decide on three colors and layer three sheets of the fadeless papers in those colors together in one stack. Draw or trace your subject on the back of the fadeless papers so that no pencil lines appear on the front.

**4** Use an X-Acto knife to cut out the shapes in relation to your subject. Remove shapes from the first layer to allow the second color to be seen and shapes from the second sheet to show the bottom layer of color. Make sure to keep a balance of the three colors. Use small dabs of rubber cement to secure the image at the four corners and wherever else is needed.

## Evaluate It

• What insights about color have you gained through this experience?

• How can you foresee applying this knowledge to your future work?

5-55 **Student work, Erin Santye.** Cut paper, 18" x 12" (45.7 x 30.5 cm).

### Write About It!

In two or three paragraphs, compare the effect of color in your paintings. How does your design change with each color family? Which color family interests you, and why? How does color affect the interaction of shape within your composition?

### Computer Option

Using a drawing program, draw a large square with a small circle and triangle overlapping within it. Copy the drawing six times on the page. Label each of the six squares with the type of color scheme you will be filling it with: primary, secondary, complementary, split complementary, analogous, and triadic. Save and print for critiquing.

## Art History

# Studio Background

The translation of the German term *scherenschnitte* is "scissor cutting." It refers to the art of paper cutting. Requiring only paper and a cutting instrument, this craft enjoys worldwide popularity. In Poland it is called *wycinanki* and in China, where the art form stretches back more than one thousand years, it is called *chien-chih*. In the United States a center for this craft is Lancaster County, Pennsylvania, where nineteenth-century immigrants brought the tradition from their German homeland. The cut-paper images were often made in celebration of a birth or wedding.

5-56 **Larger *scherenschnitte* were created by folding the paper in half and then cutting a design. This would result in a perfectly symmetrical image. Describe the balance in this example of *scherenschnitte*.** Cream-colored paper with cutwork, painted, 5³/4" x 7¹/3" (14.6 x 18.6 cm). Courtesy Winterthur Museum.

5-57  Ellen Lanyon, *Dragons and Dominoes*, 1999. Acrylic on canvas, 44" x 52" (112 x 132 cm). Photo copyright Ellen Lanyon.

5-58  James Turrell, *The Light Inside*, 1999. Site-specific installation with neon light, gypsum board, plaster, and glass. The Museum of Fine Arts, Houston; Museum commission, gift of Isabel B. and Wallace S. Wilson. An **art:21** artist

5-60  Tom Coleman, *Untitled*. Ceramic collage wall mural mounted on aluminum back, glazed with various bright-colored barium glazes, low fired porcelain clay, fired to cone 1 in oxidation, approx. 24" x 48" (61 x 121.9 cm). Courtesy of the artist.

5-59  Ellen Lanyon, *The Architect's Dream*, 1989. Acrylic on canvas, 72" x 48" (183 x 122 cm). Photo copyright Ellen Lanyon.

# Chapter Review

## Summary

This chapter is about two closely related elements: value and color. The source of both value and color is light.

*Value* refers to the range of light and dark that can be seen in a work of art. A value scale shows this range, with white at one extreme and black at the other. An object's surfaces have lighter or darker values depending on the amount of light they reflect. *Color* is a complicated subject. Usually, artists are involved with the colors of pigments rather than the colors of light. Pigments absorb light rays, reflecting only the colors not absorbed. Combining all pigments results in black, the absorption of all light rays.

*Hue* is the name of any color in the *spectrum* or color wheel. Hues can be divided into certain groups such as *primaries, secondaries, intermediates,* and *complementaries.*

Color value is the lightness or darkness of a color. Lighter values are called tints; darker values are shades.

*Intensity* describes the brightness or dullness of a color on a scale from bright to gray.

Hue, value, and intensity are affected by color interactions. Certain color combinations, or color schemes, are often used by artists and designers.

Colors may be *warm* or *cool*. Color affects people. It is a powerful tool of expression.

## Review Questions

1. **Recall:** Why are we able to see objects?

2. **Understand:** Explain how artists use value to make objects look three-dimensional.

3. **Apply:** Demonstrate mixing primary colors to create a secondary color.

4. **Analyze:** Classify Henry O. Tanner's color choices in *The Banjo Lesson.* Find examples of tints, shades, bright and dull colors, primaries and secondaries, warm and cool colors.

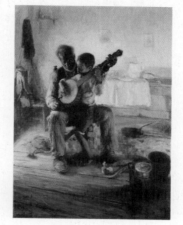

5. **Synthesize:** Produce a drawing or painting that shows chiaroscuro effects.

6. **Evaluate:** Recommend a color scheme for a new hospital. Justify your choices.

## For Your Portfolio

Incorporate what you have learned about value, intensity, and color in a simple landscape painting. Use one color, its complement, and black and white to create shapes in high and low intensities, and light and dark values. Write an artist's statement that includes your name and date and a list of the media and techniques that you used. Identify your artwork's theme, what you like about the work, and what things you would change if you reworked the piece.

## For Your Sketchbook

Study and draw the light and shadow areas of three-dimensional forms. Include different values or shades from white to black. How can you change the values gradually to suggest forms, textures, and space?

## Electronic Research

The Vincent van Gogh Gallery <http://www.vangoghgallery.com/> displays a complete online annotated catalog of van Gogh's artworks and letters. Explore the site, then click on "Commentary and Analysis" and choose one of the artworks to investigate in depth. After reading the text and following the links, write your own critique of the same work, explaining why you agree or disagree with the given commentary.

## Going Further

Did you know that most paper is made from cotton fibers? Very small amounts of fabric dyes, inks, watercolors, or even colored tissue paper can be added to the naturally white paper pulp in a blender to create an array of fascinating colors in various tints and shades. Start a collection of handmade colored papers and carefully document how you made each color.

# 6 Space

6-1 **David Hockney is best known for his paintings and photography, but he also has designed many theater sets and costumes. How has he integrated actual space and illusionary space in this stage set?** David Hockney, Large-scale painted environment with separate elements, based on Hockney's design for Mozart's opera *The Magic Flute*, 1983. Acrylic on canvas and laminated foam board. Overall size: 120" x 262" x 120" (304.8 x 665.5 x 304.8 cm). © David Hockney.

## What You'll Learn

- to identify and discuss ways artists create the appearance of space and depth in two-dimensional artworks
- how three-dimensional space is created in sculptures and architectural interiors
- to analyze pictures and artworks that show one- and two-point perspective
- to explore effects and uses of space in artworks

## What This Chapter Covers

## Art Criticism Step by Step

## Studio Experiences

## Key Terms

*English (Spanish)*

**positive space** *(espacio o forma positiva)*
**negative space** *(forma o espacio negativo)*
**picture plane** *(plano grabado)*
**overlapping** *(traslapo)*
**high-low placement**
  *(colocación alta-baja)*
**linear perspective** *(perspectiva lineal)*
**vanishing point** *(punto de desaparición)*
**one-point perspective**
  *(perspectiva del uno-punto)*
**two-point perspective**
  *(perspectiva del dos-punto)*
**eye level** *(nivel del ojo)*
**aerial perspective** *(perspectiva aérea)*
**framing** *(el enmarcar)*

## Artists

George Caleb Bingham, Hans and Torrey Butzer, Alexander Calder, Yung Ho Chang, Savador Dalí, Richard Diebenkorn, M. C. Escher, Paul Gauguin, Frank Gehry, Renée Green, Palmer Hayden, Barbara Hepworth, David Hockney, Hans Hofmann, Winslow Homer, Käthe Kollwitz, Piet Mondrian, Georgia O'Keeffe, I. M. Pei, Judy Pfaff, Camille Jacob Pissarro, John Russell Pope, Raphael, Frank Lloyd Wright, Ma Yuan

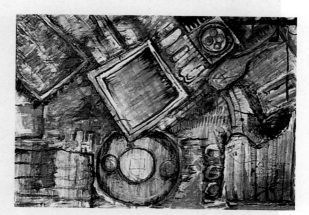

6-2 Student work, Zevan Rosser. Mixed media, 26" x 40" (66 x 101.6 cm).

In the twenty-first century, the word *space* is used in many different ways. We speak of space travel, living space, and personal space. We often think of space as empty or invisible. Yet in art, space is an important element.

The space around us isn't ever really empty—it's full of particles of various kinds. We see space in relation to its boundaries: the ceiling, walls, and floor of a room, for example, or the buildings, landforms, and plants of the outdoors.

Architects design spaces for people to live, work, and play. They consider how space will be used, and shape it to fit people's needs (fig. 6-3).

Sculptors look carefully at the spaces within and around their sculptures. Some work with open forms, creating *positive* and *negative spaces* that interact with each other in interesting ways (fig. 6-4). Other artists create forms that are dense and closed, with negative space surrounding them.

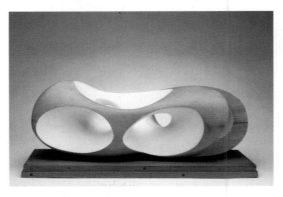

6-4 **In sculpture, the negative space, or space around the work, can be as meaningful as the work itself. Where can you see negative space in this sculpture?** Barbara Hepworth, *Pendour*, 1947. Painted wood, 12 1/8" x 28 3/8" x 9 3/8" (31 x 72 x 24 cm). Hirshhorn Museum and Sculpture Garden, Smithsonian Institution, Gift of Joseph H. Hirshhorn, 1966.

Artists who paint, draw, or make prints think of space as the two-dimensional surface on which they work. This surface is called the *picture plane*. Artists carefully consider how they will arrange shapes within this space. If they are working on lifelike, or realistic, artwork, they use special techniques to help them create the illusion of three-dimensional space, or depth.

*Overlapping* objects is a simple way to suggest depth. An object that is in front of another appears closer to us.

*High* and *low placement* of objects also helps create the illusion of depth. Objects that are placed lower in the picture seem closer than objects that are higher.

The most complicated way to show depth in two-dimensional art is through *linear perspective*. Linear perspective allows artists to imitate human vision, which sees parallel lines leading away as eventually coming together. Think of the way railroad tracks appear to meet at the horizon: that's the phenomenon on which linear perspective is based.

In *one-point perspective*, the artist establishes a *horizon line* and creates one *vanishing point* on it. The vanish-

6-3 **Architects plan the way space is used inside and outside buildings. Think of three words that would describe this interior space.** I. M. Pei, architect, East Building of the National Gallery of Art, Washington. Image © 2003 Board of Trustees, National Gallery of Art, Washington. Opened 1978.

ing point is the point at which parallel lines appear to come together. Diagonal lines extend out from the vanishing point and guide the artist to create realistic angles in geometric objects within the rest of the picture (fig. 6-5).

In *two-point linear perspective*, the artist establishes two vanishing points and two sets of diagonal lines. This allows even more realistic depth (fig. 6-6). In works using either one-point or two-point perspective, artists establish *eye level*—the height from which the viewer sees objects.

If you have noticed the way distant hills or buildings look lighter in color and less distinct than closer objects, you've seen an effect artists call ***aerial perspective***. Using variations in color and value, artists can create the illusion of distance or depth in paintings. Some artists create several "layers" of depth to make objects in the foreground (front), middle ground (middle), and background look different from each other (fig. 6-7).

Even artists who create paintings with little or no recognizable subject matter sometimes use the techniques discussed in this chapter to suggest depth.

6-5 **In one-point perspective, there is only one apparent vanishing point.**

6-6 **In two-point perspective, two vanishing points are visible.**

Another important way that artists use space creatively is by ***framing***. Artists frame a painting, drawing, or print when they choose what viewers will see in the picture. They make decisions about what will be large and small, what will be included and excluded, and where the boundaries of the picture will be. These decisions affect the meaning and overall visual impact of the artwork.

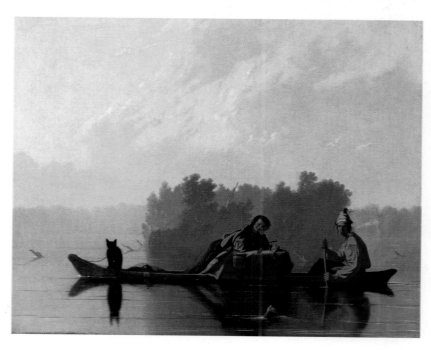

6-7 **This painting shows three techniques artists use to create depth. Can you find examples of overlapping, high and low placement, and aerial perspective in this work?** George Caleb Bingham, *Fur Traders Descending the Missouri*, 1845. Oil on canvas, 29" x 36½" (73.7 x 92.7 cm). The Metropolitan Museum of Art, Morris K. Jesup Fund, 1933. Photograph © 1992 The Metropolitan Museum of Art.

## 6.2 Space in Our Environment

We often think of space as the emptiness that surrounds objects, or the emptiness inside of hollow shapes such as boxes or buildings. Also, we think of space as invisible. So, why is it considered one of the visual elements? There are at least two answers to that question.

First, space on this earth is not really empty. It is filled with oxygen and other gases we call air. And as you know, air is not always clean and clear. Sometimes it is full of smoke, dust, or *pollution* that can be seen. Sometimes it is full of particles of water and dust that we call *clouds* (**fig. 6-8**) or *fog,* which can also be seen. So, space is not always invisible.

Second, we "see" space by seeing its *boundaries.* The space inside a room has size and form. For example, the ceiling, floor, walls, and furnishings of a room (**fig. 6-9**) determine the size and form of a space. Interior space in a room is often called *volume.* Outdoors, buildings, trees, and other objects determine the size and form of a space (**fig. 6-10**). We could say that space is "empty form."

6-8 Photograph: Adam Houston.

6-9 Yung Ho Chang, *Commune by the Great Wall* (detailed interior view of the Split House), developed by SOHO China Ltd. Photo by Mr. Fu Xing. Split house design by Atelier FCJZ. Courtesy of the architect.

**Try It Yourself**

How well do you know the location of things in your room at home? Stand in the center of the room. Then, with your eyes closed, try to find the middle drawer of your dresser. Can you sense the correct direction, distance, and height of the drawer (or other object)?

Draw a floor plan of your room (or any room in your house) from memory. Include approximate measurements in your plan. Check your plan's accuracy when you get home.

You can sense, or experience, space around you through movement. While sitting at your desk, you can sense the space under the desk simply by moving your legs and feet. You can sense the size and volume of your classroom, or its spatial *aspects*, by walking around in it. (You can also determine its spatial aspects by staying in one place and looking around the room.)

6-10 Foreign Office Building, Brasilia, Brazil.

To the architect, space is probably the most important visual element. An architect must design pleasing and interesting spaces in which people live, work, or play. I. M. Pei heeded that job description in 1978 when he designed the central court of the East Building of the National Gallery of Art (fig. 6-11). The spaces in the central court vary in size, form, and even level. These provide an exciting environment for strolling and viewing art.

The interior of the National Gallery's Rotunda (fig. 6-12) is very different. The rotunda was designed by John Russell Pope and completed in 1941. The rotunda is a large, circular area defined by huge columns. It does not have the

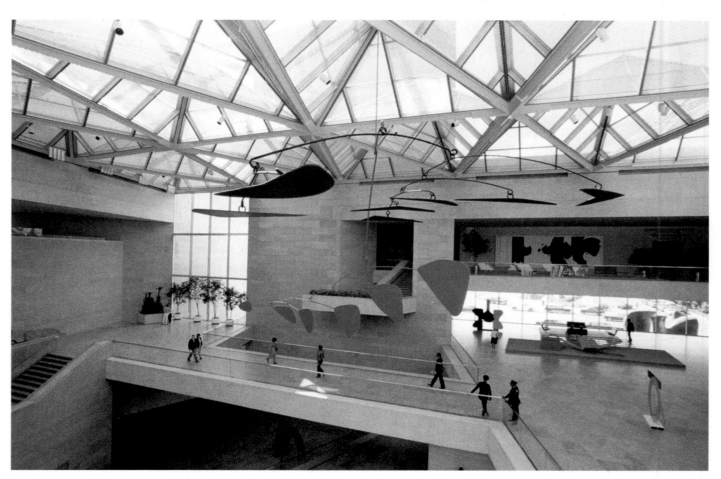

6-11 **In a preliminary design of this atrium, the ceiling was the underside of an upper floor and was made of concrete panels. If that design had been implemented, how would it have affected the sense of space in the atrium?** I. M. Pei, architect, East Building of the National Gallery of Art, Washington. Image © 2003 Board of Trustees, National Gallery of Art, Washington. Opened 1978.

variety of Pei's court. Yet the rotunda is as dramatic as the newer interior. Pope's design is formal and follows traditional rules of public architecture. Pei's design is modern and informal. Which of the two spaces do you prefer? Why?

Space is also important to the sculptor. Modern sculptors often work with open forms, as George Rickey did in *Four Lines Oblique* (**fig. 4-39, page 75**). Barbara Hepworth's *Pendour* (**fig. 6-13**) is of carved wood. The artist intentionally carved openings in it to create a unique relationship between form and space, or **positive** and **negative**.

An example of open form on a much larger scale is Alexander Calder's huge *mobile*. Part of this mobile can be seen in **figure 6-11**. The mobile hangs in the East Building of the National Gallery.

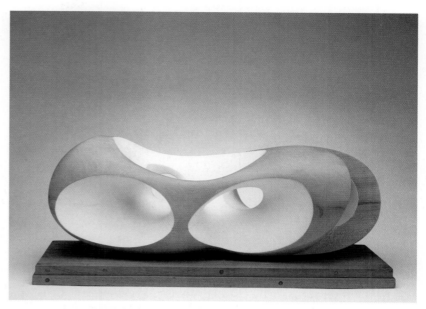

6-13 **It is said that the holes, or space, in Hepworth's sculptures are just as important as the material, or mass. Using this work as an example, do you agree or disagree with this statement?** Barbara Hepworth, *Pendour*, 1947. Painted wood, 12⅛" x 28⅜" x 9⅜" (31 x 72 x 24 cm). Hirshhorn Museum and Sculpture Garden, Smithsonian Institution, Gift of Joseph H. Hirshhorn, 1966.

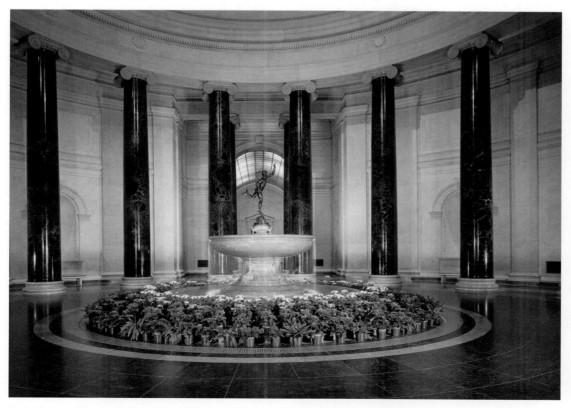

6-12 **This architect also designed the Jefferson Memorial, where he again made use of a circular, domed space. What words would you use to describe a circular space? In what ways is it different from a rectilinear space?** John Russell Pope, architect, West Building of the National Gallery of Art, Washington (Rotunda). Image © 2003 Board of Trustees, National Gallery of Art, Washington.

## Linking Discipline
## Music

**Edgar Varese**

(1883–1965) believed that musical space is open, rather than bounded. Both silences and sounds are considered equally important in his music. He also rebelled against listening to the same old sounds in music. Listen to *Ionisation* (1929–31) for the sirens, the three sections of percussion, and the silences. Why might a sculptor or architect seek a similar balance between sound and silence? To what end might architects designing a public memorial want to incorporate "silences" into their creation?

## Space in Public Art

In Oklahoma City, a place of peace and beauty rests where shock and horror occurred in 1995. Combining grandeur with intimacy, the Oklahoma City National Memorial **(fig. 6-14)** honors those who died in the bombing that destroyed the Alfred P. Murrah Federal Building. The memorial was designed by the Butzer Design Partnership (see **Artist Biography**, page 125).

Two enormous gates stand like huge bookends at either end of a long reflecting pool. The East Gate **(fig. 6-15)** represents 9:01, the moment before the explosion. The West Gate represents 9:03, by which time the city was changed forever.

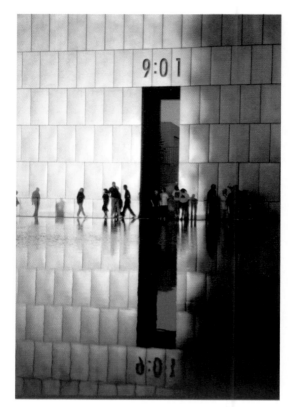

6-15 Butzer Design Partnership, Oklahoma City National Memorial. © 2003 ALLproof/Anthony L. Lindsey.

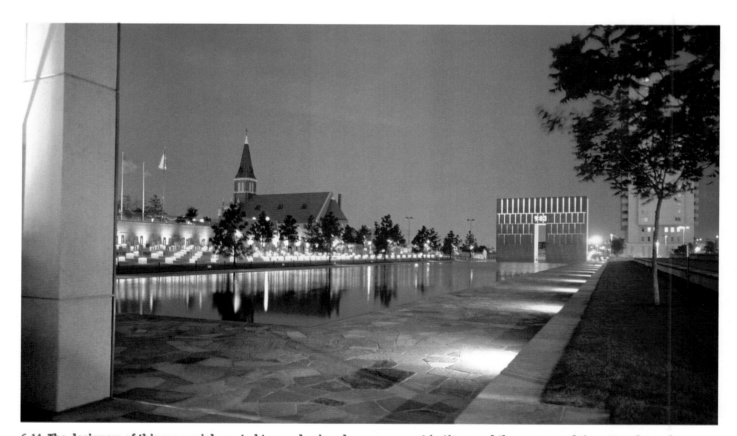

6-14 **The designers of this memorial wanted to emphasize place, a moment in time, and the passage of time. How have they achieved this goal?** Butzer Design Partnership, Oklahoma City National Memorial. © 2003 ALLproof/Anthony L. Lindsey.

The powerful centerpiece of the memorial depicts a field of 168 empty chairs—one for each victim of the bombing (fig. 6-16). The chairs are placed in nine rows, representing the nine floors on which the victims worked or visited.

A large fence, installed to protect the bombed site, became an armature for people to leave tokens of love and remembrance. A two-hundred-foot section of the original fence now stands along the west wall of the memorial for people to continue placing tokens.

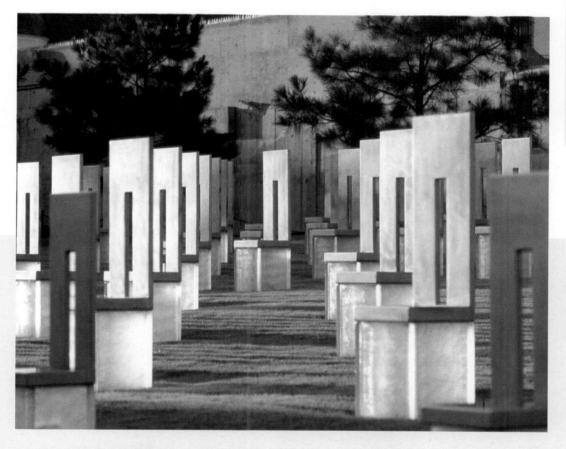

6-16 Butzer Design Partnership, Oklahoma City National Memorial. © 2003 ALLproof/ Anthony L. Lindsey.

**Torrey and Hans Butzer, with Sven Berg (center)**

**Artist Biography**
## Hans Butzer
(b. 1966)
## Torrey Butzer
(b. 1966)

Husband-wife architectural team Hans and Torrey Butzer founded the Butzer Design Partnership in 1990, after graduating from the University of Texas, Austin. In the early nineties, Torrey, who hails from Nowata, Oklahoma,

and Hans, originally from Madison, Wisconsin, relocated to Germany, where they spent 5 1/2 years working with several architectural firms.

In 1997, the Butzers won an international design competition to create the outdoor symbolic component of the Oklahoma City National Memorial. Though the Butzers, along with associate Sven Berg, came up with the original design for the memorial, they also used input from the victims' families and survivors of the bombing. The Oklahoma City Memorial was unveiled in April of 2000, and for years to come will convey to its viewers the pain as well as the healing process that Oklahoma City has undergone.

**Try It Yourself**

Take a blank sheet of paper. Think of the surface of the paper as "space." Place a cutout image of a house or tree somewhere in the middle of this space. This image becomes a frame of reference. Now take a cutout of an animal or person and observe how that image looks small when placed below the frame of reference. Does it appear small? When placed above the frame of reference, it should appear large **(fig. 6-17)**. What accounts for this "magical" effect? (For an answer, read page 70 on size constancy in **Chapter 4, Shape and Form**.)

6-17 **Which of these animal forms appears larger?**

So far, in this discussion the word *space* has been used to mean a three-dimensional area. Some artists, however, use the term to refer to the flat two-dimensional surface of a painting. The flat surface of a painting is sometimes called the **picture plane**. Modern artists, especially those who paint abstract paintings, take great care in deciding where to place shapes on the picture plane. For example, they may place shapes high or low, to the right or to the left, on the picture plane.

Piet Mondrian was a very skilled abstract artist. He took great care in arranging each line, shape, and color on the picture plane. The space in his *Composition in White, Black, and Red* **(fig. 6-18)** is very balanced.

Artists sometimes define space as the unfilled areas of the picture plane. They also use space to refer to the "background" of a painting, or to the ground of a figure-ground relationship.

(A "figure" stands out on top of a ground. A "ground" appears to be underneath and surrounding a figure.) These areas are sometimes called *negative space*. In the Mondrian painting, negative space would be the white areas. In *Self-Portrait* **(fig. 6-19)**, a woodcut by Käthe Kollwitz, it would be the black areas.

6-19 **In this work the artist keeps the image right on the surface of the picture plane. Why is this a particularly effective technique for a portrait?** Käthe Kollwitz, *Self-Portrait*, 1924. Woodcut on soft Japan paper, 8 1/4" x 11 3/4" (20.8 x 30 cm). Courtesy Galerie St. Etienne, New York.

6-18 **Sometimes a painter creates a feeling of space extending beyond the edges of the picture plane. What elements help contribute to this effect in Mondrian's work?** Piet Mondrian, *Composition in White, Black, and Red*, 1936. Oil on canvas, 40 1/4" x 41" (102.2 x 104.1 cm). The Museum of Modern Art, New York, NY, Gift of the Advisory Committee. Licensed by Scala/Art Resource, NY.

## 6.5 Representing 3-D Space in 2-D Art

Many pictures, especially those we call "realistic," appear to have three-dimensional space: height, width, and depth. But of course, these pictures do not have actual depth. In Chapter 4, Shape and Form, you learned that depth can be created by foreshortening (fig. 4-23, page 67). In Chapter 5, Value and Color, you learned that depth can also be created by shading (fig. 5-11, page 93). These methods make an object seem solid and three-dimensional. Depth can also be created by changing the size of an object to make it appear closer or farther away (fig. 4-31, page 70).

In this chapter, we will study four more ways to create a sense of depth: *overlapping, high and low placement, linear perspective,* and *aerial perspective.* Pissarro's *The Boulevard Montmartre on a Winter Morning* (fig. 6-22), which you first saw in Chapter 4, will be used to illustrate the first two methods.

### Overlapping

A simple way to suggest depth in a picture is by having things overlap. An object is placed in front of, and partially covering, something else (fig. 6-20). In the Pissarro painting, the carriage heading away from us in the right foreground of the picture appears to be closer to us than its driver. And the driver is closer to us than the horse that pulls them down the boulevard.

### High and Low Placement

Usually, something that is lower in a picture appears closer to us than something that is higher (fig. 6-21). The carriage in the right foreground of the painting is placed lower in the picture than any other carriage. Therefore, it is closer to us than the others.

6-20 **Overlapping forms.**

6-21 **High and low placement.**

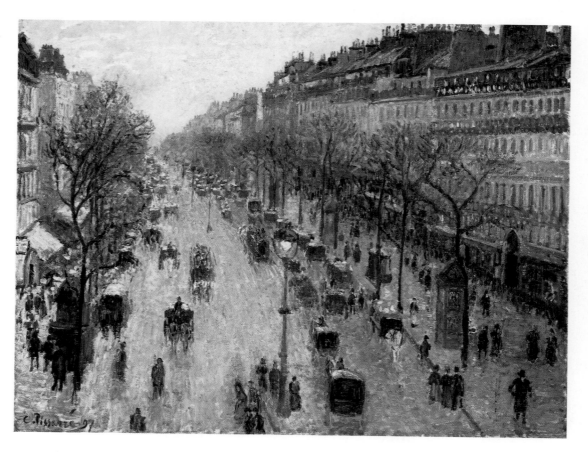

6-22 **In this painting, Pissarro uses several instances of both overlapping and high and low placement to lead the viewer's eye through a bustling urban space. Identify at least two ways in which he achieves each of these effects.** Camille Jacob Pissarro, *The Boulevard Montmartre on a Winter Morning,* 1897. Oil on canvas, 25½" x 32" (64.8 x 81.3 cm). The Metropolitan Museum of Art, Gift of Katrin S. Vietor, in loving memory of Ernest G. Vietor, 1960. Photograph © 1990 The Metropolitan Museum of Art.

## Linear Perspective

*Linear perspective* is the most complicated method for showing depth. Look at the drawing of a football field **(fig. 6-24)**. Vertical lines are used for the posts supporting the floodlights and the uprights of the goalposts. Horizontal lines are used for the sidelines. The yard lines and the crossbars of the goalposts appear to be parallel with one another. But in fact, they are not. They *converge,* or come together, at a point in the distance. This is called the **vanishing point**. When all these lines are extended by dotted lines they meet at the point.

This type of perspective is called **one-point perspective**.

*The School of Athens* by Raphael **(fig. 6-23)** was also created with one-point perspective. Some lines, such as the walls and niches of statues, are vertical; some, such as the steps, are horizontal. Some lines converge, as in the moldings below the arched ceiling and lines of the floor tiles going away from us. The converging lines, when extended, meet at a point near the left wrist of Plato, the left figure in the middle. (Actually the point is at some infinite distance beyond Plato's wrist.) Look at the diagram in **figure 6-27**.

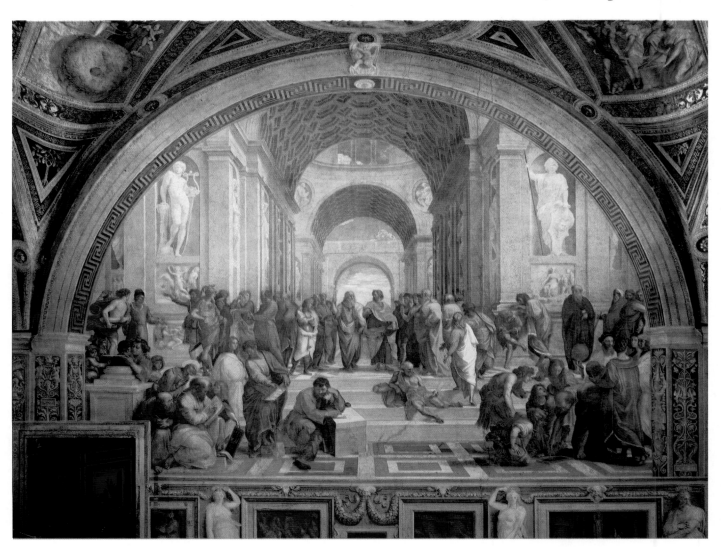

6-23 **This fresco decorates one wall in a room that was designated as the library of Pope Julius II, and it is populated with depictions of many important thinkers from antiquity and other periods. How does the artist use space and perspective to tell the viewer that the two key figures in this gathering of great thinkers are Plato and his student, Aristotle?** Raphael, *The School of Athens.* Fresco in lunette: 25' 3 ¼" (7.7 m) at base. Stanza della Segnatura, Vatican Palace, Vatican State. Photo courtesy Scala/Art Resource, NY.

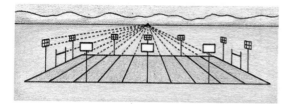

6-24 **One-point perspective.**

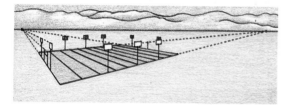

6-25 **Two-point perspective.**

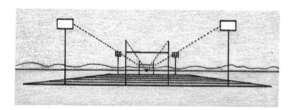

6-26 **Eye-Level perspective.**

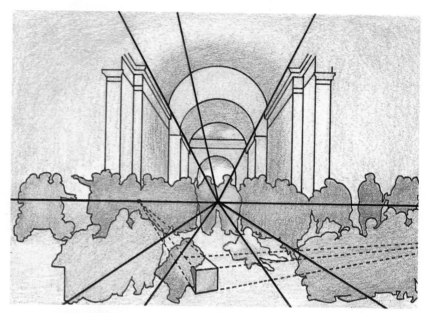

6-27 **Converging lines show the vanishing point in Raphael's** *School of Athens.*

*Two-point linear perspective* is used in the second drawing of a football field (fig. 6-25). In this case, there are vertical lines and *two* sets of converging lines. There are no horizontal lines. The yard lines and crossbars of the goalposts, when extended, converge at the left vanishing point. The sidelines, which are the other set of converging lines, go to the right vanishing point.

Compare the drawing of the football field in figure 6-26 with figures 6-24 and 6-25. Figure 6-26 is an example of one-point perspective—like figure 6-24. However, the viewer seems to be standing on the ground. In the first two illustrations, the eye level is above. The viewer is sitting on the twenty-sixth row of the bleachers. *Eye level* has to do with the height of the viewer's eyes rela-

tive to the ground. In the third illustration, the eye level is below the lights and the top edges of the goalposts.

Where is the eye level in relationship to the men in *The School of Athens?* Look again at the diagram in figure 6-27. You, the viewer, are looking down at the men on the floor in front, but looking up slightly at the men at the top of the stairs. This means you are standing on, probably, the second step of a stairs facing the scene.

Not everything in this mural is in one-point perspective. The block of marble in the foreground on which a burly man is resting is in two-point perspective. Only the left vanishing point is within the frame of the picture, however.

## Aerial Perspective

Recall that air is often filled with fog, smog, or air pollution. When the air is filled with particles, objects become less visible.

But even in the countryside, and on clear days, moisture in the air can affect the appearance of things in the distance. When an object is far away, its colors become lighter and duller. The distant colors lack hue- and value-contrast. A distant object's outlines and detail become less distinct. Notice this effect with regard to rock and land formations on a California beach as they recede farther in the distance (fig. 6-28).

In a picture, this effect is known as **aerial perspective**. See how George Caleb Bingham used colors to create aerial perspective in *Fur Traders Descending the Missouri* (fig. 6-29).

With variations in color and value, Bingham created four layers in the scene—each layer appearing at a greater distance. Notice the boat, a hazy island behind the boat, a hazier island beyond it, and the still hazier riverbank in the background.

In traditional Chinese ink painting, aerial perspective is used to create glowing mountain scenes. In *Bare Willows and Distant Mountains* (fig. 6-30), the artist was able to suggest various degrees of distance. Although the ink technique is monochromatic, the Chinese artist controlled the values and clarity of details. The trees in the lower right are relatively dark and distinct. The trees and houses across the river are hazy and shrouded in mist. The mountains in the background almost disappear.

6-28 Photograph: Hiram Paley.

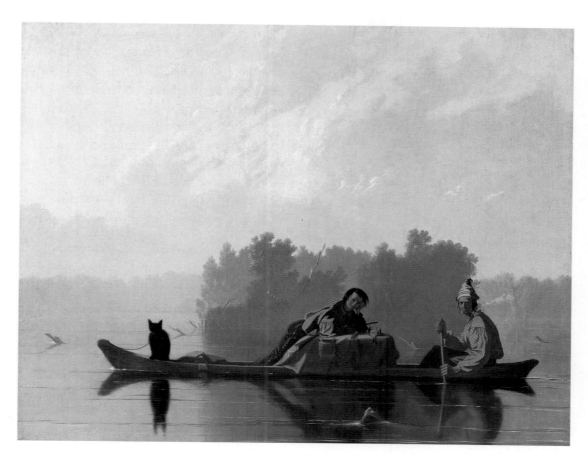

6-29 **The audience for this painting was the urban population in the northeastern part of the US. What impressions about the frontier might an Easterner have drawn from this painting?** George Caleb Bingham, *Fur Traders Descending the Missouri,* 1845. Oil on canvas, 29" x 36½" (73.7 x 92.7 cm). The Metropolitan Museum of Art, Morris K. Jesup Fund, 1933. Photograph © 1992 The Metropolitan Museum of Art.

6-30 **Traditional Chinese painting does not make use of linear perspective. How has the artist managed to convey a strong sense of distance in this very small painting?** Ma Yuan, *Bare Willows and Distant Mountains,* end of 12th century. Ink and light color on silk, 9³/₈" x 9½" (23.8 x 24.2 cm). Museum of Fine Arts, Boston, Special Chinese and Japanese Fund. Photograph © 2003 Museum of Fine Arts, Boston.

6-31 Paul Gauguin, *Tahitian Idyll*, 1892. Oil on canvas, 34 1/2" x 44 3/4" (87.5 x 113.7 cm). Hermitage, St. Petersburg. Photo by Erich Lessing/Art Resource, NY.

People tend to think that abstract art does not show spatial depth. Painters of abstract works are concerned with more than just the two-dimensional space of the picture plane. For some abstract painters, the suggestion of three-dimensional space is equally a concern. Look at the depth in Paul Gauguin's stylized picture of a South Pacific scene (fig. 6-31). It conveys a sense of depth through employing variations of size, overlapping, and high-low placement.

In *The Golden Wall* (fig. 6-32), Hans Hofmann manipulated depth by both overlapping and color variation. The blue rectangle on the right seems to be on top of the yellow patches that it overlaps. Yet the yellow patches tend to come forward because they are warmer and lighter than the blue rectangle. See especially how the large yellow square in the lower left corner comes forward.

6-32 **"Push and pull" is the name Hofmann gave to his technique for using color and shape to create a sense of space, depth, and movement. Which colors and shapes in this painting "push"? Which ones "pull"?** Hans Hofmann, *The Golden Wall*, 1961. Oil on canvas, 59 1/2" x 71 1/2" (151 x 182 cm). The Art Institute of Chicago, Mr. and Mrs. Frank G. Logan Prize Fund. Photo by Greg Williams.

## 6.7 Framing

*Framing* establishes the limits of what is seen in a picture. Winslow Homer framed *The Country School* (**fig. 6-34**) so that we see almost the whole one-room school. Because of the teacher's size and location, she is the most important person. But she, along with the students, is relatively small in comparison to the size of the picture. Therefore, she appears to be relatively far away.

Framing can affect the space, the point of view, and the meaning of a scene. Look at the single boy sitting on the bench near the teacher. He is one of the farthest-away people. In the new frame (**fig. 6-33**) he is much larger in comparison to the size of the picture. Therefore, he appears to be very close. Pictures like this that are framed very close to the central figure are sometimes called *close-ups*.

In the new picture the focus is just on the boy and what he is doing. In the original, he was merely a small part of a large scene. In what ways do you think the story has been changed? Is the new story more interesting or less interesting than the original?

### Try It Yourself

Try to find the vanishing point and eye level of *The Country School* (**fig. 6-34**). (Tip: Lay your straightedge along the lines formed by the benches on either side of the room, the top edge of the window on the left, and the top edge of the wall on the right.)

6-33 **Creating a close-up is one result of changing the frame of a picture.** Winslow Homer, *The Country School* (detail), 1871. Oil on canvas, 21 3/8" x 38 3/8" (54 x 98 cm). The Saint Louis Art Museum (Purchase).

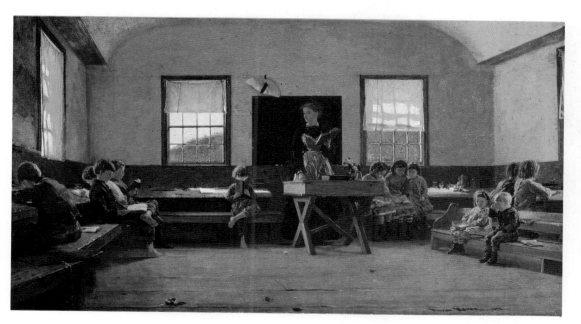

6-34 **One of the reasons Homer is such a popular artist is because his works always "tell" an interesting story. Why is framing a key factor in establishing the boundaries of a narrative, or storytelling, image?** Winslow Homer, *The Country School*, 1871. Oil on canvas, 21 3/8" x 38 3/8" (54 x 98 cm). The Saint Louis Art Museum (Purchase).

# An American Abstract Landscape

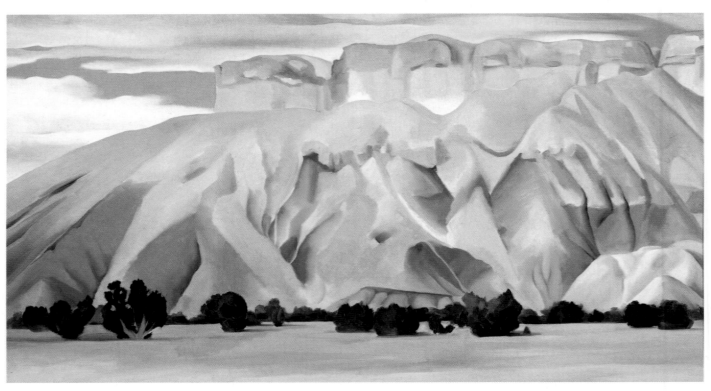

6-35 **Painters of the first half of the twentieth century used simple shapes, bright colors, and new approaches to spatial depth to reinvent the world of art. Their works frequently combine traditional views of reality with the elements of mystery that characterize abstract paintings.** Georgia O'Keeffe, *My Backyard*, 1937. Oil on canvas. New Orleans Museum of Art: Museum.Purchase, City of New Orleans Capital Funds.

**About the Artist**
## Georgia O'Keeffe
**(1897–1986)**

Born on a farm in Sun Prairie, Wisconsin, **Georgia O'Keeffe** claimed that by age ten she knew she would be an artist. From 1914 to 1915 she was in New York studying with artist and art educator Arthur Wesley Dow. Dow advocated a free, personally expressive approach to subject matter that was in tune with O'Keeffe's inclinations. In 1929 O'Keeffe spent her first summer in New Mexico. The openness of the Southwest was a welcome relief from the bustle of the city, which had begun to fail her as a source of inspiration for her work. In 1949 O'Keeffe moved permanently to New Mexico. Failing eyesight made her abandon oil painting in the 1970s. She worked in pencil and water-color until 1982 and, finally, moved to clay objects until 1984, when her health failed greatly.

## ① Describe What You See

When you describe an artwork, you identify things about the work that you can see, name, and describe with certainty. You should not include opinions, evaluations, or possible meanings here.

- List the artist, title of the work, medium, and date.
- What style or styles is the work done in?
- List nature forms you see. Are they true to life? Why or why not?
- Does space appear flat, shallow, or deep?
- Where do you see warm, cool, related, and contrasting color?
- Have you seen colors or forms similar to these? If so, where?

## ② Analyze the Way It's Organized

When you analyze an artwork, you tell how the subject matter and elements of the work have been organized by the artist. You tell how they work together.

- What dominates space in the composition, and why?
- How does the depiction of space differ from traditional perspective?
- Can you locate a focal point or area? If so, why does it draw attention?
- How is the appearance of advancing and receding forms in the cliff achieved?
- Why do the trees appear to advance in front of the cliff?

## ③ Interpret What It's Saying

Use the information from your description and analysis to help you identify the meaning of the work—that is, what it tells you about the human experience.

- What do you think was most important to the artist—realistic presentation of subject matter, or patterns of form and color derived from the subject?
- What feelings or moods do you identify with the painting?
- Explore a simile or metaphor to help clarify what this artwork says to you.

## ④ Evaluate Its Success

Using your analysis in the first three steps, judge the quality or success of this work.

- Which philosophical view is best for judgment of this work? A successful artwork: (1) is true to life, imitates reality, (2) is designed for perfect relationship among art elements, (3) expresses ideas, feelings, emotions, (4) advances human interests, a purpose, or a cause.
- How do you judge the success of the work in terms of the philosophy?
- How original is the artist's presentation of a landscape? Consider space, colors, forms, and combination of styles.
- How well known are the artist, her style, and achievements?
- Does the work arouse your interest, hold your attention, relate to your experiences, provide a new way of seeing the subject matter?

### More Art!
See page 146 for more artworks by Georgia O'Keeffe

### Web Links
www.davis-art.com
www.okeeffemuseum.org

## Technique Tip

When creating your color drawing, use the strongest colors on the shapes themselves, and allow the colors to become lighter as they approach the vanishing point. This technique will enhance the sense of depth in your drawing.

# One-Point Perspective Design

How can you create the illusion of three-dimensional form in a two-dimensional design? In this exercise, you will apply your understanding of linear perspective and blended color to create a design of interlocking shapes.

6-36 Student work, Tory Censits. Colored pencil, 18" x 12" (45.7 x 30.5 cm).

## Before You Begin

Observe and analyze the use of one-point perspective, horizon line, and vanishing point in several paintings in this chapter. Consider the differences between objects that are placed at eye level, below eye level, and above eye level.

## You Will Need

• newsprint paper
• white vellum
• pencils and erasers, colored pencils
• T-square, ruler, triangle

## Create It

❶ Using a T-square, draw a horizon line in pencil across the center of the newsprint. Add a dot to the center of the line for a vanishing point.

❷ Draw a variety of simple geometric shapes on the horizon line (eye level) and above and below eye level. Use a ruler or T-square to create shapes with straight edges.

❸ Place a ruler alongside a corner of a shape and the vanishing point. Lightly draw a line from each corner toward the vanishing point. The line does not have to meet the vanishing point. Repeat the process for each corner of each shape.

❹ Add a variety of unusual shapes that overlap the shapes you have already drawn. Carefully interlock the shapes and vary their lengths to create a strong sense of depth.

❺ Develop your most interesting shapes as well as new ones on white vellum. Use colored pencil to develop the drawing. Blend and repeat colors. Allow them to progress from dark to light as they recede toward the vanishing point.

## Evaluate It

• What challenges did you have when overlapping and interlocking shapes?

• Which shapes are at eye level? above eye level? below eye level?

• How does color increase the sense of depth in your composition?

6-38 Student work, Katrina Chu. Colored pencil, 9" x 12" (22.8 x 30.5 cm).

6-37 Student work, Megan Karlick. Colored pencil, 12" x 9" (30.5 x 22.8 cm).

## Write About It!

Describe what you see in Palmer Hayden's *The Janitor Who Paints* (fig. 6-39). What kind of room is the artist's studio, and who are the other people in the room? What are the objects that the artist has chosen to depict, and why these objects? Near what object do the lines of the floorboards and the water pipes angling along the ceiling converge? Write a metaphor that you believe captures the central concern of the painting.

**Art History**

# Studio Background

Palmer Hayden maintained that *The Janitor Who Paints* was painted in homage to his friend and fellow painter Cloyde Boykin, who worked as a janitor and never received recognition as a painter. The work also has autobiographical overtones because Hayden did custodial work himself to earn a living while he was painting. Hayden's work shows us slices of daily life among the inhabitants of New York's Harlem. The artist was part of the Harlem Renaissance, a post–World War I literary and art movement that celebrated African-American life and tradition.

6-39 **Note that as your eye is led through the painting, you are told a story. What aspects of African-American life does the artist wish to emphasize or celebrate in this work?** Palmer Hayden, *The Janitor Who Paints*, c. 1937. Oil on canvas, 39⅛" x 32⅞" (99.4 x 83.5 cm). Smithsonian American Art Museum, Gift of the Harmon Foundation.

## Technique Tip

The media of colored pencils and fine-line markers works best to highlight the exact forms and shapes.

## Computer Option

Scan or photograph your previous two-dimensional works of art into a paint program. Use the paint program to open a 8½" x 11" horizontal canvas. Draw a horizon line with two vanishing points near the edge of your canvas. Draw a vertical line midway between the two points. This will be an interior corner of your personal gallery. Draw straight vertical lines near the vanishing points to indicate the ends of the walls of the gallery. Use the place image command to start inputting your artwork into the gallery. For each image, use a distort or perspective tool to manipulate the outside shape of the artwork to match the perspective of the wall.

# Floating Art Museum

Imagine visiting a museum that floats freely through space. By applying the principles of two-point perspective, you can develop a design for an art museum for the future.

6-40 Student work, David Jou. Colored pencil, 20" x 15" (50.8 x 38.1 cm).

## Before You Begin

Review the principles of one-and two-point perspective drawing. Understand the importance of utilizing vanishing points to create consistent angles of a given form. Look at examples of recent and contemporary architecture, including museum designs by Frank Lloyd Wright and Frank Gehry.

## You Will Need

• scrap paper or sketchbook
• pencils, colored pencils
• fine-line markers
• straightedge
• white drawing paper or illustration board

❶ Envision a future in which people can fly freely throughout the universe, where they might encounter your imagined art museum. What does it look like? Begin making initial sketches in pencil on scrap paper or in your sketchbook.

❷ Holding the paper vertically, draw a light horizon line across the center of the page.

❸ Place two vanishing points near the edges of the paper. Theses points will be the edges of your horizon line.

❹ Using a straightedge, draw your museum, with every line going to one of the two vanishing points. Use the illustration board or white drawing paper to draw the final image.

❺ Apply color to complete your image. The color should be mixed and repeated to support the idea of unity. Selectively develop your color scheme, but you can choose to leave some shapes white.

## Evaluate It

• Are the principles of two-point perspective drawing applied throughout your image?
• What qualities make any structure inviting? Does your image reflect those qualities?
• What aspects of this project were the most challenging?
• What features of a museum are apparent in your design?

6-41 Student work, Josh Kirsch. Colored pencil, 18" x 12" (45.7 x 30.5 cm).

6-42 Student work, Ellie Gluck. Colored pencil, 18" x 12" (45.7 x 30.5 cm).

Art History

# Studio Background

Considered by many to be America's greatest architect, Frank Lloyd Wright was commissioned in 1943 to build a museum that would house the non-objective art collection of Solomon R. Guggenheim. Wright conceived a radical plan for a building that was cast completely in concrete with metal mesh and rods embedded for support. The design was so innovative that the plans, at first, were rejected by the New York City building department. The structure is a flowing, pure sculptural form—many see it as often a perfect setting for the artwork it houses. This is Wright's last work and often considered to be his masterpiece. He died just a few months before its completion in 1959.

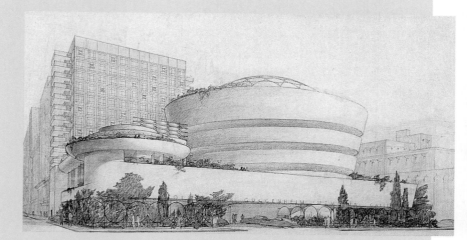

6-43 **The development of ferroconcrete allowed twentieth-century architects like Wright to design buildings in both geometric and organic shapes. In what ways does this architectural rendering for the New York Guggenheim propose a sculptural form?** Frank Lloyd Wright, architectural rendering. Copyright © 1957, 1994, 2004 The Frank Lloyd Wright Foundation, Scottsdale, AZ.

### Technique Tips

• Colored pencils allow you greater control in color blending and thus showing distance.
• The use of faded color will appear to increase your tower's height as it recedes into the sky.

### Computer Option

Digitally photograph an everyday object, such as an upright book, a backpack, or a soft drink can. Place the object on the edge of a table and photograph it from a slightly lower perspective or point of view. Input the photograph into a paint program and separate the object from the background using the select and cut tools. Open a new, horizontal 8½" x 11" canvas, and draw a horizon line with two vanishing points near the edge of the canvas. Draw a third vanishing point in the top-center of the canvas. Paste your object into the perspective drawing and use the transform, distort, or perspective tools to match your object to the vanishing points. Now draw skyscrapers and buildings surrounding your everyday object so that your object appears gigantic in proportion to them.

# Tower in Three-Point Perspective

To create the illusion of vertical distance, draw a tower in which you exaggerate the form by use of three-point perspective.

6-44  Student work, Meghan Karlick. Colored pencil, 18" x 12" (45.7 x 30.5 cm).

## Before You Begin

Review the discussion of two-point perspective on page 129, and study the diagram of three-point perspective in **figure 6-45**.

## You Will Need

• newsprint paper
• white vellum paper
• straightedges
• pencils and colored pencils

## Create It

❶ Using a no. 2 pencil, begin making initial sketches of your tower on 12" x 18" (31 x 46 cm) newsprint paper.

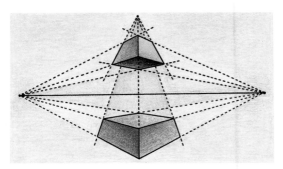

6-45  **In three-point perspective, the primary vanishing point appears at the extreme top or bottom of the composition. Two secondary vanishing points—like those used in two-point perspective—appear at the sides.**

❷ Holding the paper vertically, place a light horizon line approximately four inches from the bottom of your white vellum paper.

❸ Place two vanishing points near the edge of the paper. These points will be the edges of your horizon line.

❹ Place a third vanishing point in the center on the top of your paper. Every line drawn will go to one of these three points. Complete your tower by connecting points in the foreground of your image with each of the three vanishing points. As these lines are drawn from points in the foreground to each vanishing point, your three-dimensional tower will begin to take form.

❺ When your tower is complete, choose one or two colors and use colored pencils to create even greater depth in your drawing. Try making your colors fade as they move closer to the vanishing points.

6-46 Student work, Katrina Chu. Colored pencil, 18" x 12" (45.7 x 30.5 cm).

6-47 Student work, Mike Kuzmick. Colored pencil, 18" x 12" (45.7 x 30.5 cm).

6-48 Student work, Gizelle Uy. Colored pencil, 18" x 12" (45.7 x 30.5 cm).

## Write About It!

Imagine that you are scaling your tower into the sky. Look up. What do you see? Look down. How does the perspective differ from what you saw above you? How does the perspective change as you climb upward? Describe architectural elements, shape, size, point of view, and space.

## Evaluate It

- How did you achieve an illusion of towering height (or vertical distance) in your image?
- How easy was it to use three vanishing points to create consistent angles?
- How do the colors function as a means of personal expression and as a way to show vertical distance?

**Art History**

## Studio Background

Although Dutch graphic artist M. C. Escher died in 1972 (see Artist Biography, page 63), his images maintain a strong life in today's popular culture. As a young man traveling through Europe, Escher chose high vantage points and dramatic views to draw. The disorienting effect of some of the artist's imaginary depictions is a result of his use of multiple vanishing points. His manipulation of perspective causes the eye to become confused and dart about looking for a singular viewpoint—which it often won't find! In *Tower of Babel* there is a more regular system of three-point perspective, but the extreme viewpoint is startling.

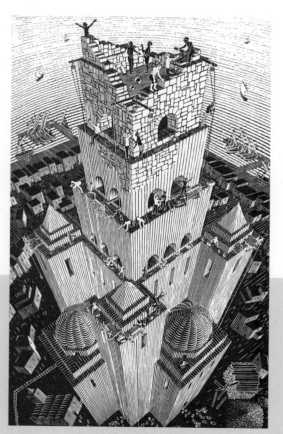

6-49 **As a young man, Escher studied architecture for a short period. Toward the end of his life he said that he considered himself more of a mathematician than an artist. How are these two interests reflected in *Tower of Babel?*** M. C. Escher, *Tower of Babel.* © 2003 Cordon Art B. V.-Baarn, Holland. All rights reserved.

# Depth in Monochromatic Collage

To explore depth in landscape, try creating an imaginary landscape using multiple values of a single color.

## Before You Begin

Study landscapes by artists such as van Gogh, Dalí, and Monet. Consider what makes up a landscape, and how these kinds of works are composed. Note how the artists use elements like line, shape, color, and space to create expression. Review collage techniques such as cutting, tearing, overlapping, and gluing.

## You Will Need

• assortment of papers
• craft wire
• white glue and water
• watercolor paint
• heavy paper or illustration board
• a viewfinder
• masking tape

## Create It

❶ Experiment with combining cut or torn paper in various ways to create a composition that is no larger than 3 1/2" square and no smaller than 2" square. For variety, use paper of a single color but in different values, thicknesses, and textures. Use a 3" x 3" viewfinder to frame your paper combinations to help you decide on the best composition; recall the discussion of value and color from Chapter 5.

❷ Use watered-down white glue to secure the final composition. Consider adding wire to your composition to provide additional color and line definition. You can also use watercolor paint as a stain on the various kinds of paper in your collage. A watercolor wash can create a sense of unity in a monochromatic landscape.

❸ Using heavy white paper, create a simple 10" x 12" mat. Measure and cut a hole that is exactly the size of your collage. Leave an equal amount of space from the opening to the top and left and right sides of the mat. Leave a generous amount of space at the bottom of

6-50 Student work, Eric Bennett. Paper collage, watercolor, 3" x 3" (7.6 x 7.6 cm).

6-51 Student work, Alerica Lattanzio. Paper collage, watercolor, 3" x 3" (7.6 x 7.6 cm).

6-52 Student work, Devi Sengupta. Paper collage, watercolor, 3" x 3" (7.6 x 7.6 cm).

## Computer Option

Take photographs with digital cameras outside your school and/or find images from various sources (for example, magazines, books) and scan them into the computer. Images should include, but not be limited to, skies, clouds, trees, mountains, lakes, and people. Use a paint program selection tool to color the images in various intensities of a single hue. Cut and paste these images to form a close interpretation of a landscape work that appears in this textbook.

the mat. Use masking tape to secure the image to the mat in final mounting.

## Evaluate It

- How has your idea of depth in a landscape changed as a result of this project?

- How does working in a small format affect the results you achieve?

- What is the benefit of working with varied papers and what effect did it have on your work?

- Was your monochromatic collage more successful or less successful than the others? Why or why not?

- What did you learn about creating landscapes in this exercise?

## Studio Background

What gives Surrealist works their special eeriness? Could it be the fact that often the unreal juxtapositions we find in Surrealism are depicted in a setting built with very accurate linear perspective and realistically rendered objects? *The Weaning of Furniture—Nutrition* shows the shoreline of a Spanish fishing village. The painting was a favorite of Dalí's and is said to represent memories of his childhood nanny. Dalí associated his bottle and nightstand with her. The crutch perhaps alludes to the support she will need in her old age.

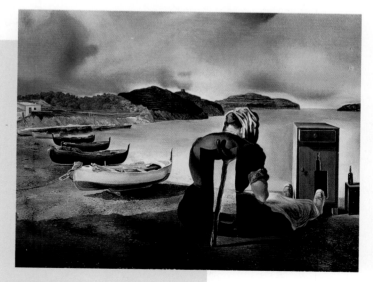

6-53 **Surrealism is often associated with a dreamlike state. Dalí called paintings such as** *The Weaning of Furniture—Nutrition* **"hand-painted dream photographs." In what ways is this work like a dream?** Salvador Dalí, *The Weaning of Furniture—Nutrition*, 1934. Oil on panel, 7" x 9½" (17.8 x 24 cm). Collection of The Salvador Dalí Museum, St. Petersburg, Florida. Copyright 2003 Salvador Dalí Museum, Inc.

### Technique Tip
Clean, simplified shapes relate well to the similar geometric qualities found in Diebenkorn's *Ocean Park* series, as do washings of multiple color layers that allow other colors to show through.

# Diebenkorn-Inspired Abstract Landscape

How can you capture the essence of a specific place? In this lesson you can explore using color and perspective in an abstract landscape composition.

6-54 Student work, Katy Hu. Oil pastel, 26" x 40" (66 x 101.6 cm).

### Before You Begin

Familiarize yourself with the terms foreground, middle ground, and background. Understand how color can be used to create the illusion of depth and how perspective can offer the viewer different views of one subject. Study examples of abstract expressionism, including Richard Diebenkorn's *Ocean Park* series (fig. 6-57).

### You Will Need

• white vellum paper
• pencils, fine-line markers
• heavy white drawing paper
• a variety of drawing and painting materials (oil pastels, acrylic paint, felt-tip markers, pen and ink, collage, and mixed media)

### Create It

❶ Take a walk around the perimeter of the school. Imagine that you are in a hot-air balloon or a helicopter looking down on the landscape. What would the school building, parking lots, and playing fields look like from this perspective?

❷ Create a line drawing of the school property from a bird's-eye perspective. Include human-made and organic shapes, such as those you observed while walking the perimeter. Fill the paper completely. Include as much detail as you can by using a fine-line marker or pen.

❸ In a second drawing, exaggerate the importance of certain areas of the school grounds. Either reduce the size of an area in which you have little interest, or increase the area size of a place that you deem more interesting. For example, if you are a sports enthusiast, enlarge the size of the gym or the

6-55 Student work, Sarah Cruser. Mixed media, 26" x 40" (66 x 101.6 cm).

6-56 Student work, Sean Keeton. Acrylic paint, 26" x 40" (66 x 101.6 cm).

football fields. Distort the image to make it less representational and more abstract.

4 Draw the final image in oversimplified geometric shapes using pencil first on the large drawing paper. Darken the lines with pen or markers. Keep in mind that you want to achieve unity while also reflecting the visual clarity of Diebenkorn's style.

## Evaluate It

• How does your final image employ form, color, and perspective to suggest a landscape from a bird's-eye view?
• Has your view of the areas you see every day changed since you began this project? If so, how?
• What have you learned about abstraction as it applies to landscape?

## Write About It!

What choices did you make in depicting landscape in your bird's-eye view of the school grounds? What parts of the landscape were most important to you? What parts turned out to be the most visually interesting? How do color, shape, and scale work to create interest in your work? If you were to create a series of landscapes in this style, what other places in your life might you choose to illustrate?

## Art History

## Studio Background

Richard Diebenkorn painted 140 abstract versions of Ocean Park, the Venice, California, neighborhood he traversed daily on his way from home to studio. Using brilliant colors and geometric shapes, the artist captured the essence of this urban place that borders the ocean. Though the paintings can be called abstract landscapes, they also are very much about the act of painting. The process that Diebenkorn went through as he painted each canvas can be seen in his pentimenti, the visible changes he made in the compositions.

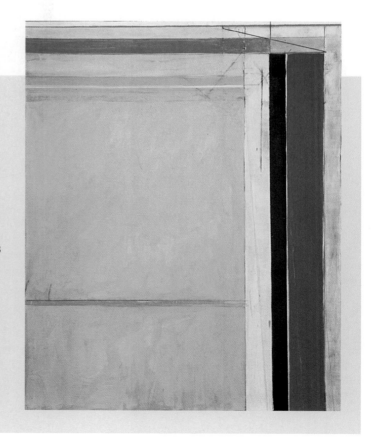

6-57 **Diebenkorn did not make studies for his *Ocean Park* series. He chose to work directly on the canvas. Do you see any references to an urban place by the sea?** Richard Diebenkorn, *Ocean Park #83*, 1975. Oil on canvas, 100" x 81" (254 x 205.7 cm). The Corcoran Gallery of Art; Museum Purchase with the aid of funds from the National Endowment for the Arts, the William A. Clark Fund, and Mary M. Hitchcock, 1975.30.

6-58 Georgia O'Keeffe, *East River from the 30th Story of the Shelton Hotel*, 1928. Oil on canvas, 30" x 48 1/8" (76.2 x 122.2 cm). New Britain Museum of American Art, Stephen B. Lawrence Fund. Photo by E. Irving Blomstrann.

6-60 Judy Pfaff, *Milagro*. Courtesy of the artist.

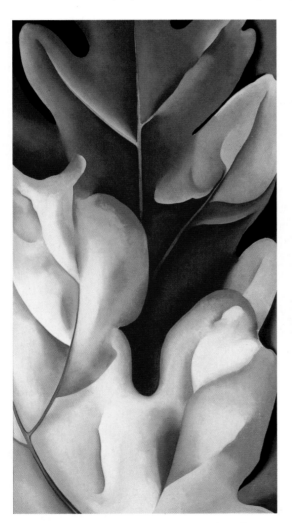

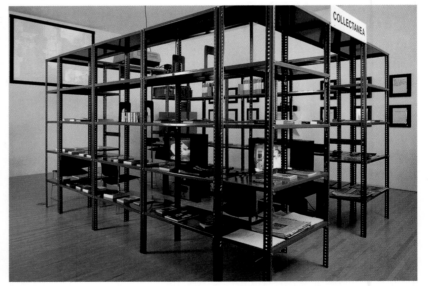

6-61 Renée Green, *Import/Export Funk Office*, 1992–93. Installation with audio, video, and reading materials. The Museum of Contemporary Art, Los Angeles, Gift of Gabi and Wilhelm Schürmann. Photo: Paula Goldman.

6-59 Georgia O'Keeffe, *Oak Leaves: Pink and Gray*, 1929. Collection Frederick R. Weisman Art Museum at the University of Minnesota, Minneapolis. Museum Purchase.

# Chapter 6 Review

## Summary

The size and form of a space can be determined by its boundaries and the objects it touches. The interior spaces of hollow objects and buildings are referred to as *volume*.

*Positive and negative space* is very important to artists who deal with three-dimensional artworks. Architects, especially, have to consider space when they design buildings and interiors. Modern sculptors often include holes in their works to create added space.

Artists who make paintings and drawings often use the word *space* to refer to the two-dimensional area of the *picture plane*.

Artists who make realistic pictures are representing depth on a two-dimensional surface. They create an illusion of three-dimensional objects and space.

Depth in a picture can be created by shading, foreshortening, and making objects large or small. (These methods were explained in Chapter 4.) In addition, depth can be created by *overlapping*, *high and low placement*, *linear perspective*, and *aerial perspective*. Some semi-abstract and abstract works employ these methods, in addition to color variation.

*Framing* involves locating the borders of a picture. Framing affects not only the space but also the point of view and meaning of a picture.

## Review Questions

1 **Recall:** Name four techniques presented in this chapter that may be used to create a sense of depth.

2 **Understand:** Explain how aerial perspective creates the illusion of depth.

3 **Apply:** Show how one-point perspective is created by drawing a simple diagram.

4 **Analyze:** Compare the creation of space and depth in Bingham's *Fur Traders* and Homer's *The Country School*.

5 **Synthesize:** Compose a brief essay on how space is used to organize and add meaning to one of the artworks in this chapter.

6 **Evaluate:** Look carefully at Holbein's *Portrait of Georg Gisze* **(fig. 4-25, page 67)**, O'Keeffe's *My Backyard*, Ma Yuan's *Bare Willows*, Homer's *The Country School*, and Hofmann's *The Golden Wall*. Rank them according to:

- use of overlap
- use of high-low placement
- use of aerial perspective
- use of color to create depth

## For Your Portfolio

Select a two-dimensional artwork reproduced in this textbook that you think is a good example of spatial organization and illusion of depth. Write a short essay in which you describe the way the artist has organized space and achieved the illusion of three-dimensional space. Your essay will provide evidence that you can analyze the composition of an artwork.

## For Your Sketchbook

Choose a simple object to draw. Use the object to create an example of each of the perspective techniques described in this chapter. Practice drawing some boxlike forms in linear perspective. Combine them with other forms such as cylinders.

## Electronic Research

Use a search engine to visit the Vatican Museum and other Web sites to investigate more fully the philosophical and mathematical meanings inherent in Raphael's fresco *The School of Athens*. Which philosophers in the painting have been identified through historical evidence? How did three of the philosophers pictured—Socrates, Plato, and Aristotle—each contribute to the development of perspective? Why is *The School of Athens* considered to be such a masterpiece of High Renaissance art?

## Going Further

Try to imagine the two-dimensional paintings in this chapter as three-dimensional sculptures or dioramas. Work with a group of your classmates to re-create a two-dimensional work of art as an installation. Consider appropriate placement of cutouts of foreground, middle ground, and background shapes against a painted backdrop.

# 7 Texture

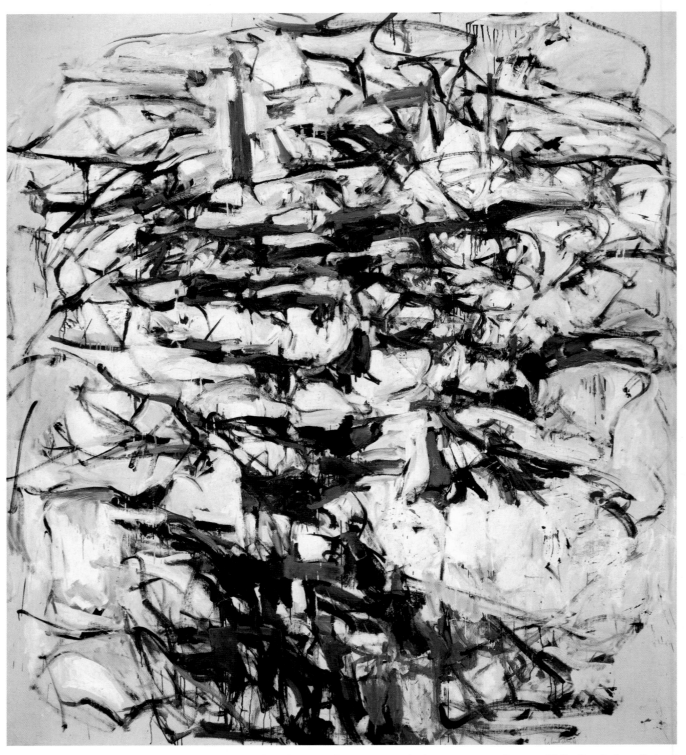

7-1 **This artist usually worked on multiple panels or large-scale canvases, aiming to create a "natural" rhythm in her abstract works. What words would you use to describe the textures found in this painting of a hemlock tree?** Joan Mitchell, *Hemlock*, 1956. Oil on canvas, 91" x 80" (231.1 x 203.2 cm). Collection of Whitney Museum of American Art, New York. Purchase, with funds from the Friends of the Whitney Museum of American Art. Photograph © Steven Sloman 2001.

## What You'll Learn

- to understand that textures can be sensed as well as felt
- to identify textures in artworks and in your environment
- to distinguish between simulated and actual textures in artworks
- to appreciate the expressive qualities of texture

## What This Chapter Covers

## Art Criticism Step by Step

## Studio Experiences

## Artists' Showcase *page 164*

## Chapter Review *page 165*

## Key Terms

*English (Spanish)*

***gloss*** *(lustre)*
***matte*** *(mate)*
***actual texture*** *(textura de veras)*
***simulated texture*** *(textura simulada)*
***invented texture*** *(textura inventada)*

## Artists

Deborah Butterfield, Michelangelo Buonarroti, Chunghi Choo, Jean Dubuffet, Jean-Charles Kerninon, Dorothea Lange, Lele peoples, Marilyn Levine, Edouard Manet, Joan Mitchell, Toshusai Sharaku, Michel Sittow, Vincent van Gogh

7-3 Student work, Meredith Ally. Mixed media, 12" x 12" (30.5 x 30.5 cm).

7-2 Student work, Meredith Ally. Torn-paper collage, 12" x 18" (30.5 x 45.7 cm).

## 7.1 A Quick Look at Texture

The way the surface of an object feels to the touch is called texture. *Rough, smooth, grainy, slick,* and *gritty* are all words that describe textures. Two common textures in art are **gloss** and **matte**. A glossy texture is slick and shiny. A matte texture is smooth but not slippery.

*Actual textures* occur in real objects that you can touch. Actual textures are all around you. Even if you can't touch an object, you can often imagine what its texture would feel like by looking carefully at the object's surface. Does it have edges that look sharp or rounded? Is the surface shiny and smooth, or uneven?

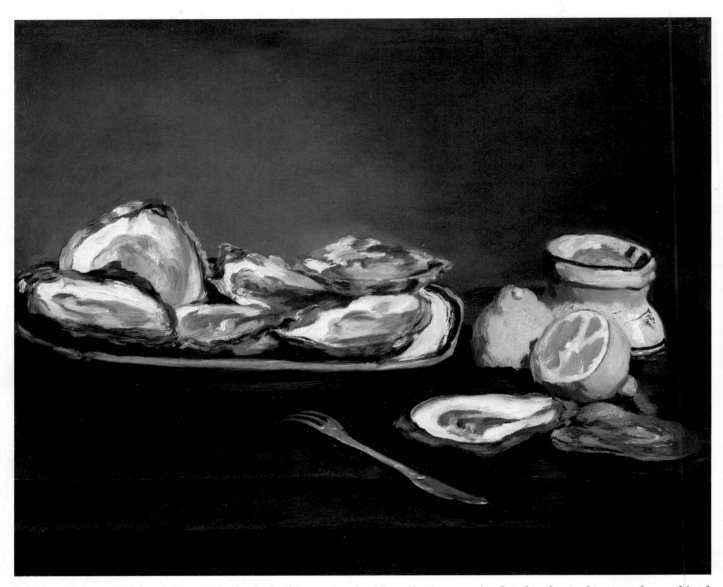

7-4 **The artist used thick paint to create the flesh of the oysters in this work. How can simulated and actual textures be combined in one painting?** Edouard Manet, *Oysters,* 1862. Oil on canvas, 15 3/8" x 18 3/8" (41 x 48 cm). Gift of the Adele R. Levy Fund, Inc. Image © 2003, Board of Trustees, National Gallery, Washington.

7-5 **How many different ways have textures been created here?** Lele peoples, *Face Mask*, Democratic Republic of the Congo, early to mid-20th century. Wood, wood pegs, copper, iron, pigment, plant fiber, cotton, wool, cowrie shells, glass beads, 11⁵/₈" x 9³/₄" x 9¹¹/₁₆" (29.5 x 24.8 x 24.6 cm). National Museum of African Art, Smithsonian Institution, Museum Purchase. Photo by Franko Khoury.

7-6 **Has the artist used simulated or actual textures in this work? How can you tell?** Marilyn Levine, *Nitro*, 1994. Ceramic with fabric lace, 5¹/₄" x 4" x 7" (2.06 x 1.57 x 2.75 cm). Collection of the artist. Photo by Richard Sargent and courtesy of the artist.

Artworks often show *simulated textures*. You can see these textures, and imagine how they would feel, but if you touch them they only feel like the surface on which they've been painted, drawn, or printed (**fig. 7-7**).

Some artists create *invented textures*. These textures are very like simulated textures, but they are not intended to resemble textures you find in real life.

Artists use the element of texture to define shapes, provide variety, create interesting surfaces, and help viewers recognize objects. Texture often contributes to the overall feel or mood of a work.

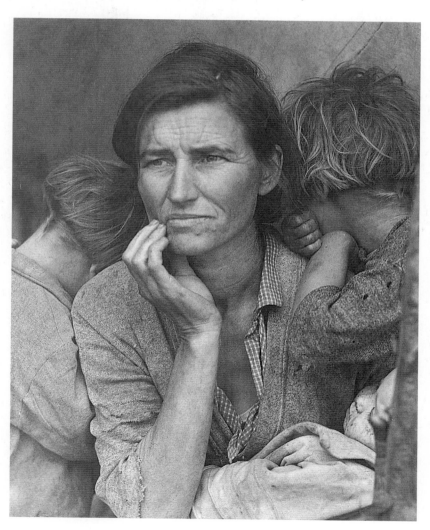

7-7 **This photograph shows lots of simulated texture, but the actual texture of the photographic print is a smooth gloss.** Dorothea Lange, *Migrant Mother, Nipomo, California*, 1936. Dorothea Lange Collection, The Oakland Museum.

**Try It Yourself**

List some things in the classroom, such as the chalkboard, a countertop, the ceiling, clothing, doorknobs, and carpet.

Describe the texture of each in a few words. Then touch some of these items. Did you discover additional qualities about their textures? If so, change or add to your descriptions. Have you ever touched the ceiling? Is it stippled? Is it a type of tile? Can you sense the texture of the ceiling by just looking at it and "touching" it in your imagination?

*Texture* refers to how the surface of something feels to the touch: coarse, silky, hard, soft, gritty, furry, and so forth. Texture is everywhere **(figs. 7-8, 7-9, and 7-10)**. Two words often used in art to describe texture are **gloss** and **matte**. Gloss refers to a surface that is smooth and shiny, like a newly waxed floor. Matte means smooth but nonslippery, like the surface of a chalkboard. But in fact, there are all kinds of textures—from rough to smooth, from soft to hard, and everything in between.

Although texture is related to touch (sometimes called the *tactile sense*), we do not always have to touch something to sense its texture. Because of our memories of touching, we can sense many textures just by looking at them.

Texture in our daily lives is very important. It is more important than we often realize. Take eating out, for example. You and your family probably choose a restaurant for the quality of its atmosphere as well as for its food. The atmosphere of a restaurant depends a

7-8 Photograph: Karen L. Durlach.

7-9 Photograph: Karen L. Durlach & David Ostrowski.

**Linking Disciplines**
Science

Have you ever thought about why some seashells are smooth and others are rough or prickly? What function does texture play in the world of plants and animals? Find several examples **of functional texture** in nature. Make photographs or drawings of your examples and display them, along with a written explanation of the function.

great deal on the textures. Examples of glossy textures include plates, cups, silverware, glasses, countertops, coffee machines, and mirrors. Matte textures may include napkins, place mats, tablecloths, and drapes. If they are thick and loosely woven, the drapes might be described as nubby; so might the carpeting. Rough textures may be found in such things as brick planters and unvarnished paneling.

What about food? Flavor is important, but so is the texture of the food, or the way it feels in the mouth. You would be very disappointed in a hamburger bun that was not fresh. It should have the correct balance between softness and firmness, and between moistness and dryness. The same, of course, is true for everything inside the bun.

7-10 Photograph: Karen L. Durlach.

## Texture in Art

All art objects have texture. In some art, however, the actual texture of the work itself is relatively unimportant.

The texture of *Migrant Mother, Nipomo, California,* Dorothea Lange's 1936 photograph of a world-weary mother and her children **(fig. 7-11)** is the slick surface of the photographic paper (which differs little from the texture of the page on which it is reproduced in this book). What is important in Lange's photograph are the textures that we can see in the picture: the lined face of the mother, her hair, her children's hair, and the material of their tattered clothes. Such textures are called ***simulated textures***. You cannot touch them, but they

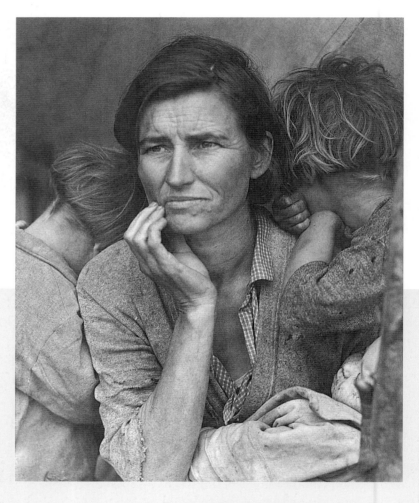

7-11 **This well-known image is one of a series of photographs Lange took during a monthlong trip to document migrant workers in California. How would the dynamics of this image have changed if the background had been highly textured?** Dorothea Lange, *Migrant Mother, Nipomo, California,* 1936. Photograph: Dorothea Lange Collection, The Oakland Museum.

## Artist Biography
### Dorothea Lange (1895–1965)

Dorothea Lange was born Dorothea Nutzhorn in Hoboken, New Jersey. She contracted polio at the age of seven, which permanently affected her right leg. Photography interested her from an early age, and she dropped out of a teachers college to complete a photography course at Columbia University.

After the stock market crash of 1929, many people began migrating to California from the drought-ravaged Midwest, looking for jobs. Dorothy, who had by this time taken her mother's name, Lange, began photographing the homeless and unemployed migrants. Her photographs caught the eye of a government worker, who hired her as a documentary photographer.

On a cold, dreary day in March 1936, Lange was returning home from a long, hard trip when she passed a sign for a migrant workers' camp. She took several pictures of a particular mother and her children, which she developed and delivered to the *San Francisco News*. Lange's photo style, which communicated emotion, presence, character, and strength, emerged during her fieldwork. These photographs and others she took at the time helped bring aid to the struggling migrant workers, and earned Dorothea a lasting reputation as a photographer of remarkable ability.

7-12 **The sculptor of this work has created a wide range of objects in ceramics that are intended to fool the eye. What qualities of a leather texture is she seeking to portray in this work?** Marilyn Levine, *Nitro*, 1994. Ceramic with fabric lace, 5¼" x 4" x 7" (2.06 x 1.57 x 2.75 cm). Collection of the artist. Photo by Richard Sargent and courtesy of the artist.

are nevertheless very visible. The simulated textures in *Migrant Mother* play an important role in telling a story about the sad plight of migrant families in the 1930s.

Like photographs, realistic paintings have simulated textures. For example, the actual surface of Michel Sittow's *Portrait of Diego de Guevara* (**fig. 7-13**) feels something like an old oilcloth or a varnished door. But the relevant textures you see—ermine fur, flesh, and hair—have been skillfully simulated by Sittow's use of the oil medium.

Many of Marilyn Levine's craft objects cause the viewer to do a double take. Her *Nitro* (**fig. 7-12**) may even require a "triple take." What is it? It looks like a mug wrapped in a leather jacket. But the wrapping is not leather; it is *ceramic* (the material from which bricks are made). Do you think *Nitro* could fool your touch?

Equally puzzling is the title. Typically, *nitro* is shorthand for *nitroglycerine*, an ingredient of dynamite. What was Levine thinking? Does the mug contain espresso, a concentrated coffee that gives you a jolt in the morning? Or is it an ice skate that blasts off at the start of a race?

7-13 **Michel Sittow was a highly respected portrait painter in the Spanish court of Isabel of Castile. How do the textures provide clues to this subject's high social status? Compare with the texture and meaning of *Migrant Mother*.** Michel Sittow, *Portrait of Diego de Guevara (?)*, c. 1515–18. Oil on panel, 13¼" x 9⁵/₁₆" (33.6 x 23.7 cm). Andrew W. Mellon Collection. Image © 2003 Board of Trustees, National Gallery of Art, Washington.

7-14 **This work must have had a place in the heart of the artist. It is an early work, yet it was found in his studio at the time of his death. What reasons might a highly successful artist such as Manet have for keeping particular works in his or her possession?** Edouard Manet, *Oysters*, 1862. Oil on canvas, 15 3/8" x 18 3/8" (41 x 48 cm). Gift of the Adele R. Levy Fund, Inc. Image © 2003 Board of Trustees, National Gallery, Washington.

## Try It Yourself

At home, look for some of your favorite personal objects, such as clothes, jewelry, a watch; or old toys, such as dolls, teddy bears, games. Is the texture of a teddy bear actual or simulated, or both?

Find a natural object from outdoors and a human-made object, such as a brick, a weathered board, or a rusty nail. Bring them to class. Describe the texture of each object.

In some paintings, like Edouard Manet's *Oysters* (fig. 7-14), actual and simulated textures play roles. The textures of the oysters, along with the lemons, are perhaps realistic enough to make you hungry. The texture of the thick strokes of paint used to create the oysters is also visible. This painting gives you the best of both worlds: simulated and actual textures. It appeals not only to your sense of sight and touch, but also to your ability to imagine the taste of food.

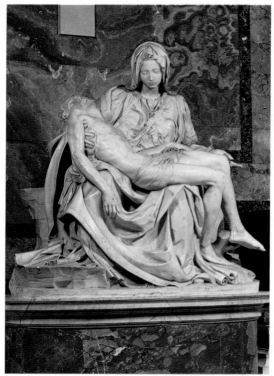

7-15 **A sculptor working in marble must make a decision regarding the degree to which the stone is polished. What factors might have led to Michelangelo's decision to highly polish this piece? What aspect of the image does the very fine texture help emphasize?** Michelangelo Buonarroti, *Pietà*, 1498–99. Marble, 5' 9" (2 m) high. St. Peter's Basilica, Vatican State. Photo courtesy Scala/Art Resource, NY.

The texture of Michelangelo's famous sculpture of the *Pietà* (Italian for *pity*) in **figure 7-15** is polished marble. But in some places, Michelangelo used his chisel to simulate textures—as seen in Jesus' hair and facial hair. In Mary's gown, the artist took pains to make it drape like a real gown. It clings to Mary in some places and gathers in heavy folds in other places. Still, we never lose sight of the fact that the *Pietà* is made of smooth stone.

There are no simulated or "trick" textures in the Lele peoples mask from the Republic of the Congo (**fig. 7-16**). It is all real texture, the things you can touch—in this case wood, copper, iron, plant fiber, cotton, and wool, among other things. In addition to the textural variety, the Lele artist has enlivened the mask with concentric lines around the eyes and a combination of cowrie shells and colorful beads across the hairline. The mask invites you to pick it up and feel its many textures—or, perhaps, to wear it.

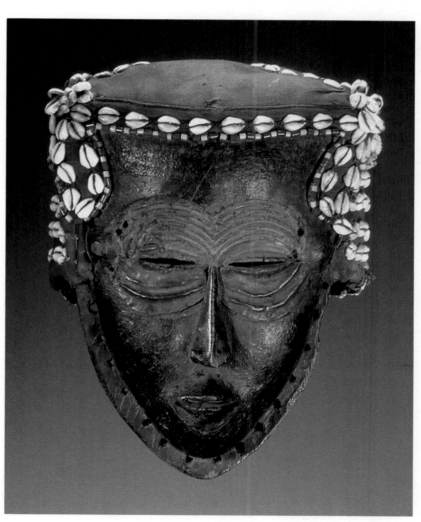

7-16 **Until the mid-1900s, cowrie shells and glass beads were used as currency and to decorate important ceremonial objects in the sub-Saharan region. What other elements of art did the artist combine with texture to create a vibrant and dynamic object?** Lele peoples, *Face Mask*, Democratic Republic of the Congo, early to mid-20th century. Wood, wood pegs, copper, iron, pigment, plant fiber, cotton, wool, cowrie shells, glass beads, 11 5/8" x 9 3/4" x 9 11/16" (29.5 x 24.8 x 24.6 cm). National Museum of African Art, Smithsonian Institution, Museum Purchase. Photo by Franko Khoury.

# An Expressionist Landscape

## Vincent van Gogh
### (1853–1890)

We know many details from the life of **Vincent van Gogh** because of his letters to his brother, Theo. It was Theo who provided support that permitted van Gogh to paint so prolifically. Even when Vincent's life was shattered by attacks of mental illness, he still painted whenever he was able to. From April 1889 to May 1890 van Gogh was a voluntary patient at an asylum near the town of Saint-Rémy, France. Eventually, he was permitted to venture into the surrounding country-side. His letters to his brother were always very coherent. In one Vincent says, "As far as I can judge, I am not really mad. You will see that the canvases I have done in the meantime are untroubled and no worse than the others."

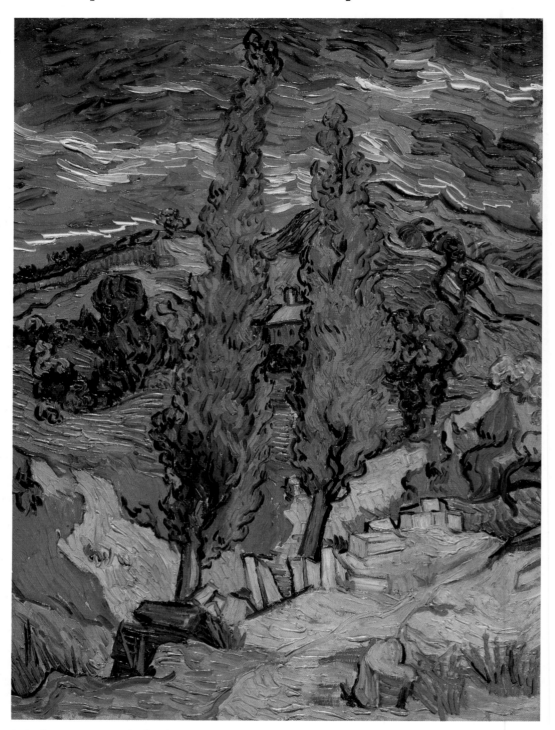

7-17 **The Post-Impressionists inherited their color palette, interest in light's effects, and love of nature from Impressionist painters like Renoir and Monet. They also inherited a love of painting outdoors. Van Gogh combined this approach with an ability to express intense feelings and emotion—thus giving name to a new style, Expressionism.** Vincent van Gogh, *The Poplars at Saint-Rémy*, 1889. Oil on fabric, (61.6 x 45.7 cm). Cleveland Museum of Art, Bequest of Leonard C. Hanna, Jr.

## ① Describe What You See

When you describe an artwork, you identify the things about the work that you can see, name, and describe with certainty. You should not include opinions, evaluations, or possible meanings here.

• List the artist, title of the work, medium, and date of the work.
• What forms do you see in the foreground, the middle ground, and the background of this landscape?
• Where do you see textures in this painting?
• What colors can you identify?
• Are colors in the trees and hills warm, cool, bright, dull?
• Are sky colors warm, cool, bright, dull?

## ② Analyze the Way It's Organized

When you analyze an artwork, you tell how the subject matter and elements of the work have been organized by the artist. You tell how they work together.

• Look closely at the foreground and trees. How were the textures created? Would these be real, or implied textures in the actual painting?
• Imagine you are creating these textures. What different brush movements would you use? Is there similarity? Variety?
• Is this a recognizable technique? Look at some other van Gogh paintings.
• What causes the feeling of movement and activity in the painting?
• List some ways in which a feeling of depth is achieved in the composition?
• What is the predominant color scheme van Gogh used in this painting?

## ③ Interpret What It's Saying

Identify the meaning of the work—what it tells you about human experience.

• List some words to describe the mood or feeling the work suggests to you. Example: *joyful, exuberant, glowing, intense,* etc.
• Explore a simile or metaphor to help you identify van Gogh's expressive purpose for this landscape. What do the glowing colors and the slashing, twisting brushstrokes suggest? What about the cool sky against the warm landscape—is it fall?
• What is your theory about the meaning, or purpose of this work?

## ④ Evaluate Its Success

Using your analysis in the first three steps, how would you judge the quality or success of this work?

• Which philosophy provides the best basis for your judgment? A successful artwork: (1) is true to life, imitates reality, (2) is designed for perfect relationship among elements, (3) expresses significant ideas, feelings, emotions, (4) advances human interests, a purpose, or a cause.
• In view of the time period for this painting, how do you judge the originality of the artist's technique with the medium in presentation of his subject?
• How well known are van Gogh and his work? Was he influential? Is he now?
• How successful is the work in presenting you with a different way of seeing nature?

**More Art!**
See pages 85, 103, 161, and 213 for more artworks by van Gogh

**Web Links**
www.moma.org
www.vangoghmuseum.nl/

# Texture Collage

In this exercise, you will first study and draw an insect, animal, or fish. Then you will use recycled posters or magazine pictures to create a torn-paper collage from your drawing to learn more about color and texture.

7-18  Student work, Anusha Subraman. Mixed media, 12" x 18" (30.5 x 45.7 cm).

7-19  Student work, Meredith Ally. Torn-Mixed media, 12" x 18" (30.5 x 45.7 cm).

## Before You Begin

View images by artists who successfully combine color and texture. Vincent van Gogh's paintings are excellent examples. Pay particular attention to the way he used oil paints to combine rich color and applied texture.

## You Will Need

- pencils
- newsprint paper
- white vellum
- colorful recycled posters or magazines
- white glue and water mixture
- watercolor brushes

## Create It

**1** Choose a subject for your collage and study its appearance. Next, create a light contour drawing of your subject on newsprint paper.

**2** When you are satisfied with your drawing, transfer it onto white vellum. Use a pencil to trace your sketch or copy it freehand.

**3** Choose the colors of your subject and background. Tear the posters or magazine pages, thinking about the shapes and textures you want to show in your collage.

**4** Brush the paper with the glue and apply the pieces to your drawing. Then, to secure the images, brush a thin layer of glue on the top surface of the torn paper. Overlap pieces to enhance the texture. Proceed slowly and thoughtfully to develop your image. Remember, your collage should show color unified with texture.

7-20 Student work, Caitlin Ryan. Mixed media, 12" x 18" (30.5 x 45.7 cm).

## Evaluation

- What role does texture play in your collage?
- How is color used in your collage to help create unity?
- Is there a relationship between color and texture in your work as in the paintings of Vincent van Gogh?

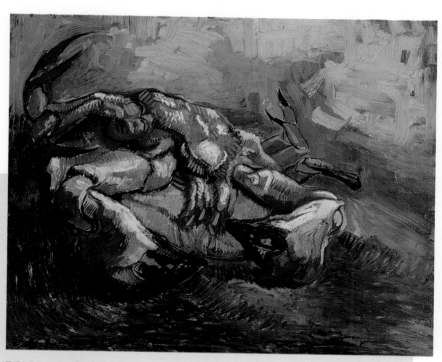

7-21 **Van Gogh sent all of his paintings to his brother, Theo, for safekeeping. Many of these works became the nucleus of the collection at Amsterdam's Van Gogh Museum. What might be advantages to keeping the works of one artist together? What might be the disadvantages?** Vincent van Gogh, *Crab on Its Back*, 1889. Oil on canvas, 15" x 18⅓" (38 x 46.5 cm). Collection, The Van Gogh Museum, Amsterdam.

**Art History**

## Studio Background

It is thought that van Gogh painted this crab during a hospital stay following his first mental collapse. Energetic brushstrokes define the textures on the underside of the crab. They also help create a charged background. The contrasting green and red colors add to the sense of turmoil. Perhaps the image can be seen as a metaphor for the artist's view of himself in the world. It was only in the last two years of his life that van Gogh exhibited at the Paris Salon des Independents, where his work was well received by fellow artists. In his final year he sold his first painting and for the first time had an article written about his work.

# Texture Printmaking

Making a relief print from a linoleum block is a good way to experiment with texture. In this exercise, you will create a two-color block print that emphasizes texture. You will begin by drawing a subject and then transfer your composition onto a linoleum block. After cutting your image on the block, you will complete a two-color print through the process of overprinting.

7-22 Student work, Sylvia Brandt. Block print, 6" x 6" (15.24 x 15.24 cm).

7-23 Student work, Erin Legg. Block print, 6" x 6" (15.24 x 15.24 cm).

## Technique Tips

- Try to make the tool glide across the plate, gouging only a shallow depth into the plate's surface. When changing the direction of the gouge, turn the plate, rather then the tool.
- Even distribution of ink on the brayer will allow even distribution on the plate. Thin and even layers of printer's ink will work best for the over-printing process.
- The paper can be lifted carefully to check to see if enough ink has been applied before the print is pulled. Additional ink can be added to the plate; just make sure that the brayer does not come in contact with the printed image.

## Computer Option

Use a digital photo of yourself taken by your teacher and open it in a paint program. Use the brightness and contrast adjustments to take away any fine details in your face. Then use a stamp filter to reduce the image to just highlights and shadows, as in a relief print. Save and print. Transfer the print, using graphite paper (or a similar method), to a printing plate. Create a variety of textures as you carve out the image. Experiment with different surfaces (collaged paper, painted surfaces) and explore colors and methods of inking the plate as you print.

## Before You Begin

Look at a variety of examples of print-making to see how texture can greatly influence the depth and richness of an image. Notice the textures that you find to be the strongest in the examples.

## You Will Need

- pencil, ballpoint pen, fine-line permanent marker
- newsprint or white printmaking paper
- linoleum block or flexible printing plate
- a variety of gouging tools
- water-based printer's ink
- brayers, wooden spoons

## Create It

❶ Choose a subject and draw it on a sheet of newsprint. Use this rough drawing to establish subject placement and overall composition.

❷ Transfer your design onto the printing plate by tracing the drawing with a pencil or copying it freehand. Go over the drawing with a pen or marker so that it doesn't smudge when you handle the block or plate.

❸ Use your gouging tools to carefully cut away the areas you want to remain white.

❹ Roll an even layer of ink onto the raised areas of your design.

❺ Place a sheet of paper carefully on the block. Apply pressure to the paper with a wooden spoon. Lift the paper off

7-24 Student work, Mike Cheng. Block print, 6" x 9" (15.24 x 22.8 cm).

of the block. Repeat the process to make five prints.

**6** Gouge more from the printing block. Choose thoughtfully and think about the texture you want to achieve. Note that the direction of the gouging can enhance the texture of the finished piece.

**7** Apply a second ink color to the block. Carefully align one of your prints to match the image on the block. Apply pressure and pull the print.

## Evaluation

- Which prints show the most texture?
- How does the direction of the gouging, use of color, and layers of overprinting impact texture in the finished print?
- How will the results of this project affect your visual awareness when drawing in the future?

### Safety Note

To avoid injury, use extreme care when working with gouging tools. Always direct the tool away from the hand that holds the plate.

### Write About It!

Consider the variety of texture in your print. Which texture appears strongest? How did you develop the texture? Describe, in a paragraph, the direction, depth, length, and width of the gouges. What makes the texture most vivid? How does the application of the ink help to reinforce the illusion of depth?

Art History

## Studio Background

Japanese printmaking of the nineteenth century is unsurpassed in quality and technique. Generally, the artist functioned as designer by creating an ink sketch of the image and then indicating the colors that should be used. The drawing was given to a publisher who oversaw the production of the print. Highly skilled carvers would transfer the image to a cherrywood block. Equally accomplished printers would apply up to twelve different colors using a separate block for each. Registration (alignment) and control of color were key to the success of the process.

7-25 **Most experts believe the true genius of Japanese prints lies in the skill of the wood carvers and printers rather than with the artists who create the design. Based on your experience, which do you think requires the greater expertise, design creation or carving and printing?** Toshusai Sharaku, *Otani Oniji II as Edohei in the play Koinyobo Somekawa Tazuna,* Edo period, 1794, Japan. Woodblock print, 15" x 9 3/4" (37.9 x 25.1 cm). The Art Institute of Chicago; Clarence Buckingham Collection.

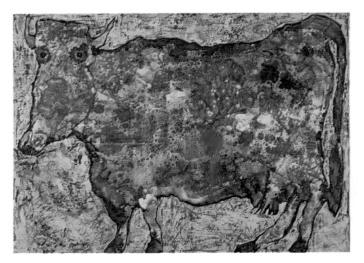

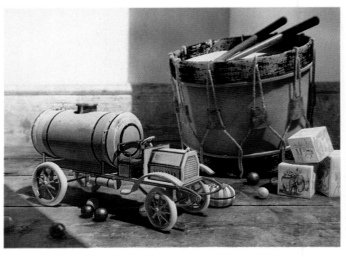

7-26 Jean Dubuffet, *The Cow with the Subtile Nose*. From the *Cows, Grass, Foliage* series, 1954. Oil and enamel on canvas, 35" x 45 3/4" (89 x 116 cm). The Museum of Modern Art, New York, NY, Benjamin Scharps and David Scharps Fund. Licensed by Scala/Art Resource, NY.

7-27 Jean-Charles Kerninon, *Old Toy I*. Computer graphic. Courtesy of the artist.

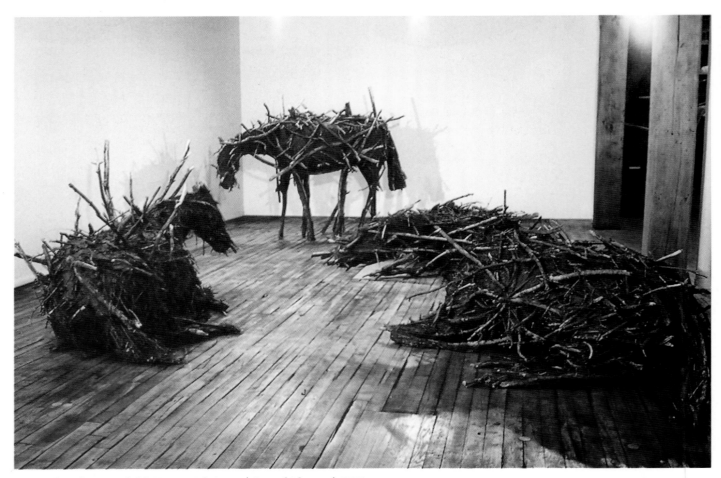

7-28 Deborah Butterfield, Horse sculptures (view of 3 horses), 1977. Mud, fiberglass, amalgam, and twigs. As seen in the Lieberman Gallery, Chicago. Photo by Zolla.

# Chapter Review

## Summary

Texture has to do with the surface quality of something—how it feels to the touch. All artworks, like all objects, have textures. Realist painters are interested in *simulating* the textures of their subjects. The same kinds of textures are seen in a photograph. The actual texture of a realistic painting or a photograph is not important.

Some painters simulate textures, but do it with such flare that we also appreciate the qualities of the oil medium and their brushwork. Some painters of semi-abstract art are more interested in manipulating the effects of paint than in simulating the textures of their subjects. And finally, some painters, like Picasso, provide a visual feast of simulated, real, and *invented* textures.

Realist sculptors working in bronze, marble, clay, wood, or plastics often provide experiences with both simulated and actual textures.

In artworks that have no subjects, such as some crafts or abstract paintings and sculptures, there are, generally, no simulated textures. The only important textures are the actual ones.

Texture is an important element in art. Artists use it to identify objects, define shapes, provide variety, enrich surfaces, and tweak both our tactile and visual senses.

## Review Questions

1. **Recall:** Define the term *simulated texture*.

2. **Understand:** Explain how a photograph can have texture.

3. **Apply:** Use a pencil to create four different textured areas on a sheet of paper.

4. **Analyze:** Compare and contrast van Gogh's use of texture in *The Poplars at Saint-Rémy* with Sittow's *Portrait of Diego de Guevara*.

5. **Synthesize:** Develop a list of five textures. For each texture, write an adjective that suggests what this texture might express in a work of art.

6. **Evaluate:** Rank the paintings in this chapter according to their use of simulated texture. The painting showing the most simulated texture would be ranked first; the one showing the least simulated texture would be last.

## For Your Portfolio

After completing each chapter of this book, insert a page into your portfolio telling about what you have learned. Get into the habit of comparing your new artworks and ideas to your earlier artworks.

## For Your Sketchbook

Find a small natural form with an interesting texture. Draw it so that the textural qualities stand out. You might create a series of drawings showing different combinations of overlapping shapes and textures. Think about a decorative design you might create based on this form from nature.

## Electronic Research

Marilyn Levine's Web site <http://users.lmi.net/ml/> offers numerous images of her startlingly realistic ceramic objects that appear to be made from leather. How do you think Levine makes the texture and form of each piece look so realistic? Which pieces do you think are most successful? Choose one and write a detailed description of it.

## Going Further

Collography is a great way to explore the expressive qualities of both real and simulated texture. A collograph is a print that has been pulled from an inked surface made up of textured materials. Gluing layered shapes of textured materials such as burlap, lace, or corrugated cardboard onto a cardboard base creates the printing surface. Roll ink over the textured surface and pull your print. Experiment with a variety of shapes, textures, and colors. The process does not require a press.

# 8 Principles of Design

8-1 **This work suggests the variety and energy of tenement life in the Latino community of New York City's Lower East Side. How does the grid formed by the buildings' windows, doorways, and fire escapes suggest a counter-theme?** Martin Wong, *La Vida*, 1988. Acrylic on canvas, 96" x 114" (243.8 x 289.5 cm). Private collection. Photo by Larry Lamay, Courtesy of the Estate of Martin Wong and PPOW, NY.

## Key Terms

*English* (*Spanish*)

**unity** (*unidad*)
**variety** (*variedad*)
**emphasis** (*énfasis*)
**rhythm** (*ritmo*)
**movement** (*movimiento*)
**balance** (*equilibrio*)
**pattern** (*patrón*)
**proportion** (*proporción*)

## Artists

Jennifer Bartlett, John Biggers, Umberto Boccioni, Alexander Calder, Paul Cézanne, Joseph Cornell, John Steuart Curry, Salvador Dalí, Richard Estes, Edward Hopper, Javanese batik artists, Lamyn Sum artisans, Gustav Klimt, Jacob Lawrence, Norman Lewis, Henri Matisse, Mughal artists, Edvard Munch, Claes Oldenburg, Pomo Indians, Bridget Riley, Faith Ringgold, Charles M. Schulz, Sandy Skoglund, Sarah Sze, Tadasky, Teotihuacán Indians, Irvin L. Trujillo, Victor Vasarely, Andy Warhol, Martin Wong, Grant Wood, Andrew Wyeth, Yoruba peoples, various unknown artists

8-2 Student work, Kim Rathyar. Mixed media, 11" x 8½" (27.9 x 21.6 cm).

You've learned to recognize the elements of art—line, shape and form, value and color, space, and texture—in artworks. Organizing the elements in an artwork creates a *composition*. The **principles of design** help artists organize compositions so that they communicate effectively. The principles are: unity, variety, emphasis, rhythm and movement, balance, pattern, and proportion (fig. 8-3).

*Unity* in an artwork occurs when all elements work together to communicate ideas or feelings. Unity is affected by *proximity* (creating groups of objects), *similarity* (making things similar to each other), and *continuation* (creating a flow of vision from one object to another). These strategies are used in both two-dimensional and three-dimensional works.

*Variety* is achieved by introducing differences in the elements of a composition. Variety is a means of avoiding monotony and increasing visual interest in an artwork.

*Emphasis* occurs when one element in an artwork, or a combination of elements, attracts more attention than anything else in a composition. This element or form is said to be *dominant* and is often a focal point in an artwork.

Artists create visual *rhythm* when they repeat specific elements (a line, a shape), alternate several elements, or by use of a progression in which an element gradually changes in size, shape, position, or color.

Rhythm creates a feeling of *movement* within an artwork. When nothing really moves, we call this *implied movement*.

8-3 **This painting makes use of at least five of the principles of design. How many can you identify? How do these principles help the artist communicate feelings and ideas?** John Biggers, *Shotguns, 4th Ward*, 1987. Oil and acrylic on board, 32" x 41¾" (81.3 x 106 cm). Hampton University Museum, Hampton, VA.

8-4 **Where can you see patterns that seem to create movement in this African crown? Where does the movement lead your eye?** Yoruba, Nigeria, Africa, *Crown (ade)*, early 20th century. Glass and jasper beads, cotton cloth, raffia cloth, cane, and iron, 29½" x 7¼" (74.9 x 18.4 cm). The Museum of Fine Arts, Houston. Gift of an anonymous donor in honor of Anthony and Andrew Cochran.

8-5 **Some artists use size relationships (proportion) to help them make a statement or create a mood. Notice how large Wyeth has made the field in this work. What effect does this have on your feelings about the girl and her world?** Andrew Wyeth, *Christina's World,* 1948. Tempera on gessoed panel, 32¼" x 47¾" (81.9 x 121.3 cm). The Museum of Modern Art, New York, NY, Purchase. Licensed by Scala/Art Resource, NY.

Directional lines, shapes, forms, figures in action, color gradations, etc., can also imply movement in artworks. A *sequence* of pictures is another way to imply movement and the passage of time. Some artists arrange lines and shapes to create optical illusions of movement in nonobjective works. This is called *optical movement.* Actual movement occurs in works called *kinetic art,* which have parts that can be set in motion.

**Balance** occurs when the visual weight in an artwork feels equally distributed. Four balance arrangements in art are: *asymmetrical, symmetrical, approximately symmetrical,* and *radial.*

Repeating lines, shapes, or other elements in a recognizable way over the surface of an area creates **pattern**. The repeated elements are called *motifs.* Patterns add movement and variety to artworks (**fig. 8-4**).

**Proportion** in art concerns the size relationships between parts of an artwork (**fig. 8-5**). This should not be confused with *scale,* which refers to the size of an object in relation to the size of other objects around it, or its environment.

The principles of design are interdependent. They are not rules. They describe effects that may occur within a composition. They can help you compose, analyze, and interpret works of art.

The process of composition is basic to creating and analyzing artworks. *Composition* refers to the way the art elements (line, shape and form, color and value, space, and texture) are arranged in an artwork. The artist organizes the visual elements so they work together in the final form.

If the artist has composed well, we respond to the whole composition, rather than to individual elements. There are no formulas for achieving good composition in an artwork. There are, however, some **principles of design** that can help you compose your artwork and analyze your works and those of professional artists. They are:

*unity, variety, emphasis, rhythm, movement, balance, pattern,* and *proportion.* Think of these principles not as rules to follow but as effects that may result when the art elements are structured to achieve good organization.

The principles of design are easy to recognize. For example, are you or a classmate wearing something with a pattern? Can you tap out a rhythm? How is movement suggested in a cartoon? Are you concerned about your proportions of height and weight? What is the dominant color of your classroom? Do you and your friends wear a variety of hairstyles? How do you arrange a room so that it feels balanced? What does it

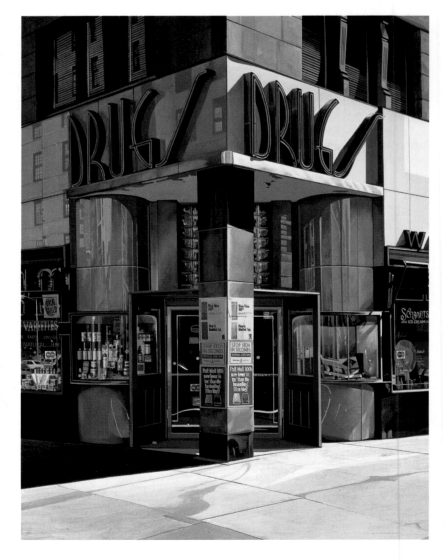

8-6 **Estes is a Photo Realist painter who utilizes photographs and slides to help with the meticulous detail and reflections he includes in his work. What balance arrangement is evident in this painting—symmetrical, approximately symmetrical, asymmetrical, or radial?** Richard Estes, *Drugstore*, 1970. Oil on canvas, 60" x 44" (152.4 x 112.7 cm). The Art Institute of Chicago, Restricted gift of Edgar Kaufmann.

mean when the coach says a team must have unity?

Alexander Calder's mobile (fig. 8-7) is suspended from a ceiling and moves with air currents. Try identifying the compositional arrangements in the mobile:

- What elements are similar and contribute to *unity* in the mobile? What ties the different shapes together?
- What is *varied?*
- Which shape or group of shapes *dominates* the work?
- Where did the artist suggest *rhythm* through repetition of an element?
- What shape contributes to the physical and visual *balance* of the mobile?

**Compositional Arrangements in the Mobile**  You probably noticed that the row of triangular shapes are similar. The supporting spines tie them together. The shapes and their sizes are varied, and one shape has a hole in it. The red and black shape at the top dominates. Rhythm occurs in the repetition of the linear spines and the lower row of shapes. The rounded wire shape with vertical lines at the right contributes to both physical and visual balance.

**Compositional Arrangements in the Painting**  Now that you have had some practice, let's examine some compositional arrangements in Richard Estes' painting *Drugstore* (fig. 8-6). What is the *dominant* form—the form you first focus on? Where do you see *pattern?* Where do you see lines that suggest *movement?* What kinds of *variety* are evident?

For most viewers the post and the rectangular block it supports are *dominant*, because all of the lines recede from these forms and the corner above them in linear perspective. This per-

8-7 **Air currents continually move the parts of a mobile, presenting viewers with constantly changing, asymmetrically balanced arrangements of lines and shapes. Which balance arrangement do you feel is the most exciting—symmetrical or asymmetrical? Which arrangement suggests the most movement?** Alexander Calder, *Lobster Trap and Fish Tail*, 1939. Hanging mobile, painted steel wire and sheet aluminum, 8' 6" x 9' 6" (260 x 290 cm). Commissioned by the Advisory Committee for the stairwell of the Museum. The Museum of Modern Art, New York, NY. Digital Image © The Museum of Modern Art/Licensed by Scala. © ARS, NY.

spective arrangement makes the corner, including the post and sign block, seem to advance. The sidewalk is divided into a *pattern* of rectangular shapes, as are the stone blocks in the wall. Let your eye follow the diagonal lines and vertical lines of the building to experience visual *movement.* You can see *variety* in colors, direction of lines, and forms (rectangles, rounded entrance forms, letters, and window displays).

In the following pages we will deal at greater length with each of the design principles and how they can help in analyzing composition. As we discuss these principles, keep in mind that the *aesthetic*, or communicative success, of an artwork results from the combined effects of design, art materials, and the artist's objective and technique.

*Unity* is as important in composing art as it is in daily living. We value unity of effort, of ideas, a common cause, coordinated dress, a house united. A basketball team consists of five players. If the team is to be successful, the coach must make individual members play as a unit. Likewise, the success of an artwork depends on the artist's ability to arrange the art elements so they work together as a unit. A basketball team without unity results in chaotic play on the floor. An artwork without unity will appear to be a collection of individual components. If an artwork has unity, you are aware of the whole form before looking at individual parts.

Several strategies that artists use to achieve unity in composition are based on our natural tendency to *structure* the visual information we receive from our environment. These strategies can easily be demonstrated by examining Edward Hopper's *Nighthawks* (**fig. 8-8**). The first is *proximity*, the tendency to see things that are overlapped, touching, or close together as groups. In Hopper's painting you see a group of three people due to their proximity, and one lone figure due to his distance from the group.

We also tend to organize things based on their *similarity* in color, value, texture, shape, or form. Some of the shapes and forms in Hopper's painting are unified by *both* proximity and similarity. Because of their closeness and similarity, you see a pair of coffee urns, a row of stool tops, and a row of second-story windows. There are simi-

8-8 **Unified artworks seem to be well arranged into a successful whole. When you first glance at this picture, which are you more aware of, the parts, or the entire form?** Edward Hopper, *Nighthawks*, 1942. Oil on canvas, 33" x 60" (84.1 x 152.4 cm). The Art Institute of Chicago, Friends of American Art Collection.

lar colors in the counter, the background building, and the outside walls of the diner. Look for similarity in horizontal and rectangular shapes throughout the painting. Do you see other similarities?

A third natural way of seeing is *continuation.* When you examine any visual form, including artworks, your eyes move. Your flow of vision is directed by lines, edges of shapes, and arrangement of elements that lead your eyes from one place to another. In Hopper's painting the diner counter and the upper and lower walls of the building create triangular forms that direct vision from the right side of the painting to the shadowed left end of the background building. The horizontal lines in that building, the curb, and the shadow in the street direct vision to the right. The line caused by the strong contrast of light inside the diner and the outside darkness continues the visual flow to the vertical support on the right, which takes you back down to the countertop. The curb line directs attention back to the countertop and lower wall of the diner. As you can see, continuation is often reinforced by the similarity and proximity of elements in artworks.

These structuring strategies apply to three-dimensional forms as well. Notice the similarity of round shapes in the mask from a Buddhist monastery in Mongolia **(fig. 8-9).** The alternation of colors and textures in the three-eyed figure's skin, features, and hair also helps to direct your flow of vision over the mask.

Using the strategies of proximity, similarity, and continuation will help you create unity in your own artwork, as well as analyze works by professionals.

8-9 **This mask was probably once worn in a ceremonial dance, held at the beginning of the year, to exorcise evil. How does the third eye at the top help unify this sculptural form?** Tchoijin Lamyn Sum "Tsam" dance mask representing "Dagiraza," 19th century. Papier-mâché. © Setboun Michel/Corbis SYGMA. Photo: Michel Setboun.

*Variety* and unity are complementary. Variety is a safeguard against too much of the same thing. A composition can be so unified that it is uninteresting. For example, think of the pattern in a tile floor. All of the tiles are the same color and size, in close proximity, and constantly repeated. There is maximum unity, but not much excitement. To avoid monotony where it is not wanted, the artist includes some *variations* in elements of the artwork. Variety can be achieved by using different materials in the work, or different forms of the same thing. Colors, values, textures, shapes, forms, and lines can be varied.

Refer again to Hopper's painting **(fig. 8-8, page 172)**. It includes a variety of strong and subtle value contrasts. He varied the size of rectangular shapes, which occur in both vertical and diagonal positions. The rounded shapes in the diner vary from the geometric shapes in the background. Note the letter shapes above the diner. You can find additional varied elements in this work.

An artist may avoid *variety* and use unrelieved repetition on purpose. Andy Warhol did just that in *Green Coca-Cola Bottles* **(fig. 8-10)**. Only the figure-ground arrangement offers a hint of variation. By using overpowering unrelieved repetition in works such as this, perhaps Warhol was criticizing our assembly-line culture and the visually overwhelming stacks of products in our supermarkets. Do you find such displays lacking in variety, and boring?

On the other hand, the artist may include a great deal of variety, as in the crown from the Yoruba peoples of Nigeria **(fig. 8-11)**. Made of glass and gem beads, cotton and raffia cloth, cane, and iron, the crown is worn by the *oba*, or king, on important state occasions. In Faith Ringgold's *Tar Beach 2* **(fig. 8-12)**, different patterns appear on each of the four border strips. A wide variety of shapes and objects and human figures engaged in varied activities are included inside the framing border. Some objects appear flat, and others imply depth. Contrasting and related colors lend fur-

8-10 **What alternating arrangement provides a little variety in this composition?** Andy Warhol, *Green Coca-Cola Bottles*, 1962. Oil on canvas 82½" x 57" (209.55 x 144.78 cm) Whitney Museum of American Art, New York; Purchase, with funds from the Friends of the Whitney Museum of American Art. Photograph by Jerry L. Thompson.

8-11 **This crown reflects an exciting variety of colors, shapes, and materials, but the parts hang together to create a pleasing whole. How do proximity, similarity, and continuation lend unity to the crown?** Yoruba, Nigeria, Africa, *Crown (ade)*, early 20th century. Glass and jasper beads, cotton cloth, raffia cloth, cane, and iron. 29 1/2" x 7 1/4" (74.9 x 18.4 cm). The Museum of Fine Arts, Houston. Gift of an anonymous donor in honor of Anthony and Andrew Cochran.

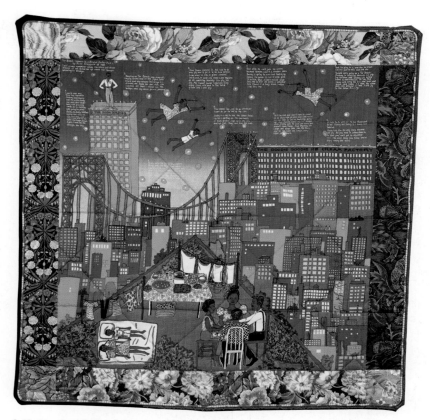

8-12 *Tar Beach* **combines autobiography, fictional narrative, and screen printing. What makes the composition appear dreamlike? What do the flying figures suggest?** Faith Ringgold, *Tar Beach 2*, 1990. Quilt. Silk, 66" x 64 1/2" (167.6 x 168.8 cm). Philadelphia Museum of Art: Purchased with funds contributed by W. B. Dixon Stroud, 1992. Photo by Graydon Wood, 2002.

8-13 **Beneath the tray shown in this box are many different objects. Could the artist be commenting on our tendency to collect and keep odds and ends?** Joseph Cornell, *Object*, 1942–53. Wooden box with 21 compasses set into a tray resting on Plexiglas-topped and partitioned section, divided into 17 compartments containing small misc. objects, and three-part hinged lid covered inside with parts of maps of New Guinea and Australia, 2 5/8" x 21 1/4" x 10 3/8" (7 x 54 x 26 cm). The Museum of Modern Art, New York, NY, Mr. & Mrs. Gerald Murphy Fund. Licensed by Scala/Art Resource, NY.

ther variety. All of this variety is held together by the framing patterned strips, the triangular movements into the center of the composition, and the asymmetrical balance of buildings on the right with buildings and a bridge on the left.

If you were to remove the tray in Joseph Cornell's *Object* (fig. 8-13), it would reveal a somewhat confusing variety of objects. The inner compartments include such things as maps, rocks, a spring, seeds, and pictures. Cornell has pushed variety to the limit in this three-dimensional work.

When one element in an artwork appears to be more important or attracts the most attention, we say it creates ***emphasis***. The element or form of emphasis is usually a focal point in a composition—a place we tend to look at first. There are many ways an artist can create emphasis in an artwork.

A shape or form may be made dominant by *placement*, so that everything radiates from it in circular or linear fashion, or recedes from it, as in linear perspective.

*Contrast* is frequently used to make an element of a composition dominant. Kinds of contrast include contrasting materials; contrasts of line, shape, size, color, value, or texture; contrast of direction, such as a vertical among many horizontals. Contrast can be based on difference, as in a geometric shape among organic ones, or a rounded form among angular ones.

Emphasis can be established by the addition of *detail* in one area or form, *grouping* of elements, a recognizable form among abstract ones, and so on.

Before reading any further, look again at Hopper's *Nighthawks* (fig. 8-16). What is the dominant area in the painting? Which of the strategies listed above did Hopper use?

The dominant or focal area in Hopper's painting is the group of three figures. Placement, contrast, and grouping are all factors. Left and right diagonal edges of the countertop lead to them. The brightest light in the composition is in that corner of the room. The right angle caused by the strong contrast of light on the inside wall of the diner against the darkened window leads down to the group of figures. The vertical window support on the right frames the three figures. The isolated man looks toward the group—we follow his line of sight. The woman's red dress is the warmest color in the composition.

Norman Lewis's painting *The Yellow Hat* (fig. 8-14) includes a dominant form due to contrast. Can you identify it before reading further? Did you determine that the hat stands out because it is the only circular form among many straight lines?

8-14 **Notice how color contrasts create the ledge on which the girl sits, and a corner behind her. What other contrasts can you see?** Norman W. Lewis, *The Yellow Hat*, 1936. Oil on burlap, 36 1/2" x 26" (92.7 x 66.1 cm). The Estate of Reginald Lewis. Photo by Frank Stewart. Courtesy of Landor Fine Arts, Newark, NJ.

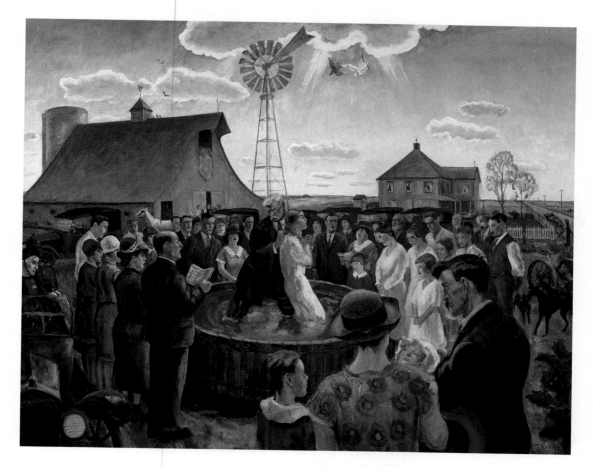

8-15 John Steuart Curry was a Regionalist artist from Kansas who concentrated on rural American themes that were generally popular with the people of the Midwest. Why might this painting have been popular with Kansans in the 1930s? John Steuart Curry, *Baptism in Kansas*, 1928. Oil on canvas, 40" x 50" (101.6 x 127 cm). Photograph © 1996, Whitney Museum of American Art, New York. Gift of Gertrude Vanderbilt Whitney. Photo by Geoffrey Clements.

An element, or form, does not have to be in the center of an artwork to create emphasis. The preacher and the young woman are dominant in John Steuart Curry's painting *Baptism in Kansas* (fig. 8-15), even though the largest figures are located in the lower right corner. The two figures are centrally located at the hub of three increasingly larger circles. The first is formed by the water tank. The second is formed by the ring of onlookers. A third circle is partially formed by the surrounding cars. In addition, most of the people are looking at the central pair of figures. Their lines of sight direct our attention to the pair. Have you ever looked where other people are looking or pointing?

8-16 Edward Hopper, *Nighthawks*, 1942. Oil on canvas, 33" x 60" (84.1 x 152.4 cm). The Art Institute of Chicago, Friends of American Art Collection.

**Linking Disciplines**
Literature
Read aloud a piece of poetry that you particularly like. Listen for the **rhythm of the words**. Create a sketch that conveys that same sense of rhythm. Try to visually communicate the poem's tempo.

You are familiar with rhythm that results from the regular repetition of something, such as the beat in music, the strokes of a swimmer, or the rise and fall of waves. In an artwork, rhythm may result from the regular repetition of an element such as line or shape, or the repeated alternation of an element such as light and dark. Where there is rhythm, there is also a feeling of movement.

There are three methods for creating rhythm: (1) by *repeating* the *same* element such as a shape or a figure, with little or no variation; (2) by repeating two or more elements on an *alternating basis*, such as circle/square, circle/square; or (3) by *progression*, in which an element gradually changes shape, size, position, or color.

Most artworks include more than one kind of rhythm. John Biggers's painting *Shotguns* (fig. 8-17) includes all three rhythm arrangements. The house forms, figures, and railroad ties are repeated with little variation. The rail ties and spaces between them are *alternated* across the foreground. The triangular white gable shapes alternate in position in each of the six rows of houses. The gables become progressively smaller in each of the six rows. These three rhythm arrangements suggest horizontal movement left and right, on diagonals to the left and right, and upward to the top of the composition.

*The Scream*, by Edvard Munch (fig. 8-18), involves a rhythm of undulating shapes and twisting lines that direct attention from the upper left to the lower right where the screaming figure is located. The shapes in the bridge become progressively smaller, directing attention back to the upper left of the composition.

8-17 **This artist used alternating shapes and color values to create rhythm and movement. Where does the movement seem to lead?** John Biggers, *Shotguns, 4th Ward*, 1987. Oil and acrylic on board, 32" x 41¾" (81.3 x 106 cm). Hampton University Museum, Hampton, VA.

8-18 **Edvard Munch's works are concerned with anxiety, loneliness, tragedy, and death. How does rhythmic movement communicate the mood of this painting?** Edvard Munch, *The Scream*, 1893. Oil on canvas, 32¾" x 26" (83.5 x 66 cm). © Munch Museum/ Munch-Ellingsen Group/ARS 2003. Photo © Munch Museum (Andersen/de Jong).

8-19 Edward Hopper, *Nighthawks*, 1942. Oil on canvas, 33" x 60" (84.1 x 152.4 cm). The Art Institute of Chicago, Friends of American Art Collection.

We can identify rhythm and movement in Hopper's *Nighthawks* (fig. 8-19). Diagonal lines in the diner's walls, window, and counter create three triangular shapes that imply movement from the right to the left side of the composition. The stool tops provide a rhythmic alternation of shape and space, as do the second-story windows in the background building. There is a progression of values from the bright light inside the diner, to the foreground light, to low light in the middle ground, to dark in the background.

Rhythm arrangements direct viewer attention through a composition. They help establish dominant areas and contribute to the mood of an artwork. Over the centuries artists have developed strategies to imply motion and the passing of time in static artworks. These strategies can be categorized as *implied movement, sequence, optical movement,* and *actual movement.*

## Implied Movement

An image, whether a picture or a sculpture, captures a moment in time. By stopping time, it implies a relationship to time and movement. The subject may be as motionless as the drapery and objects in Cézanne's *Still Life* (fig. 8-20). And yet, your eyes move, following the curving lines in the drapery, and the contrasting straight lines in the background. This implied movement creates a focal point.

The devices used to *imply* movement in static artworks rely on your experience and knowledge about movement. You learn about movement by participating in and watching physical activities, and through observation of your environment.

The search for ways to communicate movement in static artworks predates recorded history. People of the Ice Age portrayed animals with extended legs to suggest running. The ancient Greeks placed figures in twisting and unstable positions, stopping the action to show a split second of a movement such as leaping or the throwing of a spear. Other strategies for implying movement include pointing, direction of the eyes, and, in two-dimensional work, multiple images of moving parts.

Before reading further, examine the abstract sculpture of a walking figure by Umberto Boccioni (**fig. 8-21**). Based on what you know, list three visual cues you see in the work that imply movement. How many of the following cues

8-21 **To fully enjoy implied movement in a sculpture, you need to walk around it. Imagine how your view of this sculpture would change as you moved.** Umberto Boccioni, *Unique Forms of Continuity in Space,* 1913. Bronze (cast 1931), 34⅞" x 15¾" x 4⅞" (86.4 x 38.1 x 10.2 cm). The Museum of Modern Art, New York, NY, Acquired through the Lillie P. Bliss Bequest. Licensed by Scala/Art Resource, NY.

did you list? The diagonal line of the extended rear leg and tilted torso imply a forward movement. The bend of the right leg suggests a forward stride. The bulging muscles of the forward leg imply straining movement. The fin-like forms and the creases and ridges throughout the torso and legs suggest the invisible force of wind pressing against a rapidly moving figure.

## Sequence

Sequence is one of the oldest methods of implying movement and the passage of time. The narrative sequence—a series of images arranged in logical, storytelling order—was used by ancient cultures including the Egyptians and Sumerians over 4,000 years ago. Sequential images might tell the story of a battle or describe the planting of crops.

In the photograph of the gymnast (fig. 8-22), both *sequence* and *multiple images* are used to imply motion. We see one figure in an overlapping sequence of poses, with slight changes in each successive position. Multiple images allow us to see all the gymnast's movements through a brief moment in time.

The contemporary comic strip's main purpose is to tell a story (fig. 8-23). The use of sequential pictures, each presenting a segment of the action, implies

movement and the passage of time. Some strategies used to suggest movement include: the position and stance of figures; characters and props positioned to direct the viewer's eye from frame to frame; multiple contour lines, breeze lines, and little dust clouds; shifts in viewing angles from frame to frame; close-ups and long views; and for extreme speed or action, characters or objects lifted off the ground.

Movies also rely on a sequence of pictures (shots) to tell a story and to imply movement. **Figure 8-24** is a scene from a series of shots for a battle sequence in the movie *Star Wars*. Single images like this—called still pictures—are run through a projector at the rate of twenty-four images per second, creating a convincing illusion of actual movement on the big screen.

8-22 **This photograph was made using a technique called multiple exposure. What makes multiple exposure photography a useful device for telling a story?** AFP Photo/Kazuhiro Nogi. © AFP/Corbis.

8-24 **What tells you that this photograph caught and froze a moment of action?** Still of Ewan McGregor in scene from *Star Wars: Episode II–Attack of the Clones.* © 2002 Lucasfilm Ltd. All rights reserved.

## Optical Movement

We responded to movement in the artworks we have looked at so far because the artists created visual patterns that directed our eyes around the compositions. Optical Art, a twentieth-century art style, concentrates on the *illusion of movement*. There are no objects or figures that suggest movement in these totally *nonobjective* works—works that have no recognizable subject matter. Instead, repetitive patterns of hard-edged lines and shapes provoke *optical illusions* when you stare at them for a few seconds. Responses to these images involve the retina of the eye rather than your stored knowledge and experience. Do these patterns "move"? Before reading further, stare at Bridget Riley's *Current* (fig. 8-25) for a few seconds to find out.

Did you perceive a swimming sensation? Did the lines undulate, ripple, billow in and out? You see movement when there really isn't any because this optical illusion involves the retina of

8-26 **Vasarely is considered the leader of the Op Art movement in America. Op Art began in the early 1960s. Why do we call movement in compositions like this optical, rather than implied or real?** Victor Vasarely, *Banya*, 1964.
© ARS, NY. © Tate Gallery, London/Art Resource, NY.

your eye, which is packed with receptor cells that are alternately on and off. As some of these cells fatigue, others take over to sustain the image. Consequently, you perceive movement when there is none. The parallel, curving, and bending lines in Riley's painting provide no places for the eyes to stop and focus. The illusion never stops until you stop looking.

Victor Vasarely added the elements of shape and color to his Optical works. Stare at *Banya* (fig. 8-26) for a few seconds to experience the surprise of optical illusion in this work. Do the red diamond shapes seem to move? What shapes seem to come forward? Where can you detect some three-dimensionality?

8-25 **Some Op Art, like *Current*, which is almost five feet square, can quickly cause optical strain and discomfort. Where do you see some blurring, some left-right movement, and some up-down waves?** Bridget Riley, *Current*, 1964. Synthetic polymer paint on composition board, 58 3/8" x 58 7/8" (148 x 145.5 cm). The Museum of Modern Art, New York, NY, Philip Johnson Fund. Licensed by Scala/Art Resource, NY.

Creating successful Optical Art requires craftsmanship and an understanding of the principles of optical effects. There are no accidental effects or organic forms, only geometric clarity in these works. We are looking at small reproductions, but the original works are large enough to engulf the viewer in the painted environment.

The surprise and pleasure people derive from optical illusion is well known in the advertising world. Watch for it on CD covers, book jackets, magazine covers, advertisements, posters, trademarks, and even some fabrics.

## Actual Movement

Although the lines and shapes created by Op artists seem to move, their works are static, and movement is not real. Actual movement occurs in works called *kinetic art*. Many kinetic works, past and present, are connected by belts and chains to electric motors that produce real movement in the work. Others use fans. Alexander Calder was the first artist to set his works in natural motion—that is, without motors. His mobiles are made of rods, wires, and sheet metal shapes so delicately balanced that they move with the currents of air in a room (fig. 8-7, page 171). Sarah Sze creates site-specific installations from domestic and industrial materials such as clothespins, plastic flowers, brooms, bottle caps, nuts and bolts, lamps, and crates. Sze animates some of her works with lights and fans. *The Letting Go* (fig. 8-27) has many moving parts. One movement creates another as the suspended components respond to air currents in the museum environment.

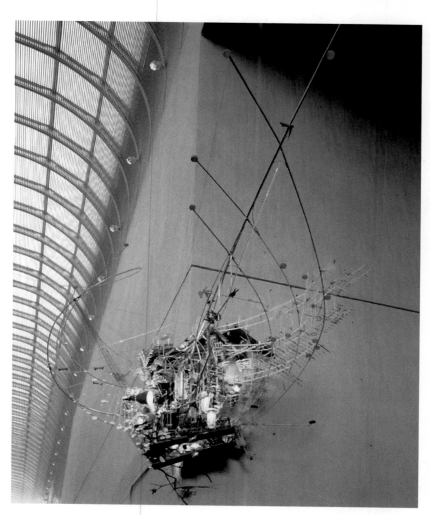

8-27 **The moving forms in Sarah Sze's installations, which include all kinds of items discarded by our industrial civilization, reflect concern for the urban environment. What metaphor for the urban environment does this sculpture suggest?** Sarah Sze, *The Letting Go*, 2003. Mixed media, dimensions variable. Installation at the Boston Museum of Fine Arts. Photo courtesy Mary Boesky Gallery and the artist.

Look at the two examples of Jacob Lawrence's painting (figs. 8-28 and 8-29) and decide which one you are most satisfied with. Most people choose the version shown in figure 8-28 as most satisfactory. Can you explain what is affected by removing the seated, dark-cloaked figures from the lower, right front of the picture? Why?

The *balance* of the composition is affected by removing the figures. The unchanged reproduction of *The Library* is asymmetrically balanced. The artist achieved a feeling of equally distributed visual weights with figures and objects

8-28

8-29 **This version of Jacob Lawrence's painting has been photographically altered. Which version do you think is better balanced?** Jacob Lawrence, *The Library*, 1960. Tempera on fiberboard, 24" x 29⅞" (60.9 x 75.8 cm). Smithsonian American Art Museum, Washington, DC/Art Resource, NY.

that are different. Removal of the two figures in the lower right makes the left side of the composition seem heavier.

Balance is a mental, physical, and emotional force in our lives. You know the necessity of physical balance in skating, gymnastics, or riding a bike. Balance in art is more subtle because it is optical—when we look at artworks, our senses suggest whether or not they are balanced. Balance in art refers to a feeling of equal distribution of *visual weight* in an artwork. This perceived stability in a composition is affected by the placement and treatment of the art elements, figures, and objects included in an artwork. There are four balance arrangements in art: *asymmetrical, symmetrical, approximately symmetrical,* and *radial.*

Sometimes an artist, architect, or graphic designer will purposely arrange elements of an artwork, an advertisement, or a building to create a feeling of imbalance and tension to attract and hold your attention. Return again to *Nighthawks* (fig. 8-8, page 172) to see how Edward Hopper used *asymmetrical balance.* Lay a string vertically in the middle of the picture, touching the left shoulder of the lone male figure, to divide the composition in half. Most of the diner's interior and exterior walls, the group of three figures, the coffee urns, counter, and so on are well to the right of center. The strongest value contrast—glaring interior light against the dark exterior—is also at the far right. Hopper balanced this visual weight on the right with the repeated

triangular forms of the outer and inner diner walls and the counter. These triangular forms extend well into the left half of the painting. The lone figure also helps balance the weight on the right. The subtle contrasts of light and shadow on the sidewalk and street left of the central axis help to balance the brightly lit interior wall to the far right.

*Symmetrical balance* is easier to arrange and to recognize. In symmetrical balance, elements are equally distributed on either side of a central

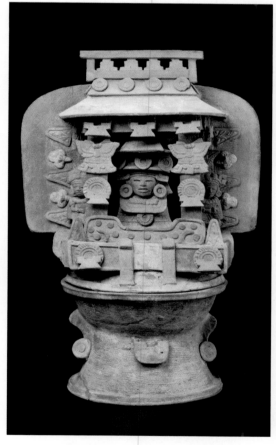

8-30 **Pre-Columbian ceramic forms like this incense burner were hand-formed and technically excellent, with thin walls, and decorated with colored clay slips. This ceramic form is two feet high. How would you go about making and assembling all of the parts in a ceramic form this large?** *Effigy Incense Burner*, Maya, Early Classic Period, c. 400–550, Guatemala, Southern Highlands. Earthenware with traces of red and yellow post-fire paint, 17 1/8" x 17 1/16" x 11" (43.5 x 43.4 x 28 cm). Museum of Fine Arts, Boston, Gift of Landon T. Clay. Photograph © 2003 Museum of Fine Arts, Boston.

vertical axis. One side is a mirror image of the other, as demonstrated by the Teotihuacán incense burner (fig. 8-30). The figure of a deity is located at the axis of the form, which is meant to be viewed from the front.

Sometimes the two sides of a composition are similar enough to imply a vertical central axis, and varied just enough to challenge you to identify the differences. This kind of balance is called *approximate symmetry*, and can be seen in the painting called *Mae West* by Salvador Dalí (fig. 8-31). At first glance this appears to be a symmetrical painting, but look closely and you will discover a number of differences between the two sides.

## Write About It!

Look around the room. Look at the architecture, school supplies, furniture, even people. Are most objects symmetrical, asymmetrical, or radial? Which objects most appeal to you? Think about what element of balance catches your attention and holds it. Write a brief description of that object. Explain what elements appeal to you most.

*Radial balance* results from the repetitive placement of two or more identical or very similar elements branching or radiating out from a central point. Frequently, but not always, radial designs are circular. The Pomo Indians (see **Artist Biography**, below) wove into their baskets geometric designs that radiate outward from a central point. The radial arrangement creates a spiraling movement over inner and outer surfaces of the basket.

Tadasky's painting *A-101* (fig. 8-33) is a radially balanced Optical painting designed to create the illusion of movement. Stare at the center of the concentric circles until the black lines begin to whirl. You can see that Tadasky intensifies the sense of movement with an optical illusion. Does the white inner circle seem to advance or recede as you stare at the work?

The Mughal rosette shown in **figure 8-34** is a radial design from a book illustration. The flower form includes numerous concentric circles that become increasingly larger as they radiate out from a common center. During the Mughal period in India, between the twelfth and sixteenth centuries, mosaics were also used to decorate palace walls and floors with geometric motifs like this one. The radial design of the rosette implies a great deal of movement.

8-32 **What design principles has the artist used in the composition of this basket?** Pomo peoples, *Basket*. Feathers, abalone shells, and willow, 4½" x 16" x 12¾" (11.4 x 40.6 x 32.4 cm). Collection of The Newark Museum, Newark, New Jersey/ Art Resource, NY.

## Artist Biography
## Pomo Indians

Like many Native American peoples, the Pomo Indians have quite a turbulent history. However, one thing that has remained constant for them throughout the ages is their basketry, which is some of the finest in the world.

In their heyday, the Pomo inhabited much of the area north of San Francisco, in California. During the nineteenth century, their way of life was turned upside down by invading Russian fur traders and later by American settlers, both of whom used them as slaves. Conditions were insufferable, and Pomo numbers declined until the 1880s, when, with the help of income earned from their basketry, they were able to buy some land back. The delicate, unique baskets of the Pomo were seen by the whites in the area as commodities that could be sold at high prices. Traditionally, only Pomo women wove the baskets, but in this economic circumstance men began to learn the craft as well. Today, the majority of the remaining 4,900 Pomo live on reservations scattered about northern California. Still, they do not forget how important baskets are to their history. Says Pomo weaver Susan Billy, "Everything in our lifestyle was connected to those baskets. Our lives were bound the way the baskets were bound together."

8-33 **Depending on which way the spirals appear to rotate, this image will appear to expand or contract. This is an example of radial balance. What are your feelings after staring at this image for a minute?** Tadasky, *A-101*, 1964. Synthetic polymer paint on canvas, 52" x 52" (132.1 x 132.1 cm). The Museum of Modern Art, New York, NY, Larry Aldrich Foundation Fund. Licensed by Scala/Art Resource, NY.

For an example of radial balance in a representational painting, refer back to John Curry's *Baptism in Kansas* (fig. 8-15) in the discussion of emphasis on page 177.

There are more ways of achieving each of the four balance arrangements than we have shown you in these few examples. Every composition calls for a solution relevant to the artist's purpose. You saw how Hopper and Lawrence used two different arrangements to achieve asymmetrical balance in their paintings. On the other hand, you studied only one example of an approximately symmetrical composition, Dalí's *Mae West.* As you continue to analyze artworks, look for the different ways in which artists arrange elements and subject matter to achieve the different balance arrangements.

8-34 **Notice how this illuminated page employs both geometric and organic forms. How has the page's balance arrangement been varied in the area outside the rosette?** Attributed to India, *Rosette (Shamsa) bearing the name and titles of the Emperor Shah Jahan (r. 1628–58),* Illuminated page or Shamsa (recto)/calligraphy (verso), 17th century, Mughal. Ink, colors, and gold on paper, 15 3/16" x 10 3/16" (38.6 x 26.5 cm). The Metropolitan Museum of Art, Purchase, Rogers Fund and The Kevorkian Foundation Gift, 1955. Photograph © 1980 The Metropolitan Museum of Art.

Have you ever admired the pattern of an unopened pinecone, the scales of a fish, bird tracks in sand or snow, or a leopard's spots? Patterns, whether in nature or in art, result from the repetition of an element or combination of elements in a recognizable organization over the surface of an area or form. The repeated element is called a *motif*. A motif may be made up of one or several parts. Your everyday environment is made more interesting with patterns in clothing, wallpaper, border designs, dishware, rugs, drapes, packaging, and so on. Look around your classroom for patterns in clothing and accessories as well as the room walls, floor, and ceiling. Identify the motif. Do some motifs include several elements?

When pattern is used in an artwork, the repeated element or motif establishes a visual rhythm that encourages our perception of the whole pattern rather than the individual motif. Pattern can add movement and variety to an artwork. It may be used to establish a dominant area or form and to enrich the surfaces of both two- and three-dimensional artworks.

Our lives would be dull without some variety, and that certainly is what pattern brings to Matisse's painting *Woman in a Purple Coat* (fig. 8-35). The painting is full of implied movements in vertical, diagonal, and horizontal directions resulting from the patterns. The movement implied by these patterns also unifies the composition. You probably focus on the upper part of the figure first, then follow patterned shapes and surfaces left, then down through the table, diagonally right with a pattern, and back to the figure. Look for similar elements in the various patterns that help with unity. Critics might say that patterns create a lot of rhythmical movement in this painting. Locate three patterns that could support this observation.

It is hard to draw a line between *texture* and *pattern*. Burlap, for example, has a tactile texture—you can feel it. The weave is so coarse that you can also see the repeated pattern. But patterns do not necessarily arouse tactile sensations. They are usually two-dimensional and decorative.

8-35 **Parisians were shocked by Matisse's paintings and those of his fellow exhibitors when they were shown in 1904. Viewers thought the paintings were irrational, and called the artists "Wild Beasts." How many different patterns can you find in this painting?** Henri Matisse, *Femme au manteau violet (Woman in a Purple Coat)*, 1937. Oil on canvas, 37⁷/8" x 25¹¹/₁₆" (80.9 x 65.2 cm). Museum of Fine Arts, Houston. © 1999 Succession H. Matisse, Paris/Artists Rights Society (ARS), New York.

8-36 **Klimt was part of a group of painters known as the Symbolists who rose to prominence prior to World War I. Their works are inclined to be exotic, esoteric, dreamlike, and mysterious. What moods do the patterns in this painting suggest to you?** Gustav Klimt, *The Kiss*, 1907–8. Oil on canvas, 70 7/8" x 70 7/8" (180 x 180 cm). Oesterreichische Galerie, Vienna, Austria. Photo by Erich Lessing/Art Resource.

Gustav Klimt's painting *The Kiss* (fig. 8-36) provides examples of both texture and decorative patterns. There are several patterns in the garments—can you identify the motifs? The figures are placed on a mosaic-like pattern of flowers. Notice how patterns differ on the man's and woman's side. Why do you think the artist did that? Where is texture implied?

*Stone City, Iowa*, by Grant Wood (fig. 8-37), demonstrates how patterns may contribute to unity of parts, variety, and visual interest, and lead the eye from one area to another. This finely detailed painting includes repeated patterns of plants, trees, and hills, alternating patterns of dark and light, and patterns that become progressively smaller. In addition to directing our eyes through the composition, patterns provide a decorative richness to this landscape.

**Linking Discipline**
**Mathematics**
Do you see the pattern in 1, 1, 2, 3, 5, 8 . . .? What will be the next number in the sequence? The **Fibonacci sequence** is named for the Italian mathematician who developed it in 1202. It is a sequence of numbers in which each term after the first two terms is the sum of the two preceding terms. This sequence appears in growth patterns in natural objects such as shells and sunflowers, and has fascinated mathematicians and artists for centuries. Find out more about this mathematical pattern.

8-37 **Grant Wood's farmscapes have a dreamlike quality. What idea or feeling do you think Wood wished to communicate by arranging nature this way?** Grant Wood, *Stone City, Iowa*, 1930. Oil on wood panel, 30 1/4" x 40" (76.8 x 101.6 cm). Art Institute of Omaha Collection, Joslyn Art Museum, Omaha, Nebraska. © Grant Wood/Licensed by VAGA, New York, NY.

**Write About It!**

Research the Golden Section, also known as the Golden Ratio, or Divine Proportion. Extend your search to determine how Leonardo da Vinci adapted it to illustrate the ideal human proportions.

It is almost impossible not to see proportion in our contemporary society. We are constantly reminded through advertising and entertainment media about the ideal proportions for men and women. Judgments about the ratio of shoulders to waists, length of legs, whether a person is short, stout, or thin—all of these are judgments about proportion, or the size relationship of parts to one another and to a whole.

Proportion is crucial in architecture. The roof of a house must not look too heavy, nor should the doors look too large. Decorative components on public buildings must relate proportionately to the size of the structure. The ancient Greeks developed the Golden Section, or Ratio, as an ideal basis for architec-ture. They designed temples with this harmonic principle as a guide. Expressed in numbers, the Golden Ratio is .618034 to one. The front and rear elevations of the Parthenon (fig. 11-14, page 300) conform to the Golden Ratio.

The artist must consider the size relationship of the parts of an artwork to one another. Proportion can be used to show emphasis, distance in space, and balance. Do not confuse proportion with *scale*, which refers to the size of an object in relation to the size of other objects around it or its environment. An example of a *scale* relationship is Claes Oldenburg's *Clothespin* (fig. 8-38), which is forty-five feet tall. A wooden clothespin is $3\,5/16$ inches long.

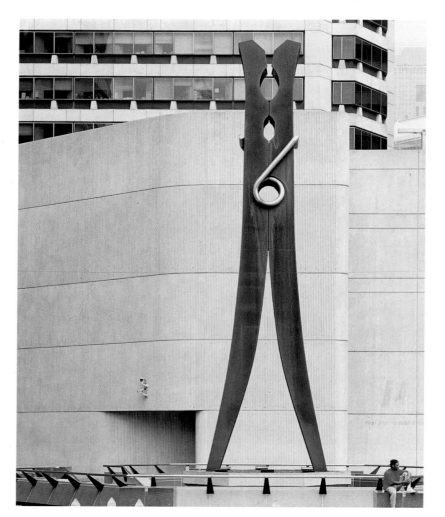

8-38 **Instead of commemorative figures or monoliths, Oldenburg produces monumental public sculptures of common, mass-produced objects. What symbolic meaning might be given a gigantic clothespin standing like an icon in a busy urban plaza?** Claes Oldenburg, *Clothespin*, 1976. 45' x 12' 3" x 4' 6" (13.7 x 3.7 x 1.4 m). Centre Square Plaza, Fifteenth and Market Streets, Philadelphia. Fabricated by Lippincott, Inc. North Haven, CT. Photograph by Attilio Maranzano.

Consider the scale relation between the heights of this monumental sculpture and that of the people who view it. Now, look at a regular clothespin to see how the artist used *proportion* to emphasize the length and suggestive character of the "legs."

Proportion is one principle Andrew Wyeth used to indicate spatial distance in *Christina's World* (fig. 8-39). The relative size of the foreground figure to the house and barn are obvious indicators of distance in space. The size of the house relative to the other buildings makes it the dominant form on the horizon. Placement of the largest form in the left foreground also helps to *balance* the progression of buildings on the upper right horizon.

Proportion in artworks is not limited to the size of shapes and forms. Color can be used in differing proportions to suggest a mood or idea. If you were doing a portrait and decided to paint the lips large and brilliant red, that would be emphasis rather than proportion. If you filled a major portion of the painting with red, as Matisse did in *Large Red Interior* (fig. 8-40), that would be a proportion decision. This is a portrait of Matisse's studio. How do you think Matisse felt about the room?

The principles of design are interdependent. They describe *effects*, not rules, which may occur in a composition. They may not all be applicable to every artwork, depending on the artist's expressive objectives. They can, however, help you analyze and appreciate a variety of artworks, including your own.

8-39 **Apart from size relationships, how has the artist created depth in this painting?** Andrew Wyeth, *Christina's World*, 1948. Tempera on gessoed panel, 32¼" x 47¾" (81.9 x 121.3 cm). The Museum of Modern Art, New York, NY, Purchase. Licensed by Scala/Art Resource, NY.

8-40 **This painting is full of humor. One of Matisse's paintings hangs on the right wall, and an open window is on the left. A flat dog chases an equally flat cat at the bottom. What is the dominant art element in this painting? What unifies it?** Henri Matisse, *Large Red Interior*, 1948. Oil on canvas, 57½" x 38" (146 x 97 cm). Photo by Jean-Claude Planchet. © Succession H. Matisse, Paris/ARS, NY. Musée National d'Art Moderne, Centre Georges Pompidou, Paris, France. Photo courtesy CNAC/MNAM/Dist. Réunion des Musées Nationaux/Art Resource, NY.

# A Contemporary Installation

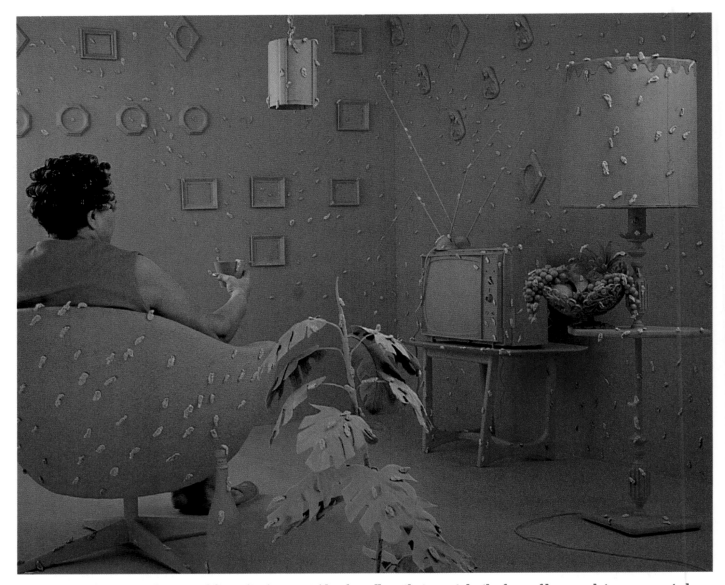

8-41 **Installations are works created for a site, in or outside of a gallery, that may take the form of large sculptures or created environments. The installation shown here, like most, was eventually disassembled. The photographs are all that remain for our viewing.** Sandy Skoglund, *Germs Are Everywhere*, 1984. Copyright Sandy Skoglund.

### About the Artist
## Sandy Skoglund
### (b. 1946)

Born in Quincy, Massachusetts, **Sandy Skoglund** has made a career of photographing the sculpted and painted cats, goldfish, squirrels, foxes, and germs she places in rooms with her live models. After graduating from Smith College, she went on to study in the master's program in painting at the University of Iowa. She moved to New York in 1972 and began working as a conceptual artist. A desire to document her installation work led Skoglund to teach herself photography. Since then, she has been recognized as a leading photographer and installation artist.

Skoglund says she is thinking about the photography at all stages of developing her installations. She continues to reside in New York City, teaching photography and the art of installation/multimedia at Rutgers University, where she has held a post since 1976.

## 1 Describe What You See

When you describe an artwork, you identify the things about the work that you can see, name, and describe with certainty. You should not include opinions, evaluations, or possible meanings here.

- Identify the artist, title of work, category of art, and date.
- List any other label information about content and materials.
- Describe everything you see in the room: the figure, furnishings, arrangement, germs, etc., and the colors that are used.
- What is the woman doing?

## 2 Analyze the Way It's Organized

When you analyze an artwork, you tell how the subject matter and elements of the work have been organized by the artist. You tell how they work together.

- How are objects and the figure arranged?
- What is the first thing you notice in the room?
- Describe the movement of your eyes through the room. Why does your attention return to an area of the room?
- How is variety provided in this bright green environment?
- Is the woman aware of the germs surrounding her?

## 3 Interpret What It's Saying

Use the information from your description and analysis to help you identify the meaning of the work—what it tells you about human experience. (Clue: Skoglund criticizes the stereotype that says suburban life offers escape from the squalor of the city.)

- What do the color and the room's germs remind you of—something from TV, a movie, a story, or fantasy?
- What do you associate germs with?
- What moods or feelings are suggested?
- Compose a simile or metaphor you feel describes the meaning of this work. What is the message of the work?

## 4 Evaluate Its Success

Using your analysis in the first three steps, how would you judge the quality or success of this work?

- Which philosophy will you base your judgment on? A successful artwork: (1) is true to life, imitates reality, (2) is designed for perfect relationship among art elements, (3) expresses major ideas, feelings, emotions, (4) advances human interests, a purpose, or a cause.
- How do you judge the success of the work in communicating its purpose—criticizing the stereotyped image of suburban living?
- To what degree is your interest and imagination aroused by this work? Does it make you think, provoke ideas?
- What is the degree of recognition the artist has achieved for her installation works? Has she established a recognizable style in this medium?

**More Art!**
See page 204 for more artworks by Sandy Skoglund

**Web Links**
www.davis-art.com
www.sandyskoglund.com
www.getty.edu/artsed.net

## Technique Tips

• As you repeat your image, pay close attention to the use of negative space and the overall pattern you are creating.

• As you develop the image with colored pencil and watercolor, use changes in color density to add richness and expressiveness to your chosen image.

• Consider beginning with a wash before using colored pencil for fine detail.

# Designing Pattern from Foreign Currency

Have you ever taken a close look at the images and symbols printed on paper currency? Try framing and enlarging a section of a foreign currency in a drawing. Then use that image to create a repeated pattern in expressive color.

8-42 Isolated area from currency.

8-43 Student work, Siena Artuso. Pencil, colored pencil, 4" (10.2 cm) diameter.

### Before You Begin

Look at paper money from a number of different countries. Choose a currency that you find visually engaging.

### You Will Need

• foam-core board
• a variety of foreign currency
• tracing paper
• oak tag
• newsprint and white vellum paper
• pencils, colored pencils, watercolors

### Create It

❶ Using masking tape, mount your chosen currency onto a small sheet of foam core.

❷ Isolate an area from the currency by cutting a shape out of white paper and laying it over the currency.

❸ Observe the varied shapes, color, and texture of the section of the currency. Draw the chosen area, making it twice the size. Then use a combination of watercolor and colored pencil to develop the image as realistically as possible.

8-44 Student work, Siena Artuso. Pencil, colored pencil, watercolor, 24" x 18" (45.7 x 60.9 cm).

④ To develop a pattern, trace the contour and transfer it to a sheet of oak tag. Use the oak tag as a template to repeatedly trace the shape of your image onto newsprint. Redraw the design onto a sheet of white paper.

⑤ Use pencil to trace the most important elements in your enlarged selection. Include bold lines and shapes, but not fine details. Repeat in each shape on the final white paper.

⑥ Choose any single medium or mixed media and make changes such as varying line, repeating mixed color, and changing media density. The overall pattern you develop will look similar to a swatch of fabric in which you see only a section of a larger surface.

## Evaluate It

• How well is the selected image replicated in terms of color, line, shape, texture, and scale enlargement?

• How is your pattern established? Do your images reflect changes in color density?

8-45 **Student work, Diana Nojcik.** Pencil, colored pencil, watercolor, 24" x 18" (61 x 45.7 cm).

• Does your pattern reflect visual rhythm?

• Is the overall image visually engaging? How so? To what degree is personal expression apparent?

### Write About It!

Imagine you are Director of the Treasury for a newly established utopian nation, or ideal state. It is your job to design and print the new nation's first form of paper currency. What creative choices will you make in conceiving of a general design that will work for all of the different monetary denominations to be used? What images of your utopia's people, places, or things will appear on your currency? How could organic and geometric shapes be combined and repeated to create interesting patterns? Finally, how might the beliefs and ideals of your utopia be reflected in the images you choose?

## Art History

## Studio Background

Suriname is located on the north-central coast of South America. The country is noted for its beautifully colored and designed currency. The Suriname note is part of a millennium series that features plants and animals of the country. It was issued on January 1, 2000. The design of currency has several built-in complexities. It must thwart counterfeiters. (The myriad of patterns and colors found on a banknote are often there in the service of security.) The Surinamese note also includes a metal foil, watermark, and Braille feeler.

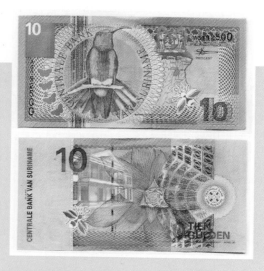

8-46 **The use of a guilder currency system in Suriname (formerly Dutch Guinea) is a legacy of the era of Dutch colonization that ended in 1975 when the country became independent. What principles of design do you think are most important in the creation of paper currency?** Suriname banknote, detail.

# A Unified Seasonal Collage

How can you express visually the essence of a single season of the year? Try creating a collage that reflects a unified composition. You decide just how to achieve that unity.

8-47  Student work, Jenna Maurer. Mixed media, 8 1/2" x 11" (21.6 x 27.9 cm).

## Technique Tips

• Carefully study your glued image before adding any other media.
• To unify the final work, apply paint or pen and ink to the glued image either opaquely or translucently.
• Avoid using glossy magazine covers for your collage. Shiny covers printed with ultraviolet-cured inks or coatings contain a clay content used as a stabilizer. When glue is applied to coated paper, the clay is moistened and printed colors tend to run to a grayish white.

## Computer Option

Scan or photograph a landscape into a paint program. Convert to grayscale and then use color paintbrushes to color the scene to the warm colors of fall. To build up color on the grayscale landscape, set the paintbrushes to 50 percent transparency or less. If necessary, use a dodge and burn tool to lighten and darken areas of the grayscale landscape so that they blend with the colors better. Open a second grayscale of the landscape and repeat the process for the cool colors of winter. Save and print both versions for critique.

8-48  Student work, Erin Santye. Mixed media, 8 1/2" x 11" (21.6 x 27.9 cm).

## Before You Begin

Review the principle of unity as described in this chapter and how it is achieved in artworks. Look through a number of magazines and collect a series of subjects and colors that you feel could express a given season. Find handmade or recycled paper to support your idea. Pay close attention to color and to how you will unify your composition.

## You Will Need

• recycled magazines and posters
• a variety of handmade paper, lace paper
• watercolor or acrylic paints
• pen and ink
• scissors
• white glue, watered-down mixture
• illustration board or mat board

## Create It

**1** Arrange and rearrange your collected images. Try several different compositions before deciding which one will work best to maintain the viewer's interest.

**2** Brush the glue mixture onto the board. Compose your collage, carefully placing the images onto the board.

**3** Brush the glue mixture over each piece after placement.

**4** Use paint and/or pen and ink to help unify your image.

## Evaluate It

• What visual elements did you use to represent the seasons?

• What design strategies did you use to achieve unity in your composition and maintain visual interest?

8-49 **Student work, Kim Rathyar.** Mixed media, 11 x 8 ½" (21.6 x 27.9 cm).

### Write About It!

Take a visual walk through your composition. How do your eyes move? How do grouping and overlapping function in creating unity? Did you choose warm or cool colors to represent your season? Compare your color choices to those outside. Do they fit with what you see, or do they represent a different season or place? In a few paragraphs, describe how you expressed the essence of your season.

**Art History**

# Studio Background

Unity is an important part of clothing design. If you purchase a pair of pants, a retailer tries hard to persuade you to purchase a matching shirt at the same time. Coordinated outfits are all about unity. Unity of color and style also help in creating store and catalog arrangements. Harmonized colors in a single style make for an attractive display. Economics plays a part too. It is cost-effective for a manufacturer to buy large quantities of fabric, dye it a variety of colors, and cut and sew one particular pattern. That is why you will often see a single style offered in a multitude of colors.

8-50 **A designer must take numerous factors into account in the creation of a line of clothing. How does season, or the temperature of a locale, have a bearing on the texture, color, and fabric weight that a designer chooses?**

# Movement in a Comic Strip

Have you ever noticed how cartoonists can suggest motion and time progression with just a few simple lines? In this exercise, you can explore ways to tell a story in an original comic strip. A good way to develop a cartoon is to start with expressive line.

8-51 Student work, Sabrina Chu. Pencil and fine-line marker.

8-52 Student work, Scott Kalison. Pencil and fine-line marker.

## Before You Begin

Discuss cartoons you have seen and where you saw them. To create your own character, brainstorm a series of thumbnail pencil sketches. Start with a circle, then add lines and shapes to develop your ideas. Repeat the process using a square, rectangle, triangle, and an organic shape. Which shape works best for a character?

## You Will Need

• a sketchbook
• pencil and eraser
• white vellum drawing paper
• black fine-line marker

## Create It

❶ Choose your best sketches. On a separate page, develop your character to show movement and to tell a story. Think of ways to use expressive line to show walking, running, swimming, jumping, or whatever movement you choose.

**2** On the next page, create sketches of your character from different sides: front, back, left, and right. Consider ways to show movement in these drawings by placement of the subject within the individual frame. Experiment with adding props and scenery to support your cartoon.

**3** On vellum, create a final comic strip. In six to eight frames, show the progression of an activity that will feature the most movement, such as dancing, skating, or playing basketball. Do not use words. Add your chosen props and scenery. Decide how you will compose each frame. Vary the perspective or composition from frame to frame to imply movement and the passage of time. Make sure the sequence of frames shows a logical progression.

### Evaluate It

• How did you use expressive line to create your character and show movement?

• Describe the progression of your comic. How did it tell a story?

• In what ways were you able to make your comic humorous?

### Write About It!
Congratulations! You have just been offered a chance to turn your comic strip into a major motion picture. Compose a sequel to your comic strip. Write a short movie script based on your comic strip character or characters. Include a description of scenery and props corresponding with your comic. Keep your audience entertained by showing action and humor.

8-53 Student work, Alex Kim. Pencil and fine-line marker.

### Art History

## Studio Background

The word *comic* came into use in the United States in the early 1900s. The term evolved because so many of the popular cartoons of that time were funny, or comic. Throughout the first half of the twentieth century, the success of the medium increased. In 1938 Superman made his first appearance in Action Comics, published by DC Comics. The superhero trend had begun, and soon, The Flash, Wonder Woman, Green Lantern, and Plastic Man followed. These same characters, and a multitude of others, populate today's comic books.

8-54 **Expressiveness is essential to the creation of a strong cartoon character. What gives this drawing of a superhero its expressiveness?** Super Hero © Images.com/Corbis.

**Technique Tip**

When the tape is removed, you may see places where the paint seeped under the tape. These can be touched up with black acrylic paint.

**Computer Option**

Go on a scavenger hunt and look for natural and human-made objects that are examples of symmetrical and radial balance. Using a digital camera, photograph three to five examples of each. After printing out your images, arrange seven to ten of your best examples and glue these down in an asymmetrical composition on poster-board. After you have glued your images, add labels that tell what kind of balance each represents.

# Varied Forms of Balance

In this exercise, try to create one cut-paper design for each form of balance: asymmetrical, symmetrical, approximately symmetrical, and radial. Then choose one design to develop and include in a composite wall hanging in paint on fabric.

8-55 Student work, Giselle Uy. Acrylic on fabric.

8-56 **Transferring a design to fabric.**

## Before You Begin

Discuss the definitions of symmetrical, asymmetrical, approximately symmetrical, and radial balance. Identify and discuss each kind of balance in images of artworks and in natural objects.

## You Will Need
- construction paper in various colors
- scissors and white glue
- black fabric
- metallic acrylic paint

## Create It

❶ On three pieces of white paper, arrange black strips of construction paper to create one asymmetrical, one symmetrical, and one radial design. For each design, try different arrangements until you find one you like. Glue the strips in place.

❷ On a fourth piece of white paper, create an approximately symmetrical design using two contrasting colors of your choice.

❸ Choose your strongest design; you will later transfer it onto black fabric. Create an enlarged drawing of the design on 15" x 18" paper. Adjust the design to fit the rectangular paper.

❹ Reproduce your enlarged design on fabric. Use strips of masking tape of different widths to re-create the paper strip design. Work with five other classmates to arrange a panel of six designs.

❺ Choose two or three colors and paint the shapes created by the masking tape. Decide where to repeat colors to create unity in your design.

8-57 Student work, collaboration (detail). Acrylic on fabric.

8-58 **Banners displayed in the school courtyard.**

**6** When you are sure the paint is dry, remove the tape. The panels can now be sewn together to create a larger wall hanging.

## Evaluate It

- Where will viewers see balance in your enlarged design?
- How does your design create visual interest?
- What was the most challenging part of this project? How did you work out the difficulties?

### Write About It!

How did your group compose your panel to achieve interest, unity, and balance? Look for recurring elements, or *motifs,* common to the designs. How do the patterns work together to create interest across the wall hanging? Write a few paragraphs describing the elements that pull your eye in and maintain your interest.

**Art History**

## Studio Background

Batik textiles have been produced in Java for over 1,000 years. The Javanese use two methods for creating the patterns. The first, traditionally used by women, involves placing the fabric on a stretcher and dripping wax on those areas of the fabric not to be dyed. The other method is more often employed by men and requires a metal stamp to be dipped in wax and repeatedly placed on the fabric. The cloth is immersed in a dye bath, and then the wax is removed in a hot-water rinse. Multicolor effects are achieved with additional waxing and baths.

8-59 **The traditional blue of Javanese batik is the oldest color used in this craft and is made from the indigo plant. Based on the above example, name three principles of design that are fundamental to the art of batik.** Batik with floral designs, Indonesia, Java. Courtesy Davis Art Images.

**Computer Option**

Find ten advertisements from large national companies and ten from local small businesses. Compare and describe the strengths and weaknesses of each advertisement. Scan the five weakest ads into a paint or drawing program. Modify them to improve their visual elements or design qualities. Print out each one of your new ads and present them together with the old advertisements. Be sure to explain how your changes improved the advertisement.

# Advertising with Emphasis

Why are some advertisements more appealing than others? Discover the qualities of effective commercial design by developing a two-dimensional magazine advertisement and a three-dimensional package design for a new product that you think will make the world a better place to live. Using the principle of emphasis will help you to make your point.

8-60 Student work, Josh Jones. Mixed media.

## Before You Begin

Research advertising campaigns that show imaginative artistic qualities. Study ads and product design in magazines, newspapers, consumer products, billboards, and store displays. Think about what aspects of a product design make you take a second look. What elements are emphasized in the best ads? Decide what kind of product you will create.

## You Will Need

- white vellum drawing paper
- a variety of drawing and painting materials: colored pencils, markers, pen and ink, colored chalk, acrylic paint, watercolor paint
- railroad or illustration board in a variety of sizes
- gray bogus paper
- glue sticks or white glue

## Create It

**1** Select the media you want to use to develop your magazine ad. Use computer-generated lettering for a professional presentation. On the white paper, create an ad that will catch people's attention. Use your name, first or last, in the product design. Create a serious ad or create something funny. Consider readability and strong composition as you design your ad.

**2** Create a three-dimensional package design for your product. Think about what size will work best for your design. Use gray bogus paper to work out a rough copy of the size, folds, and tabs for gluing. Think about what would make the package design appealing and eye-catching.

**3** Use heavy white paper such as railroad board for the final color version of your package design. Use glue sticks to finalize the design. Display your package design with your print ad.

## Evaluate It

- What makes your design appealing?
- To whom would it be most appealing? Why?
- How does emphasis occur in your design?
- On a scale of one to ten, how would you rate your design in terms of readability and composition?
- How will your product contribute something significant to society?

Does your lawn **OVERWHELM** you?

Try CAINCO'S new 2 inch grass.
Your lawnmower will thank you.

8-61 Student work, Kevin Cain. Mixed media.

LEARN TO LOVE
**By Erin**

*"If we ... to live ... peace, we must come to know each other better."*
—Lynden B. Johnson

... a camel ride ... market ... a jungle ...
a desert ... PEOPLE

*This book, written ... children, contains pictures, addresses and stories of real life children around the world ...*

START PEACE WITH ...
**LEARN TO LOVE**

8-62 Student work, Erin Daniels. Mixed media.

**Art History**

# Studio Background

Designers of commercial messages pay lots of attention to emphasis. Flip through the ads in a teen magazine. You will find that very often the emphasis is on fun, body image, self-esteem, or being cool. By understanding the design principle of emphasis, you will be better able to discern the true message of an ad. Of course, many ads do focus on the product. The company that manufactures Zapzyt, an acne cream, asks teens to vote on the company Web site for their favorite variation of an ad design. Where is the emphasis in this Zapzyt ad? What message does the ad send to you?

8-63 **The teenage market spends an estimated $150 billion a year. What do you think advertisers focus on when they try to reach you?** Courtesy Waltman Pharmaceuticals.

**Zit happens.**

ZAPZYT kills acne-causing bacteria fast. So results are all you see.

8-64 Sandy Skoglund, *Thirty Burgers with Mustard*, 1995. Cibachrome photograph, c. 14" x 11" (35.5 x 27.9 cm), © 1995 Sandy Skoglund.

8-66 Irvin L. Trujillo, *The Hook and the Spider*, 1995. Naturally dyed wool, 92 1/2" x 54" x 1/4" (235 x 137.2 x .6 cm). Smithsonian American Art Museum, Gift of Mr. and Mrs. Andrew Anderson III. © 1995 Irvin L. Trujillo.

8-65 Sandy Skoglund, *At the Shore*, 1994. Cibachrome photograph, c. 11" x 14" (27.9 x 35.5 cm), © 1994 Sandy Skoglund.

8-67 Jennifer Bartlett, *Air: 24 Hours, Eleven A.M.*, 1991–92. Oil on canvas, 84" x 84" (213.4 x 213.4 cm). Smithsonian American Art Museum, Gift of Mr. and Mrs. Barney A. Ebsworth. © 1992 Jennifer Bartlett.

# Chapter Review

## Summary

Each step in creating an artwork—the selection of a subject, generation of an idea to express about the subject, what images can be used for expression, and how to organize the work—involves thinking. Planning is thinking, and anything that is planned is designed.

Previous chapters identified the art elements as line, shape, form, color, value, space, and texture. This chapter identified the design principles—*unity, variety, emphasis, rhythm, movement, balance, pattern,* and *proportion*—as visual effects that can be helpful in the structural organization of the art elements. Design in art is the ordered arrangement of the visual elements so they all contribute to the final form.

The more familiar you become with how other artists have dealt with the manipulation of images and elements to express ideas, the better equipped you will be to solve your own compositional problems.

The principles of design are very interdependent. They describe *effects* that may occur in a composition. They may not all be applicable to every artwork, depending on the artist's expressive objectives. They can, however, help you to analyze and appreciate a variety of artworks. You may also find them helpful in creating and evaluating your own works of art.

## Review Questions

1 **Recall:** Name three types of balance.

2 **Understand:** Explain how proximity, similarity, and continuation help create unity.

3 **Apply:** Demonstrate your understanding of rhythm. Show, in three simple drawings, the difference between repetition, alternation, and progression.

4 **Analyze:** Look closely at Faith Ringgold's *Tar Beach 2.* List the principles of design you see in use in this artwork. Which principle is most apparent? Explain why you think so.

5 **Synthesize:** Using magazine or newspaper photographs or drawings, compose an illustrated chart that shows each of the principles of design. Label and define each principle.

6 **Evaluate:** Choose an artwork from this chapter and describe a principle of design that it does *not* show. Support your evaluation with descriptions of how the principle might have been shown, but is not.

## For Your Portfolio

Whenever you add an artwork to your portfolio, make sure to sign and date it. Attach a page to the artwork explaining the assignment, what you learned, and why you have selected this artwork for the portfolio. This information will be useful when you return to consider how you have developed as an artist.

## For Your Sketchbook

Find examples of relief sculpture on the facades of buildings in your community. Make sketches of the examples and accompany them with brief descriptions of the forms and how they are organized by the principles of design. You might also take photographs of the facades and include them in your sketchbook, along with the name and location of the building and the date of construction.

## Electronic Research

To learn more about Faith Ringgold, visit her Web site <http://www.faithringgold.com/>. Read her biography and browse through images of her many works to understand how her art has evolved over time. Find one of her most popular artworks, *Tar Beach,* which was re-created as a children's book. Compare and contrast it with *Tar Beach 2,* found on page 175 of this text. Explain how each effectively utilizes the principles of design.

## Going Further

How have the designs of products you use every day changed over time? For example, how have cars, telephones, or toasters changed from decade to decade since they were first invented? Select a product (such as a specific make of automobile) and research how its design has evolved. Prepare an illustrated report explaining how, and if possible, why, the visual elements and overall forms changed.

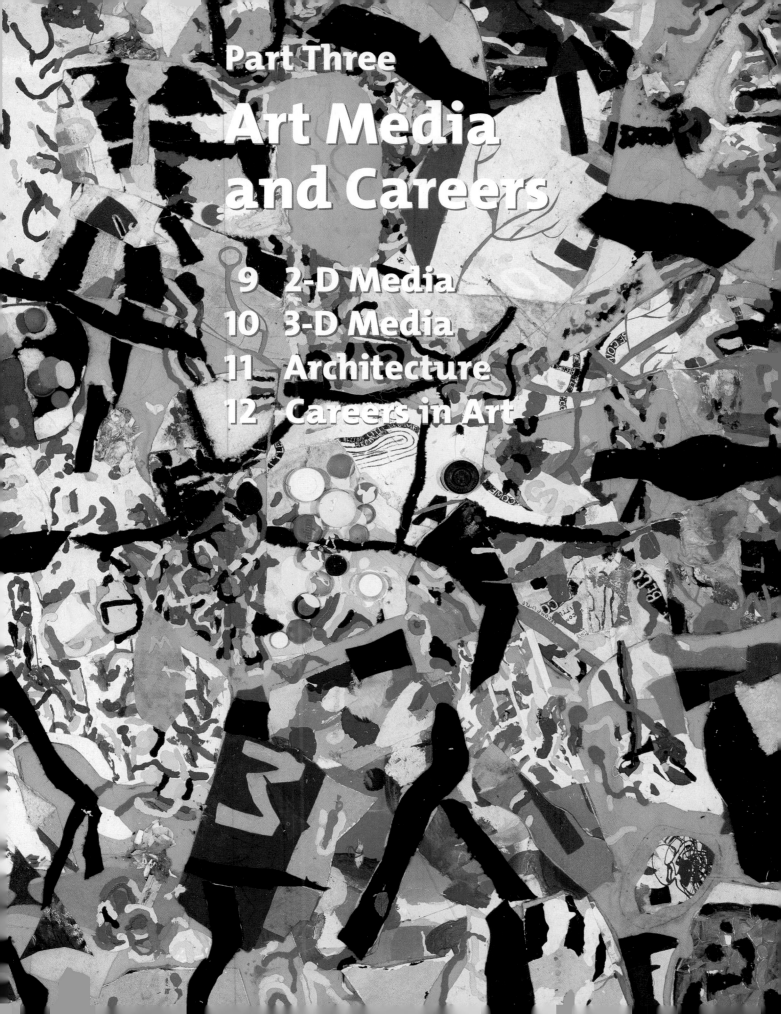

# Part Three

# Art Media
# and Careers

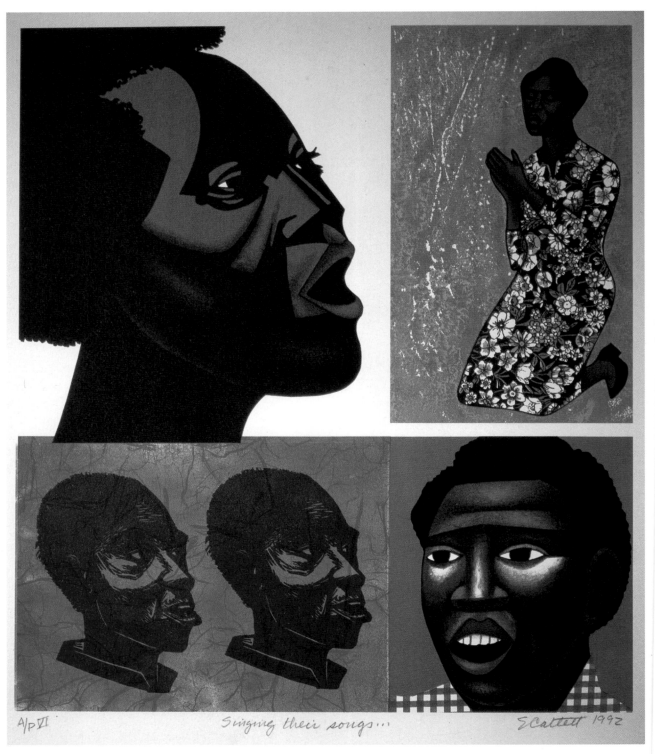

**9-1 In lithography, the artist creates lines on a printing plate that will later receive ink and be transferred to paper. What benefit do you think might be gained from producing artworks in this way? What are the drawbacks, if any, to this technique?** Elizabeth Catlett, *Singing Their Songs*, 1992. Lithograph on paper, 15 ¾" x 13 ¾" (40 x 35 cm). National Museum of Women in the Arts, Purchased with funds donated in memory of Florence Davis by her family, friends, and the NMWA Women's Committee.

## What You'll Learn

- what two-dimensional media are, and examples of each
- the history, origins, and expressive possibilities of two-dimensional media
- advantages and disadvantages of using particular media
- how to identify the medium of an artwork

## What This Chapter Covers

## Art Criticism Step by Step

## Studio Experiences

## Key Terms

*English (Spanish)*

*medium (medio)*
*drawing (dibujo)*
*painting (pintura)*
*printmaking (técnicas de grabado)*
*photography (fotografía)*
*film (película)*
*video art (arte video)*
*computer art (arte de la computadora)*
*mixed media (medios mezclados)*

## Artists

Ansel Adams, Robert Bateman, Dawoud Bey, Mary Cassatt, Elizabeth Catlett, Paul Cézanne, Judy Chicago, Emilio Cruz, Albrecht Dürer, Helen Frankenthaler, Benjamin Fry, William Michael Harnett, David Hockney, Hokusai, Collata Holcomb, Winslow Homer, Felix Klee, Jacob Lawrence, Simone Martini, Nam June Paik, Alix Pearlstein, Pablo Picasso, Clayton Pond, Diego Rivera, Betye Saar, Gino Severini, Cyprian Mpho Shilakoe, Shin'chi, Joseph Stella, David Szafranski, Dox Thrash, Henri de Toulouse-Lautrec, John Valadez, Vincent van Gogh, Andy Warhol, Grant Wood, Andrew Wyeth

9-2 Student work, Josh Kirsch.
Color stencil print, 11" x 8¹/2" (27.9 x 21.6 cm).

You can see many art forms in the early chapters of this book. Some, like painting, printmaking, and photography, are **two-dimensional**. They have height and width but no real depth. The material an artist uses to make an artwork is called the **medium**. (The plural is *media*.) Artists choose a medium carefully for each work of art. Their choices are often related to the *subject matter*—what they want to show—and what they want to *express*. Most media may be used in several ways. For example, pen and ink and ink wash are two *techniques* for drawing with ink. Each medium has capabilities and limitations that the artist must understand in order to master the medium and achieve his or her purpose. Thus, an artist's subject, purpose, medium, and technique are closely interrelated.

**Drawing** media date back thousands of years. Pencils, charcoal, and india ink are *monochromatic* media, used to create artworks in different shades of one color.

Pencils and charcoal produce darker tones the harder you press on them. When india ink is used straight from the bottle, it is *opaque* (you cannot see through it). It can also be thinned with water to produce washes, which are *translucent*, or somewhat see-through, also called *semitransparent*. Chalk and pastel (**fig. 9-3**) are dry media that offer artists a variety of colors.

**Painting** media are made of colored powders mixed with a liquid. *Watercolor* is pigment mixed with water. It is thin and relatively transparent. *Tempera* is pigment mixed with water and oil emulsion. Tempera colors are creamy and opaque. *Oil* paint, the best known of painting media, is made of pigment mixed with linseed oil. It dries slowly, and can be used thinly or thickly. *Acrylic* paint (**fig. 9-4**) is a plastic material in a water-soluble liquid. It can be thinned or thickened, and dries much more quickly than oil paint.

*Fresco* is one of the oldest painting media. To make a fresco, the artist spreads wet plaster onto a wall or ceiling, and applies colors before the plaster dries. *Mosaic*, another ancient art form, is a picture made from thousands of

9-3 **Pastel colors don't need to be mixed and don't require special surfaces, as do paints. Why do these characteristics make it a good medium for portraits of children?** Mary Cassatt, *Margot in a Dark Red Costume Seated on a Round Backed Chair (La Petite).* Pastel on buff paper. Private collection. © Christie's Images Ltd.

9-4 **"I have treated the fur as landscape," says the artist who painted this bear. What do you think he means by this statement? How might his choice of medium have helped him?** Robert Bateman, *Polar Bear Profile*, 1976. Acrylic on canvas, 24" x 36" (60.96 x 91.44 cm). © Robert Bateman. By arrangement with Mill Pond Press, Inc. Venice, FL.

tiny pieces of stone or glass. These *tesserae* (pronounced *tess-ah-RAY*) are set in cement.

**Prints** are produced on paper, like drawings. Unlike drawings, however, prints can be reproduced many times. Prints are made with ink, paper, and a *plate*—a surface on which the picture or design is made. Paper is pressed against the plate to create the print. *Relief prints* (fig. 9-5) are made by carving into the surface of a plate. Ink clings to the uncarved surface of the plate. *Intaglio (in-TAH-lee-oh)* prints are the opposite of relief prints: ink fills the lines cut into the plate, and is transferred to paper by the pressure of a press. In *lithography* prints, the image is drawn on the surface of the plate with a greasy tool. Ink sticks to the drawn lines and can then be transferred to paper. In *screen printing,* ink is forced through a fine screen on which a stencil has been created. The ink passes through the stenciled image to the paper or other surface.

Photographs, like prints, can be reproduced many times. A photographer captures a scene on light-sensitive film using a camera. The film is developed in a chemical solution, and becomes a *negative,* a semitransparent image in which lights and darks are reversed.

To print the image, the photographer passes light through the negative onto light-sensitive paper, which is then developed.

**Film** and **video art** (fig. 9-6) record moving images that can be viewed again and again. Films are made using cameras that take many still images. When the images are printed onto film and projected onto a screen, they re-create the motion the camera captured. Videos are created by converting scanned images into electronic signals. The signals are transmitted to a television, where they are converted back into images by a "gun" that fires them at the screen.

Like video, **computer art** is electronic. Images are made up of pixels, tiny dots on the computer screen. Artists can use special programs and techniques to create the illusion of three dimensions on the two-dimensional surface, just as painters and printmakers do.

Some artists combine several media in one work of art. These works are called **mixed media**. *Collage* is a mixed-media collection of materials—often papers—on a flat surface. *Montage* is a collage made of photographs or other pictures.

9-5 **Many people in nineteenth-century Japan wanted to buy Hokusai's artwork. Why might he have chosen printmaking as his medium when planning his series of views of a popular tourist attraction?** Katsushika Hokusai, *In the Hollow of a Wave off the Coast at Kanagawa* (popularly called *The Great Wave of Kanagawa),* 1830–31. Full credit page 227.

9-6 **Although you cannot see it here, the images in these video screens change constantly. What advantages might this offer for the artist? What might be some disadvantages?** Nam June Paik, *Video Flag,* 1985–96. Full credit page 234.

### Try It Yourself

Do you have pencils with different grades, like 2H (medium hard), 5H (very hard), or 5B (very soft)? If so, discover the different kinds of lines they make.

## Monochromatic Media

When you draw, you make controlled marks on paper with a tool such as charcoal, pen and ink, pencil, crayon, or felt marker. Some of these tools date back thousands of years. During the Ice Age (around 12,000 BCE), hunter-artists used pieces of charcoal or red ocher on cave walls to outline shapes of animals. As early as 2500 BCE, Egyptian scribes used ink on sheets of *papyrus* made from a plant that still grows along the Nile. In the 1400s, European artists began using pencils.

You have used some of these tools since you were a child. However, that does not mean that drawing is necessarily easy. Often, the artist has only two colors to work with—the color of the tool and the color of the paper. Works created this way are *monochromatic*. That is, they employ various intensities of a single hue.

You learned about values and shading in Chapter 5. You can often get different values just by changing the amount of pressure on the pencil or drawing tool. If you rub a stick of charcoal hard, it makes very dark tones. The marks conceal the white of the paper. If you rub the stick lightly, it makes lighter tones. Observe how Joseph Stella used the tool to create a powerful image of a Venetian gondolier (fig. 9-7). In most places the charcoal rendering is very dark. In others, such as the man's right hand, shoes, and the pole, the grains of charcoal are very sparse or missing altogether. Stella's drawing demonstrates what a skillful artist can do just with a simple stick of charcoal.

Varieties of light and dark can be produced by certain kinds of pencils.

9-7 **The artist varied the pressure on the charcoal tool to create this drawing. What does the artist's use of value and line tell us about the nature of this man's work?** Joseph Stella, *Man with a Pole.* Charcoal on paper. Courtesy Corbis.

9-8 **Notice how the thicker lines create darker values than the thin lines. Why do you think the artist may have chosen to do this drawing in pencil?** Felix Klee, *Fritzi*, 1919. Pencil on paper, 7⅝" x 10⅝" (19.4 x 26.9 cm). The Museum of Modern Art, New York, NY, Gift of Mrs. Donald B. Straus. Licensed by Scala/Art Resource, NY.

9-9 **The different values in this pen and ink drawing were created by various hatching techniques. What technique did the artist use to bring the background of the picture to life?** Vincent van Gogh, *Peasant of the Camargue*, 1888. Drawing with brown ink over graphite on white paper (49.4 cm. x 38 cm).

The amount of graphite in the pencil determines the type of line it can make. (Note: Pencils used in school are usually 2B, or medium soft.) With just a few pencil strokes, Felix Klee captured the quality of a sleeping kitten **(fig. 9-8)**. Did he press harder in some places than others, use more than one type of pencil, or both?

Different values can also be obtained from ink. Ink poured directly from the bottle is *opaque,* that is, not transparent. When applied to paper it completely masks the color of the paper. *Peasant of the Camargue* **(fig. 9-9)** is a very compelling pen and brown ink portrait of a man whom Vincent van Gogh also portrayed in paint. Notice how the artist effectively described each contour of the old man's face by means of pen strokes. At the same time, through variations in their widths and density, the strokes also function as shading.

Japanese artist Shin'chi used ink in a different way to create shaded effects and depth. In his work **(fig. 9-10)**, the artist used *ink washes,* which are films of water-thinned ink spread with a brush. An ink wash is semitransparent, or *translucent.* It allows the white of the paper to show through and produce gray. To control the values, Shin'chi con-

9-10 **The artist has used a thick wash to create value in the trees and mountaintops. Why is ink wash a useful medium for depicting this subject?** Hisamaatsu Shin'chi. Ink wash. Courtesy Davis Art Images.

trolled the amount of the water in the mixture, and overlapped some of the washes. Notice how the thinnest washes were used for the lighter parts of the scene (where the sun shines in the morning mist). The white of the paper itself represents the lightest part of all.

## Colored Chalk or Pastel

Colored *chalks* lie somewhere between drawing and painting media. Like charcoal sticks or pencils, sticks of colored chalk can be applied directly to paper. But unlike most drawing media, colored chalks are multicolored. Ice Age hunter-artists may have used a rudimentary form of colored chalk. No one knows for sure, but some think that these individuals mixed clay with iron oxide, a pigment that produces brownish reds and yellows (sometimes called red or yellow ocher).

*Pastels* (fig. 9-11) are a high-quality form of chalk with a wide range of hues. They were introduced in the 1700s. At that time they were especially popular with portraitists. Pastels allow the artist to use a variety of colors without needing to mix paints or prepare canvas. However, they are quite fragile. The surface of a picture made with chalk or pastel is easily smeared or dusted away. Pastel drawings must be sprayed with *fixative*—a mixture of shellac and alcohol—or framed under glass.

9-11 **John Valadez's pastels involve layers of pigment built up on the paper. Why might he have found this approach to be useful for illustrating the dreamlike "battle" scene of this painting?** John Valadez, *La Frontera/The Border* (panel #2), 1993. Pastel on paper, 50" x 56½" x 2¾" (127 x 143.5 x 6.9 cm). Carnegie Art Museum Collection, City of Oxnard.

Gino Severini's *Paris Subway, Ferris Wheel, and Eiffel Tower* (fig. 9-12) is in the style of *Cubism*. (Cubism will be discussed in **Chapter 16, Western Art History II**.) Those familiar with the style are surprised when they see this work and realize that it is not a painting. That fact demonstrates just how versatile the medium of pastel can be in the hands of an experienced artist.

Mary Cassatt was one of the most skillful artists to use pastels, and she was also uniquely skillful in portraying children. Her pastel rendition of a young child (fig. 9-13) is more than adequately realistic as a portrait. At the same time Cassatt made no attempt to conceal the strokes of her chalky medium, which she so deftly applied—particularly in the chair and the background. The portrait radiates charm and freshness, qualities we associate with its young subject.

9-12 **Gino Severini was part of a small group of Italian artists, called the Futurists, who sought to represent the dynamism of the modern age. Would this work be considered a good representation of their ideals? Why or why not?** Gino Severini, *Paris Subway, Ferris Wheel, and Eiffel Tower,* c. 1912–13. Pastel and charcoal, 23½" x 19" (59.6 x 48.2 cm). © The Cleveland Museum of Art; Gift of Malcolm L. McBride.

## Artist Biography
# Mary Cassatt (1844–1926)

Born in Pennsylvania, Mary Cassatt lived most of her life in France. Over her parents' objections, in 1861 she boldly enrolled at the Pennsylvania Academy of Fine Arts. This was at a time when art was frowned upon as an occupation for women.

Cassatt's keen desire to learn brought her to Paris, the center of the art world, in 1865. There she was able to pursue her studies of the great masters of the past, while working with influential Impressionist artists.

Inspired by what she saw, Cassatt began to create paintings and prints, especially on the subject of mothers and children. She chose not to marry or have children herself. Rather, she focused her life on the pursuit of technical expertise in painting and printmaking, and on achieving a beauty in her art that is uniquely her own.

9-13 **Mary Cassatt was encouraged by her close friend the artist Degas to begin using pastels in her work. Why might Cassatt have made the face of the child more finished, but left the remainder of the work rather sketchy?** Mary Cassatt, *Margot in a Dark Red Costume Seated on a Round Backed Chair (La Petite).* Pastel on buff paper. Private Collection. © Christie's Images Ltd.

Mention the word *art*, and most people think of painting. All painting media consist of colored powders called *pigments* and a liquid that the pigments are mixed in. The paint is applied to a surface, such as a wall, board, paper, or canvas, called the support.

### Watercolor

Watercolors (fig. 9-14) consist of pigments mixed with water. They are applied with brush to white paper. Like ink, watercolors have been around for centuries. At first they were used only to add a little color to drawings. In the early 1800s watercolors came into their own. At that time their potentials were discovered and developed by English watercolorists. Since then, this medium has been very popular, especially for making colorful, lively outdoor scenes.

### Tempera

The tempera that artists use is not the same that you use in school. Artists' tempera can be applied to paper, wood, or canvas. It consists of pigments mixed with an *emulsion*. An emulsion is a watery liquid with droplets of oil suspended in it. Egg yolk, a natural

9-14 **Watercolors are easily portable and ideal for capturing a sense of immediacy. Why would these traits have been useful to Winslow Homer, who painted many scenes with a strong emphasis on the forces of nature?** Winslow Homer, *The Lookout (Tynemouth),* 1882. Watercolor over graphite on heavy white wove paper, 14 1/2" x 21 3/4" (37.1 x 55.3 cm). Fogg Art Museum; Anonymous Gift.

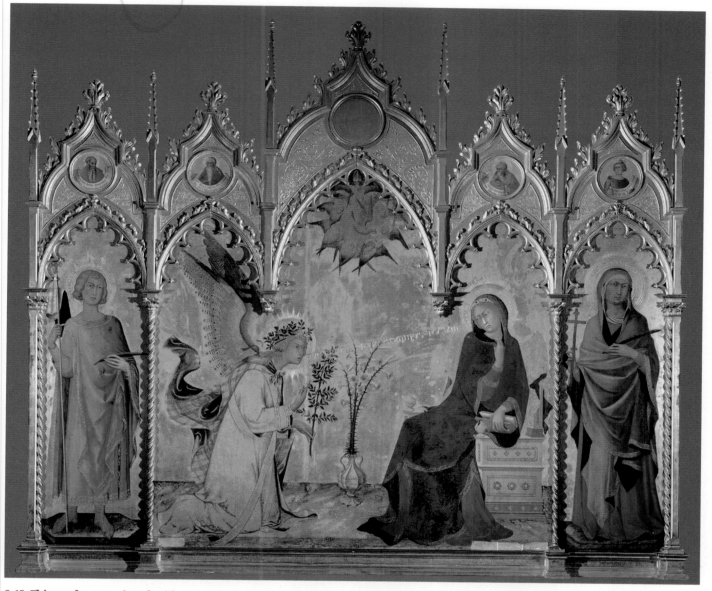

9-15 **This work was painted with natural pigments such as those derived from lapis lazuli, a semiprecious stone used to produce a rich azure blue. How would this painting and *The Lookout* (fig. 9-14) have been different had each been executed in the other medium?** Simone Martini, *The Annunciation; Saints Asano and Margaret. Four medallions: Prophets Jeremiah, Ezechiel, Isaiah, and Daniel.* Tempera on wood, 104 1/3" x 120" (265 x 305 cm). Uffizi, Florence. © Erich Lessing/Art Resource, NY.

emulsion, has been the traditional emulsion used in tempera. Today there are many different emulsions. These can be based on casein (a milk product), gum arabic, and wax. (See the next section, on gouache.)

Unlike watercolors, which are thin and relatively transparent, tempera is creamy and opaque. To make an area white, the artist usually uses white paint, not the paper (as in transparent watercolors). To lighten a color, the artist adds white paint, not water. Water is used as a thin-ner only to make the paint flow better. It is also used as a solvent to clean brushes.

Tempera reached a peak of popularity in the late Middle Ages, between 1100 and 1500. It was the favorite medium for paintings on wooden panels like *The Annunciation* **(fig. 9-15)** by Simone Martini. Tempera dries quickly with a soft, matte finish, and lends itself to fine detail. Because it is opaque, it allows the artist to paint over previously painted areas and continually improve

effects of shading or texture. (This method does not work well with water-colors.)

*The Annunciation* has a greeting-card charm that is due to the characteristics of the medium. Note the delicate colors, in many places embellished with gold foil. Note also the detail of the figures and ornament, especially in the angel's marvelous wings.

The advantages of tempera for some kinds of painting, however, are disadvantages for other kinds. Rapid drying does not allow for the easy blending of colors.

Tempera produces delicate effects instead of lively, spontaneous-looking effects. Furthermore, tempera colors tend to change while drying, making it difficult to predict the final results. Tempera gave way to oil in the 1400 and 1500s. Still, some artists, notably Andrew Wyeth, use it to this day. When painting subjects like *Braids* **(fig. 9-16)**, Wyeth finds the characteristics of tempera to be ideal for his purposes.

9-16 **This painting is perhaps the most famous in a series of 240 works created in a variety of media that Andrew Wyeth made using his neighbor Helga Testorf as his single subject. Why do you think he chose tempera to create this image?** Andrew Wyeth, *Braids,* 1979. Tempera. Courtesy Ann Kendal Richards, Inc.

9-17 **Jacob Lawrence was part of the African-American community of Harlem for over forty years. What did he have to say about life there in 1943?** Jacob Lawrence, *This Is Harlem*, 1943. Gouache on paper, 15 3/8" x 22 11/16" (39.1 x 57.6 cm). Hirshhorn Museum and Sculpture Garden, Smithsonian Institution; gift of Joseph H. Hirshhorn, 1966. © Gwendolyn Knight Lawrence, Courtesy of the Jacob and Gwendolyn Lawrence Foundation.

## Gouache

Gouache might be considered a compromise between watercolor and tempera. It is not as difficult to prepare or as expensive as tempera, but like tempera, it is opaque. Gouache consists of pigments, including white pigment, mixed with *gum arabic* (a water-soluble binder). Like watercolors, gouache is water-based and is usually applied to paper. Gouache, however, is easier to control than watercolor—especially for creating whites and a variety of values.

(Sometimes, artists mix white pigment with watercolors to make them function more like gouache.)

Compared to a watercolor, a gouache painting is usually flatter, sometimes even "chalky" looking. But this does not mean it has to be lifeless. Witness the lively energy in Jacob Lawrence's portrayal of a Harlem street **(fig. 9-17)**. The vibrant colors and detail of Lawrence's *This Is Harlem* are suggestive of similar characteristics found in a tempera painting.

## Oil

Oil has for years been the star attraction—not just of painting but of all media. Oil consists of pigments mixed with linseed oil. Turpentine is the thinner or solvent. The popularity of oil dates to the 1400s. It was first used for colored *glazes*—thin films of transparent varnish. Glazes were brushed over tempera paintings to give them more luster. Somewhat later, at about the time of Leonardo da Vinci, artists did away with the tempera underpainting and began using the oil medium from start to finish. Later still, in the middle of the 1500s, canvas replaced wood as the principal type of support. To this day *oil on canvas* is perhaps the most popular medium of all.

Oil is much more flexible than tempera. It can be opaque or translucent. It can be as thick as plaster or as thin as watercolor. Most importantly, it dries slowly. It allows an artist more freedom to blend colors and create a great variety of effects. You have seen some of that variety reproduced in the pages of this book. How does the dry brushwork of Hopper's *House by the Railroad* (fig. 4-37, page 73), for example, differ from the fluid brushwork of Munch's *The Scream* (fig. 8-18, page 178)? For more examples of oil paint's variety, compare and contrast the styles of Rembrandt (fig. 4-35, page 72), Marie-Denise Villers (fig. 5-14, page 95), Renoir (fig. 2-17, page 20), and Mondrian (fig. 6-18, page 126).

9-18 **Notice the results this artist has achieved through the application of transparent oil colors. What words would you use to describe these effects?** Emilio Cruz, *Veiled Passage Through Archaic Moments*, 1984. Oil on canvas, 60" x 72" (152.4 x 182.8 cm). Photo by Patricia Cruz. From The Museum of the Rhode Island School of Design. Copyright by the artist Emilio Cruz.

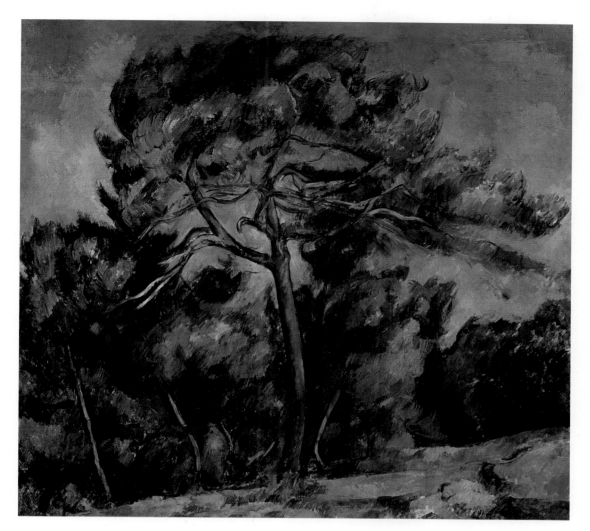

The works in **figures 9-18** and **9-19** are good examples of the flexibility of the oil medium. In *Veiled Passage Through Archaic Moments,* Emilio Cruz both reveals and conceals the skeletal four-legged mammal as it passes through translucent layers of oil color. Are we seeing real remains, or just a dream, or both? The forms of *The Great Pine* **(fig. 9-19)** are likewise representational, simplified, and leaning toward abstraction. Using colors of equal intensity in all areas of the composition, Cézanne causes pictorial space to appear shallow, thus concentrating attention on the subject.

Canvas is the most common support for oil paintings. It has several advantages for the artist. For one thing, it is very light. One person can carry a large painting. If thoroughly dry, the canvas can even be removed from its thin wooden frame (stretchers), rolled, and shipped in a mailing tube. The same-size painting on wood would be very heavy and very awkward to handle or ship. It may surprise you to know that oil rots fabric, including canvas fabric. To prevent canvases from rotting, artists have to coat them with a layer or two of a special glue or gesso (a plasterlike substance) before applying paints. Today synthetic products are available for preparing canvases.

**9-20** This artist uses a stained-canvas approach to create her abstract forms in acrylics. Why might this technique be well suited to the creation of paintings lacking recognizable subjects or figures? Helen Frankenthaler, *Canal*, 1963. Acrylic on canvas, 81" x 57¹/2" (205.7 x 146 cm). Purchased with the aid of funds from the National Endowment for the Arts in Washington, DC, a Federal Agency. Matching funds contributed by Evelyn Sharp, 1976. Copyright the Solomon R. Guggenheim Foundation, New York. Photo by David Heald.

## Acrylic

Acrylic is a synthetic medium that came into use after World War II. Acrylics are made from plastic material suspended in a water-soluble liquid, or polymer. Acrylic can be applied to any support, including canvas. Acrylic is the most versatile medium we've covered so far. When thinned with water, it acts like watercolors. When its colors are extended with liquid polymer, they can be used as glazes. Special materials can be added to acrylic to make it thicker than oils. Normally fast drying, it can be made slow drying by the addition of *retarders*. Because acrylic is water-soluble, tools and brushes can be cleaned in water rather than turpentine. Most importantly, it can be applied directly to canvas without rotting it.

Helen Frankenthaler has taken advantage of this capability by pouring water-thinned acrylics onto raw canvas. This new approach to painting that Frankenthaler herself has pioneered is called *stained canvas*. The results of colors spreading, mixing, and sinking into the canvas are visible in *Canal* (fig. 9-20); sometimes the canvas is warped or tilted in different directions during the process.

9-21 **Notice how this polar bear's partially flowing, partially matted fur is almost vivid enough to touch. What does this tell us about the capabilities of acrylic paint?** Robert Bateman, *Polar Bear Profile*, 1976. Acrylic on canvas, 24" x 36" (60.96 x 91.44 cm). © Robert Bateman. By arrangement with Mill Pond Press, Inc. Venice, FL.

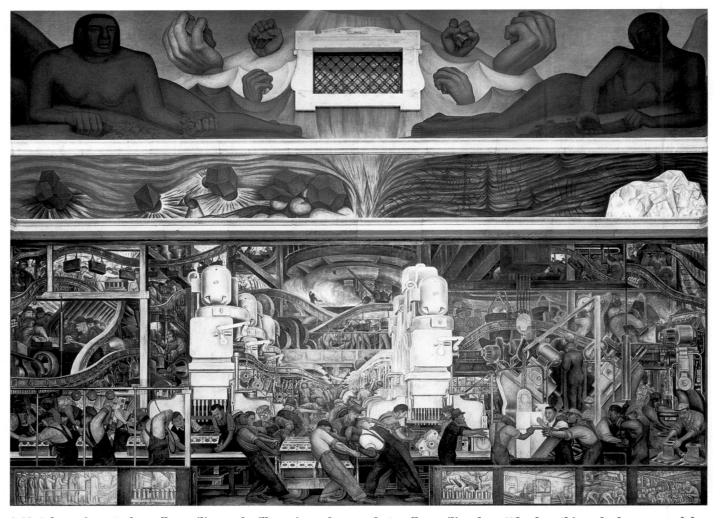

9-22 **A fresco is part of a wall or ceiling and will survive as long as that wall or ceiling does. Why does this make fresco a useful medium for historical subjects?** Diego Rivera, *Detroit Industry*, North Wall, 1932–33. Fresco, mural. Gift of Edsel B. Ford, Photograph © 2001 Detroit Institute of the Arts.

## Write About It!

Imagine yourself standing in front of Diego Rivera's *Detroit Industry*. What do you think he's trying to tell us about the working conditions in industry? How do the image size and medium illustrate the hardship of the working class in Detroit? How do you think you would feel standing in front of such a huge image?

## Fresco

If acrylic is the newest paint medium, fresco is one of the oldest. It is used to make *murals*, that is, paintings on walls. True fresco consists of mixing pigments in water, spreading an area of wet plaster onto a wall or ceiling, and applying the colors to the plaster before it dries. (Many cultures painted on a wall or ceiling after the plaster dried, a method called *secco*.)

As you know, plaster dries quickly. Therefore the artist must plan ahead when spreading plaster. He or she must be able to paint the area within a few hours. A large mural, such as Raphael's *School of Athens*, (fig. 6-23, page 128) or Michelangelo's mural on the Sistine ceiling (see **Chapter 15**), had to be painted in sections.

This would also be true for Diego Rivera's large mural, *Detroit Industry* (fig. 9-22). To avoid leaving a watermark, Rivera probably ended each section at the edge of a figure or object, rather than in the middle of it. Probably this meant that Rivera could do only a few of the laborers or one machine at a time. Because of the difficulties of working with the fresco method, the artist cannot easily make in-process changes or add fussy details. Perhaps this is why Rivera made the forms in his mural so clear and imposing.

Unlike oil or acrylic, fresco is not flexible and versatile. But it does have two advantages: durability and permanence. It is *in* the plaster, not a film of paint *on* the plaster. Fresco can better withstand the effects of air pollution, as well as wear and tear in general.

## Mosaic

A mosaic is a design or picture composed of numerous pieces of stone or glass. These pieces, called *tesserae,* are set in cement. Mosaics are typically used to decorate a wall, ceiling, or floor. An artist must piece together thousands of individual pieces of tesserae to complete a mosaic. In some ways, a mosaic is more like a crossword puzzle than a drawing or painting. Mosaic has been called "painting in stone." Mosaic is colorful, durable, and part of a wall or ceiling. In these ways, it is similar to fresco.

Mosaics have not been very popular since the 1300s, but they were more popular than frescos at one time. The Romans, who embedded mosaic designs in floors as well as walls, used tesserae made of stone cubes.

The early Christians covered the walls and ceilings of their churches with mosaics made from pieces of glass. Because glass reflects and tesserae do not lie on a uniformly flat plane, the mosaics reflect in all directions. Imagine the glittering effect inside a church filled with mosaics like *The Emperor Justinian and His Attendants* **(fig. 9-23)**. Even more than fresco, the medium of mosaic forces the artist to think in terms of simple, clear images. The strict simplicity of the design in *The Emperor Justinian,* however, is tempered by the sparkle of its surface.

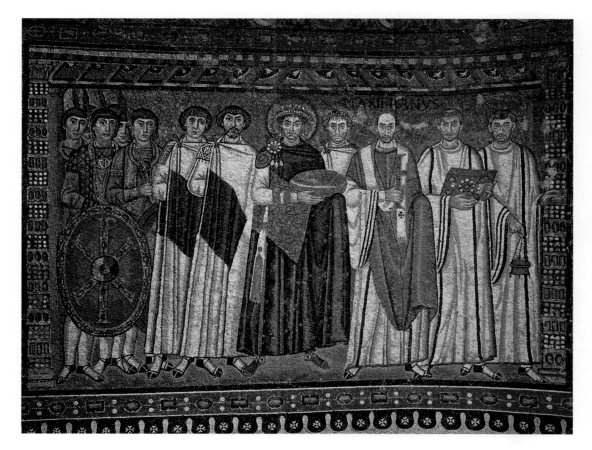

9-23 **Note the simplicity of both the composition and the individual figures in this work. Why might an artist working in mosaic find it useful to avoid overly complicated designs?** *The Emperor Justinian and His Attendants,* Byzantine, Court of Justinian, 500–525 CE. Early Christian mosaic from San Vitale, Ravenna, Italy. Photo courtesy Scala/Art Resource, NY.

Like drawings, prints are produced on paper, but with an important difference. A print can be produced several times. The major techniques of printmaking involve the use of ink, paper, and a *plate.* A plate is the surface on which the picture or design is made. A plate can be a piece of wood, metal, stone, or a screen. To produce a print, a piece of paper is pressed against an inked plate. This process can be repeated many times, making many prints of one image.

### Relief Prints

A relief print is so called because the image on the plate is in relief, that is, it projects up from the surface of the plate (see **Student Handbook**, page 490). Traditionally, the woodcut was the most common kind of relief printing. (Today, some artists use linoleum cuts.) The artist draws on a block of wood, and then cuts away the areas that are to remain white. The parts that will be printed are raised from the background. Black ink is rolled across the plate and clings to those parts that are in relief. When paper is pressed against the plate, the black ink is transferred to the paper, making the finished print.

Albrecht Dürer was a skilled German artist of the 1500s. Study his woodcut of a rhinoceros **(fig. 9-24)**. Every black line that describes a shape or detail, including every hatching line, is intact. Dürer had to cut *around* each of these lines. Dürer's approach to the medium is very different from that of Käthe Kollwitz's *Self-Portrait* **(see fig. 6-19, page 126)**. In the self-portrait the marks of the cutting tool are much more evident.

Making a colored woodcut is basically the same as making a single-colored woodcut. But for each print, the artist must use a separate plate for each color. In his *Great Wave* **(fig. 9-25)**, Japanese artist Hokusai had to register the print carefully each time he pressed the paper against one of the plates. Mount Fuji can be seen in the distance just right of center. The excitement of waves and desperate boaters in the foreground steals attention from the venerated mountain.

### Intaglio Prints

*Intaglio (in-TAH-lee-oh)* (Italian for *to cut in*), a printing medium that began to replace the woodcut in Dürer's time, is the opposite of relief printing. Rather than being above the surface, an intaglio image is below it (see **Student Handbook**, page 490). The lines, unlike those in relief printing, do not project. The artist cuts the lines that are to print

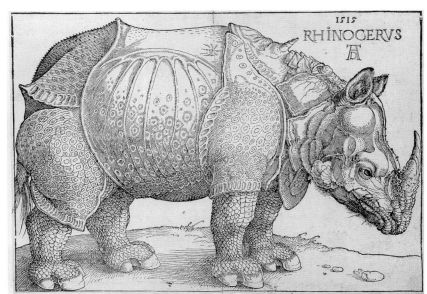

9-24 **You might find it hard to believe that this complex image is in fact a woodcut. How does Dürer's careful detailing lend itself to a realistic depiction of this wild animal?** Albrecht Dürer, *The Rhinoceros,* 1515. Woodcut on paper, 8½" x 11¾" (21.3 x 30 cm). The Art Institute of Chicago, Gift of Mr. and Mrs. Potter Palmer.

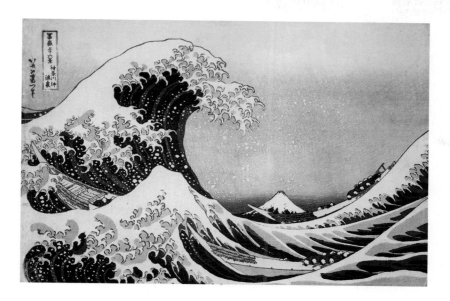

9-25 **Japanese artist Hokusai illustrated the highest and most sacred mountain of Japan many times using colored woodcuts. How does the application of multiple colors contribute to the success of the final image?** Katsushika Hokusai, publisher: Nishjmura-ya Yohachi, (Eijudo), *In the Hollow of a Wave off the Coast at Kanagawa* (popularly called *The Great Wave of Kanagawa*), 1830–31. Woodblock print, ink and color on paper, horizontal oban; 10 3/16" x 14 15/16" (25.8 x 38 cm). Museum of Fine Arts, Boston, William S. and John T. Spaulding Collection. Photograph © 2003 Museum of Fine Arts, Boston.

*into* the plate. An intaglio plate is metal, usually a sheet of copper or zinc (although sheet plastic is sometimes used).

The two kinds of intaglio are *engraving* and *etching*. To do engraving, the artist cuts lines into the plate using a special gouge called a *burin*. To do an etching, the artist covers the plate with a layer of wax, called a *ground*, and

9-26 **In places, such as the center of the boy's face and his hand, the etched or aquatinted areas received relatively few immersions in acid. In the darker places, such as the top of the head and the clothes, the etching processes were repeated several times. How does this variation add to the etching's expressiveness?** Cyprian Mpho Shilakoe, *The Blind* (detail), 1969. Etching on paper, 30 1/4" x 20 1/4" (76.8 x 51.4 cm). National Museum of African Art, Smithsonian Institution, Museum purchase.

draws into the layer with a needle. When the plate is placed in acid, the acid eats into the exposed lines. Usually, the artist has to repeat the procedure of applying ground, cutting into the ground, and immersing the plate in acid a number of times to create an image. *Aquatint* is a variation of etching. With aquatint, the artist bonds particles of resin to the plate, then blocks out those areas that are not to be eaten by the acid with a coat of shellac. When the plate is placed in the acid, only the very small spaces between the resin particles are eaten.

Both engraving and etching use the same printing technique. Black ink is rubbed into the engraved or etched lines. These are transferred to a piece of paper under the extreme pressure of an intaglio press. Engraved lines look hard and "steely." Etched lines appear softer. Etched areas using aquatint appear gritty.

*The Blind* (fig. 9-26) is a touching portrait of a boy victimized both by blindness and by South Africa's system of racial oppression in the 1960s. To make *The Blind*, Cyprian Mpho Shilakoe used a variation of acid "baths" to achieve his expression.

## Lithography

In lithography, the image is *on* the surface of the plate (see **Student Handbook**, page 491). Lithography is one of the most widely used of all print-making methods. It is based on the principle that oil and water do not mix. The artist draws on the flat surface of a block of limestone with a greasy crayon. Then the surface is dampened with water. Of course, the grease lines do not absorb the water. When the artist rolls oily ink onto the plate, the damp part of the surface repels the ink. The crayoned lines, however, receive the ink. These lines are then transferred to paper. (In contemporary lithography, artists often use liquids instead of crayon, and zinc or aluminum plates instead of stone.)

The final print often reflects the marks of the crayon. A lithograph therefore tends to resemble a drawing made with crayon or charcoal. Dox Thrash's brooding *Harmonica Blues* (**fig. 9-27**) looks like a charcoal drawing in places. In other places, such as the crosshatching in the lower part of the print, it resembles an ink drawing or even an etching. Thrash even used abrasives on part of the stone to achieve still other effects.

In the hands of other artists, lithography takes on the characteristics of painting, rather than charcoal. Toulouse-Lautrec (**fig. 9-28**) used the medium to make posters for a Paris nightclub that he frequented. One of his favorite subjects was Jane Avril, who sometimes entertained customers by dancing the can-can.

9-27 **Dox Thrash focused on the African-American community for his subject matter at a time when its identity was becoming more strongly defined. How can art help strengthen the identity of a cultural group?** Dox Thrash, *Harmonic Blues*, 1940. Courtesy The Free Library of Philadelphia.

## Silkscreen

*Screen printing* is the newest of the printmaking media. It is essentially a stenciling process. The artist creates a design or image on a stencil, and places it on a screen made of nylon or polyester that is stretched tightly over a frame (see **Student Handbook**, page 491). The stencil, which can be made of paper, photo-screen emulsion, or other block-out or resistant materials, is adhered to the screen. The artist forces ink through the open areas of the screen with a squeegee. A separate screen is needed for each color printed. Because silkscreen does not require heavy plates

9-28 **The poster began to thrive as an art form with the invention of color lithography in the late nineteenth century. How does the artist use his design to emphasize the grace and excitement of this famous dancer?** Henri de Toulouse-Lautrec, *Jane Avril*, 1899. Five-color lithograph poster, Rosenwald Collection, Image © 2003 Board of Trustees, National Gallery of Art, Washington.

or presses, it is popular with artists. It lends itself to whimsical subjects such as Clayton Pond's *Self-Portrait in the Bathtub* (fig. 9-29). Silkscreen is also a popular medium for commercial artists and amateurs. Do you or your friends own silkscreened T-shirts?

Other whimsical examples of silkscreen consist of Andy Warhol's deadpan series of Campbell's soup cans, actress Marilyn Monroe, and even Marilyn's lips. Some of his works have persisted in the public's imagination to such an extent that they have become well-known icons. But Warhol also had a serious side, making, for example, images of electric chairs in a grim commentary on the death penalty, and images of car accidents to remind us of the dangers of careless driving. Warhol also ventured into environmentalism with a series of prints on the subject of animals in danger of extinction. The directness with which he captures the essence and dignity of these creatures is readily apparent in *Endangered Species: Orangutan* (fig. 9-30). Other animals depicted in the series include the Siberian tiger, bald eagle, and giant panda.

9-30 **The vividness and immediacy of the silkscreen medium is a perfect match for the theme and subjects of the series for which this image was produced. What aspects of the orangutan, as an endangered species, has the artist chosen to communicate in this image?** Andy Warhol, *Endangered Species: Orangutan*, 1983. Serigraph on museum board, 38" x 38" (96.5 x 96.5 cm). Courtesy of the Pennsylvania Academy of the Fine Arts, Philadelphia. Gift of Bernice McIlhenny Wintersteen.

9-29 **The term** *serigraph* **is often used to describe a fine art image created in a limited edition using the silkscreen process. Approximately how many screens do you think were used to produce this work?** Clayton Pond, *Self-Portrait in the Bathtub.* Serigraph, 23" x 29" (58.4 x 73.6 cm). Edition of 100, from the suite of eight images titled *Things in My Studio*. Printed and published by the artist. © Clayton Pond, 1973.

**Try It Yourself**

Look for interesting photographs in magazines like *National Geographic, Smithsonian,* and *Sports Illustrated.* Identify those with interesting points of view: low eye level, high eye level, close-up, and so forth. Also identify those that used wide-angle lenses or telephoto lenses. Are you able to tell which are which?

## Photography

Photography has become the modern *folk* medium, or art of the general public. Probably you and your friends have all used cameras at some time. However, you and your friends may not know much about the technology of photography. Though digital cameras are increasingly popular among amateur and commercial photographers, most serious photographers use film. This is due to the superior reproduction qualities of photographic as opposed to digital images.

9-31 **Wide-angle lens.** Photograph: Jack Hobbs.

9-32 **Telephoto lens.** Photograph: Jack Hobbs.

Like printmaking, photography is capable of producing identical copies. The finished product is even called a *print.* But photographers select scenes from life, and capture the light reflected from those scenes on light-sensitive film with a camera. (A digital camera begins this process the same way: light enters the camera through a lens. But rather than focusing that light onto film, it focuses it onto a computer chip.) A camera is simply a dark box with a *lens* that lets in light when the photographer trips its *shutter,* which opens and closes rapidly. To make the image of the scene visible, film must be *developed.* This involves immersing it in special chemicals. At this stage the film has become a *negative.* A negative is a semi-transparent image of the scene wherein the lights and darks are reversed. In a black-and-white film negative, the whites are opaque and blacks are clear. Light grays are barely translucent, dark grays are semitransparent. The negative is to a photographer what the plate is to a printmaker.

To make a print of the image, the photographer passes light through the film negative onto light-sensitized paper, which is then developed. This becomes the print, the final product. The print is a positive image of the original scene.

The photographer can control some things such as lighting, time of day, point of view, and distance. The photographer can also control film speed, width of lens opening, focus, shutter speed, and flash (see "Film Selection Guide" in the **Student Handbook**, page 494). The time and temperature of the chemical bath and length of exposure on the contact paper can also affect the final photograph.

9-33 **On his first trip to Yosemite as a young teenager, Ansel Adams was given a camera by his parents. The result was a life spent living in and photographing the Yosemite Valley. Why do you think Adams allowed the Sierra Club to widely disseminate images such as this one?** Ansel Adams, *Half Dome, Merced River, Winter, Yosemite Valley*, c. 1938. Silverprint, 15" x 19" (38 x 49 cm). Founders Society Purchase, John S. Newberry Fund. Photograph © Detroit Institute of the Arts.

Using available light is very important. For example, suppose a subject is very dark and the photographer does not have a flash. He or she would need to use fast film (which is the most sensitive to light), a wide lens opening to let in as much light as possible, and a slow shutter speed.

A most interesting variable is the *focal length* of the lens. This is the distance between the lens and the plane of the film in the back of the camera. By changing the focal length, the photographer can control the composition of the subject within the frame. The longer the focal length, the larger the subject appears to be and the more it fills the frame (see "Focal Length" in the **Student Handbook**, page 494). Lenses with short focal lengths (sometimes called wide-angle lenses) are good for indoor scenes or situations where the photographer is too close to the subject and wants to show more of it (**fig. 9-31**). Lenses with long focal lengths (telephoto lenses) are good for enlarging subjects that are too distant (**fig. 9-32**). Some lenses have fixed focal lengths. Some have changeable focal lengths; these are called *zoom* lenses.

Consider the decisions that Ansel Adams made when he photographed *Half Dome, Merced River, Winter, Yosemite Valley* (**fig. 9-33**). Did he journey some distance to locate the subject? Did he search for the spot from which to shoot it? Did he try different lenses to compose the scene within the frame? Did he wait long for the light and the cloud formations to appear before shooting? Did he take a number of shots?

## Write About It!

Dawoud Bey's photographs explore the inner character of teenagers to reflect the culture and drama of urban youth. Think about the culture in your community. Think about the population at your school—jocks, brainy, artsy, popular, not-so-popular. Look at their body language, expressions, friendships. How might a photographer like Bey use images to portray the youth at your school, or your circle of friends? What insights might the photographs reveal about teenage culture at your school?

Adams's photographs are about the grandeur and drama of the outdoors. Dawoud Bey's are about the ferment and drama of ordinary life, especially the life of urban teenagers. He portrays them in large formats, often in joined panels. Bey's portraits are definitely not the commercial type in which subjects are encouraged to say "cheese." The artist seeks to reveal the inner character of his sitters. His pictures also reveal insights about youth culture in general. The triple portrait *Sean* **(fig. 9-34)** is typical. Here Bey employs three panels, or a *triptych* format. (Triptychs were commonly used in the Middle Ages as altarpieces in Christian cathedrals.) Notice how the triptych arrangement achieves an asymmetrical balance. Bey often uses such devices to unify his multi-paneled portraits.

## Film

People have always been fascinated by moving pictures. The "peep show" was a machine that created the illusion of motion. The viewer turned a crank to move a series of photographs. Each photograph showed an image in a slightly different position. If the viewer turned the crank rapidly, the images appeared to be moving. If the viewer turned the crank too slowly, the viewer saw the individual pictures begin to separate. The illusion of motion disappeared. Today's movie projector is based on the same principle of still pictures moving in rapid succession. Of course, the pictures are printed on a long strip of film and projected on a screen for many to see.

The film camera, like a still-photography camera, is an enclosed box. The

9-34 **The artist who took these pictures has said he began photographing young people as the central subjects of his work because he believed that "a continuing set of social cliches and stereotypes cling to this population." In what new way does he make us see this teenager?** Dawoud Bey, *Sean*, 1998. Polacolor, 30" x 66" (72.6 x 167.6 cm). © Dawoud Bey, 1998. Courtesy Gorney Bravin + Lee, New York.

9-35 **The movie still is an important marketing tool for commercial films. What kinds of things do marketers need to consider when brainstorming ideas for a still photograph? What does this still seek to convey about the movie Charlie's Angels?** Columbia TriStar Home Entertainment. © 2000 Global Entertainment Productions GmbH & Co. Courtesy Corbis.

film is contained in large reels called film *magazines*. The film has holes on the sides; sprockets in the camera engage the film and briefly hold it in place. The film is fed through the camera in a rapid stop-and-go motion. A single frame is pulled into position behind the shutter, the film stops, and the shutter opens, and a single image is exposed. This is repeated twenty-four times a second—the standard rate of speed for sound film. After the film is developed it is run through a projector at the same speed and with the same stop-and-go action.

All the variables of still photography apply to film (except shutter speed, which is constant). In addition, the filmmaker must also consider the movement of people and objects, and the movement of the camera itself. (In **Chapter 8, Principles of Design**, you learned the concept of the shot and sequence.)

After the film has been shot, the scenes are cut and put together into the final product. This stage of filmmaking is called *editing*. The editor does not use all the film that was taken. Most editors working today use computers or digital editing systems to compile a film.

Commercial films, like *Titanic, Braveheart,* or *Charlie's Angels* (**fig. 9-35**), are the creation of a *director* who supervises an army of people: writers, artists, musicians, carpenters, camera operators, sound technicians, editors, stunt men and women, not to mention actors and actresses. Think of it. All of these people are involved in the making of an *illusion*.

Ordinarily, we don't think of painters and sculptors as filmmakers. But in the 1960s and early 1970s, some experimented with small handheld cameras and did their own editing.

*Video* refers to the picture portion of television. The images seen on television are created by electronic signals. A video camera is a tube with a lens and a photosensitive electronic plate in the back. For broadcast, the image on the plate is converted to electric signals by a scanner. The signals are transmitted through the air or carried by cable to a television *receiver*. There, the signals are converted back to the original image. Television signals can also be stored on magnetic tape that can be played back at any time.

Because of recent breakthroughs in technology, many artists now use video instead of film. They use *camcorders*. Camcorders are handheld units that combine the functions of camera and recorder. Camcorders are small, easy to operate, and relatively inexpensive. They produce high-quality images. Thus, for the individual artist, video has distinct advantages over film. Tape is cheaper than film. The artist can play it back immediately on a camcorder instead of waiting for a film to be processed in a laboratory, threaded through a projector, and viewed in a darkened room.

Nam June Paik (fig. 9-36) was one of the pioneers of video art. He began making works for galleries and public television as early as the late 1950s—long before camcorders hit the market.

A good example of mixed-media video is *Partners/Parallel Play*, a series by artist Alix Pearlstein. Pearlstein mounts large photo prints on the gallery wall (fig. 9-37). She situates a single computer monitor on the gallery floor. The art is completed by Pearlstein's antics on screen, in which she "performs" a series of videotaped dances or poses while using cutouts of people as props.

The technology for computer art is developing rapidly and constantly changing. Today, it is commonplace for people to create two-dimensional images on their home computers. A few years ago, larger systems and technical sophistication were needed to produce three-dimensional images and animation. But now, even these can be done on home systems.

9-36 **Nam June Paik manipulates images electronically to create moving geometric patterns. Some have jokingly called these patterns "moving wallpaper."** Nam June Paik, *Video Flag*, 1985–96. Seventy video monitors, four laser disc players, computer, timers, electrical devices, wood and metal housing on rubber wheels, 94 3/8" x 139 3/4" x 47 3/4" (239.7 x 354.9 x 121.3 cm). Hirshhorn Museum and Sculpture Garden, Smithsonian Institution, Holenia Purchase Fund, in Memory of Joseph H. Hirshhorn, 1996.

9-37 **The photos in an Alix Pearlstein display consist of stills drawn from her various video performances. In what way do you think creating still shots from a video might increase an artist's creative choices?** Alix Pearlstein, *Partners/ Parallel Play,* 1998. Large color photographs, nylon thread, video, and mixed media, dimensions variable. Courtesy of the artist.

The brain of the computer, the central processing unit (CPU), is basically a board with electrical circuits and transistors. The smallest unit of information for the CPU is a *bit* or *binary* digit. Binary refers to two numbers: 1 and 0. Think of a bit as an electrical switch: 1 is on, 0 is off. A string of binary numbers, that is, a pattern of on-off switches, makes up a *pixel.* A pixel can be translated into a dot in a specific location on the video screen. Of course, dots can be extended into lines, and lines can form images.

To create the effect of three dimensions, the artist uses the tools of foreshortening, perspective, aerial perspective, shading, texture, cast shadows, and reflections—just as a traditional painter would. Special *programs* are required for these tools on a computer.

David Szafranski prints out his computer-generated compositions (**fig. 9-38**) that, like paintings or prints, can be hung on a wall. Employing the power of the computer, he creates tantalizingly complex colorful abstractions.

9-38 **Notice how the computer artist has created a seemingly endless modular pattern in this work. How do computer abstractions like this one differ from the abstract paintings in other media that you've seen in this book?** David Szafranski, *God Is in the Details,* 1998. Digital ink jet on paper, variable dimensions. Courtesy of the artist.

### Linking Disciplines
#### Literature

Many of the creation stories from different cultures were developed to explain natural phenomena or how something came to be. Select an art medium discussed in this chapter and make up a story to explain how and why it came into existence. Then use that art medium to produce an illustration for your story.

So far, we have seen everything from mosaics to computer art in this chapter. During the 1900s, new media like acrylics, silkscreen, photography, film, video, and computer art have either been invented or come into their own. No doubt, the list of two-dimensional media will continue to grow in this century.

The discussion of media in our day is further complicated by the fact that many artists no longer keep the media separate. Some artists mix two or more together, or add "foreign" materials. Recall, for example, the stuffed goat attached to a painting in Chapter 1 (fig. 1-12, page 9). The artist of that work, Robert Rauschenberg, has made a career out of what he calls "combine paintings." Some of these works often are not paintings at all. Betye Saar combined assorted fabrics, brass, hardware, jewelry, knickknacks, and pictorial elements in *Wizard* (fig. 9-39). Like Rauschenberg's goat, Saar's mixed-media work is difficult to interpret. Because it tends to mix two-dimensional and three-dimensional approaches, Saar's work is also difficult to classify. (In the next chapter, you will see many examples of three-dimensional mixed media.)

### Collage

A collage consists of fragments of things pasted on a flat surface. The artist may use photographs, colored paper, pieces of material, news clippings, and other odds and ends. In addition, strokes of paint, charcoal smears, or anything, as long as it is basically flat, may be combined with the above. Invented around 1912 by Pablo Picasso and Georges Braque, collages have become very popular in recent years.

*Still Life with Chair Caning* (fig. 9-40) is believed to be the first fine art collage ever created. Picasso combined oil painting with a piece of oilcloth that has a woven caning pattern printed on it. He used a piece of hemp rope to create the frame. Picasso indicated in later years that the purpose of these early collages was to introduce different textures into compositions and to blur the line between the artworks and reality.

9-39 **Betye Saar collects and stores objects and materials in anticipation of using them in a future work. How might the use of found materials both limit and expand creative possibilities?** Betye Saar (b. 1926), *Wizard,* 1972. Assemblage box and mixed media, 13 1/4" x 11" x 1" (34 x 28 x 2.5 cm). Courtesy of Michael Rosenfeld Gallery, New York, NY. Photo by Frank J. Thomas.

9-40 **Many consider this collage to be a key piece in the development of Cubism, as well as an important work in the history of collage. What role does the rope frame play in the design?** Pablo Picasso, *Still Life with Chair Caning*, 1911. Oil and pasted oilcloth simulating chair caning, oval 10 5/8" x 13 3/4" (27 x 35 cm). Copyright 1993 ARS, New York/SPADEM, Paris.

## Documented Art

During the late 1960s and early 1970s some artists began to expand their media into areas where art was created for a particular site or mixed with the life around it. Their works engaged the viewer in ways very different from that of traditional media. Examples of this include the Sandra Skoglund installation in Chapter 8 **(fig. 8-41, page 192)** and the wrapped coastline discussed in Chapter 1 **(fig. 1-11, page 9)**. (You will learn more about these art forms, called *installation art* and *environmental art*, in the next chapter.)

Other artists began a trend going in the opposite direction. They reduced their art to just its idea or concept.

Some of these artists have argued that it is possible to create art without objects. This type of art is sometimes called *conceptual art* (this art form, too, will be discussed in the next chapter).

One thing that all these developments had in common was the use of documentation. Because the works were temporary, a record of them had to be made. Works were documented in the form of writing, photocopies, photographs, film, audiotape, or videotape. The Christo and Skoglund works are documented with photographs. Pearlstein's whimsical poses are documented with large photo prints **(fig. 9-37, page 235)**.

# An American Regionalist Painting

9-41 **You may recognize the couple portrayed in this painting because of its use in posters and advertisements. The work deserves recognition as a dedication to the American farmer in the early 1930s, a time of crisis and upheaval in American history.** Grant Wood, *American Gothic*, 1930. Oil on beaverboard, 29" x 24½" (74.3 x 62.4 cm). Friends of American Art Collection, All rights reserved by The Art Institute of Chicago and VAGA, New York, NY.

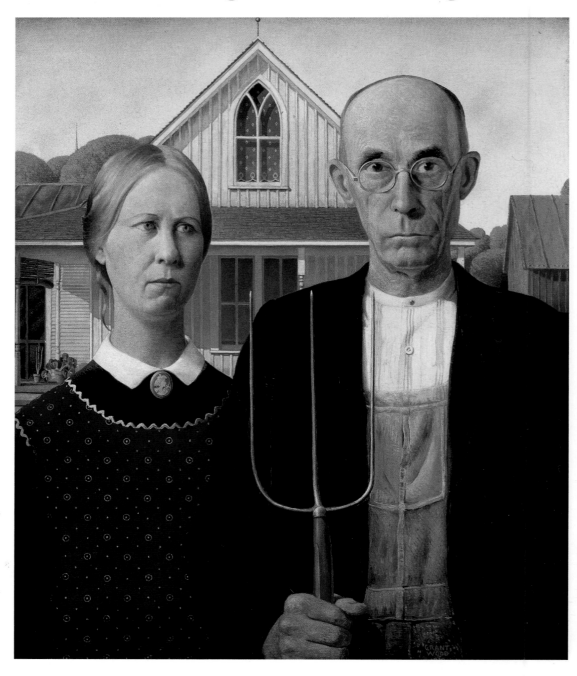

### About the Artist
## Grant Wood (1891–1942)

Growing up in Iowa placed a lasting mark on the art and career of **Grant Wood**. Wood studied art in Europe on his four trips there between 1920 and 1928. He resolved to incorporate what he had learned into a distinctive style and use it to depict the American landscape and people. Wood, with Thomas Hart Benton and John Steuart Curry, formed the heart of the American art movement known as Regionalism. He lectured and taught throughout the United States with the goal of promoting a regionalist approach to art.

## 1 Describe **What You See**

When you describe an artwork, you identify the things about the work that you can see, name, and describe with certainty. You should not include opinions, evaluations, or possible meanings here.

- Identify the artist, title, date, medium, and style of the work.
- What forms, objects, and environment are represented?
- What are figures doing, and how are they dressed?
- Identify different kinds of line, and their locations. Where do you see patterns?
- How is depth implied in the painting?

## 2 Analyze **the Way It's Organized**

When you analyze an artwork, you tell how the subject matter and elements of the work have been organized by the artist. You tell how they work together.

- How do overlapping forms direct your eyes?
- Where do you see repetition of elements and shapes?
- Identify large-to-small progression of forms.
- Where are the darkest (heavier) colors located, and why?
- What causes the dominant vertical movement, and what counters it?
- Why is the man the dominant form?
- How does the house gable relate to the figures?

## 3 Interpret **What It's Saying**

Use the information from your description and analysis to help you identify the meaning of the work—what it tells you about human experience.

- What moods or feelings does the work suggest? What does it remind you of?
- What elements of the composition contribute to that feeling?
- Look up the term *Gothic*. Why did Wood use elements of the Gothic painting style in the figures and house?
- With what profession do you associate the man's dark coat and high button collar?
- Create a simile or metaphor to help determine the idea or meaning of the work.
- What do you think the work is about?

## 4 Evaluate **Its Success**

Using your analysis in the first three steps, how would you judge the quality or success of this work?

- Which philosophy do you base your judgment on? A successful artwork: (1) is true to life, imitates reality, (2) is designed for perfect relationship among elements, (3) expresses significant ideas, feelings, emotions, or (4) advances human interests, a purpose, or a cause.
- How successful is the work in communicating a significant idea?
- How successful is the arrangement of elements and forms in achieving compositional unity?
- How successful is the interrelation of subject, purpose, and painting technique?
- How well known is the artist? this painting?

**More Art!**
See page 252 for more artworks by Grant Wood

**Web Links**
www.davis-art.com

### Computer Option
Scan a grouping of small objects, such as keys, fabrics, ticket stubs, concert tickets, photos, charms, and jewelry, in an interesting composition. You may want to use objects that have special meaning for you. Print out one color copy of your scanned composition on 8½" x 11" paper. Print another copy in black and white. Using the color copy, draw the composition to scale as realistically as possible on another sheet of paper in black and white with a 2B pencil. (Your values and textures should be identical to the color copy except yours are in gray values.) Now, hand-color the black-and-white printout using colored pencils. Compare your images to the scanned images as you critique your success with *trompe l'oeil* techniques.

# Trompe l'Oeil in Value Study

How can you use pencil to show high contrast and a wide range in value? Try creating a small *trompe l'oeil* still life by drawing a variety of well-lit found objects arranged as a low relief.

9-42  Student work, Heather Freeman (detail). Pencil, 7" x 9" (17.8 x 22.9 cm).

### Before You Begin
Study works such as those by the American artists William Michael Harnett (fig. 9-45) and Alan Magee. Think about the French term *trompe l'oeil*, which translates to "trick of the eye" or "deceiving the eye through optical illusion."

9-43

### You Will Need
- found objects such as keys, ticket stubs, jewelry, stamps
- foam core
- tape, pins, white glue
- white drawing paper
- drawing pencils

### Create It
❶ Select 3–5 found objects to mount on a piece of foam core. Arrange objects as a low relief that you will use as the inspiration for your *trompe l'oeil* still life, demonstrating value and contrast. Focus the composition so that it measures approximately 7" x 9" in the upper portion of the foam-core board. Use pins, glue, or tape to make sure the objects remain fixed to the board.

**2** Create contrast between the objects and the foam core by introducing a strong light source either with a portable clip-on light or by working in an area of the classroom where there is good natural light. Allow the light source to cast shadows that will enhance different shapes and textures of the objects.

**3** Use pencil on your white drawing paper to first draw light gray contour lines to establish the composition. Save for last the development of the rich dark gray values to black.

## Evaluate It

- How does your work show a clear range of values?
- How well did your chosen objects serve as subjects for a value study?
- Which object was the most challenging to draw? Why?
- How did working in a miniature format help you to produce rich values and experiment with ranges of gray scale?

9-44 Student work, David Betz. Pencil, 9" x 7" (22.9 x 17.8 cm).

### Technique Tip

Proceed slowly, moving from the lightest grays to the darkest to avoid smearing.

### Write About It!

William Michael Harnett's *Old Violin* **(fig. 9-45)** clearly represents music, and the subjects he chose to depict were well known and popular among the middle class in the nineteenth century. Are the objects you chose to draw easily recognizable as everyday items? How do your objects reflect your interests? Why did you choose them? Do you use them in your daily life? Are they meaningful or do they provoke special memories for you?

**Art History**

## Studio Background

For centuries artists have created illusions to trick the viewer's eye. Roman mosaicists created "unswept floors" that caused the onlooker to think there were morsels from a recent meal still strewn on the floor.

In the later nineteenth century, several American artists excelled at *trompe l'oeil*. The acknowledged master was William Michael Harnett. When his work *The Old Violin* was first exhibited, people flocked to see it. There are reports of viewers reaching out to touch the violin and attempting to pull the curled sheet music from the wooden door. These *trompe l'oeil* paintings found great favor with the public, who applauded them and found meaning in their subject matter. Interestingly, the critics were not particularly receptive to the works and viewed them merely as tricks or imitations.

9-45 **The sheet music in this work represents melodies that were popular and known to the middle class of 1886, and the violin is an eighteenth-century instrument from the artist's collection. How do value and shadow in this painting play a key role in "tricking" the viewer?** William Michael Harnett (American, 1848–1892), *The Old Violin*, 1886. Oil on canvas, 38" x 23 5/8" (96.5 x 60 cm). Gift of Mr. and Mrs. Richard Mellon Scaife in honor of Paul Mellon, National Gallery of Art, Washington, DC.

### Technique Tip
Draw while looking at the subject and stop when looking down at the paper. The pencil can be picked up at any time, but it should only be moved when your eyes are on the model.

### Write About It!
Study the lines and shapes in your drawing. How did your watercolor wash change the way you see your image? How did it help unify it? Look at the blending of media, density, line, shape, and color. Did it work the way you thought it would? What unexpected additions did you find?

# Figure Study in Watercolor Wash

Use a watercolor wash on a contour drawing of a human figure to show how the wash technique can be used to create both rich mixed color applications and subtle colors.

### Before You Begin
Understand that a contour line is not limited to the edge of a given form. Practice making a series of contour line drawings of the human form, using your classmates as rotating models.

### You Will Need
• vellum or watercolor paper
• assorted watercolors
• pencil
• watercolor brushes

### Create It
❶ Start by taking 10 to 15 minutes to sketch a series of figures, using your classmates as rotating models. Then sketch for about 20 minutes to create a large contour drawing of the human figure using a modified contour line.

❷ Fragment, grid, or divide the drawing in such a way as to create a more visually interesting image using either linear or spiral lines. Experiment to increase the number of pre-existing

9-46 Student work, Josh Kirsch. Watercolor, 30" x 24" (76.2 x 60.9 cm).

shapes inside and outside of the human form. Imagine how this will work when color is applied.

❸ Apply watercolor washes by mixing colors. Change the color density within the image. Use denser applications to create a richer color and less to make a more transparent wash.

### Evaluate It
• How did you divide your image to help focus the viewer and create a stronger composition?
• Where do you find the effects of color mixing and changes in density in your work?
• What aspect of your image do you feel is most visually striking?

9-47 Student work, Alisandra Wederich. Watercolor, 18" x 24" (45.7 x 60.9 cm)

9-48 Student work, Chiu Chen Yeh. Watercolor, 24" x 18" (60.9 x 45.7 cm)

9-49 Student work, Siena Artuso. Watercolor, 24" x 18" (60.9 x 45.7 cm)

## Computer Option

Scan your contour figure drawing into a paint program. Use the selection tool to select, copy, and paste parts of the drawing. When each part is pasted, it should appear directly above its background. Use the move tool to shift each copied part to place it slightly out of line with the background. This will give your drawing a fractured, Cubist look. Choose each layer and color it with the paint bucket and a color scheme of your choosing. Now select layers and vary their transparency so that you can see through them to your original drawing. Save and print your image.

## Studio Background

Winslow Homer was responsible for advancing watercolor beyond its traditional use for sketching to a respected position as a painting medium. *The Adirondack Guide* shows the artist's versatility in the use of both the looser washes of the background and the more finished handling of the figure and boat. Homer had several techniques for creating light areas besides the traditional method of reserving areas of white in the composition. He sometimes would wipe a color to lighten it, and on occasion would scrape away paint with a knife. The artist is truly one of the great watercolorists. His words "You will see, in the future I will live by my watercolors" indicate that he himself understood his unparalleled mastery of the medium.

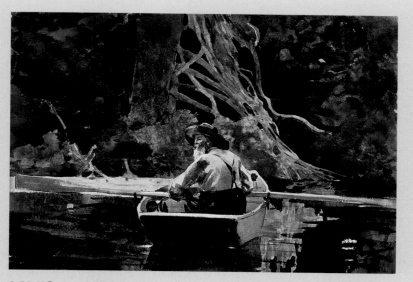

9-50 **When painting with watercolor, an artist works from lights to darks. The medium cannot be completely controlled, especially with regard to the merging of color, so an artist must have a sure understanding of the technique. Can you find areas of color in this painting where the merging was not entirely controlled?** Winslow Homer, *The Adirondack Guide*, 1894. Otis Norcross Fund. © Museum of Fine Arts, Boston.

# Color Mixing with Acrylic Paint

In this exercise, you'll receive a small portion of a famous painting, which you will attempt to replicate on an enlarged scale by paying close attention to color and the textures created by those colors.

**Technique Tip**
Use watercolors to practice color mixing.

**Write About It!**

How did your painting's texture and color change once it was enlarged? How were they different from your first impression on the small image? Does it look like the same picture? What looks different? What stands out now that it's big? Does it look like it's from the same painting and artist, or has the style changed? What looks different?

## Before You Begin

Study the color wheel, defining primary, secondary, complementary, and inter-mixes of color. Review warm and cool colors and analogous colors (see **Chapter 5, Value and Color**).

## You Will Need
- circle of paper
- watercolor paper
- illustration board
- acrylic paint, paper palettes, brushes

## Create It

**1** Create a color wheel on the 12-inch circle of paper using only the three primary colors. Start by placing the three primaries a third of the entire paper distance apart. This is followed by mixing the secondaries and then the intermixes between each series of color. Focus on how much color is mixed before it becomes a completely different color. Try to make a smooth transition from one color to the next through the entire circular color wheel.

**2** Practice shades and tints using acrylic on a sheet of 9" x 12" watercolor paper. Add white to a given color (tinting) and add black (shading). Select any color and make a transition from that color on one side of the paper to the other, by adding small amounts of white to that original color. Then take the same color and add small amounts of black. The results of both shading and tinting will show a transition in your chosen color to pure white or black on the opposites sides of the paper.

**3** Paint an enlarged view on the illustration board of the smaller portion of a famous painting seen on the 3" x 4" color swatch you are given by your teacher. You may use a few pencil lines

9-51 Student work

9-52

9-53 Student works (detail). Acrylic on illustration board.

9-54 Student works.
Acrylic on illustration board.

to begin to proportionally enlarge the visual information onto the larger illustration board panel. Aim to match the color, texture, and direction in which the media was applied in the original swatch.

## Evaluate It

• What is the effect of mixing complementary colors together?

• What did you learn about color mixing and color blending when developing the color wheel?

• How close was your color mixing in the enlarged version of the small poster reproduction?

• Can the viewer see how the texture, color, and movement were replicated? Does the complete image hold together?

## Art History

# Studio Background

The nineteenth century saw the invention of two items critical to the career of Vincent van Gogh: the paint tube and the portable easel. The portable easel let the artist paint wherever he was—whether it was outdoors, or in his room in the hospital at St. Rémy.

The availability and convenience of paint tubes allowed van Gogh to apply color to his canvas in a manner never seen before. Sometimes using a palette knife, and sometimes even applying color directly from the tube onto his canvas, the artist developed the intensely colored and textured surfaces for which he is so well known.

9-55 **This image shows a detail, or small portion, from van Gogh's** *Starry Night*, **which is a scene of imagination and emotion rather than of a specific place. What adjectives come to mind when describing this work? In what ways does the actual texture of the paint help contribute to your impressions?** Vincent van Gogh, *The Starry Night* (detail), 1889. Oil on canvas, 29" x 36¼" (73.6 x 92 cm). The Museum of Modern Art, New York, NY. Acquired through the Lillie P. Bliss Bequest. Licensed by SCALA/Art Resource, NY.

# Creating Visual Movement Through Printmaking

Express the visual quality of movement through the process of printmaking by creating an overprinted image.

9-56 Student work, Steve Adams. Block print, 6" x 8" (15.2 x 20.3 cm).

9-57 Student work, Matt Stillwell. Block print, 6" x 6" (15.2 x 15.2 cm).

## Before You Begin

Study examples of printmaking that show movement, such as Hokusai's *The Great Wave* (fig. 9-25, page 227). Look at the placement or angle of the subject, changes in color density, and any additional directional lines that enhance movement.

## You Will Need

• newsprint paper and printmaking paper
• a linoleum block or flexible printing plate
• a variety of gouging tools
• printers ink in a variety of colors
• pencil, fine-line permanent marker, ballpoint pen

## Create It

**1** Select a subject that offers a quality of movement, such as skiing, skateboarding, cars, planes, etc. Sketch the subject on a sheet of newsprint paper, establishing the overall composition. Transfer the image onto the plate using pencil by tracing it or freehand. Use a marker to darken the final lines. Remove any lines or shapes you wish to remain white.

**2** Use gouging tools to carefully carve the surface of the plate. Direct the tool away from the hand holding the plate and turn the plate, not the tool. Roll an even layer of ink onto the plate. Place a sheet of printing paper onto the inked plate. Use a wooden spoon or baren to apply pressure. Lift the paper carefully to make sure enough ink has been applied before the print is actually pulled. Add additional ink, if necessary, not letting the brayer touch the printed image. Pull a series of five single-color prints.

**3** For a second printing, gouge and remove more of the plate to create a greater sense of movement in the final

9-58 Student work, Alan Sweeton. Block print, 6" x 6" (15.2 x 15.2 cm).

overprinted image. Apply a second color evenly to the surface of the plate. Carefully align the first print before pressure is applied to create an overprinted image.

## Evaluate It

- What did you learn about the placement of the subject to increase the concept of movement?
- Which images from the class demand the most attention? Why?
- Which of your prints show the most movement? How was that accomplished?

### Write About It!

Put yourself inside your image. Imagine yourself moving. What does it feel like inside the borders of your print? Is it fast, slow, windy, calm, quiet, or loud? What elements (color, directional line) make it feel that way? Use your imagination to dream about where your print is taking you.

### Safety Note

Direct the gouging tool away from the hand holding the plate and turn the plate, not the tool.

## Art History

# Studio Background

In an era when newspapers did not yet have images to illustrate their stories, Currier and Ives found a niche in the popular mass market selling color lithographs. These prints depicted disaster scenes, portraits, ships, trains, city scenes, and a host of other subjects. Printed in a factory in New York City, the images were hand-colored by women who sat on an assembly line. Each colorist was assigned a single hue and used a master image as a guide to know where the color should be placed.

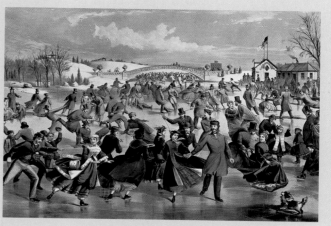

9-59 **During the course of the late nineteenth century, Currier and Ives built an inventory of over 7,000 subjects. The prints ranged in price from a few dollars to less than fifty cents. How has the artist constructed compositional movement to lead your eye through the image to the bridge in the rear?** Lyman W. Atwater, after a painting by Charles R. Parsons, *Central Park, Winter: The Skating Pond,* Published by Currier and Ives, 1862. Museum of the City of New York; J. Clarence Davies Collection.

**Write About It!**

Look back at Clayton Pond's *Self-Portrait in the Bathtub* **(fig. 9-29, page 229)**. How does he accentuate the positive and negative space in his print? What compositional strategies did he use to create balance and emphasis? Think about his point of view, but also shape, color, and composition. What strategies were you able to employ to maintain visual interest in your own print?

# Balancing Positive and Negative Through Stencil Printing

In this exercise, you will develop an expressive self-portrait that accentuates balance and awareness of positive and negative space through stencil printing.

9-60  Student work, Josh Kirsch. Color stencil print, 8¹/₂" x 11" (21.6 x 27.9 cm).

9-61  Student work, Dianna Wojeck. Stencil print on fabric, 8¹/₂" x 11" (21.6 x 27.9 cm).

## Before You Begin

Understand that stencil printing in America dates back hundreds of years and was used as a decorative element on walls and blanket chests. Today this technique is used in more individually expressive ways.

### You Will Need
• white vellum paper
• oak tag or stencil paper
• black acrylic paint
• stencil brushes
• pencil

## Create It

❶  Draw, in pencil, a vertical self-portrait on the white vellum paper. Fill the entire sheet, leaving a small amount of compositional space in the background, in which to write your name in cursive. Trace this drawing onto oak tag or stencil paper so that the image can be cut into a series of negative spaces.

❷  Decide what is to be cut from the entire picture plane, creating negative spaces from the human face. First cut your name, in order to understand which areas can be removed but still maintain integrity and readability. Leave borders determined by the size of your drawing on the oak tag for support. Fifty percent of the finished image will be in positive shapes and fifty percent will be in negative.

**3** Practice by using paper in order to judge how much paint is needed to create a successful print. A minimum of four prints are expected using acrylic paint as the medium. The first two, on paper in black, the third on fabric in black, and a fourth on paper using personalized color. Realize that the surface texture affects the quantity of paint needed and you will need to make adjustments.

**4** Finally, print your image on a piece of white cotton fabric. Print it on the class panel as instructed by your teacher.

## Evaluate It

• How effectively did you balance positive and negative space in the final image?

• How does your composition maintain interest?

9-62 Student works. Stencil prints on cotton fabric hung together in front of a large window.

### Computer Option

Using a variety of vegetables sliced in half (provided by your teacher), take digital photos of each cross section. In a paint program, select, copy and paste into a blank 8½" by 11" canvas. Combine these in one interesting and well-developed composition. Use a paint tool or a stamp filter to reduce them to simpler shapes and lines, and positive and negative spaces, and use only black-and-white in your reduction image. Emphasize the positive/negative and the simple shapes and lines. Save, print, and critique.

## Art History

## Studio Background

A type of stenciling called theorem painting was imported to the United States in the late eighteenth century. It arrived just after it had been introduced to England from China. The technique allowed those unable to purchase canvases by professional artists to create a type of painting for home decoration. The technique flourished among American women in the early nineteenth century. It involves using several stencils to outline objects in the composition. The stencils are cut in such a way that no two adjacent areas can be placed on the same stencil. Details are then added by hand.

9-63 **Stencils similar to those used for this painting also were employed in the decoration of walls and furniture during the early days of the country. How has the artist balanced this composition?** Collata Holcomb, *Still Life, Fluted Bowl*, c. 1820. Oil on velvet, 14" x 16½". Fenimore Art Museum, Cooperstown, NY.

**Technique Tip**

When taking photographs, the way your subjects are shown will affect not just how recognizable they are but also the mood you achieve. Whether your subjects are people or objects, be conscious of the way your subjects are lit, and also the perspective from which they are photographed.

# Creative Photomontage

How can you use the techniques of Cubism to tell a personal story in a photomontage, or a collage using fragments of photographs? Try using photographs of your room at home, and yourself in your room, to create a photomontage in David Hockney's "visual story" style.

9-64  Student work, Deirdre Coyle. Photomontage, 18" x 24" (45.7 x 61 cm).

9-65  Student work, Jason Saro. Photomontage, 18" x 24" (45.7 x 61 cm).

## Before You Begin

View works in the style of Cubism by Braque and Picasso. Then compare them to David Hockney's work, including his photographic collages (fig. 9-67). Ask yourself: What do Cubism and the work of David Hockney have in common? Understand that the combined effect of many photographs, as well as the use of fragmented images, creates a total visual impact.

## You Will Need

• throwaway camera or borrowed camera
• illustration board
• X-Acto knife, scissors
• a glue stick

## Create It

**1** View your room and decide which shots you would like to take of it. Take the entire roll of film (have a family member or friend photograph you.) Think about which things in your room are important to you, or what you would like to share with the viewer about yourself. You may wish to do this by repeating shots of the same view of one personal item, such as a pet, musical instrument, or stuffed animal. Develop the film and bring the pictures to class.

**2** Begin viewing, cutting, and arranging a composition with the photographs on an illustration board. Always view the composition before gluing it to make sure you will be satisfied with the final results.

**3** Use an X-Acto knife or scissors to cut the photographs into fragments that best relate you to your space. This arrangement should give the viewer insight about who you are and what you think. If you feel that your room does

9-66  Student work, Jessica Stanton. Photomontage, 18" x 24" (45.7 x 61 cm).

not fully represent you, feel free to manipulate the images, or create a contradiction that is visually interesting to you. Glue the final montage in place and let dry.

## Evaluate It

- How does your work reflect both Cubism and Hockney's approach to photomontage?

- What did you find most challenging about creating your composition?

- What would your photomontage tell a viewer about you and your personality?

## Write About It!

Write a brief autobiography supporting your photomontage in words. What do your photographs say about your personality, hobbies, family, and interests? What relevance do the photographs hold? Add a few sentences explaining the relevance of light, composition, and perspective in your construction.

## Safety Note

X-Acto knife blades are extremely dangerous. To prevent injury, use caution in cutting with these tools and in changing the blade. Keep plenty of free space around you. Always pull the knife toward you, keeping your free hand well out of the way.

**Art History**

# Studio Background

David Hockney has admired and studied Picasso since the 1950s. The influence of this giant of twentieth-century art is evident in much of Hockney's work. The connection between Cubism and the artist's photomontages is readily visible. Much as the Cubists fractured time and space by showing multiple aspects of a subject, the Hockney photomontages break apart continuous space and also are imbued with a sense of lapsed time. Hockney accomplishes this by taking multiple photographs of the same image in quick succession and then assembling them into a composition that is fluid, rather than fixed, in its portrayal of time and place.

9-67  **David Hockney creates his montages from a series of individually photographed details of a particular scene or figure that he then pieces together to make a composition. With which aspects of this scene do you think the artist was most fascinated?** David Hockney, *Sitting in the Zen Garden at the Ryoanji Temple, Kyoto, Feb. 19, 1983*. Photographic collage, Edition: 20, 57" x 46" (144.8 x 116.8 cm) © David Hockney.

9-68 Grant Wood, *Death on the Ridge Road*, 1935. Oil on masonite, 39" x 46" (99 x 117 cm). Williams College Museum of Art, Gift of Cole Porter.

9-69 Grant Wood, *The Good Influence*, 1936. Pencil, ink, gouache on wove paper, 12" x 9 1/2" (30.75 x 24.25 cm). Courtesy of the Pennsylvania Academy of the Fine Arts, Philadelphia. Collections Fund.

9-70 Benjamin Fry, *Valence*. Computer graphic. MIT Media Laboratory, Aesthetics + Computation Group. Copyright 1999–2002.

9-71 Judy Chicago, *Virginia Woolf* from *Reincarnation Triptych*, 1973. Sprayed acrylic on canvas, 5' x 5' (153 x 153 cm). Private Collection. Photo courtesy Through the Flower Archives.

## Summary

This chapter organized two-dimensional media under the headings of *drawing, painting, print-making, photography and film, video and computer art,* and *mixed media.*

Charcoal, pencil, and ink are examples of drawing media. They are monochromatic. They involve only the color of a single tool mixed with that of the paper. Colored chalks and pastels are multicolored and resemble painting. However, like other drawing media, they have a relatively fragile surface.

Painting media include watercolors, tempera, oils, acrylic, and fresco. Most painting media have ancient origins. Oil and acrylic paints were developed in more recent centuries.

Printmaking methods include relief, intaglio, lithography, and silkscreen processes. The oldest of these media is the woodcut, a relief process. Engraving and etching, both intaglio methods, later replaced the woodcut.

Traditional photography and film involve photochemical processes. Video art and computer art, involving electronic processes, use more modern technologies.

Mixed media reflect new ideas. Many artists of the twentieth century experimented with using media in novel ways. They even attempted to eliminate the medium altogether and keep just the idea.

## Review Questions

1 **Recall:** Name the colored powders that are mixed with liquids to produce paints.

2 **Understand:** Explain the difference between relief and intaglio printing.

3 **Apply:** Imagine that you have been asked to design an artwork that will commemorate a century of achievements by athletes in your school. Describe how and why you chose a particular medium and subject, and where the final artwork will be located.

4 **Analyze:** Choose an artwork from this chapter. Explain why its medium is appropriate for its subject matter, and how its impact might be lessened by another choice of medium.

5 **Synthesize:** Someone you know has told you that photographs can show people, places, or events as they really are, but can't really show ideas. Explain why you disagree.

6 **Evaluate:** Justify choosing Mary Cassatt as the artist who will be available to create children's portraits at your town or city's summer festival next year. Refer to her work in this chapter to support your argument.

## For Your Portfolio

Select one of the completed artworks you made in this chapter to insert in your portfolio. Attach an artist's statement describing the media and techniques used, the subject matter, how satisfied you are with the completed artwork, and why you think it is successful.

## For Your Sketchbook

Sketching and doodling help artists and designers think visually. Experiment with doodles using different media. Make a sequence of doodles that start with a simple shape. What ideas come to mind as you work with the shape? What media lends itself best to doodling?

## Electronic Research

To better understand how Diego Rivera's artwork developed over time, investigate The Virtual Diego Rivera Web Museum <http://www.diegorivera.com/> and The Diego Rivera Mural Project <http://www.riveramural.org/rivera/index.html>. How did he effectively create the illusion of volume with two-dimensional media? How and why did his art represent the historical events of his time?

## Going Further

How are art materials made? For example, what are the ingredients of tempera paint? Tempera paint used in schools is not the same as the tempera used by artists today and in the past. Research the history of tempera paint, how it is made, the techniques for its use, and the traditional support or ground for tempera painting. See if you can find directions for making egg tempera using artist-grade dry pigments. Work with a team of classmates to produce a variety of colors. Create a series of egg tempera paintings and write a report on your findings.

# 10 3-D Media

10-1 **This artist's sculptures are often described as "mysterious." Do you think the element of mystery is heightened by her choice of a three- rather than two-dimensional medium? Why or why not?** Magdalena Abakanowicz, *Four on a Bench*, 1990. Burlap, resin, and wood, 71½" x 88⅝" x 19" (181.6 x 225.1 x 48.3 cm). Hirshhorn Museum and Sculpture Garden, Smithsonian Institution, Museum Purchase, 1992.

- the major categories of three-dimensional art, and their characteristics
- the difference between sculpture in the round and relief sculpture
- basic techniques for sculptural media
- to identify media and techniques used in three-dimensional artwork
- to analyze relationships among media, subject matter, and meaning in three-dimensional artworks

**What This Chapter Covers**

**Art Criticism Step by Step**

**Studio Experiences**

**Key Terms**

*English (Spanish)*

*sculpture in the round*
   (*escultura en bulto redondo*)
*relief sculpture* (*escultura en relieve*)
*conceptual art* (*arte conceptual*)
*performance art*
   (*arte del funcionamiento*)
*environmental art* (*arte ambiental*)
*installation art* (*instalaciones*)
*fiber art* (*arte textil*)
*soft sculpture* (*escultura suave*)

**Artists**

Magdalena Abakanowicz, Adele Akers, Jose Alvarez, John Baldessari, Herbert Bayer, Gian Lorenzo Bernini, Xu Bing, Barbara Bohnett, George Borglum and Son, Elizabeth Catlett, Dale Chihuly, Christo and Jeanne-Claude, Colette, Viola Frey, Lorenzo Ghiberti, Julio González, Ann Hamilton, Duane Hanson, Lutz Haufschild, Dianne Itters, Jasper Johns, Ilya Kabakov, Joseph Kosuth, Earl Krentzin, Don Miguel Linares and family, Marisol, László Moholy-Nagy, Jesús Moroles, Robert Putnam, Diego Rivera, Meda Rives, Auguste Rodin, Jane Sauer, George Segal, Robert Smithson, Christine L. Sundt, Sarah Sze, Tom Turner, Kurt Webb, Claire Zeisler

**10-2** Student work, collaboration (detail). Painted river stones.

Drawings, paintings, and prints are two-dimensional works: they have height and width, but artists can only imply depth in them. Three-dimensional works, however, have height, width, and *actual* depth.

Many different media are used for three-dimensional artworks. You can probably think of works you have seen in stone, wood, or metal. Three-dimensional art can also be made from fibers, plastic, paper, glass, and clay. Some recent artworks have involved leaves, human beings, and even sound.

Sculpture is the largest category of three-dimensional artwork. Today, sculptures are created from almost any available material that is safe to work with. Sculpture that is meant to be viewed from all sides is called ***sculpture in the round***, or freestanding (fig. 10-3). Sculpture that is not freestanding but projects from a background surface is called ***relief sculpture***.

There are four main ways to make sculpture: it can be carved, cast, modeled, or constructed. Wood and stone are usually *carved*: their forms are shaped by removing material.

*Casting* involves creating a hollow shape called a *mold*, and filling it with a material that will harden. Ancient cultures developed the method we now call *lost-wax casting* to make large figures in bronze. Plastics, plaster, and concrete mixtures are also used to produce cast forms.

*Modeling* is the shaping of a form from a piece of soft, workable material.

10-3 **Have you ever seen this sculpture before? Casting allows many sculptures to be made from the same mold.** Auguste Rodin, *The Thinker (Le Penseur)*, model 1880, cast 1901. Bronze, 28 1/8" x 14 5/16" x 23 7/16" (71.5 x 36.4 x 59.5 cm). Gift of Mrs. John W. Simpson, Image © 2003 Board of Trustees, National Gallery of Art, Washington.

10-4 **Assemblage makes use of objects we may not expect to see in art. How has Marisol surprised you with some of her choices in this sculpture?** Marisol, *Women and Dog*, 1964. Wood, plaster, synthetic polymer and miscellaneous items. Installed: 72 1/4" x 73" x 30 15/16" (183.5 x 185.4 x 78.6 cm). Collection of the Whitney Museum of American Art. Purchase, with Funds from the Friends of the Whitney Museum of American Art. Photography by Robert E. Mates, NJ.

10-5 **This installation fills every surface of a large space with books, scrolls, and newspapers hand-printed with calligraphy.** Xu Bing, *A Book from the Sky*. Installed at the University Art Museum in Albany, NY, 1995.

*Constructions* are sculptures built from traditional or industrial materials shaped by the artist. The parts may be of a single material, such as metal, or a variety of materials.

*Assemblages* (**fig. 10-4**) are sculptures constructed from a variety of ready-made materials and objects not often intended for making art.

*Kinetic sculpture* is sculpture that moves. Kinetic sculptures may get their energy from wind, falling water, temperature changes, springs, air pumps, pull strings, or computers.

In the last half century, a number of new art forms, emphasizing the idea behind the work, have been identified as **conceptual art**. These include performance art, environmental art, and installations.

In **performance art**, the artist is a part of the work and interacts with viewers. **Environmental art** includes works that interact with, but do not alter, the natural environment, and works that involve a human-made environment. *Earthworks* refer to forms made primarily of earth, rocks, and plants. *Site-specific* works are those designed for the specific place in which they are displayed.

**Installations** are impermanent works that often bring together two- and three-dimensional objects and materials. Some of these works are simply large sculptures; others create an environment (**fig. 10-5**).

The methods for making *pottery* by hand are similar to those used for clay modeling. *Throwing* is the term used to describe forming clay into rounded symmetrical forms on the potter's wheel.

*Metal enameling* is a centuries-old process. In *cloisonné*, which is a form of metal enameling, gold and silver wire shapes are filled with colored, powdered glass, which is then fused to the metal by heating it to a high temperature.

**Fiber art** (**fig. 10-6**) is made from natural and synthetic fibers and fabrics. Weaving is the most common of the fiber arts. *Macrame* creates three-dimensional forms from knots; **soft sculpture** is made from combinations of fabrics and fibers.

The first *glass* beads and solid shapes were made by the Egyptians. Today, glass can be cast flat, blown into hollow forms in the open air, or blown into a mold. Stained glass is used to make both two- and three-dimensional forms.

10-6 **Imagine trying to create a form like this using fine wire. What challenges might you encounter?** Claire Zeisler, *Tri-Color Arch*, 1983–84. Hemp, synthetic fiber knotted, wrapped, 74" x 11" (188 x 28 cm), spill 66" x 44" (168 x 112 cm). The Metropolitan Museum of Art; Gift of Peter Florsheim, Thomas W. Florsheim, and Joan Florsheim-Binkley, 1987. Photograph © 1995 The Metropolitan Museum of Art.

**Try It Yourself**

If there are examples of freestanding sculpture in your community, find out who created them, what they are made of, and what their purposes are. Look for examples of relief sculpture on public buildings—are they low or high relief? Do the reliefs record or symbolize events, or is their purpose simply decorative?

The ancient Greeks defined sculpture as carving and modeling. Today, *sculpture* refers to any way of creating three-dimensional forms from any available materials.

### Sculpture in the Round

Historically sculpture has been produced by carving, modeling, casting, construction, or a combination of these processes. Some sculpture is meant to be seen from all sides and is called *in the round*, or freestanding. Gian Lorenzo Bernini carved his marble sculpture of *David* (fig. 10-7) as a man whose stance and expression show attitude and purpose. The twisting body induces the viewer to walk around the sculpture.

During the last Ice Age, people used stone tools to create the first sculptures. They began by scratching images in stone or on fragments of bone or animal horn. Later, they carved rock so that the image was raised from the surface in low relief. Eventually they carved small, rounded figures.

The discovery of bronze enabled ancient cultures to carve soft stone and wear down hard stone. The Egyptian figures of Rahotep and his wife Nofret are more than 4,500 years old (fig. 10-8). The figures were sculpted from limestone, which is relatively soft.

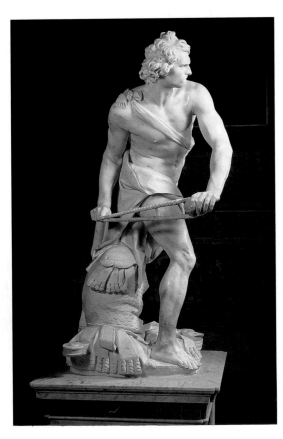

10-7 **The artist spent two years perfecting the mood and movement of this freestanding sculpture. Notice the momentary stance and coiled muscles.** Gian Lorenzo Bernini, *David* (from the left side), post-restoration, 1623–24. Marble. Galleria Borghese, Rome, Italy. Photo courtesy Scala/Art Resource.

10-8 **The discovery of bronze made it easier for Egyptian sculptors to carve limestone.** *Prince Rahotep and His Wife Nofret*, c. 2580 BCE. Painted limestone, height 47¼" (120 cm). Egyptian Museum, Cairo.

Iron tools were available to sculptors after about 500 BCE.

Wood carving dates back to ancient times, and, like stone carving, the sculpture is shaped by removing material. Although wood is easier to carve than stone and can be worked in fine detail, its grains and notches pose problems for the sculptor. Wood contracts and expands with heat and humidity, and is subject to mold and wood worms. Despite these limitations, the natural beauty of wood makes carving it worthwhile (fig. 10-9).

Sculpting stone or wood is very demanding. The artist may make drawings and clay models to show what the sculpture will look like from all sides. Preliminary rough-shaping of large works in stone is done with steel chisels and pneumatic hammers. Having rough-shaped the form, the sculptor uses wooden mauls, chisels,

and points for chipping and carving, and a small air hammer for details. He or she may smooth surfaces with files and disk sanders.

Wood is carved with mauls, sharp chisels, and gouges. A drill may be used to reach places a chisel can't.

Whatever material the sculptor uses, he or she is concerned with interrelating all the positive and negative areas on the surface of the artwork. Positive and negative forms provide contrasts and create shadows, as do polished and textured areas.

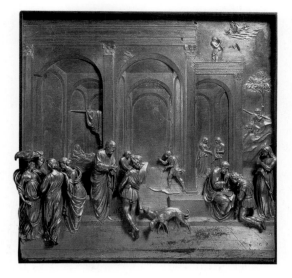

10-10 **Notice how lifelike these figures are. What perspective techniques add to the illusion of depth?** Lorenzo Ghiberti, *Story of Jacob and Esau* (detail from *The Gates of Paradise*, post-restoration), c. 1435. Gilt bronze, 31¼" (79 cm) square. Museo dell'Opera del Duomo, Florence, Italy. Scala/Art Resource, NY.

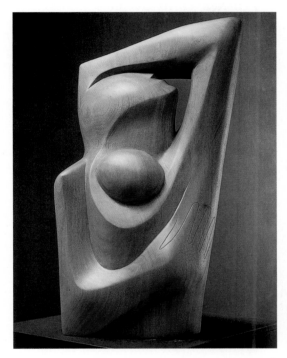

10-9 **What contributes to eye movement around and over the form of this sculpture?** Elizabeth Catlett, *Mother and Child #2*, 1971. Walnut. Malcolm Brown Gallery.

## Relief Sculpture

Sculpture that is not freestanding but projects from a background surface is called *relief* sculpture. If the projection from the background is slight and there is no undercutting of the carved form, the sculpture is called *low relief.* You can see low relief on any US coin.

In *high relief* sculpture, half or more of the modeled surface projects out from the background. Figures are often undercut to such a degree that you can take hold of them with your hand. You can see both high and low relief in Ghiberti's *Story of Jacob and Esau* (fig. 10-10), which was cast in bronze and ornaments a door. The gigantic relief carving of four US presidents on Mount Rushmore (fig. 10-11) required the use of dynamite, pneumatic hammers, and chisels driven by compressed air.

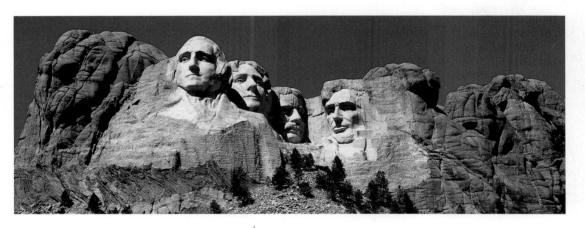

10-11 **These familiar faces are carved in high relief. Why might the artist have sculpted each to look in a different direction?** George Borglum and Son, *The Presidents*, 1927–41. Carved granite, Mount Rushmore National Memorial, South Dakota. Photo by Kirkendall/Spring, Edmonds, WA.

## Casting Sculpture

Wood or stone sculptures are created by removing material from the block with hammers and chisels. **Casting** involves filling a mold with a material that will harden and reproduce the volume and surface detail of the mold. For example, you could press your hand in wet sand to make a *mold*. Filling the mold with liquid plaster would make a cast. When the cast hardened, you would remove it from the mold.

**Lost-Wax Bronze Casting**  The first lost-wax castings were of small solid objects. Solid metal figures could not be made very large because of the weight and expense of the metal. In order to make large, even monumental figures, ancient cultures developed the method of hollow bronze casting. The procedure is called *lost-wax* (from the French term *cire-perdue*). The metal sculptures you see in parks, plazas, and around state buildings are made with a lost-wax process.

There are several steps in this process. First, oil-based clay is applied over an armature to make a full-size model. A plaster mold, made in sections, is formed over the clay model. The mold sections are removed and coated with wax about 1/8-inch thick. The wax castings are removed from the molds and assembled in sections. Then each wax cast is suspended in a container, and a liquid, heat-resistant mixture called *investment* is poured inside and outside of the wax casts. There is now an outside and inside mold core separated by the wax. The molds are baked in a kiln until the wax runs out. The molds are placed in a pit and surrounded with sand to prevent leaks when the molten metal is poured in to fill the space left by the wax. Finally, the outer and inner mold material is removed, and the casts are welded together. The surface is filed and sanded and a patina is applied.

Rodin's *The Thinker* (**fig. 10-12**) shows us how medium, technique, and the artist's objectives are all related. Rodin chose to create in cast bronze a firmly modeled, muscular figure, on a base with a textured, spontaneous surface. His technique was influenced by Impressionism (discussed in **Chapter 16, Western Art History II**, page 442). *The Thinker* is Rodin's best-known sculpture.

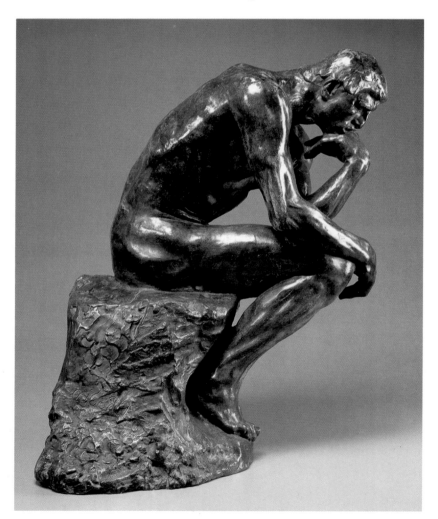

10-12 **The bronze casting process can be manipulated in many ways. Would you call this sculpture highly detailed or simplified?** Auguste Rodin, *The Thinker (Le Penseur),* model 1880, cast 1901. Bronze, 28 1/8" x 14 5/16" x 23 7/16" (71.5 x 36.4 x 59.5 cm). Gift of Mrs. John W. Simpson, Image © 2003 Board of Trustees, National Gallery of Art, Washington.

**Plastic and Plaster Casting** Without the caption, you might think that **figure 10-14** is a photograph of a football player. Yet the life-size football player is a sculpture. It was cast in a plaster mold reinforced with fiberglass. Duane Hanson applied plaster gauze strips directly to the body of a live model to make a mold. The person's skin and hair were heavily greased so the plaster would not stick. The inner surfaces of the molds were covered with a parting agent that helps separate the cast from the mold. The insides of the mold pieces were painted with flesh-colored polyvinyl gel and laminated with several layers of fiberglass for strength. The cast sections were assembled, and seams were brushed with plastic from inside. Paint was used to tint the flesh.

George Segal, like Hanson, forms molds of plaster gauze around living models. Exposed hair and skin is covered with lotion so the plaster can be removed painlessly. The clothing is ruined. The molds, which are made in sections for various parts of the body, are reassembled to become the sculpture (**fig. 10-13**). The most detailed features remain on the interiors.

Sculptors seldom use plaster as a final material because it is not permanent. Segal, however, sometimes pours hydrostone, a strong, industrial plaster, into his figure molds, allowing it to harden. Removal of the mold reveals a detailed cast.

**Concrete Casting** Concrete mixtures are used to cast works in both relief and sculpture in the round. The relief forms are frequently used on architecture. The molds may be made of Styrofoam, sand, or plaster. Three-dimensional concrete sculpture, including figures and fountains, can be found in city squares, courtyards, and around public buildings.

10-14 **Only the uniform and the hair on the figure's arms and head are real. What does this tell you about plastic casting as a medium?** Duane Hanson, *Football Player,* 1981. Oil on polyvinyl, 43¼" x 30" x 31½" (110 x 76 x 80 cm). Collection of the Lowe Art Museum, University of Miami, Museum purchase through funds from the Friends of Art and public subscription.

10-13 **Instead of making a cast from the plaster mold, Segal uses the rough-textured mold itself as the sculpture. How might this add meaning to his work?** George Segal, *The Parking Garage,* 1968. Plaster, wood, metal, electrical parts and light bulbs, 10' x 12' 8" x 4' (3 x 4 x 1.3 m). Collection of The Newark Museum. Purchase 1968 with Funds from the National Council on the Arts Trustee contributions.

10-15 **This bronze sculpture was first modeled in clay.** Jasper Johns, *Flashlight III*, 1958. Bronze, glass, aluminum paint, cast 1987, 5 1/8" x 8 1/8" x 3 3/4" (13 x 20.6 x 9.5 cm). The Museum of Modern Art; Promised Gift of Agnes Gund. Photo by Dorothy Zeidman.

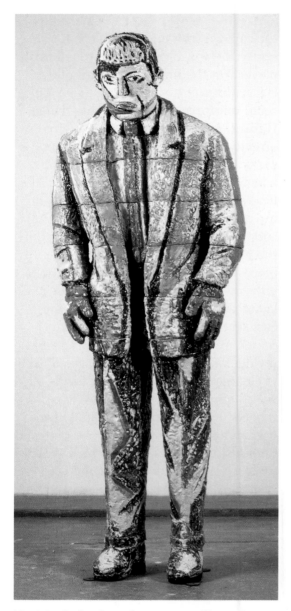

10-16 **Look closely, and you can see lines where clay sections were joined. Do you sense a tension resulting from the figure's slight lean?** Viola Frey, *Leaning Man III*, 1985. Clay and glazes, handbuilt, 102 1/2" x 35" x 18" (260 x 89 x 46 cm). Rena Bransten Gallery, San Francisco.

## Modeling

*Modeling* is a method that produces a sculpture from a pliable material like clay, papier-mâché, wax, or plaster. Clay can be shaped, dried, and kiln-fired to rock-hard forms called *ceramics*. The form may be given a second firing to add a matte or gloss *glaze*, consisting of oxides that melt to form a glassy surface. Forms made of low-fire, red-brown clays, often left unglazed, are called *terra-cotta*. Ceramic forms may be modeled in clay using the hands, or with tools, including metal and wooden spatulas, wire loops on wooden handles, paddles, scrapers, and knives. Even table knives, forks, and spoons can be useful modeling tools. Terra-cotta reliefs and sculptures were produced by ancient cultures throughout the world.

**Solid Modeling** The initial shaping of a solid form from a piece of wedged clay is done mainly with the hands and fingers. Clay can be added in large amounts, using the power of the fist or heel of the hand. Wood paddles may be used to consolidate the clay and help with shaping. Parts can be pulled out of the clay form, or they may be added by making secure joints. Walls of modeled clay forms must be no thicker than one inch, or the sculpture will explode when fired. Solid modeling in clay is usually limited to small forms like Jasper Johns' *Flashlight III* (**fig. 10-15**).

**Clay Slab Building** Clay forms that will be fired are best constructed hollow. Both *slab* and *coil* procedures are used for hollow building. Slabs are sheets of clay beaten out with the hand, a paddle, or spread with a rolling pin to an even thickness.

Viola Frey creates seven- to ten-foot ceramic figures of women and men, using slabs and coils in their construction. Her figures are so large that she must form and fire them in sections. The sections are stacked upon each other when finished to complete the sculpture (**fig. 10-16**). Some of Frey's huge sculptures are based on figurines found in variety stores and flea markets.

**Coil Building** All of the hand-building methods for clay were familiar to ancient cultures. The coiling procedure was used by the Chinese over two thousand years ago to create the life-size horse and warrior shown in **figure 10-17**. Coil building is more difficult than slab. Coils are made by rolling ropes of clay with flattened hands to a desired thickness on a canvas-covered surface. The wet coils are placed on top of each other and welded together with vertical wiping movements of the thumb or back of the nails.

## Papier-Mâché

*Papier-mâché* is a French term that means *masticated paper*, or paper reduced to a pulp. In ancient times this paper pulp was used as a modeling medium. Chinese soldiers used it to mold body armor before the Bronze Age. The Linares family in Mexico creates fantastic sculptures with papier-mâché and paper lamination (**fig. 10-18**).

Today, papier-mâché often refers to lamination of paper strips and glue. Strips of paper soaked in wheat paste can be placed over cardboard, tubes, bound paper shapes, and boxes.

10-17 **Thousands of figures like this were found during excavations at an emperor's tomb. The clay "army" was intended to guard the emperor in the afterlife.** Cavalryman and saddle horse, Qin Dynasty (221–206 BCE), terra-cotta. Height of man is 5' 10 1/2" (180 cm), height of horse is 5' 7 1/2" (172 cm). Excavated from Trench 12, Pit No. 2, Lintong, Shaanxi Province. Shaanxi Provincial Museum. Courtesy of Cultural Relics Bureau, Beijing, and The Metropolitan Museum of Art, NY.

10-18 **How have the artists of this work created a sense of movement in their papier-mâché figures?** Don Miguel Linares and Family, *Dream of a Sunday Afternoon in Alameda Park*, 1985. Papier-mâché and paint, fifteen figures 8' x 20' x 20'. Collection of the Modern Art Museum of Fort Worth, Museum Purchase.

10-19 **The invention of welding made metal constructions like this possible. Where do you see joined pieces?** Julio González, *Monsieur "Cactus" (Cactus Man I)*, 1939 (cast 1953–54). Bronze and patina, 23 5/16" x 9 13/16" x 6 11/16" (64.3 x 25 x 17 cm). The Solomon R. Guggenheim Foundation, New York, Peggy Guggenheim Collection, Venice, 1976. Photo by David Heald. Julio González © Artists Rights Society (ARS), New York/ADAGP, Paris.

## Construction

*Constructions* are sculptures built not only from traditional materials, but also those made available by modern industrial technology. For example, welding was developed in 1895. In the early 1920s, Spanish artist Julio González pioneered the use of the welding torch to cut and build metal sculpture. *Cactus Man 1* is one of his later works, in which he included more massive forms and surface texture (**fig. 10-19**).

Artists also create works constructed with newer materials, including sheet plastic, nylon monofilament, and stainless steel.

## Assemblage

*Assemblages* are sculptures constructed from a variety of readymade parts and materials that were not originally meant to be used in artworks. Some assemblages of the 1950s were called *junk sculpture*, and were made up of just that. Louise Nevelson confined her assemblages of found objects to monochromatically painted wooden objects and boxes. She nailed, glued, and pegged them together in carefully designed relief sculptures (see **fig. 16-39, page 465**).

Artists have great freedom in choosing materials to express their ideas in an assemblage. Marisol mixed real objects with wooden blocks that have some carved parts. The figures are detailed with cast plaster, drawing, and painting (**fig. 10-22**). Her assemblages often include plaster life masks, fabric, shoes, and photographs along with skillful carpentry and carving.

## Kinetic Sculpture

You learned in Chapter 8 that Alexander Calder was one of the first artists to explore the possibilities of *kinetic sculpture,* or sculpture that moves. He relied on wind and air currents to set his works in motion. Recall, too, George Rickey's sculpture *Four Lines Oblique* (**fig. 4-39, page 75**) and Sarah Sze's installation *The Letting Go* (**fig. 8-27, page 183, and fig. 10-20**).

Jim Jenkins comments on our dance with high technology in his kinetic work (**fig. 10-21**). The motorized arms and hands simultaneously rub the top (head) and screen (stomach) of the TV. What do you think Jenkins is saying about human interaction with technology? Other sources of energy for kinetic sculpture include falling water, temperature changes, springs, air pumps, pull strings, and the computer.

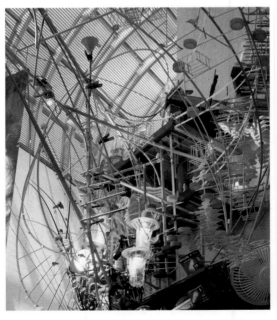

10-20  Sarah Sze, *The Letting Go* (detail), 2003. Mixed media, dimensions variable. Installation at the Boston Museum of Fine Arts. Photo courtesy Mary Boesky Gallery and the artist.

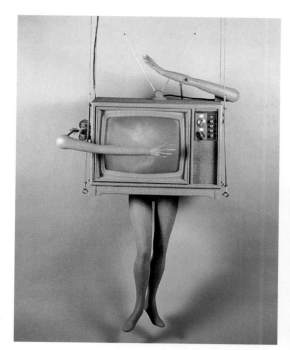

10-21 **The motion of the arms in this sculpture makes the whole form twist and turn. How does this add to its message?** Jim Jenkins, *Coordinated Programming*, 1987. Television, mannequin limbs, and motor. 6' x 4' x 3'. Photograph: Jeff Atherton. Courtesy of the Artist.

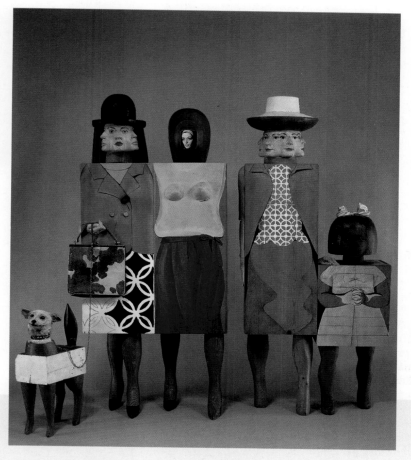

10-22 **Look closely to find the found objects in this sculpture. How many can you identify?** Marisol, *Women and Dog*, 1964. Wood, plaster, synthetic polymer, and miscellaneous items. Installed: 72 1/4" x 73" x 30 15/16" (183.5 x 185.4 x 78.6 cm). Collection of the Whitney Museum of American Art. Purchase, with Funds from the Friends of the Whitney Museum of American Art. Photography by Robert E. Mates, NJ.

### Artist Biography
## Marisol (b. 1930)

Born in Paris, Marisol Escobar spent the early years of her life traveling the world with her wealthy Venezuelan parents. Her mother died when Marisol was eleven, and Marisol looked to her father for support. With his encouragement, Marisol was able to become an adventurous artist and a creative individual.

Her travels took her from Europe to New York in 1950 where she studied art and developed friendships with other artists. At this time, Marisol explored a variety of different art media, searching for her own artistic style. During this quest for originality and independence, she discarded her last name.

In New York, Marisol discovered her own way of expressing herself in sculpture, combining unusual materials in new ways. Using power saws and other carpenter's tools in combination with traditional art supplies, she began creating a highly recognizable personal style.

During the late 1960s and early 1970s artists began to consider new ways to engage the viewer. While much of modern art had explored the question "What is art?" these new art forms also demanded that people consider the question "What is an artwork?"

*Conceptual art* places its emphasis on the idea rather than on the object. How did this movement evolve? There were several factors. Prices in the art market had begun to rise, making artworks seem available only to the very rich. Also, an anti-establishment mood permeated the 1960s. Anti-war protests, the civil rights movement, and the women's movement all questioned established institutions. Similarly, conceptual artists wanted to break away from the power structure that held the art world in its grip. They devised ways to create art that did not involve galleries or art critics. For example, a mass mailing or an ad in a newspaper or magazine would be a work of art. There was no need for a gallery to view the art, no need to go through traditional channels to exhibit or win recognition. In addition, artists wanted to break away from traditional media such as painting and sculpture.

Joseph Kosuth was at one time the best-known American conceptual artist working in this international movement. His *One and Three Chairs* (fig. 10-23) reflects a facet of conceptual art that dwelled on the *idea* of art rather than on the artwork itself. In this piece the artist encourages the viewer to consider the three ways a work of art is perceived: As the representation of the object (life-size photograph), the real-world object (chair), and the idea of what a chair is (dictionary definition). In one work, there are three ways that you would consider the "chair."

10-23 **Critics hotly debated Joseph Kosuth's assertion that in artwork the idea is more important than the object. Do you agree or disagree with him? Why?** Joseph Kosuth, *One and Three Chairs*, 1965. Wooden folding chair, photographic copy of a chair, and photographic enlargement of a dictionary definition of a chair, chair 32 3/8" x 14 7/8" x 20 7/8" (82.2 x 37.8 x 53 cm); photo panel 36" x 24 1/8" (91.4 x 61.3 cm); text panel 24" x 24 1/8" (60.9 x 61.3 cm). The Museum of Modern Art, New York, NY, Larry Aldrich Foundation Fund. Licensed by Scala/Art Resource, NY.

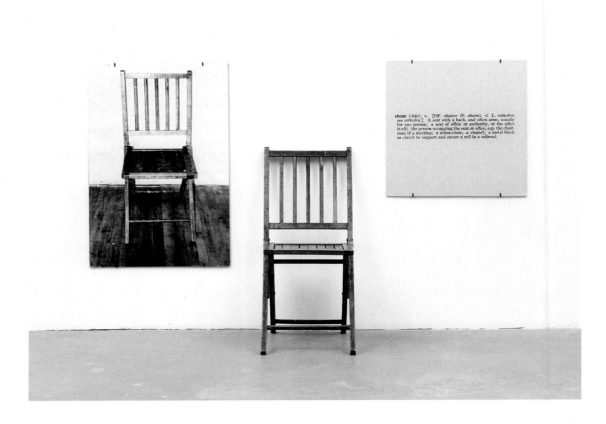

10-24 **Conceptual artists made works that were temporary and thus could not become commodities on the art market. Why might they have wanted to avoid artworks becoming luxury items?** John Baldessari, *Cremation Piece*, 1969. As shown at The Jewish Museum in the exhibition Software, 1970.

"One of several proposals to rid my life of accumulated art. With this project I will have all of my accumulated paintings cremated by a mortuary. The container of ashes will be interred inside a wall of the Jewish Museum. For the length of the show, there will be a commemorative plaque on the wall behind which the ashes are located. It is a reductive, recycling piece. I consider all these paintings a body of work in the real sense of the word. Will I save my life by losing it? Will a Phoenix arise from the ashes? Will the paintings having become dust become art materials again? I don't know, but I feel better."

John Baldessari's *Cremation Piece* **(fig. 10-24)** is documented in a printed statement. The statement describes the idea, as well as some of the actions that Baldessari took to carry out his idea back in 1969. His is a prime example of the documented art discussed in Chapter 9.

***Performance art*** also was a global art movement born in the late 1960s. It grew out of some artists' desire to interact more directly with viewers. Initially, performance art was a unique, pre-planned event of short duration, often occurring in a gallery or outdoors. Since the late 1970s, with the expansion of technology, performance art has come to encompass repeat performances in theaters, clubs, and other venues. Artists use a variety of elements such as music, poetry, dance, theater, and video to create their works.

Technology has allowed a new generation of performance artists to expand the scope and audience of a piece in ways that were not envisioned when the art form was first developed. Jose Alvarez **(fig. 10-25)** performs on global network television, and considers such mass media coverage an aspect of his work. Drawing from all of the visual and performing arts disciplines, performance art today is a rich and hybrid art form.

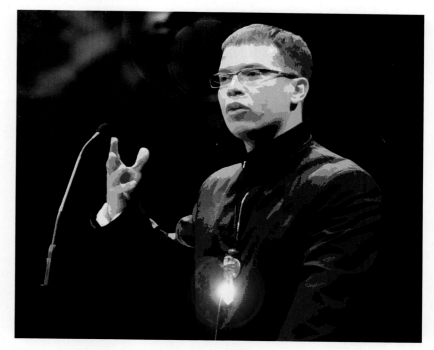

10-25 **Performance art relies on a live audience and occurs over a period of time. What are the disadvantages of considering a performance piece only through the documentation provided by a single image, like this one?** Jose Alvarez, *Knowledge Sessions "number IV (tonal)."* The Whitney Museum of American Art.

### Try It Yourself

Earthworks and environmental works like *Circular Embankment* and *Surrounded Islands* are conceptual, emphasizing art as ideas and experiences, rather than as a commodity to buy and sell. Discuss how these works relate to their environments, and how they make you think about the environment. How would they be affected by changing light conditions, shadow, the wind? How do they involve people in the art experience?

Artists whose works can be included in this category have taken several directions in recent decades. All of these works are conceptual, emphasizing the idea behind the work, and often involving the viewer.

Sculptural forms made primarily of earth, rocks, and plants are called *earthworks*. Timbers and concrete are sometimes used. Although these works do change the natural setting, they are designed to merge with the landscape. The artist may employ a construction crew and earth-moving equipment to complete an earthwork. In 1970, Robert Smithson, one of the founders of the earthwork movement, bulldozed 6,650 tons of rock and earth into a spiral 1,500 feet long, swirling out into the water of Great Salt Lake (fig. 10-26). *Spiral Jetty* was gradually submerged by the changing levels of the lake. In 2003, however, following a five-year drought, the jetty was once again totally visible.

Herbert Bayer's *Mill Creek Canyon* turned an abused environmental area with a drainage problem into a pleasant park area with sculpted grass mounds and ponds connected by paths and bridges (fig. 10-27).

10-26 **According to legend, a giant whirlpool used to form at the center of the Great Salt Lake. How has the artist incorporated the legend into this earthwork?** Robert Smithson, *Spiral Jetty*, April 1970. Black rock, salt crystals, earth, red water (algae), 3½' x 15' x 1500' (1.06 x 4.57 x 457.2 m) Great Salt Lake, Utah. Photograph by Gianfranco Gorgoni, Courtesy James Cohan Gallery, NY. Collection DIA Center for the Arts, NY. © Estate of Robert Smithson/Licensed by VAGA, NY.

Works that erect, or place various materials and objects on, or over, a location but do not alter the site, can be called *environmental art*. (They, too, are a form of conceptual art.) The largest environmental projects have been created by Christo and Jeanne-Claude. Their *Wrapped Coast* is shown in Chapter 1 (**fig. 1-11, page 9**). In 1983 they finished surrounding eleven islands in Biscayne Bay with 6,500,000 square feet of pink fabric that floated in the water (**fig. 10-28**). The fabric extended 200 feet from the shore of each island. From an airplane, the site revealed eleven pink-skirted islands covered with lush vegetation, surrounded by blue-green water.

Works conceived for the specific place in which they are displayed are called *site specific*. Because they may be located in heavily visited public places, site works such as *Lapstrake* by Jesús Moroles (**fig. 10-48, page 280**) are sometimes called public art. See also *Clothespin* by Claes Oldenburg (**fig. 8-38, page 190**). While some site works are commissioned by corporations, others are commissioned by local governments with taxpayers' money. This raises an interesting question. Should the public have a voice in decisions about what artworks will be placed in a public site?

10-28 **This photograph is an aerial view. Imagine what the view would be like from one of the islands. How would the impact of a ground-level perspective differ from that of the bird's-eye view?** Christo and Jeanne-Claude, *Surrounded Islands, Biscayne Bay, Greater Miami, Florida,* 1980–83. 585,000 square meters (6½ million square feet) of fabric floating around eleven islands. © Christo 1983. Photograph by Wolfgang Volz.

10-27 **Why might this be called a "sculpted landscape"?** Herbert Bayer, *Circular Embankment with Path,* Kent, Washington. Photo Courtesy of Art on File.

Since the mid-1960s, artists from a variety of backgrounds have been assembling *installations* that often juxtapose two- and three-dimensional objects and materials. (A Sandy Skoglund installation was the subject of the Art Criticism Step by Step exercise in Chapter 8.) These works of art may take up all or a large part of a gallery. Unless given a permanent location, installations are eventually disassembled. You may experience some of these works as large sculptures or experience other works as a created environment. In either case, these, too, are forms of conceptual art—ones in which the artist perceives you as part of the work.

Soon after its first installation in Beijing, Xu Bing's *A Book from the Sky* (fig. 10-29) was criticized by the Chinese government as meaningless and possibly subversive. The artist later emigrated to the United States.

Ilya Kabakov's *The Man Who Flew into Space* (fig. 10-30) was one of ten rooms making up a complex installation called "Ten Characters." The rooms were like those of a shabby communal apartment in an oppressive society. This room was inhabited by an imaginary person who achieved his dream of flying into space by being hurled from a catapult suspended by springs. The ceiling and roof were blown off at the moment of launching.

Ann Hamilton's installation (fig. 10-31) presents the viewer with a lone figure engaged in some sort of repetitive task involving cotton balls. The woman sits on a wood slab in front of a horizontal wood panel, both of which are suspended from the ceiling with steel cables. Her

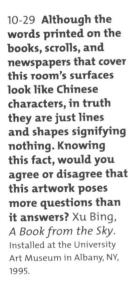

10-29 **Although the words printed on the books, scrolls, and newspapers that cover this room's surfaces look like Chinese characters, in truth they are just lines and shapes signifying nothing. Knowing this fact, would you agree or disagree that this artwork poses more questions than it answers?** Xu Bing, *A Book from the Sky*. Installed at the University Art Museum in Albany, NY, 1995.

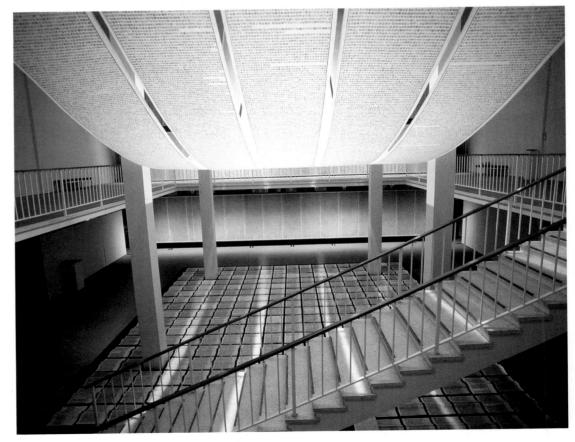

feet rest on a box, and she appears suspended in space. A three-sided screen covered with a sheer material that can be seen through sits in front of her. There are large cotton balls on the table, and the woman holds one in her hand. She appears to intently study the cotton ball. The installation is housed in a large, barren room with wood-paneled walls, one of which glows with light. The shadowed figure can look through the screen toward the light as she looks for answers in that cotton ball. What intellectual and sensory sensations do you think she is experiencing? What sensations might you, as a viewer, share with this person? What sensory responses do you think the artist is trying to elicit from viewers?

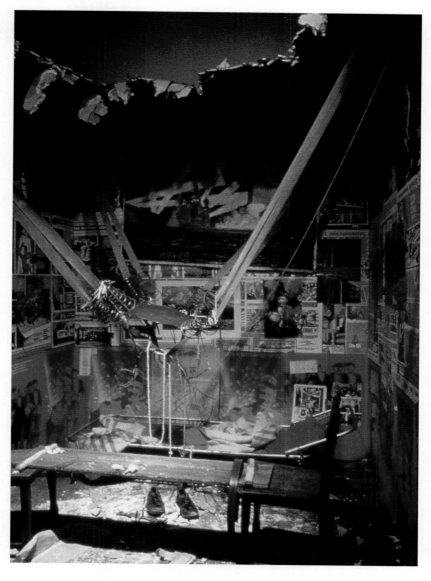

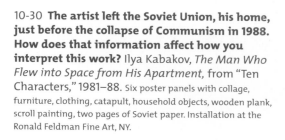

10-30 **The artist left the Soviet Union, his home, just before the collapse of Communism in 1988. How does that information affect how you interpret this work?** Ilya Kabakov, *The Man Who Flew into Space from His Apartment,* from "Ten Characters," 1981–88. Six poster panels with collage, furniture, clothing, catapult, household objects, wooden plank, scroll painting, two pages of Soviet paper. Installation at the Ronald Feldman Fine Art, NY.

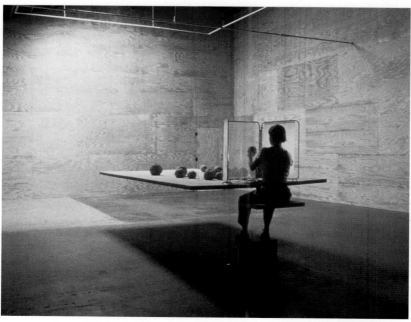

10-31 **Notice the many different materials the artist has used to create this installation.** Ann Hamilton, *Lineament,* 1994. Installation of plywood, steel cables, figure, books, steel frame, silk organza, wood box, movie projector, overall dimensions: 23' x 27' x 48' (7 x 8.2 x 14.6 m). Courtesy Sean Kelly Gallery, NY. An **art:21** artist

**Write About It!**

Every early culture developed its own style of pottery. Research a culture and write a short report on its pottery. How was it made, decorated, and fired? Were there forms or decorative styles unique to the culture? What was the pottery used for?

Imagine life without containers to eat and drink from or to store things in. Prehistoric people used animal skins, shells, gourds, and woven baskets as containers. The baskets were sometimes coated on the inside with clay to seal them. We do not know for certain how early people discovered that firing clay objects would make them permanent. We do know that the first earthenware pots and clay figures were fired in shallow pits lined and covered with twigs and dry wood.

### Hand Building

The methods for making pottery by hand are similar to those used for ceramic sculpture.

Pinch pots begin as a ball of clay. Pressing a thumb into the center makes an indentation. Press and pinch rapidly to deepen the hole. Form thin walls by squeezing up and out while rotating the pot. Some artists add a coil to the bottom for stability. Designs can be incised, impressed, or pressed on the surface (fig. 10-32).

Slab-built containers start with flattened sheets of clay no thicker than one-half inch. The surfaces of clay slabs can be decorated with textures before or after construction. Slab pottery can be shaped by wrapping it around a paper-covered form that will burn out in the kiln, or draping it over a shaping object until firm (fig. 10-33).

Coil pots can be made in almost any shape and size. Coils are rolled to a desired thickness, attached to a base, and added on top of each other until the pot is completed. The form can be curved outward or inward by making coils progressively wider or narrower in circumference. Coils can be guided into

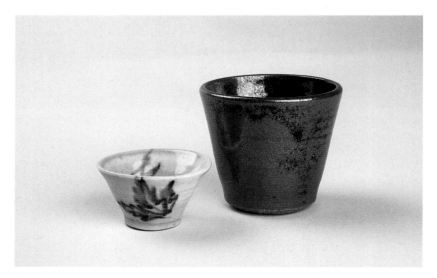

10-32 **Even simple pinch pots can be elegant.** Japanese, Sake cup and raku teacup. Glazed ceramic, 2" (5 cm) and 2½" (6.3 cm) diameter. Private collection.

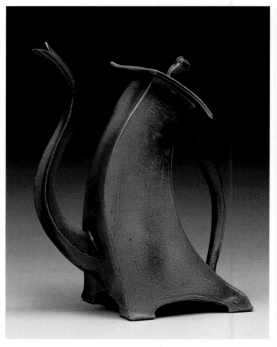

10-33 **What makes this teapot appear to be dancing?** Robert Putnam, *Ewer.* Stoneware, slab-built cone 9 reduction, 13" (33 cm) high. Courtesy of the artist. Photo by Janet Ryan.

organic forms that are not practical for the potter's wheel. While most artists smooth the coils on the inside for strength, some leave coils visible on the exterior. (For more about clay hand-building techniques, see the **Student Handbook**, page 492.)

Kurt Webb creates very large coil-built and carved clay vessel forms **(fig. 10-34)**. The example shown was fired by artist Dan Anderson in a single-chamber wood-firing kiln. The themes Webb uses on his vessels involve stories from around the world, some of which are told completely with pictures.

## Throwing on the Wheel

*Throwing* is the term used to describe forming clay on the potter's wheel. The production of small wheel-thrown pots began about 3000 BCE. The wheel lets a person make rounded symmetrical forms in much less time than the coil method. The potter centers a ball of clay on a rapidly turning wheel, and raises the clay with careful hard movements into a cylinder or rounded form.

Wheel-thrown ceramic forms may be both decorative and functional. The Hydria is a type of Greek water jar. Around 530 BCE, Greek ceramicists developed the red-figure technique **(fig. 10-35)**, which used black glaze for the background, leaving the figures a luminous red. Interior markings in the figures were applied with a syringe-like instrument that squeezed out black glaze, or were painted with fine brushes.

Tom Turner used a high-fire stoneware clay to produce the well-balanced ceramic jar in **figure 10-36**. The lid was thrown separately. Countless hours were spent in the decorative process. The chrome green and white glaze spots were applied by brush. A wax-resist procedure was used to obtain the ocher- and umber-colored stains resulting from a wood ash glaze.

## Linking Disciplines
### Science
What changes clay into ceramics? What changes sand into glass? Find out more about the ingredients and the chemical and compositional changes that occur during the processes of making ceramics and glass. Compare ancient techniques to methods used by contemporary artists and manufacturers.

10-34 **Using coils allows the artist to create very large forms.** Kurt Webb, *Story Jar.* Coil built. Courtesy the artist.

10-35 **This style of water jar is one of six used extensively by the Greeks.** Attributed to the painter of the Yale Oinochoe, *Red-Figure Hydria,* Early Classical period, c. 470–60 BCE. Ceramic, 13 3/4" x 13 1/4" x 12" (34.9 x 33.6 x 30.5 cm). The Museum of Fine Arts, Houston; Gift of General and Mrs. Maurice Hirsch.

10-36 **Two wheel-thrown pots were joined to create this jar. How might the final work look different if it had been created by the coil method?** Tom Turner, *High-Fire Stoneware Jar.* Courtesy Richard Salome.

Prehistoric people made jewelry from bone, wood, seeds, stones, shells, hair, and teeth. The materials used then for adornment were considered valuable. For example, a Stone Age necklace of shells and animal teeth was as valuable to its owner as a gold chain or pearl necklace would be to you. Once metalworking procedures were developed, metal became the most common material for jewelry and ceremonial objects.

For over 6,000 years, gold has been the most sought-after metal. Gold is beautiful, it never tarnishes, and it is easy to stretch. One ounce of gold can be hammered into a sheet of one hundred square feet! This ability of gold or any metal to be extended or shaped by hammering is called *malleability*. Because gold is so malleable, ancient metalworkers used it to create paper-thin objects. Using a process called *repoussé*, the metal is hammered and tooled on one side to create shapes and patterns on the other side, which is placed against a soft material. The features of the mask **(fig. 10-37)** were raised in relief by pressing the lines and shapes out from the inside with modeling tools.

Other metalworking procedures developed over 2,500 years ago include casting, annealing (heating metal to make it easier to form), soldering, bending metal over steel stakes or into depressions, cutting, piercing, and engraving. Christine Sundt's *Book #3* **(fig. 10-38)** is a pendant made of non-precious materials suspended on a gold chain. The design on the front of the polished brass cover was created with the repoussé process. The cover and the papyrus paper pages wrap around a piece of brass tube, through which the gold chain passes. The clasp is made of copper buttons and raffia. Common materials combined with craftsmanship result in a unique piece of jewelry.

10-37 **Ceremonial objects, like this mask, were often made of gold. What gold objects have you seen? What makes them attractive?** Mycenae Death Mask (also known as Mask of Agamemnon), about 1500 BCE. Beaten gold, about 12" (30 cm) high. Royal tombs, Mycenae. Photo © 2001 Thomas Sakoulas.

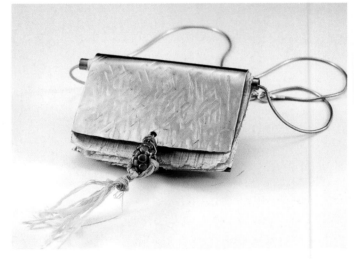

10-38 **If you had to choose a single object to show in a piece of jewelry, what would it be?** Christine L. Sundt, *Book #3* (neckpiece), 1999. Hammered brass, brass tubing, papyrus, raffia, 14k gold chain, L: 20" (50.8 cm). Photograph: Christine L. Sundt.

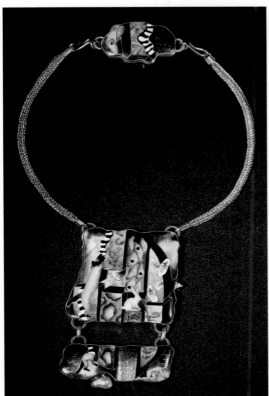

Metal enameling is a centuries-old process. Enamels are made from ground glass and metal oxides for color. They are fused to metal by heating them to about 1450°F in a kiln. Several methods have been developed for enameling jewelry. One of the more complex procedures is *cloisonné.* A contemporary example is shown in **figure 10-39.** All of the figures and shapes are enclosed with gold and silver wire that is soldered to the base form. Enamels of different colors are placed inside the wire shapes and background areas. The two halves are enclosed with gold bezel, and joined with clasps in back.

Today, some artists use the materials, tools, and procedures needed to make jewelry to produce small sculptures (**fig. 10-40**). Krentzin may be a jeweler, a sculptor, or both. He produces carefully crafted art forms that challenge your imagination.

10-40 **Can you tell which parts of this work were sawed, pierced, bent, and shaped by hammering and casting, before being soldered together?** Earl Krentzin, *Truck.* Silver, 18k gold, semiprecious stones, 6 3/4" tall. Courtesy of the artist.

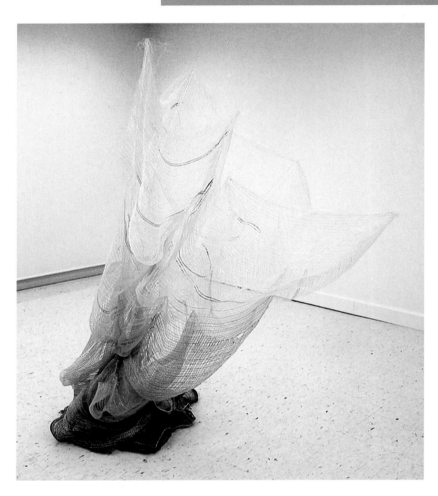

Weaving is the most common method of working with fibers. Weaving can be done on a complex motorized loom or a simple wooden frame. In plain weaving, one thread, called the *weft*, crosses alternately over and under *warp* threads. The warp threads are stretched on the loom. Many artists who work with fibers have abandoned the loom and taken fibers into the realm of sculpture in a variety of ways. For the work shown in **figure 10-41**, layers of fibers were woven together. Then the layers were gathered to create depth. Some fibers such as grasses, raffia, and twigs are strong enough to provide support for three-dimensional forms. Fibers may be knotted and braided for strength. They may also be formed around supporting materials such as wire, kapok, foam rubber, or Styrofoam.

The three forms that make up *Implications* (**fig. 10-44**) by Jane Sauer have knotted inner cores. Strands of the fiber were pulled from the cores to give the forms a hairy texture.

For *Spire: A Spiritual Journey* (**fig. 10-43**), Meda Rives laminated 160 three-foot-square panels. The panels were handmade from abaca, a long, strong, and easily manipulated fiber obtained from the leaf of the banana tree. Rives laminated seven to nine layers of fiber in each panel for strength. They were suspended from above by cotton threads. The installation required fourteen hundred square feet

10-41 **One of the dominant characteristics of most fiber art is the pliability of the materials. Despite this trait, what aspects of this weaving had to be well thought out in advance?** Barbara Bohnett, *Untitled*. Textile, 84" x 54" x 50" (213.3 x 137.2 x 127 cm). Collection, The University Museum, Illinois State University, Normal, IL.

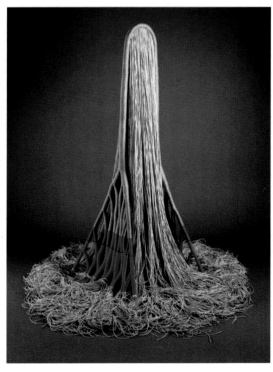

10-42 **Claire Zeisler is considered one of the most important fiber artists of the twentieth century. What contrasts in her medium has she emphasized here?** Claire Zeisler, *Tri-Color Arch*, 1983–84. Hemp, synthetic fiber knotted, wrapped, 74" x 11" (188 x 28 cm), spill 66" x 44" (168 x 112 cm). The Metropolitan Museum of Art; Gift of Peter Florsheim, Thomas W. Florsheim, and Joan Florsheim-Binkley, 1987. Photograph © 1995 The Metropolitan Museum of Art.

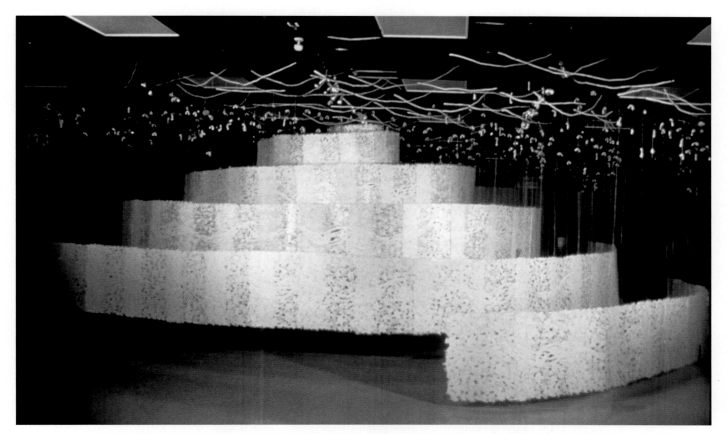

10-43 **This artist is skilled in the art of papermaking. What kinds of problems would she have had to solve in order to create this paper installation?** Meda Rives, *Spire: A Spiritual Journey*, 1998. Handmade abaca paper, dimensions variable. Courtesy of the artist.

of space, and rose to a height of twelve feet. When moving through the interior space, the viewer perceived the subtle wavelike movement of the translucent panels.

Claire Zeisler was one of the first artists to explore the three-dimensional possibilities of fiber. She constructed *Tri-Color Arch* by wrapping a synthetic fiber around a rope-like core of braided hemp **(fig. 10-42)**. For tall pieces like this one (about six feet), the artist may wrap fiber around a wire armature.

10-44 **What do these forms remind you of? Try to imagine how they would feel if touched.** Jane Sauer, *Implications*, 1985. Waxed linen, paint, knotted, 14" x 6" (36 x 15 cm); 8½" x 5" (22 x 13 cm); 3½" x 3½" (9 x 9 cm). Courtesy of the artist.

Glass is a two- or three-dimensional art medium with a long history. The Egyptians discovered how to make glass around 3000 BCE. The first glass objects were beads and solid shapes. Sometime between 1500 and 1350 BCE the Egyptians produced glass vessels. The invention of the blowpipe between 200 and 100 BCE was to glass making what the potter's wheel was to ceramics. The blowpipe made it possible to produce hollow glass forms rapidly. Glass can be cast flat or into a mold, formed on the blowpipe in the open air, or blown into a mold.

Hot glass can be bent, twisted, and pulled into shapes, and glass can be fused to glass. When glass is free blown, the heated tip of a blowpipe is barely dipped in molten glass. Then the blowpipe is rotated to wind the glass into a gather on a flat metal surface to allow the glass to chill. The artist is also able to center the gather on the blowpipe. Next, the artist aims the blowpipe toward the floor and blows a small bubble.

Working at the glass blower's bench, the artist rolls the pipe back and forth on the bench arms to form the hot glass. Forming tools include concave wooden blocks, paddles, the jacks, cutting shears, and even a wad pad of newspaper.

Each time it is blown in this forming stage, the vessel increases in size. To keep the glass in a workable stage, the artist periodically reheats it by inserting the vessel into the furnace opening. The vessel is transferred from the blowpipe to a long metal pipe called a *pontil* for final shaping. The hot glass may be opened up by using a paddle on the inside of the rotating form. After shaping, the glass form is cooled slowly in an oven. Additional enhancing may be done by etching or engraving, sandblasting, cutting, grinding, and polishing the glass.

Dale Chihuly directs a team of glass blowers in creating sculptural displays consisting of multicolored blown and molded glass forms (fig. 10-45). To make each form, a molten gather of glass is

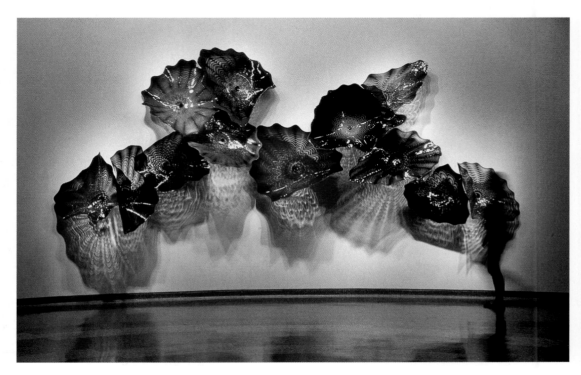

10-45 **When Chihuly was a graduate student he was accepted as an apprentice at one of the great glass-blowing factories in the Venice region of Italy. Why might it be important for artists to ground themselves in traditional methods before pursuing new approaches?** Dale Chihuly, GTE Installation, 1991. Large-scale architectural installation for GTE World Headquarters in Irving, TX. Blown glass. Courtesy the Chihuly Studio.

10-46 **Artists must understand the physical properties of the materials they use. What things about the science of glass would be important for a stained glass artist to know?** John Forbes, *Red Car*, Constructed by Bonny Doon Art Glass, 1995–96. Glass, approx: 3' x 4' (1 x 1⅛ m). Private commission.

revolved and a strand of colored glass is wound around it. The glass is inflated, reheated, and inserted into a metal *optic mold*, which is shaped something like a vase and has fluted edges inside. The glass form is reheated in the furnace, and then rotated on the pontil, causing the glass to splay outward into the forms you see here.

## Stained Glass

Stained glass is used to make both two- and three-dimensional forms. Windows of stained glass cause a special excitement in a room when the incoming light is transformed by the colors of the glass. Before constructing a stained glass form, the artist makes a full-size drawing of a design on paper. The pattern shapes are cut out and used to guide the cutting of each glass shape.

If the work is composed of shapes with straight or gently curved edges,

pieces can be held in place with channeled lead strips called came. These strips are soldered together at joints where they meet.

Lead came is not practical for three-dimensional forms such as containers or lamps when intricate, curved shapes are involved. A procedure called foiling is used for making objects like lamp shades. The edges of each piece of glass are wrapped with paper-thin copper foil, leaving an overlap of one-sixteenth of an inch. The pieces of glass are soldered together on both sides along the foiled edges.

*Red Car* (**fig. 10-46**) includes mostly curved shapes and undulating edges that also required the foiling process. Glass paint was used to add details such as the figure's hair and facial features, and the car tires. Do you know what kind of car is represented?

Lutz Haufschild's *Questions of the Heart* (**fig. 10-47**) is a multiple-techniques work. Stained glass works can be etched and painted, and plates of glass may be fused to one another.

10-47 **"I see the artist working with art glass as a custodian of light,"** says Lutz Haufschild, **"conductor of a visual symphony—the different colors as his instruments." What do you think he means by this statement?** Lutz Haufschild, *Questions of the Heart*, 1989–90. Stained glass, wood frame (139.5 x 139.5 cm).

# A Monumental Public Sculpture

**About the Artist**

## Jesús Moroles
**(b. 1950)**

**Jesús Moroles** was born in Corpus Christi, Texas, and was given strong support as a young man to pursue his interest in sculpture. Returning to Texas in 1980 after a year of studio work in Italy, he decided to commit himself to large-scale abstract stone sculpture. He set about building a state-of-the-art facility that he planned to be the best in the country for making monumental sculptures. Recognition for his art came quickly, and commissions for his work arrived from across the country. In the mid-1980s, he bought property outside of Sante Fe, New Mexico, with the hope of eventually building an exhibition and studio space. In 1996, he opened the Cerillos Cultural Center, a venue for exhibitions and music and art performances.

10-48 **Although site-specific works are designed by artists, other people may produce or install them. A large-scale sculpture in granite, such as this one, could not have been installed without the use of a construction crane.** Jesús Moroles, *Lapstrake,* 1987. Sardinian granite, 22' x 12' x 4' (6.7 x 3.6 x 1.2 m). E. F. Hutton, CBS Plaza, New York City. Courtesy of the artist.

**1** **Describe What You See**

When you describe an artwork, you identify things about the work that you can see, name, and describe with certainty. You should not include opinions, evaluations, or possible meanings here.

- Note the artist, title of the work, medium, date, and location.
- What is the size of this sculpture?
- Where do you see geometric and organic forms?
- What is the function of the organic shapes?
- Identify the convex, concave forms in the sculpture.
- What kinds of line do you see?
- Describe the textures you see.

**2** **Analyze the Way It's Organized**

When you analyze an artwork, you tell how the subject matter and elements of the work have been organized by the artist. You tell how they work together.

- What has the artist done to create a feeling of rhythm in the form?
- Describe the directional movement implied by the rectangular granite slabs.
- Concentrate on the left and right sides of the supporting organic forms to see columns. What ancient architectural construction method is suggested? (Turn to Chapter 11, Architecture.)
- How has the artist created variety in this monumental form?
- How is the work organized to achieve both physical and visual balance?
- Do geometric or organic forms dominate? How?

**3** **Interpret What It's Saying**

Use the information from your description and analysis to help you identify the meaning of the work—that is, what it tells you about the human experience.

- Based on your knowledge of this work's size and appearance, list some ideas or feelings you associate with it.
- What does it remind you of? Elements of the surrounding buildings? Art of ancient civilizations shown in your text?
- Check the *Oxford English Dictionary* to see if the title, *Lapstrake*, provides clues.
- Write a simile or metaphor that suggests what the work means or reminds you of.
- If necessary, further clarify what the work means.

**4** **Evaluate Its Success**

Using your analysis in the first three steps, judge the quality or success of this work. Two philosophies may be used. Try these:

- How would you evaluate this work based on the philosophy that a successful work is designed for perfect relationship among elements?
- How would you evaluate the work based on the philosophy that a successful artwork expresses significant ideas or feelings?
- How well does the work relate to the site, its surroundings, the natural elements, changing seasons?
- How well known is the artist for his achievements and his style?

**More Art!**
See page 294 for more works by Jesús Moroles.

**Web Links**
www.davis-art.com
www.moroles.com/

# Kinetic Sculpture for Public Space

Like flying insects, kinetic sculptures can seem to defy gravity. Try creating a three-dimensional insect form. Then combine your form with those of your classmates to create a kinetic sculpture, or mobile.

## Write About It!

Apply your study of insect forms and your experience with kinetic sculpture in writing a poem about your insect and its experience of the natural world. Try to express, in verse, a poetic equivalent to Calder's loose, linear style of kinetic sculpture. How will you achieve a sense in your verse of balance, of the words being lighter than air? Consider employing a refrain, or repeated word or group of words, to suggest pattern. To suggest volume without mass, try to use words that suggest spontaneity, variety, and movement through space. How will the lines be broken? Think about not only the way the words sound but also how they look on the page.

10-49 **Students creating a linear sculpture.**

## Before You Begin

Research insect forms. Observe the linear aspect of insects' bodies. View examples of drawings by Alberto Giacometti, sculptures by Henry Moore, and mobiles by Alexander Calder. Notice how Giacometti and Moore used a loose, linear style to imply volume.

## You Will Need

• basket reed
• scissors
• string
• white glue
• rice paper

## Create It

❶ Begin by creating a line drawing of the insect you wish to make into a three-dimensional structure.

❷ Using your line drawing as a reference, bend, cut, and tie the reed together to form the body of the insect. Concentrate on the form's linear structure.

❸ Add white glue to the intersections to add strength.

❹ Glue rice paper over the frames, emphasizing the visual planes of the insect's body. Cover about half the structure with the rice paper so the viewer can appreciate the linear aspect and the overall form.

❺ Work with your classmates to combine six to eight of the insect forms into a single mobile. Consider balance, variety, and movement as you construct your final piece.

## Evaluate It

- What design challenges did you encounter?
- In what ways does your structure imply volume?
- How is balance achieved in the mobile?
- How does your insect form contribute to the overall structure of the mobile?

10-50 **Student work.** Basket reed and rice paper in the shape of a wasp.

10-51 **Student work.** Basket reed and rice paper in the shape of a grasshopper.

## Computer Option

Have a classmate take a digital photo of you in a variety of stretched-out poses. Choose the best pose and open it in a photo or paint program. Use the selection tool to cut out your image from the background. Copy and paste the image into a new 8½" x 11" canvas. Use the transform tool and color balance to manipulate and stretch your image into a Giacometti- or Calder-style creation. Save and print. Glue your image onto a piece of foam-core board and carefully cut out your image using an X-Acto knife. Use clothes-hanger wire or string to combine your image with your class-mates' to make one large class mobile.

### Art History

## Studio Background

One of the earliest kinetic sculptures is a machine-like creation by the Constructivist artist László Moholy-Nagy. With the assistance of an engineer and technician, Moholy-Nagy assembled the *Light-Space Modulator* out of perforated metal discs, a rotating glass spiral, and a sliding ball, among other objects and materials. In the latter part of the century, Alexander Calder and others took the ideas developed in early kinetic works such as this one and moved in new directions.

10-52 **This early kinetic work was meant to operate within a darkened room or an enclosed box. When the motor is running, single light bulbs in different colors go on and off at various locations on the piece, as the mechanical parts move, thus causing shadows to be cast and creating a dynamic interplay of light and shade.** László Moholy-Nagy, Hungarian, *Light Prop for an Electric Stage (Light-Space Modulator)*, 1930. Aluminum, steel, nickel-plated brass, other metals, plastic, wood, and electric motor, 60" x 27½" x 27½" (151.1 x 69.9 x 69.9 cm). Courtesy of the Busch-Reisinger Museum, Harvard University Art Museums; Gift of Sibyl Moholy-Nagy. Photo courtesy Photographic Services, © 2003 President and Fellows of Harvard College.

**Technique Tip**

To avoid cracking and breaking during the drying and firing processes, do not create any portion of your sculpture that is more than ¾" thick. Avoiding extremely uneven thicknesses will also reduce the chance of cracking and breaking during firing.

**Computer Option**

Find a sculpture of a human figure that you like and scan an image of it into a photo or paint program. Find other images of things you use and wear, and places you visit, and scan them into the computer. Using the painting and drawing tools and the copy and paste tools, carefully manipulate the sculpture, background, and accessories to have the sculpture doing what you enjoy doing. Save and print for critique.

# Figurative Clay Sculpture

In this exercise, you will create a clay sculpture of a human form that expresses a quality of adolescence.

10-53  Student work, Sylvia Brandt. Plaster, 6½" x 4⅓" (16.5 x 11 cm).

10-54  Student work, Jesse Kirsch. Glazed sculpture.

## Before You Begin

Discuss art images of clay sculptures. Observe your teacher's demonstration of wedging clay, and discuss additive and subtractive sculpture techniques.

## You Will Need

• ceramic clay
• variety of clay tools

## Create It

❶ Wedge the clay to eliminate trapped air.

❷ Form the clay into your interpretation of a human figure that expresses adolescence. If you choose to use the additive technique, carefully score the surfaces of the parts that will be attached to one another. If you choose to use the subtractive technique, use clay tools to carve features into a mass of clay. With either technique, create a figure that is at least six inches tall (if standing or seated) or long (if reclined).

❸ If you are using the subtractive technique, allow the figure to dry to the leather-hard stage before hollowing it from the bottom to a ¾" thickness.

❹ When your sculpture is dry, it will be bisque fired in a kiln.

## Evaluate It

• What makes your work engaging to the viewer?

• How does your work express adolescence?

• What aspects of the class work as a whole do you think will cause viewers to look at it again?

**Write About It!**
Place your finished sculpture in front of you. Look at the work, and respond, in a single paragraph, to the question "How does your sculpture express a quality of adolescence?" Your reflective writing should convey both your idea of a distinctive quality of adolescence and an explanation of how that quality is expressed in your three-dimensional human form.

10-56  Student work, Josh Kirsch. Glazed sculpture.

10-55  Student work, Arielle Ginsberg. Plaster, 10" x 7" x 6" (25.4 x 17.8 x 15.2 cm).

**Art History**

## Studio Background

For the nineteenth-century sculptor Auguste Rodin, clay was the perfect medium in which to plan his major works. His figurative pieces were begun most often by working directly in clay in front of live models. He used clay as a means of sketching. From the clay model, he created a plaster mold, and from there, a plaster cast. He would not move to plaster, however, until he was completely satisfied with the clay model. Sometimes the process involved returning again and again to the live models as he reworked movements, gestures, and positions in clay.

10-57  **Because of the tendency of unfired clay to deteriorate with time, few clay working models from the great sculptors survive. Why is clay a good medium to use in the early stages of creating sculpture?** Auguste Rodin, Study for *The Thinker*. Terra-cotta, 9½" x 7¾" x 4" (24.5 x 19.8 x 9.9 cm). Musée Rodin/ADAGP, Paris.

# Expressing Personality Through Sculpture

In this exercise, you will create a plaster gauze relief mask of yourself. You will express qualities of your personality using the mask and other media to create a reflective sculpture.

10-58  Student work, Allison Motto. Plaster, gauze, 20" x 12" (50.8 x 30.5 cm).

10-59  Student work, Jay Thompson. Mixed media, 10" x 10" x 20" (25.4 x 25.4 x 50.8 cm).

## Before You Begin

View examples of the work of sculptors such as George Segal and Marisol. Join two other students to form a working group. One of you will be the model, while the other two will apply the mask material.

## You Will Need

- plaster-covered gauze (plaster craft)
- petroleum jelly (for covering face)
- acrylic paint
- found objects

## Create It

**1** Apply a thin coating of petroleum jelly on your face and under your chin, paying extra attention to the hairline and eyebrows.

**2** The two other students will dip the plaster gauze into water, apply it to your face, and smooth it out, overlapping each layer to make a strong bond. The students should not cover your eyes or the end of your nose, as the lime in the plaster can irritate the eyes.

**3** Leave on for about twenty-five minutes. Carefully remove the mask and cover the eye areas and the tip of the nose from the inside.

**4** Use found objects or objects brought from home as well as varied media to express an aspect of your personality as an artist.

## Evaluate It

- Does your work reveal aspects of your personality?

10-61 Student work, Frank Pinelli. Mixed media, 18" x 16" (45.7 x 40.8 cm).

10-60 Student work, Carl Lessing. Mixed media.

- What elements of yourself did you include in your sculpture that you feel the viewer will easily understand?
- Can the viewer see expression and aspects of your personality in the work?
- What new insights or opinions were gained concerning contemporary sculpture?

10-62 **Bernini concentrated on capturing the essence of Francesco I d'Este's personality and appearance—the true him. With that in mind, what does the sculpture's emphasis on hair indicate about the fashions of the mid-seventeenth century?** Gian Lorenzo Bernini, *Francesco I d'Este*, c. 1651. © Arte & Immagini srl/Corbis.

## Art History

## Studio Background

The seventeenth-century sculptor Gian Lorenzo Bernini had a knack for capturing both the appearance and the personality of his subjects. It is said that he followed them around and took notes before doing a portrait. Bernini's work reflects the "naturalistic" style prevalent in architecture of the Baroque period in Europe. (The art of the Baroque will be discussed in **Chapter 16, Western Art History II**.) In his bust of Francesco I d'Este (fig. 10-62), Bernini created a likeness of a young man with long, curling hair, two thick locks of which descend over his chest. The head and line of sight turned to the viewer's left contrast with the implied movement of lines and forms in the cape to the right. They provide a feeling of momentary action—a moment in time caught forever. While a sculpture is a static form, the artist has purposefully suggested movement to make the work more vital, more interesting.

# River Stone Sculpture Garden

In this exercise, you will create a design on a river stone that includes two main elements: a circle (symbolic of unity) and a significant line (representing connectedness). Your stone will be placed in relation to other students' painted stones in a way that creates a visually connected, yet movable, outdoor sculpture.

## Computer Option

Bring three different textured or colored stones to digitally photograph in class. These stones will be your inspiration and models as you create your own virtual sculpture garden. Next, take a digital photo of an open space in your school (courtyard, playing fields, front of the building, etc.) and using a photo or paint program combine the stone images into the background photo to create a virtual peaceful space where students could meditate or study. Copy and paste the stones multiple times to create paths or areas of stones. Use a transform tool to resize and rotate as needed to fit your vision. Save and print.

## Before You Begin

Select a single river stone to paint, paying careful attention to its natural markings. Choose a stone in which the texture, grain, or size inspires you. Examine the stone's unique imperfections.

## You Will Need

- smooth river stones
- gesso
- oil-based paint
- spray varnish

## Create It

❶ The stone's painted design should include two visual elements: a significant line that runs over the stone, and at least one circle. The line will ultimately show the connection between your work and that of the other students. Use pencil to draw the line and circle.

❷ Apply gesso (painting ground) onto the areas that will be painted. Consider carefully as you apply color. Work slowly and do not paint the entire stone. Instead, let the natural color of the stone show through, allowing the viewer to see more of the natural qualities of the stone. Paint the line in gold as a metaphor for a thread of life passing through the different elements.

❸ Use two coats of clear varnish spray as a finish on the stones when the paint is dry.

### Safety Note

To avoid inhaling noxious fumes, spray varnish on the stones outdoors, not in the art room.

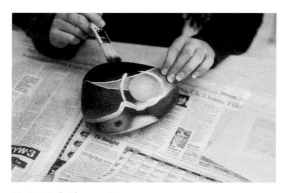

10-63 **Painting a stone.**

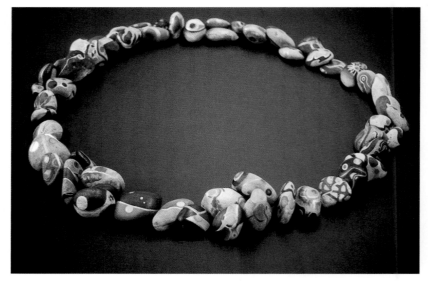

10-64  Student work, collaboration (full view). River stones, gesso, oil-based paint, varnish, 11' in diameter (3.36 m).

4. Place your stone with your classmates' stones on a large paper surface in the art room before moving it outdoors. As a class, discuss the items in the Evaluate It section. Arrange the stones, evaluating and reconsidering the composition.

## Evaluate It

- Does your design make the viewer want to pick up your stone and turn it over to see more?

- Do you see a continuous flow in the design or in line and color.

- Does the sculpture reflect the goals of the project?

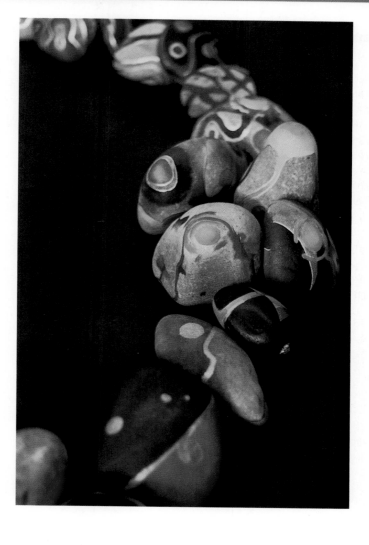

10-65 Student work, collaboration (detail). River stones, gesso, oil-based paint, varnish, 11' in diameter (3.36 m).

## Studio Background

With the spread of Buddhism in Japan, Japanese gardens began to include symbolic stone groupings. The dry garden at Ryoanji Temple is a Zen place of meditation. It includes fifteen rocks, arranged in five groupings, set in a sea of white pebbles. The rocks are believed by some to represent a tigress crossing the sea with her cubs. Others perceive the design to indicate the Chinese characters for the heart. More recently, computer analysis has led some scholars to conclude that the rock grouping suggests an image of a tree, created by the space among the rocks, and that this is the cause for the feeling of peace and serenity that descends upon all who spend time in the garden.

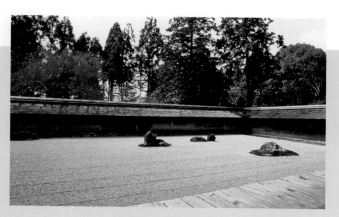

10-66 The fifteen stones in this garden are arranged in such a way that only fourteen can be viewed at any one time. It is said that the fifteenth is seen in the mind's eye when spiritual enlightenment is attained. Why do rock gardens such as this inspire meditation? Zen Garden at Ryoanji Temple, Kyoto. Photo by Oliver Radford. Courtesy Davis Art Images.

# Coil-Built Mask

In this exercise, you will use the coil method of clay sculpture to create a mask and then an expressive vessel. A major part of the vessel's form will be a face.

10-67  Student work, Xiaojing Huang. Terra-cotta clay, 7½" x 9" (19 x 22.8 cm).

10-69  Student work, David Jou. Terra-cotta clay, 7½" x 9" (19 x 22.8 cm).

10-68  Student work, Brandon Osborne. Terra-cotta clay, 10" x 6" x 6" (25.4 x 15.2 x 15.2 cm).

## Before You Begin

Observe and discuss a variety of masks from around the world. Note examples that show a linear approach to mask-making. Draw a plan for your own linear mask.

## You Will Need

• terra-cotta clay
• clay tools

## Create It

❶ From newspaper, create a form to support the basic mask shape. Add features by taping smaller pieces of crumpled newspaper to the base form. Secure the form to a tile or other support.

❷ Wedge the clay, roll it into a ¼" slab, and cut the slab into strips. Roll each strip into a coil.

**3** Using each coil as a "line," "draw" the mask on the newspaper form. Follow the contours of the form. Attach coils to one another as needed to create the "lines" of the face.

**4** To create the vessel's base, wedge the clay, roll it into a ¼" slab, and cut a circle from it. Cut the rest of the slab into strips and roll them into coils.

**5** Build the sides of the vessel. Shape the face as you go.

**6** To seal the inside of the vessel, carefully blend the coils with your fingertips before adding the next coil.

## Evaluate It

• How did you create expression in your mask?

• How well crafted is your vessel?

• What did you learn about the coil hand-building technique?

10-70 Student work, Josh Kirsh. Terra-cotta clay, 13" x 6" x 8" (33 x 15.2 x 20.3 cm).

### Write About It!

If your mask could speak, what would it say? Try to give voice to the expressive personality of your mask. In a single paragraph, write a dramatic monologue that expresses the essence of your mask's character. Is your mask frightening, or humorous, or a little of both? Is your mask young, or old? Does it have a story to tell? If so, let's hear it!

**Art History**

## Studio Background

The tradition of Puerto Rican mask-making is closely tied to the February carnival celebration that precedes the Christian Lenten season. Called *caretas*, the papier-mâché masks typically are noted for their horns and bared teeth. They are meant to represent demon-like beasts, and wearers (called *vejigantes*) roam the parades scaring onlookers. It is believed that the masks hark back to both traditional Spanish festivals, where devil-like creatures were meant to frighten sinners, and to the mask-making tradition brought to the United States by African slaves. Today, the town of Ponce is the main center for the craft and is associated with the horned-mask style.

10-71 **Masks have played a part in the rituals of human-kind for 20,000 years, and they can be found across the globe. Why do you think people are so drawn to masks?**
Puerto Rican Carnival Mask. © 2002 Smithsonian National Museum of American History. Photograph by Smithsonian Institution.

## Write About It!

Who are the important people in your life, and how have they had impact on your development? Describe them by name, their relationship to you, and why you think they are important. If the picture you used of a particular person has special relevance to why that person is important, explain that relevance. Finally, describe how you chose your three-dimensional structure, and why it is a suitable form for your photo structure.

# Inside-Outside Photo Form

In this exercise, you will use photographs of yourself and important people in your life to create a symbolic, three-dimensional photo structure.

### Before You Begin

Take a series of candid pictures of yourself (or have someone take them for you) and people who have had a significant impact on your life. If desired, make color photocopies of childhood photographs or photos of family members who live far away.

### You Will Need

- photographs or photocopies of existing photographs
- foam-core board
- scissors, X-Acto knife
- white glue, adhesive, straight pins

### Create It

❶ Cut shapes from foam-core board and build a three-dimensional structure. Leave openings in the structure to create views of the inside. The size and design of the structure is up to you and will depend on the number of photos you have. Use straight pins to hold the structure together.

❷ Decide how your photographs will be arranged on the structure. Plan to affix photos of yourself to the outside surfaces of the structure and photos of others to the inside surfaces.

❸ Take the structure apart and affix photos to all surfaces. Cut the photos as needed to fit the surfaces.

❹ Use straight pins and white glue to reassemble the final structure. Make the structure as strong and sturdy as possible.

10-72 Student work, David Stewart. Mixed media, 13" x 9" x 9" (33 x 22.8 x 22.8 cm).

10-73 Student work, Abby Schneider. Mixed media, 15" x 15" x 10" (38.1 x 38.1 x 25.4 cm).

10-74  Student work, Josh Kirsch. Mixed media, 9" x 6" x 14" (22.8x 15.2 x 35.5 cm).

**5** Cover the foam-core edges with black, gold, or silver foil paper, or strips cut from the remaining photos. Cover any visible glue or pins as best you can. The finished form can be freestanding or hung using nylon thread.

## Evaluate It

• What design challenges did you encounter? How did you overcome those challenges?

• How have the people shown on the inside of your structure influenced you? How does the finished structure represent you?

10-75  Student work, David Jou. Mixed media, 18" x 7" x 7" (45.7 x 17.8 x 17.8 cm).

**Art History**

## Studio Background

The Mexican Revolution (1910–20) spawned the creation of a vast series of painted public murals celebrating the history and culture of the Mexican people. Diego Rivera was a key individual in this effort as he developed a style of art that was purely Mexican in character. His monumental images on the interior and exterior walls of government buildings reflect his belief in the importance of the common people of Mexico, their daily life, and their indigenous past. The murals sent a message about the long, rich cultural history of the country and the value of celebrating and preserving it.

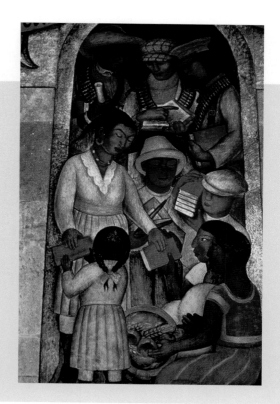

10-76  **Some of the murals in Rivera's Ministry of Education series address the social changes that took place after the Mexican Revolution. Why do you think Rivera chose to use simplified forms to deliver his messages?** Diego Rivera, *The People Receive Books*, 1923–28. Fresco. Located in the Education Ministry, Mexico City. Photo by Mark Rogovin. Courtesy Davis Art Images.

**Computer Option**

Use a scanner or digital camera to input photographs of six people that are significant in your life. Open each image in a photo or paint program. Crop each image to an 8" x 8" square. Use a lasso or other selection tool and copy the person on each image onto a second layer directly above the original. Reduce the background opacity by 50 percent. Use the text tool to type a carefully worded paragraph on the background of each image, explaining why the person is important to you. Save and print. Paste onto foam core and build a cube from the six images.

10-77 Diane Itter, *Southern Borders*, 1982. Linen, 15 1/2" x 10 3/8" (39.4 x 26.4 cm). Collection of the Museum of Arts & Design. Gift of Nancy and Richard Bloch, 1991. Photo by Eva Heyd.

10-79 Jesús Moroles, *Black Temple Totem*. Academy black granite, 92 7/8" x 13 7/8" x 12 7/8" (235.9 x 35.2 x 32.7 cm) and 108 1/8" x 13 1/2" x 12 1/2" (274.6 x 34.3 x 31.8 cm). Courtesy of the artist.

10-78 Adele Akers, *Four Corners*, 2000. Fine linen and horsehair, 36" x 41" (91.4 x 104.1 cm). Courtesy Thirteen Moons Gallery.

10-80 Jesús Moroles, *Granite Weaving*, 2003. Dakota mahogany, 9' 3/4" x 9' 3/4" x 32 1/2" (297.2 x 297.2 x 82.5 cm), 20,000 lbs. Latino Cultural Center, Dallas, Texas. Courtesy of the artist.

# Chapter Review

## Summary

Humans have created modeled and sculpted forms since prehistoric times. Until recently, sculpture was defined as modeling, carving, and casting. Today, artists create three-dimensional forms with almost any material that is safe to work with. Sculpture can be in low or high *relief*, or freestanding and visible from all sides. Sculpture comes in all sizes and can be designed for indoor or outdoor display.

Most sculptures are produced in one of four ways: they are carved, cast, modeled, or constructed. Wood, stone, clay, and bronze are traditional media for sculpture. Fibers, metal, and glass are also materials that have been in use for thousands of years, and continue to be used in three-dimensional works today.

Some types of art that have emerged in the last century include constructions, assemblages, kinetic art, *conceptual* and *performance art*, and *installations*.

Many new materials and procedures have been added to an already impressive list of media for creating artworks in the twenty-first century. Given the exploratory nature of artists, the list will continue to grow. The forms that three-dimensional art may take and the purposes that it serves will probably become even more diverse in the years ahead.

## Review Questions

1. **Recall:** Define relief sculpture.

2. **Understand:** Describe the process of coil building.

3. **Apply:** Draw or describe a series of five steps used to create a papier-mâché sculpture.

4. **Analyze:** Compare and contrast Duane Hanson's sculpture *Football Player* (fig. 10-14, page 261) with Rodin's *The Thinker*. How did the two artists' intentions differ, in your opinion?

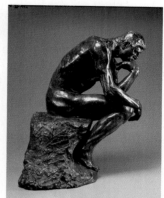

5. **Synthesize:** Compose a list of materials that you would like to use in an assemblage. Explain how the materials would work together to send a message.

6. **Evaluate:** Choose the environmental work from this chapter that you find most successful. Recommend that it be installed in your area. Describe where it should be and why you think it would be an important addition to the artwork of your town or city.

## For Your Portfolio

Design a relief sculpture for a special area of your school. Your finished work should include a proposal, your rendering of the work from several viewpoints, a set of working drawings, and cost estimates.

## For Your Sketchbook

Sketch several designs for a ceramic object, fiber work, or piece of jewelry. Then write a brief paragraph about how your idea would look as a finished work of art. What materials would you use to create the piece? What functions would your piece serve?

## Electronic Research

Dale Chihuly and Jesús Moroles are two sculptors who are masters of extremely different media, respectively glass and granite. Investigate their Web sites <http://www.chihuly.com/> <http://www.moroles.com/> to evaluate their work. How does each capitalize on the special characteristics and limitations determined by his chosen media? Since both of these artists often work on commissions, write a proposal for a commission for one of them from the point of view of a museum.

## Going Further

How can you apply traditional handbuilt pottery processes such as coil or slab methods to the creation of an abstract sculpture? Experiment with the structural and design possibilities for using coils and slabs to create abstract ceramic sculptures based on natural forms. Consider repetition of units and variations on a nature theme.

# 11 Architecture

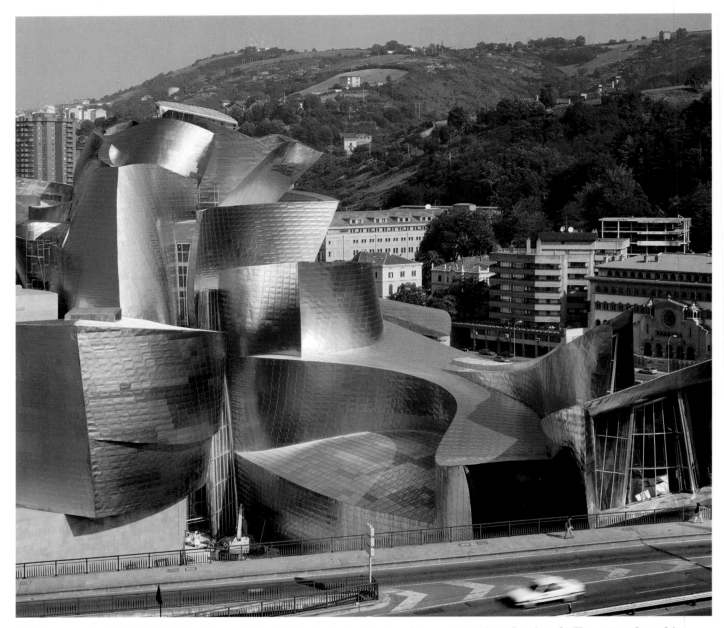

11-1 **The overall effect of the Bilbao Guggenheim is like that of a giant sculpture set against the city of Bilbao. How does this building challenge your notion of what architecture can be?** Frank O. Gehry, Guggenheim Museum. Bilbao, Spain. Photo by Timothy Hursley.

## What You'll Learn

- the major principles of construction and how they changed architecture
- advantages and disadvantages of the construction techniques
- how to recognize buildings that use these construction techniques
- major achievements in architecture around the world from ancient times to the present

## Key Terms

*English* (*Spanish*)

*post and lintel* (*pilar y dintel*)
*arch* (*arco*)
*corbeled arch* (*arco lobulado*)
*dome* (*bóveda*)
*frame construction* (*armazon*)
*ferroconcrete* (*hormigón armado*)

## Architects

Filippo Brunelleschi, Santiago Calatrava, Gustave Eiffel, Foster and Partners, Frank Gehry, Giovannini, Michael Graves, Zaha Hadid, Iktinos and Kallikrates, Thomas Jefferson, Le Corbusier, Louis Le Vau and Jules Hardouin-Mansart, Maya Lin, Ludwig Mies van der Rohe and Philip Johnson, José Rafael Moneo, Richard Rogers and Renzo Piano, Moshe Safdie, Joern Utzon, Robert Venturi and Denise Scott Brown, Frank Lloyd Wright

**11-3  Student work, Nima Ashe.** Collage of wallpaper remnants, magazine text, and construction paper, 19" x 16" (48.3 x 40.6 cm).

**11-2  A selection of student-made bisque-fired tiles.**

11-4 **Post and lintel.**

11-5 **Rounded arch.**

11-6 **Dome.**

11-7 **Frame construction.**

11-8 **Steel frame construction.**

11-9 **Ferroconcrete.**

Architecture is all around you. It probably affects you more than any of the visual arts, since you eat, sleep, play, learn, shop, and work in it. But how much do you understand about the ways buildings are built, or about architectural styles, past and present?

Buildings may look very different from one another, but the main construction techniques that have been developed to build them can be boiled down to: post and lintel, arch, dome, frame, and ferroconcrete. The first three can be found in structures built from ancient times to about the middle of the 1800s. The last two are found in buildings in the more recent past and in our own era.

***Post and lintel*** (fig. 11-4) construction is the oldest and simplest of the five methods. Posts, columns, walls, or piers are vertical members. They support horizontal members such as lintels or beams.

The development of the ***arch*** (fig. 11-5) allowed for spanning greater distance. An arch, built of *masonry* (stone, brick, or poured concrete), bridges the space between two columns or walls with a series of blocks. An arch supports a ceiling, the roof, or a wall, carrying the weight outward and downward to the ground. Also, the arch can be extended in depth to form a *vault*.

The Maya of Central America and some other ancient cultures developed a "stepped" arch called the ***corbeled arch***. It was not nearly as efficient as the round arch, but it did allow them to make rooms and hallways within their stone buildings.

The ancient Romans pioneered the construction of domes. A ***dome*** (fig. 11-6) is a radial form of arch that covers a circular, octagonal, or square area. Perhaps you've noticed that many public buildings in the United States have domes.

The next major breakthrough in basic construction techniques did not come

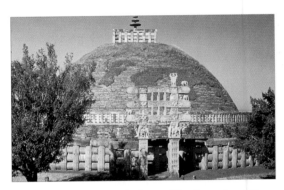

11-11 **The Great Stupa's dome-like form is solid masonry, built of many circles of brick. The Stupa's design is not based on the arch form, but developed instead from a burial mound.** India, Great Stupa, Sanchi, 75–50 BCE. Dome. Courtesy Davis Art Images.

11-10 **The Parthenon is a well-known example of post and lintel construction. Can you identify which members are posts and which are lintels in this photograph?** Iktinos & Kallikrates, Acropolis, Parthenon (east side), 447–32 BCE, Athens. Courtesy Davis Art Images.

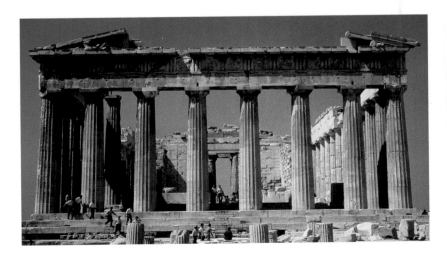

until the 1800s. In frame construction (fig. 11-7), vertical and horizontal members form a kind of cage, and inside and outside wall materials are no longer load bearing. Instead, they are attached to the supporting framework. After 1860, when steel was developed (fig. 11-8), architects could design much larger spaces that were strong and fire resistant. At the end of the nineteenth century, after the invention of the passenger elevator, the first skyscrapers were built.

Although concrete was used extensively by the Romans, it was not used by Europeans or Americans until the 1700s. One drawback of concrete is that by itself it isn't strong enough to support large structures. When steel production began in the 1860s, concrete became popular again as a building material. Steel rods or cables could be embedded in concrete to strengthen it. This material became known as steel-reinforced concrete, or *ferroconcrete* (fig. 11-9). Ferroconcrete can take many different shapes while retaining its strength. This moldability allowed for a variety of styles.

Today's architecture has many different forms, and uses a variety of new technologies. Watch as new buildings go up in your area. What styles do they show? What materials have the architects chosen? What building techniques can you identify?

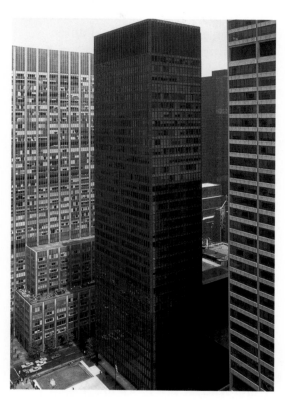

11-12 **In the twentieth century, the steel and glass skyscraper came to dominate urban architecture.** Ludwig Mies van der Rohe, with Philip Johnson (interiors), Seagram Building, 1954–58. Tinted glass and bronze I-beams. New York, New York. Courtesy Davis Art Images.

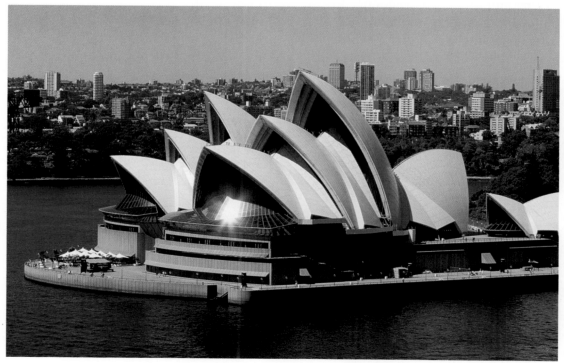

11-13 **This building took over fifteen years to finish, as its design was slightly ahead of available technology. What would you say makes Utzon's design innovative? Can you see any shapes from ancient architecture?** Joern Utzon, Sydney Opera House, 1959–72, Sydney, Australia. © Paul A. Souders/Corbis.

Architecture serves many purposes—from urban squares and shopping malls to private homes, from churches and temples to office buildings, and from courthouses to public schools. Buildings and public spaces come in many varieties, as we will see in this chapter.

While buildings have taken a range of forms across time and place, the ways of erecting them can be boiled down to a few major principles of construction.

The oldest and simplest method of construction is ***post and lintel*** (fig. 11-15). It consists of vertical members (posts, columns, or piers) supporting horizontal members (lintels or beams). Many of the oldest buildings still standing are post and lintel consisting of *masonry* material—stone, brick, adobe, cement block, or concrete.

11-15 **Post and lintel.**

Although there are many buildings older than the Greek Parthenon in Athens (fig. 11-14), it is a good example of post and lintel construction. This building symbolizes the power of Athens during the mid-fifth century BCE. Builders in the early Republic of the United States imitated aspects of this style in much of their architecture.

On the outside, the Parthenon's post and lintel colonnade is made of marble. Inside, thinner masonry walls or columns supported lintels of wood. The major drawback to masonry post and lintel construction is that it lacks *tensile strength*. This means that the horizontal members, supported at the ends but not in the middle, will break of their own weight if much longer than twenty feet. The inside lintels of the Parthenon were of wood, not stone. Therefore, they could be much longer than twenty feet. But of course, wood can burn. If it doesn't burn, it will eventually rot away. It's no surprise that the ceiling of the Parthenon vanished long ago.

An ***arch*** bridges a space between two columns with a series of wedge-shaped masonry blocks (*voussoirs*) arranged in a curve (fig. 11-16). During construction of the arch, the stones are held in place by a temporary wooden scaffolding called *centering,* until the topmost stone, the *keystone,* is inserted. The weight of an arch is directed outward and downward to the ground. Because of this, the walls or piers supporting an arch need to be very thick or given extra strength, or *buttressing,* along its sides. Otherwise, the walls might collapse.

11-16 **Arch.**

A single arch is good for making a gateway, while a whole row of arches can make a bridge. But what about a shelter that has walls and a ceiling? The Roman Colosseum (fig. 11-17) contained corridors on several levels that went around the stadium. By extending an arch in depth, it is possible to create a *vault.*

11-14 **Note how the Parthenon's exterior columns are placed close together in order to support the lintels around the outside of the building. Can you think of any US buildings with columns like these?** Iktinos & Kallikrates, Acropolis, Parthenon (east side), 447–32 BCE, Athens. Courtesy Davis Art Images.

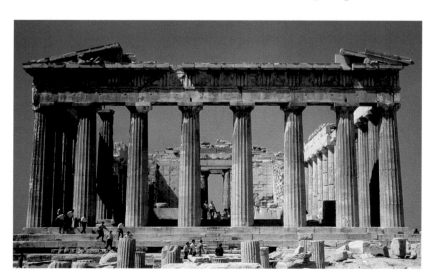

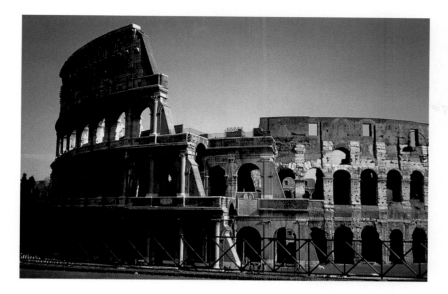

## Try It Yourself

The Mayan builders at Labná who made the vault in **figure 11-21** did not have metal tools—nor did they have wheels or horses. Imagine that you are an archaeologist—a scientist studying the remains of a people's culture. How do you think the Maya were able to carve such perfect blocks of stone using only stone tools? How were they able to carry and raise blocks of stone to build their magnificent temples without the aid of horses and wagons?

The *barrel vault* (fig. 11-18) developed by the Romans could be used to create a corridor or shelter for many different purposes.

11-18 **Barrel vault.**

A corridor could also be formed using the cross-vault technique. Formed by two intersecting barrel vaults, the *cross vault* (fig. 11-19) is an improvement on the barrel vault because the support is focused at four points instead of along the length of a wall. It is also more open than the barrel vault. To make a long corridor, the builders would connect a row of cross vaults.

11-19 **Cross vault.**

The *corbeled arch* (fig. 11-20) preceded the round arch of the Romans in cultures as diverse as the ancient Mycenaeans, the precursors of ancient Greek culture, and ancient cultures of Central America.

11-20 **Corbeled arch.**

The Maya of Central America developed the corbeled arch sometime in the period c. 400–200 BCE. This allowed Mayan architects to make rooms and hallways within their stone buildings. The Maya created the corbeled arch by moving each row of stones a little farther inward until they reached the top. This kind of arch cannot span a wide area, and it requires a lot of masonry material for support. It is useful, however, for creating a vault. The elegant vault at the Mayan city of Labná (fig. 11-21) has such refined corbeling that the gradual inset of each row is hardly apparent.

11-21 **The Labná Vault is adjacent to the Castle at Labná and was intended as a passageway between two important courtyards. What other construction technique do you see on this structure?** The Labná Vault, Mayan, Late Classic c. 600–900 CE, Labná, Mexico. Courtesy Davis Art Images.

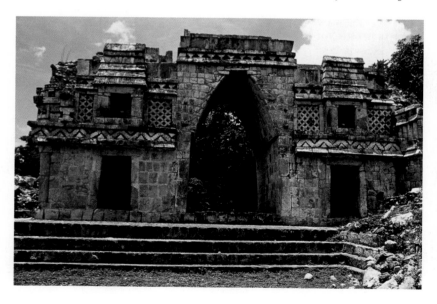

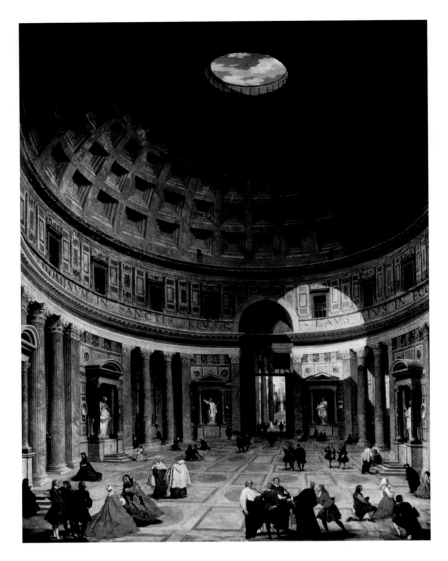

ingenious examples is the Pantheon (fig. 11-22) in Rome, a temple of all of the Roman gods. It is one of the best-preserved buildings from the ancient world, and has been one of the most influential designs in architectural history. The height of the dome of the Pantheon is precisely equal to the diameter of the circular space it covers.

Similar in shape but completely different in construction is a huge dome-like structure in India, the Great Stupa at Sanchi (fig. 11-24). It was meant as a place to honor and worship the Buddha. Unlike the Pantheon, the Great Stupa does not consist of a radial arch, but rather concentric circles of masonry that get gradually smaller as they move toward the center. Like the Pantheon, it is one of the best-preserved and most influential architectural monuments of the ancient world.

## Romanesque

In western Europe during the so-called Dark Ages (c. 400–800 CE), the art of masonry construction entered a period of decline. Although such construction continued in the East, builders in the West did not regain proficiency in masonry construction until between 1000 and 1200, when a new style of architecture emerged.

The style is called *Romanesque* because, like Roman architecture, it employed round arches. In their overall appearance, Romanesque buildings differed from what the Romans built. The style is best seen in the great pilgrimage churches built during the eleventh and twelfth centuries. The Romanesque period was one during which the Church in Rome was very powerful and initiated a construction boom in churches and monasteries that is unparalleled in history. Many of these great churches, like Saint-Sernin

11-22 **The Pantheon shows the full potential, and the Roman genius, for the use of concrete in construction. Besides the Pantheon, what other examples of dome construction can you think of?** Giovanni Paolo Panini, *Interior of the Pantheon*, c. 1740. © Francis G. Mayer/Corbis.

Yet another variation of the arch that covers a space with a vault is the ***dome*** (fig. 11-23). A dome is simply a radial form of arch to cover a circular, octagonal, or even square area.

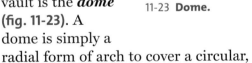

11-23 **Dome.**

Now, if the Roman builders had had modern, lightweight materials such as we have in the twenty-first century, they probably would have covered the Colosseum with a dome. But for somewhat smaller areas, like temples, they did make domes, using, of course, masonry materials. One of the most

in Toulouse, France (fig. 11-25), were on pilgrimage trails that led to major Christian shrines.

The central hall, or *nave*, of Saint-Sernin, like other churches in the Romanesque style, is formed by a barrel vault. The columns on either side form *arcades*, a series of arches supported on columns. Romanesque churches were built to emphasize height, which was meant to awe and inspire worshippers. The walls and arcades had to be very thick to support the great weight of a masonry ceiling.

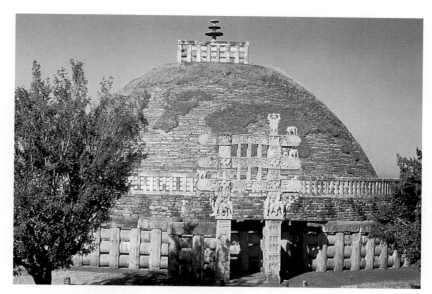

11-24 **The walls of the Stupa are composed of packed earth lined with brick and rubble. How does the way the building was used make it similar to the Pantheon?** India, Great Stupa, Sanchi, 75–50 BCE. Dome. Courtesy Davis Art Images.

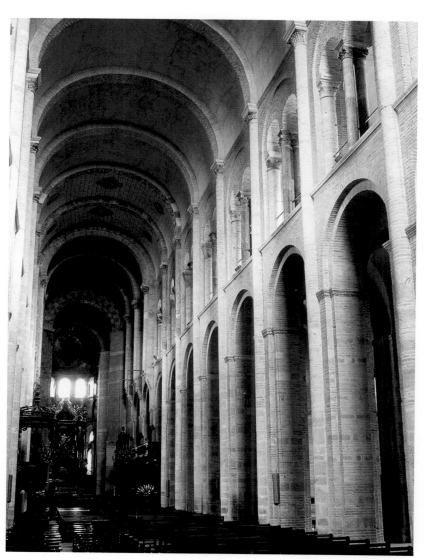

11-25 **Notice how the form of the arch is emphasized in the** *ribs* **that spring from the large columns on either side of the nave, creating a rhythm that leads the eye to the rear of the church. How would it make you feel to stand in the nave of this building?** Nave of Saint-Sernin (interior toward the east), c. 1075–1125.
Courtesy Davis Art Images.

## Linking Disciplines
### Science/ Mathematics

Did you ever climb on a **geodesic dome** when you were a child? The lightweight, domed structure formed from triangular segments was once a popular piece of playground equipment. It was also proposed as a design for living space. Engineer, mathematician, and architect R. Buckminster Fuller patented the design of the dome in 1947. Find out more about this pioneering scientist's contributions to architecture and the science of geodesic domes.

By the 1200s, architects had surpassed the Romans in their development of a unique kind of arch construction. Called *Gothic* architecture (seen mostly in churches and cathedrals), this construction used the *pointed arch* and *flying buttresses*. The pointed arch (fig. 11-27) was more stable than the round arch and allowed for

11-27 **Pointed arch.**

higher buildings. The sharper angle of the arch directed the weight downward more than outward. The flying buttress (fig. 11-28) was a half arch extending from a masonry pier to the outside wall of the building. It gave support at the weakest point in the wall, where ceiling meets wall, which is also the point of the greatest weight.

11-28 **Flying buttresses.**

The combination of flying buttresses, pointed arches, and vaults eliminated the need for very thick walls and massive piers for support. This allowed larger windows in the thinner, taller walls. Gothic churches (fig. 11-26) were flooded with light that streamed through beautiful stained glass windows.

## Renaissance

During the Renaissance in western Europe (c. 1400–1575), the art and architectural styles of ancient Greece and Rome—also known as *classicism*—were studied and imitated. The *Duomo*, or Cathedral of Florence (fig. 11-29), was the first large domed structure to be built since ancient Rome. For inspiration, the architect, Filippo Brunelleschi, studied the construction of the dome of the Pantheon in Rome.

The cathedral's dome, like that of the Pantheon, is thinner and lighter toward the top. However, its shape is based on the pointed arch, rather than the round arch. The large curving support beams of the dome shift the weight to the ground, much like the pointed arch in Gothic churches. Brunelleschi's dome served as a model for many domed buildings to follow.

11-26 **Gothic churches such as this one include flying buttresses and pointed arches.** Notre Dame, begun 1165, from east end. Paris, France.
Courtesy Davis Art Images.

Aside from the great Brunelleschi, the Renaissance architect most closely associated with the classicism of Greek and Rome may be the Venetian Andrea Palladio. Palladio's genius was for the villa, the ancient form of country house created by the Romans.

The Villa Rotondo (fig. 11-30), at Vicenza, near Venice, borrows its columned-and-porticoed exterior from the Greeks and its domed central space from the Romans. An array of fine sculpture unifies the premises.

11-29 **The cathedral in Florence, Santa Maria del Fiore, is the fourth largest church in the world. How does the shape of its dome differ from that of the Pantheon in Rome (fig. 11-22, page 302)?** Filippo Brunelleschi, Dome and Apse of Santa Maria del Fiore, 1421–36. Florence, Italy. © Alinari/Art Resource, NY.

11-30 **The Renaissance discovery and application of ancient styles is clearly evident in the designs of Andrea Palladio. In what ways does his Villa Rotondo reflect the classical influences of Greek and Roman architecture?** Andrea Palladio, Villa Rotondo, Vicenza, Italy, c. 1566–70. Courtesy Davis Art Images.

11-31 **The Golden Pavilion was built originally as a villa, and was turned into a temple in 1397. In what ways might this structure's design be appropriate for a place of quiet contemplation?** Golden Pavilion, 5th century.

Photo by Wyatt Wade. Courtesy Davis Art Images.

In Japan during the same period, architecture was modeled on that of China. Architecture in Asia from ancient times had been based on the same fundamental principle of construction as that in the West: post and lintel. Interiors were largely without walls, space being sectioned by screens. Roofs were supported on rows of posts on the inside of buildings.

Flared overhanging roof eaves are a hallmark of Chinese architecture, and the Golden Pavilion (Kinkaku) at Rokuon-ji (**fig. 11-31**) is a perfect example of the elegant Chinese style adopted by Japanese architects. It is part of the grounds of a Zen Buddhist temple, meant as a place for meditation on the gardens, moon, and stars.

## Baroque

By 1600, architects in Italy and northern Europe had developed the style now known as the Baroque. (You will read more about the art of the period in **Chapter 16, Western Art History II**).

Baroque architecture saw the continued use of classical features, such as

11-32 **The palace of Versailles, of which this is the central block, is a quarter of a mile long. What do you think it would be like to live in such a gigantic home?** Chateau at Versailles, the Garden Facade, 1669–85, by Louis Le Vau and Jules Hardouin-Mansart. Courtesy Davis Art Images.

columns, round arches, and domes. But these elements were given special flair. The major features of Baroque architecture are size and ornateness, thus reflecting the inflated visions of the powerful kings in western Europe who established colonies in other parts of the world. The period witnessed the construction of enormous churches, public buildings, and palaces, such as the palace of Versailles outside of Paris (fig. 11-32). Versailles is masonry and vaulted construction on a grand scale, combining many elements seen in ancient architecture such as columns, arches, and profuse decoration of the exterior.

## Neoclassicism

The classicism that was revived in art and architecture during the Renaissance and Baroque periods would endure in building design into the early twentieth century. A movement called *Neoclassicism* was given new impetus in the West during the eighteenth century with the discovery and excavation of ruins from the ancient Roman city of Pompeii.

In the young Republic of the United States in the 1700s and 1800s, the style spread far and wide, due in large part to the influence of Thomas Jefferson, third president of the United States. He was an architect as well, and had carefully studied the methods of ancient Greek and Roman builders and the Neoclassical style in Europe. He designed many structures in the Neoclassical style, including the campus of the University of Virginia and his own home of Monticello (fig. 11-33).

Because the American Republic was founded in part on the ideals of the ancient Greek democracies, Jefferson believed that Neoclassicism was an appropriate style for government buildings in the United States. Interestingly, most domed structures in western Europe are cathedrals or churches. In the United States, almost all are government buildings. Nearly all of the domes in US buildings are reinforced with steel.

**Linking Disciplines**
### History/ Literature
Just how many US Presidents designed their own home—or a university campus? How can you find out more about **Thomas Jefferson**, the architect and the statesman? Examine his work and his philosophy.

11-33 **Jefferson was first attracted to Neoclassicism when he was ambassador to France. What features of classical building construction can you identify in the design of his home?** Thomas Jefferson, Monticello, 1773–1809. Charlottesville, Virginia. Photo by Jaci Hanson. Courtesy Davis Art Images.

11-34 **At 984 feet high, Eiffel's design was the highest structure in the world at the time of its construction. What symbolic meaning might such a bold undertaking have for the people of a city or a nation?** Gustave Eiffel, Eiffel Tower, 1887–89. Paris, France. Courtesy Davis Art Images.

A new method of building, ***frame construction***, was developed in the 1800s. Frame construction, like post and lintel, typically uses vertical and horizontal members, but the vertical members are non-load-carrying; together, the upright and horizontal members support each other to form a standing *cage*. Because interior and

11-36 John J. E. Mayall, The Crystal Palace at Hyde Park, London, 1851. Daguerreotype, Imperial plate: 12" x 9 11/16" (30.5 x 24.6 cm). The J. Paul Getty Museum, Los Angeles.

exterior walls of frame buildings do not need to carry weight, multiple-story buildings were possible, and there were more options for the design of interior spaces. Exterior walls no longer needed to be of masonry to carry weight.

Early frame construction used wooden members **(fig. 11-35)**. (Virtually all home and much one-story commercial construction is wood frame to this day.) Although bridges had been built of cast iron since the eighteenth century, it was not until the mid- to late nineteenth

11-35 **Frame construction.**

century that iron and steel frame construction was developed. The strength of iron and, after 1860, steel, permitted architects to design huge enclosed spaces that were sturdy and fire resistant. Early examples were the great train stations and exposition halls such as the

Crystal Palace in London (fig. 11-36). The metal frame structures of the French architect Gustave Eiffel (fig. 11-34) were an important contribution to the development of twentieth-century skyscraper architecture.

In the late nineteenth century, the cost of real estate in American cities was rising. The new technology of metal frame construction was taking hold. The passenger elevator was invented. All these factors helped encourage American architects to think creatively. Taking advantage of vertical airspace instead of costly real estate on the ground, the skyscraper was born, and with it the modern era.

The skyscraper form was pioneered in Chicago. It relied on a steel frame (fig. 11-37), and until the middle of the twentieth century was usually clad in a masonry facade.

11-37 **Steel frame construction.**

Because masonry was not needed to bear the weight of the floors, the facades of sky-scrapers had rows and rows of windows. This helped combine interior and exterior, much as the Eiffel Tower had done in its airy design.

Innovative designs in architecture were also developed in Germany during the early twentieth century. German architects were the first to clad steel frame buildings completely in glass. Because the steel frame bears the weight of the building, glass cladding is actually hung from the frame. The resulting glass facade is sometimes called a *curtain wall.* Ludwig Mies van der Rohe's and Philip Johnson's Seagram Building (fig. 11-38), in New York City, was the end result of development of the skyscraper—a steel cage enveloped in a glass skin.

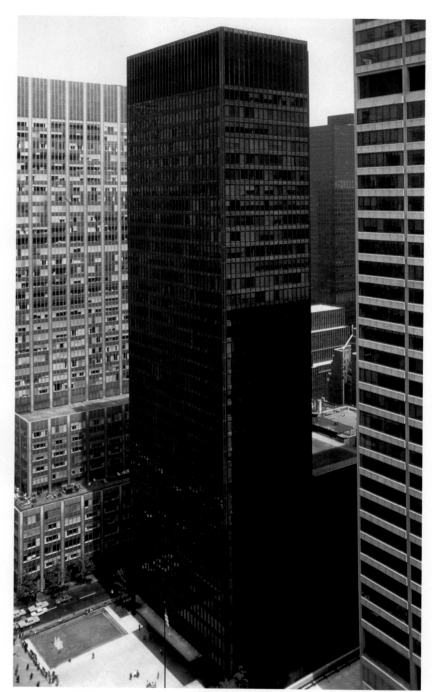

11-38 **Because the concrete, steel, and glass style was easily imitated, this type of building could be seen all over the world and is often called the International Style. What do you think it's like to live in a city dominated by these kinds of buildings?** Ludwig Mies van der Rohe, with Philip Johnson (interiors), Seagram Building, 1954–58. Tinted glass and bronze I-beams. New York, New York. Courtesy Davis Art Images.

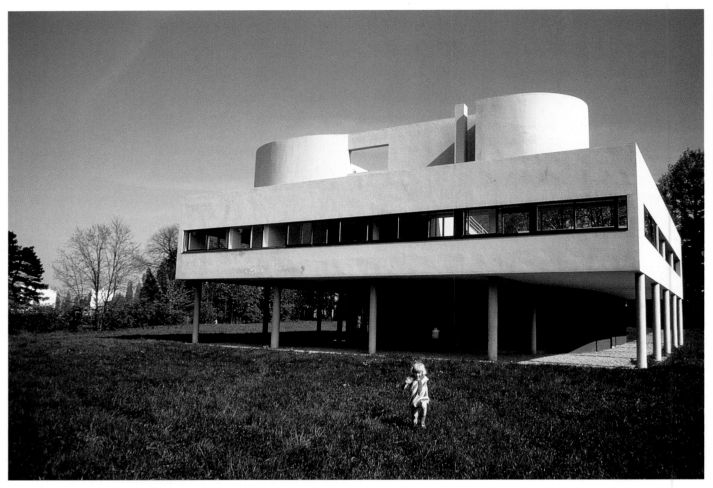

11-39 **Like Mies van der Rohe's and Johnson's Seagram Building, the ground floor of this structure is set back, with the upper floors resting on slender steel "stilts." The recessed ground floor and "stilt" arcade are hallmarks of the International Style.**
Le Corbusier, Villa Savoye, 1928–30. Paris, France. Courtesy Davis Art Images.

Concrete, a lost art since Roman times, was rediscovered in the 1800s. Concrete, like any form of masonry, lacks tensile strength—the strength to span great spaces. This handicap is overcome by embedding steel rods or cables in the material, a combination called ***ferroconcrete***, or *steel-reinforced concrete* (fig. 11-40).

11-40 **Ferroconcrete.**

French architect Le Corbusier is well known for his use of ferroconcrete. Like his contemporary Mies van der Rohe,

Le Corbusier came to believe that modern architecture should be designed in simple geometric shapes and uncluttered by surface decoration. Le Corbusier's use of ferroconcrete created an alternative to the glass boxes of Mies van der Rohe. His Villa Savoye (fig. 11-39) is a radical reinvention of the country house.

Ferroconcrete is more versatile than previous materials. This allowed buildings to be constructed in organic shapes rather than simply geometric ones. Many buildings, such as Frank Lloyd Wright's Guggenheim Museum in New York (fig. 11-41), took on a sculptural quality never before seen in architecture.

## About the Architect
# Frank Lloyd Wright (1867–1959)

"Every great architect is a great poet. He must be a great original interpreter of his time, his day, his age." Frank Lloyd Wright worked to live up to his words, and became one of the most respected architects of the twentieth century.

Wright was born in Wisconsin. When he was a very young child, his mother hung pictures of great buildings in his nursery, in hopes that he would become an architect.

In 1887, at age twenty, Wright moved to Chicago and landed a job at Adler and Sullivan, an important architectural firm at the time. He flourished in his job there, and considered architect Louis Sullivan to be his mentor. (Sullivan's Wainwright Building is shown in **figure 1-9, page 8**.) Wright took Sullivan's idea, "form follows function," and modified it for his own purposes. Said Wright, "Form follows function—that has been misunderstood. Form and function should be one, joined in a spiritual union." This idea would define Wright's career in architecture.

Wright's signature "Prairie Style" emphasized long, flowing, open interior spaces. One reason his designs were so popular was his ability to situate the buildings he designed within their natural surroundings. His design for Fallingwater, a home in western Pennsylvania, is a perfect example of this ideal.

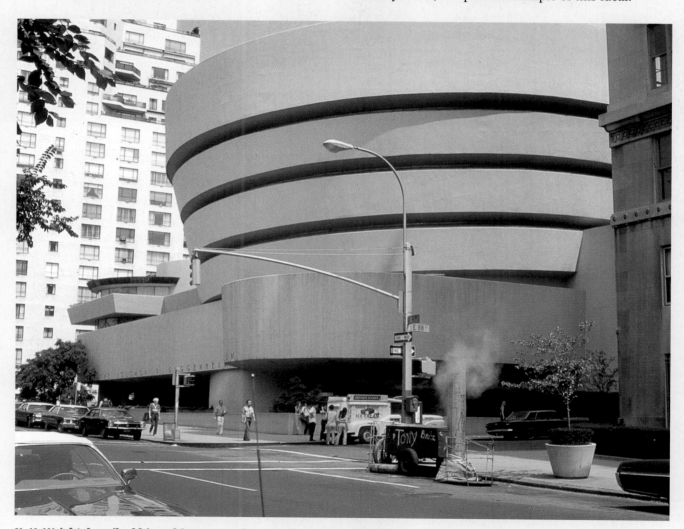

11-41 **Wright described his architecture as "organic," and introduced curves and circles into some of his buildings in the 1930s. Which sea creature's shell do you think might have served as the inspiration for the Guggenheim's spiraling design?** Frank Lloyd Wright, Guggenheim Museum (from south), 1943–59. New York, New York. Courtesy Davis Art Images.

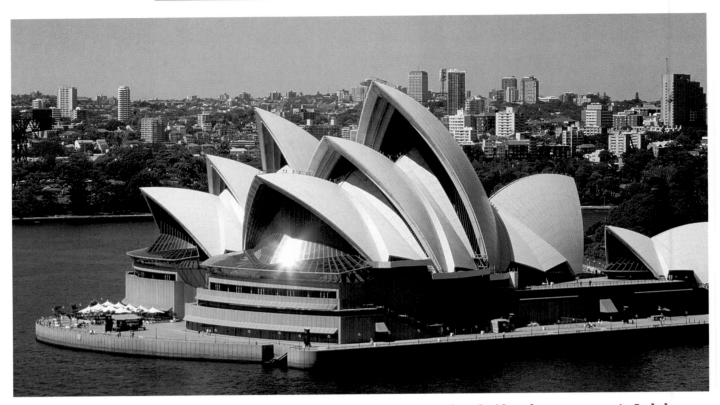

**11-42** Danish architect Joern Utzon's triple-dome design is said to have been based on the idea of orange segments. Each dome terminates at the top in a giant Gothic pointed arch. In what ways does this building suggest the idea of music? Joern Utzon, Sydney Opera House, 1959–72. Sydney, Australia. © Paul A. Souders/Corbis.

**11-43** The 354 pre-fabricated modules of Habitat 67 form 158 apartments in fifteen different configurations, from one to four bedrooms. What might be some benefits and drawbacks of living in such a "stacked up" configuration of apartments? Moshe Safdie, Habitat, 1967. Photo by Timothy Hursley.

In the 1960s, architects began some daring experiments in building. The strength of ferroconcrete made innovative designs possible. Joern Utzon's Sydney Opera House (fig. 11-42), begun in the late 1950s, was finished only in the 1970s, when the construction technology needed for some parts of the design became available.

Ferroconcrete also made the idea of *pre-fabricated* (pre-fab) construction possible. In pre-fab construction, sections, sometimes whole units of buildings, are produced by pouring concrete into steel or wooden molds containing steel rods. The result is often a cold, unadorned concrete surface. One of the best known pre-fabricated buildings is the Habitat apartment complex in Montreal, Quebec (fig. 11-43).

By the 1970s, many architects rejected modernist styles as cold and antisocial in cities whose skylines were filled with "glass boxes." These innovators felt that modernism ignored human beings who lived in the urban environment.

In contrast to the simplicity of *Modernism*, the *Postmodernism* of the 1970s through the 1990s included many styles. Many postmodernist architects borrowed elements of historical architectural styles, often transforming them by using high-tech materials, contrasting past and present. Buildings also became more ornamented.

One postmodernist ideal for urban architecture was that a building should reflect the nature of urban life, and no building does this better than the Pompidou Center in Paris (**figs. 11-44, 11-45**). The Pompidou's architects located the building's heating, cooling, and plumbing components on the outside of the structure, resulting in an industrial look that is a reminder of the mechanisms of a modern city.

## Write About It!
How does the architecture in your community reflect the location, character, history, and practices (occupational, economic, religious, and educational) of your community? Look at building sizes and architectural and construction styles. You may even wish to look into building codes or the layout of your community. Think about your community's population. Do you live in a farming or rural community, suburb or city? How do the buildings' size, setting, and architectural styles reflect the population of your town?

11-44 **The Pompidou Center is the home of the French National Museum of Modern Art. What practical reason do you think the architects may have had for placing the center's utilities such as water pipes and air-conditioning and heating ducts on the outside of the building?** Richard Rogers and Renzo Piano, Centre Pompidou, also called the Centre Beaubourg (detail). Paris, France. © Sheldan Collins/Corbis.

11-45 The Pompidou Center, Paris, France. © Sheldan Collins/Corbis.

11-46 **This office building brings together many historical references in its construction. What details of the architect's design add dramatic interest to the building?** Michael Graves, Humana Building, Louisville, Kentucky. Courtesy Michael Graves & Associates, Princeton, NJ.

**Linking Disciplines**

Literature

Ayn Rand wrote *The Fountainhead* in 1943. It's a classic story of an idealistic architect's struggles against a compromising society. If you can't find the book, you can rent the movie. It's worth attending to, both for the insights into the realities of architecture as well as character development and plot.

One of most important things to remember about postmodernist architects is that they reject the modernist idea that a structure's form should reflect its purpose. They also reject Mies van der Rohe's statement "Less is more." Postmodernists believe that decorative elements, which include reflections of everyday life, should cover the structural core.

Architects such as Michael Graves base their designs on classical forms of the past, combined in unusual and dramatic ways. Like many other postmodernist designers, Graves prefers to clad his buildings in masonry. He likes to use fine materials such as expensive granites and gold leaf detailing on the outsides of his buildings, such as the Humana Building (fig. 11-46).

Some architects, like Robert Venturi and his wife/partner Denise Scott Brown, design buildings that use popular symbolism as decoration, while attempting to make their designs fit in well with the traditional architecture of an area. Venturi mocked modernist architecture by saying "Less is a bore."

The Coxe-Hayden House and Studio (fig. 11-47) are examples of how Venturi and Brown take a traditional local style and modify it with contemporary exaggerations.

The term *deconstructivist architecture* was coined by architect Philip Johnson in the 1980s to refer to a movement that was meant to revive Modernism and reject the variety of styles in Postmodernism. The movement primarily stressed that architecture did not need to pay attention to the classical principles of order, balance, stability, harmony, symmetry, and regularity. Deconstructivist architecture often appears to be a haphazard arrangement of building masses, lighting, and spatial relationships. It challenges our notion of what architectural form really is.

Frank Gehry is an architect whose name is closely associated with Deconstructivist architecture. His Guggenheim Museum in Bilbao, Spain (fig. 11-1, page 296), has organic, rolling surfaces that make it look different from every angle viewed. Spanish architect José Rafael Moneo's design for the the new cathedral in Los Angeles, Our Lady of the Angels (fig. 11-48), may be said to offer a similar variety, in this case using geometric forms. The principal challenge in planning for this building, said Moneo, was coming to a definition of what makes a space sacred today, especially in a community where so many different heritages intersect.

11-47 **An example of postmodern home design, this house and studio blend tradition with surprise. How have the architects employed asymmetry in the buildings' exteriors?** Coxe-Hayden House and Studio, 1981, Block Island, Rhode Island, by Robert Venturi and Denise Scott Brown. Venturi, Scott Brown and Associates, Inc. Photo by Tom Bernard.

11-48 **Is this cathedral modernist, postmodernist, or deconstructivist? The opinions of critics may vary, but it's not likely that the architect himself was concerned with such labels.** José Rafael Moneo, Cathedral of Our Lady of the Angels, Los Angeles. Photo Reuters/ Fred Prouser. © Reuters News Media Inc./Corbis.

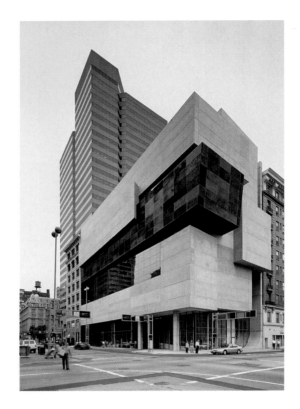

often learn architectural styles in countries other than their own and establish firms there. Iraqi-born Zaha Hadid designed the Cincinnati Contemporary Arts Center (fig. 11-49). It is organized in what Hadid terms an "Urban Carpet," a combination of dynamic interior and exterior public space, with people moving all around it. Zaha Hadid is one of the first women architects to have impact internationally.

11-49 **The Cincinnati Contemporary Arts Center is the first major museum in the United States to be designed solely by a woman. What has the architect done to upset traditional ideals of order?** Zaha Hadid, Contemporary Arts Center, Cincinnati, Ohio. Photograph: Roland, Halbe 2003.

It is difficult to define a single, main architecture trend in the twenty-first century. Deconstructivist, modernist, and postmodernist styles continue to appear side by side in urban settings. Major cities in many countries display these styles in their skylines. Architecture is no longer confined to local tradition in either form or style. Shanghai, China (fig. 11-50), is a perfect example of a city that, within fifty years, went from a regional port to an international economic center with some of the most trend-setting architecture in the world.

With computers, the Internet, cable and digital television, and the rapid movement of data around the world, Earth in the twenty-first century has truly emerged as a global community. The same is true with contemporary architectural styles. Architects from around the world work in many different countries other than their own. They

At the turn to the twenty-first century, many countries commissioned new architectural monuments to commemorate the event. These structures were designed in the most up-to-date styles, using cutting-edge technology.

11-50 **Shanghai is the largest city in China, and the Pudong area of Shanghai is the financial center of the Eastern world. What might the style of these buildings say about Chinese culture today?** © Liu Liqun/Corbis.

They were intended to be symbols of humankind's advanced culture going into the new century. After its opening in June of 2000, the Millennium Footbridge (fig. 11-51) in London was closed for two years while engineers decided how to stabilize the bridge, which swayed from side to side under the weight of heavy pedestrian traffic. This was eventually accomplished with fifty-four sets of equipment called *viscous movement dampers.*

New styles and cutting-edge technology have also been applied to initiatives in architecture intended to provide decent housing for people with low incomes. In the past, some of these initiatives involved planned, "utopian" communities. In the late twentieth and early-twenty-first centuries, such initiatives have taken the form of organizations mobilized largely by volunteers and corporate donations. These organizations identify housing needs and actually build homes. Habitat for Humanity, Interface America, and Rural Studio (fig. 11-52) are examples of such initiatives.

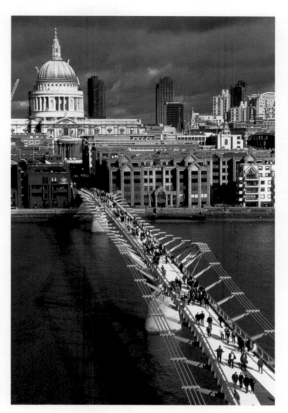

11-51 **This shallow suspension bridge is 330 meters long with a four-meter-wide aluminum deck for foot traffic. How does a pedestrian bridge reflect environmental concerns in the twenty-first century?** Foster and Partners, Millennium Bridge, London. Aerial view of bridge looking toward St. Paul's. Photo by Nigel Young/Foster and Partners.

**Write About It!**
Make a visual inventory of a public building in your community. What style, materials, and method were used in its construction? How is the building's function reflected in its construction? What works or doesn't work in its functional design? Try to address the size, materials, style, construction, location, and use.

11-52 **The Rural Studio program allows architecture students to plan, design, and build homes in a socially responsible manner, while actually living in the communities in which they are working. How might this make for a more people-friendly architecture?** The Lucy House, 2001–2, Mason's Bend, Alabama, a collaboration of Rural Studio with Interface America. Photograph: Timothy Hursley.

# A Memorial Library

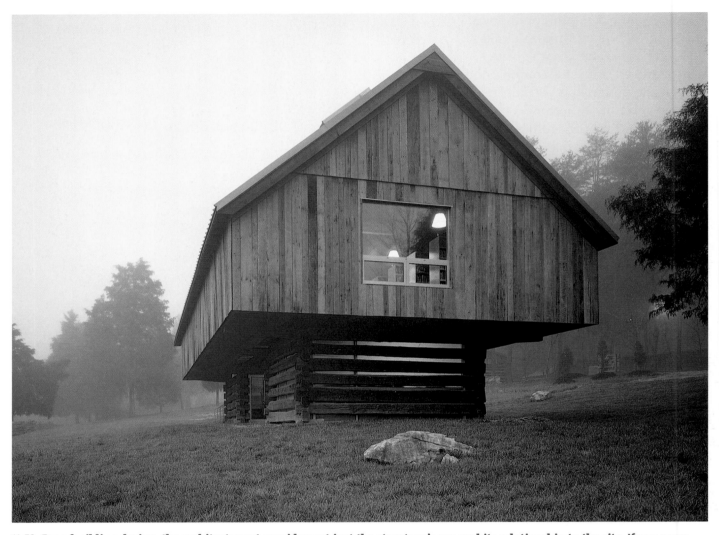

**11-53** **For a building design, the architect must consider not just the structure's use and its relationship to the site. If you were asked to design a library or museum, you would also want to ask yourself, What are the needs of those who will live and work in relation to this building?** Maya Lin, Langston Hughes Library, 1999. Children's Defense Fund, Haley Farm, Clinton, Tennessee. An **art:21** artist

### About the Architect
## Maya Lin (b. 1959)

Born in Athens, Ohio, Maya Lin is the daughter of two Chinese immigrants. She maintains that her American-Asian heritage makes it impossible to separate the Western and non-Western influences that infuse her work. She also says that the environmental concerns that guide her decisions have been a part of her life since she was a young girl and the notion of extinction caught her attention. Lin's work also is influenced by the Earth art movement of the 1960s and 1970s. Her designs always show a great sensitivity to the site where they are placed, and her materials are either recycled, natural, or living. About her desire to have her designs form a connection between people and nature, she says, ". . . you can make people feel a part of nature—not above it, not superior to it, and not conquering it. So I guess you can say I still feel the need for us to tread lightly on the landscape."

# ① Describe What You See

When you describe a work of architecture, you identify things about the work that you can see, name, and describe with certainty. You should not include opinions, evaluations, or possible meanings here.

- List the title of the work, designing architect, renovating architect, date of renovation.
- Where is the structure located?
- Describe the barn (not the composition of the photo).
- Describe the site—what you see around the barn.
- What kinds of line do you see in the structure?

# ② Analyze the Way It's Organized

When you analyze a work of architecture, you tell how the subject matter and elements of the work have been organized by the architect. You tell how they work together.
   Concentrate on the architecture and surroundings. Note: *Only the interior* of this barn was renovated to convert it into a memorial library.

- What is unique about the structure of this barn? Consider proportionate relationships between the lower and upper forms.
- Identify the direction of lines in the structure. What is the dominant direction?
- How is variety achieved in the building?
- How do the horizontals in the lower structure relate to the upper structure and the ground?
- Where do you see a contrast of warm and cold?
- What dominates the site?

# ③ Interpret What It's Saying

Use the information from your description and analysis to help you identify the meaning of the work—that is, what it tells you about the human experience.

- List some words that describe the mood of the building and environment (site).
- How does the building relate to its surroundings?
- Compose a simile or metaphor that helps describe your perception of the building and site.
- Based on your analyses, what is the meaning or purpose of this work?

# ④ Evaluate Its Success

Using your analysis in the first three steps, judge the quality or success of this work.

- How successful is the work in advancing a human need or cause?
- How successful is the relation of the structure to its surroundings?
- How effectively does the work evoke ideas and emotions for you and others?
- How original is the concept of housing a library of human accomplishments in an old barn in a tranquil farm clearing?
- How well known is this artist/architect? Was this building and farm owned by a famous person? Does the memorial relate to a famous person? Do its contents play a role in our history? Research these questions for a complete understanding of this structure's significance.

**More Architecture!**
For more designs by Maya Lin, see page 324.

**Web Link**
www.davis-art.com

### Write About It!

Work with your classmates to analyze your class's relief composition. Look at the various architectural styles and the composition and makeup of the unit. What similarities or differences do you notice across architectural styles? What do you think most unifies the design of your classroom's unit? Which styles most interest you and why? How do they work with the others to maintain interest across the relief composition?

# Architectural Clay Relief

How can you demonstrate your appreciation and understanding of architectural styles? In this exercise, you are asked to create a ceramic, low-relief tile in a particular architectural style that you find interesting. You can work with your classmates to assemble your tiles into one large wall unit.

11-54  **A selection of student-made, bisque-fired terra-cotta clay tiles.**

### Before You Begin

Discuss architectural styles and their differences. Find examples of Western and non-Western architecture, and explore the various forms used in several eras and styles, including Greek and Roman, Romanesque, Gothic, Renaissance, Baroque, and Neoclassical.

### You Will Need

• sketch paper
• terra-cotta clay
• plywood
• adhesive
• foam core

### Create It

❶ Using images from your discussion as reference material, create a few small sketches of styles you like. Decide which specific style you want to work with and develop a 6" square drawing. Document the historical period, name of the style and country where it was developed, and influences on that style.

❷ Begin working in clay. Start by wedging, measuring the 6" size of the tile, and then designing the relief. Refer often to your pencil drawing and a photocopy of the original image.

❸ Decide where your image will work best in relation to classmates' images. To do this, arrange and rearrange the drawings on a foam core panel. At times, you may need to add lines to the clay to show a visual connection to the other images.

11-55 **A student arranging finished tiles.**

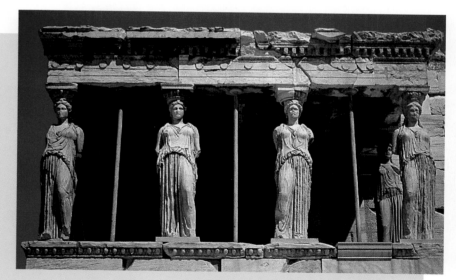

11-56 **Student work on top of lockers.** Terra-cotta, plywood, 2' x 8' (61 x 274 cm).

**Technique Tip**
If time permits, create extra tiles for areas that need a stronger visual connection in the overall composition.

④ When you are finished with your relief design, allow the tile to dry. Then it will be fired in a kiln. With classmates, stain the plywood.

⑤ Work with classmates to arrange the finished tiles on the plywood. Use a commercial adhesive in a caulking gun to attach tiles.

## Evaluate It

- What did you learn about architectural styles?

- What problems did you encounter in creating your image and in relating your image to your classmates'? How did you solve the problems?

- How does your image reflect your chosen architectural style?

- What did you learn about working cooperatively?

**Art History**

## Studio Background

Mention the phrase *Greek column* and almost everyone will picture a straight, simple, maybe fluted, architectural element made of marble. The ancient Greeks also developed another type of architectural support called the *caryatid*, where the column takes the form of a carved female figure. The most famous examples are found on the Erechtheion on the Acropolis in Athens, Greece. *Atalantes*, or *telamones*, are the male counterparts. It was a logical invention from a culture so interested in the representation of the human form. The column type has remained a part of Western architectural vocabulary even to the present.

11-57 **The original caryatids are now housed in the Acropolis Museum, where they are protected from the pollution of modern-day Athens. How are the figures posed so that they appear actually to be bearing the weight of the building?** Porch of the Maidens, Erechtheion. Photo by Oliver Radford. Courtesy Davis Art Images.

## Computer Option

Use a digital camera to photograph the bricks, tiles, windows, benches, and other details of your school building. Scan into a paint or photo program a sketch that you have made of your school. You will then cut and paste and use the transform tool to fit your details onto the sketch. Pay attention to perspective and reshoot any details that seem out of perspective. Save and print for critique.

# Architectural Collage

What approach would you use to show architectural space in an abstract composition? Studying the design elements within your school environment, create sketches of the building or buildings based on views that have an interesting combination of lines, shapes, and patterns. Then develop one view into a collage that applies the principles of linear perspective.

## Before You Begin

Make a series of small sketches of interesting segments of the school's architecture. Look for views that have: focal points (areas that catch the viewer's eye), supporting shapes (shapes that move the viewer's eye), quiet spaces (areas that rest the viewer's eye), and strong diagonals and converging lines to lead the viewer's eye into the composition.

## You Will Need

- newsprint paper
- pencil and eraser
- mat board or cardboard
- collage materials: recycled magazines, posters, wallpaper remnants, etc.
- glue and glue brush

## Create It

**1** From your series of sketches, select the most interesting composition and draw it to actual size on a sheet of newsprint. Transfer your drawing to a sheet of mat board, cardboard, or poster board.

**2** Develop your transferred drawing into a collage. As you look for collage materials, select papers that: catch the eye (have high contrasts, interesting imagery), carry the eye (have patterns or textural qualities such as written or printed words), and rest the eye (have solid colors or blank spaces). Keep your collage unified by limiting your choices to no more than five different kinds of paper. Remember: "When you have too many, you don't see any."

11-58 **Student work, Nima Ashe.** Collage of wallpaper remnants, magazine text, and construction paper, 19" x 16" (48.3 x 40.6 cm).

**3** Use the collage materials to fill in the shapes on your drawing. Use your busiest papers at the focal point. Use the supporting paper to move the viewer's eyes around the picture plane, and fill in the rest with "quiet" paper. Explore and experiment with various selections before gluing one final design in place.

## Evaluate It

- How did you use focal point, supporting shape, and quiet space to reflect the principles of one- and two-point perspective in your collage?

- How did you use color, overlapping, and high and low placement to create a sense of architectural space in your collage?

- "When you have too many, you don't see any." How does this quote apply to this project, and how can you connect it with everyday life?

11-59 Student work, Jennifer Prather. Collage of wallpaper remnants, magazine text, and construction paper, 15" x 15" (38.1 x 38.1 cm).

### Write About It!
Picture yourself inside your perspective drawing. Now, imagine that you are the focal point or main character of your collage. How do you support your audience and supporting cast to maintain overall interest and balance? What elements lead your audience's eye through your composition? What element leads them off track or confuses? Look at weight, balance, line, shapes, and patterns.

### Technique Tip
Look at magazines upside down when selecting collage materials. This way, you see the textures, patterns, and colors, rather than the images and information.

**Art History**

## Studio Background

When first experimenting with abstraction, the Dutch painter Piet Mondrian worked from natural objects. He looked for natural harmonies, such as rhythm, and painted those—thus abstracting the object. Can you see the reference to the trunk and main branch of the tree? The rhythm of the other branches is captured in the curving lines that run across the canvas. Note that the painting is still very ordered. Mondrian was striving for ways to reduce both the representation of the object and the actual method of constructing the composition. His later, very simple geometric abstractions, which used only a few pure colors, were a logical conclusion to this quest.

11-60 **This work falls in the middle of a group of tree paintings by Mondrian that show a progression from somewhat representational to extreme abstraction. How does this painting reflect simplified brushwork in the construction of the composition?** Piet Mondrian, *Tree*, 1913. © ARS, NY. © Tate Gallery, London/Art Resource, NY.

11-61 Maya Lin, *Wave Field*, 1993–95. Sculpted earth; 100' x 100' (30.5 x 30.5 m). University of Michigan, Ann Arbor, MI. An **art:21** artist

11-62 Maya Lin, Vietnam Veterans Memorial, Washington, DC, 1982. Black granite, each wall: 246' long x 10½' high (74.9 x 3.2 m). An **art:21** artist

11-63 Santiago Calatrava, Quadracci Pavilion at the Milwaukee Art Museum. Photo by Timothy Hursley.

11-64 Joseph Giovannini (architect), for artist Robert Skotak's one-bedroom apartment in Los Angeles. Photograph: Michael Moran.

## Summary

Architecture is everywhere, and it affects your life in many ways. Five major construction techniques have influenced architecture since the time of the Greeks: post and lintel, arch, dome, frame, and ferroconcrete. *Post and lintel* construction is created when vertical members support horizontal members. The development of the *arch* allowed masonry construction to bear much heavier loads. *Dome* construction is ideal for covering large spaces that are round, square, or octagonal. Most modern construction is frame or ferroconcrete. *Frame construction,* whether wood or metal, eliminates the need for heavy load-bearing walls. *Ferroconcrete* is steel-reinforced concrete. It is strong and can be molded, making it a versatile building material.

New technologies and materials continue to affect the look and function of buildings. Investigate the architecture around you, and pay attention to new construction. What is it made of, and why? How does its use relate to the way it is built?

## Review Questions

1. **Recall:** Name the oldest and simplest construction method.

2. **Understand:** Explain why the roof of the Parthenon no longer exists.

3. **Apply:** Make a drawing of an arch between two columns. In writing, explain why the arch does not fall down, and how weight is carried by it.

4. **Analyze:** Compare and contrast the palace of Versailles with Mies van der Rohe's and Johnson's Seagram Building.

5. **Synthesize:** Design a building for the center of your town or city that makes use of one of the major principles of construction. Consider the buildings that are already there, and plan yours in a style that will fit in with the buildings surrounding it. Write a description of why you think this building will fit in well, and how it will contribute to the overall look of the area.

6. **Evaluate:** Choose a building you are familiar with. Script an imagined conversation between a neoclassicist, a modernist, and a deconstructivist about the building. Which one would like it? Which would hate it? How might each defend or condemn it? The three architects need not agree by the end of the conversation.

## For Your Portfolio

Always keep your portfolio organized. Date and clearly identify each item. Place a sheet of tissue paper or newsprint between each piece. On a regular basis, check the contents, and decide what to remove and what to keep.

## For Your Sketchbook

Consider what buildings mean to their owners or users. Fill a page in your sketchbook with designs of buildings that evoke an important quality such as security, wisdom, strength, courage, peace, honesty, or creativity. For example, you could evoke security with a building that has features of a combination lock. Be playful in your designs, and have some fun.

## Electronic Research

Five separate art museums around the globe share the Guggenheim name. They are found in New York, Bilbao, Venice, Berlin, and Las Vegas, but you can enter the Guggenheim gateway at http://www.guggenheim.org/ and then explore each of the museums in depth. Who were their architects? What architectural characteristics do they share? How do they differ? Write a comparison of them as an art-oriented travel feature for a newspaper.

## Going Further

What is the architectural heritage of your community? Work with a group of your classmates to produce a video that documents the various architectural styles and features in your community or region of the country.

# 12 Careers

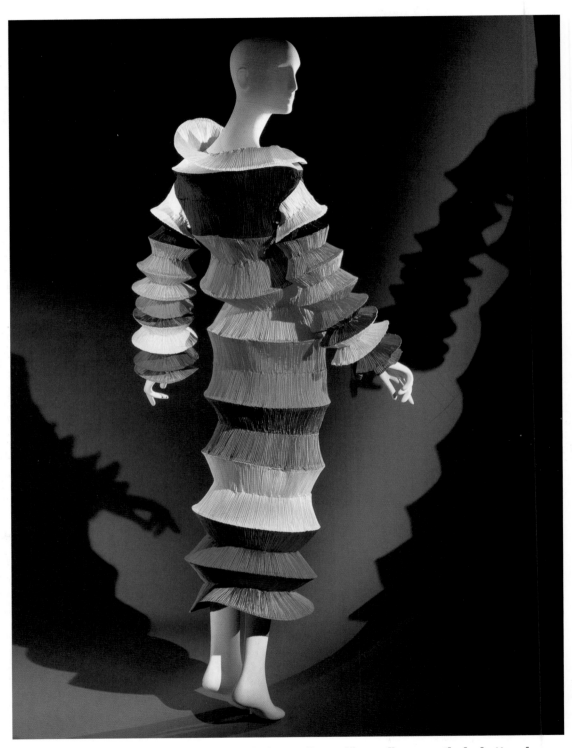

12-1 **The designer of this garment wants his designs to "extend" as well as cover the body. How does this design accomplish that aim?** Issey Miyake, "Flying Saucer" Dress, Spring/Summer 1994. Heat-set polyester. Philadelphia Museum of Art: Gift of Issey Miyake. Photo by Lynn Rosenthal and Graydon Wood, 1997.

## Key Terms

*English* (*Spanish*)

*environmental design*
  (*diseño ambiental*)
*communications design*
  (*diseño de las comunicaciones*)
*graphic design* (*diseño gráfico*)
*industrial design* (*diseño industrial*)
*product and fashion design*
  (*producto y diseño de la manera*)
*multimedia design*
  (*diseño de los multimedia*)
*curator* (*guardián*)
*conservator* (*conservador*)

## Artists

Deena Appel, Fern Cunningham, Tommy Hilfiger, Ollie Johnston, Annie Leibovitz, Issey Miyake, Chris Soentpiet, Jaune Quick-to-See Smith, Christine Sundt

12-2 Student portfolio, Steve Lynch.

## 12.1 A Quick Look at Careers

You've seen many examples of fine art—paintings, sculptures, prints—in the earlier chapters of this book. Fine artists work to express ideas and feelings. They care most about how their artworks look and what they mean. But fine art represents only a small percentage of the art we experience every day. Whenever you visit a shopping mall, ride a bus, watch TV, read a newspaper, or walk in the park, you're surrounded by the work of artists.

Artists' designs affect the way nearly everything looks in our human-made environment—homes, clothing, cars, toys, and your school building, to name a few. There are many more art careers than can be described in this chapter. So we've chosen five broad areas in which artists play major roles, and explored some of the common careers within them.

To help you understand them better, we've divided art careers into five major categories.

12-3 **It would be unusual to spend a day in the United States without seeing the work of a graphic designer. Why do images and words make up so much of our daily lives?** Courtesy Osborn & Delong, Bloomington, IL.

12-4 **People visit Web sites for information and to buy products. Why is it important that a Web site be easy to navigate?** Courtesy WGBH Boston.

12-5 **If you were designing a new vacuum cleaner, what shape would you start with? What do the shapes and colors of this one suggest to you?** Prototype of vacuum in polyurethane foam, lacquer painted. Courtesy Eureka Vacuum Company.

*Environmental design* careers center around the spaces and places you live in and visit. *Architects* design houses, schools, factories, and office buildings. *Landscape architects* design specific plots of land. *Interior and display designers* (fig. 12-6) decide how interior space will work, from fabrics and furniture to cabinets and paint colors.

There are many art careers within the realm of **communications design**. **Graphic designers** (fig. 12-3) arrange words and images to create the materials you read every day, from Web sites (fig. 12-4) to magazine articles to road signs. *Illustrators* respond to written concepts and help others understand them. *Photographers* create the pictures we see in newspapers and magazines, catalogs, displays, portraits, and advertising.

**Product and fashion designs** take up a lot of space in your life. *Product designers* (fig. 12-5) decide how your laptop or vacuum cleaner will look. *Fashion designers* choose the colors you'll wear and the width of your belt, tie, or pants leg.

Do you like *entertainment?* A career as an *animator* (fig. 12-7) might appeal to you if you're skilled in computer use and know how to draw quickly and accurately. Or, if you prefer the stage, you might consider work as a *scenic designer,* making the setting of a play come to life.

Many artists provide *cultural enrichment* to our society. *Fine artists* and *craftspeople* create thought-provoking works and objects of beauty, while working in an intensely competitive field. *Art teachers* pass along their love of art to others. *Museum professionals* oversee museum operations, purchase artworks, curate exhibits, care for and document artworks, and help others to see and learn about a museum's collections.

If you think a career in art is for you, one way you can take action right now is to begin to create a *portfolio.* This record of your growth as an artist will allow college and university staff to get a sense of your strengths and interests, and will give you a way to showcase your best work.

12-7 **Ollie Johnston was an animator for numerous Disney films, including** *Fantasia, Sleeping Beauty,* **and** *The Many Adventures of Winnie the Pooh.* **Although computers play a large role in animation today, animators still need excellent drawing skills.**
© Douglas Kirkland/Corbis.

12-6 **This model shows a design for a space to be used within a convention center. In what ways is a company's exhibit display an important form of advertising?**
Neil Forsythe, Krups Corporation, Exhibit booth model.

12-8 **Architecture is both an art and a science. Why is this building such a clear demonstration of that statement?** Longaberger Company Home Office Building, Newark, Ohio. Photograph copyright 1997. Reprinted with permission.

12-9 **Why might experience with drawing techniques be helpful to an architect?** Davis Mansion, 1872, Bloomington, Illinois (east side elevation). Architectural drawing for restoration project. Courtesy Middleton Association Architectural Services, Normal, IL.

## Architecture

*Architects* create designs for buildings (figs. 12-8, 12-9), draw plans, and supervise the construction process, all of which must meet building codes, environmental and legal restrictions, and the client's needs. Architects are responsible for the look of both the exterior and interior of a structure, and for everything that goes into it, including foundation and structural materials, heating, plumbing, wiring, ventilation, stairways, and lighting.

It takes five years to complete a university program in architecture, and three years of internship to obtain a license. Required skills and knowledge include drawing, drafting, architectural design, mathematics, construction methods and materials, urban planning, and history of architecture.

*Architectural renderers* create drawings of a proposed structure so that everyone can see what it will look like. The renderer usually makes sketches based on information from the client and the architect and discusses them with the architectural team before creating the final illustrations. These illustrations suggest scale and show how the building will look in the selected environment. The drawings clearly show construction materials such as brick, wood, aluminum, steel, and stone.

Architectural renderers need skill in freehand drawing with a variety of drawing media, drafting, and watercolor and acrylic painting. Background in architectural design and history, computer-aided design, and graphics are also helpful.

*Landscape architects* design landscapes for public and private recreational areas, housing developments, and businesses. They plan the land contours, watering systems, drainage, and plantings.

Most landscape architects attend colleges that offer architectural degrees. They are skilled in the use of drawing and painting media, mechanical drawing, model building, surveying, botany, geology, ecology, and landscape construction methods.

## Interior and Display Design

*Interior designers* plan the look and shape of interior space for everything from houses and automobiles to factories and ocean liners. These designers advise clients on color schemes, furniture, fixtures, fabrics, lighting, floor, counter, and wall coverings, and even artwork. The designer may develop drawings, three-dimensional computer images, and scaled floor plans for approval. Once a design is approved, the designer buys all materials and furnishings and supervises their installation (fig. 12-10).

Most interior designers have a degree in interior design and complete an apprenticeship with a professional designer. The job requires a strong sense of design and color, attention to details, and the ability to work with people and organizations.

*Exhibit and display designers* plan and construct exhibits and displays for stores, museums, and conventions (fig. 12-11). They are responsible for

planning the total exhibit, including display cases, space dividers, and lighting. The designer provides drawings and scale models for clients to evaluate prior to the actual construction. Many designers freelance for several different businesses, although some large department stores employ display designers full-time.

Exhibit and display designers need skills in representational drawing, design, lettering, illustration, computer graphic design, type, color, display, theatrical lighting, and carpentry.

12-10 **Look carefully at this kitchen. How many different materials and fixtures did the interior designer have to choose or recommend?** Hariri & Hariri, Belmont House (kitchen). © Hariri & Hariri—Architecture, New York City. Photography by Cesar Rubio.

12-11 **A strong exhibit display conveys subtle messages about identity and credibility.** Neil Forsythe, Krups Corporation, Exhibit booth model.

### Career Focus

**Art directors** coordinate the efforts of teams of artists and designers in places such as advertising agencies, film or television production studios, publishing companies, or large corporations. An art director must understand artistic production processes from beginning to end and must have a good sense of design and effective organizational and planning skills. Art directors must be skilled team leaders and good administrators who can work well with people at all levels of production and marketing.

### Graphic Design

Can you imagine a world without books, magazines, videos, or advertisements? *Graphic designers* work with printed words and images to create visual presentations that attract attention, convey ideas, and sell products. Their work bombards you every day through signs and symbols, logos, advertisements in print and on TV and the Internet, displays, packaging, book and magazine covers, computer games, posters, and billboards.

Graphic designers are employed by a wide variety of businesses and organizations. Many work as freelancers. Graphic designers usually complete a college or art school program, including courses in design, drawing, painting, collage, art history, lettering and typefaces, photography, computer graphics and design, marketing, and advertising. Following are just a few of the many career paths graphic designers may take.

Graphic design agencies employ graphic designers who plan text and visual layouts for clients with a variety of promotional needs (fig. 12-12).

*Corporate graphic designers* plan advertisements and promotions for a particular company's products or services. They often work under an art director, and are responsible for photographs, illustrations, and layout.

*Advertising agency designers* create print and electronic advertising campaigns designed to sell a product or service for a client. An agency graphic designer is part of a team that includes an art director, illustrators, copywriters, photographers, and digital designers.

*Publications designers* combine text and illustrations to create appealing books, magazines (fig. 12-13), and newspapers for many different audiences. (Graphic designers at WGBH Design, for example, helped make hundreds of decisions about this textbook's overall look and feel.)

12-12 **Graphic designers today depend on computers when they draw images, select typefaces, and place text. Here, a designer carefully checks a printer's proof.** Graphic design agency workstation. Courtesy Osborn & Delong, Bloomington, IL.

12-13 Photograph: Tom Fiorelli.

*Web designers* create colorful, attractive, and useful pages for the Web sites of businesses, colleges, and organizations (**fig. 12-14**). As the World Wide Web expands, the need for designers who understand the special requirements of electronic design and organization expands as well.

*Sign designers* plan layouts of text and images for signs that communicate a client's message and work well with a physical site (**fig. 12-15**). The sign industry is divided into three general categories: *outdoor* (billboards, wall graphics, and off-premises advertising), *electric* (backlighted signs, neon, pylon, monument signs, and electronic message centers), and *commercial* (non-illuminated panel signs, wood signs, vehicle graphics, banners, and show cards).

12-14 **Think about how many decisions on colors, typefaces, and organization the designer of this Web page had to make. What features help make the page easy to read?** Courtesy WGBH Boston.

12-15 **This small shop sign was designed on a computer, transferred to a wooden panel, and then hand painted. What kinds of signs attract your attention? Why?** Mark Blumenshine, Prairie Signs, Bloomington, IL.

## Illustration

The art of illustration has a lot in common with drawing or painting, but the key difference is that most illustrations are closely linked to written ideas. The illustrator generally responds to a written concept, and his or her illustration helps others understand or appreciate the concept.

*Editorial illustrators* use drawing and painting media to create artwork for books (fig. 12-16), magazines, newspapers, posters, and storyboards. Their drawings and paintings must complement written text. Most illustrators have completed a four-year program, majoring in drawing and painting.

12-16 **Chris Soentpiet is a children's book illustrator. This illustration, from** *Dear Santa, Please Come to the 19th Floor,* **written by Yin and illustrated by Chris Soentpiet, was one of thirty he painted for the book. What do you think the book's text for this page might say?** Watercolor on watercolor board. Courtesy of the artist.

*Technical illustrators* produce detailed, descriptive drawings for science and industry that help others assemble, install, and understand working parts, and maintain complex machinery and equipment. Drawings for the interior of an automobile engine or the assembly of a bicycle are examples of their work. Most technical illustrators have attended schools with strong programs in drawing, technical illustration, and computer graphics.

*Medical illustrators* create accurate two- and three-dimensional pictures of the human body. They are employed by medical schools and supply companies, medical publishers, and advertising agencies. Required skills are similar to those of a technical illustrator.

*Cartoonists* produce drawings that entertain, educate, and persuade viewers. *Comic strip artists* present humorous short stories or jokes with a series of pictures, usually including words. *Comic book artists* illustrate longer stories. *Editorial cartoonists* comment on our society with pictures that are funny and may express satire. *Panel cartoons* combine a drawing with a humorous sentence, or may convey the idea without text. *Advertising cartoons* are meant to sell products. Cartoonists must have rich imaginations, be able to draw well and in a distinctive style, and generate ideas continually.

*Fashion illustrators* draw clothing and models to show how clothing fits and looks. They must be able to illustrate the texture and special qualities of fabrics, draw the human figure quickly and descriptively, and make the clothing and models look attractive. Illustrators are employed by textile companies, garment manufacturers, design houses, and stores. A fashion illustrator needs creative skill with a variety of drawing and painting media, and a background in fashion design.

## Photography

Photographs surround you every day, and you probably take them for granted. In the hands of an experienced professional, however, photography is an art form. The field includes many specialities, a few of which are described below. All require broad technical understanding, a sense of composition, and knowledge of darkroom procedures.

*Photojournalists* travel to many different locations to create the pictures you see in magazines and newspapers and on TV (**fig. 12-17**). They are familiar with a variety of cameras, including digital cameras, and must be able to handle them with speed and accuracy. Because it takes years to establish a reputation as a photojournalist, many start as freelance photographers.

*Fashion photographers* create pictures for magazines, catalogs, and displays. They work in studios or outdoors on location. They are skilled in creating special lighting effects and posing models to create the proper mood in their pictures.

*Portrait photographers* make photo studies of their subjects. They generally have a studio, but will go to locations for special events such as graduations, weddings, birthdays, and awards ceremonies. Portrait photographers are expert at posing subjects and arranging lighting (**fig. 12-18**).

*Product photographers* specialize in composing photographs that make products look attractive. They photograph products ranging from food to heavy machinery, and must know how to deal with the way light is reflected by many different surfaces.

All of these photography careers require a variety of skills, training, practice, and communication abilities. To land a job as a professional photographer, you'll need a college degree and a strong portfolio.

12-17 **Photojournalists cover news and sports events in hopes of making pictures that tell stories. What story does this photograph tell?** © AFP/Corbis. Photograph: Mark Leffingwell.

12-18 **What gives this photograph a mysterious quality? Why might someone want to look mysterious in a portrait?** Marc Boon portrait by Ann Charback. JMC Photo and Digital Service.

## Industrial Design

*Industrial designers* work to improve the appearance, quality, and safety of manufactured products. Designers are responsible for the form and function of all the objects that are part of your daily life, from hair dryers and couches to skateboards and computers. Industrial designers must understand production processes, the characteristics of materials, safety concerns, the function of the product, its market, competition, and style trends.

Industrial designers usually hold a four-year degree from an industrial design program. They must be able to visualize and plan three-dimensionally. They need drawing skills and the ability to construct models and use computer-aided industrial design programs.

*Product and package designers* are employed by manufacturers of consumer products. The products they design (figs. 12-19, 12-20) must serve their purpose well, be attractive to consumers, and be economical to manufacture. The designer works in concert with engineers to produce detailed concept drawings. Once a design is approved, the team uses computer-aided design tools to create a series of models of the product.

*Furniture designers* create new furnishings that work well and look attractive. Designers must consider *ergonomics* (how a piece of furniture fits the human body and helps people function efficiently), purpose, comfort, durability, and sometimes storage. They must be familiar with the charac-

12-19 **Why might a designer want a vacuum cleaner to look like a rocket?**
Prototype of vacuum in polyurethane foam, lacquer painted. Courtesy Eureka Vacuum Company.

12-20 Production box for vacuum. Courtesy Eureka Vacuum Company.

teristics of a wide variety of materials, and know production and manufacturing processes.

*Toy designers* are employed by manufacturers to create toys and games that appeal to children of various ages, meet safety standards, and are durable and cost effective to produce. They are responsible for research and development from concept through exploratory drawings, model building, and final production drawings. Toy designers must be innovative, be able to think three-dimensionally, and know children's interests.

*Screen print designers* utilize computer programs and photo-screen procedures to create multicolored images for a multitude of commercial products including clothing (**fig. 12-21**). A background in art and computer graphics is helpful.

## Fashion Design

**Fashion designers** create designs for all types of clothing, hats, scarves, purses, and costume jewelry. Most specialize in one type of clothing, and work for textile, clothing, and pattern manufacturers, fashion salons, and specialty shops. A few produce one-of-a-kind designs for high-fashion houses (**fig. 12-1, page 326**). The majority create fashions for mass production, adapting styles and materials to meet market price requirements. Most have attended a fashion design school or completed a four-year program with a fashion design major. They have background in math, business, design, drawing, art history, costume history, textiles, pattern making, sewing, and computer-assisted design.

The creation of a garment begins with the designer's rough sketch. A paper pattern is made, and pieces are

12-21 **A separate screen was designed for each color in this print. How many colors can you identify? Can you identify some shapes that appeared on individual screens?** Armbrust Truck Racing Shirts. Courtesy Minerva Sportswear, Inc.

cut out of a material like muslin. The pieces are sewn together and fitted on a model. Modifications are made to complete the design. Finally, sample garments are made in the fabric the designer selects. If a garment is well received at a buyer's show, it will be mass-produced for sale in stores. New styles are produced four times a year for the seasons, and a designer must create dozens of styles for each showing. Fashion designers must have a complete knowledge of available fabrics, and they must know consumer trends and public tastes.

## Linking Disciplines

### Language Arts

Wanting a job and getting it are not the same. Landing the right job also requires more than just being a skilled artist. You need to have the appropriate verbal and writing skills to make an impression on a potential employer. Ask your language arts teachers to help you develop good writing and interviewing skills.

## Multimedia Design

If you've ever been impressed by a movie's special effects, or delighted by a funny ad on television, you've appreciated the work of entertainment artists. The growth of the entertainment industry has increased the need for skilled artists, designers, and technicians. All require a strong background in art. Here are a few of the best-known careers.

*Animators* use computer programs to draw and color sequenced pictures for animated films (fig. 12-22). They work as part of a large team, creating animal and human characters for films. Animators must be able to work with rapid accuracy on projects that require repetition, time, and patience. They must have excellent drawing and design skills and mastery of design animation techniques, and be able to meet strict deadlines. Many animation studios offer training programs for artists with strong portfolios.

*Storyboard artists* create sequential sketches that illustrate the action in a story or production for films, videotapes, and TV commercials (fig. 12-23). The director uses the storyboard, which is similar to a comic strip, as an outline of the shot sequence to be filmed. Storyboard artists are employed by large advertising agencies and the film and TV industries. They must be able to produce descriptive drawings very rapidly. They must understand filming and animation procedures, photography, staging, lighting, and acting.

*Game designers* research and then create the characters and scenes that make up interactive electronic games, such as those played in arcades, on home computers, on handheld devices, or online (fig. 12-24). They usually work as part of a design team, planning and "building" the many components necessary to make the game work. Game designers need to be able to master complex computer programs, understand two- and three-dimensional space, and apply imagination and creativity to game design.

12-22 **To create a single second of film, artists like Disney animator Ollie Johnston must produce twenty-four drawings. Think about the number of drawings necessary to make a ninety-minute film!** © Douglas Kirkland/Corbis.

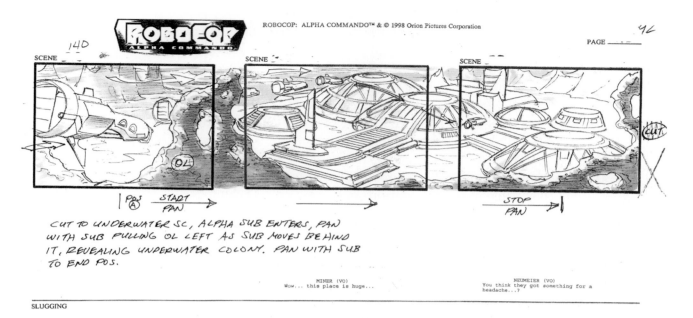

SCENE

SCENE

SCENE

POS
A

STADT
PAN

STOP
PAN

CUT TO UNDERWATER SC, ALPHA SUB ENTERS, PAN
WITH SUB PULLING OL LEFT AS SUB MOVES BEHIND
IT, REVEALING UNDERWATER COLONY. PAN WITH SUB
TO END POS.

MINER (VO)
Wow... this place is huge...

NEUMEIER (VO)
You think they got something for a
headache...?

SLUGGING

**12-23 Why might it be cost effective for a director to review storyboards before beginning shooting on a film, video, or commercial?**
David Hoover, *RoboCop* storyboard. Courtesy of the artist.

**12-24 In *Asheron's Call 2: Fallen Kings*, a Tumerok character embarks on his journey through the Tumerok tutorial dungeon before questing in the land of Dereth. What spatial effects have this online game's artists used to create a compelling world?**
Courtesy Turbine Entertainment Software.

## Set and Costume Design

Have you ever put on a play? If you have, you'll know that it takes lots of people to stage a good production. The actors are the most visible, but the action is greatly enhanced by the behind-the-scenes work of scenic designers, costume designers, and lighting technicians, among many others. Art plays a large role in the foundations of these careers.

Whether creating a mysterious forest or a space station in the future, *scenic designers* are responsible for projecting the feeling of "place" in individual scenes of a play. The scenic designer is involved in all steps in the design process, from sketches to scale models to actual set construction (**fig. 12-25**). Knowledge of construction techniques and materials is important, as are research skills, the ability to meet deadlines, and interest in working as part of a team.

*Lighting designers* use lights of different sizes and colors, and in varied positions to help create a play's mood. Lights are controlled in a production

12-25 **Outdoor performances present different problems for set designers than those presented indoors. Notice how lighting has been built into the huge skeleton for this outdoor performance.** Stage set *A Masked Ball*, Rehearsal. © Reuters NewMedia Inc./Corbis.

according to a special schedule that is created during the play's development. Lighting designers must be knowledgeable about the effects of light and color, stagecraft, and available lighting technology.

*Costume designers* work with the director, scenic designer, and lighting designer to create the clothing actors will wear during the shooting of a movie or performance of a play (fig. 12-26). They create both rough and detailed sketches of each costume in the production. They search for appropriate fabrics and accessories, and oversee the creation of patterns and the sewing, fitting, and final approval of all costumes.

12-26 **How might knowledge of fashion history have helped costume designer Deena Appel create costumes for *Goldmember*?** Deena Appel, *Goldmember* costumes. *Austin Powers III*. Photo: Melinda Sue Gordon SMPSP, Courtesy New Line Productions/© 2002 New Line Productions.

### Artist Biography
## Deena Appel (b. 1962)

Anyone who has seen any of the films in the *Austin Powers* trilogy knows about the outrageous 1960s fashions that the characters are known for. The mastermind behind these fanciful outfits is Deena Appel.

According to Deena, designing costumes is not simply fashion design for the movies. "Costume design is very different from fashion design. You have to have an inherent sense of fashion, but also of the body, and of storytelling, and so much of what we do is about trying to help tell the story through clothes."

There are other factors that also differentiate fashion and costume design. For example, Deena describes the script as a "constantly changing, living, breathing thing." As the script changes, it has a profound effect on her job—if a new scene is suddenly added at the last minute, a new costume might be needed as well. Fashion designers also, for the most part, do not have to take their customers' sizes into account. But for the *Austin Powers* films, Deena had to design different costumes for the thirty-two-inch-tall "Mini-Me" and for another character with an eighty-inch waistline! This combination of creativity and flexibility is what makes Deena Appel a successful costume designer.

As we said at the beginning of this chapter, examples of the work of *fine artists* (fig. 12-27) and *craftspeople* (fig. 12-28) can be seen throughout this book. A career in any area of the fine arts or crafts can be rewarding, but you must be well trained and ready for a challenge. There are very few successful self-taught artists today. Most artists have both bachelor's and master's of fine arts degrees. They usually work alone, motivating themselves to produce their art. In order to become known by the art-buying public, artists must establish a connection with a gallery that will show, advertise, and sell their works. It can take years for an artist to establish a reputation and become familiar to the public. For that reason, most artists must have a second source of income, such as college and university teaching or an art-related job. Artists in all media must be self-disciplined and highly motivated to continually produce artwork that will attract buyers. The life of a fine artist is attractive and has many advantages, but it is a demanding occupation that requires constant work and experimentation to achieve success.

12-27 **Jaune Quick-to-See Smith is one of today's best-known Native American artists.** Courtesy of the artist.

12-28 **Christine Sundt uses precious metals, faceted or natural stones, and even found objects to create her jewelry designs.** Courtesy of the artist.

## Teaching

There are a variety of career opportunities to teach art in the elementary and secondary schools and in higher education. Art education is part of the public school curriculum from kindergarten through grade twelve, and many school districts employ *art teachers* for all grade levels. Colleges and universities employ *professors* in art education, fine arts, graphic design, and art history.

A career as an art teacher provides opportunities to help students develop an understanding and appreciation for art, as well as allowing them to create art. Art teachers at all levels are expected to stay abreast of current educational trends, and many of these educators are themselves productive artists **(fig. 12-29)**.

If you have an interest in all aspects of art, a desire to share your knowledge, and enjoy working with young people, teaching may be an appropriate career for you. Art teachers must have good organizational and speaking skills and must work well with groups of students or individuals. Elementary and secondary art teachers must complete a four-year teacher training program that includes a broad range of courses and experiences as a student teacher. Most art educators at the college level complete a doctoral degree.

12-31 **An effective museum educator can help make the museum-going experience come alive.** © Jose Luis Pelaez, Inc./Corbis.

## Museum Careers

Museums house and exhibit artwork, but they also help educate others about art, to restore damaged or aging artwork, and to provide library and research opportunities. Within a museum's walls are many art-related careers.

A *museum director* oversees the operations and growth of a museum, and is responsible for its planning, organization, budget, and staff. **Curators** purchase new artworks, develop and oversee exhibitions, and help prepare materials to help announce and advertise exhibitions. *Conservators* (fig. 12-30) care for a museum's collection of artworks, find out the age of artworks, determine whether they are authentic or fake, and decide how to clean and preserve them. *Museum photographers* document every work in a museum's collection, and provide photographs or digital images to conservators, museum librarians, and public relations staff. *Museum educators* work with teachers and students in their community, arranging tours and helping them learn about the museum's collection (fig. 12-31).

## Conclusion

There are many other art-related careers we haven't discussed in this chapter. For more information about careers in art, ask your art teacher or school guidance counselor. Your local library has books on careers. You can also request catalogs from colleges, universities, and professional art schools that describe program content and entrance requirements.

## Portfolio Preparation

If you're thinking of attending a college, university, or art school to major in some area of the arts, you should begin saving your best works for a portfolio (fig. 12-32). Most schools require an art portfolio that provides information about you, your goals, and examples of your artwork. Before sending a portfolio anywhere, contact the college's art department and ask for portfolio guidelines. Your art teacher can help you organize a portfolio of written and visual materials. Here are some general suggestions.

- Keep your work neat and clean, without tears, wrinkles, or smudges. Remember, the portfolio will present your artistic abilities to people who may be your future professors.
- Include twelve to twenty works, created during a period of two to three years, that show how you've grown in composition ability, mastery of techniques, and creativity.
- Include works in a variety of media to demonstrate your flexibility as an artist.
- Keep matting simple, or mount artworks on boards. Clearly label each piece.
- Include works that demonstrate an understanding of design and color.
- Do not include copied work.

- If you have good three-dimensional work, make well-composed slides to include with your two-dimensional examples.
- If you are asked to send original works, put them in a sturdy container that will protect them during mailing.
- If a school requests slides or digital images rather than two-dimensional work, they should be of very good quality and without distracting background clutter.
- If you include written descriptions or other written work, check spelling, sentence structure, and punctuation.
- If you have done some successful work outside of school, include an example or two.

12-32 **Your portfolio should show your best work and reflect your growth as an artist.** Student portfolio, Ali Horeanopoulos.

## Visual Culture: A Magazine Ad

**About the Artist**
## Annie Leibovitz
(b. 1949)

The most famous series in the "Got Milk?" campaign depicts celebrities with milk mustaches. Who better to do the photo shoots than **Annie Leibovitz**. Since the 1970s, she has been known for her celebrity portrait photography. Leibovitz worked as a staff photographer for *Rolling Stone* magazine and later for *Vanity Fair*. She believes she is able to make a connection with her subjects because she is very straightforward. She does not talk about things like the weather to distract her clients during the shoot. Instead she talks about the matter at hand, taking pictures. Of her world-renowned subjects she says, "Most people, especially successful people, are hardworking. They want to participate. They want to do things well."

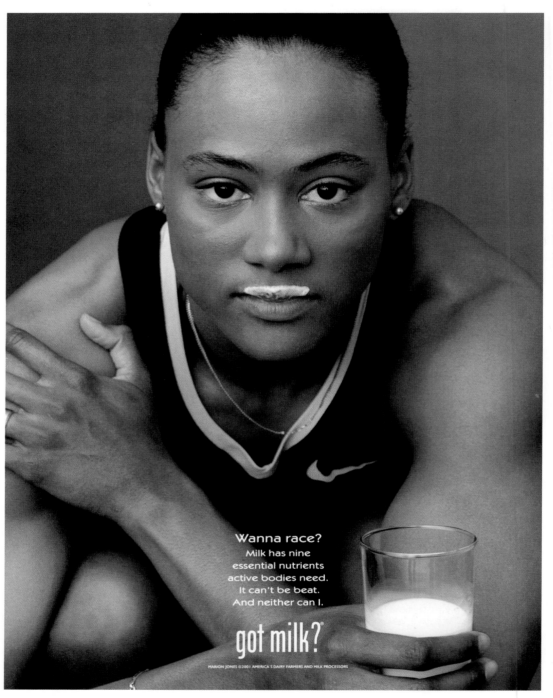

Wanna race?
Milk has nine
essential nutrients
active bodies need.
It can't be beat.
And neither can I.

## got milk?

MARION JONES ©2001 AMERICA'S DAIRY FARMERS AND MILK PROCESSORS

12-33 **The critical skills you use to think about works of art can also be used in thoughtful analysis of advertising messages—or any other aspect of our visual world.** Marion Jones. © 2001 America's Dairy Farmers and Milk Producers

## 1 Describe What You See

When you describe an artwork, you identify things about the work that you can see, name, and describe with certainty. You should not include opinions, evaluations, or possible meanings here.

- Refer to label information for this advertisement. What is the sponsoring agency? Who is the young woman? Why is she famous?
- Describe the woman's position, including the placement of her arms.
- What is she holding? Where is she looking?
- What does the milk residue on her upper lip suggest she has just done?

## 2 Analyze the Way It's Organized

When you analyze an artwork, you tell how the subject matter and elements of the work have been organized by the artist. You tell how they work together.

- What do you focus on first in the picture? Why?
- What shape is suggested by the figure's left arm? the right arm?
- Where else is this shape repeated?
- What form appears closest to the viewer?
- Analyze how the forms of the woman's shoulders and arms direct visual movement.

## 3 Interpret What It's Saying

Use the information from your description and analysis to help you identify the meaning of the work—in this case, what the message tells you about the human experience.

- What words would you use to describe the figure's attitude or body language?
- Create a simile or metaphor about milk and this athlete's powers. Example: milk is my power bar.
- What is this advertisement saying?

## 4 Evaluate Its Success

Using your analysis in the first three steps, judge the quality or success of this work.

- Which of the philosophies of art are relevant to this image? Successful art: (1) is true to life, (2) is carefully arranged/designed, (3) communicates ideas or emotions, or (4) advances a cause.
- How do you judge the design arrangement?
- How original do you feel the treatment of the idea is?
- How successful is the image in attracting and holding your attention long enough for you to understand the message?
- How persuasive is the ad? Does it make you want to drink milk?

### Web Link
www.whymilk.com

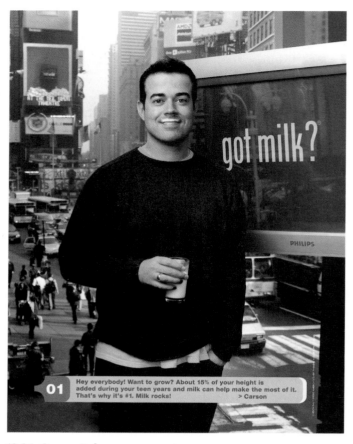

12-34 Carson Daly © 2000 America's Dairy Farmers and Milk Producers

12-35 Newsletter cover. Courtesy WGBH Boston.

12-36 Landscape architecture by Greenview Companies, Normal-Bloomington, Illinois.

12-37 Tommy Hilfiger fashion show, New York City. AFP photo Stan Honda. © AFP/Corbis.

# Chapter Review

## Summary

Careers in the fine arts—painting, sculpture, printmaking—represent only a fraction of the careers available to trained artists. To help you understand the many careers in which artists have a hand, we divided them into five broad categories: environmental design, communications design, product and fashion design, entertainment, and cultural enrichment.

*Environmental design* includes careers such as architect, landscape architect, and interior designer. In *communications,* you'll find graphic design, cartooning, and illustration as possible careers. *Product and fashion design* encompasses the development of everything from cars to sneakers. *Entertainment* includes the realms of film, multimedia, and theater, and offers careers such as animator, game designer, and costume designer. *Cultural enrichment* is the category that includes fine artists and craftspeople, art teachers at all levels, and museum staff.

If you think a career in the arts is for you, you'll need to develop a portfolio, a selection of your best work, to present to college admissions staff.

## Review Questions

**1** **Recall:** Explain the differences between environmental design careers and those in product and fashion design.

**2** **Understand:** Choose one of the five major categories of careers in art described in this chapter. Describe how the activities of artists in this category affect your life or the lives of others.

**3** **Apply:** Write a newspaper advertisement for a job in the arts. Create a fictitious company. Then, using other newspaper job advertisements as a guide, advertise a job with your company, outlining responsibilities, requirements for training and experience, salary, and so on. Share ads with classmates. Which jobs would you most want to apply for? Why?

**4** **Analyze:** Compare and contrast the responsibilities of an architect with those of a toy designer.

**5** **Synthesize:** Design a building, book cover, piece of furniture, complete outfit of clothing, or stage set. Describe the design process you followed, some of the decisions you made, and how other people would have to be involved to actually bring your project to life.

**6** **Evaluate:** Choose five careers from this chapter. Research them and rank by necessary training. Which requires the longest period of study, advanced degrees, or special skills?

## For Your Portfolio

Make two collections of advertisements: one of advertisements that appeal strongly, and the other of advertisements that lack appeal. Write an analysis of the two groups of advertisements to see if there is a relationship between good design and appeal of the ads. Suggest ways to improve the design of the ads with low appeal.

## For Your Sketchbook

Use a portion of your sketchbook for a color diary. Paste in scrap pieces of watercolor paper and record each color as it comes directly from the container of paint. Label each sample by manufacturer and name of paint. Then mix values and intensities of each color, noting how the colors were mixed.

## Electronic Research

Pixar Animation Studio has created state-of-the-art computer animated films such as *Toy Story* and *Finding Nemo.* Explore Pixar's Web site at http://www.pixar.com, especially Artist's Corner, which gives in-depth profiles of the different kinds of artists that work at the studio. What kinds of interests, skills, training, and experience would be needed to become an animation artist? Conduct an Internet search to discover colleges, universities, or art institutes that offer such training.

## Going Further

Select an art career that you are interested in and find someone who works in that field to interview. Plan your questions in advance. Consider asking about training, responsibilities, skills, rewards, and disadvantages. Share your information with the class.

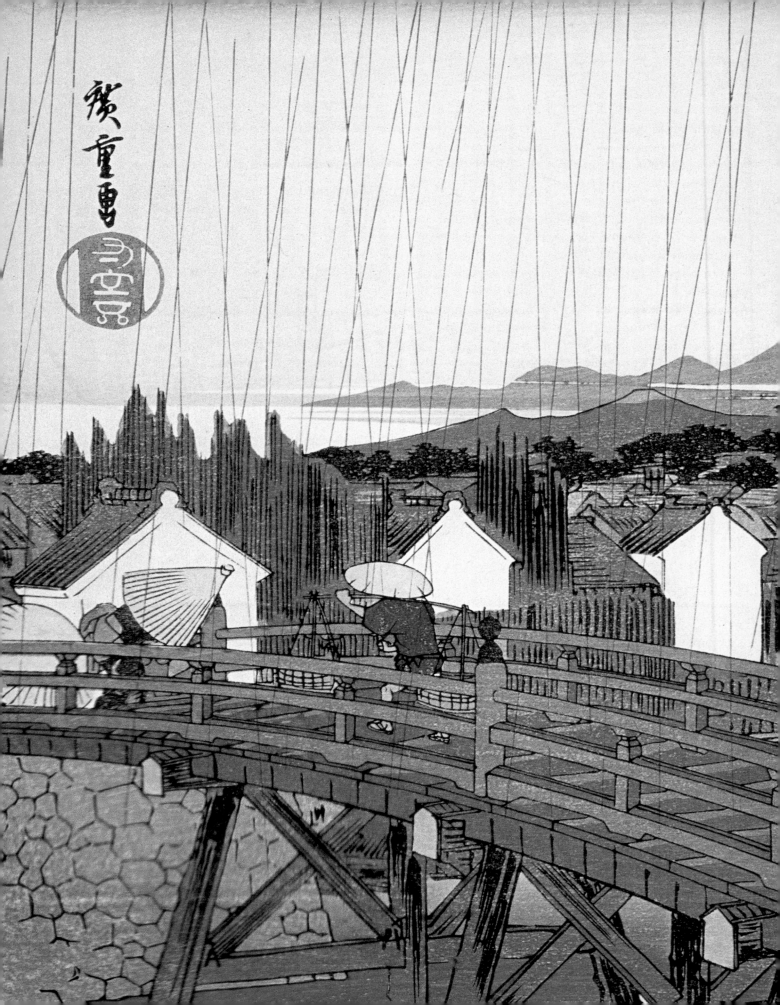

# Part Four
# Art History

Utagawa Hiroshige, *Evening Shower at Nihonbashi.* Color woodcut (26 x 39 cm). Private collection.

# 13 Non-Western Art History I

13-1 **The artist who created these glass works is a Japanese-born sculptor who lives in the United States. In today's global community, do you think the traditional distinction between Western and non-Western art is still useful? Why or why not?** Jun Kaneko, *Installation A.* Glass. At the Bullseye Connection Gallery. Courtesy of the artist.

## What You'll Learn

- that all cultures create art
- that non-Western cultures represent a wide variety of peoples, geography, history, and beliefs
- ways in which understanding the history and beliefs of non-Western cultures can help you understand their art
- to recognize representative art styles and subject matter from India, Southeast Asia, China, Japan, and Korea

## What This Chapter Covers

## Art Criticism Step by Step

## Studio Experiences

13-2 Student works. Mixed-media umbrella forms.

## Key Terms

*English* (*Spanish*)

*Hinduism* (*Hinduismo*)
*Buddhism* (*Budismo*)
*dynasty* (*dinastía*)
*Taoism* (*Taoísmo*)
*Confucianism* (*Confucianismo*)
*porcelain* (*porcelana*)
*Shintoism* (*Sintoísmo*)
*shogun* (*sogún*)
*samurai* (*samurai*)
*Zen Buddhism* (*Budismo Zen*)
*celadon* (*celadón*)

## Artists

Ambreen Butt, Christo and Jeanne-Claude, Zhang Dali, Carmen Lomas Garza, Utagawa Hiroshige, Toshio Iwai, Jun Kaneko, Ma Yuan, Ogata Kenzan, Sim Sajong, Tokan Shugetsu, Toba Sojo, Yi Chae-Gwan

13-3 Student work, Carol Ma. Mixed media, 18" x 12" (45.7 x 30.5 cm).

The great civilizations of Asia, the Pacific, Islam, ancient Mexico and South America, and the native cultures of Africa and North America are often called non-Western cultures. Historians use the term *non-Western* to refer to any culture that is not related to the United States and Canada or to western Europe. In this chapter you'll be introduced to the art of India, Southeast Asia, China, Japan, and Korea.

India is one of the oldest continuing civilizations in the world. India's religions have influenced many of its artworks during its long history. **Hinduism**, India's main religion, is based on the worship of many gods, and a belief in reincarnation, or the endless life, death, and rebirth of the soul. **Buddhism**, another major religion, developed as

a reformist version of Hinduism. Indian artworks often express qualities of peace and inner wisdom. The poses and hand gestures of figures in the artworks often have symbolic meanings **(fig. 13-4)**.

Indian culture, including Buddhism, spread to Southeast Asia and took hold well over one thousand years ago. Cambodia embraced both Hinduism and Buddhism. Cambodia is known for its ceramic works. Vietnam reflects Indian influences but was also influenced by China, which controlled it for a thousand years. In eighth-century Indonesia, both Hinduism and Buddhism flourished, and influences came from India and China. The Javanese perfected the art of batik, a process of dyeing cloth that uses the

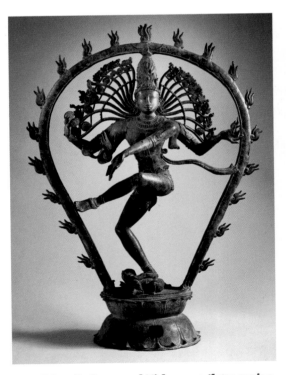

13-4 **Shiva, Brahma, and Vishnu are three major Hindu gods. This detailed bronze sculpture shows Shiva performing a dance of reincarnation.** Tamil Nadu, India, *Shiva as the Lord of the Dance,* c. 950–1000. Copper alloy, 30" x 22½" x 7" (76.2 x 57.15 x 17.78 cm). Los Angeles County Museum of Art, Anonymous Gift. Photograph © 2004 Museum Associates/LACMA.

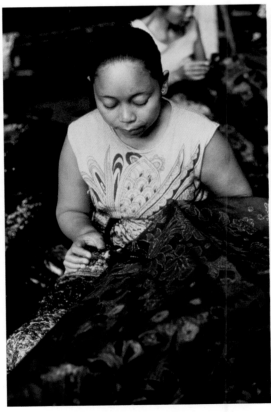

13-5 **The Javanese perfected the ancient art of batik, a technique for dyeing cloth. In the wax-resist method, the waxed areas of the cloth do not require dye.** Courtesy Davis Art Images.

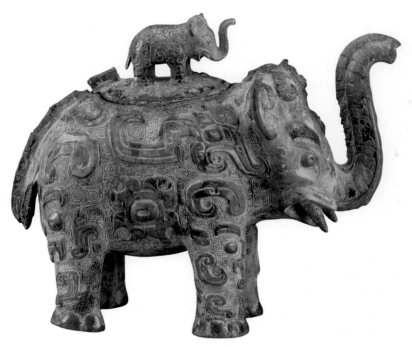

13-6 **Some of the most beautiful artworks of the Shang Dynasty were ritual bronze vessels. This decorative work was cast in a piece mold.** Ritual wine vessel *(huo)* in the form of an elephant, 12th–11th centuries BCE. Bronze, 6 3/4" x 4 1/8" x 8 1/2" (17.2 x 10.7 x 21.4 cm). Freer Gallery of Art, Smithsonian Institution, Washington, DC: Purchase.

13-7 **In Japanese painting, a few bold strokes can capture the essence of a subject. How is depth achieved in this painting?** Tokan Shugetsu, *Haboku (Flung Ink) Landscape,* c. 1510. Hanging scroll, ink on paper, 23 1/2" x 10 1/2" (59.5 x 26.9 cm). © The Cleveland Museum of Art, Purchase from J. H. Wade Fund.

*wax-resist* method of dyeing cloth (fig. 13-5).

China is twenty times as old as the United States. China's isolation because of ocean, mountains, and desert allowed its culture to develop for centuries without many outside influences. The religions of *Taoism*, *Confucianism*, and Buddhism all influenced Chinese art. You can see reverence for nature, respect for order, and a sense of serenity reflected in Chinese scroll paintings, bronzes **(fig. 13-6)**, and ceramics, including *porcelain*.

Although Japan had its own culture before Buddhism was introduced, Japanese ideas and ways of living were heavily influenced by China after 405 CE. *Shintoism*, Japan's major religion, emphasizes reverence for the family, the Japanese race, and rulers, who are believed to be descendants of gods. Japanese art is known for its understated beauty and elegant simplicity, which reflect influences of *Zen Buddhism* **(fig. 13-7)**.

Buddhism is the long-accepted religion in Korea, which has also been influenced by Chinese Confucianism and Chinese culture in general. Korea is well known for its ceramics, especially its porcelain. Pale green-blue *celadon* is its best-known porcelain. Korean painting, though strongly influenced at first by Chinese painting, eventually came to reflect indigenous Korean tastes.

India can trace its roots to settlements near Mohenjo-daro on the Indus River (modern-day Pakistan) **(fig. 13-8)**. Several large cities, such as Mohenjo-daro, developed in the Indus Valley between 2500 and 1700 BCE. Excavations of the area revealed that these cities consisted of hundreds of houses, wells, and drainage systems. The people wrote contracts and signed legal documents. One of the most striking art forms found in Mohenjo-daro are carved stone seals **(fig. 13-9)**. The seals were used to stamp documents written on tablets of damp clay.

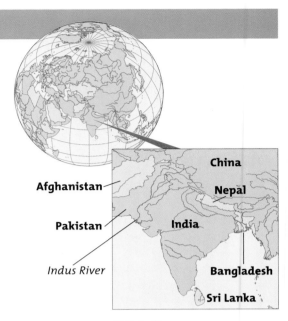

13-8 **India.**

## Try It Yourself

Imagine you are an archaeologist in the year 3011 and you come across a twenty-first-century landfill (such as the one in your home-town). What objects, if any, would you save to put in a museum? Bring an "artifact" (any human-made object) to school—the older the better: photograph, letters, military medals, diaries, household implements, etc. Don't identify your artifact or discuss the date and the story behind it. Divide up into teams of archae-ologists and see how well your team can deduce the identity and story of one another's artifacts.

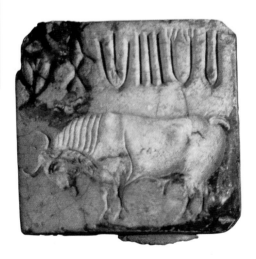

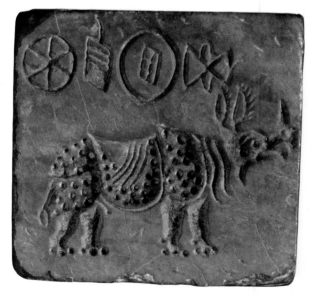

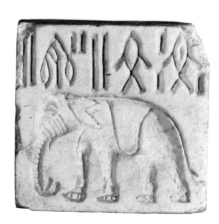

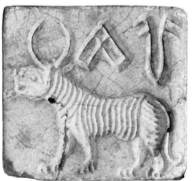

13-9 **Like artisans in the ancient Near East, the Indus peoples used these seals to make impressions in clay. The seal made business transactions official.** Four seals from Mohenjo Daro (Indus Valley culture) with a bull, a rhinoc-eros, an elephant, and a horned tiger. Karachi Museum, Karachi, Pakistan. Photo courtesy Scala/Art Resource, NY.

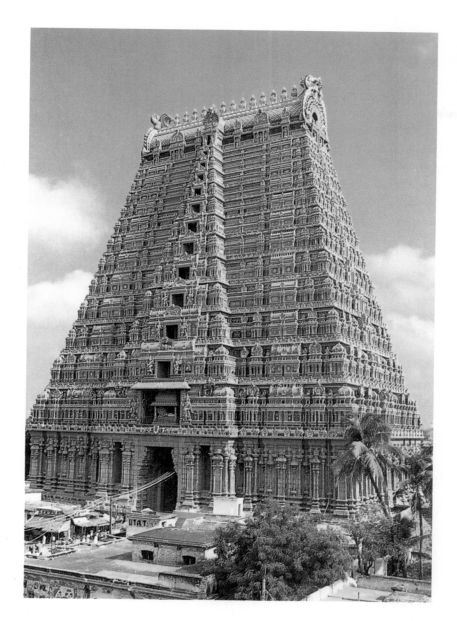

13-10 **At a height of 236 feet (78 meters), this is probably the tallest temple gateway tower in India. What other cultures have used multistory structures like this?** Ranganathaswamy Temple, Tamil Nadu, southern India. Photograph courtesy James Ellison Thomas.

Modern India can claim to be one of the oldest continuing civilizations in the world. It is home to more people than all of North and South America combined, in a space about half the size of the United States. India's people speak fourteen different languages and are divided among several ethnic groups. Although Hinduism is the main religion, there are many others. India is a rich mixture of cultures.

Around 1700 BCE, invaders from the north conquered the Indus Valley culture. The newcomers introduced their own hymns, called Vedas. These hymns marked the beginnings of *Hinduism*, one of the world's oldest religions. Hindus worship many gods. One of the key features of the faith is the belief in reincarnation, which holds that a person's soul experiences an endless cycle of life, death, and rebirth.

Some of the major gods in Hinduism are Shiva, the destroyer, Brahma, the creator, and Vishnu, the preserver. The Ranganathaswamy Temple, with its majestic gateway towers (fig. 13-10), is probably the largest in India. Its main building is dedicated to Vishnu, and was built mostly between the fourteenth and seventeenth centuries. Seven rings of walls surround the temple.

How are ideals and beliefs
passed on from one
generation to another?
In some societies beliefs
are written down. Others
have a tradition of oral
storytelling. Find out
more about the form and
content of beliefs and
creation stories around
the globe.

Hinduism was the dominant religion of India for about fifteen hundred years, until the birth of Buddha (c. 563–483 BCE). Born a prince, during his youth Buddha had a vision in which he saw the endless succession of death and rebirth in the stream of life. He believed that the only way to escape this wheel of life, death, and rebirth was to free the heart from all worldly desires. This final blessed state is called enlightenment.

Buddha did not seem to consider himself a religious leader. He preached reform of the existing Hindu faith. However, the worship of the Buddha, which grew after his death, eventually became almost as strong in India as Hinduism. **Buddhism** eventually spread to become one of the largest religions in the world.

Images of the Buddha did not appear until about the second century CE, in Gandhara or Mathura. The Gandhara region, in what is now Afghanistan and Pakistan, had once been occupied by the ancient Greeks under Alexander the Great, who died in 323 BCE. The work of artists who lived in Gandhara showed some influence of Greek art. Therefore, many early images of the Buddha have some characteristics of Greek sculpture such as a relatively muscular body under a toga-like gown with rhythmic folds. The Buddha from Gandhara (fig. 13-11), although an early example, already expresses the Buddhist qualities of inner peace and wisdom.

13-11 **Buddha preached the virtues of freedom from material needs and desires. How are those teachings reflected in this sculpture's posture and expression?** Seated Buddha, Gandhara, 1st–3rd century CE. Black schist, 2' 4¾" x 22½" (73 x 57 cm). Yale University Art Gallery (Anonymous gift through Alfred R. Bellinger).

The bulge on the head symbolizes the great wisdom of the Buddha, while the elongated ear lobes represent his rejection of his princely life in removing the heavy earrings that had stretched them out.

Later artists established the style of Buddha figure that has endured for centuries. The Buddha from Sarnath (fig. 13-12) wears a thin monk's robe and has a softly curved, slender body. In addition to the signs of perfection found in the Gandhara example, the Sarnath Buddha displays a *mudra*—a hand gesture with a specific meaning. There are several types of mudras, each one signifying an aspect of the Buddha. This mudra symbolizes the Turning of the Wheel of the Law.

Although Buddhism became the dominant religion in other parts of Asia, it never overtook Hinduism in India. Because Buddhism had started out as a reform movement of Hinduism,

Hinduism eventually named Buddha as one of its many gods. Sculptures of Hindu gods show the gods in various symbolic poses. These poses use different symbols, be it four faces for Brahma, or four arms for Shiva, to suggest different religious ideas or states of being.

Notice how the bronze sculpture of Shiva (fig. 13-13) displays the same curving, slender body as the Sarnath Buddha. Within the flaming orb representing the sun, Shiva performs a cosmic dance, his hands representing the mudras for destruction (the far left), and "fear not, approach" (inner right) as the far right hand beats the drum. Shiva, Lord of the Dance, stomping on the demon of ignorance with his right foot, is one of many aspects of Shiva.

13-13 **Shiva's cosmic dance takes place within the symmetrical orb of the sun. What principles of design can be used to analyze this sculpture?** Tamil Nadu, India, *Shiva as the Lord of the Dance*, c. 950–1000. Copper alloy, 30" x 22½" x 7" (76.2 x 57.15 x 17.78 cm). Los Angeles County Museum of Art, Anonymous Gift. Photograph © 2004 Museum Associates/ LACMA.

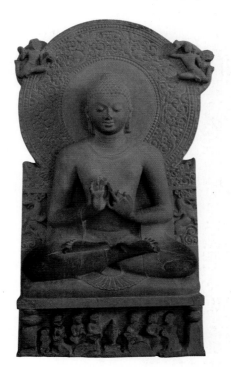

13-12 **The circular, parasol-shaped form behind the Buddha's head symbolizes the sun. What meaning does the sun hold for you? Why might it appear in this sculpture?** Buddha with halo, from Sarnath, Gupta dynasty, 5th century. Museum Sarnath, Uttar Pradesh, India. Photo courtesy Borromeo/Art Resource, NY.

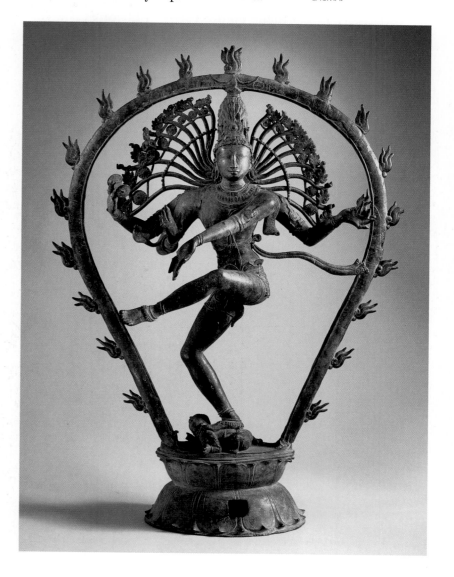

Indian culture spread to Burma, Thailand, Cambodia, Sumatra, and Java (fig. 13-14). Buddhism spread to Tibet, Mongolia, China, Japan, and Southeast Asia.

Cambodia was overwhelmingly influenced by India, both culturally and in the arts. Both Buddhism and Hinduism were imported from India.

In 802 CE King Jayavarman II established the Angkor Dynasty, which would rule Cambodia for the next four hundred years. A *dynasty* is a succession of rulers who are members of the same family. The Angkor kings constructed the giant temple complex at Angkor. The "temple mountains" that make up the Tower of Bayon at Angkor Thom (fig. 13-15) were dedicated to Vishnu, Shiva, the Buddha, or the

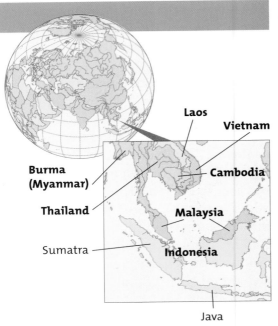

13-14 **Southeast Asia.**

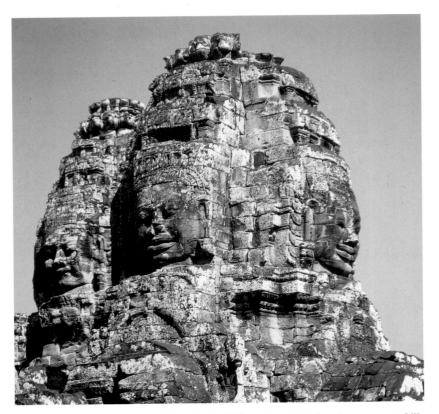

13-15 **Angkor Thom was built in the twelfth century by King Jayavarman VII both to serve as his tomb and to honor Buddha. What other structures can you think of in which the sculpture is integrated within the architecture?** Bayon temple (detail), Angkor Thom, Cambodia, built about 1190 CE. Photo courtesy Giraudon/Art Resource, NY.

13-16 **How does this lidded vessel incorporate an architectural motif with organic details?** Unidentified, Khmer, Cylindrical lidded vessel with knob, 10th–11th century, Angkorean Period (802–1431 CE), Cambodia. Light-gray stoneware with ash glaze, 3 1/3" x 3" x 3" (8.6 x 7.5 x 7.5 cm). Arthur M. Sackler Gallery, Smithsonian Institution, Washington, DC. Gift of Victor and Takako Hauge.

13-17 **This bronze vessel with the design of ships is similar to Chinese bronze work of the Shang Dynasty.** Vietnamese Bronze and Iron Age. Bronze; 8 1/4 in. (21 cm). The Metropolitan Museum of Art. Samuel Eilenberg Collection, Bequest of Samuel Eilenberg, 1998. Photograph © 1980 The Metropolitan Museum of Art.

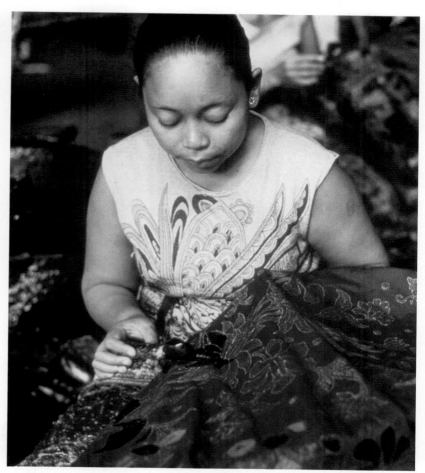

13-18 **The wax in batik is used to define form by outlining the area to be dyed or by creating solid areas to resist the dye. How is the wax being used in this batik?** Courtesy Davis Art Images.

ancestors of the ruling king. The colossal heads located on each side of the towers make this temple one of a kind.

In addition to monumental works in stone, Cambodian artists produced an array of glazed stoneware for everyday use by the privileged class. Everyday objects combining both architectural stateliness and organic decorative qualities were produced throughout Southeast Asia, yet examples such as the ash-glazed vessel shown in **figure 13-16** were unique to Cambodian culture.

Vietnam has a deep and varied cultural history. Like much of the rest of Southeast Asia, its art reflects Indian influences. It also has a unique relationship with China. China directly controlled Vietnam for a thousand years, starting sometime between 206 BCE and 200 CE. Vietnamese metalwork (**fig. 13-17**) dates back to that period.

On the island of Java, which is part of the country of Indonesia, Hinduism and Buddhism flourished between 700 and 900 CE. During this time, Java received influences from both India and China. The Chinese had produced wax-dyed fabrics as early as the eighth century CE, but it was the Javanese (**fig. 13-18**) who perfected the craft. Batik is the *wax-resist* method of dyeing cloth. In this process, wax is drawn or stamped onto cloth. The wax area does not receive dye and so preserves the color below to produce a repeated design. Today there are batik centers in many major cities of Java and Indonesia.

## Linking Disciplines
### Literature

A **Javanese gamelan**, or gong orchestra, builds layers of sound, similar to the architectural levels of the stupa (**fig. 11-24, page 303**). The music is organized in cycles of beats. Huge gongs play once every thirty-two or sixty-four beats, while the smallest, highest-pitched instruments play on every beat. Build a collage of related objects in different sizes. Organize the objects to show their relationship like the layers in the stupa or gamelan.

### Linking Disciplines
#### History

How do ideas spread across the globe? Find out more about how explorers, traders, traveling craftsmen, and artists have introduced people to the ideas of other cultures. For example, you might research the origins and traditions of papermaking, and how the process moved from East to West. Consider how the Silk Road contributed to changes in both Eastern and Western artistic production.

Modern China (fig. 13-19) is a country of great rivers, fertile valleys, plains, mountains, and natural harbors. It is similar to the United States in size and geography, but its population is four times as large. In history, China is twenty times as old.

China is diverse, but it has a common racial heritage and a culture as old as India's. There is a standard written language, but there are great differences between its spoken language in one area and another. Bordered by the Pacific Ocean in the east, high mountains in the south and southwest, and desert in the west and north, China was isolated through most of its history, developing its own cultural traditions in relative security.

The earliest discovered art of historic China is from the Shang Dynasty, which flourished from c. 1500 to c. 1050 BCE. Most of the objects were vessels for

13-19 **China.**

holding wine, water, grain, or wheat used in sacrificial ceremonies (fig. 13-20).

Chinese philosophy flowered during the Zhou Dynasty (c. 1050–256 BCE). The sixth century BCE—the century of Buddha's birth—is considered the golden age of Chinese philosophers.

One of these philosophers, Lao-tzu (c. 604–521 BCE), recommended complete withdrawal from the hubbub of society to become one with nature. He founded a philosophy called *Taoism*. In Taoism, the secret of wisdom and lasting happiness is to follow a life of simplicity, modesty, patience, and obedience to the laws of nature. To this day the idea of submitting to nature is deeply ingrained in the Chinese mind.

China's greatest thinker was Confucius (551–479 BCE; fig. 13-21). Like Lao-tzu, Confucius advocated humility, patience, and respect for nature. Unlike Lao-tzu, he recommended taking an active role in society. Confucius taught by word of mouth, but his disciples wrote down his teachings. The discipline of *Confucianism* influenced the whole of Chinese culture and spread to Korea, Japan, and parts of southeast Asia.

13-20 **Ritual bronze vessels such as this one show an advanced casting technique that indicates the art form was practiced for centuries before the Shang.** Ritual wine vessel (*huo*) in the form of an elephant, 12th–11th centuries BCE, Shang (c. 1600–1050 BCE), China. Bronze, 6³/₄" x 4¹/₈" x 8¹/₂" (17.2 x 10.7 x 21.4 cm). Freer Gallery of Art, Smithsonian Institution, Washington, DC: Purchase.

13-21 **Although Confucius' philosophy emphasizes humility, patience, reasonableness and modesty, Confucius was not of humble origins. What in this portrait indicates that?** Portrait of Confucius based on Ancient Traditions. Relief from the Stele in the Pei Lin of Sigan-Fou. © The Bettmann Archive/Corbis.

13-22 **Carved of relatively soft sandstone, this bodhisattva strikes a pose similar to images of the Buddha. How does the carving of the garments compare to Gandhara versions of the Buddha such as that shown in figure 13-11 (page 358)?** Chinese, Seated Bodhisattva, c. 483, Northern Wei dynasty, (386–534). Sandstone, H: 57½" (146.1 cm). The Metropolitan Museum of Art, Rogers Fund, 1922. Photograph © 1979 The Metropolitan Museum of Art.

Shih Huang-ti, who ruled during the years 221–210 BCE, was China's first emperor. His reign ushered in the Qin Dynasty (221–206 BCE). During the Qin Dynasty, architecture and sculpture flourished as art forms.

The Han Dynasty (206 BCE–263 CE) succeeded the Qin. The Roman Republic (which became the Roman Empire) in the West existed simultaneously. Just as Rome extended its boundaries all over Europe and north Africa at the time, China extended its own boundaries to Korea, Vietnam, and Afghanistan. Silk production increased dramatically and trade routes penetrated as far as the Roman Empire in the west.

Confucianism was made the official policy of the state. During this period Buddhism was introduced into China. Unfortunately, like the Roman Empire, the Han Dynasty ended during a series of barbarian invasions from the north.

The new religion provided some readymade subject matter and styles in art. A fifth century CE sculpture of a *bodhisattva* **(fig. 13-22)**—an enlightened being—reflects some of the qualities of Indian sculptures of the Buddha. Its soft features and mudras are similar to the Buddha from Sarnath **(fig. 13-12, page 359)**. The passive face and body capture the spirit of serenity preached by Buddha.

The T'ang Dynasty (618–906) was a dynamic period in China's history. An enlightened emperor, Tai Zong (ruled 627–649), brought order to the northern borders. He reestablished trade routes and built libraries and universities. Tai Zong encouraged the arts and the development of printing. Students from all over Asia flocked to China's capital.

The energetic horse and rider shown in **figure 13-23** reflects the vigor of the T'ang period. This sculpture, intended for the inside of a tomb, represents a mounted soldier, a key figure for keeping order and protecting trade routes and China's borders.

The T'ang Dynasty ended in a series of civil wars after three centuries. During this troubled period, the Chinese turned to landscape painting and a reverence for nature as a source of hope. Chinese artists may have painted landscapes before the T'ang Dynasty, but the finest examples of this art were created during the Sung Dynasty (960–1276).

Sung artists expressed all three elements of China's spiritual heritage in their landscapes: Taoism, Confucianism, and Buddhism. They combined a reverence for nature, a respect for order, and a sense of serenity. Ma Yuan's *Bare Willows and Distant Mountains* (**fig. 13-24**) is a good example of this combination. The same work was discussed in Chapter 6 as an example of aerial perspective (**fig. 6-30, page 131**).

Ma Yuan used the technique of ink wash on silk to create the effects of mist and endless space. In addition to washes, Ma Yuan used darker lines for detail and to provide focus.

Chinese paintings were often stored as scrolls. They were meant to be viewed in private, as one might read a book of poems. The Sung landscape paintings expressed the deepest spiritual values of China. Such fine landscapes continue to be produced to the present day.

Ceramics as an art form date back to prehistoric China. Discovery of pottery at sites in Hunan have been dated to 3000 BCE and earlier. The Chinese of the Qin period produced life-sized ceramic sculptures. (These Qin figures, as you learned in Chapter 10, were made via the slab and coil technique.) Under the T'ang emperors, the Chinese produced bowls, plates, jars, vases, bottles, flasks, and pitchers that were both functional and graceful.

13-23 **Burial figures like these were intended to accompany and serve the dead master into the afterlife. Why might someone have wanted to place this horse and rider in their tomb?** Terracotta grave figurine, T'ang dynasty. The Museum of Far Eastern Antiquities, Stockholm. Photo by Erik Cornelius.

13-24 **Ink wash paintings require great care because the ink, once applied, sinks quickly into the pores of the fabric. How does this technique create a "mystical" feeling?** Ma Yuan, *Bare Willows and Distant Mountains*, Chinese, Southern Sung dynasty, end of 12th century. Ink and light color on silk, 9 3/8" x 9 1/2" (23.8 x 24.2 cm). Museum of Fine Arts, Boston, Special Chinese and Japanese Fund. Photograph © 2003 Museum of Fine Arts, Boston.

It may have been during the T'ang Dynasty that ***porcelain*** ware was perfected in China. Porcelain is a hard, semi-transparent variety of ceramic ware made with a fine white clay and fired at a high temperature (over 2300°F). Porcelain ware is pure white, delicate, and rings when struck. Later, westerners prized porcelain for its semi-transparency; the Chinese valued the vessel for the tone produced when struck with a wooden stick. Sung potters produced porcelain in great quantities. It was not until the 1700s that Europeans learned to produce porcelain.

The Chinese believed that Sung artists produced the most classic examples of ceramic wares, whether porcelain or stoneware. But to westerners, pottery of the Ming Dynasty (1368–1644), which tends to be more lavishly decorated, was the most popular. The blue and white porcelain (fig. 13-25) is a good example of the type of porcelain European potters tried to imitate—mostly without success—during the sixteenth and seventeenth centuries.

13-25 **From what you know about porcelain described in this chapter, what aesthetic element of the art form do you think appealed to western Europeans: the painted decoration, the shape of the vase, or its delicacy?** Anonymous, Blue and white vase. Ming Dynasty. Musée des Arts Asiatiques-Guimet, Paris. © Giraudon/Art Resource, NY.

## 13.5 Japan

Over the centuries, Japan (fig. 13-26) alternated between isolation and exchange with other countries. It was heavily influenced by the culture of its huge neighbor, China, primarily after the introduction of Buddhism. But Japan had its own culture before the introduction of Buddhism. Buddhism came to Japan by way of a Korean monk, around 405 CE. It changed Japan markedly as the Japanese adopted Chinese culture. They began using Chinese script and imported Chinese ideas about civic models, art, culture, and imperial rule. While recognizing China's cultural superiority, Japan maintained independence from China.

The facts of early Japanese history are clouded in mystery. According to tradition, Japan was founded around 660 BCE by the emperor Jimmu, a descendant of the sun goddess Amaterasu. Jimmu is a direct ancestor of the present-day imperial family. We do know that the islands were settled by peoples from the Asian mainland organized in collections of clans (a family claiming descent from

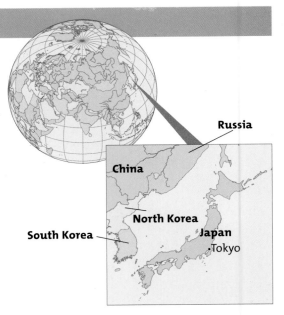

13-26 **Japan.**

a common ancestor). *Shintoism*, the oldest living, and still largest religion in Japan, developed out of a form of ancestor worship. Shinto means "way of the gods." The religion emphasizes reverence for family, race, and above all, the ruling family as direct descendants from the gods.

Buddhism became firmly established in Japan within two centuries from its

13-27 **The artist of this work was possibly a monk. The animals could be caricatures of monks he knew. Compare this to contemporary political cartoons in your local newspaper.** Detail of Monkeys Worshiping a Frog from Choju Giga Handscrolls attributed to Toba Sojo. © Barney Burstein Collection/Corbis.

introduction. In 710 the Japanese established a capital for the emperor in Nara. In 794 the capital was moved to Kyoto. The subsequent two-century period, known as Heian, is sometimes considered the golden age in Japan. The emperor became a leader in name only, while powerful military clans attached to the court held the real power. The Heian period saw a flourishing in the arts of painting and wood sculpture.

Artists also produced ink drawings on scrolls that used humor. In one humorous scroll a collection of monkeys, a cat, a rabbit, and a fox are paying homage to Buddha, in the form of a frog (**fig. 13-27**).

In 1185, a clique of military families overthrew the last rulers of the Heian period and installed a military dictatorship called a **shogunate**. They moved the center of power to Kamakura. As a reaction to the refined, stylized court style of Kyoto, art of the Kamakura Period (1185–1333) leaned toward realism. Figure sculpture was lifelike and colorful. The temple guardian shown in **figure 13-28** was made to ward off demons and evil spirits.

The Kamakura shoguns could not maintain authority over the military nobility (**samurai**) in the provinces. Those somewhat independent families ruled large sections of Japan, and the power of both emperor and shogun began to disappear. Eventually, the shogunate court returned to Kyoto. There, reunited with the imperial court, the shoguns returned to an emphasis on luxury and refinement. To satisfy this taste, trade rapidly grew with China for art. This increased trade created a prosperous merchant class.

The Sung painting style was influenced by **Zen Buddhism**, a Buddhist sect that aims at enlightenment by direct intuition through meditation. Sung paintings appealed to both aristocracy and warrior class alike. Zen Buddhism

13-28 **Heightened realism plus caricature lend this figure a grotesque or frightening quality. This is intentional, and makes the figure appear as if it could walk off the pedestal at any moment.** Guardian figure: Japan, Kamakura period, c. 1200. Wood: chestnut and cypress, H: 66" (167.9 cm) © The Cleveland Museum of Art, 2003. Bequest of Leonard C. Hanna, Jr.

valued understated beauty, spontaneity of creativity, and elegant simplicity. The monochromatic "flung ink" style of painting that was popular in China also became popular in Japan. In this approach, landscape was suggested just as much as it was actually painted. Japanese artists relied more heavily on brushwork.

Sesshu (c. 1420–1506) was the most celebrated of the Zen painters. Shugetsu was a student of Sesshu, and like the master could capture the essence of a scene (fig. 13-29) with just a few bold strokes. Do you recall the principle of closure from Chapter 3, Line? To fully see a Sesshu scene, the viewer must supply the missing details and contours.

The Zen strain of Buddhism gave rise to the tea ceremony, a major social concern of the aristocracy. It featured many precise movements performed in a strictly regulated series. Drinking the tea was the least important part. Supplying tea ceremony needs dominated the work of ceramic artists who pro-duced bowls (fig. 13-30), water jars (fig. 13-31), and tea powder jars. These wares, like Sesshu's paintings, tried to strike a delicate balance between refine-ment and spontaneity.

The Ashikaga (1185–1336), Muromachi (1338–1537), and Momoyama (1537–1615) shogunates failed to stem the growing tide of civil war among the mil-itary families. In 1617, the Tokugawa military family under Ieyasu (1542–1616) emerged as leaders, moving the capital to Edo, which is modern-day Tokyo. The Tokugawa imposed strict social, civil, and trade laws on Japan to maintain order, particularly over the samurai. Trade was restricted to China and Korea, and social mobility was banned. The nobility and samurai were the highest class; farmers, artists, and merchants the lowest. Because lines between social classes could not be broken, each level developed its own culture.

The shoguns ruled Japan throughout the subsequent period, known as the Edo. During this time Japan became isolated from the rest of the world due to the fear of invasion on the part of her rulers. This cultural isolation resulted in a uniquely Japanese form

13-29 **Zen enlighten-ment was believed to be spontaneous. How does the brushwork in this painting reflect that belief?** Tokan Shugetsu, *Haboku (Flung Ink) Landscape*, c. 1510. Hanging scroll, ink on paper, 23½" x 10½" (59.5 x 26.9 cm). © The Cleveland Museum of Art, Purchase from J. H. Wade Fund.

13-30 **How does the brushwork in this bowl's decoration reflect the Zen Buddhist ideal of elegant simplicity?** Tea bowl with design of pampas grass, early 18th century, Edo period (1615–1868), Kyoto, Japan. Buff clay, white slip, cobalt, and iron pigments under transparent glaze, 2¾" x 4⅓" (6.9 x 11.1 cm). Freer Gallery of Art, Smithsonian Institution, Washington, DC: Gift of Charles Lang Freer.

of art and artistic expression. Zen land-scapes continued to cater to the tastes of the aristocracy and samurai. But a new kind of picture, popular with the merchant class, was developed.

You may remember *ukiyo-e*, which translates as "images of the floating world," from the Art Criticism Step by Step exercise in Chapter 3. Ukiyo-e took its subject matter from popular entertainment, popular fiction, and sightseeing. Because of its depiction of everyday life of the common people, ukiyo-e can be compared to the humor-ous Heian scrolls (fig. 13-27, page 366). The favored medium was the woodcut, invented by the Chinese during the T'ang dynasty and introduced to Japan during the eighth century. With this method, ukiyo-e artists could produce scores of inexpensive copies from a single design.

Scenes such as *Fireworks, Ryogoku Bridge* (fig. 13-32) provide vivid glimpses of Japanese life during the Edo (Tokugawa) period. They came to be valued in the West during the late 1800s for their aesthetic qualities.

13-31 **Ogata Kenzan created casual patterns covered with heavy glaze for tea ceremony vessels.** Ogata Kenzan, Water jar with design of maple leaves, c. 1731–43, Edo period (1615–1868), Japan. Buff clay, white slip, iron pigment under transparent glaze, and enamels over glaze; lacquer additions, lacquered wooden lid, 5 1/2" x 6 1/8" (14.2 x 15.9 cm). Freer Gallery of Art, Smithsonian Institution, Washington, DC: Gift of Charles Lang Freer.

13-32 **European artists were influenced by Japanese artists' ability to create lines and shapes in beautiful colors and bold, open compositions. How do the patterns of lines and shapes direct your eyes through this composition?** Utagawa Hiroshige, *Fireworks, Ryogoku Bridge.* 9 7/8" x 14 3/4" (25 x 37.5 cm). The Newark Museum; George T. Rockwell Collection. © The Newark Museum/ Art Resource, NY.

## Artist Biography
## Hiroshige (1797–1858)

Born in the city of Edo (present-day Tokyo), Ando Hiroshige lost both his mother and father at age twelve. An industrious student, he made the most of a subsequent opportunity to attend art school. Upon being adopted into the Utagawa school, he took the name Utagawa Hiroshige. He would go on to become one of the great Japanese land-scape artists of all time.

Early in Hiroshige's professional career, he focused on actors and women as his subjects. However, his admiration for the work of Japanese landscape artists led him to explore working in that genre. In 1830, traveling along the Tokaido Road for nearly eight weeks, he made sketches of everything he saw. The series of more than fifty single-sheet prints he would publish based on these sketches was a resounding success.

Hiroshige would go on to produce prints of flowers and birds, in addition to ukiyo-e, but it is for his several landscape series that he is most celebrated. His work was popular in Japan during his lifetime, but his works' importance was not really felt until later. This was when their influence on Western artists such as Monet, van Gogh, and Toulouse-Lautrec became apparent.

**Write About It!**

How does the non-Western art you have seen so far differ from the kind or art you are familiar with? Has it changed any of your ideas about art or what art should be? Explain.

## 13.6 Korea

The racial origins of the Korean people are Mongol and Chinese. By about 4000 BCE a continuing culture was evident. By the Bronze Age (c. 400–60 BCE) there were numerous communities on the peninsula. The first recorded centralized communities appeared during the first century BCE when three distinct kingdoms formed: Koguryo (37 BCE–668 CE), Paekche (18 BCE–653 CE), and Old Silla (57 BCE–668 CE). Buddhism was accepted in Korea between the fourth and fifth centuries CE. In 668 CE the Silla kingdom conquered Koguryo and Paekche and formed the Unified Silla Kingdom, the first unified nation on the Korean peninsula (fig. 13-33). Under the Unified Silla, many temples were built, Buddhist texts were printed in the woodblock technique, and stone and metal sculpture flourished.

The Koryo Dynasty replaced the Unified Silla in 918 CE. During the Koryo Dynasty, laws were modeled on

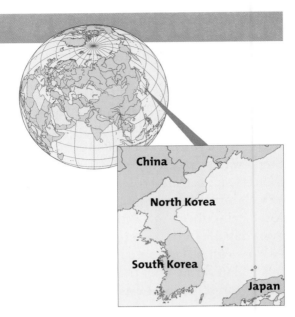

13-33 **Korea.**

Chinese Confucian beliefs. Ceramics, especially porcelain, reached a peak of perfection, and painting began to flourish. In 1392 the Koryo fell to the Yi family, who ruled until Japanese invasion in 1910.

For centuries Korea acted as a conduit of Chinese culture to Japan. Naturally,

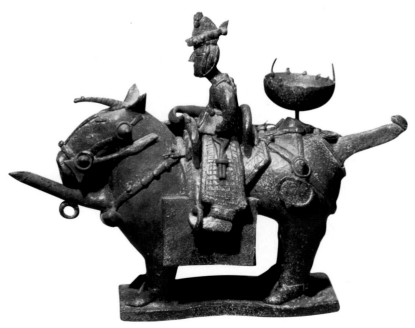

13-34 **The highly detailed figure of the warrior gives us a good idea about life in Korea at the time. How does it compare to the Chinese horse and rider in 13-23, page 364?** Vessel in the shape of a mounted warrior, 5th–6th century. Stoneware. Courtesy Davis Art Images.

13-35 **This shape, unique to Korea, was typical of vessels used to serve wine. How do you think Korean porcelain compares to Chinese?** Wine ewer, 12th century. Celadon ware, 8" x 5 3/4" (20.3 x 14.7 cm). © The Cleveland Museum of Art, Gift of John L. Severance.

Korean art was heavily influenced by its large northern neighbor. As in China, stoneware (fig. 13-34) was the ceramic ware preferred by aristocrat and common person alike. Porcelain was perfected during the Koryo period, when Chinese culture was eagerly adopted by Korea. The highly refined Korean *celadon* ware (fig. 13-35) was a pale green-blue porcelain. Its introduction to Japan marked the beginning of porcelain production in that country. Such was the mania for Korean ceramics in Japan that Korean ceramic artists were often kidnapped to work in Japan. This occurred primarily during the Yi Dynasty.

Painting too was heavily influenced by Chinese painting, especially that of the Sung period. During the Koryo period Buddhist painting was preeminent. These works are remarkable for their bright colors. In contrast to Chinese painting, Korean artists used much gold leaf for decorative patterns. Landscape painting during the Yi Dynasty was based largely on the Chinese tradition.

During the eighteenth century, Chinese influence on Korean painting waned, and Korean painting came into its own. Two major indigenous movements developed. The first was the "Real Landscape" school (fig. 13-36), a style based on direct observation of elements in nature. The second was a type of painting style founded in the depiction of activities from everyday Korean life. It was the latter movement that encouraged a refinement in portraiture (fig. 13-37) during the late eighteenth to early nineteenth centuries.

13-36 **How does this landscape differ from the Shugetsu shown in figure 13-29, page 368?** Sim Sajong, Landscape, late Choson period, Korea, c. 1700–1800. Hanging scroll, ink on paper, 10 1/2" x 8 3/4" (26.67 x 22.22 cm). Los Angeles County Museum of Art, Purchased with Museum Funds. Photograph © 2004 Museum Associates/LACMA

13-37 **How would you compare the realism and use of expressive line in this Korean painted scroll to that of the Japanese ukiyo-e print in figure 3-23, page 44?** Yi Chae-Gwan, Hanging scroll: Portrait of Kang Yi-O, 19th century. Ink on silk. Courtesy Davis Art Images.

# A Contemporary Fantasy

## About the Artist
## Ambreen Butt
(b. 1969)

During her art training in Lahore, Pakistan, **Ambreen Butt** learned how to paint in the Indian miniature tradition (see **Non-Western Art History II,** page 387). To make a brush that would create the tiny strokes that are so integral to the style, she learned to pull strands of squirrel fur through a hollow pigeon quill. When she was twenty-three, she moved to Boston to continue her studies. The transition from a Muslim culture to that of a modern Western city was significant. This accomplished young artist's work reflects her past memories and also addresses ideas about independence and the complex relations between men and women.

13-38 **The Indian miniature style, used in book illustrations from the sixteenth to eighteenth centuries, often combined exquisite detail with strong narrative content. How does this painting reflect some of those same qualities?** Ambreen Butt, *Untitled*, 2003, from the series *I Must Utter What Comes to My Lips.* Watercolor and white gouache on Wasili paper, 11" x 7" (27.9 x 17.8 cm). Courtesy of the artist and the Bernard Toale Gallery.

## ❶ Describe What You See

When you describe an artwork, you identify the things about the work that you can see, name, and describe with certainty. You should not include opinions, evaluations, or possible meanings here.

- Identify the artist, title, medium, style of work, and note size.
- Describe the actions of the two people; the bird; the fish in the upper right; and the three fish by the man's head.
- Describe the pattern of line in the water.
- What is the shape of the opening in the brown layer?
- In what shape are the figures, bird, and water trailing from the bird arranged?
- Where do you see a pocket- or sack-like form in the brown layer?

## ❷ Analyze the Way It's Organized

When you analyze an artwork, you tell how the subject matter and elements of the work have been organized by the artist. You tell how they work together.

- Beginning with the bird and trail of water as the top layer, count the number of overlapping layers in this work.
- What gives the appearance of depth in the painting?
- Locate linear edges caused by color or texture contrasts.
- Where is the initial focal point in the painting? Identify elements that direct your eye around the composition. Examples: continuous lines and edges and directional shapes, including life-forms.
- Now, trace the visual movement around the composition. Try beginning with the fish pointing at the man's head.

## ❸ Interpret What It's Saying

Use the information from your description and analysis to help you identify the meaning of the work—what it tells you about human experience.

- What mood do you associate with the work? Examples: Happy, celebratory, religious, fantasy, sensual, confused, dreaming, turmoil, conflict, emotional, etc.
- Are the two people interested in one another?
- Are the fish-devouring bird and the swirling waters good or bad omens? Try a simile or metaphor to clarify the meaning. Example: love is like swimming in a river full of undercurrents.
- What do you think the work is about?

## ❹ Evaluate Its Success

Using your analysis in the first three steps, how would you judge the quality or success of this work?

- Which philosophy do you base your judgment on? A successful artwork: (1) is true to life, imitates reality (2) is designed for perfect relationship among elements, (3) expresses significant ideas, feelings, emotions, (4) advances human interests, a purpose, or a cause.
- How do you judge the success of the work in expressing a significant idea?
- Do the arrangement of elements and forms achieve compositional unity?
- How do you judge the artist's technical skill and craftsmanship with the media?

**More Art!**
See page 378 for more artworks by Ambreen Butt.

**Web Link**
www.davis-art.com

# The Soul of Japan: Mixed-Media Umbrella Form

How do artists represent individual cultures in meaningful ways? One way is by exploring symbols and themes. Try working with a classmate to create a panel for a sculptural umbrella collage that represents your chosen theme to suggest an essence of Japanese culture.

## Before You Begin

Umbrellas in Japan serve both practical and decorative functions, and are often handmade, created using bamboo and rice paper. Read the description of Christo and Jeanne-Claude's *The Umbrellas,* as described in the **Studio Background** on page 375. Think about the uses and thematic significance of umbrellas in Japanese culture, and why these artists may have chosen umbrellas as the medium for their large-scale environmental project.

### Safety Note
Wear a mask when using spray paint, and do so only in a well-ventilated area.

Consult with your partner to select a theme for your panel collage. Your theme may reflect religion (Zen Buddhism or Shintoism), landscape (for example, maps, geography, volcanoes, Zen gardens), the arts (theater, dance, visual art, design, architecture, etc.), or people (fashion, politics, artistic design, historic clothing, etc.).

## You Will Need
- large wooden market umbrella
- large roll paper, manufactured and handmade rice paper or tissue paper
- recycled magazines, Japanese newspapers, images downloaded from the Internet
- colored pencils, markers, watercolor paints, black india ink, spray paint
- paintbrushes, scissors
- glue-water mixture
- masking tape, fishing line

## Create It
❶ Consider using a bright spray paint, such as a bold red-orange, to completely cover the panels of the umbrella, thus creating a striking armature

❷ Collect visual information on the theme you and your partners choose to depict. Images can be drawn, painted, photocopied, or printed from the computer.

❸ Arrange and rearrange your images to create a balanced composition with a discernible focal point.

13-39 Student works. Mixed-media umbrella forms.

**4** The umbrella armature divides naturally into eight triangular panels of equal size. You and your classmates can create eight finished images, each sized to match the dimensions of the umbrella's panels.

**5** Apply your items to the white triangular paper using the glue-water mixture. Enhance and add details with your choice of drawing media. You can also use Japanese letter forms *(kanji)* as part of the design. The name you choose for your thematic area can be translated from English to Japanese and used as a recurring design element.

**6** Attach the finished panels to the umbrella armature.

**7** Use fishing line to attach the umbrella to the ceiling in a suitable display space.

## Evaluate It
• To what degree is your image expressive of a visual essence of the Japanese culture?

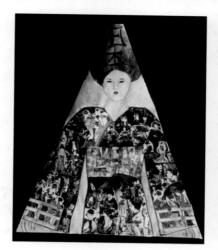
13-40 Student work, Erica Wraight. Mixed media, 36" x 30" (91.4 x 76 cm).

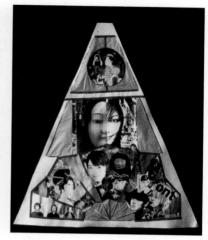
13-41 Student work, Courtney Dunn. Mixed media, 36" x 30" (91.4 x 76 cm).

• In what ways was your understanding of Japanese culture increased by this project?
• How does the overall composition of this umbrella reflect balance and unity?
• What aspect of this work was the most challenging? How did you overcome your difficulties?

# Studio Background

*The Umbrellas* project was a two-part environmental work focused on two valleys, one in Japan, and one in California. It involved placing and simultaneously opening a series of 3,100 umbrellas across the two valleys. The umbrellas were left open for eighteen days. The 1,340 blue umbrellas in Japan were placed at close intervals across a twelve-mile stretch of valley. The color reflected the verdant countryside, and the close placement recalled the scarcity of land and dense population of the country. This was intended to contrast with the yellow umbrellas used in California, representing the dryness, spaciousness, and low density of the US valley that lay across the ocean from the Japanese valley. To accomplish the Japanese half of the project, the artists obtained permission from 459 landowners, mostly rice farmers, and from government agencies.

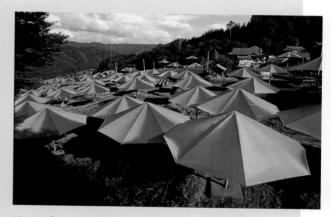
13-42 **The artists who placed these umbrellas saw them as shaped canvases that created settlements of houses without walls. Why might an umbrella be a useful symbol for a home?** Christo and Jeanne-Claude, *The Umbrellas*, Japan-U.S.A. © Christo and Jeanne-Claude.

# Photomontage: Our International Origins

At some point most of our ancestors were part of the immigration process. So where did you come from? Try to find out more about your family's heritage, and tell the story of what you learn through a photomontage that reflects a thoughtful and visually interesting design.

## Technique Tips

• Use gesso on your combined arrangement to soften one image into another or to eliminate unwanted gray areas.
• Use fine-line black markers to make linear connections between your images before adding color.

## Safety Note

X-Acto knife blades are extremely dangerous. To prevent injury, use caution in cutting with these tools and in changing the blade. Keep plenty of free space around you. Always pull the knife toward you, keeping your free hand well out of the way.

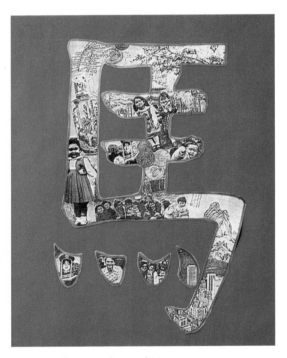

13-43 Student work, Carol Ma. Mixed media, 18" x 12" (45.7 x 30.5 cm).

13-44 Student work, Jessica Stanton. Mixed media, 11" x 8½" (28 x 21.6 cm).

## Before You Begin

Talk to your family and find out whether your ancestors immigrated to this country, and if so, from what country and when. If your ancestors were Native American, or you do not know what country they emigrated from or when, find out as much as you can about your family's background, including where your ancestors lived.

## You Will Need

• a photograph of yourself
• images, items, and documents pertinent to your family's heritage
• a variety of drawing and painting materials (watercolor paint, pastels, colored pencils, felt-tip markers)
• illustration board
• white glue
• scissors and X-Acto knives

## Create It

❶ Collect old family photos and documents such as birth certificates, passports, and family heirlooms and bring them into class along with a photograph of yourself at any age. Collect, copy from books, or download from the Internet and print maps that reflect your family's geographical background.

❷ Arrange and enlarge or reduce by photocopying each of your items—the maps, photographs, the heirloom—according to their significance to you. Take steps to assure that important materials are handled carefully and not damaged. Once you have completed photocopying, see that the items are

13-45 Student work, Grace Maa. Mixed media.

④ Make a single photocopy of the combined image arrangement. Work directly on the actual photocopy or create a montage of photocopies, glued onto illustration board using white glue.

⑤ Use line (fine-line marker, pencil) to suggest connections between the components of your photomontage. Use color (pencil, pastel, or watercolor) to help develop visual interest and to unify your final composition.

### Evaluate It

- Does your final composition succeed in telling the story of your family's heritage? Is the composition personally meaningful?

- How did you employ line, color, and the principles of design to create visual interest? Is your final image balanced and unified? Does it reflect rhythm, movement, or pattern? What design problems did you encounter, and how did you resolve those challenges?

safely returned to your home and family at the first opportunity.

③ Sort, arrange, and rearrange your photocopied images until they relate in a way that reflects what you want to convey about your family structure. Keep in mind the principles of design (unity, variety, emphasis, rhythm, and movement, balance, pattern, and proportion), and try to employ them in your arrangement.

**Write About It!**

Reflect in writing on how creating your photomontage has increased your understanding of your heritage. What did you learn about your family's heritage that you didn't already know? To what degree did your use of maps and US or world geography increase your understanding of your family's origins?

**Art History**

## Studio Background

The Chicano movement of the late 1960s prompted Carmen Lomas Garza to create narrative paintings that capture the daily life and special events of the Mexican-American experience. The purpose of her painting is to celebrate and instill pride in her community's way of life. She also wants to educate those outside of the community about its customs and traditions. A happy outcome of her work is that it has motivated Mexican-Americans to rediscover traditions that they had experienced with their parents, but had let slide as adults. For example, *La Tamalada* has encouraged people to renew the custom of making tamales in the kitchen as a family.

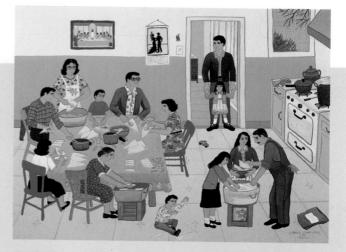

13-46 **Garza celebrates the Mexican-American community by depicting memories of her life among family and friends as a young girl in Texas. In a world that is becoming increasingly globalized, why might it be a good thing to retain some diversity of culture?** Carmen Lomas Garza, *La Tamalada (Making Tamales)*, 1984. Gouache, 20" x 27" (50.8 x 68.6 cm). Photo by Wolfgang Dietze. Collection of Leonila Ramirez, Don Ramon's Restaurant, San Francisco. Courtesy of the artist.

13-48 Ambreen Butt, *Untitled*, 2003, from the series *Farewell*. Collage, watercolor, white gouache, stitching, text on mylar, 17" x 14" (43.2 x 35.6 cm). Courtesy of the artist and Bernard Toale Gallery.

13-47 Ambreen Butt, *Untitled*, 2003. Watercolor and white gouache on Wasili paper, 11" x 7" (27.9 x 17.8 cm). Courtesy of the artist and Bernard Toale Gallery.

13-50 Zhang Dali, *Demolition—Forbidden City, Beijing*, 1998. Print on photo paper, size is 59" x 39 1/3" (150 x 100 cm). Photo courtesy of the artist.

13-49 Toshio Iwai, *Wall of Lights*. © Exploratorium <www.exploratorium.edu>.

# Chapter Review

## Summary

*Non-Western* is a term that refers to any culture that is not related to the United States or western Europe. This chapter introduced the art and culture of India, Southeast Asia, China, Japan, and Korea. Many of these cultures influenced one another's art.

Much art in India has been shaped by religious beliefs. Both *Hindu* and *Buddhist* artworks use symbols to help emphasize the characteristics of their gods.

Southeast Asian art is known for its complex styles and symbolism. Cambodia has produced unique ceramics. Vietnamese metalwork is renowned for detailed decoration. Javanese artists have perfected the art of batik fabric dyeing.

China's many *dynasties* have influenced art since the fifteenth century BCE. Taoist and *Confucian* beliefs are reflected in delicate landscape paintings, graceful *porcelain* work, and ceramic sculpture. Zen Buddhism has had a major influence on Japan's simple, elegant paintings, prints, and ceramics. Korean artists, while influenced by neighboring China, have distinguished themselves in the creation of *celadon* porcelain and in landscape and portrait paintings.

## Review Questions

1. **Recall:** Why do some images of the Buddha resemble Greek sculpture?

2. **Understand:** Explain one way in which Confucianism affected the style or subject matter of Chinese art.

3. **Apply:** Create a pencil sketch that uses the subject matter explored in Japanese ukiyo-e artwork.

4. **Analyze:** Compare and contrast the Chinese porcelain vase in **figure 13-25** (page 365) with the Korean wine pitcher in **figure 13-35** (page 370). Which would you prefer to own? Why?

5. **Synthesize:** Using local newspapers, magazines, tourist brochures, and your own artwork, develop a guide to the geography, people, history, and beliefs of your city, town, or an area around you. Imagine you will be sending it to someone your age who lives far away and is considering moving nearby.

6. **Evaluate:** Choose three artworks from this chapter that show natural objects or scenes. Rank them in these different ways: Most realistic to least realistic; most expressive to least expressive; simplest to most complex. Is the simplest also the most expressive? Is the most realistic the most complex?

## For Your Portfolio

Develop an artwork based on the theme of nature. Exchange your artwork with a classmate and write a critique of each other's work. Describe important details and make connections between what you see and the artwork's message about nature. Comment on strengths and weaknesses and offer suggestions for improvement. Respond to the peer review. Include all this in your portfolio.

## For Your Sketchbook

Practice simplifying natural forms. The purpose is to capture the essence of the form. First draw the natural shape you see—leaf, shell, branch, animal. Then draw it again, but this time leave out some lines in detailed areas. Each time you draw it, leave out more and more detail.

## Electronic Research

The Japanese-born artist Jun Kaneko, whose glass installation is shown on the first page of this chapter, is best known for his large painted ceramic "dangos" (from the Japanese word for dumpling), so-called for their plump, rounded forms. Look for online images of Kaneko's dangos, and find out how they are produced, including the technical challenges involved in building and firing such large-scale ceramic works.

## Going Further

How do climate, topography, and natural resources influence artistic production in various cultures around the world? For example, why do dwellings in North Africa look they way they do? Select a country or cultural region from this chapter and prepare a bulletin board display to show the relationship between artistic production and the natural environment of one or more cultural areas.

# 14 Non-Western Art History II

14-1 **This contemporary photographic collage refers to the artist's Native American tradition in a nontraditional medium. What messages do you think her work conveys?**
Pamela Shields, *Ghost Dance Remnant,* 1990. Liquid light on muslin. Courtesy of the artist.

## What You'll Learn

- that art can be a primary source of information about past civilizations
- how to discuss a culture's art in terms of its characteristics, functions, and history
- how to identify artworks of several cultures by their subject matter or style
- the contributions and influences of non-Western cultures on the world's art

## What This Chapter Covers

## Art Criticism Step by Step

## Studio Experiences

## Artists' Showcase *page 408*

## Chapter Review *page 409*

14-2 **Student works.** Plywood, oil paint, 8′ (2.4 m) high.

## Key Terms

*English* (Spanish)

*Islam* (Islam)
*monotheism* (monoteísmo)
*mosque* (mezquita)
*minaret* (alminar)
*arabesque* (arabesco)
*pre-Columbian* (precolombino)
*totem* (tótem)

## Artists

Anasazi peoples, Arapaho peoples, Aztec peoples, Benin peoples, Chokwe peoples, Dan-Ngere peoples, Dogon peoples, Garth Erasmus, Haida peoples, Ife peoples, Inca peoples, Luis Jimenez, Kwakiutl peoples, Maria Martinez, Moche peoples, Barthosa Nkurumeh, Pueblo peoples, Pamela Shields, Jaune Quick-to-See Smith, Tlingit peoples, Toltec peoples, various unknown artists

14-3 **Student work, Josh Jones.** Mixed media.

In this second chapter on non-Western art, we look at the art of Islam, Africa, Pre-Columbian Central and South America, and native North America.

*Islam* refers to the religion of the Muslims, and also to a way of life bound by religious laws and duties. Islamic cultures exist worldwide, but we will be looking at examples from Spain, North Africa, and the Middle East between 700 and 1600. The most significant Islamic architecture is the *mosque*, the Muslim place of worship. Muslims do not believe in creating sculptures of humans or animals, but their artworks contain rich colors and patterns. Islamic craftwork—including ceramic, bronze, silver, glass, and textiles—is highly valued for its ornate decoration and intricate designs. Only in Persian book illustration did Islamic artists display pictorial skills including human representation (**fig. 14-4**).

Africa is a large continent with widely varying religions, belief systems, and geographical features. The art of Africa has many different functions—celebratory, magical, political, etc.—and takes many different forms. The Dogon, in Mali, are best known for imaginative wood sculptures. The Ife society of Nigeria created lifelike sculptures in bronze between 1100 and 1300 CE, as did the kingdom of Benin, which flourished from the 1400s to the 1700s (**fig. 14-5**). Masks were used as uniforms

14-4 **How does the artist create a sense of space in this miniature?** *Two Warriors Fighting in a Landscape,* from Persian manuscript, 1396. Reproduced by Courtesy of the Trustees of the British Museum. © The British Museum.

14-5 **This figure represents a musician in the retinue of the oba, or king, of the kingdom of Benin.** Bronze figure of a hornblower, late 16th–early 17th century CE. From Benin, Nigeria. The British Museum, London, Great Britain. Photo by HIP/Scala/Art Resource.

14-6 **Wide, grand stairways often can be found on the interiors and exteriors of buildings. How do they differ in impression from narrow stairways? When and where are they used?** Pre-Columbian Mexico, Temple at Chichen Itza, 600–900 CE. Courtesy Davis Art Images

14-7 **Totems and wooden chests were common art objects of the Northwest Coast Indians.** Haida, Chest for clothes and jewelry, 19th century. Tsimshian Nisga'a chest. © Canadian Museum of Civilization.

among the Dan-Ngere people of the Ivory Coast. Each mask expresses a different role in the society. In African societies, art is closely related to everyday life.

Pre-Columbian Central and South America refers to the *indigenous,* or native, civilizations that flourished in Mexico, Central America, and South America before the arrival of the Spanish in the 1500s. Pre-Columbian art was created by such civilizations as the Moche, Incas, Aztecs, and Maya. The Moche were known for their sophisticated, slip-decorated pottery (fig. 14-8). Inca masonry is so tightly constructed that it is difficult to slip a knife blade between its stones. The Maya developed intricate carved stone calendars and the corbeled arch (discussed in Chapter 11, Architecture), which allowed them to make rooms and hallways within their stone buildings (fig. 14-6).

The indigenous peoples of North America include the Anasazi, Pueblo, Navajo, and the Northwest Coast Indians—the Tlingit, Haida (fig. 14-7), and Kwakiutl. The Plains Indians include the Crow, Sioux, Comanche, Cheyenne, and Arapahoe. The artworks of these peoples reveal successful examples of both abstract and representational designs.

14-8 **Many Moche portrait vessels have survived from ancient Peru. The unique facial features found on each one have led scholars to conclude that they are individual portraits.** Pre-Columbian, Peru, Mochica, Portrait Head Jar, c. 400–600 CE. Painted ceramic, H: 11 3/4" (30 cm). © Davis Art Images.

## Linking Disciplines
### Science

Much Islamic art depends upon geometric shapes, which can often be found in nature. To watch crystals grow, dissolve about a tablespoon of table salt in ¼ cup water. Using a glass slide and microscope, watch crystals form as the water evaporates. How can you translate the science of crystals into the language of art?

□ Majority Islamic population
○ Significant minority Islamic population

14-9 **Modern-day Islam.**

*Islam* is one of the world's major religions. Followers of Islam are called *Muslims*. Islam can also refer to nations that practice the Islamic religion.

The Muslim prophet Muhammad is said to have been born in Mecca (on the west coast of Arabia) 570 years after Christ, and over eleven hundred years after Buddha. Not long after Muhammad's death, his followers converted the peoples of the Middle East, North Africa, and Spain in a lightning series of conquests (**fig. 14-9**).

The teachings of Muhammad were collected in the *Koran*, Islam's sacred book. The content of the Koran is closely related to the Christian Bible. It teaches *monotheism*, or the belief in one god. Stories about the Jewish prophets of the Old Testament are included in the Koran, but Jesus is identified as one of the prophets rather than as the son of God. Muslims believe that Muhammad is the last of the prophets. Muslims must pray in the direction of Mecca five times every day. There are no priests in Islam. Public worship takes place on Fridays at noon.

14-10 **The arches in the Cordova mosque are made with stones of contrasting colors. Arches are placed one on top of the other. How do these double-tiered arches add complexity and drama to the mosque experience?** Great Mosque of Cordova. © Paul Almasy/Corbis.

## Mosques

The Muslim place of worship is called a ***mosque***. Early mosques were very simple, sometimes just walled rectangles. A mosque might cover ten acres in size and be big enough to contain all the worshippers of a large town. Every mosque is oriented to face Mecca. The *qibla*, or wall on the Mecca side, has a small prayer niche called a *mihrab* in the center. Opposite the qibla is the ***minaret***, or prayer tower. A *muezzin* (myoo-EZ-in), or crier, calls the faithful to prayer from the minaret.

By the tenth century, Cordova, Spain, was one of the world's great centers of culture and learning. It is said to have had 500,000 inhabitants and 700 mosques. The mosque at Cordova (fig. 14-10) is a rich example of developed mosque architecture. Its interior, with its many arches and pillars, is quite dramatic. The pillars are spaced to create multiple aisles.

The Court of Lions of the Alhambra, a palace in Granada, Spain (fig. 14-11), is an outstanding example of Islamic arch construction.

The splendor of Granada's Islamic heritage, especially its architecture, left a lasting impression on the European imagination.

14-11 **The Alhambra arches are richly decorated with stucco and tile reliefs that are delicate and create an airy effect. The arches themselves seem almost to hang from, rather than support, the ceiling.** A Courtyard at the Alhambra, Granada, Spain, c. 1318–54. © Dallas and John Heaton/Corbis. Photo: Dallas and John Heaton.

## Islamic Decoration

Muhammad was opposed to *idolatry,* the worship of idols. He smashed all of Mecca's sculptures of gods and goddesses. Indeed, he did not allow the use of religious images of any kind. To this day, mosques—unlike Buddhist temples and Christian cathedrals—have no statues or pictures of human or animal figures.

However, abstract decorations were allowed. Muslim artists covered the insides of Islamic buildings with inventive designs. The term **arabesque**, meaning "in the Arab style," was coined to describe such complex designs. The designs featured patterns of intertwined lines and shapes.

The kind of lacework arabesques seen in the Alhambra arches (**fig. 14-11, page 385**) are also found in Islamic decorative arts. Objects of ceramic, bronze, silver, and glass were all richly covered with arabesque decoration. These objects were used to furnish mosques and palaces.

But the most highly valued Islamic artworks were textiles, especially woven carpets. The carpet in **figure 14-12** may have as many as three hundred knots to the square inch. The medallion design is surrounded by stylized and interlaced leaves and flowers. Simply to study such an intricate design must have been a moving experience.

14-12 **This carpet was probably made by a group of weavers, rather than a single artist. Why do Islamic carpet weavers rely so heavily on floral and geometric patterns?** Iranian, *Coronation Carpet,* Safavid dynasty, c. 1520–30. Wool, 144" x 276" (365.76 x 701 cm). Los Angeles County Museum of Art. Gift of J. Paul Getty. Photograph © 2004 Museum Associates/LACMA.

The absence of human or animal figures in most Islamic artworks is due in part to the Islamic aversion to idolatry. Another reason is that Islamic artists tended to specialize in the decorative arts, rather than sculpture and painting.

Book illustration was an exception, however. Islamic artists, especially in Persia, illustrated poems and books with miniature paintings. Persia, which is now Iran, had a highly developed culture. It was also a crossroads for traders and invaders from east and west. In the 1200s, Persia was invaded by the Mongols under the notorious Genghis Khan (the grandfather of Kublai Khan). The Persian book illustration *Two Warriors Fighting in a Landscape* **(fig. 14-13)** shows how Persian painting was influenced by the Mongols. Notice the artist's deft handling of space in this work. The rocks and mountains are somewhat Chinese in style. But the delicate details and two-dimensional design are typically Islamic.

For centuries Islam led Christian Europe in government, philosophy, literature, science, mathematics, medicine, architecture, and the decorative arts. Many Islamic contributions entered European culture during the Crusades (to be discussed in **Chapter 16, Western Art History II)**. The extent of the Islamic legacy is reflected in the English language. Many Arabic words have entered the vocabulary: *alcohol, bazaar, caravan, check, chemistry, nadir, satin, tariff,* and *zenith,* among others. Arabic numerals (1, 2, 3, 4, etc.), together with the concept of zero and algebra, replaced Roman numerals. (Imagine trying to divide XLV by IX!)

European architects enriched their cathedrals by borrowing the pointed arch, stained glass, and arabesque designs from the Muslims. And European artists learned the secrets of porcelain and silk—which came from China through the Muslims.

14-13 **This illustration demonstrates the use of vertical perspective, which can be read from bottom to top. Can you explain how it works?** *Two Warriors Fighting in a Landscape,* from Persian manuscript, 1396. Reproduced by Courtesy of the Trustees of the British Museum. © The British Museum.

14-14 **Notice how the Dogon sculptor has geometricized the human forms in this work. How are positive and negative forms related to one another?** Wood Sculpture of Primordial Couple, c. 19th century. © The Barnes Foundation, Merion Station, PA/Corbis.

## 14.3 Africa

Africa (fig. 14-15) is a checkerboard of religions and belief systems. The African continent consists of deserts, highlands, grassy savannas, and river forests. Its population is divided among nomadic cultures, farming villages, and great kingdoms—each with its own language.

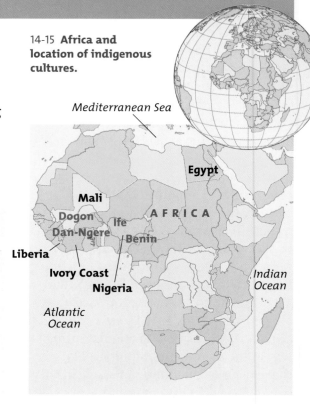

14-15 **Africa and location of indigenous cultures.**

14-14 **Notice how the Dogon sculptor has geometricized the human forms in this work. How are positive and negative forms related to one another?** Wood Sculpture of Primordial Couple, c. 19th century. © The Barnes Foundation, Merion Station, PA/Corbis.

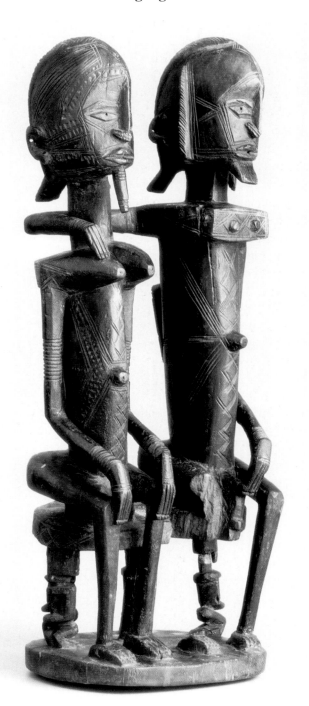

There is no such thing as a single style of African art. The style of an object depends on the culture in which it is created, its purpose, or sometimes the whims of the individual artist. African art can be realistic or abstract. It can be highly structured or relatively formless. African art does not always fall into the typical categories of sculpture or decorative art. For example, a footstool can look like a human figure. A jar handle can be shaped like a crocodile, and a hat can look like a pair of antlers.

Africans did not (and still do not) make sharp distinctions between art and life, as westerners do. Some of their art, like Western art, was intended to be permanent. But much of it was made to be used for a special occasion and then thrown away. Its functions are as varied as Africa's different beliefs. The art may be intended to appease spirits, to honor ancestors, to ensure fertility, to

symbolize authority, to frighten enemies, or simply to celebrate. For these reasons, African art is difficult to analyze. Yet this art, as a class of objects, has captured the imagination of modern artists and collectors. With this in mind, we will look at a sampling from those regions of Africa that are especially noted for their art.

## Dogon

The Dogon are a farming people in Mali. They are well known for their imaginative wood sculptures. Dogon sculptors carved bowls, jars, stools, masks, granary doors, and figurines in human and animal form. They sometimes even combined both forms.

Although Dogon styles vary, their human figures exhibit a sensitive blend of organic and geometric forms. The Dogon sculpture in **figure 14-14** symbolizes the mythical ancestors of the human race. It presents qualities essential to the idea, rather than realistic physical appearances. For the Dogon sculptor, this work does not represent the idea; the work is the idea. The abstractness of this style appealed to early-twentieth-

century artists and collectors. We must remember, however, that Dogon images were made for ritual purposes and not to be admired as art objects.

The Dogon are also known for their architecture. The houses and granaries of the Dogon village in **figure 14-16** are organically related to the natural contours of the hillside. They provide an interesting variety of levels and spaces. The buildings themselves, which were built by hand, have the qualities of sculptures.

However, it is the plan of the houses and layout of the village that interests twentieth-century sociologists and city planners. Each house is intended to symbolize a human body. The kitchen area is the head. On a larger scale, the arrangement of houses and granaries in a village is also intended to represent a human body. The symbolic connection between the houses and the village reflects a sense of community that is a part of the Dogon culture. In the Dogon society, families are linked both by marriage and by collective ownership. Each Dogon citizen is connected socially and symbolically to the village.

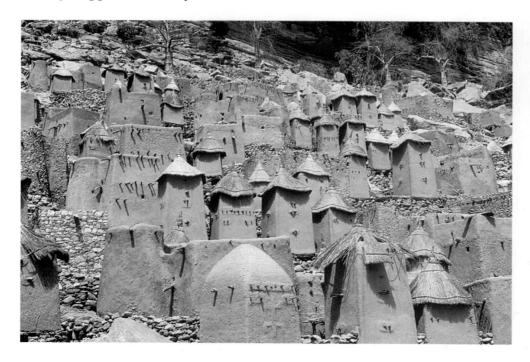

14-16 **The Dogon people have populated the cliffs of the Bandiagara Plateau for the past six hundred years.** Dogon architecture in Banani Village.
© Wolfgang Kaehler/Corbis.

## Ife

Unlike the village culture of the Dogon, the Ife society in Nigeria was aristocratic. This society flourished in the 1400s. Its art is lifelike, not abstract, as shown by the bronze head of a king in **figure 14-17**. The facial features are correct and realistic. The details of his royal headgear are faithfully depicted. Even the tattoos, which follow the contours of the king's face, are shown. The superb craftsmanship of Ife art calls to mind the art of ancient Egypt, classical Greece, and Renaissance Italy (to be discussed in **Chapter 15, Western Art History I**).

## Benin

A little to the south of Ife was the Benin kingdom, which flourished between the 1400s and 1700s. Possibly, the Ife and Benin kingdoms had historical ties. At any rate, Benin sculptors, like their Ife neighbors, also used the lost-wax method of casting. They created bronze castings of a high technical level.

The body of the little horn blower in **figure 14-18** neatly combines realism with caricature. His proportions (the relationship of the parts to a whole) are obviously exaggerated. His overall height is about three times the height of his head, whereas the ratio of height to

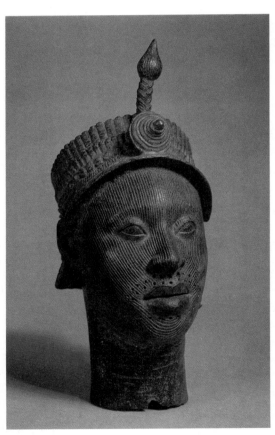

14-17 **Ife bronzes were made by the lost-wax method of casting described in Chapter 10.** Bronze head with a beaded crown and plume, Yoruba, probably 12th–14th century CE. From Ife, Nigeria. Height: 14" (36 cm). Purchased with the assistance of the National Art Collections Fund. © The British Museum.

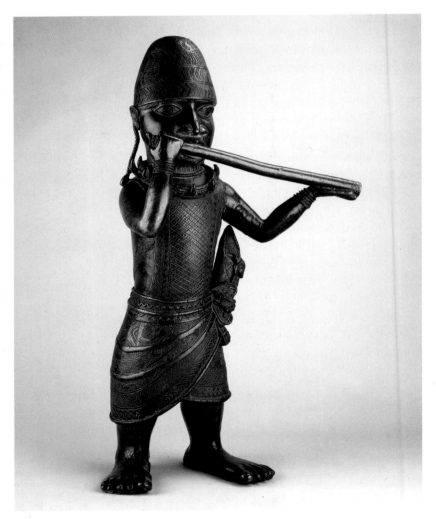

14-18 **Like the Ife head in figure 14-17, this sculpture was made by the lost-wax process and is decorated with engraved designs. How does the horn blower combine realism with caricature?** Bronze figure of a horn blower, late 16th–early 17th century CE. From Benin, Nigeria. The British Museum, London. Photo by HIP/Scala/Art Resource.

head size in an average-sized adult human is about seven to one. The proportions in his face are not lifelike. The head and feet are exaggerated. Nevertheless, there is something very lifelike about him. Look at his large almond-shaped eyes, the folds of his kilt, his stubby legs, and, especially, the way his little arms support the instrument. His body and clothes, like the Ife king's, are heavily decorated with engraved designs.

## Dan-Ngere

Masks are produced by cultures all over the world. Perhaps wearing a mask satisfies a universal urge to change identity, be anonymous, or assume the power of another person or animal. In many societies, masks are used in dances and rituals. The purpose of a ritual could vary from a sacrificial offering to entertainment.

Among other functions, the masks of the Dan-Ngere people of the Ivory Coast were emblems of authority, much like a police uniform. A person wearing the mask of a judge was not pretending, but being a real judge who could try and convict people. Each Dan mask expressed the personality of a particular role. The roles one might take on varied from teacher to executioner. Thus, mask sculptors were challenged to develop a range of forms and styles. Some masks were smooth, highly polished, and had delicate features. Some, like the one in **figure 14-19**, were coarse with enlarged features. With its large nose, staring eyes, gaping mouth, and fur, the mask is very striking. Was it intended to represent a sage, a philosopher, a hermit, a cranky old man, or all of the above?

In Africa, art is not separated from life but expresses the social and spiritual values of each culture. Daily living, the natural, and the supernatural are all mingled in African art.

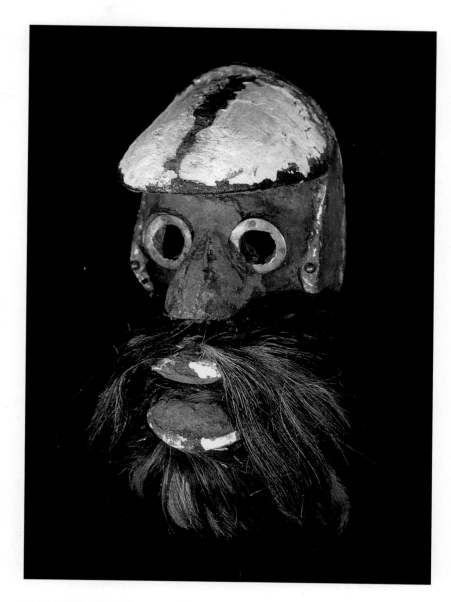

14-19 **Which of the visual elements is emphasized in this mask?** Dan-Ngere Peoples, Mask, Ivory Coast. Wood, animal hair, copper, and pigment, 11 3/4" x 6 1/2" x 8". Collection, The Illinois State Museum, F. Louis Hoover Collection of African Art.

## Try It Yourself

Create a clay sculpture of a person—yourself, someone you know, or a fictional person—standing upright. The sculpture should show realistic proportions. Pay careful attention to the position of arms, legs, and feet: How people stand can tell a lot about what they are feeling or thinking. When you are finished, ask another student what kind of personality your sculpture suggests.

14-21 **Many Moche portrait vessels have survived from ancient Peru. The unique facial features found on each one have led scholars to conclude that they are individual portraits.** Pre-Columbian, Peru, Mochica, Portrait Head Jar, c. 400–600. Painted ceramic, H: 11¾" (30 cm). Courtesy Davis Art Images.

Between about 18,000 and 13,000 BCE, people of Asian stock began migrating to the New World, and eventually settled in both North and South America. ***Pre-Columbian***, as the name implies, refers to the history of those people up to the time of Columbus. However, the term is most often used when we refer to the Indian civilizations that flourished in Mexico, Central America, and South America **(fig. 14-20)** before the Spanish invasions in the 1500s.

14-20 **Modern-day Mexico, Central America, and South America, and locations of indigenous cultures.**

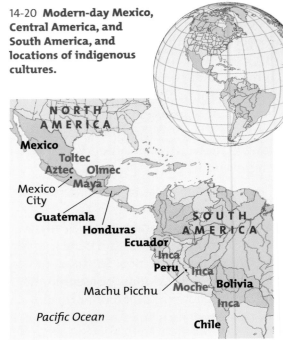

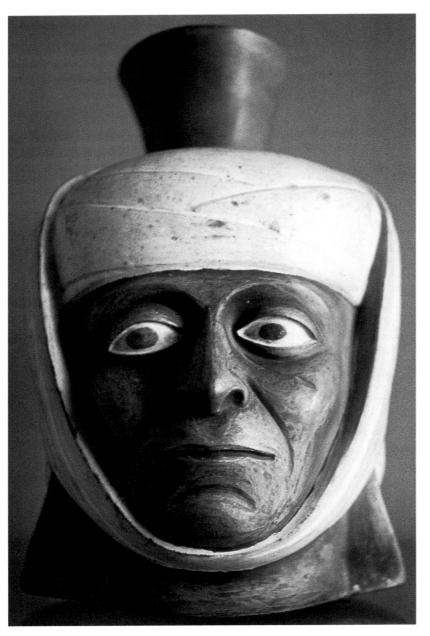

## South America

The civilizations of South America developed mostly in the central Andes Mountains. The earliest civilization was fully developed by 700 BCE (around the time of China's Chou Dynasty). This civilization was known for its irrigation canals. The Moche culture arrived on the scene somewhat later. Thriving from 1 to 800 CE, the Moche people were known for their metallurgy and sun-dried brick pyramids. They were also known for their remarkable ceramics.

No culture in pre-Columbian times used a potter's wheel, so all pottery was hand-built or formed from molds. Glaze also was unknown, so their pots were decorated only with slip. However, Moche potters were so skilled that their round vessels appear wheel-thrown. The surfaces of their pots resemble those of glazed ware.

The portrait jar in **figure 14-21** is obviously not wheel-thrown. However, it is an example of their superb craftsmanship. The dual function of portrait and storage vessel is in itself a skillful

achievement. As a portrait, it is as solemn and dignified as the Ife bronze. As a vessel, it is both functional and lightweight.

## Inca

Around 800, the Moche kingdom, along with other groups in the highlands and along the coast of modern Peru and Bolivia, came to an end. They may have been conquered by another people, but this is not certain. It is certain, however, that around 1400, another ambitious group started from Cuzco (Peru), and rapidly overran all the other Peruvian cultures. Named for the title of their leader, Inca, these people proceeded to establish an empire that stretched over 2,000 miles from northern Ecuador to Chile.

The main regions of their empire were scattered along the most rugged mountains of the world. To connect Cuzco to these regions, the Incas strung hanging bridges across rivers and built solid masonry roads. To grow crops, they learned to terrace and irrigate. They also domesticated the llama and the alpaca. To record their business transactions, they used a unique system of knotted cords for numerals. They worshipped gods of thunder, earth, sea, mountains, and rivers. Of these, the most important was the sun god, who they believed was their ancestor. Sun temples were built all over the empire, including one at Machu Picchu (fig. 14-22).

Located on top of a high mountain, Machu Picchu might seem an extraordinary place to locate a temple. And it was more than a temple: It was a palace and religious retreat for Pachacuti Inca, the ruler of the Incas. The site has nearly two hundred buildings, many of which housed workers and caretakers. Incan masonry is remarkable. Stones are fitted so closely that a knife blade cannot be run between them. This is even more remarkable when one considers that the stones were not cut to uniform sizes.

Today Machu Picchu is sometimes called the City in the Sky or the Lost City. It was rediscovered by Western explorers in 1911, after being abandoned by the Incas about 1527, after the Spanish invasions.

## Try It Yourself

In a detailed drawing, create a settlement for a group of people who want to relocate in a protected area. Think about where your settlement will be, and what building materials will be available to you. Design the layout of the settlement and the surrounding landscape. In a written statement, describe how your group will get water and food, and why you chose this site as your protected location.

14-22 **Located at an altitude of about eight thousand feet, the Machu Picchu community included houses, palaces, and temples. It was populated by about twelve hundred people.** Pre-Columbian, Peru, Machu Picchu (general view), 15th century. Courtesy Davis Art Images.

## Write About It!

Imagine you can dial a toll-free number and ask the person receiving the call anything you want to know about cultures that flourished in the pre-Columbian period. Develop a script that includes questions related to the way art fit into the daily life of a Moche, Inca, Teotihuacán, or Mayan person.

## Mesoamerica

Mesoamerica refers to the area of modern Mexico and the northern countries of Central America. The pre-Columbian civilizations that arose there differed from the Incas and the others of South America. They developed mainly in the central highlands of Mexico, the lowlands along the Gulf of Mexico, and the lowlands of the Yucatán Peninsula.

The oldest civilization was the *Olmec* culture that flourished between 1500 BCE and 100 CE. The Olmecs settled in the swampy lowlands along the coast in the current Mexican states of Tabasco and Veracruz. The culture's name was derived from the Aztec word *Olman*, which means "rubber tree country," a designation for the region dominated by the Olmecs.

14-24 **The name Quetzalcoatl comes from the word *quetzal*, meaning "brilliantly plumed bird" and *coatl*, meaning "snake." Judging by the fierceness of his image, Quetzalcoatl clearly commanded respect.** Pre-Columbian Mexico, Teotihuacán, Temple of Quetzalcoatl, plumed serpent head. Photo © Davis Art Images.

14-23 **This twenty-five ton carved stone is made of basalt. It was unearthed in 1760 in Mexico City's main square.** Aztec Carved Calendar Stone, c. 1479. © Archivo Iconografico, S.A./Corbis.

Another group, centered around the city of Teotihuacán, was just beginning to get organized in the central highlands north of modern Mexico City. The culture dominated the region from 300 BCE to 800 CE. (This period corresponds roughly to the time the Han and T'ang dynasties ruled China.) Like the Incas, the Teotihuacán worshipped nature. Their worship centered around *Tlaloc*, god of rain, and *Quetzalcoatl*, a culture hero who was later deified as a feathered serpent. To feed their gods and produce unity between the gods and the people, the Teotihuacán practiced human sacrifice. These rituals occurred frequently at their capital, Teotihuacán, which meant "place of gods." It was perhaps the largest city in pre-Columbian America. Estimates of its peak population range from one hundred thousand to almost one million.

The ritual center of the city had many temples and palaces, and was planned around a broad avenue. The largest temple, dedicated to the sun, was a five-

tiered pyramid with a broad stairway. A smaller temple was decorated with sculptures of the heads of Quetzalcoatl (**fig. 14-24**) and Tlaloc.

The downfall of Teotihuacán, around 800, coincided with the rise of the *Toltecs*. The Toltecs took over many aspects of Teotihuacán culture, though their language (Nahuatl) may have been different.

Around 1300, the *Aztecs*, another Nahuatl-speaking group, came to power. The Aztecs established Tenochtitlán (modern Mexico City) as their capital. A very warlike people, the Aztecs expanded their empire to include all of Mexico. However, the Aztecs would fall to the Spaniards when Iszo and Cortez invaded Mexico.

While Teotihuacán culture was growing in the highlands, the *Maya* were building their own culture in the lowlands of Guatemala and Honduras. Of all the cultures of pre-Columbian time, the Mayan culture was perhaps the finest. The Maya developed writing, a form of arithmetic, a calendar, and the corbeled arch (discussed in Chapter 11). Mayan numerals—a dot (equal to the number 1), a bar (equal to five dots), and a crescent (equal to four bars)— have been compared to Arabic numerals for their simplicity and effectiveness.

The Mayan year was divided into eighteen twenty-day months, with five extra days for special religious observations. This resembles a modern calendar in principle. The relief carving in **figure 14-23** illustrates not only the Aztec version of the Mayan calendar, but also an example of Aztec carving. To the Maya, the calendar and the related science of astronomy were so important that many of their priests were astronomers.

Around 900, the Maya abandoned their sites in Guatemala and Honduras and moved to the Yucatán Peninsula. We still do not know why. Was it due to drought, crop failure, foreign intervention, or perhaps a combination of these?

Despite this mysterious move, and later invasions by Toltec peoples, the Maya are responsible for building some of the finest architecture in pre-Columbian Mexico. The major temple at Chichén Itzá (**fig. 14-25**) rises grandly from the Yucatán plain. It stands not only as an example of handsome Mayan architecture, but also as a reminder of a once-proud culture.

**Linking Disciplines**
Mathematics
How did ancient peoples keep track of time without using a clock? The early Maya developed sophisticated calendars and an advanced numerical system. They kept track of solar and lunar years, eclipses, and cycles of visible planets. A few simple symbols in varying combinations expressed numerals. Locate a chart of Mayan numerical symbols online or in the library. Write the Mayan equivalent of a formula related to astronomy. Exchange papers with a partner and see if you can decipher each other's formulas.

14-25 **Mayan temples were usually built on tiered pyramids, similar to those at Teotihuacán. They were richly decorated with relief carvings and covered with stucco.** Pre-Columbian Mexico, Temple at Chichén Itzá, 600–900. Courtesy Davis Art Images.

The previous review of South American and Mesoamerican cultures looked at their history before Europeans came. The review of North American Indian art in this section looks at its development after Europeans came. Little is known about the history of the indigenous North American peoples prior to the 1500s. Unlike the Maya, they left behind no writing, and few monuments of architecture and sculpture. What we do know of their days prior to European contact comes mostly from graves and burial mounds.

We do know a great deal about their history since the 1500s, however. Unlike the Incas, Toltecs, Aztecs, and Maya, the native North American cultures were not immediately destroyed or absorbed by conquerors. Despite displacement and massacres by the white settlers, most of them managed to maintain their cultural identities through the 1800s. Since the late 1800s, native North Americans have been the object of intense study by historians and anthropologists.

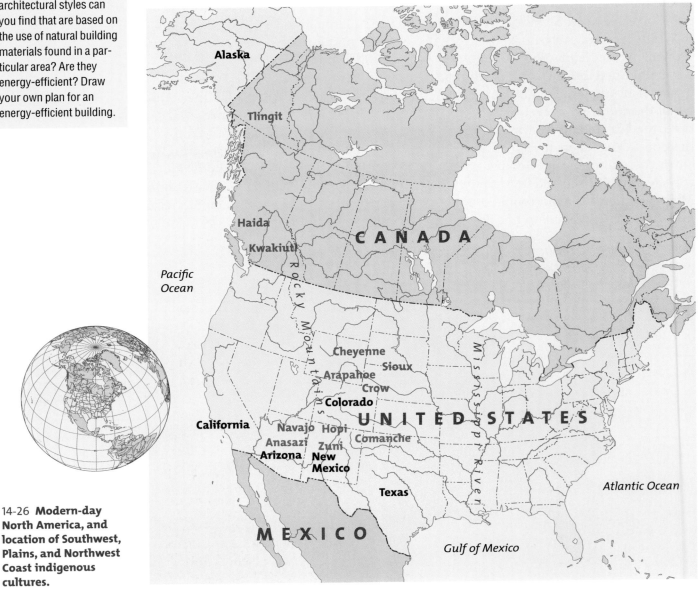

14-26 **Modern-day North America, and location of Southwest, Plains, and Northwest Coast indigenous cultures.**

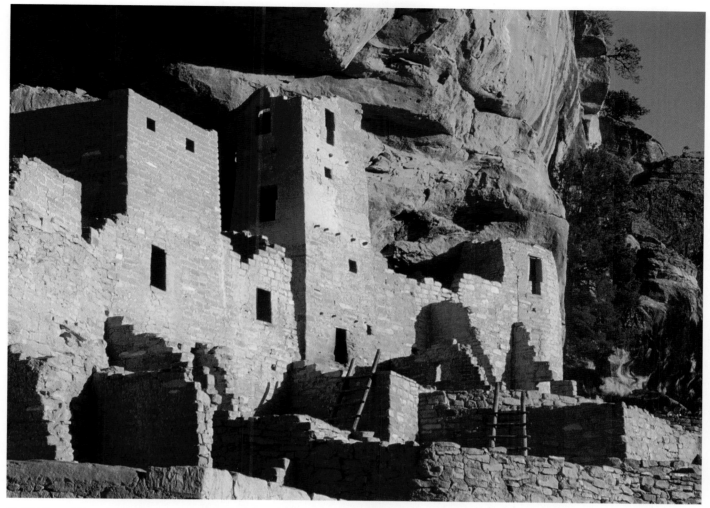

14-27 **The settlement at Mesa Verde has over two hundred rooms and twenty-three kivas, with an excellent view of what is now Mesa Verde National Park. At one time, at least twenty-three clans lived here.** Cliff Palace, The Anasazi ruins of Cliff Palace in Mesa Verde National Park, Colorado, c. 1200. © Tom Bean/Corbis.

Native North American cultural groups had numerous customs and beliefs. One expert counted fifty-six different languages. But all groups, except perhaps the Plains Indians, lived near rivers and lakes. They raised *maize* (corn), beans, and squash. Although they had a number of different religions, all practiced nature worship.

## Southwest

**Anasazi** One early culture, the Anasazi, did leave a substantial record of their existence. Located in the plateau country of what is now New Mexico, northern Arizona, and southwestern Colorado, the Anasazi made pottery and weavings. They built masonry-walled structures as early as the first century CE. Chapels, called *kivas,* were built partially underground.

The Anasazi also built cliff dwellings at Mesa Verde (**fig. 14-27**). The Mesa Verde dwellings are similar to the Dogon village shown in **figure 14-16**. Made of stone, timber, and some *adobe* (sun-dried bricks), the dwellings are multileveled and interconnected.

**Pueblo** The Pueblo Indians were a farming culture made up of the Zuni and Hopi tribes. They came after the Anasazi people. The Pueblo lived in traditional adobe dwellings. The Pueblo still live in New Mexico and Arizona, and still produce art using some of their traditional styles and methods (see Artist Biography).

The handmade Acoma water jar shown in **figure 14-29** would likely have been carried by an Acoma woman on her head as she ascended a sheer rock face to a fresh spring on the side of the pueblo. The pattern on the jar is an abstract representation of sky and mesa.

## Artist Biography
# Maria Martinez (c. 1887–1980)

Some of the most refined pottery ever produced in North America came from the Pueblo cultures. A unique technique for creating "black-on-black" pottery (fig. 14-28) was developed by Maria Montoya Martinez, a Native American artist.

Maria Martinez was born at San Ildefonso Pueblo in New Mexico. She lived and worked in this small community for over eighty years. There, Maria ritually collected sacred clay from special sources in the surrounding mountains. Mixing these clays with proportions of water and volcanic ash, she produced a workable material appropriate for potting. Maria's husband, Julian, and son, Popovi Da, helped to decorate the pottery.

Martinez's pottery, like that of most traditional Pueblo, is made using the coil hand-building method. When the height and amount of clay are correct, the pot is smoothed and shaped with pieces of gourd. Slip is applied and burnished. The pit firing is smothered with manure to produce a reduction atmosphere, making the pots turn black. The cooled pots are cleaned with a soft cloth.

Today Maria and her black-on-black pottery are known worldwide. Her knowledge and expertise has been passed on to other generations of potters in her community, enlivening the economy and culture of the Pueblo people.

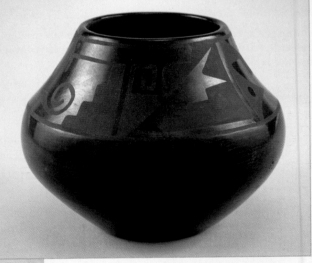

14-28 Maria Martinez, Bowl. Painted clay. Courtesy Gil and Jean Davis.

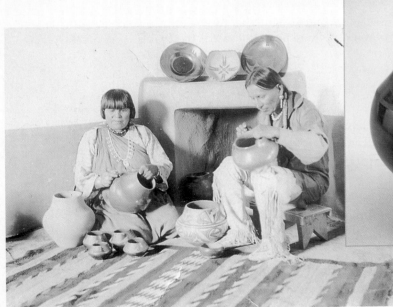

Maria and Julian Martinez, c. 1920. Photograph: Pedro de Lemos.

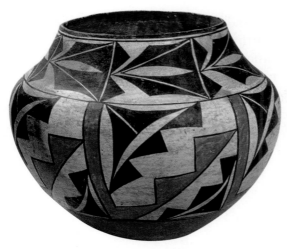

**14-29 The abstract designs and repeated pattern shown in this vase's decoration reflect a stylistic preference widespread among Pueblo peoples.** North American Indian, Acoma Pueblo, New Mexico, Jar, 1900–10. Painted clay, H: 58½" (23 cm). Santa Fe Museum of New Mexico.

**Navajo** The Navajo were originally a nomadic hunting culture until they settled in the Southwest during the sixteenth century. They learned the art of weaving from the neighboring Pueblo. Navajo blankets and rugs are among the finest in the world.

Compare the design of the Navajo rug in **figure 14-30** with that of the Persian rug (**fig. 14-12**). The Persian design contains stylized leaves, flowers, and geometric shapes. And, because of its arabesque interlacing of figures, shapes, and lines, it is much more complicated than the Navajo example. On the other hand, the Navajo design is starkly abstract. It contains precisely outlined, flat shapes. The shapes are subtly related and balanced between positive shapes, creating a reversible pattern.

**Try It Yourself**
Create a geometric design for a Navajo-style rug and experiment with unified color schemes. Choose one color of paint and add one or two colors that use the first color as a base. For example, if you use red as your main color, you could add red-orange and red-violet. You might also add tints or shades of red by adding white or black to your original red.

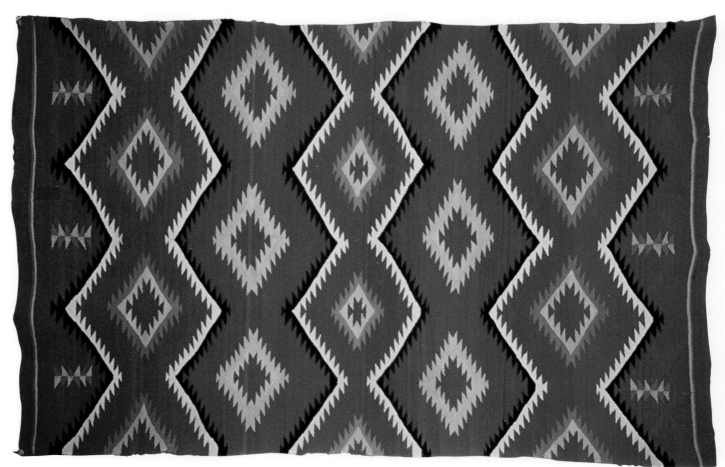

**14-30 North American Indian, Navajo rug, c. 1880, Arizona/New Mexico.** Aniline dyes on wool, 55½" x 84½" (141 x 215 cm). Photo by R. Gray Gallery, Chicago.

**Write About It!**

What kind of story might a totem pole tell? Make up an abbreviated family history that could explain the images carved into the totem pole shown in **figure 14-31** or another picture of a totem pole you find. Be sure to include the tribal or clan affiliation of the artist who carved the totem pole.

## Northwest Coast

The Northwest coast of North America included the Indian cultures of the *Tlingit, Haida,* and *Kwakiutl.* These cultures lived along the Pacific coast from Alaska to California. They depended mainly on food from the ocean, but they also farmed and hunted. Unlike the Pueblo, who built boxy houses of adobe brick, the Northwest Indians built gable-roofed houses of cedar planks. Wood was their most important raw material. They used it to make canoes, totem poles, and boxes.

***Totems*** are natural objects, usually animals, that are adopted as symbols of a family or clan. Totem poles **(fig. 14-31)** are large, carved works of art that feature those animals. North American cultures made them for several reasons: to honor a deceased elder, to record the number of names and rights a person had acquired over a lifetime, or to commemorate an encounter with a supernatural being.

Other objects were also often decorated with symbolic animals. Haida artists, for example, carved reliefs of clan symbols on the outside of the wooden chest in **figure 14-32**. There are two central figures, shown facing forward. The largest may be a bear, and the smaller seems to be human. Beside them are profiles of the heads of other animals—perhaps birds or fish. Although their heads are in profile, their eyes are facing frontward. The design is perfectly symmetrical. One side is a mirror image of the other.

In addition to totem poles and chests, Northwest artists decorated their canoes and houses, and made masks, rattles, charms, and wooden dishes. Like the chest and the totem pole, many of these have exuberant designs of stylized animals and humans.

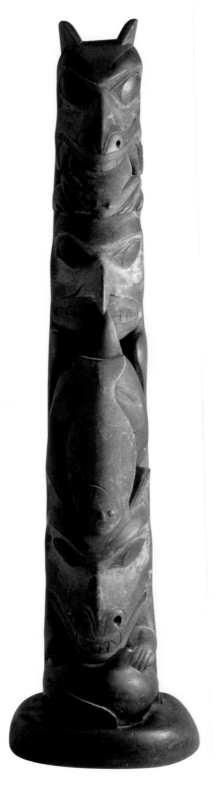

14-31 Haida Peoples (Northwest Coast), *Totem Pole,* before 1850. Wood with malachite and pigments, height: 39 3/4" (101 cm). © Minneapolis Institute of Arts. Gift of George Rickey.

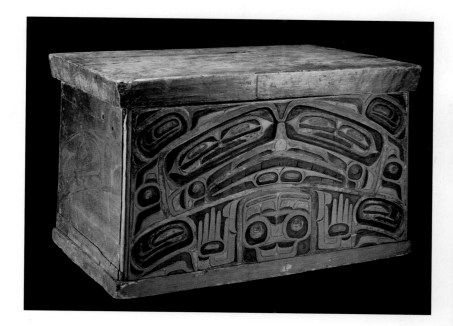

14-32 **Compare this chest with the carved totem (fig. 14-31). Based on these two artworks, name a dominating characteristic of Northwest Coast art.** Tsimshian Nisga'a chest. © Canadian Museum of Civilization.

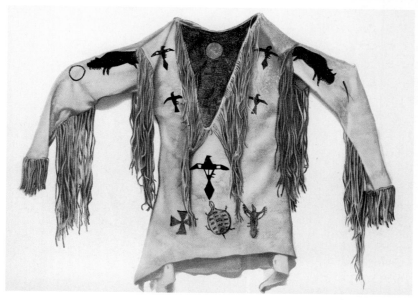

14-33 Arapaho Peoples, Ghost Dance Shirt, Central Plains States, 1890. National Anthropological Archives, Smithsonian Institution, Washington, DC.

14-34 **Contemporary artist Jaune Quick-to-See Smith was raised on the Flathead Reservation in Montana. How does this print combine representational and abstract images?** Jaune Quick-to-See Smith, *Flathead Dress*, 2001. Seven-color lithograph on white BFK Rives 300g paper, 26" x 20" (66 x 50.8 cm). Courtesy of the artist.

## Plains

Such cultures as the *Crow, Sioux, Comanche, Cheyenne,* and *Arapahoe* roamed the Great Plains, which stretch from the Mississippi to the Rockies. Plains culture changed dramatically with the arrival of Europeans, who brought with them the horse and rifle. Prior to the nineteenth century, the Plains peoples were nomadic, following the migrations of herds of buffalo that they used for food, clothing, and shelter.

Buffalo hides were even the source of Plains art. Buffalo-skin robes, tepees, and tepee linings were painted with geometric designs. Leather shirts **(fig. 14-33)** were decorated with feathers, beads, and hair. Plains Indians assembled headgear out of pelts and feathers. They made necklaces out of beads, bones, claws, or horns, and vests out of fur and leather strings.

# A South African Collage

## Garth Erasmus

### (b. 1956)

Growing up in the South African apartheid system meant that **Garth Erasmus** had limited educational opportunities and no chance as a boy to study art. He was fortunate that his parents were school-teachers; that meant he always had pencils and papers at his home in Port Elizabeth. It wasn't until he transferred to a teachers college in Cape Town that he was able to take an art class.

   In 1976, in Cape Town, Erasmus witnessed student uprisings against apartheid. At about the same time, his parents sent him his very first set of paints for his birthday. The coinciding of these public and personal events resulted in the artist's decision to dedicate "my talent to that struggle to uplift my community."

14-35 **This work speaks to the subject of apartheid—the long history of division between South Africa's black, white, and "colored" (mixed-race, south Asian, and Arab) peoples.** Garth Erasmus, *The Muse 3,* 1995. Acrylic on paper collage, 30¹⁵/₁₆" x 20³/₁₆" x 1³/₈" (78.6 x 51.3 x 3.5 cm). National Museum of African Art, Smithsonian Institution; Museum purchase. Photograph by Frank Khoury.

## ① Describe What You See

When you describe an artwork, you identify things about the work that you can see, name, and describe with certainty. You should not include opinions, evaluations, or possible meanings here.

- List the artist's name, title of the work, media, and date.
- Where is this artist from?
- What representational forms appear three-dimensional?
- What representational shapes do you see? Are they alike or different?
- What flesh colors can you identify in the right profile? in the left? What colors do you see in the rest of the composition?
- Is space shallow or deep?

## ② Analyze the Way It's Organized

When you analyze an artwork, you tell how the subject matter and elements of the work have been organized by the artist. You tell how they work together.

- What do you look at first in this artwork—what is dominant?
- What forms demonstrate proximity and similarity? How do they differ?
- Stare at the two profiles. Where do the eyes look? Can you see a reversing image—something that seems to join, then part?
- Does visual movement in this work seem continuous, interrupted, or both? Explain.
- What balance strategy has the artist employed?

## ③ Interpret What It's Saying

Use the information from your description and analysis to help you identify the meaning of the work—that is, what it tells you about the human experience.

- What is the meaning of the word *muse?* Did the artist use the term in the title as a noun, or as a verb?
- What do the profiles that seem to meld, then part again, suggest?
- What mood do you associate with the artwork?
- Try a simile or metaphor to help you clarify the work's meaning. For example, men are shadows in apartheid's ugly darkness.
- What do you believe the work communicates? You may use historical information.

## ④ Evaluate Its Success

Using your analysis in the first three steps, how would you judge the quality or success of this work?

- Which philosophy provides a basis for judgment? A successful artwork: (1) is true to life, imitates reality; (2) is designed for perfect relationship among elements; (3) expresses ideas, emotions; (4) advances a human purpose or cause.
- How do you judge the success of the work in terms of the selected philosophy?
- How inventive do you feel the artist's treatment of the subject is?
- To what extent does the work make you think about the artist's message, and your world?

### More Art!

See page 408 for more artworks by Garth Erasmus.

### Web Link

www.davis-art.com

# Expressing Personality in a Mask Form

The face we show to the outside world is not necessarily indicative of how we feel inside. In this exercise you will create a mask that reflects five parts of your personality.

## Computer Option

In a drawing program, create a basic mask shape. Add facial details and experiment with variations. For example, if you change the overall mask color to a much brighter or duller hue, how does it affect the feeling of the work? Or if you lower the mouth or raise the eyes, what different expression comes forth? Would this be a good exercise to pursue before creating any three-dimensional work? Why or why not?

## Write About It!

Describe the five psychological aspects of yourself that are represented in your mask. How did your choices of media, color, texture, and form reflect the parts of your personality?

## Before You Begin

Often we notice the physical, superficial aspects of ourselves and others. What are some deeper aspects? Consider your own personal psychological qualities—those nonphysical parts of yourself that make you a unique person. Are you outgoing or shy? Calm or anxious? What is important to you?

List five parts of yourself that are present "under the surface." Use your sketchbook to explore using artistic language such as form, color, and line to represent these aspects.

## You Will Need

• paper
• wire
• papier-mâché
• clay
• copper sheets
• plaster-covered gauze
• acrylic paint, glaze, brushes
• glue, staples
• fabric, feathers, glitter, hardware, beads, etc.

## Create It

❶ Decide on a medium for your mask form. Consider the amount of time you will need to work in the medium you choose. A plaster mask, for example, can be created in one class period whereas ceramic clay will take additional time for drying and firing.

❷ As you work on the basic mask, think ahead to plan the colors and textures you will use to show your chosen psychological qualities. How can you symbolically represent certain aspects? Don't hesitate to exaggerate your presentation of these aspects.

❸ Using additional media, complete your mask. Take time to enhance its strong points so that the five parts of yourself can be seen.

## Evaluate It

• Did you choose colors and textures that help reflect your inner self?
• How does your choice of media relate to your psychological qualities?
• What finishing details did you include that help reinforce the mask's overall effect?

14-36 Student work, Deirdre Coyle. Mixed media.

14-39 Student work, Alerica Lattanzio. Mixed media.

14-37 Student work, Josh Jones. Mixed media.

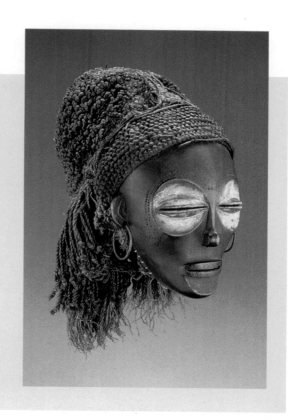

**Art History**

# Studio Background

Masks are used for ceremonies and celebrations in nearly every culture worldwide. Masks can be pure fun, or have a sacred, symbolic significance.

The *pwo* masks of the Chokwe peoples represent ideal young female beauty. They are worn in dances that honor female ancestors. The mask wearers are always male, but are disguised in women's costumes as they mimic young females' graceful movements. This fine-featured mask has high cheekbones and large eyes covered by white clay (kaolin). The hairstyle, created with plant fiber, also reflects a simple, classic beauty.

14-40 **Consider how physical and spiritual elements play important roles in the meaning of this mask. How is a pwo mask different in meaning from the mask that you have created?** Chokwe Peoples, Face Mask (Pwo), Democratic Republic of the Congo, early 20th century. Wood, plant fiber, pigment, copper alloy, 15 3/8" x 8 3/8" x 9 1/4" (39.1 x 21.3 x 23.5 cm). National Museum of African Art, Smithsonian Institution. Museum Purchase. Photo by Frank Khoury.

# Symbolic Sculpture: A Contemporary Totem Pole

Through this exercise, you will understand the significance of totem poles in Native American culture and work with other students to create a large-scale public artwork based on your own concepts of self and community.

## Before You Begin

Research Native American art, particularly the totem poles of Northwest coastal cultures. What or who do the carvings symbolize? What purpose did they serve in the community?

You will plan your contemporary totem pole in pieces, with each student responsible for a single cut and painted piece. You will then work in a group to assemble the pieces. Your image should represent an aspect of yourself or your community. How can you design a simplified version of this concept so that it has a strong visual presence?

## You Will Need

- drawing paper and pencils
- precut plywood
- sandpaper
- paint and brushes
- hardware (nuts and bolts) and poles

## Create It

**1** Make many small sketches before deciding upon your meaningful symbol. Save a small drawing of your final design.

**2** Draw a larger version of your design on plywood.

**3** Cut, sand, prime, and paint your piece.

**4** While the paint is drying, plan the sculptural arrangement with the rest of the class by assembling the small drawings in various ways, experimenting with possibilities until everyone is satisfied.

**5** Lay the wooden pieces out according to the agreed-upon paper design. Are the totem pole designs visually balanced? Rearrange if necessary before bolting into place. Consider the arrangement of the poles in relation to one another before installing the works in their final location.

## Evaluate It

- Did you experiment with many different arrangements before settling on a design?
- Were all pieces carefully sanded and painted before assembly?
- Do the finished poles relate well to one another?

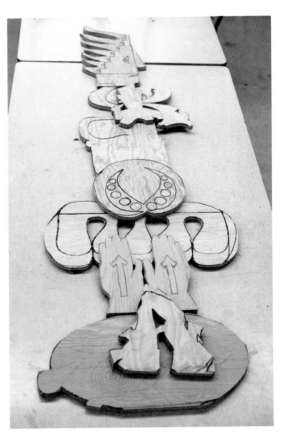

14-41 **Totem pole design being assembled.**

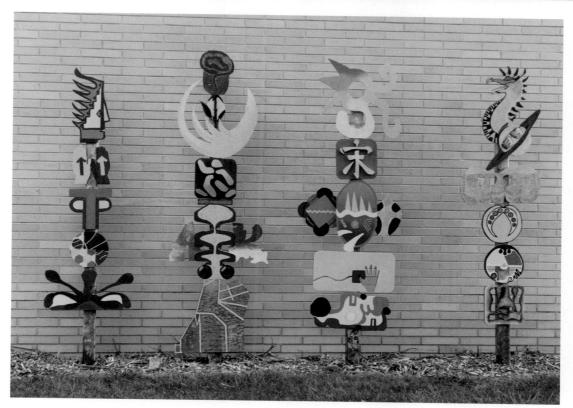

14-42 Student works, collaborations. Oil on plywood, H: 8' (2.4 m).

## Computer Option

Research architectural styles for building facades and choose three styles that your sculpture might look well with. Scan in a photograph of your finished sculpture, and crop or silhouette the poles to eliminate the background (make the background transparent).

Now import into a drawing program with the canvas size set larger than the photo. Make three copies of the file. Draw new backgrounds, creating a different architectural style for each one.

**Art History**

# Studio Background

Though a popular icon for tourism, totem poles are actually visual documents. They carry information about the communities of the Northwest Coast Native Americans that produced them.

Totem poles are a centuries-old tradition but were relatively rare until the early nineteenth century, when an increase in tribal wealth was brought by the fur trade. More families were then able to commission poles. The Haida, Tlingit, and Tsimshian excelled in carving poles. Eventually the form was linked to many of the Northwest Coast tribes in Alaska and British Columbia.

The images on some totem poles provided a family's ancestry. Others represented legends or honored individuals. The family, or clan, owning the pole passed their knowledge of its meaning to the next generation.

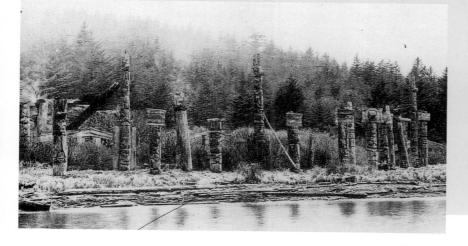

14-43 **Some poles were interior posts and supported roof beams. Others were placed against the fronts of buildings, or were free-standing carvings erected in front of a house. Today totem poles are sometimes placed near ceremonial or civic buildings.** Totem poles at the Haida village of Ninstints, Anthony Island, Queen Charlotte Islands, 1898. British Columbia Archives & Royal BC Museum.

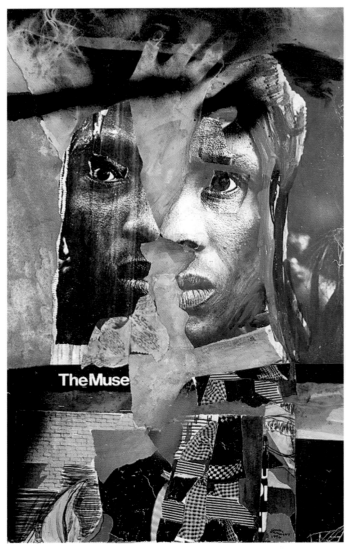

14-44 Garth Erasmus, *The Muse 1*, 1995. Acrylic on paper collage, 30⁷⁄₈" x 20¼" x 1⁵⁄₁₆" (78.5 x 51.4 x 3.3 cm). National Museum of African Art, Smithsonian Institution. Museum purchase. Photograph by Frank Khoury.

14-45 Garth Erasmus, *Subject to Change*, 1990. Mixed media on cardboard, 25¼" x 56⅛" (64.2 x 142.5 cm). National Museum of African Art, Smithsonian Institution. Museum purchase. Photograph by Frank Khoury.

14-46 Barthosa Nkurumeh, *Ojemba: Moonwatch*, 1997. Acrylic on board, 42" x 32" (107 x 81 cm). Courtesy of the artist.

14-47 Luis Jimenez, *Vaquero*, modeled 1980, cast 1990. Acrylic urethane, fiberglass, steel armature, 199" x 114" x 67" (505.5 x 289.6 x 170.2 cm). Smithsonian American Art Museum, Gift of Judith and Wilbur L. Ross, Jr., Anne and Ronald Abramson, Thelma and Melvin Lenkin. © 1980, Luis Jimenez.

# Chapter Review

## Summary

In this chapter you were introduced to the art and cultures of *Islam* and Africa; the indigenous cultures of Central and South America, as they existed before 1500; and the cultures of native North America.

Islamic art is known for its complex, detailed designs in weaving, stained glass, book miniatures, and mosaics. Islam's most important architecture is the *mosque*.

Because African peoples don't separate art from everyday life, much African art was made to be used for a special occasion and then thrown away. Its functions are as varied as Africa's different beliefs. Dogon wood sculptures, Ife bronzes, and Dan-Ngere masks represent only a small part of the diversity of African art.

*Pre-Columbian* cultures are those that flourished before the arrival of Columbus from Spain in the 1500s. The Moche of South America made refined hand-built pottery. The Inca built large masonry structures of closely fitted stones. The Maya of Central America developed writing, a form of arithmetic, a calendar, and the corbeled arch.

In North America, the Pueblo and Navajo cultures are known for their adobe architecture, pottery, and rugs. Cultures of the Northwest Coast of North America made intricately carved *totem* poles, canoes, and boxes.

## Review Questions

1. **Recall:** Why will you find no images of humans or animals in Islamic mosques?

2. **Understand:** Explain how Dogon houses are constructed and planned.

3. **Apply:** Create a design for a mask that gives you a special ability or power that you now lack. Carefully draw the materials you would use to make the mask, whether they are natural, found objects, or manufactured.

4. **Analyze:** Choose two cultures from this chapter and compare and contrast their approach to pattern, the human face or figure, or nature.

5. **Synthesize:** Create a timeline that shows the artwork of this chapter's four major cultural groupings in historical relation to one another. Decorate the timeline with motifs from each of the cultures shown.

6. **Evaluate:** Recommend the installation of a major art show made up of work from one of the cultural groups explored in Chapter 13 or 14. Base your recommendation on characteristics you observe about your own town or city: what ties can you see between the recommended artwork and your own cultural experience?

## For Your Portfolio

Create a decorative piece for your portfolio that demonstrates your willingness to explore the design potential of calligraphy and inventive letterforms. Before beginning your piece, consider how Islamic artists use calligraphy and letterforms in their work.

## For Your Sketchbook

Create a series of decorative borders for several pages in your sketchbook. For each border select a different motif from the cultural artifacts in this and the preceding chapter.

## Electronic Research

Study the work of a historic Indian potter at Touched by Fire: The Art, Life, and Legacy of Maria Martinez <http://www.miaclab.org/exhibits/maria/index.html>, then conduct an online search to find the work of the contemporary Indian artist Jaune Quick-to-See Smith. Compare and contrast the two artists. Are there any similarities between the two? How do they differ? How does their work reflect the times and cultures in which it was created?

## Going Further

How can you visually present information to educate the general public that there is no single style of African art or Islamic art, for example? South American, Mesoamerican, and North American Indian cultures are also quite varied. Work with a team of classmates to develop a PowerPoint presentation comparing a specific art form (for example, weaving) across different cultures.

# 15 Western Art History I

15-1 **Egyptians believed that breaking strict artistic rules might harm the soul of a deceased person. How is this death mask realistic? How is it unlike a real human face?** Funeral Mask of Tutankhamen, c. 1320 BCE © Roger Wood/Corbis. Photo by Roger Wood.

## Key Terms

*English (Spanish)*

*hieroglyphics (jeroglíficos)*
*humanism (humanismo)*
*idealism (idealismo)*
*weight shift (distribución del peso)*
*decorative arts (arte decorativo)*
*Middle Ages (Edad Media)*
*pilgrimage (peregrinación)*
*relic (reliquia)*
*Gothic (Gótico)*
*manuscript illumination*
   *(manuscrito iluminado)*
*Renaissance (Renacimiento)*
*High Renaissance (Alto Renacimiento)*

## Artists

Muriel Castanis, Donatello, Albrecht Dürer, Lorenzo Ghiberti, Leonardo da Vinci, Carlo Maria Mariani, Masaccio, Michelangelo Buonarroti, Myron of Athens, I. M. Pei, various unknown artists

15-3  Student work, close-up of several panels from Sistine Chapel–Inspired Ceiling Mural Studio Experience.

15-2  Student work, Allie Shehorn. Plaster, acrylic paint. 12" x 18" (30.5 x 45.7 cm).

The production of art began with the earliest of cultures, many thousands of years ago, and continues right up to today. This is such a big subject that only a few periods can be reviewed in the following pages. This chapter will introduce you to art from the prehistoric era to the High Renaissance. **Chapter 16, Western Art History II**, will cover art from the 1600s to the present.

Even during the Ice Age, people created art. Cave paintings, discovered in the late 1800s, show us that prehistoric people painted detailed pictures of animals **(fig. 15-4)**. They also carved stone sculptures.

We know much more about Egyptian art. A form of picture writing, called **hieroglyphics**, reveals how Egyptians lived. They were skilled in engineering and construction, building huge, sophisticated monuments. The Egyptians believed in life after death: they filled the tombs of high-ranking people with beautiful art objects for the afterlife **(fig. 15-5)**. Their art followed strict rules of style and changed little over the centuries.

The great era of Greek art is known as the Classical Period. During this period, Greek art reflected two tendencies. It reflected **humanism**, a focus on the actual nature of human experience. For this reason, classical sculptures are much more lifelike than those of earlier cultures. Greek art also reflected **idealism**, or a belief in perfection. Greek sculptors developed a system for showing ideal human proportions **(fig. 15-6)**. Classical sculptures are much more lifelike than those of earlier cultures. **Idealism** is a

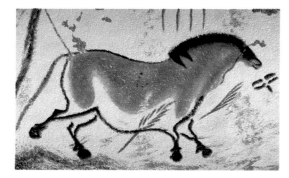

15-4 **Animals in Ice Age art are shown from the side only.** Chinese horse cave painting at Lascaux, c. 13,000 BCE. ©Francis G. Mayer/Corbis. Photo by Franics G. Mayer.

15-5 **The decorative objects treasured by ancient Egyptians held both aesthetic and symbolic value.** Pendant from the tomb of King Tutankhamen in the form of a "Wedjat eye," symbol of protection and good health, flanked by the vulture goddess, Nekhbet and the snake goddess Wadjet, protectors of Upper & Lower Egypt. 18th dynasty. Egyptian Museum, Cairo. © Werner Forman/Art Resource, NY.

15-6 **In what ways does this sculpture show both humanism and idealism?** Myron of Athens, *Athena*, 1st copy of an original by Myron, 5th century BCE. Marble from the gardens of Lucullus, Rome. Liebieghaus, Frankfurt am Main, Germany. Photo by Erich Lessing/Art Resource, NY.

**15-7 This fine silver piece and its decorative forms reflect the essence of the Roman aesthetic.** Silver cup, decorated with female bust. From the Treasure of Boscoreale. Roman, 1st century BCE–1st century CE. Diam. 8⅞" (22.5 cm). Photo: Hervé Lewandowski. Réunion des Musées Nationaux/Art Resource, NY. Louvre, Paris, France.

**15-8 Rome's desire for luxury brought imported goods from all over the world.** Jewelry and glassware from Pompeii.
© Mimmo Jodice/Corbis. Photo by Mimmo Jodice.

**15-9 How does one-point perspective operate in this fresco?** Leonardo da Vinci, *The Last Supper* (post-restoration), 1498.
Frescoe, Santa Maria delle Grazie, Milan, Italy. Photo by Alinari/Art Resource, NY.

belief in perfection. Greek sculptors developed a system for showing ideal human proportions.

The Romans admired and copied Greek art, but are mainly known for their innovations in architecture (see Chapter 11, Architecture). They valued luxury, and as their empire expanded, they surrounded themselves with decorative arts from around the world: silks, jewelry, glassware, and metalwork (figs. 15-7, 15-8).

The medieval era (also called the *Middle Ages*) was the long period between the fall of Rome and the Renaissance. Migratory peoples moved into the former Roman Empire and brought decorative arts traditions with them—jewelry, weaponry, horse ornaments. Charlemagne, a great patron of the arts, united most of western Europe into the Holy Roman Empire. The 1100s were the time of *pilgrimages*: people traveled long distances to see large churches and the *relics*—objects belonging to a saint—they contained.

Medieval Christians focused on God and the divine world, and it is reflected in their art.

The *Gothic* period is associated with the age of great cathedrals. Powerful church leaders commissioned buildings and stained glass windows. *Manuscript illumination*—the hand copying and decorating of books—was a major art form.

The *Renaissance* ("rebirth") revived the spirit of humanism. There was an explosion of artistic output, especially in Florence, Italy. One-point perspective was developed. The *High Renaissance* culminated the achievements of the Renaissance. Leonardo da Vinci (fig. 15-9) and Michelangelo Buonarroti are two of the best-known artists of the time. The influence of the Renaissance was felt throughout Europe long after the movement itself had ended.

The first discovery of prehistoric art occurred in 1897 in northern Spain. An amateur archaeologist, Marcelino de Sautuola, took his five-year-old daughter with him to explore a cave near their home. They discovered paintings that Sautuola believed were very ancient, although others were skeptical at first.

Later, other cave paintings were discovered in northern Spain and southern France, some partially concealed by calcium deposits thousands of years old. Eventually people realized that these were the world's oldest known paintings, probably painted at the end of the last glacial age.

### Ice Age Art

Europe during the Ice Age was inhabited by people who hunted animals for food, clothing, and shelter. They also produced art. While Ice Age people sculpted clay, wood, bone, and stone, they are best known for their cave paintings (fig. 15-11).

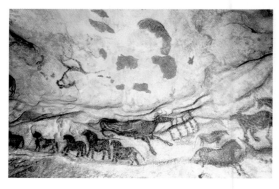

15-11 Cave painting, Lascaux. Photo by Sylvain Julienne/ COSMOS. Courtesy Woodfin Camp and Associates, Incorporated.

Ice Age artists made pigments from natural materials: gypsum for white, iron oxide for reds and yellows, and charcoal for black. They may have mixed these with animal fat or blood and brushed it on the walls with animal bristles or sticks frayed at one end. Some of the artists may have used blowpipes to spray the paint. Blowpipes would have allowed for hints of chiaroscuro to suggest an animal's roundness (fig. 15-10).

15-10 **Imagine painting in a dim cave with a stick dipped in pigment and animal fat, as prehistoric people did. What kind of detail could you achieve?** Lascaux Caves. Photo by H. Lewandowski. Musée des Antiquites Nationales, St. Germain-en-Laye, France. Art Resource, NY.

Animals in Ice Age art are vivid in shape and color, but they are shown from the side only, with little, if any, evidence of foreshortening (fig. 15-13). Many seem to have been placed on the wall without regard to their surroundings. Their seemingly haphazard placement suggests the artists had little interest in compositional arrangement.

Scientists speculate that these animal paintings served magical purposes. Ice Age people may have thought that painting an animal gave them power over that animal. The caves may have been temple-sanctuaries, where hunter-artists gathered to paint and magically ensure success in their hunt.

Magic may also have played a role in sculpture produced during the prehistoric period. Sculpted figures, such as the so-called *Venus of Willendorf* (fig. 15-12), may have been produced to magically ensure successful childbirth. Such a concern was vital during the Ice Age, when the life span of an average adult was only about thirty years.

Eventually, warmer temperatures in Europe led to changes in the animal population and in hunting methods. The Ice Age paintings stopped being produced, and remained hidden for tens of thousands of years.

15-12 **How would you describe this small, ancient sculpture to someone who couldn't see it? Why might Ice Age people have thought it powerful?** *Venus of Willendorf* (side view). Limestone figure, Aurignacian (late Paleolithic) c. 25,000 BCE. Naturhistorisches Museum, Vienna, Austria. Erich Lessing/Art Resource, NY.

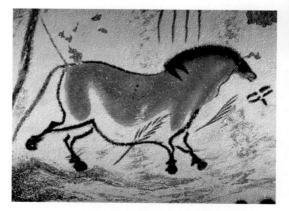

15-13 **How would you describe the artist's use of line and color in this cave painting?** Chinese horse cave painting at Lascaux, c. 13,000 BCE.
©Francis G. Mayer/Corbis. Photo by Franics G. Mayer.

Much more is known about the art and beliefs of the ancient Egyptians. Many of their monuments are still standing. Their written language, a form of symbolic picture writing called ***hieroglyphics***, tells much about this history.

Egypt developed along the banks of the Nile River. The success of Egyptian farms along the Nile eventually led to the development of towns and cities. Egypt's civilization was sophisticated, with expertise in mathematics, engineering, and construction. These skills are evident in the scale of its surviving monuments (**fig. 15-17**).

The Egyptian religion was polytheistic—Egyptians worshipped more than one god. They also believed in immortality, or life after death, especially for pharaohs, priests, and nobility. High-

ranking people were carefully preserved after death to ensure that they lived forever. Each body was embalmed and mummified, and the tomb was filled with the deceased's earthly belongings. Also included were paintings of the deceased's family, servants, and even animals.

The most impressive Egyptian art comes from the tombs of pharaohs, such as the cache of treasures from the tomb of Tutankhamen (**fig. 15-1, page 410**). People below the pharaoh in rank were usually buried in more modest tombs, often simply a series of chambers carved into cliffs. The tomb of Nebamun from Thebes was richly decorated with wall paintings. Nebamun was a scribe and counter of grain in Thebes. One painting (**fig. 15-14**) shows him enjoying

15-14 **In ancient Egyptian paintings, men's skin was traditionally painted red, while women's was a yellowish brown. What does the size difference between the male and female figures in this work suggest about Egyptian society?** *Fowling in the Marshes:* fragment of wall painting from the tomb of Nebamun (no. 10) Thebes, Egypt, 18th Dynasty, around 1350 BCE. Height: 32 3/4" (83 cm), Width: 38 1/2" (98 cm), Thickness: 8 5/8" (22 cm). Photo by HIP/Scala/Art Resource, NY.

15-15 **Why might an Egyptian king have wanted this pendant to be included in his tomb?** Pendant from the tomb of King Tutankhamen in the form of a "Wedjat eye," symbol of protection and good health, flanked by the vulture goddess, Nekhbet and the snake goddess Wadjet, protectors of Upper & Lower Egypt. 18th dynasty. Egyptian Museum, Cairo. © Werner Forman/Art Resource, NY.

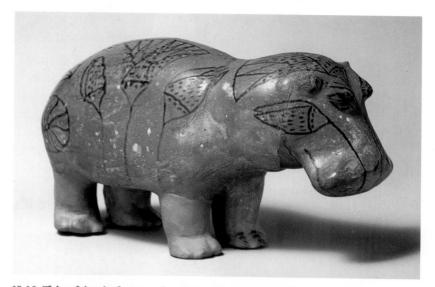

15-16 **This whimsical statue has lotus flowers painted on its body. In what other way has the artist suggested the hippo's watery world?** Egyptian, Middle Egypt, Meir, *Statuette of a Hippopotamus*, c. 1991–1783 BCE, Dynasty 12, Middle Kingdom. Faience, H: 4 3/8" (11.2 cm). L: 7 7/8" (20 cm). The Metropolitan Museum of Art, Gift of Edward S. Harkness, 1917 (17.9.1). Photograph © 1997 The Metropolitan Museum of Art.

the pleasures of eternity, which closely resemble those he enjoyed while alive. Above Nebamun the sky is filled with birds, while below, the water of the Nile is teeming with fish.

Egyptian art follows some strict rules of style. Notice that although many things are represented in the Nebamun painting, it lacks three-dimensional depth. Overlapping is minimal. The figures of the people are larger or smaller, not to show their placement in space but to indicate their importance or rank in society. The animals show no evidence of shading.

The style of Egyptian art is related to its magical role of ensuring continued existence in the afterlife. Nebamun's figure follows a strict formula with head, legs, and feet shown in profile, while one eye and the shoulders are shown frontally. This style was meant to convey the main features of the body as clearly as possible. To depart from this formula would have done magical harm to the

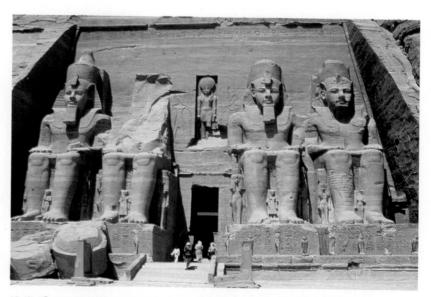

15-17 **These standing figures are roughly three times the height of an average single-family home.** Ancient Egypt, Abu Simbel, Temple of Ramses II, c. 1257 BCE. Carved, solid rock, each figure 60' (18 m). Courtesy Davis Art Images.

soul of the deceased person. This style, established very early in Egyptian art, persisted until the time of Roman occupation (c. 30 BCE).

Egyptian society, like Egyptian art, was very conservative. All of its cultural forms changed little over thousands of years.

By contrast with Egyptian art, Greek art changed stylistically over time. Look at the two statues of female figures shown here. They were sculpted a little less than one hundred years apart. The young woman (**fig. 15-18**) sculpted in 530 BCE is simple and unmoving. Contrast this with the naturalism and movement of the sculpture of Athena (**fig. 15-19**).

The great era of Greek culture, known as the Classical Period, lasted from about 480 to 323 BCE. The fifth century (400 BCE) was the time of many famous people: the philosophers Plato and Socrates; the writers of tragedies Sophocles and Euripides; and Pericles, the leader of Athens who established that city as the center of art and culture of the Greek world.

*Humanism* is a view of life based on the nature and interests of people. *Idealism* is a belief in the concept of perfection. Humanism and idealism predominated in Greek art and philosophy. The Greeks investigated the workings of the physical world, questioning old superstitions. The philosopher Protagoras declared, "Man is the measure of all things." In order to reach a sublime state and understand the divine, Plato advised, "Know yourself."

Myron's *Athena* (**fig. 15-19**) conveys both humanism and idealism. Athena is idealized: she is obviously young, athletic, and beautifully proportioned. Greek sculptors developed a whole system of ideal proportions for the human figure. Greek philosophers reasoned that there was a perfect, or ideal, form for everything.

This statue is Myron's attempt to depict an ideal woman. Within the idealism, however, Myron has accurately depicted how a human figure looks when putting most weight on one leg, and bending the other. One of the *Athena*'s legs is as straight as a column, while the left is bent in action. Such depiction of *weight shift* was a real breakthrough in the art of representing the human figure.

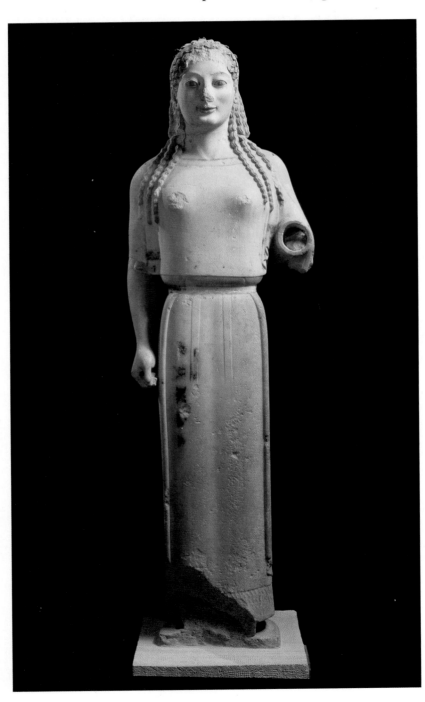

15-18 **What makes this sculpture of a young maiden seem unnatural?** Kore with Dorian peplos, Acropolis, Athens, c. 530 BCE. Marble, approx. H: 48" (122 cm) high. Acropolis Museum, Athens. Nimatallah/Art Resource, NY.

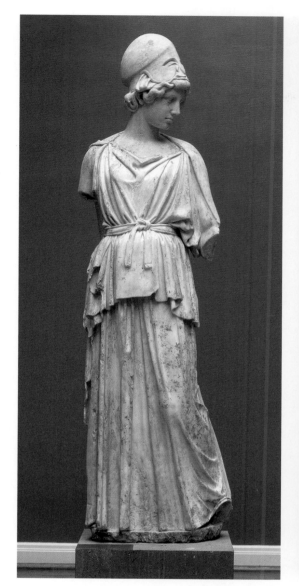

15-19 **Greek artworks express both humanism and idealism: they show how real people stand and look, but they also express belief in an ideal human form.** Myron of Athens, 5th century BCE. *Athena,* Roman copy of Greek original. Marble from the gardens of Lucullus, Rome. Liebieghaus, Frankfurt am Main, Germany. Photo by Erich Lessing/Art Resource, NY.

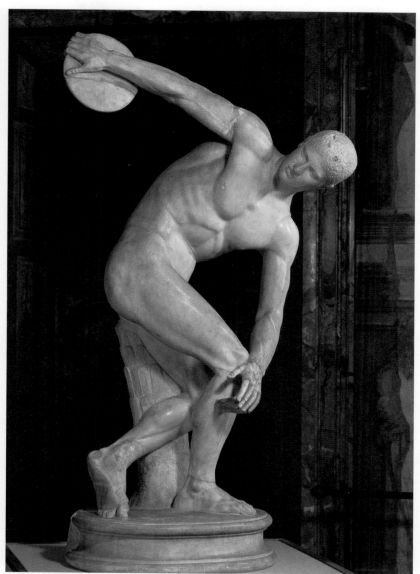

15-20 **Athletics were an important part of Greek culture. The extreme movement shown in this sculpture is particularly daring for its time.** Myron of Athens, 5th century BCE. *The Discobolos* (Discus Thrower). Roman copy of Greek original (c. 450 BCE). Museo Nazionale Romano delle Terme, Rome, Italy. Scala/Art Resource, NY.

Myron's sculpture of a discus thrower (fig. 15-20) is his attempt to depict an ideal male. The ancient Greeks highly prized physical fitness because they believed that a well-developed body was beautiful and a reflection of divine beauty. Idealism is seen in the balanced posture, symmetrical proportions, and passive facial features.

Much of the ancient world was in awe of Greek achievements, not only in art and architecture, but also in philosophy, literature, science, and mathematics. Later generations of Europeans shared that awe. As we'll see in this chapter, much of European art bears the influence of Greek styles.

The Romans were the principal heirs of Greek culture. They greatly admired Greek culture, and copied Greek sculptures by the thousands. We know Myron's *Athena* and many other Greek works only through Roman copies.

Original Roman sculptures resemble Greek works. Notice that the figure of the emperor Augustus **(fig. 15-21)** is both realistic and idealized. By contrast, the bust of the legislator **(fig. 15-22)** contains an almost unflattering amount of realism. As in ancient Egyptian depictions of people, in Roman art those of higher status are accorded more idealism than are those of lower rank.

Although no examples of ancient Greek painting have survived, it is known that Roman painting was largely based on Greek painting. The pleasant rural scene **(fig. 15-23)** creates pictorial depth with several methods you have learned of in other chapters—foreshortening, chiaroscuro, placement, variations in scale, and aerial perspective. Neither the Greeks nor the Romans, however, had developed the system of one- or two-point perspective.

Like other cultures of the ancient world, wealthy Romans enjoyed surrounding themselves with beautiful decorations. Mosaics were used as wall and floor decoration in ancient Roman buildings. They were particularly popular in dining rooms, an important gathering place in Roman culture. The theater mask mosaic from Boscoreale **(fig. 15-25)** was probably a wall mosaic.

As the Roman Empire expanded, wealthy Romans demanded more and more luxury goods. Artisans from various parts of the empire produced costly silks ornamented with gold jewelry, gold and silver dishes for Roman nobles' tables, and multicolored glass vessels **(figs. 15-24 and 15-26)**.

Because of the extent of the empire, these ***decorative arts*** introduced Romans to tastes from distant regions of the world. If not for the Roman passion for showy display, many original works of art from other cultures, especially Greece, would have been lost.

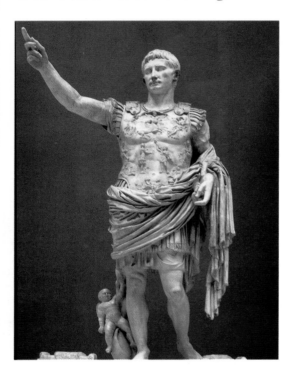

15-21 **This is an idealized portrait of the emperor Augustus as a general. What tells you that the artist has used "weight shift" in this sculpture?**
Emperor Augustus in military dress. Marble figure from the Prima Porta, H: 6' 8" (204 cm). Vatican Museums, Vatican State. Photo by Erich Lessing/Art Resource, NY.

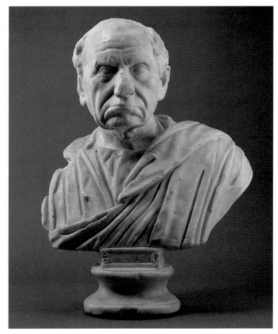

15-22 Roman, *Roman Gentleman*, c. 120. Marble, 17" x 23 5/8" x 10 3/4" (43.2 x 60 x 27.3 cm). The Nelson-Atkins Museum of Art, Kansas City, Missouri; Purchase Nelson Trust. Photograph by Robert Newcombe.

15-23 **Look carefully at the buildings in this painting. How would they look different if the artist had used one-point perspective?** Landscape from Villa of Agrippa Postumo at Boscotrecase. Naples, National Archeological Museum. Courtesy of Canali Photobank, Milan, Italy.

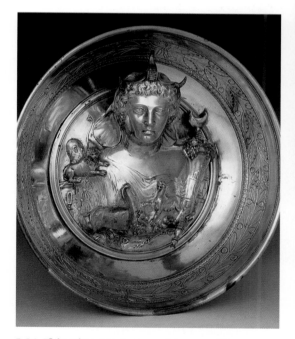

15-26 **The Romans valued decorative objects more for their beauty than for their symbolic attributes.** Jewelry and glassware from Pompeii. © Mimmo Jodice/Corbis. Photo by Mimmo Jodice.

5-24 **This wine cup was used in a wealthy Roman household. What details can you see inside it?** Silver cup, decorated with female bust. From the Treasure of Boscoreale. Roman, 1st century BCE—1st century CE. Diam. 8 7/8" (22.5 cm). Photo: Hervé Lewandowski. Réunion des Musées Nationaux/Art Resource, NY. Louvre, Paris, France.

**Linking Disciplines**
History

When you look at the artworks in this chapter, how can you see that the world has changed? What can art tell you about history? How can a knowledge of history help you to better understand what artworks might have meant to the people living at the time they were made, and why artworks look the way they do?

From about 400 CE, western Europe entered the medieval era, or Middle Ages. This term refers to the long period between the fall of Rome and the Renaissance in the 1400s. In the early part of the Middle Ages, between about 500 and 800, the centralized culture and authority of the Roman Empire gradually disappeared. Early medieval civilization became a fusion of Christianity, the Greco-Roman heritage, and the vibrant yet different cultures of the Celtic-Germanic "barbarians," as the Romans called the peoples who lived beyond the borders of the empire.

Numerous migratory peoples—Franks, Vandals, Goths, and others—moved into areas of the Roman Empire in late antiquity. These people merged with the citizens of Roman provinces in Europe, developing social and political institutions that would eventually lead to the formation of modern European countries.

Few large-scale architectural programs, paintings, or sculptures were undertaken during this period, but decorative arts thrived, infused with stylistic elements from the "barbarian" cultures. These cultures did not have a tradition of figurative painting or sculpture, but they produced sophisticated jewelry (fig. 15-27), decorations for weaponry (fig. 15-28), and articles of harness for horses. Such pieces show us the importance of art in these cultures.

In the 800s, the Frankish king Charlemagne united most of western Europe into a "Holy Roman Empire." Charlemagne was a great patron of the arts as well as a statesman and military leader. In an effort to revive ancient Roman culture, he imported scholars, architects, and artists primarily from Constantinople (modern-day Istanbul, Turkey), which was the capital of the Byzantine Empire.

The Byzantine Empire (modern Turkey, Armenia, Greece, Serbia, Macedonia, and parts of Eastern Europe) contained the eastern part of the Roman Empire, and had preserved Greco-Roman culture. Charlemagne's contact with the Byzantines helped revive large-scale masonry architecture, manuscript illumination, and sculpture.

Charlemagne's death ended the dream of a reunified empire in western Europe. But the remains of this empire, a cluster of German kingdoms in the east and Frankish kingdoms in the west—together the states controlled by the church in Italy and the Anglo-Saxon kingdoms across the Channel—formed the power blocs of medieval Europe. France was in the forefront of this transformation to high medieval culture.

15-27 **The intricate technique of cloisonné enamel (enamel laid down between gold wire) was the major art form of early medieval England. Notice the patterns and interlace designs.** Hinged clasp, 7th century. British Museum, London. Photo: Art Resource, NY.

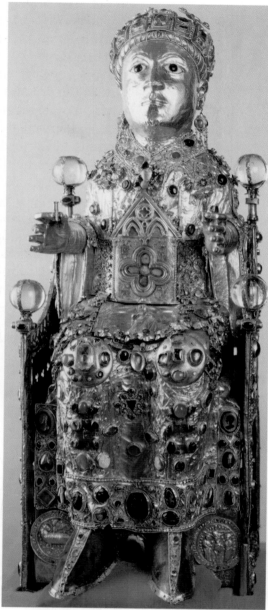

## Medieval Pilgrimages

By the 1000s and 1100s, large churches were beginning to be built all over Europe, particularly in France (discussed in Chapter 11, Architecture). This was the time of *pilgrimages*. Europeans would travel long distances, often on foot, to see one of these churches, especially if it contained a relic. A *relic* is an object believed to have belonged to a saint: it might be a remnant of clothing, even a bone. People believed that a relic had the power to cure disease, forgive sins, and perform miracles. The reliquary *Statue of the Majesty of Sainte-Foy* (fig. 15-29) contains such a relic. It commemorates the martyrdom of a third-century girl.

Compare the style of the reliquary to *Athena* and *The Discobolus* (figs. 15-19 and 15-20). Unlike the bodies of Greek sculptures, the *Sainte-Foy* is stylized, stiff, and obviously not based on a real human figure. Some of these characteristics are due to the dictates of the medium, but most are due to a dramatic difference in point of view. Greeks and Romans focused on humans and the natural world. The medieval Christians focused on God and the divine world.

15-29 **The art of the Middle Ages was largely religious.** *Statue of the Majesty of Sainte-Foy*, 985. © Archivo Iconografico, S.A./ Corbis.

The pilgrimage style of church eventually evolved into the *Gothic* style. (Recall the discussion of Gothic architecture in Chapter 11). This discussion will focus on other art forms of the Gothic period.

The Church was the most important patron of the arts in the medieval world. One of the greatest patrons of the arts was Abbot Suger (1085–1151) of Saint-Denis, the royal abbey outside Paris. He commissioned (ordered and paid for) extensive building programs in the Gothic style, executed a series of ambitious stained glass programs for his own church, and supported the decorative arts. The chalice (fig. 15-30) Suger commissioned is an example of the wealth of the Church, and how that wealth was a driving force behind the evolution of style in art.

The exact origins of stained glass are unknown, although it came possibly from the Islamic practice of inserting colored glass panels between the alabaster or plaster grilles of windows.

Examples of stained glass seen in such churches as the cathedral in Reims (fig. 15-31), France, are actually combinations of stained glass and painted glass. Details are painted on the larger sections with a material that was fused to the glass in a kiln. The rose (or "wheel") windows at Reims are at the west (entrance) end of the church. Such windows became common in Gothic cathedrals.

Some scholars believe that stained glass window design was influenced by *manuscript illumination*, an art form that flourished at the same time. This form of book illustration was common

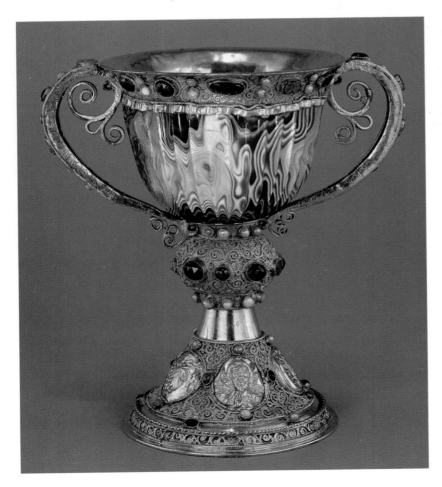

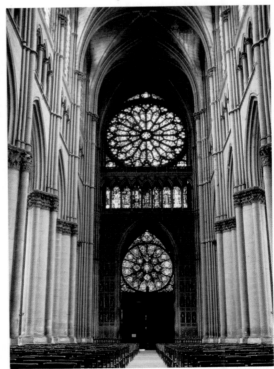

15-31 **During the Gothic period, taller buildings with thinner walls and bigger windows allowed stained glass artists to create stunning color combinations.** Jean d'Orbais, Jean de Loup, & G. de Reims Cathedral, 1211–60. Interior nave to west. Courtesy Davis Art Images.

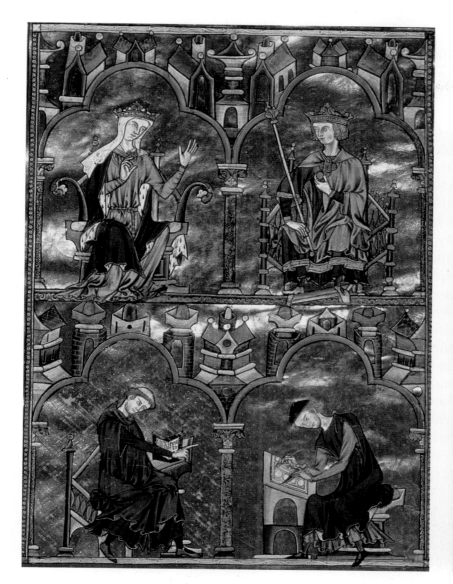

during the Middle Ages because hand copying and decorating of books was the only way to disseminate learning.

Although the Chinese made paper as early as 105 CE, and paper was introduced into Spain in the 11th century and Italy in the 13th century, it was not used widely in Europe until the 15th century. Manuscripts such as the Moralized Bible of Louis IX (fig. 15-32) were created using tempera paint on parchment (animal skin that had been stretched and bleached).

Sculpture during the Gothic period, like the rest of the Middle Ages, remained primarily associated with church decoration. The figures on the jambs of the main entrance of Chartres Cathedral represent the kings and queens of the Old Testament (fig. 15-33). In some respects, these figures are quite three-dimensional and natural looking compared to the figure of Sainte-Foy (fig. 15-29). They are unnaturally thin, however, and seem bound to their narrow column. Their gestures are almost as stiff as those of the Sainte-Foy reliquary statue. However, the differences between the two periods shows that, over the years, medieval art and artists were changing.

## Linking Disciplines
### Music

Renaissance composers often used popular tunes of the day in music for the Church. Listen to *The Armed Man Mass (Missa L'homme armé)* by **Josquin Des Prez** (1455–1521). Like the artists of their time, these composers tried to combine the spiritual and the secular. Design a picture based on a moral or spiritual idea, and use pop culture, symbols, and personalities to convey your message.

15-34 **Ghiberti has used one-point perspective to construct this scene. Look closely to find the vanishing point.** Lorenzo Ghiberti, Story of Joseph (relief from *The Gates of Paradise,* post-restoration), 1425–52. Gilt bronze. Museo dell'Opera del Duomo, Florence, Italy. Scala/Art Resource, NY.

*Renaissance* literally means rebirth. It refers to a period, starting as early as the mid-1300s, when the spirit of humanism was being revived, particularly in Florence, Italy.

Like the Greeks, the Florentine thinkers focused on people and earthly life. Their investigations led to major advances in science. Leonardo da Vinci (see **Artist Biography**, page 429) studied the fields of optics, mechanics, and human anatomy. Explorers from Spain, Italy, England, France, and Portugal began exploring the world. Nicolaus Copernicus, in the fifteenth century, put forth the revolutionary theory that the earth revolved around the sun.

Renaissance scholars also revived interest in classical art and literature. They studied the writings of ancient philosophers like Plato. The art and architecture of ancient Greece and Rome, which had been neglected during the Middle Ages, became admired and emulated by artists and architects.

One example of the new spirit in sculpture is the statue of Saint Mark by Donatello (**fig. 15-36**). Compared to the Royal Portal figures from Chartres (**fig. 15-33, page 425**), the Saint Mark indicates that Donatello had much more awareness than the earlier sculptor, or sculptors, of how to depict a lifelike body underneath clothing. Compare it to the *Athena* by Myron (**fig. 15-19**) and the *Augustus* of Prima Porta (**fig. 15-21**). Donatello has obviously mastered the idea of the weight-shift pose. One differ-

ence between the antique sculptures and Donatello's is the facial features. The antique sculptures have a classical calm, while Donatello's expresses passion and seriousness.

The explosion of artistic output during the Renaissance was especially evident in the city of Florence. Florentine architect and sculptor Lorenzo Ghiberti won a competition to design bronze doors for the baptistry of Florence Cathedral. The resulting gilt bronze doors were called "The Gates of Paradise" by an impressed Michelangelo. A close-up of the Story of Joseph (**fig. 15-34**) reveals both sculptural and painting methods. From foreground to background, the figures go from high relief to very low relief to indicate depth. Another indication of depth, obviously learned from painters of the day, if not entirely suc-

cessful in this instance, is the use of one-point perspective. *The Gates of Paradise* is still one of the main tourist attractions in Florence.

*The Tribute Money* (fig. 15-35), a fresco by Masaccio, tells a story from the Book of Matthew. The men's bodies are shaded on the left with bold strokes of chiaroscuro, and illuminated from the right. They appear quite three-dimensional and seem as weighty and solid as sculptures. This is especially true of the Roman tax collector, in the short tunic, who is shown twice: first, at the center, requesting the temple tax of Peter; and, second, at right, receiving the coin that Peter has miraculously, and at Jesus' instruction, taken from the fish's mouth in the scene shown at the far left of the painting. The space the figures are in has depth. This fresco, one of a series on the life of Saint Peter, later served as inspiration for Leonardo and Michelangelo.

15-36 **Donatello's sculpture reflects the new humanism of the Renaissance. How has the artist shown the size and shape of arms and legs under the drapery?**
Donatello, *St. Mark the Evangelist*, 1411–13. Marble, approx. 7' 9" (236 cm) high. Orsanmichele, Florence, Italy. Scala/Art Resource, NY.

15-35 **The building on the right may be one of the first in art history to be painted in one-point perspective. What other methods has the artist used to create depth?**
Masaccio, *The Tribute Money*, c. 1427. Fresco, Brancacci Chapel, Santa Maria del Carmine, Florence, Italy. Scala/Art Resource, NY.

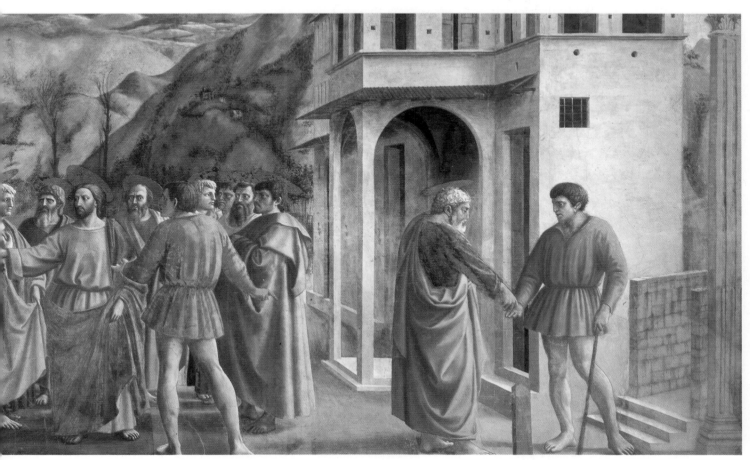

**Write About It!**

Use library resources, the Web, and work with your history teacher to prepare a report on how the work of Leonardo da Vinci was influenced by the scientific, political, and religious values of his society and time. Consider Leonardo's powerful intellectual curiosity, and the legacy of his accomplishments in art and science.

At the end of the 1400s, art in western Europe entered a phase called the ***High Renaissance***, which lasted about twenty years. This phase brought to perfection the experiments of artists such as Donatello and Masaccio.

No other artist is a better example of the spirit of the High Renaissance than Leonardo da Vinci. Although renowned for his paintings and drawings, he was also a sculptor, architect, engineer, scientist, and inventor. Before Leonardo, no artist had succeeded in showing people moving around in a picture without the composition becoming "destabilized." In Masaccio's *The Tribute Money* (fig. 15-35, pages 426–27), for example, the composition is stable, but the men are relatively still. In Ghiberti's bronze panel (fig. 15-34, page 426), the people seem to move about freely, but the composition is relatively unstable. *The Last Supper* is the first major painting to reconcile movement and stability.

One of the reasons for this success is that the composition is deceptively simple. The picture is horizontal. The long table is symmetrical and parallel with the plane of the picture. Not only is Jesus located at the middle of the table; his head is at the center of the picture, directly in front of the vanishing point that defines the space of the room. These aspects provide stability.

Movement is seen in the twelve disciples as they react to Jesus' statement, "One of you will betray me." Despite their agitation, all have idealized bodies and graceful gestures. The one on the left who is leaning back with his face in shadow is Judas. All fit comfortably into the rectangular space. *The Last Supper* was the first painting to successfully integrate active figures in a realistic spatial world. It has been popular from the time it was completed in 1498.

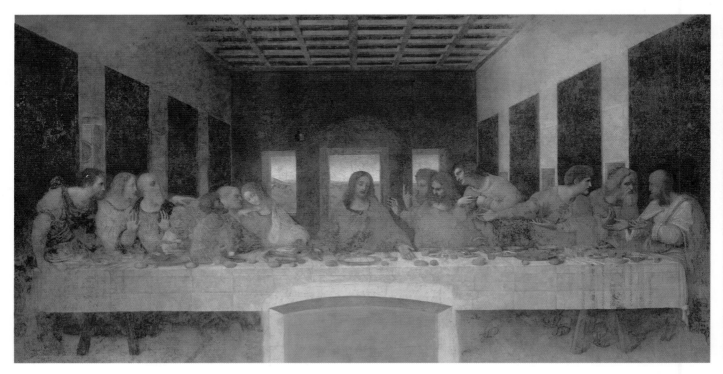

15-37 **Leonardo's fresco shows many of the achievements of the High Renaissance: one-point perspective, movement, stability, realism, and emotion.** Leonardo da Vinci, *The Last Supper* (post-restoration), 1498. Frescoe, Santa Maria delle Grazie, Milan, Italy. Photo by Alinari/Art Resource, NY.

## Artist Biography
# Leonardo da Vinci
### (1452–1519)

Throughout his life, Leonardo da Vinci worked for many different people on hundreds of different projects. Because he was incredibly inquisitive, and proficient in so many media, he often found it difficult to focus on one thing at a time. He produced thousands of notebooks full of studies on many different subjects. It's likely he thought of himself more as a scientist than as an artist.

Leonardo da Vinci was born outside Florence, Italy. When he was fifteen, his father apprenticed him to painter and family friend Andrea del Verrochio. Leonardo immediately showed himself to be so unusually gifted, his early works so impressive, that it is said del Verrochio vowed never to paint again.

Many of Leonardo da Vinci's artworks were left unfinished, and the number of paintings he produced is not very large. Yet the quality and originality of his finest drawings and paintings is beyond doubt, his influence on his contemporaries and successive generations profound.

**15-38 As a draftsman, Leonardo had few equals. How do the drawings and writings on this page from his notebooks reflect a restless scientific intelligence?** Leonardo da Vinci, *Embryo in the Womb,* c. 1510. Pen and ink. The Royal Collection © 2003, Her Majesty Queen Elizabeth II.

The works of Leonardo's younger contemporary, Michelangelo Buonarroti, have also continued to be popular down through time. Both men began their careers in Florence. Both moved on to other cities: Leonardo to Milan and Michelangelo to Rome. By the time Michelangelo died, Rome rivaled Florence as a patron of the arts.

In Rome, Michelangelo first began to produce art for the Vatican, the headquarters of the Roman Church. His sculpture of Moses (fig. 15-39) is a fine example of High Renaissance sculpture.

*Moses* contains many of the hallmarks of Renaissance art: the solid, balanced triangular composition, attention to accurate anatomy, and extreme realism. What is striking in Moses compared to earlier Renaissance works, is the psychological force Michelangelo invested in his work. Notice Moses' twisting, taut pose, his beard tangled in his hand, and the intense expression on his face. Michelangelo went beyond the High Renaissance ideal by attempting to create figures of grand power both visually and spiritually.

Another of Michelangelo's powerful creations can be seen on the ceiling of the Vatican's Sistine Chapel (fig. 15-41). After protesting to Pope Julius II that he was a sculptor, not a painter, Michelangelo started the vast fresco project in 1508. It took four years to complete, but in the end, the surface of a vaulted ceiling was transformed into a complex pictorial drama. The ceiling tells the biblical story of the Creation and the Fall. Surrounding these scenes from Genesis are individual figures representing ancestors of Jesus, Old Testament prophets, and Greek oracles from mythology.

The Renaissance was a time of great achievement not just in Florence. In fact, the painters of the Low Countries (Belgium and Holland) were the first to master the new medium of oil paint, and employed rich color and realistic detail to produce stunning religious works, landscapes, and portraits. In the later Renaissance, the creative focus shifted from Florence to Venice, the home base of painters and architects including Titian, Veronese, and Palladio. Although the "movement" ended around 1600, its ideals spread throughout Europe, and remained influential for some time thereafter.

Albrecht Dürer, a German, was one of the most important artists of the Renaissance outside of Italy. Renowned as a painter and printmaker, Dürer also spent much time studying botany, animals, and insects. Because his prints

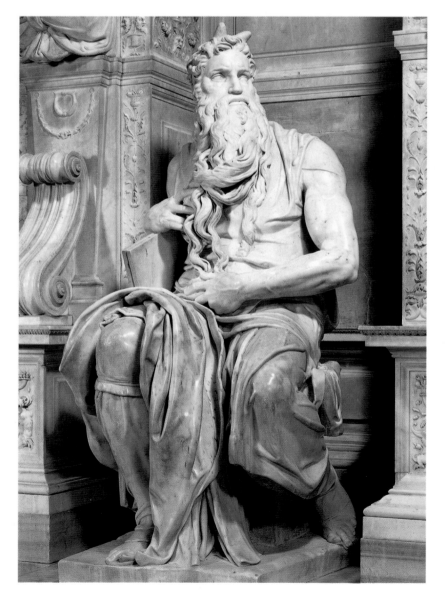

15-39 **Michelangelo paid great attention to muscle structure in this figure. What other elements of the figure must he have studied intently before carving this work?** Michelangelo Buonarroti, *Tomb of Pope Julius II, Moses* (3/4 view), 1513–15. Marble, approx. 8' 4" (254 cm) high. San Pietro in Vincoli, Rome. Photo by Scala/Art Resource, NY.

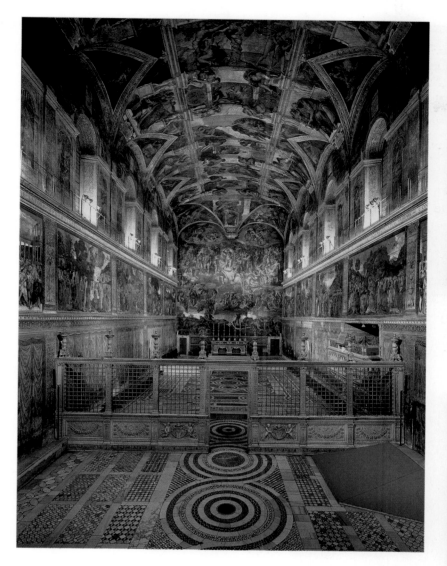

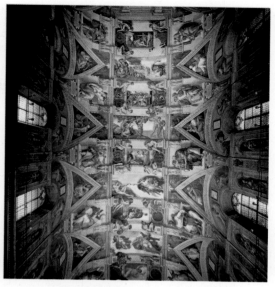

15-41 **The removal of layers of soot and grime has brought back to life colors hidden for centuries.** Michelangelo Buonarroti, *View of the Sistine Ceiling* (restored). Courtesy of Canali Photobank, Milan, Italy. On license from the Vatican Museums, Vatican State.

(fig. 15-42) were widely distributed, Dürer became well known throughout Europe. He traveled to Italy and absorbed the artistic and intellectual excitement of the time, introducing Italian ideas into German art. At the same time, his printmaking represented a perfection of the medium that established German printmaking, especially the art of woodcut, as the most significant contribution of German art to the Renaissance.

*The Riders on the Four Horses from the Apocalypse* illustrates a scene from the end of the world as spelled out in the Book of Revelations. It is an excellent example of the religious fervor in Germany at the time.

15-40 **The Sistine ceiling contains hundreds of figures moving on different planes and in different directions, and executed at various scales. Michelangelo prevented chaos by dividing each scene into its own panel.** Michelangelo Buonarroti, *View of the Sistine Chapel, Vatican Palace, Vatican State.* Photo by Scala/Art Resource, NY.

15-42 **It is said that Dürer's trip to Italy in 1494–95 and the superb creations he saw while there were quite influential on his style. How do the handling of space and the expressive qualities of this woodcut add to the dynamism of its composition?** Albrecht Dürer, *The Riders on the Four Horses from the Apocalypse,* c. 1496. Woodcut, 15¼" x 11" (39 x 28 cm). Private collection.

# A Postmodern Painting

15-43 **The Neoclassical painting style of the 1700s reflected an emphasis on classical themes and subject matter. How does this painting update motifs drawn from Greek, Roman, and Renaissance art to a modern context?** Carlo Maria Mariani, *The City 1, July 2001.* Oil on canvas, 70" x 70" (177.8 x 177.8 cm). © Carlo Maria Mariani. Courtesy of the artist. © Carlo Maria Mariani/Licensed by VAGA, New York, NY.

### About the Artist
## Carlo Maria Mariani
### (b. 1931)

**Carlo Maria Mariani** says that soon before painting *The City 1, July 2001* he moved into a new studio "with windows high up." For the first time, he could study the skies of New York.

Born in Rome, Italy, Mariani witnessed the US bombing of Rome and its surrounding areas as an adolescent during World War II. Later, he trained in Renaissance painting and drawing techniques at the Fine Arts Academy in Rome.

Exploring a wide range of styles and media, from pure abstraction to performance art, Mariani's work has been said to represent a dialogue between the history of art and the artist's personal system of images and symbols, allegories and dreams.

Mariani has been awarded the Feltrinelli Prize for lifetime achievement in painting, has represented his native Italy three times in the Venice Biennale, and has exhibited worldwide. His work is held in private and public collections in Europe and the US, including the Guggenheim Museum in New York. He lives in New York City.

## ❶ Describe What You See

When you describe an artwork, you identify the things about the work that you can see, name, and describe with certainty.

- Identify the artist, title of the work, medium, size, and date.
- Note that Mariani portrays Neoclassical figures in his paintings, drawings, and sculpture. Look at examples of classical sculpture, such as *Athena* and *Discobolus* (figs. 15-19 and 15-20, page 419), and of Neoclassical painting, such as *The Oath of the Horatii* (fig. 16-14, page 451). Observe the facial features and idealized forms of the figures in these works. What recognizable features do you see in *The City 1*?
- Describe the head. Where do the eyes look?
- What does the background consist of? Where do you see flat shapes?
- What are the largest and smallest images? Refer to the size of the painting—how big is the head?
- Describe color/value contrasts in the sky.
- Is spatial depth flat, shallow, or deep?

## ❷ Analyze the Way It's Organized

When you analyze an artwork, you tell how the subject matter and elements of the work have been organized by the artist.

- What is the dominant form in this work? What, besides size, makes it dominant?
- What elements imply movement in this composition? Consider things that appear to advance, and recede, due to size contrasts, high and low placement, aerial perspective, and warm and cool color.
- What proportion relationship is exaggerated?
- What kind of balance is demonstrated in this work? How is it achieved?

## ❸ Interpret What It's Saying

Use the information from your description and analysis to help you identify the meaning of the work.

- What do you think about the integration of a huge classical head with a dramatic sky and city skyline?
- List some words that help you describe moods or feelings aroused by elements of this work. For example: *mystical, unearthly, surreal, apocalyptic.*
- Develop a simile or metaphor to help identify the meaning of the work.

## ❹ Evaluate Its Success

Using your analysis in the first three steps, how would you judge the quality or success of this work?

- Which philosophy will you base your judgment on? A successful artwork: (1) is true to life, imitates reality, (2) is designed for perfect relationship among elements, (3) expresses significant ideas, emotions, (4) advances human interests, a purpose, or a cause.
- How do you judge the work in terms of this philosophy?
- How do you judge the artist's skill and originality in the use of medium, technique, and subject matter to communicate the meaning you attribute to the work?
- How successful is the arrangement of elements and forms to achieve unity?

### More Art!

See page 440 for more artworks by Carlo Maria Mariani

### Web Link

www.davis-art.com

# Modern-Day Egyptian Wall Painting

Ancient Egyptian artists created wall paintings for the pharaohs to record beliefs, dreams, and ideas on the walls of the rulers' tombs. It was believed that whatever the tomb contained would become a part of the pharaoh's afterlife. Create an Egyptian-style wall slab that symbolically portrays your own ideal existence. But first, make a personal inventory of things in your own life that are empowering.

15-44 Student work-in-progress, Allie Shehorn.

### Write About It!

In five lines, reflect in words on your artwork and your ideal existence. The first line should consist of only one word, the second line two words, the third line three words, the fourth line four words, and the fifth line five words. Select uncommon words and phrases for the imagery you wish to portray to your reader. Try to go beyond what the eye can see and into what the spirit and heart feel. Try not put into words anything that the viewer already knows by looking at your work of art. You may start the process by using common words and thoughts in your first draft, but once the foundation is set, replace some of the more common words with words and phrases that are unique, and thought-provoking. Consider using metaphors that add color and interest to your language. Example: *bicycle* is a common word; *land kayak* and *mechanical cheetah* are metaphors for bicycle.

### Technique Tip

If you use acrylics to paint your design, work from light colors to dark colors.

### Before You Begin

Study ancient Egypt. Focus on the wall paintings, their uses, and the techniques the artists used to create them. Take inventory of the things in your own life that are empowering by taking the following test. On a sheet of copy paper folded in fourths, answer the eight questions listed below using one square per question. Use both sides of the paper. Within each square write the answer at the top and draw a symbol that represents your answer just below it.

- What ecosystem do you feel most connected to?
- If you were a line, where would you go? (Draw one continuous, uncrossing line for two minutes.)
- If you were something that lives or works in water what would you be?
- If you were something that appeared in the sky, what would you be?
- What kind of object are you most connected to?
- If you were a shape what would you look like? (Draw an eye somewhere inside of that shape.)
- What would your ideal place look like?
- Design a set of hieroglyphics that represent your name. Use a style that is reflective of your essence.

### You Will Need
- copy and newsprint paper
- aluminum foil
- plastercraft
- watercolor or acrylic paints and brushes

## Create It

❶ Create a series of thumbnail sketches of a single composition, incorporating answers to the questions that were most important to you. Give your composition a sense of place and time. Also, integrate figures or faces to reflect family or friends.

❷ Tear a sheet of aluminum foil into a rectangle with uneven edges to have the look of a rock slab. Place the foil flat on newspaper and cover it with five or six layers of plastercraft. Create a rock-like texture. Allow to dry.

❸ Paint a coat or two of primer onto the plaster. While the primer is drying, finalize your sketch and draw it to actual size on a sheet of newsprint paper.

❹ When the primer is dry, use watercolors or watered-down acrylics to stain the plaster slab with a light wash of blue or brown. This will help to create a rock-like quality in the surface.

❺ When the wash is dry, transfer your drawing to the slab and colorize it with acrylic or tempera paint.

15-45 Student work, Erica Findley. Plaster, acrylic paint.

## Evaluate It

• What did you learn about yourself while partaking in this process?

• In what ways does your image express your ideal existence?

• How did you use symbols in the creation of your image?

## Art History

## Studio Background

A multitude of detail about ancient Egyptian life is known to us because of wall paintings such as *Fowling in the Marshes*. The murals provide information about social structure, clothing, everyday customs and wildlife. It is possible to note exact species, such as the retriever cats used by sportsmen, as well as other details. By placing the scene in his tomb, Nebamun hoped to permanently enjoy this pleasurable pastime in the afterlife. In addition to documenting ancient Egyptian life, the mural images also carry symbolism. The depiction of the lush Nile marshes, for example, is meant to symbolize eternal life.

15-46 Egyptian wall paintings were created by applying pigment to dried lime plaster. Many of the paintings survived over millennia because of the country's hot, dry climate. If you were to record the daily life of your town or neighborhood on a mural, what scenes would you include? *Fowling in the Marshes:* fragment of wall painting from the tomb of Nebamun (no. 10) Thebes, Egypt, 18th Dynasty, around 1350 BCE. Height: 32 3/4" (83 cm), Width: 38 1/2" (98 cm), Thickness: 8 5/8" (22 cm). Photo by HIP/Scala/Art Resource, NY.

# Sistine Chapel–Inspired Ceiling Mural

What does the word *culture* mean to you? Work with a group of classmates to create a panel for a large ceiling mural based on the theme of culture.

## Before You Begin

Study and discuss Renaissance artworks, including Michelangelo's Sistine Chapel ceiling. Note that Michelangelo's design reflects the culture of the High Renaissance and the artistic tastes of the Vatican, which was the artist's patron. Think about the many cultures that make up today's world, and topics that are related to the theme of culture. Focus on words that relate to the topics. For example: *integration, ideals, courtship, celebration.* Use these words as the inspiration for creating the mural.

## You Will Need

• newsprint paper
• white butcher paper
• stapler or tape
• pencils
• pastels, acrylic, or tempera

## Create It

❶ Form small groups of two or three students, depending on the size of the panels you'll be working with, with each group being assigned one of the theme words. Start by working alone, in pencil, to develop your own design reflecting the topic. Try to incorporate the topic word into your design.

❷ With the other members of your small group, compare designs and, still working in pencil, integrate everyone's design into one larger panel. Be prepared to make compromises.

15-47 **Students affixing completed panels to the ceiling.**

❸ Join with the members of other groups in your class to chart a location for your group's panel. Create connections between the lines, shapes, values, and textures of the adjoining panels in order to unify the works.

❹ Within your small group, research color schemes that Michelangelo used in the Sistine Chapel. Select a color scheme for your own panel and begin the colorization process.

❺ When your group's panel is complete, affix it to the ceiling in the designated location.

15-48 **Team working together on their panel.**

## Evaluate It

- In what ways does your group's mural reflect the theme of culture? How does the imagery you created on your panel reflect your topic?
- Describe the experience and challenges of working with classmates on a group mural. What interesting exchanges and/or dynamics developed in the process?

15-49 Student works, close-up of several panels.

## Studio Background

The Sistine Chapel was built in the late fifteenth century for papal functions and for the enclave of cardinals that met whenever a new pope was to be elected, and it is still used for this purpose today. The walls were frescoed by the great artists of the early Renaissance, but the ceiling was simply painted blue with gold stars to resemble the heavens. Michelangelo's patron, Pope Julius II, decided to commission the artist to paint the ceiling. Julius had wanted pictures of the twelve Apostles painted across it. Michelangelo urged the pope to reconsider, and in the end won him over to the idea of a more complex scheme of Old Testament scenes and figures.

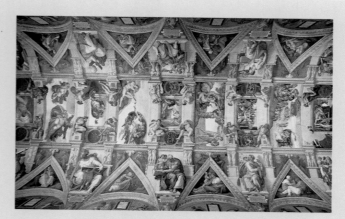

15-50 Michelangelo Buonarroti, *View of the Sistine Ceiling* (restored; detail). Courtesy of Canali Photobank, Milan, Italy. On license from the Vatican Museums, Vatican State.

# Making a Connection with Ancient Greece

Create a three-dimensional wire vessel reminiscent of ancient Greek vases. Attach images that reflect your own high school culture using the copper repoussé technique.

### Before You Begin

Understand that the ancient Greeks used images in their artworks that represented their culture at that time. Look at the detailed way that culture is represented in examples of Greek vessels. What kinds of images are repeated often?

### You Will Need

- 18-gauge steel wire
- 24-gauge copper wire
- pencils
- copper tooling foil

- wooden utensils for repoussé technique
- recycled newspaper for padded working surface
- liver of sulphur to use to antique the surface when finished
- steel wool for burnishing the surface after antiquing
- clear latex enamel spray to protect the surface

### Create It

**1** Create a linear wire armature to support your images. Use the 18-gauge wire for the horizontal circles and the 24-gauge wire for the vertical connections (see fig. 15-51).

**2** After sketching some images that represent your high school culture, select four to develop on the copper foil. These images should be about four inches square to fit the armature. Place a pad of newspaper on your desk, lay the copper down, then draw the outline. Transfer only the outline of the image onto the copper.

**3** Begin the low-level relief repoussé using an assortment of wooden tools. Press into the foil to create the desired amount of detail and imagery.

**4** Polish the surface with steel wool before applying the antiquing solution. Mix one tablespoon of the concentrated liver of sulphur (antiquing solution) with one cup of cold water. Brush or wipe this solution onto the surface of the metal. It will immediately turn black. Let dry.

15-51 Wire armatures.

15-52 Student work (collaboration). Wire, copper foil, and assorted media.

15-53 Student works (collaborations). Wire, copper foil, and assorted media.

**5** Once again, polish the surface with steel wool. Preserve the finished antique surface from oxidizing by spraying with a clear latex enamel. Fold edges or use thin wire to attach the work to the armature.

## Evaluate It

- What subjects did you choose to best represent your high school culture?
- How will the viewer see the range of subjects in the final artwork?
- What will your vessel communicate to people two thousand years from now?

## Studio Background

Over one hundred different types of ceramic vessels were used in ancient Greece. The shapes and functions of the pieces varied. The finest of these vessels were always decorated. Initially, forms were incised into the clay. In about 530 BCE a method called the "red figure" technique was invented, whereby the forms were brushed onto the clay. The brush gave the artist greater flexibility and in the ensuing years there was a more secure and natural handling of the human figure. Scenes of daily life became popular, as there was an increased ease in depicting figures in a variety of poses. The result for us is a treasure trove of information about the life and culture of ancient Greece.

15-54 Anonymous, *A Greek and a Persian warrior fighting on a Red-figured oenochoe,* mid-5th century BCE. © Erich Lessing/Art Resource, NY. Louvre, Paris.

15-56 Carlo Maria Mariani, *Profile*, 1991. Mixed media and collage on paper, 30" x 22¼" (76.2 x 56.5 cm). Courtesy of the artist. © Carlo Maria Mariani/ Licensed by VAGA, New York, NY.

15-55 Carlo Maria Mariani, *Memory*, 2002. Oil on canvas, 24" x 20" (60.9 x 50.8 cm). © Carlo Maria Mariani. Courtesy of the artist. © Carlo Maria Mariani/Licensed by VAGA, New York, NY.

15-57 I. M. Pei, Louvre Pyramid (from above), 1984–88. Paris, France. Courtesy Davis Art Images.

15-58 Muriel Castanis, *Daphne*, 1986. Cloth and epoxy, 76" x 41" x 31" (193 x 104.1 x 78.7 cm). Courtesy of O.K. Harris Works of Art, New York. Photo by James Dee. © Muriel Castanis/ Licensed by VAGA, New York, NY.

## Summary

Art from prehistoric times (10,000–12,000 BCE) to the High Renaissance (early 1500s CE) developed in dramatic ways as civilizations rose and fell. Early cave paintings were fairly simple, made perhaps to ensure success in hunting. Egyptian artworks were created according to strict rules, to serve the deceased in the afterlife.

Greek and Roman sculptures blended *humanism* with *idealism*. Greek sculptors developed a system of ideal human proportions and a technique called *weight shift* that allowed for more realism in sculpture. The Romans imported glass, jewelry, and metalwork from around the world.

In the Middle Ages, diverse peoples and their art styles merged. Artworks related to religion throughout the Gothic period. During the Renaissance, the spirit of humanism was revived, and artistic output soared. Renaissance artists developed one-point perspective and produced paintings and sculptures whose influence was felt throughout Europe for many years.

## Review Questions

1 **Recall:** Why are some figures in Egyptian paintings larger than others?

2 **Understand:** Explain how a Greek figure sculpture can show both humanism and idealism.

3 **Apply:** Design a helmet, stained glass panel, or page from an illuminated manuscript. The subject matter of your work should relate to your own life, but use what you know of life in the Middle Ages as you choose colors, motifs, and styles.

4 **Analyze:** Compare and contrast the jamb figures from Chartres Cathedral (fig. 15-33, page 425) with Donatello's Saint Mark (fig. 15-36, page 427). Focus especially on use of line, body positions, and expression.

5 **Synthesize:** Create an imaginary conversation between Myron, the fifth-century BCE Greek sculptor of Athena, and Michelangelo, Italian Renaissance sculptor of Moses. What might they admire about each other's sculptures? Where might they differ in artistic ideas?

6 **Evaluate:** Choose a period from this chapter in which you would have enjoyed being an artist. Explain why you think the period you chose is a good one for an artist such as yourself, and what you like about the works of your fellow artists.

## For Your Portfolio

You can keep your artworks, essays, and other work you have accomplished in a portfolio. Your portfolio can help you reflect on how you have developed as a maker and viewer of art.

## For Your Sketchbook

Your sketchbook is a place for collecting found images as well as creating your own. It can also be a place to collect art historical trivia. On a page in your sketchbook, paste an envelope or pocket for keeping newspaper clippings about art historical information that interests you.

## Electronic Research

Using a search engine, find and explore the extensive online resources about ancient Egyptian art at the Egyptian Museum in Cairo, the British Museum in London, and the Metropolitan Museum of Art in New York City. Write an evaluation of the three sites. Which is the most user-friendly? Which demonstrates the best graphic design? Which exhibits the largest collection online? Which has the most significant content?

## Going Further

If you were to select one artwork or detail to represent each of the major periods in the history of Western art, what images would you choose? How could you organize these images in chronological order to show the progression of art from prehistory to the High Renaissance.

# 16 Western Art History II

16-1 **Some twentieth-century artists broke up parts of their paintings and arranged them to look like the facets of a precious stone. What stories do the facets in this painting seem to tell?** Marc Chagall, *I and the Village*, 1911. Oil on canvas, 75 5/8" x 59 1/2" (192 x 151 cm). © The Museum of Modern Art, New York. © 2004 Artists Rights Society (ARS), New York/ADAGP, Paris.

# What You'll Learn

- a concise history of art from the Renaissance to the twenty-first century
- the relationship between changes in society and changes in art styles
- how art styles are influenced by existing and past styles
- the directions art is taking today

# What This Chapter Covers

# Art Criticism Step by Step

# Studio Experiences

16-2 Student-painted artist's chairs.

# Key Terms

*English* (*Spanish*)

*Reformation* (*Reforma*)
*Baroque* (*Barroco*)
*Enlightenment* (*Aclaración*)
*Rococo* (*Rococó*)
*Romanticism* (*Romanticismo*)
*Realists* (*Realistas*)
*Post-Impressionism* (*Postimpresionismo*)
*Impressionism* (*Impresionismo*)
*Industrial Revolution* (*Revolución Industrial*)
*Modernism* (*Modernism*)
*Pre-Raphaelites* (*Prerrafaelista*)
*Art Nouveau* (*Art Nouveau*)
*German Expressionists* (*Expressionists Alemanes*)
*Cubism* (*Cubismo*)
*Surrealism* (*Surrealismo*)
*Dada* (*Dadaísmo*)
*Regionalism* (*Regionalismo*)
*Abstract Expressionism* (*Expresionismo Abstracto*)
*Postmodernism* (*Poste-Modernism*)

# Artists

Henrietta Bailey and Joseph Meyer, Georges Braque, Paul Cézanne, Marc Chagall, Gustave Courbet, Salvador Dalí, Jacques-Louis David, Giorgio de Chirico, Ferdinand-Victor-Eugène Delacroix, Marcel Duchamp, Jean-Honoré Fragonard, Paul Gauguin, Arshile Gorky, Nancy Graves, Hector Guimard, Jean-Antoine Houdon, Frida Kahlo, Wassily Kandinsky, Ernst Ludwig Kirchner, Judith Leyster Roy Lichtenstein, Hung Liu, Edouard Manet, Henri Matisse, John Everett Millais, Mary Miss, Paula Modersohn-Becker, Claude Monet, Louise Nevelson, Emil Nolde, Dennis Oppenheim, Pepón Osorio, Pablo Picasso, Jackson Pollock, Rembrandt van Rijn, Peter Paul Rubens, M. Louise Stanley, Maria van Oosterwyck, Johannes Vermeer, Idelle Weber

After the Renaissance, Europe became divided into Catholic and Protestant factions, and the art of the 1600s reflects this split. Artists in Catholic northern Europe, Spain, and Italy developed the very dramatic style that has come to be called **Baroque** (fig. 16-3). In the Netherlands, where the Dutch Reformed Church discouraged religious art, artists turned mostly to scenes of everyday life.

The **Rococo** style that took hold in the first half of the 1700s did not reflect the interests of the rising middle class. The classical revival, or **Neoclassical**, style that subsequently gained favor was inspired by ancient Greek and Roman art. Neoclassicism was later popular in the United States, as the new democracy was founded on classical principles.

In the first half of the 1800s, after the bloody French Revolution, faith in reason was replaced with a renewed faith in God and in emotion. This broad cultural movement was called **Romanticism**. Romantic artworks often celebrated nature and simple ways of living.

In the mid- to late 1800s, rebellion against the overly emotional drama of Romanticism inspired artists known as **Realists**. They believed in showing landscapes or scenes of everyday life without grandeur, drama, or condescension.

**Impressionism** took Realism a step further by emphasizing the way color and light are shown in paintings (fig. 16-4). The **Post-Impressionists** learned about color from the Impressionists, but desired a more structured art.

By the end of the 1800s, pattern and color, and the expression of emotion through color and form, were beginning to take priority over realism in art.

The Industrial Revolution in the early 1900s created a boom in manufactured goods, and the mechanization of many handcrafts. **Art Nouveau** in France and the **Arts and Crafts** movement in England emphasized handmade quality and rejected industrial design.

Much innovation in style and subject matter occurred in art during the early

16-3 **This painting by Rubens is fairly typical of his and the Baroque painting style.** Peter Paul Rubens, *The Holy Family*, c. 1615. Oil on canvas, 44 7/8" x 34 5/8" (114 x 88 cm). Palazzo Pitti, Galleria Palatina, Florence, Italy. Photo courtesy Scala/Art Resource, NY.

16-4 **In the late 1800s, Monet and his peers invented a new way of representing reality as a series of "impressions."** Claude Monet, *La Grenouillère*, 1869. Oil on canvas, 29 3/8" x 39 1/4" (74.6 x 99.7 cm). The Metropolitan Museum of Art, H. O. Havemeyer Collection; Bequest of Mrs. H. O. Havemeyer, 1929. Photograph © 1989 The Metropolitan Museum of Art.

16-5 **This painting was a major precursor to what would become a significant early-twentieth-century movement: Cubism.** Pablo Picasso, *Les Demoiselles d'Avignon*, 1907. Oil on canvas, 96" x 92" (224 x 234 см). © The Museum of Modern Art, New York. © 2004 Estate of Pablo Picasso/Artists Rights Society (ARS), New York.

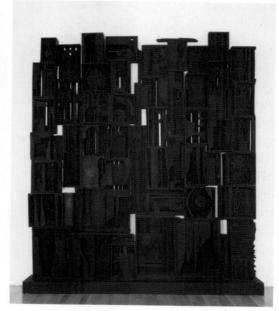

16-6 **Louise Nevelson's sculptures used Cubist techniques to fragment architectural elements.** Louise Nevelson, *Sky Cathedral*, 1958. Assemblage: wood construction painted black, 11' 3½" x 10' ¼" x 18" (344 x 305 x 46 cm). The Museum of Modern Art, New York, NY; Gift of Mr. and Mrs. Ben Wildwoff. Licensed by Scala/Art Resource, NY. © 2004 Estate of Louise Nevelson/Artists Rights Society (ARS), New York.

years of the twentieth century. The wildly colorful paintings of the *Fauves* established that artists could use pure color for its own sake. In Germany, groups of artists calling themselves *Die Brücke* (The Bridge) and *Der Blaue Reiter* (The Blue Rider) rebelled against traditional thinking about art, and expressed passionate feelings through their *Expressionist* works.

The *Cubists* (fig. 16-5) distorted objects in their paintings and collages, breaking them into flat planes like the facets of gems. The *Surrealists* specialized in subconscious experience and dreams. *Dadaists* believed that art should have nothing to do with rational thought, and they performed absurd art-related stunts.

Though home to many accomplished artists, the United States played a relatively small role in the development of Western art until the mid-1940s, when American artists began experimenting with abstraction. The *Abstract Expressionist* painters created dynamic canvases by exploring the use of *color fields* and by employing the gestural

techniques of dripping, pouring, and splashing paint. Sculptors working in this style followed the discoveries of Cubism to explore abstractions of shape and form in their three-dimensional works. (fig. 16-6).

Since the middle of the twentieth century, art has moved from Abstract Expressionism to Pop Art, from performance art and installations (fig. 16-7) to digital photography and electronic media. Art movements come and go quickly, overlapping one another. And where is art going next? That may be up to you.

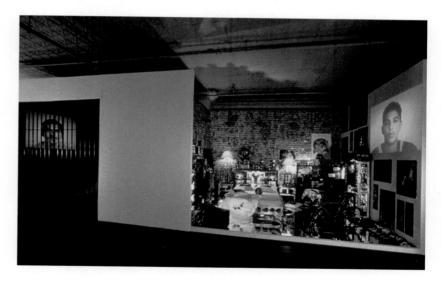

16-7 **Find the human faces in this installation. Looking at the works on these pages, how would you say artists' treatment of the human form has changed since the Baroque period of the 1600s?** Pepón Osorio, *Badge of Honor*, 1995. Installation view at Ronald Feldman Fine Arts, April 25–June 1, 1996. Mixed media installation, dimensions variable. Courtesy the Bernice Steinbaum Gallery. An **art:21** artist

The split in Christianity between Catholic and Protestant began in the 1500s. This development, known as the **Reformation**, affected both European religion and culture. In 1517, just five years after Michelangelo completed the Sistine ceiling, a German monk named Martin Luther prepared a long list of criticisms of the Catholic church. Using the new technology of printing, he circulated the list throughout Germany, and caused a revolt against the Pope and the Church. As a result, new denominations, such as Lutheran, Anglican, and Mennonite, sprang up in Germany, Scandinavia, Switzerland, the Netherlands, and England.

The Catholics responded with a *Counter-Reformation* led by Ignatius Loyola and his order of monks called the Jesuits. The Jesuits changed many Catholic church practices, and also hardened its doctrines against the Protestants. By the 1600s, the split in Christianity, which had become quite bitter, divided Europe into Catholic and Protestant factions. The art of the 1600s reflects this split.

Italy, as we've learned, was the center of developments in Renaissance art. By 1600, Gothic styles had been largely abandoned. Architects, painters, and sculptors in northern Europe, as well as those in Italy, created works in the style that, for better or worse, has come to be called **Baroque**.

Emphasizing complexity, drama, and grandeur, the Baroque style is very ornate. To this day, the word *baroque* is often applied to anything that is excessive or pompous. As an art term, it was coined by supporters of a later style whose preferences in art reflected less exuberant tastes. Versailles, King Louis XIV's palace, shown in Chapter 11 (fig. 11-32, page 306), is probably the most baroque building project ever undertaken.

One of the most successful Catholic artists of the early 1600s was Peter Paul Rubens. Rubens was from Flanders (present-day Belgium), a small country on the North Sea. Rubens painted for rulers and *aristocrats* (wealthy, privileged people) all over Europe. His subjects included portraits, classical mythology, religious scenes, historical events, and landscapes.

*The Holy Family with Saints Elizabeth and John the Baptist* (fig. 16-8) is fairly typical of Rubens's work. It depicts Joseph, Mary, and Elizabeth with the infants John the Baptist and

16-8 **In what ways is this painting of the holy family representative of the Baroque period in art? Notice clothing, complexions, and the overall atmosphere of the scene.** Peter Paul Rubens, *The Holy Family,* c. 1615. Oil on canvas, 44 7/8" x 34 5/8" (114 x 88 cm). Palazzo Pitti, Galleria Palatina, Florence, Italy. Photo courtesy Scala/Art Resource, NY.

Jesus. We usually consider the holy family to be of humble origins. Here, the adults and children, except for the elderly Elizabeth, are healthy, well fed, and well dressed. Mary and Joseph could easily be members of the middle class.

Contrast Rubens's concept of the holy family with Rembrandt's *Adoration of the Shepherds* **(fig. 16-9)**. Instead of having handsome, idealized bodies, Rembrandt's people appear more ordinary. All are dressed in peasant clothing. The setting is humble. The single light source sets the scene aglow as if lit by a dramatic spotlight. *Adoration* is more mysterious, and less theatrical, than the *Holy Family*.

In addition to numerous portraits and landscapes, Rembrandt, a native of Holland, made over eight hundred paintings, drawings, and prints of religious subjects. In this respect, he differed from most of his fellow Dutch artists, as the Reformed Dutch Church did not commission religious painting or sculpture.

16-10 **Vanitas is a commentary on people's vanity and love of material things. What does the skull seem to imply?** Maria van Oosterwyck, *Vanitas*, 1668. Oil on canvas, 28¾" x 35⅛" (73 x 89 cm). Kunsthistorisches Museum, Vienna, Austria.

The Dutch Republic was predominantly Protestant, and the Dutch church saw religious art as a type of idol worship, akin to superstition or magic. Dutch artists therefore turned to other subjects, particularly still life and scenes from everyday life. *Vanitas* (**fig. 16-10**), by Maria van Oosterwyck, explores the kind of materialism enjoyed by many in the Netherlands of the 1600s. Dutch sailors brought in goods from around the world. The clients of Dutch artists were the well-to-do middle class: merchants, bankers, lawyers, and doctors.

Johannes Vermeer also painted everyday life with unusual sensitivity. *Young Woman with a Water Pitcher* (**fig. 16-11**) shows a middle-class woman standing at a window. Vermeer was particularly skilled at depicting the effects of light. Note the jug and basin, and the diffused light coming through the window. Vermeer was able to give even ordinary household moments charm and substance.

Portraiture as a subject matter was even more popular than scenes of everyday life in Protestant countries. Dutch artists perfected the art of portraiture. While Dutch portraits reflect many moods, from melancholy to lightheartedness, depictions of the latter are probably the most prominent. Judith Leyster's self-portrait at the easel (**fig. 16-12**) reflects the down-to-earth, contented, and affluent Dutch middle class. It is also one example of the remarkable number of professional

16-11 **The Dutch of the seventeenth century were extremely proud of their prosperous cities and towns. How is that prosperity reflected in this painting?** Johannes Vermeer, *Young Woman with a Water Pitcher*, c. 1660–67. Oil on canvas, 18¼" x 16⅛" (46 x 41 cm). © The Metropolitan Museum of Art, New York, Gift of Henry G. Marquand.

women painters that emerged during the Baroque period.

Other major artists of the Baroque period include the Spaniard Diego Velázquez and the Italians Caravaggio (fig. 2-26, page 26), Annibale Carracci, and Gian Lorenzo Bernini (fig. 10-62, page 287). During the century of Rubens, Rembrandt, Vermeer, Velázquez, Caravaggio, and Bernini, the field of science was gaining momentum. Galileo Galilee, a Florentine astronomer, constructed a telescope that was able to verify Copernicus's theory that the earth revolves around the sun. Johannes Kepler, a German mathematician, determined that the planets traveled in elliptical orbits. Isaac Newton, the English inventor of calculus, brought together the research and thinking of the century and devised the law of gravity.

Conflicting beliefs about science and religion were beginning to affect European culture, and the art of the 1700s reflects some of those conflicts.

**Linking Disciplines**
Literature

Can you fully appreciate or understand an artwork just by looking at it? Reading biographies and autobiographies of artists provides insight into their work. Also, many novels have been written about artists. For a better understanding of the value individuals place on art, you might enjoy *Girl in Hyacinth Blue* by Susan Vreeland. For insight into the way Vermeer worked, read *Girl with a Pearl Earring* by Tracy Chevalier.

16-12 **What makes this self-portrait lighthearted?** Judith Leyster, *Self-Portrait*, c. 1630. Oil on canvas, 29 5/8" x 25 5/8" (75 x 65 cm). National Gallery of Art, Washington, Gift of Mr. and Mrs. Robert Woods.

The scientific boom of the 1600s led to the period of the 1700s known as the *Enlightenment*. Conservative Protestants and Roman Catholics felt the new science challenged the doctrines and beliefs of the Church. Enlightenment philosophers, however, believed that science revealed the secrets of nature and improved people's lives.

These philosophers placed their faith in reason and science more than religion. They thought of the universe as a huge clock, which God started but then left alone. This concept of the universe was

16-13 **Compare this Rococo painting to the other works on these two pages. What do they tell you about how attitudes changed during the eighteenth century?** Jean-Honoré Fragonard, *The Swing*, 1766. Oil on canvas. By Kind Permission of the Trustees of the Wallace Collection.

known as Deism. This religious view influenced some of America's founding fathers, including Benjamin Franklin, Thomas Jefferson, Thomas Paine, and George Washington.

A major art style in the 1700s was called ***Rococo***. It did not reflect the views of the Enlightenment. Instead it reflected the lifestyle of the pleasure-seeking aristocracy, or wealthy classes.

*The Swing* (fig. 16-13), by Jean-Honoré Fragonard, is typical of the style. Here is a scene of aristocrats at play in a make-believe world. *The Swing* has the fluid brushwork and lively movement that often characterized Baroque art. However, its pastel hues, satiny textures, and delicate figures are much lighter in spirit. Its content is also lighter.

Later in the century there was a reaction against the Rococo style in Europe. The middle classes grew dramatically in power and influence through the 1700s, and felt that Rococo did not represent their values. Jacques-Louis David's *Oath of the Horatii* (fig. 16-14) is an early example of the new, simpler style.

Set in a severe Roman courtyard, David's painting features Roman soldiers swearing an oath to fight to the death. Its colors are mostly primaries. The figures are sharply defined, set on a shallow "stage," much like the subjects on ancient relief carvings.

Like Renaissance art, this new style was inspired by the themes and principles of classical Greek and Roman art. It became known as the *classical revival* or *Neoclassical* style. (Neoclassicism in architecture is discussed in Chapter 11.) Intellectuals approved of Neoclassicism as a symbol of seriousness and reason. The French middle class saw it as an allegory of honor and patriotism. It also became a symbol of the French Revolution.

Neoclassicism was also reflected in eighteenth-century sculpture. Portrait

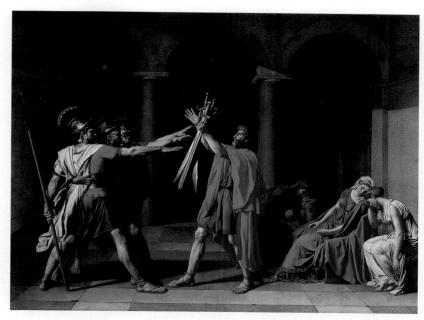

16-14  **After the Rococo, Europeans needed art with "noble simplicity and calm grandeur," according to one art historian. How well does this painting fit that description?** Jacques-Louis David, *The Oath of the Horatii*, 1784. Oil on canvas, 14' x 11' (4 x 3 meters). Musée du Louvre, Paris.

16-15  **Where can you see the influence of Roman sculpture on this neoclassical bust?** Jean-Antoine Houdon, *Bust of Thomas Jefferson*, 1789. Plaster with terra-cotta patina, nearly life-sized, Monticello, Charlottesville, Virginia.

busts, such as Houdon's portrait of Jefferson (fig. 16-15), were modeled on ancient Roman portrait sculpture, blending idealism and realism. The style became very popular in the United States after the American Revolution.

As we've seen, cultural styles occur in cycles. With time, the hopes of the Enlightenment and artistic and philosophical ideals of Neoclassicism were dashed by the atrocities of the French Revolution and the ravages of the Napoleonic Wars. Faith in reason was replaced with a renewed faith in God and in emotion. This broad cultural movement was called **Romanticism**, and it peaked in the first half of the 1800s.

Eugène Delacroix, a colorful man with strong emotions, was a leading Romantic painter. He loved the outdoors and wild animals. In his art, he celebrated the simple life of rural common people, especially the Muslims of North Africa. Many of his attitudes are expressed in *Arabs Skirmishing in the Mountains* (fig. 16-16). The colors, shades of red and orange against a brilliant sky, are vivid. The brushwork is dynamic and lively.

Marie Rosalle (Rosa) Bonheur's *Gathering for the Hunt* (fig. 16-17) expresses Romanticism and the love of the outdoors in more subdued ways.

16-16 **Morocco and North Africa were French colonies when this work was painted. How might this have affected the way Delacroix viewed Islamic culture?** Ferdinand-Victor-Eugène Delacroix, *Arabs Skirmishing in the Mountains*, 1863. Oil on linen, 36 5/8" x 29 5/8" (93 x 75 см). © National Gallery of Art, Washington, Chester Dale Collection.

16-17 **In order to study animals in the farmyard for her paintings, Bonheur had to get official police permission to be able to wear pants in public.** Rosa Bonheur, *Gathering for the Hunt*, 1856. Oil on canvas, 30 1/2" x 58 1/8" (77 x 148 cm). Haggin Collection, the Haggin Museum, Stockton, CA.

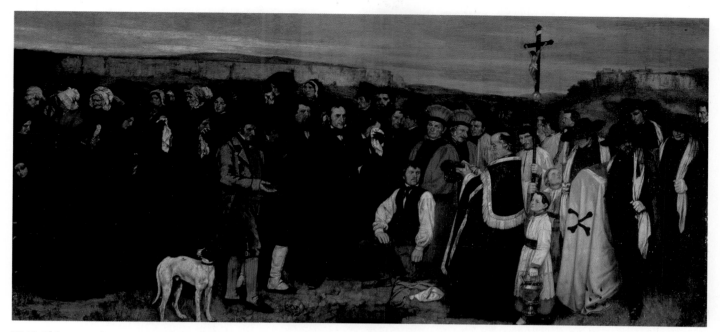

16-18 **This scene is constructed much like an ancient Roman or Greek relief sculpture. What features help make it unemotional?**
Gustave Courbet, *Burial at Ornans*, 1849. Oil on canvas, 10' x 22' (313 x 664 cm). Musée du Louvre, Paris, and Réunion des Musées Nationaux.

Her brushwork is calm, and the colors are mostly cool. Although *Gathering for the Hunt* is much less dramatic than *Arabs Skirmishing*, it is no less a tribute to nature.

By the middle of the nineteenth century, some artists had begun to rebel against the overly emotional drama of Romanticism. They believed in depicting landscapes or scenes of everyday life without grandeur, drama, or condescension. They would become known as the ***Realists***.

Gustave Courbet was a leading artist of the Realist movement. *His Burial at Ornans* **(fig. 16-18)** shows little concern for ornamentation or sentiment. At the time it was painted, the majority of the public did not believe that a realistic treatment of such a subject was worthy of being called art.

Edouard Manet, another Realist, focused on the well-to-do middle class in Paris. Like the figures in *The Gare Saint-Lazare* **(fig. 16-19)**, Manet's people often have the offhand look of someone caught in a moment of casual activity. Manet not only captured the spirit of

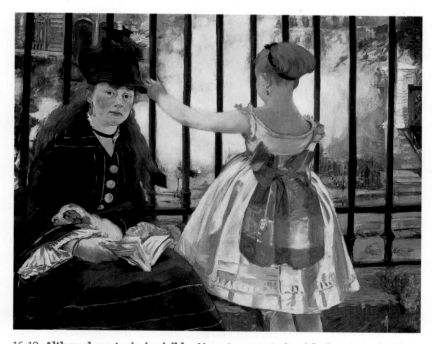

16-19 **Although no train is visible, Manet suggests it with the steam behind the fence. What other reflections of modern urban society can you see?**
Edouard Manet, *The Gare Saint-Lazare*, 1873. Oil on canvas, 36 3/4" x 43 7/8" (93 x 111 cm).
© National Gallery of Art, Washington, Gift of Horace Havemeyer in memory of his mother, Louisine W. Havemeyer.

everyday city life, but he also pioneered a fresh approach to painting. The figures, unlike those of David, Bonheur, or even Courbet, appear rather flat because of their lack of conventional shading.

Realism's stress on expressing observations in a lifelike way led to another movement of the late 1800s: ***Impressionism***. Impressionism took Realism a step further by emphasizing the way color and light can be shown in a painting. Monet's *La Grenouillère* **(fig. 16-20)** illustrates the characteristics of the style. Like Manet's work, it shows an offhand moment in the lives of some city dwellers. But Monet went beyond Manet, constructing the entire painting from nothing more than bright daubs of pure color, a method known as *broken color*. When viewed at close range, the daubs tend to be more apparent than the forms. But when viewed at a proper distance, the daubs merge into recognizable trees, people, and boats.

Monet and the other Impressionists also broke artistic tradition by painting their works entirely outdoors, or, in French, *en plein air*. In many ways, the subject matter of Monet's work was light and color, or, as he explained it, "the shifting flux of appearances."

Some artists who started in the Impressionist style eventually turned away from it. Some became known as the ***Post-Impressionists***. Although they learned about color from Impressionism, some of these artists desired a more structured art. Paul Cézanne, for example, painted the fruit and objects of his still life **(fig. 16-21)** to look solid and durable. Cézanne also took pains to balance the visual weights and directions so that the composition would be as solid and durable as the fruit.

The works of Post-Impressionist Paul Gauguin display the flatness of form found in the works of both Manet and Monet. But in Gauguin's paintings, such as his *Old Women of Arles* **(fig. 16-22)**, this flatness is much more abstract and decorative. Gauguin, like many artists of his generation, was influenced by the crisp outlines, flat patterns, and often

16-20 **How is this style of painting different from Manet's? Notice especially how Monet created rippling water.**
Claude Monet, *La Grenouillère*, 1869. Oil on canvas, 29 3/8" x 39 1/4" (74.6 x 99.7 cm). The Metropolitan Museum of Art, H. O. Havemeyer Collection; Bequest of Mrs. H. O. Havemeyer, 1929. Photograph © 1989 The Metropolitan Museum of Art.

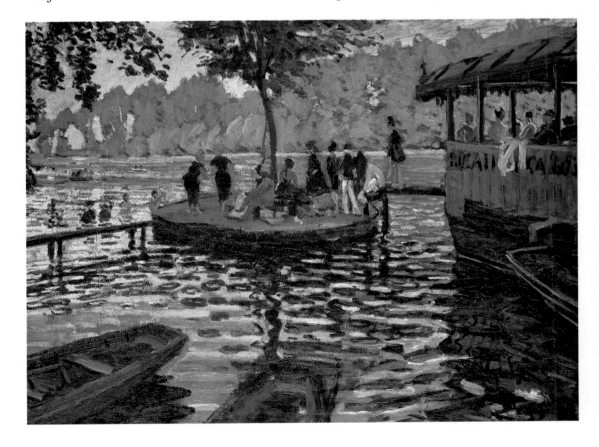

crisp outlines, flat patterns, and often off-center compositions of Japanese woodcut prints. Both Impressionists and Post-Impressionists avidly collected Japanese prints.

At the end of the 1800s, art had reached a turning point. It was turning away from the principles of pictorial realism that had been established by Renaissance artists such as Donatello and Masaccio (see Chapter 15) and had dominated European art ever since. Instead of realism, the values of pattern and color or the expression of emotion through color and form were beginning to take priority. Singular among the artists whose works reflected these qualities was Vincent van Gogh (**figs. 4-57, page 85; 5-37, page 103; 7-17, page 158; 7-21, page 161; and 9-9, page 213**). These values were to be asserted with even greater force in the twentieth century.

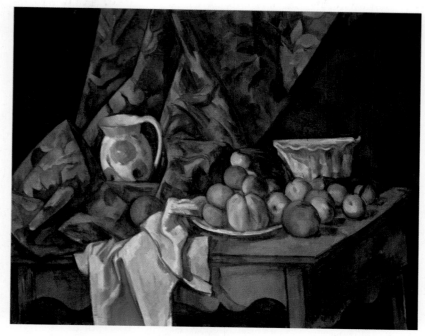

16-21 **Cézanne said he wanted to create art that was "solid and durable." How has he achieved that with this still life?** Paul Cézanne, *Still Life with Apples and Peaches,* c. 1905. Oil on canvas, 31 7/8" x 39 1/2" (81 x 100.5 cm). © National Gallery of Art, Washington, Gift of Eugene and Agnes Meyer.

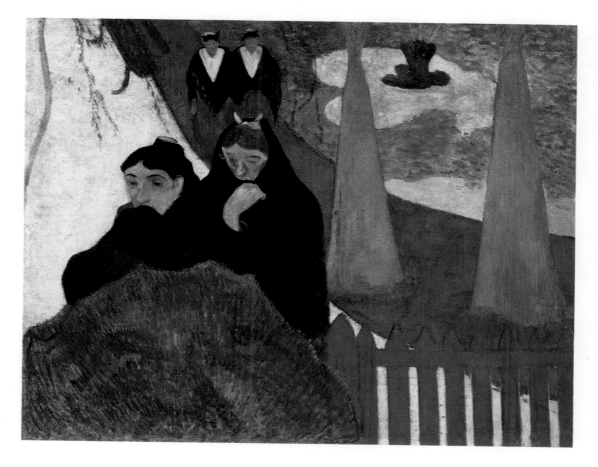

16-22 **What makes this painting look flat?** Paul Gauguin, *Old Women of Arles,* 1888. Oil on canvas, 28 3/4" x 36 1/4" (73 x 92 cm). © Art Institute of Chicago, Mr. and Mrs. Lewis Larned Coburn Memorial Collection.

In addition to art movements, the 1800s also witnessed the *Industrial Revolution*. Large industries replaced small shops, leading to a rapid changeover from handmade goods to mass production. People had more material things, like clothes, and more leisure time. This industrial society also seemed to experience more boredom and a sense of rootlessness. Look back and note the detached look of Manet's woman at Gare Saint-Lazare (**fig. 16-19**).

Despite the nonstop march toward industrialization and urbanization in Europe, some art movements arose in reaction against the impersonal nature of modern industrial society. In the industrial society of the late 1800s lay the seeds for the movements in all the arts that are known as *modernism*. The modernist movement urge in the visual arts was characterized by a deliberate departure from the traditions of the nineteenth century. One group of artists in England refused to embrace the contemporary subject matter that Realists portrayed. This group of artists were called the *Pre-Raphaelites*. They looked to the Middle Ages and Early Renaissance as the high point of Western art. The group's founder was John Everett Millais. His *Ophelia* (**fig. 16-23**) is a perfect example of the kind of subject matter the Pre-Raphaelites preferred: literary, fictional, historical, and fanciful.

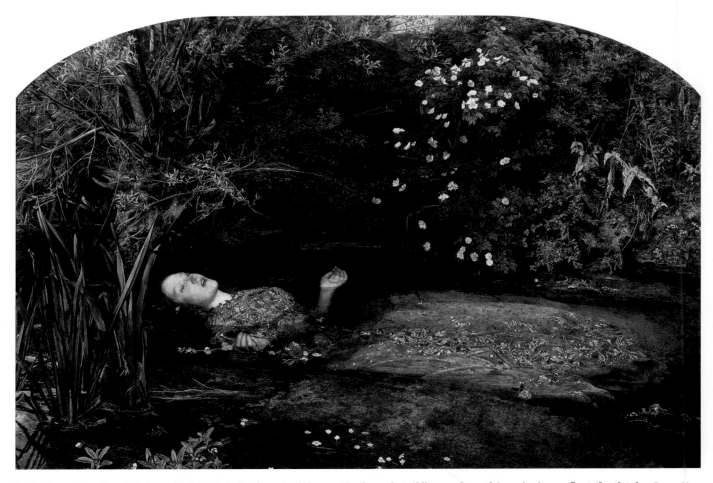

16-23 **The writer Baudelaire called Millais the "poet of the meticulous detail." How does this painting reflect that?** John Everett Millais, *Ophelia*, 1852. Oil on canvas, 30" x 44" (76 x 112 cm). Tate Gallery, London.

16-24 **In contrast to the rectangular blocks of apartments in the background, Guimard's organic lines and shapes provide graceful relief. What does mass-transit signage look like in your area?** Hector Guimard, Métro stop Palais Royal, c. 1899–1905. Cast iron and glass, Paris. Courtesy Davis Art Images.

16-25 **How are organic forms and Asian stylings reflected in the design of this Arts and Crafts vase?** Henrietta Bailey and Joseph Meyer, Vase, 1904–10. Pottery, 9" (23 cm) high. Private Collection. Courtesy Davis Art Images.

Toward the end of the 1800s, there was a movement among designers of decorative arts to resist the trend toward mass production and reintroduce handcrafted quality. *Art Nouveau* was one movement that emphasized handmade quality and a rejection of industrial design by featuring organic, Asian, and ancient forms. Guimard's Métro entrances in Paris (fig. 16-24) are a prime example of Art Nouveau.

At the same time, the Arts and Crafts movement in England was developing. Like Art Nouveau, it stressed the superiority of handcrafting. Medieval, Renaissance, and ancient styles influenced artists of this movement, like those of Newcomb Pottery, at Sophie Newcomb College, New Orleans. (fig. 16-25). The emphasis in Arts and Crafts works is on the beauty and integrity of the materials used, as well as the quality of a handcrafted object.

The twentieth century, the century of wars, genocide, depression, inflation, and "future shock," was also a tumultuous one for art. More innovation in style and subject matter occurred in art during the years before World War I (1914–18) than had occurred in the previous four hundred years.

In 1905 a show in Paris contained paintings that were so shocking to the public in their use of color that a critic referred to the artists as *fauves* (French for "wild beasts"). Their paintings feature brilliant color and simple shapes such as those seen in Matisse's *The Red Studio* (fig. 16-26). Fauvism represented an important breakthrough in modern art: the belief that an artist should be free to define form with any pure color simply because of the beauty of the color.

In *The Red Studio*, Matisse tempered the vibrant red with small touches of cool blue. He was a master at making balanced paintings with daring color combinations.

16-26 **Compare this painting with Cézanne's *Still Life* (fig. 16-21, page 455), painted just six years before. Why might Matisse's color use have shocked viewers at the time?** Henri Matisse, *The Red Studio*, Issy-les-Moulineaux, 1911. Oil on canvas, 71¼" x 72¼" (181 x 183.5 cm). The Museum of Modern Art; Mrs. Simon Guggenheim Fund. The Museum of Modern Art/ Licensed by Scala/Art Resource, NY. © 2004 Succession H. Matisse, Paris/Artists Rights Society (ARS), New York.

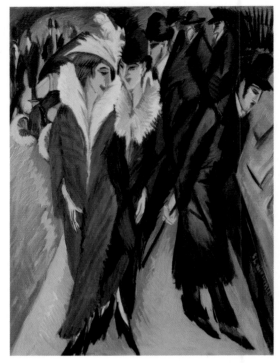

16-27 **Kirchner greatly appreciated the art of Africa. How might the figures in this painting be said to resemble those in African sculpture?** Ernst Ludwig Kirchner, *Street, Berlin*, 1913. Oil on canvas, 47⅝" x 36" (121 x 91 cm). © The Museum of Modern Art, New York.

## German Expressionism

While the Fauves were shocking Paris, artists in Germany were beginning to organize into groups and rebel against traditional thinking about art. One group in Dresden was called *Die Brücke* (The Bridge), while another, in Munich, was called *Der Blaue Reiter* (The Blue Rider). These artists, and others involved in modern experiments before the Nazi takeover in 1933, were called **German Expressionists**.

German Expressionists tended to use bright colors and flat patterns to express passionate feelings. Sometimes these feelings were disturbing. Ernst Ludwig Kirchner, leading painter of Die Brücke, used harsh colors and jagged brushwork

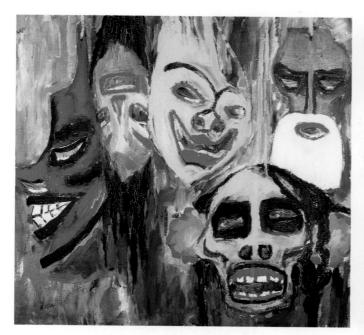

16-28 **Notice the jagged lines, unmixed color, and distortion in this painting. How does it make you feel?** Emil Nolde, *Masks*, 1911. Oil on canvas, 29" x 30" (73 x 77 cm). Nelson-Atkins Museum, Kansas City, MO.

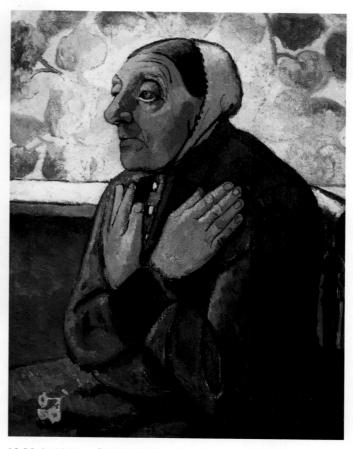

16-29 **In 1905 and 1906, Modersohn-Becker visited Paris, where she saw the works of Gauguin and Cézanne. What similarities can you see between their work and hers?** Paula Modersohn-Becker, *Old Peasant Woman Praying*, c. 1906. Oil on canvas, 29 3/4" x 22 3/4" (76 x 58 cm ). The Detroit Institute of Arts, Gift of Robert H. Tannahill.

to portray urban excess in his *Street, Berlin* (fig. 16-27).

Although the Fauves' colors shocked the public, they were not interested in making moral or political statements. The German artists, on the other hand, used their style to mock authority, address social injustice, or express despair. Emil Nolde of Die Brücke produced works as emotionally charged as Kirchner. In *Masks* (fig. 16-28), what seems to be a still life becomes an unsettling array of sinister faces.

One German Expressionist, Paula Modersohn-Becker, belonged to no group. She was aware of the works of the Post-Impressionists and began working in a modern style well before the two German groups were organized. As its title suggests, *Old Peasant Woman Praying* (fig. 16-29) expresses melancholy as well as sympathy for peasant life. Its sincerity of expression is reminiscent of the work of Vincent van Gogh, who was a major influence on German Expressionism. Had she not died at thirty-one, Modersohn-Becker would probably have become a dominant figure in the Expressionist movement.

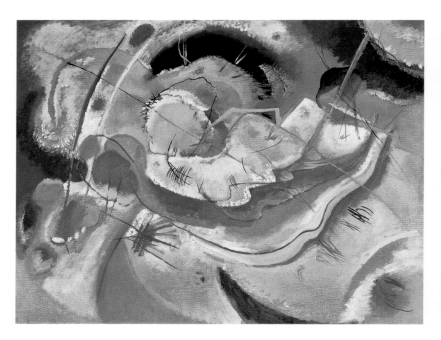

16-30 **This work may suggest emotion, but the artist was more interested in exploring abstraction than expressing feelings.** Wassily Kandinsky, *Improvisation: Little Painting with Yellow,* 1914. Oil on canvas, 31⅛" x 38⅝" (79 x 98 cm). © Philadelphia Museum of Art. © 2004 Artists Rights Society (ARS), New York/ADAGP, Paris.

Born in Russia, Wassily Kandinsky was the spiritual leader of Der Blaue Reiter and a highly respected German Expressionist. Most significantly, Kandinsky was the first artist to explore total abstraction. As early as 1910 he made a watercolor that was completely without subject matter and recognizable imagery. His *Improvisation: Little Painting with Yellow* (fig. 16-30) was painted at the outbreak of World War I.

## Cubism

In 1905, the year of the Fauvist show in Paris, the Spaniard Pablo Picasso was a struggling young painter in that city. His *The Old Guitarist* is shown in Chapter 5 (fig. 5-36, page 102). Inspired by the success of Fauvism, he began experimenting with redefining pictorial space in 1906. He also experimented with forms from African sculpture. The result of these efforts, *Les Demoiselles d'Avignon* (fig. 16-32), was unveiled in 1907. In this painting, the human figure is distorted, reduced to flat, geometric shapes and sharp angles.

Imagine how radical this painting must have seemed to the 1907 public. Even Matisse was shocked, calling it a

16-31 **Facet Cubist works show a subject from different angles, suggesting the movement of the viewer. This in turn introduced the element of time.** Georges Braque, *Violin and Palette,* 1909–10. Oil on canvas, 36¼" x 16⅞" (92 x 43 cm). Solomon R. Guggenheim Museum, New York. © 2004 Artists Rights Society (ARS), New York/ADAGP, Paris.

mockery of the modern movement. The figures and the background are distorted to create a system of shallow peaks and valleys, as if the whole canvas had been wadded up and then spread flat. *Les Demoiselles* foreshadowed a significant early-twentieth-century style: *Cubism.*

Picasso and French artist Georges Braque experimented with an early variety of Cubism called Analytical or *Facet Cubism.* A good example is

Braque's *Violin and Palette* (fig. 16-31). In this work, still life objects are broken up and recombined into a network of tilted planes or facets—like the surface of a gem. Almost from the time it was introduced, Facet Cubism influenced other artists such as Marc Chagall (fig. 16-1, page 442).

Another form of Cubism developed by Braque and Picasso was called *Synthetic Cubism*. This style combined collage and objects from the real world. Synthetic Cubism had a much broader palette than Facet Cubism.

### Artist Biography
## Pablo Picasso (1881–1973)

One of the most prolific and influential artists of the twentieth century, Picasso was born in Malaga, in southern Spain. His mother claimed that his first word was *piz* (short for the Spanish word *lapiz*, or pencil), and that he was able to draw before he could speak. The sketches the young Picasso would go on to produce were impressive in their detail and quality. Many years later, while viewing an exhibition of children's art, he remarked that it had taken him years to be able to draw like those children.

Picasso studied in Barcelona, Madrid, and Paris, where he befriended many artists and writers, including the painter Henri Matisse and the wealthy American author Gertrude Stein, one of his earliest biographers. After experimenting with several styles of painting, Picasso and his peer Georges Braque changed the art world forever with their forays into what has become known as Cubism. While technically quite complex, *Les Demoiselles d'Avignon* seemed to express the simplicity and directness of tribal art. Picasso's and Braque's paintings in this vein startled

16-32 **This painting shocked even Henri Matisse. Does it shock your twenty-first-century eye?** Pablo Picasso, *Les Demoiselles d'Avignon*, 1907. Oil on canvas, 96" x 92" (224 x 234 cm). © The Museum of Modern Art, New York. © 2004 Estate of Pablo Picasso/Artists Rights Society (ARS), New York.

their contemporaries because of the way they distorted the human body.

Though Picasso worked in many styles, he is most frequently associated with his Cubist work in painting, sculpture, and mixed media. He remains an important touchstone for artists to this day.

## Surrealism

Picasso and Braque experimented with new approaches to style and media in the second decade of the twentieth century. At the same time, Giorgio de Chirico experimented with a new approach to subject matter.

The style of *The Soothsayer's Recompense* (fig. 16-33) is not particularly new, especially for 1913. But the subject matter is unusual. Here, we see a peculiar mix of objects: a deserted square, a classical sculpture, a detached arch, and a pair of palm trees, all coexisting uneasily. The stillness is stressed both by the silent passing of a train on the horizon and by the passage of time measured by the clock on the building. It is all strange, like a dream.

The paintings of de Chirico, along with the writings of Sigmund Freud, the father of modern psychology, influenced the art movement known as **Surrealism**. The Surrealists specialized in intuitive, subconscious experience and dreams. Salvador Dalí used a realistic style to portray fantastic visions. His *Persistence of Memory* (fig. 16-35) is an assembly of recognizable forms with unusual attributes, in an unusual context, and on an unexpected scale. Recall his *Mae West* from Chapter 8 (fig. 8-31, page 185). It is bizarre, but not necessarily shocking.

**Dada** was an energetic, short-lived movement developed in 1916, during World War I, by a small group of artists, poets, and writers who had gathered in neutral Zurich, Switzerland. Horrified by the "rational world" that had spawned the horrors of the war, the group determined that art should have nothing to do with rational thought.

16-33 **How is this Surrealist painting like a dream?**
Giorgio de Chirico, *The Soothsayer's Recompense*, 1913. Oil on canvas, 53 1/4" x 70 7/8" (136 x 180 cm). © Philadelphia Museum of Art.

The activities of the Dadaists appeared preposterous to the outside world. They wrote poetry by cutting words out of seed catalogs, danced to the sound of a barking dog, and made collages out of random arrangements of garbage. Dadaists tended to thumb their noses at everything traditional.

Dada spread to Paris, Cologne, Barcelona, Berlin, and New York. The movement died around 1922, but it had injected into art a taste for the absurd and ironic. The Dadaists were reflecting what they considered to be the absurdity of modern life, especially the absurdity of war.

*Fountain*, by Marcel Duchamp (fig. 16-34), has become a symbol for the Dada spirit. It is a urinal laid on its back and signed "R. Mutt." Duchamp, a Frenchman working in New York at the time, tried to enter *Fountain* in an art show, only to have it rejected. Today, however, a replica of Duchamp's artwork is part of a distinguished art collection.

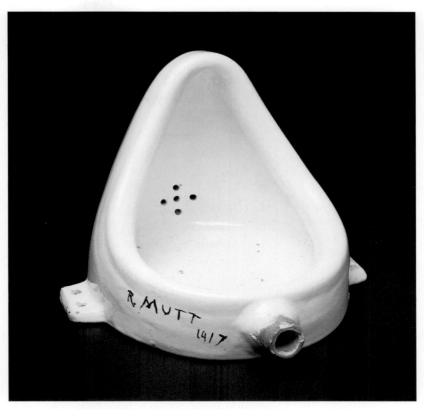

16-34 **This is a found object that Duchamp merely signed a name on. What do you think he was trying to say about sculpture, or art in general?** Marcel Duchamp, *Fountain* (Second Version), 1950. Readymade: glazed sanitary china with black paint, 12" x 15" x 18" (30.5 x 38 x 45.7 cm). Philadelphia Museum of Art; Gift (by exchange) of Mrs. Herbert Cameron Morris. Photo by Graydon Wood, 1998. © 2004 Artists Rights Society (ARS), New York/ADAGP, Paris/Succession Marcel Duchamp.

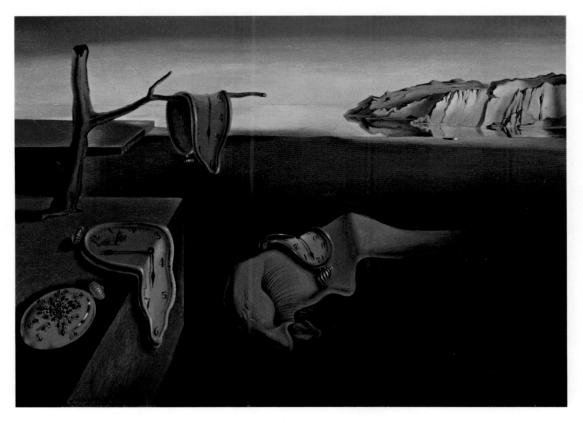

16-35 **Dali was inspired while working on this landscape by the sight of cheese melting on a plate after dinner. Where do you see this inspiration reflected?** Salvador Dali, *The Persistence of Memory,* 1931. Oil on canvas, 9½" x 13" (24 x 33 cm). © The Museum of Modern Art, New York. © 2004 Salvador Dali, Gala-Salvador Dali Foundation/Artists Rights Society (ARS), New York.

The end of World War II in 1945 marked a turning point in the twentieth century. With the dropping of US atomic bombs on Hiroshima and Nagasaki, Japan, and the end of the war, the nuclear age began. America and the Soviet Union took over the world stage as the dominant superpowers. The end of the war also marked a turning point in the modern art movement. Artistic leadership passed from Europe to America.

The most popular American art before the war was *Regionalism*. It was a conservative style that specialized in local themes, particularly the everyday life of rural Americans (fig. 9-41, page 238). The style was inappropriate after the 1940s. Americans had been thrust into a role of world leadership, and they needed their art to reflect that role.

In the mid-1940s, young American artists like Arshile Gorky began experimenting with abstraction. His *The Liver Is the Cock's Comb* (fig. 16-36) represents the beginnings of American abstract art.

But the real breakthrough came in 1947, when Jackson Pollock started his famous "drip" paintings. Pollock would lay a canvas on the floor and walk across its surface spilling, pouring, and flinging paint (fig. 16-38). The dancing lines and rhythms of *Cathedral* (fig. 16-37) reflect Pollock's bodily movements and gestures as he produced the work.

Other American painters also began making bold abstract canvases, in a variety of techniques. Their style is

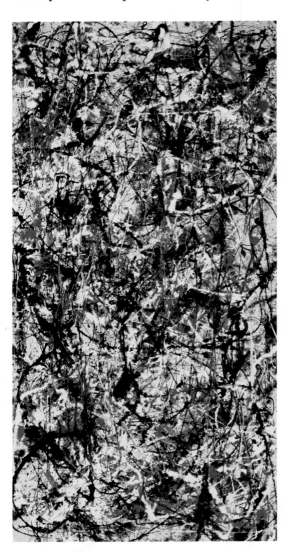

16-37 **No artist, European or American, had ever made a painting this way, on such a scale and with such energy. Why might this style also be called action painting?** Jackson Pollock, *Cathedral*, 1947. Oil on cotton duck, 75" x 35" (191 x 89 cm). Dallas Museum of Art, Gift of Mr. and Mrs Bernard J. Reis. © 2004 The Pollack-Krasner Foundation/Artists Rights Society (ARS), New York.

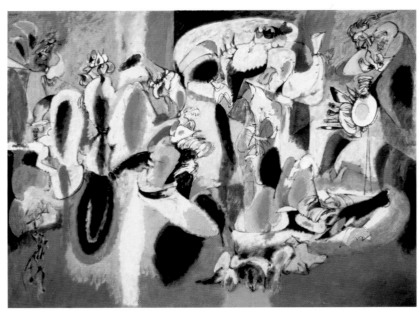

16-36 **This painting is an early example of American abstraction. How does it differ from Kandinsky's (fig. 16-30)?** Arshile Gorky, *The Liver Is the Cock's Comb*, 1944. Oil on canvas, 73 1/4" x 98 1/8" (186 x 249 cm). Albright-Knox Art Gallery, Buffalo, NY. © 2004 Artists Rights Society (ARS), New York.

called *Abstract Expressionism*. Helen Frankenthaler stains canvas with diluted pigments (figs. 5-31, page 100; 9-20, page 222). Hans Hofmann used brushes to paint works like *The Golden Wall* (fig. 6-32, page 132). Abstract Expressionism was a new style in modern art. Even Europeans were impressed by this American creativity.

American artists continued to experiment. By the end of the 1960s, many different styles and kinds of art existed. You may recall the discussion of today's artistic variety in Chapter 1. You have already encountered many examples of postwar art in previous chapters, particularly Chapters 9 and 10. We will now summarize that under a few headings and refer back to some of those examples.

## Assemblage and Collage

Braque and Picasso pioneered both collage and assemblage in the early 1900s. Assemblage experienced a revival after World War II.

One of the most influential assemblage artists was Louise Nevelson. Her *Sky Cathedral* (fig. 16-39) was one of a

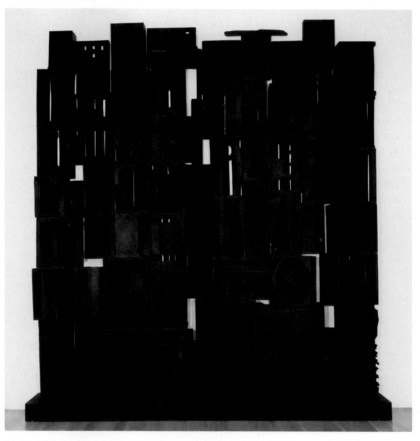

16-39 **Think about why Nevelson might have used only one color in this sculpture. What do you tend to notice instead of color?** Louise Nevelson, *Sky Cathedral*, 1958. Assemblage: wood construction painted black, 11' 3 1/2" x 10' 1/4" x 18" (344 x 305 x 46 cm). The Museum of Modern Art, New York, NY; Gift of Mr. and Mrs. Ben Wildwoff. Licensed by Scala/Art Resource, NY. © 2004 Estate of Louise Nevelson/Artists Rights Society (ARS), New York.

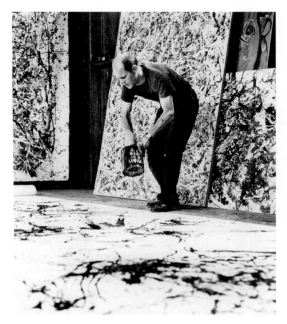

16-38 Hans Namuth, *Jackson Pollock*, 1950. Gelatin silver print, 14 3/4" x 12" (37.8 x 30.4 cm). National Portrait Gallery, Smithsonian Institution, Washington, DC; Gift of the estate of Hans Namuth. Art Resource, NY.

group of assemblages that formed an installation show in 1958 called "Moon Garden Plus One." The works were constructed primarily out of bits of wooden debris she collected on the streets of New York. *Sky Cathedral* has definite ties to Cubism in its multiple, overlapping planes.

Robert Rauschenberg's *Monogram* (fig. 1-12, page 9) was the most spectacular of his assemblages—he called them "combine paintings"—a combination of collage, assemblage, and painting. Such a work clearly has its origins in the works of the Dada artists, although it is not so much a statement as an expansion of our very definitions of art.

### More Assemblage

Marisol's *Women and Dog* (fig. 10-22, page 265), Jim Jenkins's *Coordinated Programming* (fig. 10-21, page 265)

### More Collage

Trenton Doyle Hancock's *Strudi Flooo* (pages 206–7), Pablo Picasso's *Still Life with Chair Caning* (fig. 9-40, page 237), Garth Erasmus' *The Muse 3* (fig. 14-35, page 402)

## Pop Art

The Pop Art movement emerged in the 1960s. It satirized popular culture by borrowing themes from comics, advertising, and ordinary life. Pop Art usually represented things in a straight-forward, deadpan way. Many other works, outgrowths of Pop, are ironic, witty, or satirical. Because of their humor and nose-thumbing stance, Pop Art and related styles are sometimes called neo-Dada.

Roy Lichtenstein may have defined the parameters of Pop Art better than anyone else did. Beginning in the late 1950s, he took everyday American comic strips and newspaper comics as his inspiration. The monumental scale of *Whaam!* **(fig. 16-40)** has made it a symbol of Pop painting.

## Conceptual Art

Some nontraditional forms of art can also be seen as legacies of Dada: Joseph Beuys's *Felt Suit* **(fig. 16-41)** is one example. But in general, performance art, earthworks, environmental art, and installations have almost become traditional.

*Battery Park City* **(fig. 16-42)** is a significant public artwork, the result of a collaboration between environmental artist Mary Miss, architect Stanton Eckstut, and landscape architect Susan Child. The New York City site includes rocks, natural plantings, unusual lighting, and a jetty that extends out from Battery Park in lower Manhattan into the Hudson River.

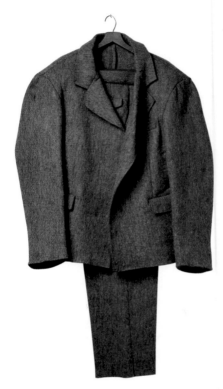

16-41 Joseph Beuys, *Felt Suit*, 1970. Felt, wood, and wire, 67" x 39" (170.2 x 99.1 cm). The Art Institute of Chicago; Twentieth Century Purchase Fund. © 2004 Artists Rights Society (ARS), New York/VG Bild-Kunst, Bonn.

16-40 **What makes this painting look so much like a comic book image? Notice its large size.** Roy Lichtenstein, *Whaam!*, 1963. Oil and magna on two panels, 68" x 160" (170 x 410 cm). Tate Gallery, London.

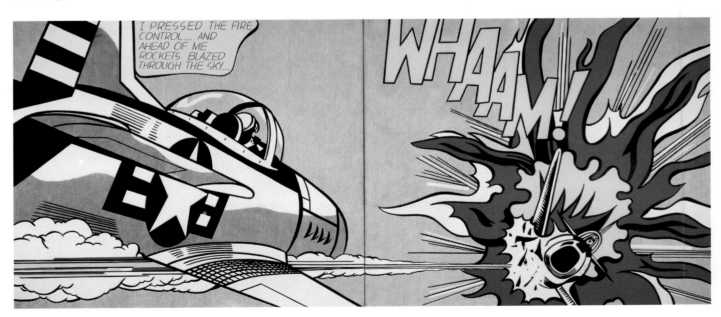

16-42 **South Cove is a calm recess along the waterfront of New York. What kind of statement does this kind of environmental art make about the environment?** Mary Miss, *Battery Park City, South Cove,* 1988. Dimensions variable. A collaboration between Miss and two architects.

## More Installation

Sandy Skoglund's *Germs Are Everywhere* **(fig. 8-41, page 192)**, Ilya Kabakov's *The Man Who Flew into Space from His Apartment* **(fig. 10-30, page 271)**, Ann Hamilton's *Lineament* **(fig. 10-31, page 271)**, Pepón Osorio's *Badge of Honor* **(figs. 16-7, page 445; 16-47, page 469)**, Xu Bing's *A Book from the Sky* **(fig. 10-29, page 270)**

## More Realism

Andrew Wyeth's *Christina's World* **(fig. 8-5, page 169)** and *Braids* **(fig. 9-16, page 218)**, Paul Georges' *Back Yard* **(fig. 2-28, page 27)**, Jean-Charles Kerninon's *Old Toy 1* **(fig. 7-27, page 164)**

## Realism

There has even been a revival of realistic art (although different from the Realism movement of the 1800s) since the 1960s. An example of this can be seen in *Blue Bird*, by Idele Weber (fig. 16-43).

16-43 **Weber paints seemingly haphazard arrangements of objects, usually garbage on the street. How can you tell that this isn't just a casual composition?** Idelle Weber, *Blue Bird,* 1972. Oil on canvas, 29" x 68" (74 x 173 cm) Seavest Collection of Contemporary American Realism, New York.

## Write About It!

Write a newspaper article based on the print *Women Working: Loom* by Hung Liu (fig. 16-45). Describe the social conditions of women in China as described in the painting. Use journalistic language, as she used imagery, to get your point across to newspaper readers.

You've learned that the artistic period known as Modernism started in the late 1800s. What about the present? Some people who study art and culture say that Modernism is past, and that we live in the **postmodern** period. They believe that the only rules left in art are those created by Modernism, and even those are being broken.

Despite the complexity and apparent lack of rules, we can make a few generalizations about the present state of art:

**It is pluralistic.** Today's art world is open to anything. Pre-modern realism coexists comfortably with Modern abstraction. Pre-modern media such as oil painting and cast metal sculpture coexist with video art, computer art, and environmental works. Whether or not Modernism is dead is not the issue. Modernism is simply one category or option in a pluralistic art world.

The sculpture of Nancy Graves (fig. 16-44) is a good example of art in the postmodern period. Her sculpture is an eclectic mix of recognizable forms, painting, and the junk sculpture associated with Pop Art.

**It is diverse in gender and culture.** Together with the acceptance of pluralism, there is a much greater acceptance of cultural diversity. The representation of minority and women artists in the art world has increased dramatically since the 1960s.

The Chinese-born artist Hung Liu (fig. 16-45) takes images from traditional Chinese painting and combines them with early-twentieth-century photographs of China taken by white tourists. Her paintings comment on the restrictive social traditions and political customs of China, both today and historically.

16-44 **Graves bases her sculptures on mostly found objects that may resemble organic forms.** Nancy Graves, *Akroterion*, 1989. Iron, stainless steel, carbon steel, aluminum, bronze, 60½" x 56" x 47" (154 x 142 x 119 cm). Art © Nancy Graves Foundation/Licensed by Vaga, New York, NY.

16-45 **Most of this artist's work focuses on dispelling stereotypes about Chinese culture, especially Chinese women.** Hung Liu, *Women Working: Loom*. Color aquatint and softground etching, Ed. 35, 40¾" x 50" (103.5 x 127 cm). © 2003 Hung Liu. Courtesy Paulson Press.

**It includes photo-related art.** Although it was invented in the 1800s, photography was not accepted as fine art until the early twentieth century. Now the majority of galleries show photography or photo-related work.

**Installations are common.** In the early 1960s, the new art form called *environments* developed, built around large-scale sculptures. Now, their descendants, called installations, or site works, are commonplace. These can vary from permanent walk-through installations, such as Oppenheim's *Bus Home* (fig. 16-46), to carefully arranged, closed, room-type settings filled with common objects, such as Pepón Osorio's *Badge of Honor* (fig. 16-47).

**It includes electronics.** Video and computer-generated art is very visible in gallery shows. Museums offer digital art online. Two major museums that have Web sites featuring digital images are the San Francisco Museum of Modern Art <sfmoma.org> and The Whitney Museum of American Art <artport.whitney.org>.

## Conclusion

This chapter reviewed developments in art from the seventeenth to the early twenty-first century. Over that period of time many changes happened, and changes became more frequent as time progressed. By 1900, art movements were coming and going so quickly that they began to overlap one another.

Think how exciting it was for people like Henri Matisse, Paula Modersohn-Becker, Wassily Kandinsky, and Pablo Picasso to be part of a cultural rebirth. Perhaps that's what's happening now. Some people who are now your age will be famous artists in the 2000s. Maybe one of them will be you.

16-46 Dennis Oppenheim, *Bus Home*, 2002. Steel, perforated steel, acrylic, concrete, point, electric lights, 36' x 100' x 50' (10.9 x 30.5 x 15.3 m). Bus transfer station at the Pacific View mall in Ventura, CA. Photo by Donna Granata.

16-47 **This installation is filled with symbolic objects, and includes a twenty-two-minute dialogue, between a boy and his imprisoned father, projected on two walls.** Pepón Osorio, *Badge of Honor* (detail; see page 445 for full installation view), 1995. Installation view at Ronald Feldman Fine Arts, April 25–June 1, 1996. Mixed media installation, dimensions variable. Courtesy the Bernice Steinbaum Gallery. An **art:21** artist

# A Contemporary Triptych

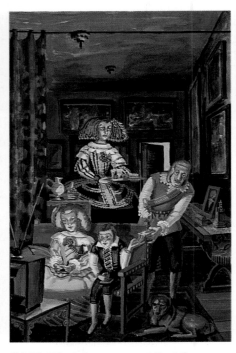

16-48 **This artwork is based on the Spanish court painter Diego Velázquez's** *Las Meninas* **(1665). What clues suggest that the triptych is a spoof of a famous seventeenth-century painting?** M. Louise Stanley, *Functional Family: Mom's Version, Dad's Version, Kids' Version*, 1993. Triptych gouache, each piece is 41" x 26" (104.1 x 66 cm). Courtesy of the artist.

## About the Artist

# M. Louise Stanley (b. 1942)

**M. Louise Stanley** uses humor to help make statements about the human condition. One way she accomplishes this is by reinterpreting and updating ancient mythology and art history. As she says, "Humor is the camouflage for the 'real' subject and a bridge to the darker, more disquieting side of the story."

Born in Charleston, West Virginia, Stanley received her painting degree from the California College of Arts and Crafts, and has long been associated with the San Francisco Bay Area art community. Women are most often the protagonists in her paintings. In fact, Stanley frequently portrays herself as the central character in the narrative.

In *Functional Family,* Stanley has dressed her subjects in seventeenth-century costumes to reflect the period of Velázquez's *Las Meninas.* The earlier painting showed a snapshot of a Spanish princess being coaxed into posing for a royal family portrait. Stanley has also borrowed from *Las Meninas* details of the artist's studio setting. These include the copies of Baroque painter Peter Paul Rubens's works hung on the walls, and even the mirror at the back of the room reflecting the image of a partially opened door.

In works such as this, the viewer recognizes the historic allusions that contain a comic twist while also being asked to examine ideas of family, gender, and other social issues.

# ① Describe What You See

When you describe an artwork, you identify the things about the work that you can see, name, and describe with certainty. You should not include opinions, evaluations, or possible meanings here.

- Attend to the descriptive title of the triptych. Note the definition of *triptych:* an artwork in three parts, arranged side by side. List the artist, date, and medium.
- Consult the artist's biography for information about the paintings' room and costumes.
- Identify things that remain essentially the same in all three paintings.
- What furnishing is absent in *Mom's Version*?
- What has been added in *Kids' Version*?
- What are family members doing in *Mom's Version*? in *Dad's Version*? in *Kids' Version*?

# ② Analyze the Way It's Organized

When you analyze an artwork, you tell how the subject matter and elements of the work have been organized by the artist. You tell how they work together.

- What art elements are emphasized in the room interior? in the figures?
- Where is the location of dark values? of light values and bright colors?
- Analyze how light sources and arrangement of figures affect similar movement in each of the three paintings.
- What is the dominant form, or center of interest, in each of the paintings?
- What is inconsistent, or humorous, about the contents of these paintings?
- Note: A partially open door is reflected in a mirror on the back wall of the room. Where might that place the viewer?

# ③ Interpret What It's Saying

Use the information from your description and analysis to help you identify the meaning of the work—what it tells you about human experience.

- What is the mood of the triptych: humorous, satirical, absurd, incongruous, etc.?
- What social issues do you feel this work advances? Think of TV's *Married with Children* or *Everybody Loves Raymond,* or the comic strip *Blondie.*
- Try a simile or metaphor to aid your interpretation. For example: Family life is like a comedy, best viewed through an open door.

# ④ Evaluate Its Success

Using your analysis in the first three steps, how would you judge the quality or success of this work?

- How do you judge the work based on the philosophy that a successful artwork makes us conscious of human needs, motives, or values?
- How inventive is the work in treatment of the issue the artist comments on?
- How do you judge the organization of elements to achieve unity and support the purpose of the work?
- How would you judge the lasting interest and enjoyment of the work for you?

**More Art!**
See page 476 for more artworks by M. Louise Stanley

**Web Link**
www.davis-art.com

## Technique Tip
Keep a written list of things that most strike you while researching your artist. Make note of any obvious style characteristics you wouldn't want to omit in your design.

## Write About It!
Reflect on style in art and how an artist establishes a recognizable style that lasts over time. How does your chosen artist's style show successful resolution of specific design challenges?

# Painting an Artist's Chair

Style in art is not always an easy thing to explain, but it can be instantly recognizable, once you know how to look. Study a well-known artist's style in order to create a painted chair that evokes the artist's stylistic essence.

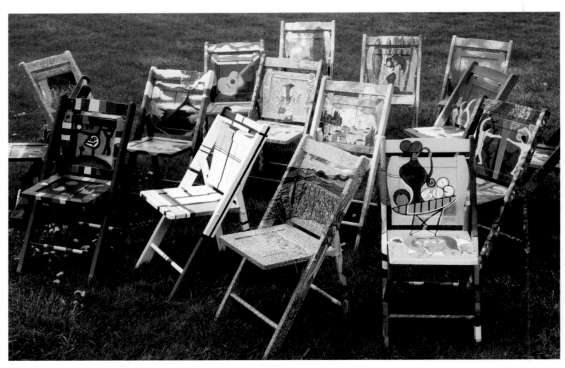

16-49 Student works, painted artist's chairs.

## Before You Begin
Team with a partner to research an artist and his or her style thoroughly, focusing on the artist's use of the elements of art and principles of design. Investigate the artist's influences and subject matter. How would you translate what you learned in your research into the decorated surface of a chair?

## You Will Need
• a chair
• white primer paint
• a pencil
• a selection of oil or acrylic paints
• various size brushes

## Create It
❶ Prepare your chair by cleaning and sanding it wherever necessary. Apply white latex paint as a primer. Give your chair two coats.

❷ Begin working with a pencil, developing images on the chair that combine the artist's subject matter and style. Keep a selection of your artist's work nearby, including images you found online and in your research books. This will serve as a reminder of the artist's style and themes while you are working.

❸ Paint the entire surface of the chair using either oil or acrylic paints. Be mindful of the overall color, composition, and methods that you are emulating. When you are finished, apply a clear varnish spray to the chair as a final coat. Let dry completely.

## Evaluate It

- How did you and your partner reflect the essence of your chosen artist's style in your work?
- Which aspect of your final piece best represents the artist you chose?

16-50 Student work, Darrel Sweet and Darren Hansen. Chair, mixed media.

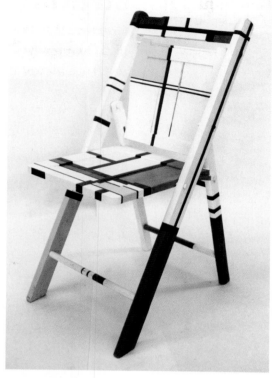

16-51 Student work, Alex Soong and Tom Laskowski. Chair, mixed media.

**Art History**

# Studio Background

Many forces help mold an artist. Time, place, culture, and education all heavily influence an artist's work. Internalizing these factors, the artist runs them through the filter of personal ability and perspective. The end result is an individual style. For example, we might be able to generally recognize Frida Kahlo's work as being from Mexico and dating from the twentieth century. Once we familiarize ourselves with her choice of a muted palette, flat brushwork, limited compositional space, and especially her surreal and often autobiographical subject matter, then we are able to quickly identify works as belonging to Kahlo.

16-52 **About a third of Kahlo's works were self-portraits. They provide great insight into her life as an invalid and as the wife of the artist Diego Rivera. How would you interpret what she is saying about herself in this painting?** Frida Kahlo, *Diego y yo,* 1949. Oil on masonite, 11 5/8" x 8 13/16" (30 x 22 cm). Courtesy Mary Ann Martin/Fine Art, New York.

# Structural Connections

Create a three-dimensional paper sculpture that incorporates what an architect is thinking when he or she plans a building structure.

## Technique Tips
- Use paper clips or clothespins to support your design during gluing.
- Craftsmanship is key to this process. Keep your white form very clean!

16-53  Student work, Vera Petrovics. Paper, 18" x 18" x 13" (45.7 x 45.7 x 33 cm).

## Before You Begin
Understand how an environment can inspire form in architecture. Research both Frank Lloyd Wright's Guggenheim in New York (figs. 11-41, page 311) and Frank Gehry's Guggenheim in Bilbao, Spain (see Studio Background, page 475).

## You Will Need
- white vellum paper
- scissors and/or X-Acto knife
- white glue and/or rubber cement
- watercolor paints, colored pencils, graphic pencils

## Create It
❶ Think about how the exterior of a building can entice visitors. Sketch out some ideas for a structure that would be so interesting, people would want to look inside. Keep in mind the flowing, organic forms used by Gehry.

❷ Compose text, images, or graphics on the white vellum paper as desired. You may wish to add a quote from a well-known architect or artist to add variety and meaning to your form.

❸ Use the vellum paper to create a cylindrical structure that is both functional and visually interesting. Use white glue or rubber cement to hold it in place.

## Evaluate It
- How does your structure present an exciting exterior and also invite the viewer to look at the inside?
- Would your structure make a good building? Why or why not?

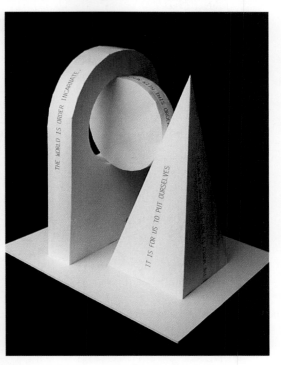

16-55  Student work, Andrew Bolen. Paper, 18" x 13" x 13" (45.7 x 33 x 33 cm).

16-54  Student work, Diana Wojcik. Paper, 18" x 15" x 9" (45.7 x 38.1 x 22.8 cm).

## Write About It!
What qualities do well-designed books share with successful buildings? Imagine that you are the publisher of a book on the topic of your choice. In a paragraph, describe how you would go about designing a cover for your book that will make readers want to buy it and read what's inside.

### Art History

## Studio Background

Frank Gehry understands that a museum must be functional. The huge exterior sculptural forms of the Bilbao Guggenheim translate into large open interior spaces that are well suited to the scale of the modern art that the building houses. A museum also must have visitors, so there is a clearly indicated entryway amid the forms. A ramp and plaza emphasize the entrance. The main door is a glassed element that is wedged between two wings of the building. While Gehry creates a striking exterior that is a work of art in its own right, he also has fulfilled his obligation to encourage visitors to explore the interior.

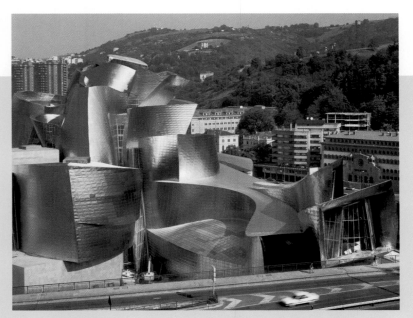

16-56  **While most architects use cut pieces of cardboard or foam core for their models, Gehry begins his projects using crumpled pieces of colored paper to create the prototypes for his buildings. Why is model making an important part of architectural design?** Frank O. Gehry, Guggenheim Museum in Bilbao. Photo by Timothy Hursley.

16-57  M. Louise Stanley, *The Three Fates: Measuring Time*, 1993. Acrylic on canvas, 72" x 96" (182.8 x 243.8 cm). Courtesy of the Artist.

16-58  M. Louise Stanley, *Trompe L'oeil*, 2002. Gouache, 19" x 26" (48.3 x 66 cm). Courtesy of the Artist.

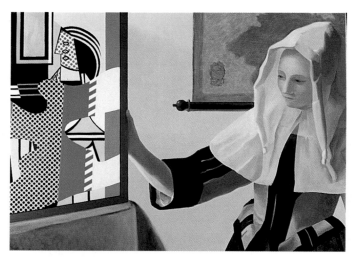

16-59  Terri Priest, *Vermeer & Lichtenstein VIII*, 2001. Oil and acrylic on canvas, 36" x 48" (91.4 x 121.9 cm). Vermeer's "Young Woman with a Jug" from the Metropolitan and Roy Lichtenstein's "Reflection on Painter and Model." Courtesy the artist.

16-60  Anda Klancic, *Embraced by Nature*, 1998. Viscose, flax, cotton polyester, metal filament, PVA fabric, 27½" x 10½" x 9½" (70.1 x 26.9 x 24 cm). Courtesy Browngrotta Arts.

# Chapter Review

## Summary

In the 400-plus years between the beginning of the seventeenth century and today, many changes took place in art as artists responded to changes in society.

In the 1600s, the ornate *Baroque* style developed, led by Rubens. Changes in church attitudes, brought on by the *Reformation,* encouraged Dutch artists like Vermeer to paint everyday scenes. One hundred years later, the Enlightenment turned attention to science. Artists of the time created lighthearted *Rococo* images for the wealthy. By the end of the 1700s, however, the rise of *Neoclassicism* had returned art to more serious subject matter.

*Romanticism* emerged as a response to the horrors of war. *Impressionists* were fascinated by the effects of light on outdoor scenes. The works of the *Post-Impressionists* took art another step away from traditional realism.

During the first half of the twentieth century, many new styles and movements emerged, including Fauvism, *Cubism,* and *Surrealism.* After World War II, the United States became a major player in the art world because of the innovations of the *Abstract Expressionists.*

Art has so many styles and movements today that it is difficult to identify a dominant direction.

## Review Questions

1. **Recall:** What was the primary subject matter of Dutch paintings of the 1600s?

2. **Understand:** Describe Rococo art.

3. **Apply:** Describe or create a color scheme for a Fauvist painting.

4. **Analyze:** Compare and contrast Rubens's *The Holy Family* with Kirchner's *Street, Berlin.* Comment on color, use of space, shading, and mood.

5. **Synthesize:** Design a poster that persuades viewers to support or become an artist in one of the art styles explained in this chapter. Your poster should explain why the style is important, powerful, and worthy of attention. Imitate the style to illustrate the poster.

6. **Evaluate:** Choose a portrait, a landscape, and a 3-D work on any subject from this book that best express your own ideas of what art should be. Explain why you chose these three artworks, and what they mean to you.

## For Your Portfolio

What evidence of your personal artistic growth can you see when you look at the works in your portfolio? Use these works to discover where your experience in art has taken you. Select four artworks from your portfolio, and write two or three paragraphs that explain how you have grown as an artist.

## For Your Sketchbook

Look through your sketchbook for evidence of a personal style or a change in the way you work. For example, what have you done consistently? Do you seem to favor certain colors? What changes do you see in the way you sketch? Use a page in your sketchbook to comment on what you discover.

## Electronic Research

Conduct an Internet search using the words *contemporary art museum.* Thoroughly explore the first ten Web sites that you find and then rank them in order of your preference. What characteristics do you find most appealing? How do they present their criteria for exhibition or explain what they consider to be contemporary art? Which site would most encourage you to visit the actual museum? Explain your reasons for your choice.

## Going Further

What does a style look like? Select a decade, for example, the 1920s, and document the look of clothing, transportation, household appliances, dwellings, etc., that dominated that decade. Make sketches or photocopies and create a display with written descriptions to characterize the predominant style of that decade.

# Conclusion

You've come to the end of your text, but the story of art certainly isn't over. The impulse to create visual images is so strong that our story began with images made on cave walls by prehistoric people, and continued through the cultures of the world, past and present.

The future will provide additional chapters. We began with questions about what art is, and how and why it is created. In the process of answering those questions, you've learned about the elements of art and principles of design, and how the artist uses them to create art. You've learned about a wide variety of art forms, media, and techniques, and you've seen how artists and architects use them to express ideas and emotions.

Studio activities gave you opportunities to explore your own ideas while using the elements and principles and some new art media. You were introduced to the art history of both Western and non-Western cultures: you learned where, when, and why artworks were created, and cultural influences on artists and art styles.

You've also learned about art-related careers, and the importance of developing a strong working portfolio of your own studio work, should you

Tom Coleman, *Untitled.* Ceramic collage wall mural mounted on aluminum back, glazed with various bright-colored barium glazes, low fired porcelain clay, fired to cone 1 in oxidation, approx. 24" x 48" (61 x 121.9 cm). Courtesy of the artist.

Jessie Oonark (Inuit), *Man and Woman with Decorated Cloth*, 1979. Colored pencil and graphite on wove paper (watermark: "BFK RIVES/FRANCE"), 30" x 20" (76 x 56 cm). National Gallery of Canada, Ottawa; Gift of the Department of Indian Affairs and Northern Development, 1989. The Public Trustee for Nunavut, estate of Jessie Oonark.

Bruno Andrade,
*Days Ahead,* 2003.
Acrylic on panel, 14" x 18"
(35.6 x 45.7 cm). Buchanan
Gallery, Galveston Island,
Texas. Courtesy of the artist.

intend to concentrate in the visual arts at the college level or to pursue an eventual career in an art-related profession.

Throughout the text, you have also practiced art criticism. The criticism step-by-steps were concerned with questions such as: What should I look for in the work? How is it organized? What does it mean? How successful is it?

Most importantly, you've discovered that the nonverbal language of art can communicate ideas and emotions. Now that you have completed the program of which this text is a part, we are certain that you not only know more about art, but are also better prepared to continue learning from it.

Art has been an important part of human affairs over the past three thousand years. The diversity of forms it has taken with the development of new technologies suggests that the art of your future will continue to expand its media, techniques, and ways of communication.

Art is a mirror that reflects pleasures you might otherwise never enjoy. We hope that you'll continue to use art as a means of learning about and enjoying the world around you.

Kuna, Mola. From the Collection of the Textile Museum of Canada.

# Part Five

# Resources

Miriam Shapiro, *I Am Dancing as Fast as I Can*, 1984. Courtesy of the artist.

# Student Handbook
## A Guide to Studio Concepts and Techniques

## Constructing a Viewfinder

**1** A viewfinder is a piece of paper with a hole in it that you can use to plan artwork.

**2** Look at a scene or subject through a viewfinder to notice shapes formed by the edge of the viewfinder and subject, and to determine which parts of a subject are most interesting.

**3** You can also construct a viewfinder with two **L**-shaped pieces of paper or cardboard. By sliding these **L** shapes together or moving them apart, you can see the shape and proportion of the area around your subject.

## Enlarging an Artwork

**1** To change the scale of an artwork, making it larger but keeping it in the same proportions as the original art . . .

**2** Draw a grid of lines over your art with a ruler. Or, draw a grid on a sheet of acetate and lay that over your artwork.

**3** Draw a second pencil grid on a larger sheet of paper. Make squares on this grid proportionally larger than the first grid. For example, to double the size of a drawing, space lines one inch apart in the first grid, but two inches apart in the larger grid. For a mural, the one-inch squares might represent one-foot squares on a wall.

**4** Carefully copy the contents of each square on the small grid into each corresponding square on the larger grid.

## Contour Drawings show the outlines of a subject

### Trust your eyes!

Look only at your subject, not your paper, when making a **blind contour drawing**. You might slightly turn your back to your paper as you sketch, or draw inside a bag so you can't see your paper. Try using one continuous line—once you begin drawing, don't lift your pen off the paper. Go slowly, noticing the little ins and outs in your subject's contour. These drawings usually aren't completely realistic, but they often suggest the essence of the subject.

Use the same technique for **modified contour drawing** that you use for blind contour drawings, but every once in a while pause to check where your pen is. Draw only while looking at your subject.

**Cross contour** lines are lines that run around an object, defining its shape.

## Gesture Drawings capture movement in a figure

Look for lines in the body showing the movement and stretch of a figure. Often, clothing folds follow these lines.

Rounded scribbles can suggest body parts and anatomy.

Because gesture drawings are drawn quickly, thirty seconds or less for a figure, artists use them to capture action in moving subjects.

## Shading

This **value scale** shows value gradations from black to white. Try creating your own value scales with various media.

Values can make a flat shape look three-dimensional. Different kinds of **pencil** lines can create shadows and suggest a form. Try blending or smudging soft pencil lines with an eraser, stomp, or tissue.

**Charcoal** is softer than pencil, making it easier to blend, shade, and erase.

### Pencil Modeling Techniques

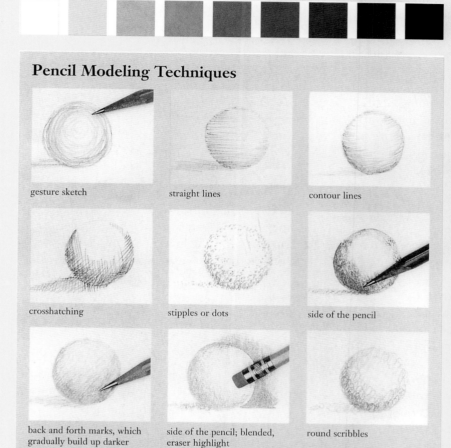

gesture sketch

straight lines

contour lines

crosshatching

stipples or dots

side of the pencil

back and forth marks, which gradually build up darker

side of the pencil; blended, eraser highlight

round scribbles

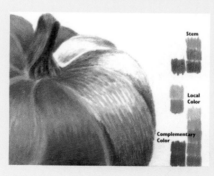

Blend **colored pencils** to create lights and darks, and suggest form. Add a color's complement in dark areas to create shadows.

Use a variety of line types when you shade with **ink**.

### Ink Modeling Techniques

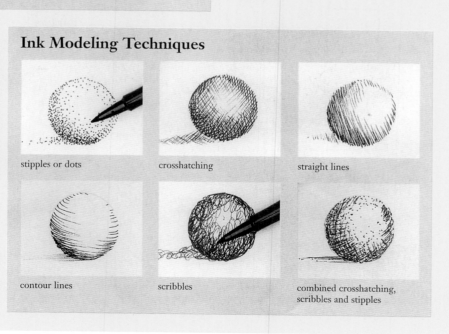

stipples or dots

crosshatching

straight lines

contour lines

scribbles

combined crosshatching, scribbles and stipples

# Linear Perspective

Extended parallel lines appear to vanish at the same point on the horizon.

## One-Point Perspective

Parallel lines vanish to one point.

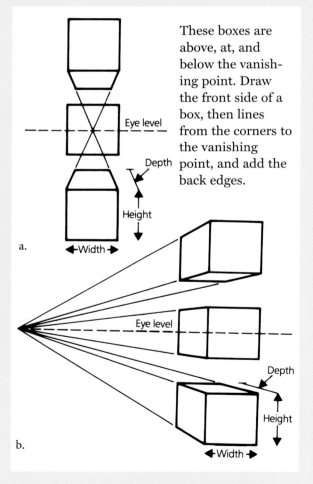

These boxes are above, at, and below the vanishing point. Draw the front side of a box, then lines from the corners to the vanishing point, and add the back edges.

Eye level

Depth

Height

a.

←Width→

Eye level

Depth

Height

b.

←Width→

## Two-Point Perspective

Parallel lines vanish to two points.

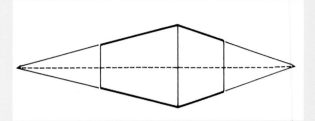

To draw a two-point perspective view of a box, draw a horizon line and add widely spaced vanishing points. Beginning with the front corner of the box, draw the lines in the order that they are numbered.

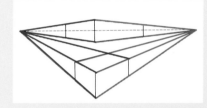

Each set of parallel lines are in the same color and extend to the same vanishing point.

## Three-Point Perspective

Parallel lines vanish to three points.

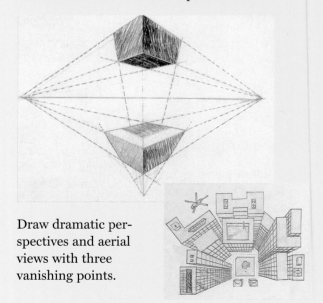

Draw dramatic perspectives and aerial views with three vanishing points.

# Drawing Figures

## Body Proportions

- Adult figures are usually between seven and eight heads tall.

- Shoulders are usually the width of three heads.

- Elbows and waist are about three heads down.

- Wrists line up with the top of the legs.

To help establish correct body proportions, mark the head heights on your paper before you begin to draw.

## Facial Proportions

- Heads are oval, slightly wider at the top.

- Eyes are in the middle of the head.

- An eye width fits between the eyes and on each side of the eyes.

- Divide the distance from the eyes to the chin in half. The nose is a little above that line and the mouth, a little below.

- The top of the ears and eyes line up, as do the bottom of the ears and nose.

- The distance from the tip of the nose to the front of the ear is about equal to the distance from the back of the head to the front of the ear.

## Foreshortening

To make parts of the figure seem to recede and look three-dimensional, draw the closer parts of the body larger than those farther from the viewer.

The tips of the fingers are drawn larger than the parts of the fingers that are farther away.

## Color Schemes for Mixing Paints

**Primary colors:** red, yellow, and blue. Mix these pigment colors to produce the rest of the colors. (Magenta, cyan, and green are the primary colors when mixing light, such as on a computer.)

**Secondary colors:** green, violet, and orange are made by mixing two primary colors.

**Tertiary or intermediate colors:** yellow-green, blue-green, red-violet, blue-violet, red-orange, yellow-orange are made by mixing a secondary color with an adjacent primary color.

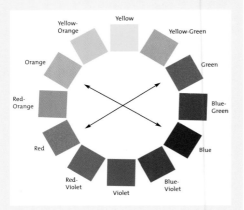

**complementary:** colors opposite each other on the color wheel such as red and green or yellow and violet.

**warm:** colors, such as red, orange, and yellow, that suggest warmth or heat.

**cool:** colors, such as violet, blue, and green, that remind people of cool places, things, and feelings.

**neutral:** colors, such as black, white, gray, or brown, that are not associated with the sprectrum.

**monochromatic:** the range of values of one color (monochrome means "one color").

**analgous:** colors that are next to each other on the color wheel; the colors have a common hue, such as red, red-orange, and orange.

**split complement:** a color and the two colors on each side of its complement, such as yellow with red-violet and blue-violet.

**triad:** any three colors spaced at an equal distance on the color wheel, such as the primary colors (red, yellow, blue) or the secondary colors (orange, green, violet).

## Intensity Scale

When complementary colors are blended together, they become duller or less intense. In this gradient the complementary colors red and green at each end are intense or bright. As each color is mixed with more of its complement, it becomes less intense. The center, with equal amounts of red and green, is a dark gray.

## Value Scale

This gradient shows dark to light values of red. Add white to a color to create tints and black to create shades.

## Transparent Watercolor

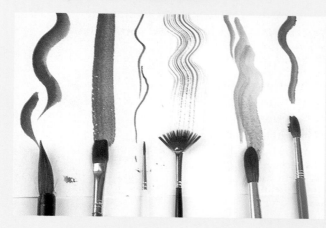

### Brushstrokes

Use different kinds of soft bristle brushes to create a variety of strokes.

With a pointed watercolor brush, press hard for a wide stroke and lift up for a thin line.

### Washes

Create a wash by pulling a bead of wet color on the tip of your brush across the paper. Washes may be an even color across a large area, or graduated—going from dark to light—by gradually adding more water to your brush as you paint.

### Wet on Wet

Paint your paper with clear water, and while it is still damp, brush watercolors over it. Control running by tilting the paper. Let the white paper sparkle through in places.

### Tempera

Paint large areas of color first before adding fine details. Experiment applying tempera with different types of brushes and strokes.

### Acrylic

Acrylic paints may be applied in thin and transparent layers or in thick-textured impastos.

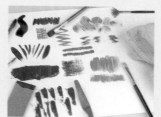

### Oil

To create thin washes, try diluting oil paints with medium or thinner such as an odorless turpentine substitute. You may sketch an under-drawing with a thin wash or pencil and then add layers of oil paint in transparent washes or paint more thickly with a stiff brush.

If you add textured impastos with a pallet knife, mix an extender with your oil paint to make your paint go farther and make it dry faster.

## Relief Prints

Woodcuts and linocuts are relief prints. Raised areas of the printing block hold the ink.

**1** Place your design and carbon paper on top of your linoleum or wood block, or black the back of your design with a dark
pencil. Trace over your design to transfer the image to the printing block. Any lettering should be backward on the printing block.

**2** With wood-carving or linoleum gouges, carve out the areas that will not print. Always cut away from your fingers. A bench hook can help you safely hold your block as you carve.

**3** Roll print-ing ink on a flat surface until it is tacky, and then roll ink on the printing block surface.

**4** Place a sheet of paper over your inked block and rub the back of the paper to trans-fer ink to the paper. Carefully pull the printed paper away

## Intaglio Prints

Engravings, etchings, and aquatints are intaglio prints. Grooves in the print plate hold the ink.

### Etching

**1** Cover a metal plate with a ground (such as asphaltum). Scratch the lines of your image into this ground with a sharp pointed tool to expose the metal.

**2** Place the plate in diluted acid. The acid etches any exposed metal. Remove the plate from the acid when the grooves are deep enough to hold ink. Remove the ground with solvent.

**3** Cover the plate with ink. Rub the ink into the grooves with a soft cloth.

**4** Wipe the plate's surface clean, leaving ink in the grooves. Remove the last traces of ink with the side of your hand.

**5** Set your inked plate face up on the press platen. Lay a damp piece of paper over the plate and cover with a felt pad. As you roll this sand-wich through the
press, the ink is pressed from the grooves onto the paper. Pull the paper from the plate.

## Lithographs

These are printed from a flat surface.

**1** On a special lime-stone slab or metal plate, draw or paint a design with a greasy crayon or ink (tusche).

**2** Treat the surface of the stone with a solution of gum arabic and nitric acid so that the image will attract greasy ink. Dissolve the original drawing's ink with turpentine.

**3** Keep the printing surface wet during printing. Water will collect on the blank areas.

**4** Roll ink over the print surface. Water repels the ink on the wet areas so that the ink only sticks to the marks of the original drawing.

**5** Place paper on top of the stone and cover with a backing sheet and a tympan (stiff, slick-surfaced board). Roll through the press. Notice as you pull your paper from the stone that the image is printed in reverse.

## Screen Prints

or serigraphs, are stencil prints.

**1** Stretch a thin fabric such as silk or polyester over a frame. Put a stencil on the fabric to block the ink. The stencil may be paper, a special blocking film, a photographic emulsion that hardens in bright light, or a painted screen filler. Lay a piece of paper under the screen.

**2** Place ink along one side of the screen. As you pull the ink across the screen with a squeegee, the ink is pressed through the unmasked area of the silk screen onto the paper.

## Matting and Signing a Print

Number, title, and sign your prints in pencil just below the lower edge of the print.

Print edition number. The first number refers to the order in the series, and the number after the slash shows how many prints were in the series. For example, this print was the second print in a series of four.

mat

2/4   Title of work   *signature*

Mat or mount prints so that the signature and all four sides of the print are visible.

# Clay Sculpture

## Modeling Figures

Model individual body parts and join securely together or pull head, arms, and legs from a clay ball. Add textures and details.

## Relief Sculptures

1 Carve away areas of a clay slab with clay tools.

2 Press and pull clay to mold recesses and extensions.

3 Press objects into the slab to create textures.

4 Add small coils and clay balls and scratch lines into the surface to create a variety of textures.

## Coil Pots and Forms

1 Roll clay coils to about the thickness of your thumb.

2 Form a flat base. Score edge. Add slip and press a coil onto the scored edge of the base.

3 Add more coils.

4 Smooth coils together with your fingers or a clay tool.

## Slab Forms

1 With a rolling pin, roll clay flat between two pieces of wood that are the same thickness.

2 Cut the slab into shapes to join together. Score edges of shapes.

3 Join edges with slip and reinforce inside of joints with coils.

4 Pinch outside edges together and smooth.

## Pinch Pots and Forms

1 Press your thumb into a ball of clay.

2 Widen the indentation by slowly rotating the pot as you pinch the clay between your thumb and fingers.

3 Smooth the inside and outside of the pot with a scraper.

## Join Two Pinch Pots to Create a Ball

1 Score the edge of each pot and add slip.

2 Press two pots together. Reinforce the seam where they join with a coil.

3 Smooth edges together.

# Sculpture

## Wire Armature

Create wire armatures to support sculpted figures. Attach the wire firmly to a piece of wood. Add oil-based clay, wax, or plaster to the armature to form a figure.

## Papier-Mâché

Begin with an armature made of wire, folded paper or foil, or recycled objects.

Affix paper with tape to fill out your sculpture's form.

Tear strips of newspaper or paper towels.

Dip paper strips into paste (such as thinned white glue, wallpaper paste, acrylic medium, or liquid starch). With your fingers, squeegee excess glue from the strips.

Cover the taped form with at least two layers of the papier-mâché strips.

Paint your dried sculpture with acrylic or tempera paint.

## Carved Forms

Try carving forms from materials such as balsa wood, soap, plaster of Paris, clay, and alabaster. Carve away the parts of your block that are not part of your sculpture.

## Paper Sculpture Techniques

Use these techniques to create freestanding paper sculptures or embellish papier-mâché forms.

## Wood Sculpture

Select wood shapes, scraps, or branches to join together with glue or nails. Use a rasp or saw to change the shape of some pieces.

## Photography

### Focal Length

This is the distance between the film and the camera lens. The farther the film is from the lens, the larger the subject appears in the frame.

Scene being photographed

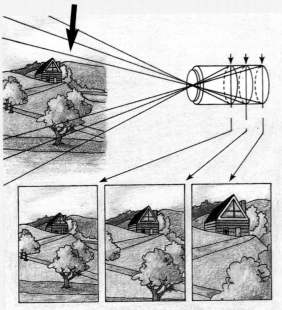

Shortest focal length        Longest focal length

### Film Selection Guide

In general, faster films are grainier than slower films.

| Film Speed (ISO number) | Subject |
|---|---|
| 100 | bright sunlight |
| 200 | sunlight, flash |
| 400 | flash, indoors, action |
| 800 | low light, action |

## Storing Your Artwork

### Making a Portfolio for Your Artwork

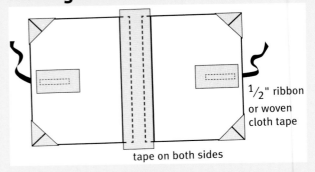

1/2" ribbon or woven cloth tape

tape on both sides

**1** Place two pieces of 18" x 24" cardboard about 1" apart as in the diagram. Tape the inside and then the outside with colored tape.

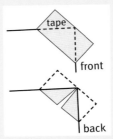

**2** Cover the corners with tape.

**3** Add ribbons to tie closed.

### Making a Box for Your Artwork

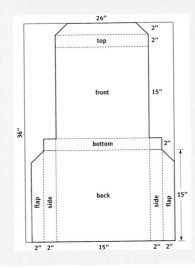

Draw this box pattern on 24" x 36" cardboard. Cut on the solid lines and score the dotted lines. Fold the box together and glue side flaps.

## Matting Your Artwork

**1** On the back of your artwork, draw a line in light pencil ¼" in from the edges. To find the center point of your art, lightly draw pencil lines dividing your paper into four equal parts.

**2** Cut poster or mat board 6" longer and 6" wider than your artwork. Find the center of your mat by drawing a vertical and horizontal line bisecting each edge on the back of the mat.

**3** Place your artwork facedown on the back of the mat board and line up the pencil lines.

Tack your art to the mat with a few small pieces of tape. Trace around the outer corners of the artwork.

**4** ¼" in from each corner of your artwork, where the outer guidelines cross, press a pin through your artwork, into the mat board, and through to the front of the mat.

**5** Place the mat face up on a sheet of cardboard. Lay a metal ruler or yardstick between two holes and parallel to the mat edge. Cut along the edge of the ruler with a sharp mat knife. Repeat this, cutting between the other pinholes to cut the mat "window."

**6** Remove the "window." Align your artwork on the back of the mat over the opening. Tack with tape, check alignment, and add more tape.

**7** Your completed mat should protect and enhance your artwork.

## Mounting Your Artwork

**1** Center your artwork on a heavy paper or board. Measure to check that the borders are even. With pencil, lightly trace around artwork corners.

**2** Put glue or double sided-tape on the back of your artwork.

**3** Position your artwork inside the corner marks and press it onto the mount.

**4** Print a label with your name and other information about the artwork, such as a title, date, medium, your grade, and your teacher's and school's name.

# Glossary with Pronunciation Guide

**abstract** Describing an artwork based on an identifiable subject, but with few or no details, and whose visual elements are simplified or rearranged.

**abstract art** Art stressing the form of its subject rather than its actual appearance. The subject is broken down into elements: line, shape, etc., not necessarily resembling the subject itself.

**Abstract Expressionism** A twentieth-century style in which feelings and emotions are emphasized. Accident and chance are stressed rather than accurate representation of subject matter.

**abstract line** Lines found in very abstract and nonobjective artworks that do not describe anything. They are meant to be seen only as lines.

**acrylic paint** A synthetic painting medium in which pigments are mixed with acrylic, a plastic emulsion that acts as a vehicle and a binder.

**aerial perspective** The diminishing of color intensity to lighter and duller hues to give the illusion of distance.

**aesthetic** (es-*thet*-ik) The theory of perceiving and enjoying something for its beauty and pleasurable qualities. This theory tries to explain and categorize our responses to art forms.

**aesthetic experience** The experience of seeing and enjoying something for its own sake, or for its beauty and pleasurable qualities.

**analogous colors** Colors that are next to each other on the color wheel and are closely related, such as yellow, yellow-orange, yellow-green, and green.

**analysis** The examination of the relationships among the facts (objects, people, shapes, colors) in an artwork.

**approximate symmetry** The use of forms that are similar yet different, on either side of a vertical axis.

**aquatint** A form of intaglio printmaking in which resin is melted on the metal plate to resist the biting action of acid so that tonal areas can be produced when the plate is printed. May be combined with engraving and etching on the same plate.

**arabesque** (*air*-uh-besk) A flowing, intricate pattern of stylized organic motifs arranged in symmetrical designs.

**arcade** A series of repeated arches, in some cases supported by columns.

**arch** A masonry construction in which a number of wedge-shaped stones, held in place by pressing against one another, form a semicircular curve.

**architect** A person who designs and directs construction of buildings and environmental areas.

**architecture** The art and science of designing and constructing buildings.

**aristocracy** A privileged class whose wealth and privileges are inherited from previous generations.

**armature** A framework used to support material being modeled in sculpture.

**art** Produced or intended primarily for aesthetic purposes rather than utility. Any of the art forms, such as sculpture, painting, or music.

**art criticism** A systematic discussion of the characteristics of an artwork, usually involving four stages: description, analysis, interpretation, and evaluation.

**art education** An area of education that provides programs in art production, art history, aesthetics, and art criticism for students in the public schools.

**art elements** The sensory elements including line, shape, form, color, value, space, and texture that are used to create artworks.

**artist** A person who makes artworks and is skilled in composing subject matter and the art elements with a variety of art materials and procedures.

**Art Nouveau** A decorative style of art, popular in Europe and America from the 1880s to the 1930s. This style is usually characterized by flowing lines, flat shapes, and vines and flowers.

**Arts and Crafts Movement** A movement in architecture and decorative arts flourishing in England and the United States from about 1870 to 1920 and characterized by simplicity of design, hand-crafted objects, and use of local materials.

**artwork** An object or performance that satisfies conditions or requirements recognized by the art world as necessary for an artwork.

**assemblage** (ah-*sem*-blij) An artwork composed of objects, parts of objects, or materials originally intended for purposes other than art.

**asymmetrical balance** A feeling of balance attained when the visual units on either side of a vertical axis are actually different but are placed in the composition to create a "felt" balance of the total artwork.

**balance** A principle of design referring to the arrangement of visual elements to create stability in an artwork. There are four balance arrangements in art: asymmetrical, symmetrical, approximately symmetrical, and radial.

**Baroque** (bar-*oak*) A period and style in seventeenth-century European art in which painters, sculptors, and architects used dramatic movement, light, soaring spatial illusions, and ornate detail to encourage emotional involvement.

**barrel vault** A semicircular masonry ceiling.

**bas relief** (*bah* ree-leef) See *low relief.*

**batik** (ba-*teek*) A method of dyeing cloth using removable wax to repel the dye on parts of the design where dye is not wanted.

**Blaue Reiter, Der** (*blah*-way *right*-er, dehr) (The Blue Rider) A group of Munich artists including expatriates such as the Russian Wassily Kandinsky and the Swiss-born Paul Klee. Its concerns were with presentation of subjective feelings toward reality, and imagination. This group greatly influenced the development of modern art.

**Brücke, Die** (*broock*-eh, dee) (The Bridge) A small group of German artists, led by Ernst L. Kirchner, who emphasized violent color and distortion of features in their paintings and woodcuts in protest of the economic and social conditions in Germany prior to World War I. Emil Nolde was also a member.

**Buddha** (*boo*-dah) Any Buddha sage who has achieved enlightenment in accordance with the teachings of Gautama Siddhartha, founder of Buddhism.

**Buddhism** (boo-dizm) A religious belief based on the teachings of Gautama Siddhartha, who held that suffering is a part of life but that mental and moral self-purification can bring about a state of illumination, carrying the believer beyond suffering and material existence.

**calligraphy** Handwriting or letters formed by hand. Elegant penmanship usually featuring a flowery, precise line.

**came** Channeled lead strips, either H- or U-shaped, used in stained glass windows to join the pieces of glass together. The U shape is used on outer edges of the design and the H for all other purposes.

**caricature** A likeness of a person, distorted by exaggerated features or mannerisms.

**cartoon** A comic strip or caricature showing some action, situation, or person. May be single or multiple frame. In painting, a full-size preliminary drawing from which a painting is made.

**carving** The process of producing a sculpture by cutting, chipping, or hewing wood or stone.

**casein** (*kay*-seen) A type of paint made from milk or cheese protein, used to achieve a transparent or opaque effect.

**casting** The process of making forms by pouring a fluid substance such as molten metal, liquid plaster, or plastic into a mold.

**celadon** (*sel*-a-dawn) A type of pottery having a pale green glaze, originally produced in China.

**ceramics** Objects made of clay and fired in a kiln to a permanent form. Ceramics are often decorated with glazes and fired again to fuse the glazes to the clay body.

**chalk** A stick of color including a binder, preservative, chalk, and pigment, mixed with water, formed into sticks, and dried.

**chiaroscuro** (key-ah-roh-*skew*-roh) From the Italian meaning "light-dark." The use of value contrasts to represent the effects of light and shadow.

**cire perdue** (sear per-*dew*) See *lost-wax process.*

**classical** The art of ancient Greece produced in the 400s and 300s BCE. Any art form influenced by ancient Greek or Roman examples.

**cloisonné** (kloy-soh-*nay*) A decorative enameling technique in which thin metal strips are attached to a metal base to outline design areas, or cloisons, which are then filled with enamels and fired.

**close-up** In the graphic arts (including comic strips), figures and objects made large to appear close to the viewer. Also, a close film shot.

**closed form** Forms in painting and sculpture that have few or no openings, or negative shapes.

**closure** The tendency to complete partial forms or shapes by seeing lines that do not exist.

**collage** A two-dimensional composition made by gluing various materials such as paper and fabric, etc., on a flat, firm surface. Introduced by the Cubist artists Picasso and Braque.

**color** An art element with three properties: hue, value, and intensity. Also, the character of surfaces created by the response of vision to wavelengths of reflected light.

**color harmonies** Combinations of colors that are considered satisfying or that produce certain effects.

**commemorative art** Art that is produced in remembrance of something or someone.

**communications design** Careers, such as graphic design, cartooning, medical illustration, and photojournalism, that communicate a wide variety of subjects to an intended audience.

**complementary colors** Two colors that are directly opposite each other on the color wheel, meaning they are in extreme contrast with each other.

**composition** The act of organizing the elements of an artwork into a harmoniously unified whole.

**computer art** Electronic art made up of pixels (tiny dots on the computer screen).

**concave** Surfaces that are hollow or curved inward.

**conceptual art** A style emphasizing the idea behind the work of art rather than the work itself. Artists try to de-emphasize the artwork in favor of the concept in order to demonstrate that the conception of the work is more important than the product.

**conditions** Requirements that philosophers and critics of art generally agree something must fulfill to be an artwork.

**Confucianism** The teachings of Confucius. Confucius advocated humility, patience, and respect for nature and he recommended taking an active role in society.

**conservator** A career in which the person is dedicated to caring for a museum's collection of artworks, as well as finding out the age of artworks, determining whether they are authentic or fake, and deciding how to clean and preserve them.

**construction** A sculpture built by connecting several or many parts to one another. The parts may be made of a single material or of a variety of materials.

**contemporary art** Artworks created in our own time.

**continuation** A strategy for achieving unity in an artwork in which an element or series of elements that occur through a composition may direct the viewer's attention from one place to another.

**contour line** Lines that define the outer edges of forms and surfaces within a form, such as shapes or wrinkles and folds. Used in contour drawings to suggest depth in addition to height and width.

**contrast** A principle of design that refers to differences between elements such as color, texture, value, and shape. A painting might have bright colors, contrasted with dull or angular shapes, contrasted with round ones.

**converging lines** In linear perspective, lines that represent the parallel edges of an object; these may be drawn to converge to a single vanishing point.

**convex** Surfaces that curve outward.

**cool colors** Those colors in which blue is dominant, found on the right side of the color wheel.

**corbeled arch** (*kore*-bell-d) An arch constructed from an overlapping arrangement of stones, each layer projecting a bit beyond the row beneath it, and held in place by the pressure of the stones against one another.

**Corinthian** One of the classical styles of ancient Greek architecture featuring tall, slender columns topped with ornate capitals.

**Counter-Reformation** The reform movement in the Catholic Church following the Reformation.

**crafts** Works of art that may be expressive, but generally have utilitarian purposes. This includes fiber arts, ceramics, metalsmithing, fabrics, furniture, basketry, etc.

**crosshatching** Shading created by crossed parallel lines.

**cross vault** A masonry ceiling consisting of two barrel vaults intersecting at right angles.

**crusade** A military expedition of Christian knights against the Muslims in Palestine and/or other parts of the Near East from the eleventh through the thirteenth century.

**Cubism** A twentieth-century art movement developed mainly by Picasso and Braque in which the subject matter is broken up, analyzed, and reassembled in an abstract form, emphasizing geometric shapes.

**culture** The attitudes, values, beliefs, patterns of behavior, social organization, and concepts of reality of a given people that persist through time.

**cultural enrichment** Careers, such as fine art, crafts, teaching, and museum education, that provide art-related goods and services to society.

**curator** A career in which the person is responsible for the purchase of new artworks, developing and overseeing exhibitions, and preparing materials to help announce and advertise exhibitions.

**Dada** (dah-dah) A European artistic and literary movement (1916–23) that flouted conventional aesthetic and cultural values by producing works marked by nonsense, travesty, and incongruity.

**decorative arts** A collective term that includes art forms such as woodwork, furniture, ceramics, glass, jewelry, textiles, and metalwork.

**description** A listing of the facts in an artwork, such as objects, people, shapes, and colors.

**descriptive lines** Lines created with a variety of tools; can be outlines, contour lines, single lines, or hatching.

**design** The plan the artist uses to organize the art elements (line, shape, form, space, etc.) in a work of art to achieve a unified composition.

**dome** A hemispherical vault or ceiling over a circular opening.

**Doric** The earliest of the classical styles of ancient Greek architecture.

**drawing** A likeness made on a surface, using mostly lines.

**dynasty** The period of time when a certain family ruled.

**earthenware** Ceramic ware that is made from natural clay. It is soft, porous, and fired at low temperatures.

**earthworks** Sculptural forms made primarily of earth, rocks, and plants.

**eclectic** Borrowing from many sources, particularly of architecture, which imitates styles of the past.

**edge** Where one shape ends and another begins, resulting in implied line.

**elements of art** Line, shape, form, color, value, space, and texture. The building blocks the artist works with to create an artwork.

**ellipse** An oval shape produced by drawing an elongated circle so that it appears to be viewed from an angle. A foreshortened circle that is longer in one dimension than it is in the other.

**emphasis** A principle of design in which one element, or a combination of elements, create more attention than anything else in a composition. The dominant element is usually a focal point in a composition and contributes to unity by suggesting that other elements are subordinate to it.

**emulsion** A liquid in which droplets of a second liquid are suspended until painted on a surface, where they dry and bond together.

**engraving** A technique in which a design is incised in a plate of metal, wood, or plastic. A print is then made from the plate.

**Enlightenment** A philosophical movement of the eighteenth century marked by faith in science and reason.

**environmental art** An artwork that is part of the environment surrounding it, or which provides an enclosed environment that viewers can enter; or an arrangement that the viewer can walk around or through.

**environmental design** Careers that are centered on the places people visit and where they live and work. For example, these include architecture, landscape architecture, and interior design.

**etching** A technique in which a metal plate covered with an acid-resistant coating is incised by needle scratches. The plate is then immersed in acid and a print is made from the plate.

**evaluation** A process used to determine the quality or lasting importance of a work.

**Expressionism** An art movement developed at the end of the nineteenth and the beginning of the twentieth century in Germany. This style emphasized the expression of the artist's emotions through the use of strong color, exploitation of media, and the use of suggestive and symbolic imagery.

**expressive lines** Lines that are produced to express an idea, mood, or quality (for example, graceful, nervous, delicate, aggressive, etc.).

**expressiveness** The degree to which a work reflects a theme, emotion, or worldview.

**eye level** A horizontally drawn line that is even with the viewer's eye. In landscape scenes it can be the actual horizon line, but it can also be drawn in still life.

**facade** (fah-*sahd*) The front of a building. The facade accents the entrance and usually prepares the viewer for the architectural style inside.

**fashion design** Creating and producing apparel for every occasion.

**Fauvism** (foe-*vizm*) An early-twentieth-century style of painting developed in France. The artists, led by Matisse, used brilliant and explosive color to express the inner quality of their subjects, rather than how they appeared in nature. They were called Fauves, or "Wild Beasts," because critics thought they used colors in a violent, uncontrolled way.

**ferroconcrete** A principle of construction employing concrete reinforced with steel rods.

**fiber art** Artworks made up of fiber materials such as grasses, raffia, and twigs. They are sometimes woven together, braided, knotted, and gathered to create depth.

**figure-ground** The perceptual tendency to divide visual patterns into two kinds of shapes with the figure(s) appearing to be on top of, and surrounded by, the ground(s). In the pictorial arts, the relationships between images and the background. Figure and ground are often referred to as positive shape and negative shape.

**film** The recording of moving images that can be viewed again and again.

**film and television graphics** The design and production of films and tapes.

**fine artist** A person skilled in the making of symbols and the use of media and techniques; one who creates compositional arrangements that demonstrate uniqueness of interpretation and individuality of technique.

**flat wash** An area of thin paint that is uniform throughout.

**flying buttress** An external support for the wall of a Gothic cathedral consisting of a half arch connected to a narrow masonry pier outside the building.

**foreground** The area of a picture that appears to be closest to the viewer.

**foreshortening** A method of applying perspective to an object or figure so that it seems to recede in space by shortening the depth dimension, making the form appear three-dimensional.

**form** An element of design that appears three-dimensional and encloses volume such as a cube, sphere, pyramid, or cylinder. The term may also refer to the characteristics of an artwork's visual elements (lines, color, textures, etc.) as distinguished from its subject matter.

**formalism** A way of using the elements of art and the principles of design to evaluate art.

**forum** In a Roman city, a center of civic, legal, and commercial activity.

**frame** Each individual drawing in a sequence such as a comic strip or a storyboard.

**frame construction** A method of construction in which a skeleton of wooden studs and joists is erected, as in a new house. An exterior of wood, brick, metal, or plaster is added.

**framing** The space and point of view for a picture, as determined by the picture's horizontal and vertical borders.

**fresco** A method of mural painting in which pigments are applied to a thin layer of wet plaster so that they will be absorbed.

**Futurism** A style of art originating in Italy during the early twentieth century that emphasized representation of a dynamic, machine-powered world.

**genre** (*jsahn*-ra) A type of localized art that depicts realistic scenes or events from everyday life.

**genre subjects** Subject matter of ordinary people in ordinary settings.

**geometric shapes** (*rectilinear*) Mechanical, human-made shapes such as squares, triangles, circles, etc. Geometric shapes have regular edges as opposed to the irregular edges of organic shapes.

**glaze** A thin coating of minerals that gives the surface a glass-like quality. Used in painting and ceramics.

**glossy** A surface texture, such as that of a photographic print, that is shiny and smooth to the touch.

**good design** A condition that is fulfilled when a logical and harmonious relationship exists among all the parts of an object.

**Gothic** A style in European art and architecture that prevailed from the twelfth through the fifteenth century. Gothic architecture, specifically in cathedrals, was characterized by pointed arches, ribbed vaults, and flying buttresses.

**gouache** (gwash) A form of water-soluble paint used to create opacity.

**graded wash** An area of thin or transparent paint that increases or decreases in intensity from dark to light, light to dark, or both.

**graphic art** The art of printmaking in any form. In commercial art, advertising, book and magazine illustration, cartoons and signs, etc., for commercial purposes.

**graphic design** Creating visual communications with two-dimensional media and images.

**ground** The treated surface on which a painting or drawing is made. A coating such as priming or sizing is used to prepare a support (e.g., bare canvas or wood) for a painting.

**harmony** A condition in which the elements of an artwork appear to fit well together.

**hatching** Shading using closely spaced, parallel lines; used to suggest light and shadow.

**hieroglyph** (high-row-*gliff*) A form of ancient writing in which pictures or symbols are used to represent sounds, words, or ideas.

**high and low placement** A technique in which the artist places an object lower in the picture plane to make it appear closer to us than another object that is placed higher.

**High Renaissance** In art and architecture, the flowering of the Renaissance (c. 1495–1525). (See also *Renaissance.*)

**Hinduism** (*hin*-doo-izm) The world's most ancient religion. It is polytheistic (worshippers believe in many gods). Hindus believe in reincarnation, that life is an endless cycle of birth and death.

**historical context** The historical circumstances of an artwork, periods of history and style prevalent when the work was created.

**hue** The property of color that distinguishes one gradation from another and gives it its name.

**humanism** Devotion to human concerns; the study of humanity.

**hypothesis** An informed assumption proposed for the purpose of argument.

**idealism** A concept of perfection, particularly in the treatment of the human figure.

**idolatry** The worship of an image.

**illustration** A drawing with any medium used to clarify ideas.

**implied line** Lines that are indicated indirectly in artworks at edges where two shapes meet, where a form ends and the space around it begins, or by positioning several objects or figures in a row.

**implied movement** The appearance of movement in a static artwork resulting from an artist's use of elements such as: subject matter, line, shape, progression, repetition and alternation, running or pointing figures, etc.

**impressing** Making figures and shapes by stamping or pushing patterns and symbols into soft surfaces such as clay, leather, or copper foil.

**Impressionism** The first of the modern art movements, developed in France during the second half of the nineteenth century; it emphasized the momentary effects of light on color in nature.

**incising** Making lines and figures by cutting into a surface with a sharp tool.

**industrial design** A career that involves conceiving of and designing objects that meet the needs of people.

**Industrial Revolution** A significant change in the economies of Western Europe and the United States during the nineteenth century marked by the introduction of power-driven machinery and mass production.

**installation art** Often large in scale and temporary, these assembled artworks often juxtapose two- and three-dimensional objects and materials.

**intaglio** (in-*tah*-lee-oh) A technique of printmaking where lines and areas are etched, engraved, or scratched beneath the surface of a metal or plastic plate. Ink is then transferred from the plate onto paper.

**intensity** The degree of purity, saturation, or strength of a color. High-intensity colors are bright; low-intensity colors are dull.

**interior design** A career that involves planning space inside a house or building, including furnishings.

**intermediate colors** Colors produced by mixing a primary color and the adjacent secondary color on the color wheel. (For example, yellow and green for yellow-green.) They are also made by mixing unequal amounts of two primaries. (For example, adding more yellow to a combination of yellow and blue produces yellow-green.)

**interpretation** An explanation of the meaning of an artwork.

**invented texture** A simulated texture in a nonobjective artwork. (See also *nonobjective art* and *simulated texture.*)

**ionic** (eye-*ahn*-ik) Classical Greek architecture characterized by slender, elegant columns with spiral device capitals and fluted shafts.

**Islam** (is-*lahm*) The Muslim religion and the Islamic peoples of the nations in which that religion dominates.

**isometric perspective** A method of applying perspective by drawing the height, width, and depth of an object or figure on the same scale at equal angles of 120° with one another. Planes recede on the diagonal, but the parallel lines along edges remain parallel, rather than converging as in linear perspective.

**kiln** (kill-n) A furnace capable of controlled high temperatures used to fire ceramic ware and sculpture.

**kinetic art** Any art construction that contains moving elements that can be set in motion by the action of gravity, air currents, motors, springs, or magnets.

**line** An element of art that is used to define space, contours, and outlines, or suggest mass and volume. It may be a continuous mark made on a surface with a pointed tool or implied by the edges of shapes and forms.

**line of sight** Implied lines suggested by the direction in which figures in a picture are looking, or from the observer's eye to the object being looked at.

**linear perspective** A technique of creating the illusion of depth on a flat surface. All parallel lines receding into the distance are drawn to converge at one or more vanishing points on the horizon line. In one-point linear perspective, receding lines converge to one vanishing point. In two-point perspective, receding lines converge to two vanishing points.

**lithography** A method of printing from a flat stone or metal plate. A drawing is made on the stone or plate with a greasy crayon and chemically treated so that only the greasy drawing will hold ink while the remaining surface resists it. A print is then made from the plate.

**load carrying** Pertaining to a wall or post that supports a ceiling, as distinguished from a non–load carrying wall or post.

**lost-wax process** (also *cire perdue*) A method of casting metal in which a mold is lined with wax, filled with a solid core of heat-resistant materials (vestment), and heated to melt the wax, leaving a thin cavity between mold and core into which metal is poured.

**low relief** (also *bas relief*) Sculpture that projects slightly from the surface.

**Mannerism** A sixteenth-century European art style that rejected the calm balance of High Renaissance art in favor of emotion, distortion of the figure, exaggerated perspective views, and crisp treatment of light and shadow.

**manuscript illumination** Decorating or illustrating a manuscript, popular during the medieval period, in which the pages are often painted with silver, gold, and rich colors.

**masonry** A medium of architecture consisting of stone or brick.

**mastaba** (mah-*stah*-bah) A low, rectangular Egyptian tomb made of mud brick with sloping sides and a flat top.

**matte** A surface texture that is smooth but not slippery.

**medieval** (mee-*dee*-vuhl) Pertaining to the Middle Ages.

**medium** (pl. media) The materials, such as oil, watercolor, etc., used to create an artwork; or a category of art such as drawing, painting, or sculpture.

**metal frame** A principle of construction in which narrow lightweight members of iron or steel are joined to form a framework to which walls and ceiling can be attached.

**Middle Ages** The period of western European history from the decline of the Roman Empire to the beginning of the Renaissance (476 CE to 1400 CE).

**middle class** The class of society between the upper class and the lower class. In pre-industrial Europe, the class of merchants, traders, and professionals that was beneath the aristocracy and above the peasant class.

**minaret** (min-*ar*-et) A high, slender tower attached to or near a mosque with balconies from which a crier calls the people to prayer.

**minimal art** A twentieth-century style that stressed reducing an artwork to minimal colors, simple geometric forms, lines, and textures.

**mixed media** An artwork made with more than one art medium.

**mixed wash** Transparent colors are placed on a damp paper and allowed to flow together, resulting in mixed colors.

**mobile** A kinetic sculpture, invented by Alexander Calder in 1932, constructed of shapes that are balanced and arranged on wire arms and suspended from above so as to move freely in air currents.

**mold** A hollow container that produces a cast by giving its form to a substance (molten metal, plastic, or plaster) placed within it and allowed to harden.

**monochromatic** One color that is modified by changing the values and saturation of the hue by additions of black or white.

**monotheism** The belief in one god.

**mosaic** A mural technique formed by placing colored pieces of marble or glass (tesserae), small stones, or ceramic tiles in a layer of adhesive material.

**mosque** (mahsk) A Muslim house of worship.

**movement** A principle of design associated with rhythm, referring to the arrangement of parts in an artwork to create a sense of motion to the viewer's eye through the work. (See *implied movement, optical movement.*)

**multimedia design** Careers associated with various entertainment venues such as movies, games, and effects.

**mural** A large design or picture created directly on the wall or ceiling.

**negative space** The space not occupied by an object or figure but circulating in and around it, contributing to the total effect of the composition.

**Neoclassicism** ("New Classicism") A style of art in the nineteenth century in which artists and critics sought inspiration from the classical art of ancient Greece and Rome and imitated its themes, simplicity, order, and balance.

**neutral colors** Colors such as black, white, and gray, not associated with any hue and neither warm nor cool. Also, colors that have been "grayed" or reduced in saturation by mixing with a neutral or complementary color.

**non–load carrying** Pertaining to a wall attached to a frame structure. A wall that does not support a roof.

**nonobjective art** Artworks that have no recognizable subject matter such as figures, flowers, buildings, etc.

**non-Western** Any culture that is not related to the United States and Canada or to western Europe.

**one-point perspective** A way to show three-dimensional objects on a two-dimensional surface, using one vanishing point. One object faces the viewer; the lines defining other objects in the artwork recede at an angle to a single vanishing point on the horizon line. (See *perspective.*)

**Op Art** A twentieth-century style in which artists sought to create an impression of movement by means of optical illusion.

**opaque** (oh-*payk*) In the two-dimensional arts, an area that light does not pass through. The opposite of transparent.

**open form** Forms in paintings and sculpture that emphasize openings.

**opinion** A personal belief or impression that may be true for the individual but not for other people.

**optical mixing** An effect in which colors or black and white laid side by side seem to blend together; mixing takes place in the eye.

**optical movement** An illusion of movement, or implied movement, caused by the response of the eye to lines, shapes, and colors arranged in artworks. (See *Op Art.*)

**organic shapes** (also *bimorphic*) Free forms, or shapes and forms that represent living things having irregular edges, as distinguished from the regular edges of geometric shapes.

**outline** Lines with little variation that describe the outer edges of shapes that appear flat.

**overlapping** A technique in which the artist creates the illusion of depth by placing one object in front of another.

**painting** Artworks made of colored powders mixed with a liquid. Some media include: watercolor, tempera, oil, acrylic, and fresco.

**pan** Moving a camera from side to side in a stationary position.

**papier-mâché** (*pay*-per ma-*shay*) A technique of creating three-dimensional or relief sculpture by molding strips of paper soaked in glue or paste.

**pastel** A chalky, colored crayon consisting of pigment and adhesive gum. Also, paintings done with such crayons.

**patina** (pah-*tee*-nah) The surface coloration on metal caused by natural oxidation. This effect can also be produced by the application of heat, chemicals, and polishing agents.

**pattern** The repetition of elements or combinations of elements in a recognizable organization.

**performance art** Works of a theatrical nature performed by the artist before an audience. A performance may involve props, lights, sound, dialogue, etc.

**perspective** The representation of three-dimensional objects on a flat surface to produce the same impression of distance and relative size as that received by the human eye.

**philosophy of art** The study of art that involves asking and answering all kinds of questions about art, how people respond to it, and how it relates to our lives.

**photography** The art of making photographs for fine art or commercial purposes.

**picture plane** The flat surface or plane that the artist organizes the picture in.

**piece mold** A mold with sections completely free of undercuts. It may consist of two or more pieces and is generally made from plaster.

**pigment** A powdered coloring material for paint, crayons, chalks, and ink.

**pilgrimage** The journey of a pilgrim to a shrine; in the Middle Ages, the journey to a cathedral to see and be in the presence of a relic.

**plane** A flat, two-dimensional surface.

**pluralism** A condition of art or culture in which many styles and doctrines of taste coexist.

**pointed arch** A masonry construction in which a number of wedge-shaped stones form curves that come to a point.

**polytheism** The belief in many gods.

**Pop Art** An art style, also known as neo-Dada, developed in the 1950s. Pop artists depicted and satirized popular culture such as mass-media symbols, comic strips, fast food, billboards, and brand-name products.

**porcelain** Ceramic ware made from a specially prepared, fine white clay that fires at the highest temperatures. Porcelain is hard, translucent, thin walled, and rings when struck.

**positive and negative shapes** In pictures, positive shapes are the figures and negative shapes make up the ground.

**positive space** The enclosed areas or objects in an artwork. They may suggest recognizable objects or nonrepresentational shapes.

**post and lintel** A method of construction in which two vertical members (posts) support a horizontal member (lintel) to create a covered space.

**Post-Impressionism** A style developed in the 1880s in France in reaction to Impressionism. It included artists such as Cézanne, Seurat, Gauguin, and van Gogh. The first two artists explored the formal structure of art while the other two championed the expression of personal feelings.

**postmodernism** A loosely defined term referring to a new cycle in art history and culture in general.

**pottery** Ceramic ware made of clay and hardened by firing at low temperatures.

**Pre-Columbian** The history of the peoples living in Central and South America before the time of Columbus.

**Pre-Raphaelite** A painter or writer belonging to or influenced by the Pre-Raphaelite Brotherhood, a society founded in England in 1848 to advance the style and spirit of Italian painting before Raphael.

**primary colors** The three basic colors, red, yellow, and blue, from which it is possible to mix all other colors. The primaries cannot be produced by mixing pigments.

**principles of design** Unity, variety, emphasis, rhythm, movement, balance, pattern, and proportion. The effects that may result when the art elements are structured to achieve a successful composition.

**printmaking** Any of several techniques for making multiple copies of a single image. Some examples are woodcuts, etchings, collographs, and silkscreens.

**product design** A career relating to the design and creation of models for commercial products.

**proportion** A design principle reflecting the size relationship of parts to one another and to a whole.

**proximity** The tendency to see thing that are overlapped, touching, or close together as groups. A strategy used by artists to structure the visual information in an artwork.

**radial balance** A balance arrangement that results from the repetitive placement of elements radiating out from a central point.

**Realism** A mid-nineteenth-century style in which artists turned to painting familiar scenes and events as they actually appeared in nature in the belief that subject matter should be shown true to life, without stylization or idealization, as in Neoclassicism and Romanticism.

**Reformation** A sixteenth-century religious movement marked by the establishment of the Protestant Church.

**Regionalism** An art movement of the early twentieth century that concentrated on realistic depictions of the rural American Midwest.

**relic** An object that is worshipped because it is believed to be associated with, or part of the remains of, a Christian saint or martyr.

**relief** A type of sculpture in which forms project from a background. It is classified according to the degree in which it is raised from the surface: high relief, low relief, etc.

**relief print** A print produced when raised surfaces are inked and applied to paper or other materials. Woodcuts, linocuts, and collographs are examples of relief prints.

**Renaissance** (ren-eh-*sahnss*) A period in Western history (c. 1400–1600) marking a "rebirth" of cultural awareness and learning, founded largely on a revival of Classical art and writing.

**repoussé** (ree-*pooh*-say) A metalworking process of hammering or pressing sheet metal into relief on one side to create shapes or patterns on the other side.

**rhythm** A principle of design that refers to ways of combining elements to produce the appearance of movement in an artwork. It may be achieved through repetition, alternation, or progression of an element.

**ribbed vault** A cross vault reinforced at the intersections with ribs.

**Rococo** (roh-*koh*-koh) An eighteenth-century style of art and interior decoration that emphasized portrayal of the carefree life of the aristocracy, rather than historical or religious subjects.

**Romanticism** A style of art that flourished in the early nineteenth century. Romanticism emphasized personal emotions, dramatic action, and exotic settings using literary and historical subject matter.

**samurai** A professional warrior belonging to the class of the Japanese feudal military aristocracy.

**saturation** The purity, vividness, or intensity of a color.

**screen print** A print created by attaching stencils to porous fabrics such as nylon and polyester. Ink is squeezed through openings in the stencil to produce a print. Originally called silkscreen because that was the fabric first used for the process.

**sculpture** Three-dimensional forms (sculpture in the round) or forms in relief created by carving, assemblage, or modeling.

**sculpture in the round** A freestanding sculpture meant to be seen from all sides.

**secco** (*se*-koe) A mural technique created by painting on a dried lime-plaster wall with pigment ground in casein.

**secondary colors** Colors that result from a mixture of two primary colors. On the twelve-color wheel, orange, green, and violet.

**sequence** In the popular arts of comics and movies, and in multiple exposure photography, the following of one event or image after another in logical ordering.

**serigraph** (sehr-*ig*-raff) A term originated to refer to the screen process when done by an artist rather than commercially. It means "drawing on silk."

**sgraffito** (skrah-*fee*-toe) Decorating a surface such as clay, plaster, or glass, by scratching through a surface layer to expose a different color underneath.

**shade** Variations in the dark and light of color made by adding black to the color.

**shape** An element of art. An enclosed space defined by other art elements such as line, color, and texture.

**shape constancy** The tendency to see the shape of a three-dimensional object as unchanging regardless of any change in position or angle from which it is viewed.

**Shintoism** (*shin*-toe-izm) A Japanese religion that emphasizes reverence for family, race, and above all, the ruling family as direct descendants of the gods.

**shogun** The hereditary commander of the Japanese army who until 1867 exercised absolute rule under the nominal leadership of the emperor, much like a military dictatorship.

**shot and sequence** An unbroken segment of a scene or action in a film or videotape; a series of shots.

**similarity** A strategy for organizing components of an artwork, such as color, shape, texture, size, or form, that are alike in one or more ways.

**simulated texture** Texture in an artwork that can be seen but not touched, as distinguished from the actual texture of the work itself.

**size constancy** The tendency to see the size of an object as unchanging regardless of the distance between the viewer and the object.

**social context** The environment in which the artwork was created, and how it was experienced by people of that time and place; their aesthetic preferences.

**space** An element of art that indicates areas between, around, above, below, or within something.

**spectrum** Bands of colored light created when white light is passed through a prism. Also, the full range of colors.

**split complementary** On the color wheel, a hue that is combined with hues on either side of its complement.

**stabile** A term adopted by Alexander Calder to identify standing constructions that emphasize space, as do mobiles, but do not have moving parts.

**stoneware** Ceramic ware made from clay that is fired at a relatively high temperature (2200°F). It is hard and nonporous.

**storyboard** In filmmaking, a series of pictures that resemble comic strips, corresponding to a sequence. Each illustration represents a shot.

**stupa** (*stew*-pah) A large, mound-shaped Buddhist shrine.

**style** The identifying characteristics of the artwork of an individual, a group of artists, a period of time, or an entire society.

**subculture** A group of people who share in part the culture of a larger group to which they belong nationally or ethnically, but who have identifiable differences as a group.

**subject matter** The things that are represented in an artwork, such as people, buildings, trees, etc.

**Surrealism** A twentieth-century literary and artistic movement that attempts to express the workings of the subconscious and is characterized by fantastic imagery and incongruous juxtaposition of subject matter.

**symmetrical balance** A balance arrangement in which the parts of a composition are organized so that one side duplicates or mirrors the other.

**tactile** The sensation of touch. Some surfaces may be perceived through touch.

**Taoism** (*dow*-izm) A Chinese philosophy based on the belief that to achieve lasting happiness one must follow a life of simplicity, modesty, patience, and obedience to the laws of nature.

**tempera** A technique of painting in which water-based paint is mixed or tempered with egg yolk.

**tesserae** (*tess*-ah-ree) The small cubes, usually pieces of glass or clay, used in making mosaics.

**texture** The surface quality of an artwork usually perceived through the sense of touch. However, texture can also be implied, perceived visually though not felt through touch. (See also *simulated texture*.)

**three-dimensional** Having height, width and depth.

**tint** A lighter value of a hue made by adding a small amount of another color to it.

**totem** (*toe*-tem) An object, such as an animal or a plant, that serves as an emblem of a family or clan.

**track** In filmmaking, to move or follow an action.

**traditional art** Works that have form, style, and subject matter that are familiar to the public as art.

**trapezoid** A shape with four angles and four sides, only two of which are parallel.

**triadic color scheme** Any three colors equidistant on the color wheel.

**two-dimensional** Having height and width.

**two-point perspective** A way to show three-dimensional objects on a two-dimensional surface, using two vanishing points and two sets of converging lines to represent forms. These forms are seen from an angle and have two receding sides. Two dimensions appear to recede: width and depth. (See also *perspective*.)

**ukiyo-e** (oo-key-oh-eh) ("the art of the floating world") Japanese art that centered around the district of Edo and popular culture. Commonly produced in woodcuts.

**unity** A principle of design related to the sense of wholeness that results from the successful combination of the component elements of an artwork.

**value** An element of art concerned with the degree of lightness of colors. Darker colors are lower in value.

**vanishing point** A point on the eye-level line, toward which parallel lines are made to recede and meet in perspective drawing.

**variety** A principle of design concerned with the inclusion of differences in the elements of a composition to offset unity and add interest to an artwork.

**vault** An arched roof or covering made of brick, stone, or concrete. (See *barrel vault* and *cross vault*.)

**vehicle** A liquid binding agent in paint such as water, oil, or egg yolk that allows the paint to adhere to the painting surface.

**video art** Artworks made with the use of electronic media that converts scanned images to electronic signals viewed on a screen.

**viewers** For purposes of this book, people who look at and analyze artworks.

**warm colors** Those hues in which yellow and red are dominant.

**wash** A transparent layer of color applied to a surface allowing underlying lines, shapes, and colors to show through. Watercolor or ink that is diluted with water to make it lighter in value and more transparent.

**waste mold** A plaster mold from which one cast is taken. The mold is formed around a clay model in two or three removable parts, which are reassembled and filled with liquid plaster that is allowed to harden. The mold is broken away (wasted) to reveal the cast.

**wax resist** The process by which wax is drawn or stamped onto cloth.

**weight shift** A breakthrough technique in the art of representing the human figure showing how a human figure looks when putting most weight on one leg, and bending the other.

**wood engraving** A technique of relief printmaking in which a design is cut into the end grain of a wooden block. Wood engravings contain more detail than woodcuts.

**wood frame construction** A principle of construction in which narrow lightweight members of wood are joined to form a framework to which walls and ceiling can be attached.

**woodcut** A technique of relief printmaking in which a design is cut into a block of plank wood with knives and gouges, leaving raised shapes to receive ink. A print is then made from the block.

**Zen Buddhism** A school of Mahayana Buddhism that asserts that enlightenment can be attained through meditation, self-contemplation, and intuition rather than through faith and devotion and that is practiced mainly in China, Japan, Korea, and Vietnam.

**zoom** In filmmaking, to make an image appear nearer or farther by means of a zoom lens.

# Index

Page numbers in **boldface** refer to illustrations.

# Credits

38 Mariana Yampolsky, *Portrait of Elizabeth Catlett*, c. 1946. Photograph, 8⅝" x 8¾" (21.9 x 22.3 cm). National Portrait Gallery, Smithsonian Institution; Purchase from Sandra Berler, 29 May 1991. © Fundaciòn Cultural Mariana Yampolsky, A.C. 55 Alexander Calder, *Calder's Circus*, 1926–1931. Mixed media; wire, wood, metal, cloth, yarn, paper, cardboard, leather, string, rubber tubing, corks, buttons, rhinestones, pipe cleaners, bottle caps, overall: 54" x 94¼" x 94¼" (137.16 x 239.4 x 239.4 cm). Whitney Museum of American Art, New York; Purchase, with funds from a public fundraising campaign in May 1982. One half the funds were contributed by the Robert Wood Johnson Jr. Charitable Trust. Additional major donations were given by The Lauder Foundation, the Robert Lehman Foundation, Inc., the Howard and Jean Lipman Foundation, Inc., an anonymous donor, The T. M. Evan Foundation, Inc., MacAndrews & Forbes Group, Inc., the DeWitt Wallace Fund, Inc., Martin and Agneta Gruss, Anne Phillips, Mr. And Mrs. Laurance S. Rockefeller, the Simon Foundation, Inc. Marylou Whitney, Bankers Trust Company, Mr. And Mrs. Kenneth N. Dayton, Joel and Anne Ehrenkranz, Irvin and Kenneth Feld, Flora Whitney Miller. More than 500 individuals from 26 states and abroad also contributed to the campaign. Photo by Jerry Thompson. © 2004 Estate of Alexander Calder/Artist Rights Society (ARS), New York. 63 M. C. Escher, *Self-Portrait*. © 2003 Cordon Art B. V.-Baarn, Holland. All rights reserved. 93 Henry O. Tanner, *Self-Portrait*, c. 1910. Pencil and conte crayon on paper, 8½" x 8⅜" (21.6 x 21.3 cm). Smithsonian American Art Museum, Washington, DC/Art Resource, NY. 134 Alfred Stieglitz, *Georgia O'Keeffe*, 1932. Gelatin silver print, 9⅛" x 7¼" (23.2 x 18.4 cm). The Georgia O'Keeffe Museum, Santa Fe; Gift of The Georgia O'Keeffe Foundation/Art Resource, NY. © 2004 The Georgia O'Keeffe Foundation/Artists Rights Society (ARS), New York. 158 *Vincent van Gogh*, January 1873. Photograph by J. M. W. de Louw, photographer at The Hague. The Van Gogh Museum, Amsterdam; Vincent van

Gogh Foundation. 186 Pomo weaver. Photograph © Peabody Museum, Harvard University. 192 © Sandy Skoglund. 215 Mary Cassatt, *Self-Portrait*, c. 1880. Watercolor on paper, 13" x 9⅝" (33 x 24.4 cm). Photo courtesy the National Portrait Gallery, Smithsonian Institution/Art Resource. 238 Grant Wood, *Self-Portrait*, 1932. Oil on masonite panel. Collection of Figge Art Museum; Museum Purchase. © Grant Wood/ Licensed by VAGA, New York, NY. 265 Arnold Newman, *Marisol*, 1985. Photograph, 33.3cm x 22cm (13⅛" x 8¹¹/₁₆"). National Portrait Gallery, Smithsonian Institution; Purchase from Arnold Newman, 20 Dec 1991. © Arnold Newman/Getty Images. 280 Jesús Moroles, *Figure-Front View-#000059*. Baltic Brown granite, 107⅜" x 30" x 1" (272.7 x 76.2 x 2.54 cm); *Figure-Front View-#000058*, China Mauve granite, 107⅜" x 30½" x 1" (272.7 x 77.8 x 2.54 cm). Courtesy of the artist. 318 Maya Lin. Photo by Cheung Ching Ming. Courtesy of the artist. 311 Frank Lloyd Wright. Photo by OBMA. Courtesy the Frank Lloyd Wright Archives, Scottsdale, AZ. 346 Annie Leibovitz. lsd/Photo by Larry Downing Reuters. © Reuters NewMedia Inc./Corbis. 341 Deena Appel. Austin Powers III. Photo: Melinda Sue Gordon SMPSP, Courtesy of New Line Productions/© 2002 New Line Productions. 429 Leonardo da Vinci, *Self-Portrait*. Red chalk drawing. Biblioteca Reale, Turin, Italy. Scala/Art Resource, NY. 432 Carlo Maria Mariani Photo by Thomas Moore.

## Licensed by VAGA, New York, NY

© Muriel Castanis, 440; © Elizabeth Catlett, 38, 208; © The Joseph and Robert Cornell Memorial Foundation, 175; © Marisol Escobar, 256; © Janet Fish, 51; © Nancy Graves Foundation, 468; © Estate of Duane Hanson, 261; © Jasper Johns, 262; © Carlo Maria Mariani, 432, 440; © Clayton Pond, 229; © Robert Rauschenberg, 9, 14; © George and Helen Segal Foundation, 261; © Estate of Ben Shahn, 40; © Estate of Robert Smithson, 268; © Grant Wood, 189, 238, 252.

## Artists Rights Society

© 2004 The Josef and Anni Albers Foundation/ARS, NY, 7, 16, 23; Joseph Beuys Art © 2004 ARS, NY/VG Bild-Kunst, Bonn, 8, 466; Georges Braque Art © 2004 ARS, NY/ADAGP, Paris, 107, 460; © 2004 Estate

of Alexander Calder/ARS, NY, 55, 171; Marc Chagall Art © 2004 ARS, NY/ADAGP, Paris, 442; © 2004 Judy Chicago/ ARS, NY, 254; © 2004 Salvador Dalí, Gala-Salvador Dalí Foundation/ARS, NY, 143, 185, 463; Jean Dubuffet Art © 2004 ARS, NY/ADAGP, Paris, 164; © 2004 ARS, NY/ADAGP, Paris/ Succession Marcel Duchamp, 463; Julio Gonzalez Art © 2004 Artists AR), NY/ ADAGP, Paris, 264; Arshile Gorky Art © 2004 ARS, NY, 464; © 2004 Estate of Hans Hofmann/ARS, NY, 132; Wassily Kandinsky Art © 2004 ARS, NY/ADAGP, Paris, 460; Käthe Kollwitz Art © 2004 ARS, NY/VG Bild-Kunst, Bonn, 79, 126; Joseph Kosuth Art © 2004 Joseph Kosuth/ARS, NY, 266; © 2004 Gwendolyn Knight Lawrence/ARS, NY, 184, 219; Le Corbusier Art © 2004 ARS, NY/ADAGP, Paris/FLC, 310; © 2004 Succession H. Matisse, Paris/ARS, NY, 35, 36, 101, 188, 191, 458; László Moholy-Nagy Art © 2004 ARS, NY/VG Bild-Kunst, Bonn, 283; © 2004 Mondrian/Holtzman Trust c/o ARS, NY, 126, 323; © 2004 The Munch Museum/ The Munch-Ellingsen Group/ARS, NY, 178; © 2004 Estate of Louise Nevelson/ARS, NY, 445, 465; © 2004 The Georgia O'Keeffe Foundation/ARS, NY, 28, 134, 146; Eduardo Paolozzi Art © 2004 ARS, NY/DACS, London, 88; © 2004 Estate of Pablo Picasso/ ARS, NY, 65, 91, 94, 102, 237, 445, 461; © 2004 The Pollock-Krasner Foundation/ARS, NY, 464; Gino Severini Art © 2004 ARS, NY/ADAGP, Paris, 215; Victor Vasarely Art © 2004 ARS, NY/ADAGP, Paris, 182.

*Publisher:* Wyatt Wade

*Managing Editor:* David Coen

*Editorial Consultants:* Claire Mowbray Golding, Helen Ronan, Karl Cole, Alison Davis Wade

*Editorial Assistant:* Jillian Johnstone

*Manufacturing Manager:* Georgiana Rock

*Design/Production:* WGBH Design, Douglass Scott, Tong-Mei Chan, Cara Joslin, Katie Wetherby

*Production:* Victoria Hughes Waters, Matt Mayerchak

*Illustrator:* Susan Christy-Pallo